W9-DBU-837 34

To my friend Sue,
 I love you,
 Jess

7 '23
STRAND PRICE
5 00

Paula Modersohn-Becker

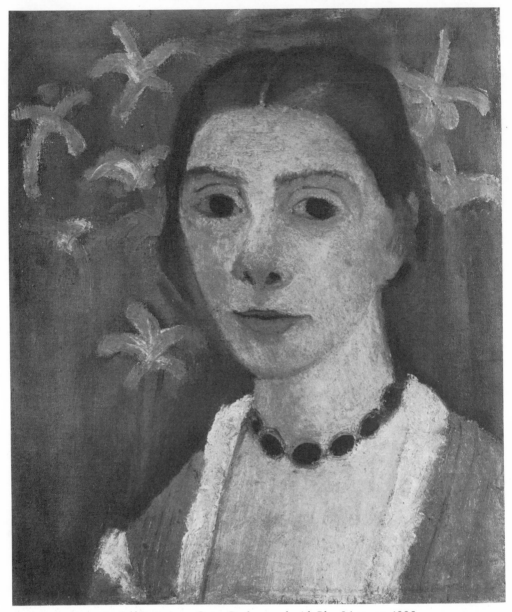

1. Self-Portrait on Green Background with Blue Irises, *ca. 1905*

Paula Modersohn-Becker

THE LETTERS AND JOURNALS

Edited by
Günter Busch and Liselotte von Reinken

Edited and Translated by
Arthur S. Wensinger and Carole Clew Hoey

TAPLINGER PUBLISHING COMPANY, NEW YORK

First published in the United States in 1983 by
Taplinger Publishing Company, Inc.
New York, New York

English translation © 1983 by Taplinger Publishing Co., Inc.

All rights reserved

Printed in the United States of America

Library of Congress Cataloging in Publication Data

Modersohn-Becker, Paula, 1876–1907.
 Paula Modersohn-Becker, the letters and journals.

 Translation of: Paula Modersohn-Becker in Briefen und
Tagebüchern.
 Bibliography: p.
 Includes index.
 1. Modersohn-Becker, Paula, 1876–1907. 2. Painters—
Germany—Correspondence. 3. Painters—Germany—Biog-
raphy. I. Busch, Günter. II. Reinken, Liselotte von.
III. Title.
ND588.M58A3 1984 759.3 [B] 82-19232
ISBN 0-8008-6264-3

PHOTO CREDITS

Bremen: Kunsthalle. Nos. 1, 8, 21, 27, 29, 30, 34, 36, 46
Paula Modersohn-Becker Archives. Nos. 2, 3, 4, 9, 11, 15, 16, 17, 18, 19, 20,
22, 23, 24, 25, 26, 28, 31, 32, 33, 37, 38, 39, 40, 41, 42, 43, 45
Michael Wildhagen. No. 6
Hamburg: Kunsthalle. No. 35
Worpswede: Willfried Cohrs. No. 13
Worpswede Archives. Nos. 7, 10, 12, 14
Wuppertal: Von der Heydt-Museum. No. 44

This book was set in Sabon, a typeface designed by Jan Tschichold
in 1964. Sabon, which is especially suited for books because it is
so readable, has a similarity to Garamond, a typeface named
after the great French printer of the sixteenth century. The size of
the type is ten points. The book is printed on Mohawk
Vellum Smooth paper.

Design: Laura Ferguson
Composition: Columbia Publishing Company, Inc.
Production: Ganis & Harris, Inc.

CONTENTS

PREFACE

During the past two decades the name and reputation of Paula Modersohn-Becker have become increasingly well known in this country. Although she never thought of herself as belonging to any one school of painting, she has nevertheless been called everything from Neo-Impressionist to primitivist to proto-Expressionist. Yet the great variety and scope of her work make it difficult to assign her to any one specific movement; her boundless experimentation with form, line, and color defies all easy categories. Whatever claims have been made for her, however, one thing is clear: Paula Modersohn-Becker is now generally acknowledged to be the most important woman painter of twentieth-century Germany.

And she left us more than her art. Her letters and journals are a stirring document of the personal life and brief career of a sensitive, enlightened woman at the turn of the century.

This, the first complete edition of the letters and journals, is the culmination of a long and somewhat complex history. In 1917, ten years after her early death, her family arranged for the publication of some of these writings. The task was put in the hands of the journalist Sophie Dorothea Gallwitz, who cautiously and diplomatically selected, arranged, and edited them. That book, the *Briefe und Tagebuchblätter [Letters and Leaves from the Journals]*, became a best seller in Germany and, after the appearance of a revised edition in 1920, went through many reprintings during the next twenty years. The inevitable result was that Paula Modersohn-Becker became first and best known as the author of her own humanly touching, but incomplete, story. Ironically, her recognition as a major modern artist followed only later.

Along with this growing reputation in the years after World War II came the realization that the full story needed to be told, that the famous torso edition could no longer stand as a satisfactory account of her life. By the mid-1970s Günter Busch, the foremost authority on Paula Modersohn-Becker, and Liselotte von Reinken (with the cooperation of the artist's daughter and Wolfgang Werner) had begun the formidable task of collecting and editing all the hitherto unknown, excerpted, and suppressed letters and other materials. In 1979 the S. Fischer Verlag of Frankfurt published this definitive text under the title *Paula Modersohn-Becker in Briefen und Tagebüchern [Paula Modersohn-Becker: The Letters and Journals]*. It is this book, now in its third large printing, which we have translated and, to the extent we felt necessary, edited for the English-speaking reader. Every known word written by the artist and a good number of those to her from members of her family have been included here. The text has been heavily annotated and the apparatus is intended to be exhaustive. What we now have here is the thorough

documentation of the short life of a remarkable woman, the persuasive and moving account of a life of conviction, liberation, and achievement.

Thanks to the painstaking work done in preparation for this book by its German editors, both the general reader and the specialist are presented with an accurate and dependable text. We are now able to see that the sentimentality and pathos that surrounded the first collection of these letters and journals were inappropriate. The new book gives the far more complete picture of this complex artist's humane and creative combination of strength, resiliency, and love. We are given her family background in her family's words, their guidance, their affection, and their perhaps fatal combination of protectiveness, encouragement, and doubt. The precarious balance between Paula Modersohn-Becker's marriage and her trips to Paris is now put in proper perspective. And we are now able to appreciate fully that this determined and divided life, with its exhilarations and depressions, had the modern makings of tragedy in the classical sense. Indeed, the book unfolds like a novel in the form of letters.

If any of the facts of the artist's life are familiar to the English-speaking reader they invariably have been associated with her role in the turn-of-the-century artists' colony at Worpswede near Bremen and her close friendship with the greatest of modern German poets, Rainer Maria Rilke. Readers of Rilke's work will know her as the woman to whom, a year after her early death, he wrote one of the supreme poems in modern German literature, the "Requiem for a Friend." They will probably not know her as one of the truly formative and powerful influences in the poet's life and on his work and way of seeing the world.

For she herself saw the world in a way that was rare for her time. It was a gift most unexpected in a proper young woman from an upper-middle-class family in the staid city of Bremen, and her devoted disobedience was the cause of much perplexity and concern. It must be realized, for instance, that during the first years of this century such a figure as Cézanne was not yet recognized as the fundamental master he has since become in the annals of modern art. Paula Modersohn-Becker was among his earliest admirers. Unlikely as it may seem, this young German artist struggling in Paris and northern Germany was one of the alert pioneers of her age. It may be no exaggeration to claim that by the end of her life, in 1907 at the age of thirty-one, she was emerging in certain basic ways as one of the important heirs of van Gogh and Gauguin and beginning to express herself in a style that looked beyond their ways of rendering the visual world.

Twelve years ago in Northampton, Massachusetts, the artist Leonard Baskin and his wife Lisa thrust a copy of the 1920 *Briefe und Tagebuchblätter [Letters and Leaves from the Journals]* into our hands and demanded that it be translated. In 1972 four students in a German translation seminar at Wesleyan University used it as a text for a group project. Then the work on that book ceased for a year or

more, until we took it up again and produced a new translation. We were about to go to press with it when we learned in 1976 that Günter Busch, director of the Kunsthalle, Bremen's principal museum, and Liselotte von Reinken had begun their work on the vastly expanded new book. Our work was cut out for us; we had to begin essentially from scratch since the earlier material had been so heavily and selectively edited and the text was in many places inaccurate and incomplete.

There are a few differences between the German and the American editions. We have been able to include eleven letters from Paula to Carl Hauptmann and his wife, Martha, and one from Carl Hauptmann to Paula, which have been obtained from the Hauptmann Archives in East Berlin, a number of postcards and notes from the artist, and certain emendations not yet incorporated in the German book. These will appear in later German editions. For the most part the annotations are essentially the same, although we have omitted a few of those in the German edition which are unnecessary for an English-speaking reader. On the other hand, we have annotated many place-names, personal, literary, and historical references, as well as certain German words and phrases that would otherwise remain unclear. The Introduction by Dr. Busch that follows was written especially for this edition. Finally, we have brought the Bibliography and the exhibition checklist up to the date of this writing, adding entries for both the United States and Europe.

The working principle behind our translation was to remain as true as possible to the tone and texture of the original. Paula Modersohn-Becker's generally unadorned and honest style, her straightforward syntax and choice of vocabulary should, we thought at the outset, have made for a relatively easy task. We were wrong. Such simplicity of style proved to be one of the hardest things to render convincingly. In tone and idiom we have tried to adhere to the educated standard English of the day without succumbing to contemporary Americanisms in the hope of bringing Paula "up to date." The few untranslatable words and phrases we encountered have been discussed in the notes. Although the artist's own words make up about eighty-five percent of the text, there are other voices here. The reader will, we trust, be made quickly aware of the distinctions among the styles of such diverse correspondents as the author's mother and father, her sister Herma, Clara Westhoff and Rainer Maria Rilke, Heinrich Vogeler, and the others.

Above all, it is the unique voice and spirit of Paula Modersohn-Becker that must suffuse these pages if the book is to be more than a routine approximation and a reference for students of art history. Our whole intent, therefore, was to capture in English something of the humanity of this rare individual. Our aspiration is to have succeeded in re-creating her life in our own language.

Arthur S. Wensinger
Carole Clew Hoey

April 1982

INTRODUCTION

Paula Becker was born in Dresden, Germany, on February 8, 1876. When she was twelve the family moved to Bremen, where her father Woldemar Becker, a civil engineer with the German railroad system, took up a new position with the Prussian Railroad Administration for the Bremen Metropolitan Area. At the turn of the century the thriving Hanseatic city of Bremen depended, as it still does today, on trade and the shipping industry; the fine arts played only a minor role in the life of this wealthy community. This situation, however, was soon to change, due in great measure first to the success of the artists at the nearby Worpswede colony and later to Paula Modersohn-Becker's eventual recognition as an artist of the first rank.

In 1892 Paula received her first instruction in drawing from a painter of local importance. Later that year she traveled to England to stay for several months with relatives in that country. The purpose of her visit was to learn English and the art of running a household. She was treated to frequent trips to London and there took lessons in sketching at one of the many art schools where pupils learned the decorous art of drawing from plaster casts rather than from living models. The following year she began a two-year training period as a tutor. Her father was of the opinion, rare at the time, that a young girl ought to learn something solid in order to become independent and support herself in later life. She passed her examinations in good order. At this same time, however, the Prussian Railroad Administration in Bremen was disbanded on the grounds that it had become an anachronism and her father was relieved of his position.

In April of the same year Bremen experienced an artistic event of a new and unusual kind. The Kunsthalle, Bremen's major museum, exhibited for the first time works by members of the so-called "Worpsweders." A few years earlier the painters Fritz Mackensen, Otto Modersohn, Fritz Overbeck, Hans am Ende, Carl Vinnen, and Heinrich Vogeler had settled in the small moor village of Worpswede, twelve and a half miles northeast of Bremen. Taking the famous French painting school of Barbizon as their model, these painters turned their backs on the world of industry and the big city and strove toward a regeneration of art in the midst of simple, unfalsified nature side by side with genuine rural people. The exhibition of paintings from the Worpswede colony received very little acclaim; indeed it was clear that the good burghers of Bremen were highly resistant to this art. They were accustomed to more "pleasant" things than these great gloomy canvases with their serious peasant men and women and their dark moor landscapes beneath leaden skies and threatening clouds. When these same painters were exhibited the following fall in the Glass Palace in Munich, however, they enjoyed an instant and huge success. Their new reputation soon found its way back to Bremen, where

the staid Kunsthalle presently bought several of their paintings.

Paula Becker was nineteen years old at the time and had followed these first public artistic happenings of her life attentively. From the moment she saw their work, the artists of Worpswede became her "great men." Following the enthusiastic lead of Frau Mathilde Becker, Paula's mother—a woman of artistic temperament, genuinely devoted to literature, music, and painting—the cultural activities of the city were regularly discussed at the family dining table. Given such a home atmosphere, it is not surprising that Paula's desire to develop her talent for drawing emerged at a relatively early age. In the spring of 1896 she was sent to a two-month course in drawing and painting at the Society of Berlin Women Artists. The following fall she continued instruction in the German capital, at which point she gave up landscape studies in order to devote her energies to portraiture. She made use of all the free time at her disposal to visit the great museums in Berlin and the frequent exhibitions that were held there. In the summer of 1897 she returned home for the holidays and together with her family took a trip out to Worpswede. On the spot, Paula decided to spend several weeks there together with a fellow woman student.

Fritz Mackensen, the founder of the painters' colony and a far more than merely competent figurative painter himself, served as their tutor and critic. It was there that Paula met for the first time her future husband, Otto Modersohn. In the fall she returned once again to Berlin and resumed her course of study under the traditional rubric of Academic Realism. At the end of the year, however, her father suggested that it was now time she accept a position as governess. His modest pension no longer permitted expensive art lessons. But a small inheritance from one member of the family and the promise of financial assistance for three years from another enabled her to remain with her art after all. In addition to her work at the art school in Berlin, she spent more and more time visiting museums and galleries. One of the most important exhibitions she saw was of lithographs by Puvis de Chavannes, Fantin-Latour, Carrière, Redon, Manet, Pissarro, Renoir, Toulouse-Lautrec, Signac, Sérusier, and Vallotton. Here she came into contact for the first time with contemporary French art. In Berlin she was likewise impressed by the works of Edvard Munch, certain of the Belgian artists, and the Hungarian Rippl-Rónai. In the fall of 1898 she moved to Worpswede and made her home in the village. There she became a friend of the painter and sculptor Clara Westhoff, later the wife of the poet Rainer Maria Rilke. Mackensen served as critical adviser to both of them.

The following year Paula attempted her first exhibition, showing several paintings at the Bremen Kunsthalle where the painter-poet Arthur Fitger criticized them in the sharpest possible terms. When one reads his comments more carefully, however, it can be seen that his criticism is directed less against the innocent beginner (whose several figurative studies exhibited in fact considerable seriousness

and strength) than against "new art" in general. To a person like Fitger that term meant above all the work of her teacher Mackensen and his circle. In his time Fitger was a well-known, indeed a famous man, first as a literary figure whose plays were produced throughout the entire German-speaking world; principally, however, he was a very active painter of historical subjects. He carried out vast decorative commissions in the spirit of the historicizing studio art of Late Romanticism, works for such buildings as the neo-Gothic stock exchange in Bremen, the city hall in Hamburg, or for numerous passenger steamships on the North Atlantic run. He must have seen in the atmospheric realism of the Worpsweders, and even more in the rigorous formalism of the younger generation, a betrayal of the ideals of the "Beautiful and Noble" to which all his life he had sworn allegiance.

In 1899 the Kunsthalle, until then a building used primarily for rotating exhibitions, appointed for the first time an art historian as its new director. His predecessors had been dilettantes who sensed their task and their interest to be in the art trade. Within the course of a few years the museum developed into a well-ordered institution adhering to the most modern principles. It was this new director, Gustav Pauli, who would be the first biographer of Paula Modersohn-Becker. Pauli belonged to that perceptive generation of German museum men who, for example, discovered the work of the French Impressionists well before this happened in their own country. Under Pauli's leadership the collections of the Kunsthalle were vastly enlarged. Within a very short period, along with paintings by the Worpswede circle and by Liebermann and Corinth, masterpieces by Manet, Monet, Pissarro, Renoir, and works by Rodin, Maillol, as well as by Courbet, Corot, and Delacroix entered the holdings of the Kunsthalle. They were to have a decisive influence on Paula Becker.

For some years she had been longing to go to Paris, which like the younger generation everywhere she saw as the center of modern art. On the New Year's Eve of the twentieth century she set out on the journey that was to prove central to the unfolding of her artistic destiny. In Paris she met her friend Clara Westhoff, who was shortly to become a pupil of Rodin. For a brief period the two lived in the same *hôtel* on the boulevard Raspail. Paula entered a private art academy run by Philippo Colarossi and also took part in an anatomy class at the École des Beaux-Arts. On a regular basis she visited the Louvre where she continued her lifelong habit of sketching favorite paintings and sculpture, principally the work of the old masters. Among contemporary artists she favored at first such painters as Charles Cottet, Jean-Pierre Laurens, and Lucien Simon. These painters from Brittany had a relationship to the Barbizon School similar both generationally and in terms of dependence to that of the Worpswede painters in Germany. And what Paula sought and discovered in them was a sense and quality of the familiar. One day, however, she took Clara Westhoff into the cellar of Ambroise Vollard's gallery where pictures were stacked with their painted sides facing the wall. She turned

them around and showed them to Clara; they were landscapes, still lifes, and figurative paintings by a painter whose name neither of them knew, Cézanne.

As early as 1896, to be sure, the first Cézanne had come into the collection of the Berlin National Gallery, but Paula seems perhaps to have taken little note of it at the time. Still, considering her extreme reticence in speaking of the work of those who most influenced her, it is difficult to be certain even of this. In any event, confrontation with the work of Cézanne in 1900 was eventually to have the greatest significance for her own art.

In the meantime, her artistic development was to follow a somewhat different course. In June the Worpsweders, Otto Modersohn, Fritz Overbeck, and Heinrich Vogeler, came to the vast World Exposition in Paris. Together with these three painters whom she so admired, Paula studied the art treasures brought together from all over the world and now on exhibition in the many and various pavilions there. The sudden death of Modersohn's first wife Helene put an abrupt end to this pleasant communality of interest and the sharing of international art. At the end of June, Paula returned to Worpswede. Again her father urged her to accept a position as governess, but Paula hesitated. She had long enjoyed a friendly relationship with Herr and Frau Modersohn. The weeks that she and Otto had spent together in Paris indulging their common interest in matters of art had brought them closer and closer together. And now the more personal side of their relationship began to develop. In a short time they were secretly engaged. Soon after that she got to know Rainer Maria Rilke. Two years earlier he had spent time in Worpswede and was now once more a guest of Heinrich Vogeler, whose house was the artistic, literary, and musical gathering point of the community. Paula and Rilke became unusually close friends with a deep understanding of each other, but it is safe to say that their relationship in no way compromised Paula's love for Otto Modersohn.

For the engaged couple and for their art there now began a period of happy and productive mutual inspiration. Under the influence of Otto's landscape painting, Paula turned away for a time from her figurative work with peasant models and returned to painting landscapes herself. The two of them would often sit in front of the same view, striving to outdo each other in a friendly spirit of competition.

Of all the artists in the Worpswede circle, Otto Modersohn was by far the most gifted, both as painter and as draftsman. As a young man in the 1880s he had done a number of small landscape studies of his native countryside around Münster which can truly compare with the best work of Constable, Menzel, or Boudin. He possessed an extraordinary sensibility for color and at the same time his talents for drawing were of a rare and natural kind. He continued to develop these unusual faculties and, inspired by the masters of Barbizon, painted his large, atmospheric Worpswede landscapes in the early 1890s. By the middle of the decade he had achieved considerable esteem and success. By 1900 he had become something of a

famous man—and also one who was eleven years older than the young woman to whom he was engaged. Paula was in a position to learn much from him. She absorbed her lessons rapidly, and after a short time their studies of birch trees and of canals running through the moors, of bathing children and of local peasant cottages, could scarcely be distinguished from one another.

The following year they were married. From entries in Otto's journal we can see how their cheerful competitiveness in art gradually became a more serious battle for the upper hand—less on Paula's side, to be sure, than on her husband's, who was soon forced to recognize how the pupil and neophyte had begun to spread her wings and fly above him. It is important, however, to point out that equivalent or similar results in this competition meant quite different things to the two of them within their own separate artistic developments. Paula was at the beginning of her career. In Paris she had been subjected to many and various sources of inspiration and influence; above all, she had recognized the enormous significance of Cézanne. Returning to Worpswede, she was reimmersed, as it were, in the art of the previous century. By this time Otto Modersohn already had his real period of development behind him. At this stage of his life he was occupied with the methodical process of building on past successes. Suddenly the provocative artistic powers of his wife appeared on the scene. The great simplicity of her forms, the uncompromising way in which she looked at the world around her, the intensity of her use of color—these things seemed to get in his way. He could not avoid recognizing her superiority. Soon his criticisms were directed against her "boldness," against her "exaggerations."

Considering this particular set of artistic and human circumstances it is understandable that Paula strove to get back "into the world," as she herself put it. Worpswede had become by now a small, established art colony, as well as the goal for certain *arrivistes*; it was clearly too confining for her. She needed a dialogue with the greater world of art—and not just art alone. In 1903 she went to Paris for the second time and studied again at the academy of Colarossi. She continued her intensive studies in the Louvre, in the other museums, and at the art galleries. This time Rembrandt's art had a strong effect on her. She got to know Egyptian and archaic sculpture. The newly discovered mummy portraits from Fayum, their closeness to nature, their stylized and remote way of depicting the human face, made a lasting impression on her. Their influence can still be detected in her late self-portraits. On this second trip to Paris she was also able to get closer to Manet, Renoir, and Degas. But finally it was Rodin, the teacher of her friend Clara, who had the strongest effect. His sculpture and his graphic works, but above all his own artistic personality, impressed her as something of truly great proportions.

By the time she returned again to Worpswede at the end of March, she had gained new and different standards not only for her own art but also for evaluating the ac-

complishments of the other artists there. More and more she began working alone, for herself. She sought little contact with the other artists, or at least avoided intimate conversations with them about her own problems as an artist. And more and more, figurative representation and the still life came to the forefront of her work. In her letters and journals, questions dealing with her own art are brought up and articulated less and less frequently.

Between February and April of 1905 she was in Paris once more, often in the company of her sister Herma, who was there to study the French language. She studied at the Académie Julian and again continued her journeys of discovery in the museums and gallery exhibitions. Bonnard, Vuillard, and now Maurice Denis entered her field of vision. During the time her husband came to visit (along with her sister Milly and the Vogelers), there was an opportunity to see the great Gauguin collection of Fayet. Typically, Paula writes nothing about it in letters or journals. The same is true for the van Gogh and Seurat retrospective exhibitions and for the first public appearance of the Fauves, all of which she saw. Instead of admitting to or discussing the profound impression they obviously made on her, she restricts herself to a few general observations, which tend for the most part to be critical.

She returned to Worpswede to digest and rework all that she had seen and learned. In November she painted the portrait of Clara Rilke-Westhoff, whose husband happened to be visiting Worpswede at the time. And it was evidently not until then that Rilke fully recognized Paula Modersohn-Becker as a painter.

During a visit to the Silesian home of the writer Carl Hauptmann (a longtime friend of Otto Modersohn) at the beginning of 1906, Paula and Otto met among others the sociologist Werner Sombart. Both Modersohns seem to have been very impressed by him; Paula painted his portrait. In its expressive simplification this important painting anticipates certain of the formal methods of early Cubism.

At the end of February she traveled for the fourth time to Paris, now with the intention of leaving Worpswede forever and ending her relationship with her husband. (The full details of this painful task and its resolution are told for the first time in the body of the text.) She moved into an atelier on the boulevard Montparnasse, enrolled in an anatomy course at the École des Beaux-Arts, and subscribed to a lecture course there in art history. She admired the Manet exhibition at the gallery of Durand-Ruel, the famous art dealer for the Impressionists. She was less impressed by Redon. Through a set of fortunate circumstances she met the gifted German sculptor Bernhard Hoetger and found in him for the first time someone with whom she could discuss the questions and problems about art that occupied her. Hoetger strengthened her in her determination as a painter. But it was also he who later persuaded her to patch up her relationship with Otto Modersohn.

In the fall her husband came to Paris. He succeeded in regaining his wife and convincing her to resume their married life together. Together they visited the great

Gauguin exhibition at the Salon d'Automne. At year's end while still in Paris they exhibited a number of their works together at the Kunsthalle in Bremen. In his review Gustav Pauli, director of the Kunsthalle, published an encouragingly positive report of her art in one of the Bremen newspapers with express reference to the devastating criticism by Fitger seven years earlier.

In the spring of 1907 Paula and Otto returned to Worpswede together. Paula was expecting a child. During the summer her condition restricted artistic activity. On the second of November she gave birth to her daughter Mathilde (Tille). On the twentieth she died of an embolism. Left on her easel was her final painting, *Still Life with Sunflower and Hollyhocks*, in which the influence of van Gogh and the Nabis is united with her own personal and lapidary style of expression.

Paula Modersohn-Becker was allotted only ten years for her life's work; three of them were years of study. But in the seven years of artistic production she worked on no fewer than 560 paintings and completed more than 700 drawings and 13 etchings. During her lifetime she sold no more than three or possibly four pictures, two of them to her friends the Rilkes and Vogelers. Much of her work in oil consists essentially of studies, not finished paintings. This applies in particular to the landscapes of her early period and her years together with Otto Modersohn. She was perfectly aware of this herself and saw in certain of her figurative pictures little more than experimental exercises toward larger, more important work.

The image of the child plays a very special role as a theme in her art. For her it was the image of the unspoiled human being, and among the peasant children of Worpswede she found ideal models for her concept of the natural, spontaneous, and unaffected. The same is also true for her representations of the peasant men and women themselves, in which the women are frequently painted as mothers with their children. However, it is essential to point out that these works represent the opposite of any folkloristic, native regional art such as we occasionally see from the hand of other painters of the Worpswede colony. The hallmark of her portraiture is a powerful disregard of all conventional notions of beauty. These paintings are documents of human truth. During the Nazi period this led to Paula Modersohn-Becker's being branded as "degenerate." All her paintings in German museums were confiscated by the so-called Säuberungs-Kommissionen, commissions for the "purification" of what was deemed to be the proper representation of *das deutsche Volk*. It was claimed that Modersohn-Becker had painted "only stupid, degenerate children" whose "bad racial makeup was the result of deplorable incest" in the moor village of Worpswede. In fact, her representations of human beings in Worpswede are scarcely to be taken as portraits of individuals; their intention was always the rendering of the fundamental and common qualities of the human being per se. In this sense, Paula Modersohn-Becker painted really very few portraits as the word is commonly understood. And when she did, they

were inevitably portraits of people close to her: her husband, Otto Modersohn's daughter Elsbeth, Clara Rilke-Westhoff, Rainer Maria Rilke, Lee Hoetger the sculptor's wife, or Werner Sombart, to name the outstanding examples. By contrast, there is a relatively large number of self-portraits and they run the entire gamut of her artistic life. But here, too, the personal element, indeed the entire personal mood or atmosphere, is suppressed in favor of an attempt to evoke and conjure the general human essence. This depersonalizing tendency grew with the years. In this connection we must bear in mind the enduring and powerful impression that the late antique and Egyptian mummy portraits had made upon her. All her striving as an artist was aimed at putting aside the external, the incidental, the specific, and getting to the fundamental, primitive qualities of the human vis-à-vis. It was thus a perfectly natural development in her art that she began early to emphasize the nude, the life study. Originally nothing more than academic exercises, these eventuated ultimately in the great nude compositions of mother and child and the wonderful nude self-portraits, including those of herself as a pregnant woman. The human being as subject and object of creation was her theme.

Along with her figurative paintings the still life is of particular importance in her work. She painted approximately seventy of them, and in contrast to many of her landscapes and portraits they were almost all "completed" in the popular sense of the word; that is, few of them contain the sketchily painted areas frequently encountered in her other work. It is clear that her experience of the art of Cézanne gave her the impetus for painting these still lifes. Obvious similarities to his method of composition can be detected without difficulty in her pictures. But in contrast to the weightless, sometimes even airborne modulation of his oils, Paula Modersohn-Becker strives to do more than merely penetrate in a formalistic way the depths of the things she is representing. In her fruits, her earthenware crockery, her flowers, and woven materials, the things with which she populates her simple compositions, she tries to make the common components of creation visible—and she does this in an equally weighted, heavy, and earthy coloration fundamentally opposite to that of Cézanne and the Impressionists before him. Finally, in the canvases done toward the end of her life we may recognize the influence of van Gogh. But here, too, it is less a matter of literal borrowings than of creation from a related aesthetic impulse.

Art critics by and large have put particular emphasis on Gauguin as a model for Modersohn-Becker, especially in connection with the late nude compositions. For certain individual motifs and one or two direct borrowings this is accurate, but in a very limited sense. Even here it would be more accurate to emphasize the inspiration of Cézanne who had an equal influence both on Gauguin and on Paula Modersohn-Becker. Nevertheless, we must be careful to detect something fundamentally absent in the work of the German painter and manifestly central to the style of the French artist: there is an almost total lack of the decorative element

and preciosity in her work, those things that lend the exotic canvases of Gauguin their particular magic and charm.

Paula Modersohn-Becker was a painter of a rare and individual sort. Her work as a graphic artist is of almost equal significance. At first her drawings are completely within the traditional framework of the old masters and their mode and manner of working. That is to say, in the very act of drawing and in her studies and compositions, she directed her inner vision toward the finished picture, never toward pleasing the viewer. Despite this she created drawings that have the artistic power of great pictures. Both in her drawing and painting she sought the truth, the inner rightness of things, and not any lovely pretense or illusion. Almost every artistic product of her hand (that is, of her eye and her heart) is saturated with a feeling of totality in a very special sense. It is the direct expression of her rare ability to distill something complete from reality and from its fragments. In contrast to the art of many of her contemporaries and of the later Expressionists *sans phrase* this happens without sentimentality or the uncontrolled overflowing of emotion. The language of her canvases is simple, sober, strict, astringent, almost tight-fisted — but it is great in its form and in its demands on the observer. And yet in every one of her works there is also, even in a hidden way, a human warmth, a heartfelt quality, and love. This is art that a woman created. However, this description of it must not be misunderstood, especially today, for hers is certainly no "feminist art." Everything programmatic or ideological was antipathetic to her personality and creativity.

First published in book form in 1919, the letters and journals of this artist appeared in Germany in one reprinting and new edition after the other. To a certain extent the text was originally falsified out of personal consideration for those still alive, from the narrow-minded point of view of earlier decades, and also from well-intentioned respect for Paula Modersohn-Becker herself, who had died little more than ten years before the first edition appeared. The book became a veritable classic and best seller in the German-speaking world. It was loved and prized even by those who had no understanding for her work as an artist and indeed by some who actively disliked it. Thus it gradually happened that the charming human personality which spoke so clearly and unequivocally from her writings was exaggerated and ultimately pushed to center stage and out in front of her artistic production and the problematical personality of her great creative talent. The judgments and thoughts of an uncommonly receptive young woman, bound and circumscribed by her own period, constitute the greater part of the early editions of this book. They were long taken to be the final word on the entire course of the artist's short life. The release and incorporation here of much new material have changed the situation in important respects. This enlarged edition corrects all previ-

ous publications and embraces a number of letters from her mother and her father, additional letters from her sister, Herma, to their mother, and letters to and from friends which have not appeared before, all of which are essential for the understanding of her own writings. A much more authentic and complete picture of Paula Modersohn-Becker, her environment, and the age in which she lived has now been made available.

<div align="right">Günter Busch</div>

ACKNOWLEDGMENTS

This new edition of the letters and journals of Paula Modersohn-Becker was made possible first and foremost by the generous and untiring cooperation of Frau Tille Modersohn, whose constant interest accompanied every step of our work. For that, we extend our most heartfelt thanks. She put at our disposal the unexpectedly voluminous correspondence and notes of Paula Modersohn-Becker that had been entrusted to her over the years, as well as the great number of letters from the artist's parents and friends. And this she did without imposing any restrictions. For these reasons this edition has gained an importance that far outweighs that of all previous publications on the subject. What we have published here represents in many respects an essential expansion and enrichment of what was heretofore known about the artist. This is particularly true in regard to the numerous and art-historically important revelations, few of which are present in the old editions.

We are also indebted to numerous members of the Becker and Modersohn families for their helpful information and assistance: Frau Renate Weinberg, Frau Eva Weinberg, Herr Wulf Becker-Glauch, and particularly Herr Christian Modersohn. They were most generous in making available important original letters and documents in their possession. We also obtained valuable information from Frau Elsbeth Modersohn, Frau Christiane Darjes, and Herr Eric Stilling.

In both word and deed, Herr Wolfgang Werner of the Graphisches Kabinett [Print Gallery], Bremen, encouraged and aided our undertaking from beginning to end. We are most especially eager to express our gratitude to him here.

The Rilke Archive in Gernsbach, together with Frau Hella and Herr Christoph Sieber-Rilke, was both helpful and cooperative in making available to us the hitherto unpublished letters of Paula Modersohn-Becker to Clara Rilke-Westhoff and Rainer Maria Rilke and also in giving us permission to publish several letters by the poet. The Haus im Schluh in Worpswede, Herr Hans Hermann Rief, and the heirs of Heinrich Vogeler granted us access to the original letters, which are in the Worpswede Archives and not printed in any of the previous editions.

And finally we are indebted to Frau Frieda Netzel of Worpswede, the Overbeck family, Herr Wilhelm Teichmann, Herr Dr. Wolfgang Mick, and last but not least Herr Helmuth Westhoff for additional information and documentary evidence. Our colleagues at the Bremen Kunsthalle and the State Archives encouraged and supported our work in the kindest possible way during the entire period of our endeavors.

L. v. R. and G. B.

FURTHER ACKNOWLEDGMENTS

There are many people whose help over the years of our work on this project should be acknowledged. Our greatest debt is owed to those in Bremen without whose cooperation this American edition would never have come about: Günter Busch, director of the Bremen Kunsthalle, and Liselotte von Reinken, the German editors of *Paula Modersohn-Becker: The Letters and Journals*—Dr. Busch for his willingness to share his knowledge and experience with us, and Frau von Reinken for her enduring patience and readiness to assist us at every turn. Mathilde Modersohn, the artist's daughter, for her encouraging involvement with this project from the start. And most especially, Herr and Frau Wolfgang Werner for their untiring cooperativeness and hospitality, both in correspondence and during repeated visits to Bremen and Worpswede.

We also want to extend our gratitude to the following people in this country. To Hilda Damiata for her help over the years in the preparation of the manuscript in its many transformations. To Richard Wood for his willingness and deftness in tracking down many references. To Pat Donnelly for her part in helping to edit the first translation in its early stages; and to Lilo Moser, not only for checking the accuracy of the final manuscript, but also for her active enthusiasm in the cause of PMB. To Ellen Oppler for her illuminating conversations and encouraging correspondence. To Barbara Perlmutter and Cornelia Wohlfahrt for smoothing the way. To Patrice Wagner, Richard Wagner, and H. Randolph Swearer. To the four students who in a sense were the first translators, over a decade ago: Roger Chaffee, Michael Hurd, William Scofield, and Nathaniel Winship.

After the German edition of the letters and journals appeared, the letters the artist wrote to Carl and Martha Hauptmann between 1900 and 1907 and a letter from Carl Hauptmann were made available to the Paula Modersohn-Becker Foundation in Bremen. These letters are kept, together with the literary remains of Carl Hauptmann, in the Literatur-Archiv of the Akademie der Künste of the German Democratic Republic in East Berlin. The editors are most grateful for permission to publish them in translation here.

We wish to dedicate our efforts in this undertaking to the memory of William and Mona Clew, and to the memory of Peter Boynton who was also up in Northampton that day when the Baskins said, "Do this book!" We did that book—and the next one as well.

C. C. H. and A. S. W.

1892–1896

Minna Hermine Paula Becker — that was her full name according to the register of baptism at the church in Friedrichstadt-Dresden — was born on February 8, 1876, in a house on Schäferstrasse. She spent the years of her childhood on Friedrichstrasse, near the so-called *Gehege* ["Preserve"], at one time a wilderness park which appears off and on in the letters of the grown-up Paula as the place where she and her friends played games as children.

Her father Carl Woldemar Becker was inspector for construction and maintenance of the Berlin–Dresden Railroad. Her mother Mathilde was born von Bültzingslöwen. Both families came from the general area of Saxony and Thuringia, but Woldemar Becker had grown up in Odessa, where his father had been the director of the Lycée Richelieu, a position that had brought him the honorary title of imperial Russian collegial counselor and a personal patent of nobility. Mathilde von Bültzingslöwen-Becker was born in Lübeck, where her father, after a difficult and adventurous youth, became the commander of a contingent of troops stationed in Lübeck. The contingent was disbanded in 1866.

The Beckers had seven children, although the fifth died in childhood. Paula was the third and the bonds among the brothers and sisters were strong and lasted throughout their lives, despite the very different ways in which they developed.

In 1888 Woldemar Becker moved to Bremen as administrator of Prussian railroads for the city-state of Bremen, a job which was very similar to the one he held in Dresden. In 1890 he achieved the rank of Prussian counselor on the Board of Works. His official residence on Schwachhauser Chausee was spacious and had a large garden, which took on great significance in the life of the family as a beloved natural sanctuary and as the site for games and social gatherings. The house still stands, but the garden has been made much smaller by the widening of the nearby railroad trunk lines.

The Becker family quickly established itself in Bremen; they were able to do so even though they were not wealthy and kept a "modest household." Apart from the new associations made through the children's school, the neighbors, and Herr Becker's colleagues, it was the warmhearted, congenial, and imaginative Frau Becker who did more than anyone else to introduce the family to its new surroundings. She had the gift of attracting people and of being a successful hostess, both at small family parties and at larger social gatherings. This was a source of great pleasure to her. For her, sociability was a friendly obligation; its purpose was to maintain a sense of community in the family, in her husband's profession, and in society at large. While she made an effort to contribute to the success of social events, she also demanded a contribution from her children, whether it was in composing poems, singing, playing a musical instrument, or painting the decorations.

Without much previous preparation, but with enthusiasm, Frau Becker became a dilettante in literature and art, in both the good and the limiting sense of the word. The German classics were the standards as well as the boundaries of her understanding. As with many of her educated contemporaries, art was her religion, and with this perspective she raised her children.

Herr Becker, on the other hand, possessed a melancholy nature. He read a great deal, and intensively, including the works of the modern scientific philosophers. In many of his intellectual approaches he was more radical than his middle-class contemporaries. He was seriously interested in the study of art. In quite a different direction, he enrolled in a course in electrotechnology when he was fifty-six years old in order to keep up with the recent developments in this field. In spite of all this intellectual activity his sense of optimism about life seems to have been broken early. He suffered from life, suffered self-torment because he imagined he was a failure in his work and blamed his early forced retirement in 1895 on this. In fact, he had been pensioned so early because the Office for the Management of Railroads for Bremen proved to be unprofitable and was liquidated. From then on he was burdened by worries about the economic security of his family. He could be rash, sharp, and particularly to his sons sometimes very harsh in his judgment. Since he was aware of this same inclination in his daughter Paula, he repeatedly warned her in his letters not to be too hasty in her judgments. He was not always a comfortable presence for his wife and children, but they all knew and felt that his crusty behavior was a shield to protect his vulnerable and kind heart. His letters to his children and theirs to him are proof of a reciprocal trust. Paula's letters to him in particular are witness to a strong bond. His youngest daughter Herma wrote later: "Our father's influence caused us always to sense strongly the presence of his powerful personality, without its ever being forced upon us.... He wanted each of his children to develop according to his or her inner necessity...." The Becker children grew up in a harmonious environment.

Part and parcel of this family life were the numerous relatives. The Beckers and von Bültzingslöwens were very close-knit clans, some of whose members had highly distinctive personalities. There was a great deal of interchange, and family gatherings were frequent and well attended. The well-to-do members supported those with fewer worldly goods, and Paula's upbringing and education were decisively shaped by the financial aid that her relatives were in a position to give her.

Such cohesiveness required constant attention. Letter writing was one of the duties regarded most seriously. All the Becker children took it for granted that whenever they were away from Bremen they were expected to write letters to the family timed to arrive on Sunday and this continued until the death of their mother in 1926. These letters were considered common property in the family and were passed on, then later preserved as family documents. The letters from Paula's parents were discovered among her effects, arranged chronologically, each year tied with a red ribbon. Paula also kept journals from the time she was a child.

The first letters of Paula Becker that we still possess come from England. Shortly after Paula's confirmation (April 7, 1892), her aunt Marie, her father's half sister, invited the sixteen-year-old girl to visit there. The niece was expected to learn English and the fundamentals of running a household on an estate near London under the tutelage of her capable relative who was the wife of a wealthy onetime plantation owner, Charles Hill. Much more important, however, is the fact that the uncle made it possible for her to take drawing lessons in London. From the existing documents it is not possible to establish exactly when Paula decided to make her artistic talent her life's work. What is clear, however, is that her mother encouraged this talent from the very beginning.

Paula returned home at Christmas, 1892, somewhat earlier than expected. Problems with her health had arisen, problems which we read about again and again during the following years. But the real reason for her return seems to have been Paula's resistance to the habits and customs of a foreign country and her reluctance to submit to the stern hand of her aunt Marie.

In 1893 Paula's father required something of her that he had previously also required from her older sister Milly—something for which later critics have taken him to task severely. These critics, however, knew little about him and never had access to his letters to Paula. Out of his farsighted and progressive conviction that young women should be able to stand on their own two feet in the event they never married, he urged Paula to train in a seminary for women teachers. In addition, he gave his daughter permission to take lessons in drawing and painting with Bernhard Wiegandt, an artist in Bremen. She also attended lectures and concerts and regularly visited exhibitions at the Kunsthalle. It was here that she first saw, in April 1895, work by the painters of the art colony in Worpswede. And the paintings by Mackensen and Modersohn particularly caught her eye.

Trips to relatives and visits with friends on the North Sea island of Spiekeroog lent spice to these years of training, which ended with the successful completion of her qualifying examination at the seminary. For reasons of health she was allowed to take time off after this examination and was not obliged to take a job right away. Probably due to the initiative of her mother, Paula Becker was allowed to enroll the following April in a month's course at the Drawing and Painting School of the Society of Berlin Women Artists on Potsdamer Strasse in Berlin. With this began a course of events which was to follow its own law from then on.

A Note on the Asterisks

The letters and journal entries marked with asterisks are from the earlier editions and though they have been restored as much as possible, the originals have been lost and are not available for rechecking. See the Notes on This Edition for an account of the restoration.

To Grandmother von Bültzingslöwen

Willey, July 29, 1892

My dear Grandmama,

I have just finished making twelve whole pounds of butter, all by myself, and of course I am terribly proud, and now I want to write you and send you Kurt's letter.

Everything is simply wonderful here in England. Right nearby we have a little woods where one can find a charming spot to sit and read a book or do some needlework. The trouble is that most of the time one doesn't do anything except look at the little rabbits and squirrels. There are hundreds of them here, almost too many.

There are three girls from Holland staying with us right now. This is very nice for me. And besides that there are also many other young girls who live nearby. I've been to London several times. When I saw the city for the first time I was really startled. So many carriages in the streets. In our quiet little Bremen we aren't used to anything like that at all. We were there just the day before yesterday. If you can imagine, we went to see a performance by a mind reader. It was really very funny. The mind reader wanted to find someone to test his powers. But nobody really wanted to because they were all too embarrassed to reveal themselves in front of the whole audience. So eventually he called on several gentlemen, but they acted as if they couldn't hear the man and they kept fidgeting with their gloves. Suddenly he called on Uncle Charles, but he didn't want to either and so he said in broken English, "We understand not your language." Then finally a woman volunteered. Her idea was that he should remove a letter from her husband's vest pocket and put it on the table.

Then she took the mind reader by one wrist and with the other hand she held his neck. After a few minutes he began to run around like mad and found everything he was supposed to. It was really very strange. After that we went into The Museum of Natural History and looked at all the stuffed animals. I liked the hummingbirds best of all; they had such glorious colors. But when I stood next to the great, big, stuffed giraffe, all I could do was get angry. I felt so tiny next to it. When I think that in two years I haven't grown a single centimeter!

The other day I caught some little tadpoles and have been watching them slowly grow into frogs. It was terribly interesting. First they grew little front legs, then rear legs, and then their little mousy mouths turned into proper, big frog mouths, and finally the tails seemed to get smaller and smaller and finally weren't there anymore. The nicest thing about it was to see how they swam at first with their tails and then gradually learned how to use their little legs. And now they are nothing more than big old ugly frogs, so I carried them away and let them go.

July 30. Dear Grandmama, Another day has slipped by and I haven't sent this

letter yet. I truly wanted to make it much longer but I haven't any time today, because today I'm learning how to sew on a sewing machine. I'll close quickly now so that at least this will get to you faster than my letter to Mama and the twins. Say hello to everybody. I send you a kiss.

<div style="text-align: right">Your Paula</div>

To her father

<div style="text-align: right">Willey, August 7, 1892</div>

My dear Father,

When your letter arrived today I was of course very happy. But I was startled to realize that you didn't want to hear anything at all about milk and butter, and I think that I had written you four pages just about milk. So now I want to make up for that. I want to try to be a small substitute for Mama, a hundredth part of her, maybe even only a one-thousandth. But I am afraid I won't be able to. Your letter was very cheerful, but I am sure that your separation from Mama and your little nestlings must be very difficult. Our big family has shrunk down to only three people. Well, I guess I really don't think of our family any more as being big, because all the people I have met here seem to have eight or ten or even twelve children. We are a pretty sparse little group in comparison.

Aunt Marie and Uncle Charles spent the whole day in London today with Professor Donndorf. Pastor Christlieb, who just now passed his examinations, is coming tomorrow [today?] And so I had to stand in for Aunt Marie and Uncle Charles. At first I thought I would have to carve at the table and could already see myself sawing away at the roast, the way Pastor Christlieb does. Once, when we were in London, we had roast duck and he had to do the carving. He was so vigorous about it that the platter and bird bounced all over the table until Käte held down the platter and the parlormaid grabbed the two legs. But Providence seemed to know all about me and my clumsiness ahead of time, so I did not have to stand in for Uncle Charles after all.

Today is already Sunday, and it's evening again. Uncle Charles is reading aloud in Dutch from Reuter's "Durchleuchting" [*sic*]. But my mind is back home with you. I had sketching lessons again today. For the first landscape I used only sepia. It looks a little as if I had made it outdoors in a rainstorm. But things will get better! I wanted so much to add a touch of life to it, but just when I had a goose half drawn it went to lie down. Then, when I had finished only the head of a horse, it was led into the stable and of course I don't have enough imagination to picture the way the rest of it should be done. I also made a drawing of Cowslip (the cow I milk), but she couldn't keep her legs still because the flies were pestering her. And so they turned out looking like four sticks. When I got home today I found that Bella, the sixteen-year-old Dutch girl, had decorated my whole room with flowers and it was really hard to take a single step without bumping into one vase after another. I

thought that was so charming of her. Next Sunday we're going to Castle Malwood again. Of course I look forward to that very much. We shall be meeting Professor Donndorf and both Christliebs there.

Dear Papa, I know my letter is very short but I must close. It may not be very interesting and probably has a lot of mistakes, but today you will have to put up with my being tired.

Just be sure to remember that I am thinking of you and that I would like to ease your loneliness a little. I would love it if you could send me a few of the letters Mama or the children have written you. Have Kurt's letters gotten there yet? Mama sent me two fine articles about Bismarck; they pleased Professor Donndorf. He is a great admirer of Bismarck. And now, good night,

<div align="right">Your Paula</div>

I am surprised that I haven't received a single letter from Milly. She probably has so much to do. If I have the time I shall write very soon again.

Just one more question.

What is the minimum height for a German soldier? I want to know because Aunt Marie has said that our soldiers don't have to be any taller than me, and I cannot have anything like that said about Germany. Good night.

To her parents

<div align="right">Willey, August 19, 1892</div>

My dear Parents,

Now I can write to the two of you together again, since the twins are probably back in school and all of you are together in your warm nest. First, I must thank you, dear Mama, for the photograph of little Ella. Of course it made me very happy, even though I find that it does her only partial justice. No picture could ever show her wonderful coloring and those eyes that are constantly darting about. I have been hoping for a letter from Papa for several days, but unfortunately in vain. Yes, I sometimes believe that I am a little homesick and sometimes I fall asleep with tears in my eyes. Naturally the times between your letters seem much longer than they really are. At first I thought I wouldn't even tell you about it, for I thought that it would become better with time, but now I don't think so. I am not going to let Aunt Marie know, because I think it would seem to her as if I were being ungrateful, and she is trying her very best with me. If I do tell her, everything will become much clearer to me. But I want to think about it as little as possible, and I can still really, sometimes, convince myself that I am not homesick. If you want to show me your love, please don't mention this at all in your letters. I think that the less we speak about it the better it is. I have only mentioned it to you to explain my dreary letters. I am really not swimming in tears, but I am getting very bored and indifferent. I sometimes seem so old to myself. When I look at the Larssen

children who can laugh for a whole half hour at absolutely nothing, I sometimes wish I could also act just as silly. I am also getting more headaches now and I'm so tired. But all of that will pass. I am trying very hard to learn a lot so I can be a good housekeeper for us and so that you will feel comfortable and satisfied with me. (I know very well that you cannot always feel the latter about me.) But now I only want to end this letter. I have been thinking for a long time about which would be better, either to take care of it all by myself or to write you about it. Perhaps it is better for you to know than to think that I am superficial. A kiss.

<div style="text-align: right">Your Paula</div>

Is that all right, you won't write anything about this in your letters? If you tried to console me it would only make me sadder. Just write some happy stories about Caro and the twins instead.

To her parents

<div style="text-align: right">Willey, September 2, 1892</div>

My dear Parents,

Today I can finally address you again in the plural and feel safe in doing so, because I have learned from Else that you are all together again in your warm nest. How I would like to catch a glimpse of the twins now! Are they as suntanned as they were on Juist? Right now we have the exact opposite of your weather, a terrible storm and pouring rain. We have not played lawn tennis for a whole week now, and can't do it today either. It is too bad, because Dr. Prate's family is coming today and they are such fine players. I am already beginning to make Christmas presents. Aunt Marie, Mrs. Prate, and I are all making the same thing, but of course I can't tell you what it is. We are all tremendously busy and each of us thinks that her work is the prettiest and is full of praise for herself. When we three women are sitting together, the other two always begin talking about their husbands. It really is awfully comical to listen to. First one complains about one thing and then the other complains about something else. Then they both begin to praise them frightfully and each one claims to have the very best husband. Just imagine, Mrs. Prate has never had an argument with her husband and in fact has never been unfriendly to him even once. Isn't that sweet?

I have just made eight and a half pounds of butter. You are probably always hearing that news from me, for Friday is my butter day. It really is a great deal of work and today it made me very tired. I received a charming letter from Günther yesterday. It does make me happy whenever I hear from him. I answered him right away and I hope he will now follow my good example. Uncle Charles had wrapped up Günther's letter in my napkin. I was feeling so sad that I had not received a letter again. Then I found it there at breakfast. Wasn't that charming? From twelve to one I read with Aunt Marie every day. At first we just read short stories, but

now I am supposed to begin learning something more serious. So we have now begun to read biographies, starting with Thackeray. When I am alone I read Scott's *Rob Roy*. I have not gotten very far into it yet, but I think it is very fine. Must close now. Farewell. A kiss for next Sunday to all of you from

<div align="right">Your Paula</div>

How terrible to hear of the cholera in Germany! Are you all eating your fruit? [On the reverse of the page:] I do not yet dare send you a "painting" by me. I fear your scorn.

*To her parents

<div align="right">Willey, September 9, 1892</div>

[...] Aunt Marie thinks that I have been writing you about my art lessons as if I were a great artist. I must sadly confess that up to now that is not the case. I don't even dare send you samples of my brushwork yet [...]

To her sister Herma

<div align="right">Fritham Lodge, Lyndhurst
September 21, 1892</div>

My dear little Herma,

Soon I will not be able to write "little" Herma anymore, because anyone who turns seven years old today is already a very grown-up and wise person. And so, my dear Sister, I wish you much happiness on your birthday. I have sent you a little package containing two little sleeves which you must wear at school, and also at home when you are doing your homework. When you have them on, think about your Paula now and then.

We have been at Castle Malwood for two days now. That is the name Uncle Charles has given to his new home. The forest here is so splendid that Aunt Marie and I say over and over again: if only the twins were here, what a fine time they would have playing in it! Whenever we walk though these woods we meet a family of pigs. A fat mama pig and a fat papa and six little black piglets. Adieu for now, my Herma. A sweet birthday kiss from

<div align="right">Your Paula</div>

To Paula from her father

<div align="right">Bremen, September 22, 1892</div>

Dear Paula,

We have received your first attempts in watercolor and rather than the scorn you were expecting, you have earned our respect. Your studies show progress and your oranges (forgive me if perhaps I am not calling the fruit by its right name) are so rounded and plastic, that if they had not been black as pitch, I would have taken a bite out of them. The fruits are beautifully shaped and the shading on them and the shadows they cast are also quite correct. If you continue to try, perhaps you can be even more successful. In any case, you must not give up your efforts but instead pursue them with all the time at your disposal. Even if you should not become a perfect artist, you can get a great deal of joy and pleasure through your efforts. I have always thought that it is very good to practice one's eye by looking at nature. But at the same time one's drawing must not be neglected, so that it is not merely one's eye but also one's hand that acquires the necessary skill. Therefore, whenever you have the opportunity be sure to practice. If you are going to London now, I hope very much that you will find the opportunity to look at many drawings and paintings. Be sure to study not so much their content as their form. In art, the latter is the main thing, even if the art disciple finds that hard to comprehend at first. The most beautiful idea is nothing, so long as the execution does not correspond to its concept. [. . .] It would also be a very good idea for you to study a bit of art history, along with your training in painting. I am not familiar with any English publications in art history, but certainly your teacher will be able to recommend some to you. The [National] Gallery in London has representative examples of the major schools, so that you can secure your knowledge in a practical way by studying them there. [. . .]

To her parents

<div align="right">London, October 21, 1892</div>

I shall begin with the latest news. Aunt Marie and I have just returned from a "school of art" that I am to enter next Monday. I shall have lessons there every day from ten until four. At first I shall only be doing drawing, beginning with very simple arabesques and other designs. If I progress, then I shall make charcoal sketches after Greek plaster casts. I have already seen several Venuses, and I must tell you I was enchanted by them; the shadows are so soft. If I advance further, I shall begin drawing and painting from live models. But I don't yet dare hope to be able to progress even that far. I shall be happy enough to be able to do a good chalk drawing of one of the Greek casts. There are between fifty and seventy ladies and gentlemen in the studio, most of whom are studying to become artists. I am the youngest, I think, and I really do not fit quite properly among all these

talented people. But on the other hand, it will be good for me if I find out that I am the furthest behind and discover how far I am capable of going. That will also spur me on in my ambition. Lessons begin next Monday. I am very grateful to Uncle Charles for this opportunity. [...]

To Paula from her father

Bremen, October 22, 1892

Dear Paula,

I have heard that Mother did not write you this week and therefore you have been without any news from us. To the extent that I am able, I wish to correct this oversight and send you our news. There is really not very much to tell. You know perfectly well how things have always been here; there is almost never a real change in our lives and the most pleasant changes are really brought about by the letters we receive. Last Sunday we had several simultaneously from Kurt, you, and Günther. Mama is particularly pleased when she can read aloud the news of her children at morning tea. No one dares to open the letters before she does, not even I, for that is her principal pleasure, slitting open the envelopes. As far as she is concerned, a letter opened is already read, and when that happens the first charm and fragrance are lost. And so everything has to wait until the moment Mother has finished her toilette and makes an entrance in her brown dressing gown. Very deliberately the coffee is poured first, the envelopes are sorted, the twins are admonished to pay attention quietly, until gradually the proper mood has been conjured up. Then the envelopes are opened very neatly with the paper knife and, *coram publico*, the reading begins. Everything must be in order, so Kurt's letter comes first. The good lad has been writing regularly up to now and every time we get a letter Mother casts a scornful look in my direction, for I had been prophesying in my pessimism that she had better not count in the future on regular correspondence with her eldest. But I have to admit in my blunt way that she is right for the time being: "The boy has only been gone three weeks." That cuts no ice with her. She says, "You have no faith in our children." So, I have been rapped on the mouth and have to be quiet. The letters from Kurt are very nicely written and give us a view of his life. We can sympathize with him whenever his noncommissioned officer scolds him. We rejoice with him when he tells us about the man's awkward barracks humor; we participate in his visit with Aunt Falcke and the Kuntzes, and in his pub crawling on Baring's birthday, etc. After the letter has been read aloud, it is most solemnly folded up again and lovingly patted several times. Mother says nothing. She expects us to be the first to voice our impression of the letter. Naturally she is convinced that we thought the letter was wonderful. She would love to be the first to burst out with praise for it, but perhaps that would make her appear a weak and prejudiced mother. And so she waits patiently until I begin to speak: "The letter is nice enough, but the boy has still not answered our questions." "But

you're demanding too much," she replies indignantly. "Is the poor boy supposed to answer an entire laundry list of questions each time? And besides, he wrote two complete sheets of paper and you know that any more would have doubled the postage. It isn't fair to demand any more." I admit defeat and in order to placate my better half, begin to praise the excellence of the letter. I find fertile soil there and we begin to chat back and forth until Mother has strengthened herself with a cup of tea. And then it is time for your letter. After the customary preparation, she begins: "My, how poorly the child writes; why, one can't even read this. That is just a lot of scribbling. You must write and tell her to pull herself together a little more." "But, my dear Wife, you are going to be writing her tomorrow. Could you not take care of that yourself?" This time she is caught. But then she adds soothingly, "That is only the fault of her thin letter paper. Annoying postal regulations! But I'm annoyed with her, too. Incidentally, the letter does not weigh anything like fifteen grams." After this preamble, the letter is now read aloud. After she finishes, she is the first to speak. "I really do not understand why Paula's letters from Schlachtensee were so much nicer. They gave us a real insight into her life and had such a nice sense of humor about them. These letters have very little of that. She does not express herself to us; she writes her letters exactly as she would write any other stranger. The child must be homesick." I don't dare contradict the business about homesickness; my views on that are different. It is true that my little girl really does not pull herself together and that she just goes rush-rush over two sheets of paper to fulfill the family letter-writing obligation, and then be alone by herself again. Well, I have said the same thing to her before but without much success. We must accept our children as they are. Their shortcomings very likely have their origins in their parents, and we all know the saying, "the apple does not fall far from the tree." It would seem that you take more after your father, you don't have the literary bent of your mother. Too bad! I really wish you were like her. Well, that really does not belong in the description of my Sunday morning.... After this letter has also been lovingly folded and patted, it is time for Günther's epistle. As scatterbrained as the boy is in other regards, his letters are very good, except for his spelling. And even that has gotten a little better. He writes us briskly about his comrades and roommates. And with that, our morning letter-reading session comes to an end. I wonder if tomorrow there will be another one just like it? I hope so, because it always makes our days sunnier in spite of the fog and rain, which are now announcing the arrival of autumn. So then, Daughter dear, you will write us a very nice letter soon, won't you, for Mother's birthday? [...]

To Paula from her mother

Bremen, October 24, 1892

Dear Heart, how happy I am to hear that you are taking such thorough instruction in drawing! It is my great wish that you concentrate all your energy in this field. I am exceedingly grateful to Uncle Charles for providing you with this good fortune. And now, in order that both body and soul are equally considered, you are also taking riding lessons! [. . .] Paula, Paula, a brown riding outfit with a Norfolk jacket! That must look enchanting. I would probably not recognize my little girl anymore. [. . .]

**To her parents*

London, October 28, 1892

[. . .] What naturally occupies my thoughts more than anything just now are my drawing lessons. The senior master is Mr. Ward, a middle-aged man, who speaks terribly fast because he probably does not have enough time to say everything he wants to. His lessons are wonderful and he never praises anybody. But he has so awfully many pupils that he really does not have enough time for each of us every day. So far he has helped me only three times. On other days he is replaced by assistants. I just wish you could have a look at our "antiqua room." If I only had the time I would spend all of it just looking around and seeing how everybody's drawings progress from day to day. All the ladies wear full, gathered smocks and sit in front of their easels on frightfully high stools, even higher than office stools. I told them I preferred one of the lower easels for men, because even though sitting on such a high perch is divinely artistic, it is much too dangerous for a poor mortal like me. Today I made a drawing of an eye with cheekbone, brow, and so forth. Even though it did not turn out exactly "antiqua," it was still frightfully ugly. At the beginning everything is three times life-size. [. . .]

**To her mother*

[Ca. November 1, 1892]

[. . .] My wish for you is that all your children will make you happy. I am almost ashamed to say that, because the only thing I can do to make you happy is to send you letters; and I know that these cannot make you very happy. My letters must come from the heart. But often when I write my letters on Fridays, my heart is completely closed. I get angry, I scold myself, but that doesn't open my heart or make it feel better. Yes, I am expected to write [my Friday] letter. It seems that you two always have your wits about you and can deal with such matters without further ado. But my wits are too small for that kind of thing and I cannot really do

anything about it. And so if I don't write you good letters it would be better for you to pity me rather than scold me; and remember that I love you in spite of it all. [...]

To her parents

London, November 10, 1892

[...] I have a lot of time on my hands today. There is a real London fog outside and the studio was plunged into such Egyptian darkness that we couldn't see a thing, and one cannot draw plaster casts by artificial light because the shadows are suddenly so different. It takes me three-quarters of an hour to reach the school. Naturally I did not want to have to come all that way in vain, so I went into the room where the live model usually sits. This time it was a man dressed as a monk. He had a fine, determined face. I tacked a fresh sheet of drawing paper to my board and sat down at my easel. But I let it go at that point because, you see, I was suddenly so terrified, surrounded by all the artists, that I put my tail between my legs and crept away. Aunt Marie is amazed that I even had the courage to go in there at all. [...]

To her parents

London, November 18, 1892

[...] More about my drawing lessons. I am putting together another sheaf of drawings and shall send them to you. I watched my neighbor sketching a skull today. She was handling the thing as if it were a handkerchief. Just looking at her doing that made a chill run up and down my spine. Someone else was drawing a skeleton. She unhinged the ribs one by one in order to get a good look at them, and then stuck them back into place—all with the greatest calm and lack of concern. No, thank you, I am in no rush to go that far. [...]

To Paula from her father

Bremen, November 21, 1892

[...] Today's letter from you announces that we are soon to receive samples of your progress in drawing. I really look forward to these pages of studies from you. Even if I tend to criticize mercilessly and to dwell on shortcomings, that does not mean that I overlook the good points. It simply seems to be a part of my nature that I see the mistakes before I see what is good. That is not a very endearing trait in my character, but who can change himself in his old age or teach himself to withhold his opinion? For that reason you must not be quite so sensitive to my reproaches. Just continue to tell yourself that to every bad remark you get, some-

thing good is to be added, even though it is not articulated. And do not let up in your endeavors. If you really prove to have talent for drawing and painting, then I will certainly want to try to continue providing lessons for you here in Germany, so that later you will be able to stand on your own two feet. When one thinks about the sudden changes we are subjected to in this age, particularly regarding the things that make a good life, and when one thinks about the strenuous work needed in our battle for existence, it is clear that every young woman must strive to make herself independent if need be. [. . .]

To her sister Milly

78 Seymour Street, Hyde Park, London W.

November 25, 1892

Dear Sister,

I have been waiting for quite a while before answering you. I thought you might send me another letter, knowing how little time I have had at my disposal, and then I would be able to kill two birds with one stone. But that was probably expecting too much. I have often done that in the past, but there really isn't much to my letters anyway. Give Papa a kiss for his sweet long letter. And now you shall have your kiss, too. Your epistle with all the descriptions of your examinations made me so very happy. But I must make short shrift of the kisses today because I have an unusual number of things to tell you. I am tempted to blurt out my news right now, but I would rather tell it as if I were writing a novel and let you dangle a little. That would have a greater effect, but that is really rather cruel. Well then, who do you suppose is in London now and who do you suppose I was sitting with in the same room only a couple of hours ago? I can see you straining your imagination but not one of you could guess correctly. It's too hard. So I will divulge the answer to you right now. Just imagine, our aunt Cora. She simply picked up, sailed over here without further ado to collect some English ideas for her house. What do you say to that? You would never have guessed that, would you? Neither would I. Naturally I do not see much of her because I am in school all day. But just to sit opposite her at table only a few minutes ago—that was a heavenly pleasure. Really, I cannot take my eyes from her. The bigger, or rather, the older I get, the more I understand her beauty and the more I can see how every movement she makes is graceful and regal. When I compare myself to her I really feel rather cheated by nature. But not everybody can be perfect. Today we all went to Fritham to visit the aunts and I think they will stay there until Monday.

Last evening was wonderful. I went to see *King Lear*; all at once Uncle Charles didn't feel well, so I was permitted to go in his place. Ellen Terry played Cordelia magnificently. She could make her face take on such a pained expression, and tears simply poured down her cheeks. The role of Lear was played by Irving. It was almost too frightening and powerful for me. The way he gradually goes insane and

finally becomes so childish. That was so terrifying for me. Really, Irving must have actually gone to study people in the madhouse. My tears simply flowed and when each act was over I would have liked just to sit there in the dark or hide my head in a pillow and cry myself out. But that old bright light always went on and I had to compose myself and stop my tears. During certain scenes I literally shuddered. Really, that kind of thing can have an effect on me for weeks. I saw it before my eyes all night long. The scenery was also glorious. At the beginning when the King returns from the hunt, one can see into a wonderful old hall. And then the retinue enters with hounds on leashes and with the game from the hunt. One feels completely transported into that period. There were no pauses between scenes. Often only half the stage was used so that the backdrop hung across the middle; and when the scene of the action was to change, the lights were dimmed; then what used to be the backdrop was drawn up like a curtain and behind it was a completely new scene. I thought it was always so sad when the fool spoke his poignant, double-edged words. In fact, his whole role was played very movingly.

Today Uncle Charles is completely recovered, but Aunt Marie says that it was better for him not to have seen the play. It would have been too painful for him. Papa would like to have a bit more news about Aunt Marie and Uncle Charles and our whole life over here. Have I been reporting too little? That is bad. I think it is because I spend most of my time in school. Well then, we live here in very nice rooms and have a dreadfully old-maidish landlady. She's frightened to death of a fire. That's why we are using oil lamps, real old-fashioned oil lamps, whose wicks one has to screw up every few hours. It's a great joke. There is no bell at the front door. God forbid, we have not progressed that far here with civilization. There is still an old-fashioned knocker on it. I love it. During the day Uncle Charles and Aunt Marie are mostly in museums or sight-seeing. At first they bought furniture for Castle Malwood but it turns out that there is no great rush about that now. After supper Uncle Charles reads to us out of some book or another while we women do our needlework. Papa asked whether I had also thrown myself into music now. Not in the slightest. In Willey I always practiced for half an hour before breakfast, but here that would upset our poor uncle. It would be pure torture in these little rooms. But now and then I do sense a little urge to play a bit on the keys. One evening Dean and I were alone, so we sang Mama's and your duets. There was no harm in that because no one could hear me. Dean [was] much too involved with her accompaniment to be able to listen to me. Have I already told you that Dean is a day pupil at a boarding school? She takes piano and singing lessons there and has a sweet little voice, but I do not believe she is very musical.

Well, a quick farewell. I really want this letter to arrive on Sunday again. What a pity that you didn't tell me about that a little earlier. It made me very sad. For all of you, a kiss from your Paula.

I have not been horseback riding all week long; that is why I [was] so out of practice today. [. . .]

[Journal?]
[About the effect of reading]

[Cannot be dated]

And then inside I am so quivering and excited, which really does not suit me at all. I do not even know whether that is good or bad for me. I really do believe, though, that it is bad for me because an excited mood like this is always followed by a reaction. Taking pity on myself, I call it melancholy; but others call it, and with some justification, grumpiness.

To Paula from her mother

Bremen, December 7, 1892

[...] Your letter arrived right on time and your experiences at the art atelier amused us greatly. Dear little Miss, where do you get the courage to make a painting of the Magi and their star? Do they look very different from those primitive "chimney sweeps" that I used to draw for all of you on the blackboard? It would be the greatest joy for me if you could really accomplish something, something more than the little bit of dabbling which all young girls can manage. [...]

To Paula from her father

Bremen, December 8, 1892

Dear Paula,
As you already know from your aunt Marie you are being given the choice of either enrolling in an English boarding school or coming home to us. Now, consider carefully which you would rather do, so that later you will not regret your decision. Either decision, so long as it is a firm one, will be fine with us, and in making it you do not need to take us into consideration. Unfortunately we have heard that your health has been disturbed recently by slight fainting spells. I do not attach much importance to such symptoms, which are temporary and in any case can, with time, be alleviated through sensible diet, clothing, and exercise. But we must not neglect such symptoms of illness and should try to diagnose them. On one hand, your present period of growth may be to blame, and on the other hand, your mother believes that you are suffering from a suppressed homesickness. She hopes, therefore, that in her care you will soon recover. [...]

To Marie Hill
[This letter and the following two were written in English]

<div align="right">Bremen, January 14, 1893</div>

My dear Tante Marie,

Since the receivel of your dear letter I bear with me the thought of answering you. But I waited always for a conclusion of my parents, whether I am to remain here or whether to come over. To-day Papa told me, that Mama thought it best I should remain here and learn busily in the household, to learn cooking and so on. I think I don't quite agree with their resolution. Here I am my own mistress, I can do what I like and leave off what I don't like. There is a great temptation in it. I still strive to act in your sense, to sow frequently fresh tuckers in my bodices, to look through the wash and so on. I am afraid you think I was not energetic enough to come over again, but really I told the parents, that my feeling was to come over again. I did not take really leave from you as I would have taken if I had known I would remain here. I thank you now once more for all your kindness and beg your pardon if I hurt you often, I think mostly I did it without willing. I remember once, when I had disobeyed you Onkel Charles saying: Either you don't care for that what T.M tells you, or you will know it better. That made a great impression upon me. I thought about it many a time. I thought, we all are sinners. Don't we care for God's laws, or think we our prudence better. I think most people don't think in sinning one of these sentences, they simply sin out of weakness —

My dear Tante Marie, I thank you very much for the patterns of the Almanach. I have already begun them and think I finish them soon. Only the colouring part renders me some scroople. But perhaps I come across somebody who will lend me his paintbox. I thank Dean very much for her letter I think to answer it when she is in her boarding-school. Could she write to me a postcard with her adress? I am glad the weather allowed you also to skate. We had charming ice. Mama sent us in the morning and in the afternoon, und we are naturally overglad to go. In the morning we two sisters go alone. We have found out a Wallgraben which is nearly not frequented. The surroundings are so lovely. Cheafly when hawfrost has gone on the night before. When in trying to make artificial circles on the ice I fall, I need not be so very much ashamed because we all people on the ice know each other, we are one society which comes every day, so one is quite at home. We don't think it a shame to fall often, because it shows one has been daring before. So it comes I fall this year much oftener than the years before —

I nearly ever go to bed at ten, there is always something to prevent me. So I must put down my sleep on a smaller quantum for we must be down for breakfast at half past seven. Frau Rassow has also sent me an invitation for the Künstlerverein [Society of Artists], in March. I think there shall be a rather large festivity, I think Mama told you already about it. *Die Rebe* [*The Grapevine*] a ballet of Rubinstein shall [be] danced. That ends in large procession. I don't know anything nearer about it. In these days I must make a visit to Frau Rassow. That's always my hor-

ror. In my next letter I can write you of our ball. Tony Rohland, Minna Kroll-mann, Else and we will give a jolly party. Tony and I scarcely know any gentleman and have already agreed in the worst case to cling together. Nearly every day there is now a practice of the little Comedy *Unerreichbar* [*Unattainable*] of Wilbrandt going on. Now I have told you so much of our pleasures and I will tell now a little of our Kurt. His rheumatism is a little better, at least he has only still pain in the left arm. Poor boy, he pines to leave the Hospital but the doctor will keep him there still two weeks. He longs for company and wrote a postcard rather down-cast. I think he will be very weak. Fancy thirty pounds he has lost in his illness. Günther is now already in his boardingschool which I think he will leave at Easter to come into a real lyceum. For to-day I have written enough. Soon I come again on little visit. I am so sorry for you both that the finishing of Castle Malwood lasts still so long. Could you not come rather for a while over? We all would be so glad. But now good-bye. This room is so awfully hot therefore I must see to get out of it as soon as possible, that's the only thing I can't accustom to, the hot rooms. A kiss to you all from your

<div align="right">affectionate Paula</div>

To Marie Hill

<div align="right">Bremen, January 22 [1893]</div>

My dear Tante Marie,

Now is the ball over. I can scarcely imagine it, for we both live still so in the re-membrances and speak still so much of it, that it seems to me still like present. It was really lovely. I hope I won't bore you in giving you quite a complete description of it. In the afternoon of this grand day we had to provide us with sleep which would not come in the night. Then began the dressing business. Mama and Milly dressed already in the costumes they would were [wear] in the comedy. At eight it began. Mama and Milly had another cloakroom which was especially for the art-ists. So I was alone. I met Frau Franzius who was the chaperon of perhaps twenty other girls. She said, now is the time that we go in. I did not think of it that I had only put one glove on but went into the room. Here were many persons who were introduced to Frau Franzius. I did not know any other girl; after standing there a little and putting my glove on there came some gentlemen, but I liked much less standing among them and withdrew again to the cloakroom. Here were now the three other girls we had invited, than Else Bücking (her mother was in mourning and had stayed at home) than Emma Ültzen, Else's friend she had taken with her. They trembled all of ballfever. But in seeing I had to play chaperon I got again courage. Papa came then to take us in. I introduced them to all my old ladies' ac-quaintances I had. In the meanwhile Papa introduced to us young men, but there were so many names flying round my ears that I did not catch one. At last the little comedy began. I had quite an especial feeling. If it would not have turned out

well, I would nearly have felt responsible for it. But so I heard around me only praise and was very much satisfied. After having very much applauded and laughed we broke up for dinner. My partner at table was one of the mimers, and I had to wait rather long for him, because he had to wash off the moustaches and the colour of his face. So I went again into the cloakroom, my place of refuge, and help Mama and Milly in dressing. Milly had played the roll of an old cook-house-keeper and she looked very jolly in Kea's dress, her hair arranged in a parting, and a white cap on it. Afterwards I thought her very pretty in her light blue dress. She has such a nice neck. Now at last we went to table. Being rather late we could not find places for all of us together. That was rather a pity, but we amused ourselves all very much having nice partners. At last came the dancing. Herr Franzius lead with Mama the Polonaise and than came one nice dance after the other. I liked it so very much. Time flew really. At last the cottillon approached. The young men had arranged it so very nicely. There had been planned a new Weserbridge but the citizens had not excepted it. Now the architects had made a very nice model of this bridge, really very neat. Illuminated with quite tiny electric lamps, and decorated with the bouquets and orders. I found it a very nice idea. There were different very nice tours in the cottillon. There were given round krackers, is that right for Knallbonbons? In each of these there was a little pipe, all differently tuned. Now people had to find out their partner, who had the same tune like them. I found it very funny. An other time the gentlemen had to go in another room and when they came out of it, they had put over them large bags of tissue paper, printed with "Flour number 4" and so on. We ladies had then to choose one of these funny specimen. So there came one fun after the other. Only in the morning at five we left, all in very good humour. Papa had played a very nice ballfather. He introduced us one partner after the other, brought us refreshments and so on. My friends were all charmed with him, we daughters naturally very proud. The next morning we had already to be at Frau Runge, a nice old lady. She had invited us for chocolate. We met here also Tony Rohland, and had naturally to change very many remembrances. Tony and just fancy also her mother left for England yesterday. I like them both so very much. I had asked Tony to take some Sauerkraut and other delicacies out off the fatherland for you with her. But now we don't know your adress. Happy to say, will Onkel Charles say having escaped that nice sent [scent], which is steaming out of this nicest of all vegetables. Yesterday morning I was at Herr Franzius to show him my drawings. He was not at all contented with them, the best he found a picture of Herma I had begun. He asked me to come every Sunday morning to draw at him, showed me the drawings and sketches of his youth and was very charming. I find it so very nice of him to look after me — I am so glad you are contented with my remaining here. I have to learn also here so much, and so many things remain for me to be done. I have to keep the upper rooms in order, and looking nicely that takes with writing letters nearly my whole morning, the end of it I mostly skate. What a charme lies in winter on the landscape. We scate on one

of the Wallgraben. An old mill in the background, and trees white by hawfrost around us. The young architects having so succeeded with the ball have their heads full of new ideas. They will erect a Quadrilleabend. But that lies still in a misty future. Now they are planning meetings on the ice. Also very nice. What we do with our evenings? Mama reads to us Grimm's *Michel Angelo*, whilst I am doing the other half of my almanach. I like it very much, but we are not quickly getting on, because one of us is mostly out or visitors are here. Tony Roelecke's photo and postcard I received. Thanks very much for sending it. Dien gets very soon a letter. But now quite quickly good bye. With a kiss for Onkel Charles and you your
<div align="right">affectionate Paula</div>

If you have perchance some patches of the brown dress, that with the jacket, I would like very much to have it, for on several places the cloth gets already shiny and will soon tear.

Don't fret or plot about my other things and treasures, you have got. When you have settled quite quietly in your new home, and they came in packing out to your hand, it is still early enough to receive them.

To Marie Hill
<div align="right">Bremen, February 4, 1893</div>

My dear Tante Marie,

Just now I have nothing to do in the house and it is the best I write some lines to you. Long won't the letter get. I feel rather ashamed writing such a short letter, for I must now buy my own stamps, and I find it rather a pity to spend 2½ d for nothing. Do you know, why I have made such a turn to the oeconomical. Papa gives us now monthly 15 s and for that we must buy our dresses, boots, cloaks and every thing, we feel rather in a frightful agony, but it is also delightful to be one's own master. Milly and I don't speak of anything else as how to make look our old summerdresses look like new ones, and often I think these large sorrows must wrinkle our front and bleech our hair. My letter getting rather short I can give for every topic as little space as possible. Now I will again tell you of my drawing. I wrote last time to you Mr. Franzius was not at all contented with my drawing. That was not quite true. In reality he was really contented with none but he had to say something at each. I accustomed myself to say he was discontented, for Mama thinks still now I have a wondrous large talent and so often I have to show my drawings. So I told her Mr. Franzius was not contented and I hope she will now not set on me large hope. I beg your pardon that I told you wrong. I did it without knowing it. I was myself quite alarmed when I perceived it. It sounded rather ungrateful for my beautiful lessons at the school—

We laughed all very much at the invitation to the fancy-ball. I must tell you what I have done with my evenings. This week we red together *Fiesco*, which we are

going to see this evening. I think I don't like him so *very* much. Because his ambition is the cheaf-thing in his character. I can't think he can really love like a husband ought to love and for me his character would be more grand if he was not married. But Mama told us this piece made a much finer impression on the stage, so I am very curious. Once Milly took me also to *Othello*. Desdemona was plaied so lovely that I could not understand her loving the moor. Her death was rather too much for me, than it is all the same to me, whether all the others die or not. When we left the theatre we were quite *zerschlagen* [exhausted]. Thursday we were in the Künstlerverein [Society of Artists] and heard a very fine speech of Prof. Bulthaupt about Wagner. He gave to all he said in words for the better explanation samples on the piano. It was really very interesting. In the Künstlerverein are now always the Thursday evenings so beautiful. The other day we heard there a very fine Quintett of Brahms and then of Schubert I think "Das Mädchen und der Tod" or something of that kind is the name. That was so very sad, that the tears really came forth into the eyes. Now my dear Tante Marie I have told you for today enough. Luckily my letter finds a schelter in Mamas envelope. With much love to Uncle Charles and Dean. Ever your affectionate

<div align="right">Paula</div>

*To Kurt Becker

<div align="right">Bremen, Schwachhauser Chaussee 29
April 26, 1893</div>

My dear old Kurt,
It has been an awfully long time since I have written to you, and now I am finally sitting down to commit my thoughts to paper for you. I really have thought a lot about you during the daytime, but the stupid act of writing it down gets in my way! You know all about that yourself. But now first of all, here is a kiss, and here is another and here's a powerful sisterly hug and squeeze. If I only had you here with me I would really kiss you so hard that you would finally have to cry, stop! That never happened before, did it? I do not know why it is, but I believe that I do not have much of a gift for writing letters, especially not birthday letters. I have such a frightfully well-balanced and temperate nature that when I sit down to write what is in my heart, it seems to me that I smother everything with too many words. And if I try to cut it short then it is no longer natural. But we know that we love each other like brother and sister. The nicest thing about that, I think, is that we do not have to use such big words with one another; we understand each other completely and nothing more is necessary.

Soon you will be feeling fine again and we will be able to see each other during the big summer vacation. Not seeing one another for over a year has really been too long. You told Papa that you wanted a glass case made for your photographs.

I made one for you myself. I hope both you and the case meet each other in good health in Wiesbaden. But I thought you would enjoy some of my brushwork even more. So I made two little pictures for you which Mama is going to bring in her writing case. I am having such a wonderful time painting and drawing. Especially now that I am having such splendid lessons with Wiegandt. I am working from live models, in charcoal. I love doing that. Naturally I would like to do the same kind of studies here at home, but of course I cannot expect anyone to be patient enough to sit hours posing for me without moving. Mama is so anxious to help me find models. Recently she asked Herr Bischof, when we were having a pleasant cup of coffee together, whether it would not be a nice idea for me to sketch him. To my horror! But our mutual hesitation did not help at all. The trouble with me is that I am simply unable to idealize people; in fact quite the contrary. Consequently I gave Herr Bischof such an angry bureaucratic look in my sketch that he departed from us with thoughts of vengeance. Ever since I have been drawing my own faithful reflection in the mirror; it, at least, is patient—

Almost every day Milly and I have been passionately playing lawn tennis. Old Frau Runge lets us come whenever we want to, so naturally we never let an opportunity slip by. Sometimes we play with the de Tierys on the parade ground. But first we have to lay out the court with boundary ribbons and put up a net. That always takes quite a bit of time. But when it is all set up it works gloriously. And now, guess what? We are hatching plans to set up a tennis court of our very own. Way at the far end of the garden, you know, where it turns the corner. Not much grows there anyhow because of the heavy shade. Potatoes are growing there now, of course, and we have to be patient until they are ready to harvest. But just the prospect of our own court is heavenly. Everything in the garden now looks magical. All the trees are covered with blossoms and the entire garden is filled with such a sweet springtime fragrance. One is tempted to wander to and fro all morning and listen to the twittering of the birds. But I suppose it is just as beautiful where you are in Wiesbaden. In fact, everybody seems to be writing that they have never experienced such a spring before. Aunt Marie and Aunt Cora wrote that it was just like being in the tropics where all of nature seems to unfold without a drop of rain. Yesterday we received some old letters from Aunt Marie. They finally seem to be setting themselves up at Castle Malwood now. They are still sleeping nearby at the sister of Uncle Charles, but they spend the days at their home. Aunt Marie sent you, through me, a complete set of Byron in English for Christmas. I gave them to Mama so that she could take them to you. But she has no more room in her luggage, so they are here in our bookcase. Shall we keep them for you in the meantime? Now, my dear Kurt, I have come to the end of the page and I must close in a hurry.

<div align="right">Always your old Paula</div>

Bremen, Schwachhauser Chaussee 29
May 5, 1893

My dear Aunt Marie

I am so happy that I can finally write in German again. When I write in English I seem to express everything in such a ponderous and formal way, and I think it is all so frightfully boring. I am sitting at Aunt Minchen's desk now, enjoying heavenly daydreams, imagining that I am back in the old days when I was still "your good child." I wish I still were, and I ask you to please forget the whole time I was in England with you. At least forget the bad impression you have of me. I am really not that way, really not. You think I am extremely egotistic. I have so often puzzled over that and tried so hard to locate this terrible egotism of mine. I cannot find it. What I have discovered is that I very much want to be in control and that I have gotten used to directing my own life. But you see, almost everybody over there seemed to submit to my wishes, and neither they nor I ever really noticed it. When I was in school I thought it was completely natural that whatever I said or wished should dominate. But does that have anything to do with egotism? And even if it does, could I help it?

Earlier I was almost always praised by Mama and I still am. At least the whole family assumed that whatever I did I was not to be blamed. Then I came to you in England, and I saw that whatever I did did not seem to please you or was contrary to your hopes. Well, I came to you with a huge amount of pride. Would you suppose that I would put up with everything, considering my past? Could this "spoiled" child get used to such a whole new situation? Every time I felt your dissatisfaction with me, I became more unhappy.

And then there came a time when I was frightened of you—up to then I had never experienced such a thing. And so I crawled more and more into myself; I became a living block of ice and stopped giving of myself and no longer felt any burning interests or desires. And those are just the things I must have. Now you have this negative impression of me. That is not the way I am; I cannot really believe that I acted that way—and so I am my own biggest puzzle. I am not used to taking orders. None of us is. I always spoke with Mama as if she were a friend. But you demanded something quite different. For example, I thought the arrangement of fans in the morning room at Willey was so pretty. I told you so, but you considered it presumptuous of me. So I kept my comments to myself from then on. I had such a strange feeling about the way you scolded me. If Mama arranges a vase in a pretty way, I simply let her know that I like it, which means that both of us then get added enjoyment from it. Something like this brings people closer together. All I can say is that fate decreed that I be the way I am. I was brought up so differently from others, perhaps, and I so often felt that I was annoying you without meaning to. But then my pride took over. It has protected me from a lot. I would tell myself, for example, that your behavior was unworthy of you. My pride is my best pos-

session. I will not put up with humiliations. They take all the spirit out of me. My pride became my soul. But you saw only the bad side of it. Accept me again as the Paula you first knew—the other one is only a caricature of me. I feel certain of that.

To Milly Becker

Bremen, Schwachhauser Chaussee 29
February 25, 1894

I have just been rereading your Sunday letter and it finally succeeded in conquering my laziness about writing you, my dear old Milly. To tell the truth, it really isn't laziness; it is simply that I am so terribly dried up inside that I could not even think of writing a letter. Well, now I have finally conquered that. Such a beautiful and free Sunday afternoon is a grand invitation to indulge in a little sisterly chitchat. There must never again be such a long interval between our letters to each other; that is against the law. Do you know, very secretly, all by myself, I am hoping for a reunion with you in April? It must work out. I shall act as your cunning and tricky agent here and put a few sweet and tiny fleas in Papa's ear. Up to now I have been racking my brains as to where I am going to get them. But just wait. One fine day they will come merrily hopping up to me.

I am enormously impressed by your letters in French. You can imagine how such a stupid little country goose like me has to prick up her ears to be able to understand everything you write. I already shudder at the thought of your asking me to reply in kind. So before it gets too late, I should confess my ignorance of the Romance tongue right now.

Let me return now to the news of my seminar. You will be pleased to hear that I can honestly confess I have not regretted my decision. There are many sessions which are anything but interesting. Nevertheless, they do direct our attention to all sorts of things that please me a great deal. I can return to them and study them thoroughly on my own. And then I discuss them with Anna Streckewald and we have wonderful discussions. [. . .] We had splendid ice again all last week. Only it's a pity that the nice skating party we had planned for today melted into water.

Do you know what I really long for now? To dance and dance until I can't dance anymore. I had a wonderful time at our Architects' Ball, of course, and hopped around like mad. But no one there could really dance a lovely waltz. At the Künstlerverein [Society of Artists] next Thursday they are having their anniversary celebration. I don't know yet whether we are going. Even if we did I probably would not be very keen on taking part in the dance because the local ladies of the gentry will probably be there in great numbers. Do you remember our sweet "Grapevine Evenings" last year? I think that kind of dancing is so much nicer when two people

are struggling through it together. When I'm doing it alone I feel very uncomfortable. [...]

So, my little one, farewell for today. Think about me a lot. If possible, in writing, too.

In true love, your Paula

To Herma Becker

Spiekeroog, c/o A. H. Röben
July 20, 1894

My dear little Miening,
What fun I had getting two such beautiful long letters from you twins. Let me thank you over and over again, my Herma.

So it's raining very hard there? What a pity. It is here, too, really. But that's the reason we are always on the beach. Because then we can look out at the wide sea and watch the waves tossing up and down. And if we are not careful, all at once an impertinent wave rolls in and gets us all wet.

The little girls here make such pretty sand gardens for their dolls. Then they build real little ponds in them so their dolls can go swimming. Grete Streckewald was thrilled at the little baby-doll you gave her and is a faithful mother to it. My dear little Herma, I think about you so much up here. There are so many little live dolls here with whom you could have such delightful games, sweet little suntanned babies and also bigger girls of your age. I'm sure you would quickly become friends with them all.

Good night now, dear Sister of my heart. I am dead tired and must go right to bed. Greetings to Günther and Kea and Alwine. And for yourself, a kiss from your

Paula

To Herma Becker

Spiekeroog [undated]

My dear little Sister,
Really, I didn't think I would be getting another letter so soon. You are really spoiling me, so I must answer you again right away, too, mustn't I? But if my handwriting is not as pretty as yours was in your last letter, you must bear in mind that I am writing here in my lap and have to do battle with the wind to prevent it from delivering my letter into the sea. The rascal wants to take it to the fish, I think. But we won't let him, will we? It is so beautiful here by the sea. The water is making such lovely big waves. And up above, the gulls are flying. They are such

splendid big birds, with snow-white feathers. From time to time they dive into the water to catch a fish.

I love watching all of that. Yesterday we took a sail in a big sailboat. It was marvelous. Just think, we sailed right past a great big ship which sank two years ago; and now all one can see is its tall masts.

What are your magpies up to, my Miening, and do you all still have to clamber in through the window? Write me very soon again. I am too cold sitting here. So here, quickly take this kiss from

Your Paula

To Kurt Becker

Bremen, Schwachhauser Chaussee 29
April 27, 1895

My dear old Brother,
Now that I have finally set myself down to write you, I really feel a great sense of relief. All winter long I felt a great need to talk to you by letter; but then each time I tried, I couldn't do it. You know as well as I do that we did not get along during the October holidays as well as we usually do. There were those constant frictions which eventually made me feel so angry inside that I am afraid I was not always exactly the most charming person myself.

All of that left a little thorn in my heart. But it has long since gone away. And now in its place there is a strong desire to regain the feeling of having a big brother who loves me and thinks about me, a big brother whom I can look up to with pride and who will be able to share the sublime and the ridiculous with me again. I could of course be writing something like this: "You know this long silence between us has completely dried up my pen, so I was unable to write." But this beautiful spring has opened up my heart so much that I can't keep everything inside. I must let the air in. So now, my Brother, I come to you today to ask that everything between us be the way it was before. Please, let's not become strangers to one another. The other day I thought of that little song, "A brother and a sister, the world knows nothing truer." It made me feel such a longing and so sad at the same time. Let's not make a liar out of the song, my Kurt.

Today is your birthday. I wonder if it brought you greetings from our dear family who are in Italy now? Once again you are going to get my letter too late. The cause of it this time is a silly old school paper which got in the way. Am I really supposed to wish you happiness? That sounds to me much too commonplace and also much too ambitious. Real happiness is something that I can't imagine for myself; I think that it doesn't even exist for us wee mortals. And if by mistake even a little ray of happiness sometimes falls to earth, when it is gone, things only look blacker. I wish you real contentment in your work and a life without too much brooding

and pondering. That can only make one melancholy. And what else do I wish for you? I wish you enough strength to overcome your pride, your pride or whatever else it might be that keeps you from writing your family what you feel and what you are going through. I think that our dear father has suffered very badly from your behavior, even though he never mentions it, which is typical of him. It is precisely because he never says anything about it and because your name is never mentioned that I know he feels that way. The twins feel it, too. Henner recently said, in that straightforward way of his, "Kurt hasn't written for such a long time I can't remember what his handwriting looks like." And the little fellow was always the first to recognize a letter from you. He would always put them face up on Papa's plate at table so that they would shine out like a beacon for him to see.

The time is finally approaching for Mother's return home. I can hardly wait. I have been longing for her more and more in recent days. I keep wanting to show her how everything is becoming green and how all the buds are swelling. I have been studying everything much more thoroughly this spring, almost as if I were storing it up for the springs to come—because this is probably the last one we will enjoy here in our dear old house. I can't even bear to think of it.

Signs of life are already beginning to appear on the tennis court. It now looks better and more solid than ever, and survived the winter in good condition. By this time the boys have progressed far beyond their teacher. They really are very nice players now. Sundays are our big days for tennis. We are always in an exuberant mood and do our best to play a good game and tell silly jokes.

This week I have been an eager visitor to the Kunsthalle. When you were here did you ever hear about the colony of painters in Worpswede? Of course you did! There is an exhibition of their work here now and there are some really wonderful things. You must have also heard of the *Sermon on the Heath*, which one of them, a man named Mackensen, painted while sitting in a glass wagon. He had it built for himself especially for painting this picture. It is an extraordinarily interesting canvas. The congregation is seated before the pastor out in the open. The artist was able to capture each one of the life-size figures perfectly! They are all so alive. Naturally everything is extremely realistic, but it is still wonderful. The only thing I cannot completely understand is the perspective. I would so like to sit down and talk about it with someone who really understands art. Do you know, the whole thing seems to slope away as if it were falling? I wonder if that is the way things really are or whether the way we foreshorten perspective is just something that has been artificially trained in us. I really can't imagine that that is true.

Another picture that interested me greatly was painted by Modersohn. He captures the various moods of the heath so beautifully; his water is so transparent and his colors are so original. There is also Vogeler, a young man from Bremen; you probably know of him. He was one of the handsome Italians at the bazaar. But he paints the craziest things! He paints all of nature in a very stylized, Pre-Raphaelite way. In these modern times all one can do is shake one's head at such funny

things; but Dr. Hurm is naturally all fire and flame for his little protégé. I haven't spoken to him myself about it yet but I have seen him at a distance in the Kunsthalle several times and he impressed me as being extremely enthusiastic. [...]

Your faithful Sister

*[Journal entry?]

[After her teachers' examination,
September 8, 1895]

It is so heavenly to think that one's poor head can digest what has been stuffed so hastily into it, and also that it can forget in peace everything that is of no interest.

To Paula from her father

Leipzig, Pfaffendorfer Strasse 18
February 6, 1896

Dear Paula,

Your good uncle Paul has been very tiresome up to now, so you must not take it amiss that I am not in the proper mood for congratulating you on your birthday. But you must know what I mean to say. I wish all of you, and you in particular, the best today. Even though I have separated myself from my family, it was only to make your lot more bearable. So then, let me embrace you and give you a birthday kiss *nolens volens* [willy-nilly] and wish you everything that you might wish for your own good that is beneficial to your well-being. First and foremost, be sound and healthy and everything else will take care of itself. I sent Mama two Langen patterns; I hope they will come in handy when you are making your woodburning pictures for Aunt Gretchen. I can already hear you say, *toujours perdrix*, never anything but birds and flowers, but I couldn't find anything appropriate, so I hope that with your talent for drawing you can invent some new designs. [...] Mama will also be giving you money from me. Use it for something suitable, and if it is not enough, blame the bad times and not me. If you should think of buying yourself a book, I can recommend these: *Die Rothenburger* by Wilbrandt, *Effi Briest* by Fontane, and *Bozena* by Ebner-Eschenbach. But before you buy one of the books, borrow it from a library first and see if it appeals to you. [...]

To her father

<div align="right">Bremen, Schwachhauser Chaussee 29
March 26, 1896</div>

My dear Father,

In this heavenly spring weather our thoughts are flying to you even more than usual. If only we could telegraph for you to come for just a quarter of an hour to our dear round table, you could have a view of all the loveliness here. Well, it will only be one more week. I look forward so much to Maundy Thursday when we can fetch you at the station and show you all this splendor. Mama and I both think that there was never a spring as beautiful as this one. The glimmering light on our dear weeping willows was never before so tender, the blackbirds never sang so sweetly, and the bluebells never blossomed so merrily. This joyful weather is contagious to everybody. It is a true pleasure to go walking in the streets. Everyone looks so pleased. What power there is in the dear sunshine! Our staunch North German vegetable and egg women are suddenly carrying heavy baskets on their heads with such ease and have assumed such a light tread, almost as pretty as I imagine their Italian counterparts do. This morning Walter Schäfer was here. He celebrated his brother's confirmation by playing tennis with me. The rascal is suddenly transformed. His leg no longer hurts and he can hardly contain himself from sheer happiness. Günther and he have great plans for the summer: getting up early and rowing and tennis.

—Along with all these happy people I saw poor Frau Dr. Hurm yesterday. She spent all morning with us in the garden. The poor woman! She burst out with such childlike sobbing. She is full of charming stories about Dr. Hurm which she recalls over and over again with tears in her eyes. Then she says, It was so beautiful just living for him. The poor heart still can't get used to the cruel thought. At Easter she plans to go quietly out to the country to visit her maid's grandfather. She needs to be alone for a long time. I think she often has too many people around her here.

Yesterday the Rassows roared past our house on the train with very happy Italy-bound faces; today Tony Rohland is going to Merseburg, where she'll spend the holiday with her mother's cousin.

I am reading the letters of Mendelssohn now with great joy. He was such a charming and fine human being. At first, he describes as a young twenty-year-old his visit with old Goethe in Weimar. The old gentleman seemed to take great pleasure in his company and invited him every day to his midday table. It is charming to read how happy that makes the young artist. Right now I am accompanying him on his trip to Italy and am at his side in Rome during the papal election. It is such fun to think of Milly who is now actually basking in the very places where I am dwelling in my thoughts. I am also reading a little art history on the side. Mendelssohn speaks of many paintings and artists about whom I want so much to learn more.

Intermission!!!

I have just come back from giving a coat of paint to our garden furniture with good Kurt Bücking. Now my poor head is so full of turpentine vapors I can't even think of writing any more. I hug you, my dear Father. [An illegible word because of smeared ink.] How beautiful. In a week we'll really be able to do it.

<div align="right">Your Paula</div>

1896–1899

Paula Becker went to Berlin on April 11, 1896, to take part in a course of barely two months' duration at the Drawing and Painting School of the Society of Berlin Women Artists. This was not thought of, however, as the beginning of training for a career as an artist. The few weeks she spent there under the strict instruction of the painter Jacob Alberts, a man she seems to have admired, were not particularly productive for her, except perhaps to strengthen her desire to remain in this atmosphere and continue to learn. When she left Berlin on the last day of May she knew that she would return in the fall. It is uncertain how or through whom this turning point came about. Somehow a reduction in the tuition was arranged and her Berlin relatives took care of her daily needs. In December her mother happily announced that she was now in a position to pay for Paula's painting lessons as she had taken an American woman boarder.

Prior to that autumn there was a summer of traveling: first a stay with friends in Jever in June and then Aunt Marie Hill's invitation to Hindelang for July and August, where the primary purpose was to strengthen Paula's health. A trip to the Allgäu included two days in Munich where she got to know the treasures of the Pinakothek and the Schack Gallery.

On October 12, 1896, Paula was back in Berlin. Knowing that she had a long winter ahead of her, she plunged into her studies. Immediately she began to seek out from among her teachers the ones she felt would be the most beneficial to her. Of all of them, the fifty-six-year-old painter Jeanna Bauck had the greatest influence.

Studying with her, she discovered where her artistic talent and inclination lay — not in landscape, but in painting and drawing people. She used all her free time to visit museums and frequently went to the theater. After the performances she would energetically discuss the plays of Hauptmann, Ibsen, and other modern playwrights.

There was also plenty of time for cheerful socializing. Her growing inner security can be detected in her letters, both from the handwriting itself, which now takes on characteristic and generous expansiveness, and from the way she expresses herself. She writes, for example, "Maybe this made me a little one-sided. But I believe that if I am ever going to get anywhere, I have to devote everything I have to it" (February 20, 1897).

Paula returned to Bremen on June 11 for her parents' twenty-fifth wedding anniversary. Following the days of celebration, a large family group made an excursion to Worpswede. Frau Becker writes in her diary, "Paula was so filled with enthusiasm that she decided to live out there with her painting companion for two weeks and paint. She wrote exuberant letters, like the ones we wrote from Italy,

and returned home with a portfolio of sketches and drawings of heads." From the dates of the letters, however, it is clear that it must have been more than a month she and Paula Ritter spent in that village on the moors, alongside the painters who made Worpswede famous.

Love of nature was born and bred into Paula Becker. To her, nature is the creation of God and God is to be experienced in nature: "I say God, and what I mean is the spirit that flows through nature" (January 24, 1899). She shared this view of things with many of her contemporaries. And as always, nature awakened a festive mood in her. In addition, she felt both happy and fortunate to have an entrée into artists' studios and to live in their midst. The result of this was not only jubilant letters to her parents but also effusive entries in her journal.

At the beginning of October she traveled to Dresden to see the great International Exhibition of Art. On the fifteenth she was back in Berlin. She lived in the city with her aunt Paula Rabe at first and then moved early in the new year to the quiet countryside of Schlachtensee where her uncle Wulf von Bültzingslöwen had his house. From there she commuted the ten miles to Berlin by train. The work of the semester was interrupted in November by an invitation to Vienna to the wedding of a girlfriend from her childhood days in Dresden. There was enough time there to roam the streets of the baroque city and visit the great art galleries.

After that, however, a life of obligation and duty threatened to intervene. Her father was soon to be completely dependent on his pension and wrote her in December 1897 that after the completion of her course she must earn her own living. She understood his concern and worry and was prepared for anything. She asked her family to find her some position of employment, but undertook nothing on her own. Again, outside intervention came to her aid. At first it was a matter of chance. At the beginning of 1898 an old grandaunt, her godmother, left Paula six hundred marks in her will. Shortly thereafter, other relatives of her father, Arthur and Grete Becker (a childless couple from Dresden), secured her immediate future education with an annual stipend of six hundred marks for three more years.

Thus she was able to continue her work without worry during her remaining months in Berlin. During this period she visited many exhibitions. The one at the Gewerbemuseum [Museum of Arts and Crafts] in March and April was very likely one of the most important for her. She saw there the lithographs of the most important contemporary artists of Germany and France. Among the sixty-six German artists were Liebermann, Menzel, and Hans Thoma. More important were the sixty-four French and Belgians, among whom she saw many for the first time here: Puvis de Chavannes, Fantin-Latour, Carrière, Manet, Meunier, Pissarro, Redon, Renoir, Sérusier, Signac, Toulouse-Lautrec, Vallotton; the Norwegian, Munch, was also represented. Paula was to encounter all of them again in France and to come to terms with the work of many of them in her own art. In April 1898 she went to the wedding of her father's youngest half brother in Leipzig and at the prompting of her father visited Max Klinger in his studio. She was deeply impressed

by his personality. In 1901 she wrote Rilke about this meeting—but she never mentioned it in her letters home, an indication of the fact that she now began to be silent about those things that touched her most strongly. For example, her mother asked about the impression that Gerhart Hauptmann's *Die Versunkene Glocke* [*The Sunken Bell*] had on her. It was a play that she had seen with her aunt Cora, who had written a most enthusiastic account of it. Paula, however, passed over this experience despite the fact that this tale of nature and its theme, the battle of the artist for the completion of his work, moved her deeply and occupied her thoughts for a long time, as her journal demonstrates.

At the end of May 1898 her months of study in Berlin came to an end. The stimulating conclusion to this period was a salmon-fishing trip in June and July in Norway on which she was invited by her uncle Wulf.

The month-long stay in Worpswede during the previous summer must have aroused the desire in Paula Becker to live and to learn in the circle of painters there. She must have spoken of this, for on May 3 her father informed her that Fritz Mackensen had "offered you his support and advice while you are studying painting during your summer holiday." There is no talk of a regular teacher-pupil relationship. Mackensen's contribution to Rolf Hetsch's book of memoirs suggests that Aline von Kapff, a member of an old and rich Bremen family (herself a painter and patroness of the Worpswede artists and also a close and helpful friend of Frau Becker) must have been the go-between here. We can therefore scarcely say that Paula Becker "chose" Mackensen as her teacher—but she did accept the needle that others had threaded for her, something she was happy to do whenever it was a matter of practical arrangements. The important thing now was that the move to Worpswede had been made possible, and as far as the parents were concerned Mackensen alone among the Worpsweders was "acceptable."

On September 7, 1898, she again went out to the village on the moor and settled at the foot of the Weyerberg, this time for a lengthy stay. Again the landscape exercised its magic on her. She was also able to enjoy freedom from the well-meant but strict supervision of her aunts. She enjoyed her little private, primitive rooms, which she could decorate to her own taste. Her appearance and her personality were pleasing, at least to people whom she wanted to please. Her friend Clara Westhoff later described her first encounter that summer with the figure of the young Paula: "There sat Paula Becker in my studio in her painting smock, without a hat, on the podium meant for my models. She told me that she had become the pupil of Mackensen, who was also my instructor in drawing and painting. She was holding on her lap a copper kettle which she had had repaired for her little household and just picked up; and she sat there and watched me work. The kettle had the color of her own beautiful and abundant hair, which was parted in the middle and loosely brushed back and swept up in three great rolls at the nape of her neck. In its full weight her hair functioned as a counterpoint to her light and sparkling face with its prettily curved and finely drawn nose. She would raise her face

with an expression of enjoymnent, as if above a surface, and from it her dark and brilliant brown eyes looked at one intelligently and merrily."

Paula was a hard worker. Day after day she went to fetch old women, young mothers, and children from the poorhouse or from the village cottages to pose as models. For her these people were not representative of a sentimentally transfigured "simple life," nor were they a living accusation of social injustice. They were human beings on whom she could practice her powers of observation, and she chose them for the simple reason that they were satisfied with the modest fee which Paula could afford to pay them. She had "charming models," said another woman painter, working at the time in Worpswede, "pretty children"—but Paula Becker was not concerned with pretty children. From the very beginning she was concerned instead with some other thing for which at first she had no name at all. Ottilie Reyländer, also at the time a pupil of Mackensen, describes in her sketch for Rolf Hetsch's book a scene that suggests the genesis of Paula's emerging individuality: "She was taking modeling instruction at the time and the great nude figure she had just begun was standing on an easel. Mackensen was making corrections and asked her with a penetrating glance whether what she had produced there was something she really saw in the nature of reality. Her answer was remarkable: an instant 'Yes' and then, hesitating, 'No,' as she gazed into the distance. [...] Even as early as this, I would often hear her express views which were totally out of harmony with those of our master." Although Paula Becker and Mackensen soon began to approach one another with a certain reserve, a letter from him, written in the summer of 1899, indicates that he acknowledged her talent. She had asked him whether he thought she was capable of taking on a pupil of her own, and in this letter he answered her with an unreserved yes.

Her first years in Worpswede were years not only of industrious painting but also of reading. No matter how much she enjoyed walking, dancing, and socializing, she still often had to be alone with her books. Her Album, which was begun in 1892 for the usual purpose of collecting friends' and relatives' autographs and thoughts, had by 1897 turned into a notebook for collecting "the fruits of reading." It is valuable to us as an indication, beyond her letters, of all the works which occupied her thoughts at the time. The first such use of the Album is a quotaton from *Rembrandt als Erzieher* [*Rembrandt as Educator*] and subsequent entries span works from the mystic nun, Mechthild, in the thirteenth century, to Hölderlin's *Hyperion*, down to her late-nineteenth-century contemporary, Maurice Maeterlinck.

Paula Becker liked being alone in her own little world, but she also enjoyed having occasional guests, such as the young twins Herma and Henner, who had a kind of second home with their big sister. Her cousin Maidli Parizot was also a visitor in July 1899, and it must have been at that time that Paula spoke to her (as she had earlier to her aunt Cora von Bültzingslöwen) about her plans to go to Paris. For by then she felt, and also said, that Worpswede was not the place where

she ought to finally settle. As early as July 14, 1897, she wrote, "I must rub elbows with the outer world even if in a very private way!" Ottilie Reyländer also reports this need of Paula's for "rubbing elbows." To come into contact with other people and to measure the powers of those greater than she—that was something different from her observation of artists in the Worpswede colony. They did not so much come into contact as set up friction with one another, "because they were too alike and at the same time too different" (February 12, 1899). This idea of "rubbing elbows" was to return in her later letters. There is also another idea expressed at this time, later to be repeated: "I long so for life. [. . .] And here there is no life; it is a dream here" (December 1899).

The year 1899 brought with it a long trip and strong impressions. Marie Hill invited her niece Paula to travel with her through Switzerland. Paula saw Zurich, and later Geneva, and on August 18 Clara Westhoff wrote her in Munich, confirming a short visit in Leipzig, where Clara was studying with Klinger. From Leipzig the trip continued to Dresden where she visited the Deutsche Kunstausstellung [Exhibition of German Art].

In November there seems to have been a series of altercations with her parents, who no longer were in accord with the artistic aspirations of their daughter. To be sure, she consoled them and asked them not to worry. But at the same time she admitted, "My destination will gradually take me further and further from yours."

Shortly before Christmas, 1899, Paula Becker exhibited two paintings and several studies in the Bremen Kunsthalle, along with works by another Worpswede painter, Marie Bock. The review by the critic Arthur Fitger, an opponent of the Worpswede artists and indeed of all modern art, was devastating. The Worpswede painter Carl Vinnen wrote a retort which, well meant as it was, made matters even worse. Gustav Pauli, director of the Kunsthalle and the one who had accepted her work for exhibition, was silent. The affair caused excited "Fitger discussions" at the home of her parents. They felt their opinion confirmed in this criticism, considered Paula's artistic aspirations failed, and spoke of her stay in Worpswede as a mistake. Thus her parents probably welcomed Paula's trip to Paris (long planned and now perhaps in part determined by the fact that Clara Westhoff was there), for they could, at least for the time being, pass over this disagreeable affair. Paula's final jubilant letter before her departure on New Year's Eve, 1899, was written to Otto Modersohn.

To her mother

<div align="right">Berlin, Perleberger Strasse 23
April 11, 1896</div>

Dearest Mother,

To stop you from worrying, which I really don't believe you are anyhow, I just want to tell you that your chick has arrived in the big city of Berlin. The trip went perfectly. I changed trains in Hannover with great nimbleness and found a seat in the compartment of a fat Jewish woman. She had some kind of connection with François Haby, hairdresser to His Royal Majesty the Kaiser and King, and Specialist in Beard Trimming. Now, whether she was his spouse or his sister or something else, my keen intuition could not fathom. I enjoyed her healthy appetite and watched her devour several sandwiches at every station stop. At the Berlin–Friedrichstrasse station brother Kurt was waiting for me, and when we arrived at the house, there was little Ella. The girl is really strikingly pretty, with her little lively face and her slender hands. My eyes are absolutely head over heels in love with her! In the evening when she sits on the edge of her bed in her little nightgown — such a picture! In fact, she is one pretty picture after another. But you need not read all of this to our boys; they might just write her about it if you do. And what high spirits that girl has, and she is a devil. I think she has one rendezvous after another with her boyfriends. I have no idea how I would behave if I were in her shoes. It really makes me curious. It is interesting to be with a little human being like that. When we're together I feel like a country bumpkin. In a thousand different ways I seem to have a conscience where she has none — still, that's very becoming to her. Pity that I am not a few years younger, or several years older. If I were, I could enter into the spirit of her high jinks a little better. [The remainder of the letter is lost.]

To Paula from her father

<div align="right">Leipzig, April 15, 1896</div>

[. . .] First of all, welcome to Berlin. May you have a good time there and benefit greatly from your drawing studies. You will sometimes feel a little lonely there, and if you do, the best prescription against homesickness is to take a sheet of paper and write your parents about what is in your heart. They will understand you, don't worry, and even if they joke a bit and call you little Auntie Frieda, you must know that there is nobody else closer to you than we. But you must become more independent and get rid of a certain amount of primness in you (that is to say,

prudishness). I hope that when you are alone and can see that people have neither the time nor the inclination to criticize everything in their fellowman or to waste energy on trivial matters about other people, you will realize that one always does the right thing when one follows inner convictions and doesn't always have to ask, what are people going to say about that. [...] Life in the big city will polish away such exaggerated timidity. [...]

That is to say, and please understand me correctly, all well-brought-up people must be considerate to others and only in that way will they be agreeable and likable. But toward yourself there is a need for less self-concern. One must not think of oneself egotistically; think more about other people, and then the exaggerated fear of doing wrong will disappear. Out of self-regard one will be careful not to do wrong to oneself; the general law of self-preservation prevents us from doing so. [...]

You write rather disparagingly about the National Gallery and quite unfairly, I think. Naturally, not all of the artworks there are of the first rank, but surely there are many glorious paintings to be seen there, which, despite the modern school, will always endure and enchant us. Here, too, you will be able to see clearly how the ability of German artists in recent years has improved. In former days the concept was generally grander than the execution; gradually the concept faded away as the idea of copying the French became the predominant factor. Indeed, now the pure rendition of nature is the loftiest thing that certain painters can imagine, no matter how insignificant the subject may be. What makes for true art is not the subject alone, just as little as it is the craftsmanship. A subject can have an artistic effect if it reproduces the individuality of the artist's perception. A painting, therefore, must affect us as something completely individual, and that person is a master who with his powers of perception can win over the feelings and the comprehension of the majority of independent thinkers. [...]

To her parents

Berlin, April 16, 1896

[...] Well, I had my second drawing lesson today. Interesting and very amusing! I'm drawing an old woman. The first day I had to start over three times because Herr Alberts is a strict instructor. When I began to draw I found that my hands were shaking from the severe way that he was criticizing the people around me: "Rubbish! Junk! Am I right?" And if the poor victim didn't quickly say "Yes" he would throw his piece of charcoal on the floor and dash over to the next easel. (So this is the way to self-knowledge, is it?) To the next victim he says, "Ridiculous! Right?" And again he would get the same meek reply, "Yes," which he would usually repeat in a half-singing and mocking manner: "Ye-e-s-s...."

What I am afraid of is that if I were to be put in the same situation, the yes would

stick in my throat, and he would interpret that as obstinacy and run away. All good Spirits, please protect me! So far I have gotten along very well—he probably has to know one better before he begins to abuse one this way.

At the third easel: "No! No! No! *Rien!* Nothing! Nothing! Work with reverence. Work with passion!" While he is shouting all of this, he smears the most delicate and careful charcoal drawing with the palm of his big hand, putting in a few shadows with his fat thumb, and adding a few highlights with a piece of bread. Suddenly the whole thing is right, ingenious, has a character of its own and is free and easy. The best thing about him is that he cares a great deal more for the concept than for the mere execution; he sees far beyond the superficial.

And when he gets to the fourth easel: "No talent, hmm? Or is it no energy? Which? No matter, it's a complete failure!" At this point he permits the quiet little wretch to reply to his thundering denunciation: "Should I start all over again?" And some other person is then denounced in a terrible way because she doesn't have enough "feeling" for the convolutions of the ear she is drawing.

Well, the whole business made me very nervous at first, but gradually it began to seem so comical that after a while I wasn't able to suppress my laughter. The major effect of it all, naturally, is that he really makes us work very hard. Today he even seemed rather pleased with my drawing. Well, "pleased" is an exaggeration, because the drawing is still much, much too trite for him, and also a little too wooden....

* *To her parents*

Berlin, April 23, 1896

[...] How quickly time is passing! I have no chance to feel lonesome or to be bored. Four mornings a week are still devoted to drawing instruction. I am completely preoccupied with it. Even when I'm not in class, I keep imagining how I would draw one or another of the faces around me. It's enormous fun studying physiognomies and trying to quickly pick out the particular characteristics of each. Whenever I talk with somebody I try hard to see just what kind of a shadow his or her nose casts, or how the deep shadow under a certain cheekbone starts out and then gradually blends into the highlights. This gradual blending is the hardest thing for me to capture. I am still drawing shadows much too distinctly. Instead of emphasizing what is important, I find I am trivializing. Until I can do that, nothing I draw will have life and blood. My heads are still too wooden, too stiff.

Herr Alberts seems to be a really fine teacher. He knows exactly what each student is capable of and demands the utmost from each of us.

He says, "It is a sin if you do not pursue your art with devotion, a sin."

Up to now I have drawn two little old women. One is a sort of smart aleck in a feather hat and the other a gentle, tired woman. I was much more successful with

the second one. The style I'm after is still so new to me — I am just beginning to get a feeling for it.

Mondays and Tuesdays I draw with Stöving. But I don't get the same joy from it. The power of Herr Alberts is missing. Stöving doesn't reprimand me severely enough perhaps, but his praise isn't right either — you never know what he really thinks is good or bad. He doesn't seem to look at a drawing as a complete thing — instead he criticizes each separate line. He doesn't seem to infect us with enthusiasm.

Two mornings a week, Fridays and Saturdays, I am completely free, and then I go to the museum. I am becoming very familiar with the German masters now, and with Holbein — but Rembrandt still remains the greatest. Those heavenly light effects! He is one who painted with devotion. Do you remember *The Vision of Daniel*? I am moved whenever I look at it. You don't have to be pious when you study it to get a feeling of the piety in Daniel's ecstasy. Rembrandt was the complete master of light and shadow; that's why he interests me so very much....
Quick to bed now, so that I can dream about all my newly discovered wealth....

To Paula from her mother

Bremen, May 7, 1896

[...] my dear old "tennis demon"! Tomorrow it will be a month since you left us, and your drawing lessons, which have been occupying you so happily, are now almost at an end. I wonder if and when it will be possible for you to continue your favorite study again; who knows? I hope and pray that it will happen for you, but how are we to make it come about? ...

To Paula from her father

Leipzig, May 11, 1896

[...] I am sorry that you are unable to continue your drawing lessons, for you have, so to speak, only begun to sniff around in art a little and so of course you can't expect any great success yet. We must see what the future holds and whether I can find the means to keep you going in your drawing and painting instruction. For, as you yourself must be able to realize, there must soon be a change in your life. You cannot always stay at home and somehow you will have to learn to become independent. When the time comes for my eyes to be closed, then you will be quite dependent upon yourself; and it will be all the more difficult for you if you do not learn to become independent soon and to rely on your own resources. However, I shall grant you the summer for rest and recreation, but after that the word is: to work! I am convinced that you have energy and strength enough to make something of yourself. I do not believe that you will become an artist of the

first rank, blessed by God. That would have already become obvious by now; but you do have, perhaps, a sweet talent for drawing which can be useful to you in the future, and you must try to develop it. Even if it is not in you to produce superior art, by sticking to it you will achieve better-than-average results and not sink into the world of the dilettante. In my view the latter is the curse of our women's education today. . . . In this regard, Englishwomen are superior to those in this country; they have enthusiastically taken up the battle for existence against their men and I do believe that they will be the first to establish for themselves a new domain of influence and a new future. . . .

*[Journal entry?]

[Prior to May 18, 1896]

[. . .] I'm still battling my material with great difficulty. I find this casual use of charcoal terribly difficult. "He" really didn't say "Rubbish." I said it to myself and became very melancholy. Terribly, terribly hard! I am supposed to keep the whole thing in view when I only have time to see one thing at a time. I live entirely with my eyes now and look at everything with the mind of an artist. When I make my pilgrimage down the Potsdamerstrasse on my way to drawing school, I study the thousand faces that pass me by and I try with a glance to discover the essential thing about each of them. It's very amusing, and I often have to try hard not to laugh aloud when strange contrasts come into view. Then I try to see everything in two dimensions, to dissolve curved lines into angular lines. It makes for great fun. I work with all my heart and soul in Alberts' class. I sometimes have such a ravenous hunger for him to praise me to the sky. But I'm still far away from that. I see much which is still so childish and untrained, too trivial, etc. And now, next Wednesday, it comes to an end. Sad, sad. When the drawing lessons are over, I shall look forward to going home. I have already decided on what I am going to draw! Herma with the little black goat, Cerberus, the two rabbits, and Minka, the white one.

*To her father

Berlin, May 18, 1896

My dear Father,
I received the happy news three days ago! I think about it all the time, but I still can't believe it. You really mean that you will let me continue with my art! I'll summon up all my energy now and make the most of myself that I possibly can. I can already see a glorious year of struggle and creativity ahead, filled with momentary satisfactions, but also with a striving for greater perfection.
 I'm drawing as much as I can every day. My portrait drawings are very success-

ful, in part—but they still have too much that is exaggerated and out of place.

Whenever I have no model to work from, I go into the garden and try to sketch the brickwork there in watercolors, or sometimes the big acanthus bush. The coarse brickwork of the building, with its reddish and bluish tones, has awakened my passion for color.

I must make a drawing of you, too, but not until you grow your beard again. Have you scolded your barber yet? Please do it. Or else entrust your dear head to a better barber, one more worthy of you. The next time we are together, I shall make a sketch for your portrait—but only if you have your beard again.

[...] Did you know that we were in Hamburg? I was lucky enough to be included. And that we saw Bismarck, our great old Bismarck? But how very old he has grown. The cheering that was music to his ears for decades seems to annoy him now. He kept waving the crowds away. He seemed to be gazing over the heads of the people without seeing them. I handed a rose to him as his carriage passed by. He took it and sniffed it. I was deeply moved. It was the first time I ever saw our great, great chancellor—but fate and old age have broken his strength. [...]

Excerpt from undated letter
Perhaps to Marie Hill

[...] I have the feeling that I have to be with you now and hug you tight. But then, if you were here with me, I probably wouldn't do it, for there is something constricted in me which doesn't permit any such luxury. I don't know why it lurks there or where it comes from, but there it sits and won't be shaken loose. Every time I try, it clamps on tighter to my soul. In the long course of my twenty years, I have gradually and very silently recognized this great power, this hidden something. It's only rarely that I will stand up to this strict tyrant, and then it really does hurt. I see, for example, how Maidli spreads her wealth of love abroad with full hands. I feel her gentle caresses. My inner being is also capable of caressing, but in the real world I cannot. If I try to do it anyhow, if I force myself to do it, then there is no spontaneity to it—it feels stiff to me and probably also to the other person.

Woldemar Becker to his wife

Leipzig, July 3, 1896

[...] What is to become of Paula? She is and remains too dependent and does not have the energy to make something of herself or to make herself independent. You

Postcard, July 30, 1896, with self-portrait lower right

started this whole art thing in Berlin without my knowledge. I did not try to put a stop to it, but do you really believe that the child will accomplish something worthwhile or can at least manage to learn how to support herself from it? I doubt it. I hope that you prove to be right, as in Milly's case. [. . .] But Paula? She is not cut from the same cloth; she is pretentious and accomplishes little, very little. You always find grounds to excuse her. She is "too delicate," and then the next time she is "too young." When it comes to having a good time she seems to have the strength to endure everything, but when it's a matter of accomplishing something sensible, then she is anemic, and so forth. I am in a bad mood and perhaps I see the dark side of things. With the best will in the world I cannot put the eternal *couleur de rose* on everything. [. . .] But now Paula has recovered enough from her work in the seminar and she could do more. Even at home she is only a sulky creature who perhaps knows how to arrange flowers and decorate the rooms with them, but one cannot make a living from that and in my way of thinking that is the essential thing. I don't believe that our daughters will marry, Paula least of all, because she is more critical of others than she is of herself and demands more from them than is justified. If they wish to go forward then they must learn to stand on their own two feet.

Still, a girl who is supposed to make her own living certainly does not have an easy time of it in this world. [. . .]

Your old Misanthrope

To Paula from her mother

Bremen, October 20, 1896

[...] it was a week yesterday when you left. Your first Sunday letter is saturated with the sheer joy of art. Child of my heart, I share your happiness at even the slightest success, at every bit of progress, no matter how small. Your sketch of the Rheinsberg, your first nature study, was left here; I found it and it made me happy. Just go on working with a confident and happy heart; strive for the highest and if you don't reach it, try to feel that the striving itself is happiness.

To Paula from her father

Bremen, November 4, 1896

Dear Paula,

We awaited with great curiosity the delivery of the drawings from your two-week course, which you announced in your birthday letter. And yesterday they arrived right on time, were unpacked, and exhibited on my sofa. The five heads are not all equally successful. The forester, or rather the bearded man, is the best, if I may say so. Less good, perhaps, is the lady who looks as if she had caught cold in the WC. Women are perhaps more difficult to capture because their features are not so clearly defined, and the treatment of larger surfaces is certainly harder, because light and shadow do not grow from the features themselves but from the whole form, and they demand finer nuances. Perhaps the medium that you chose, charcoal, is not entirely appropriate for more delicate representation. Nevertheless, each of the heads has its own character and presents to the viewer a complete personality. As far as the head in red chalk is concerned, the light and the shaded areas seem to me to have too sharp a contrast, and the light areas—for example, forehead and chin—are not sufficiently modulated. Whereas with charcoal one can achieve considerable technique by softening and wiping, with red chalk the drawing is everything. I speak to the extent that I understand these things. You the aspiring "artiste," are probably wrinkling your nose at much that I say, but that cannot stop me from practicing my criticism, no matter how far it may miss the target. Despite all your little weaknesses, however, I must certify that you have been very industrious, and judging from several of the heads, progress cannot be denied. If you continue in this way, then you will certainly achieve a considerable skill and become more and more mistress of the material and of form. [...]

To Herma Becker

Schlachtensee, November 17, 1896

My dear little Mienchen,
I must answer your elegant rose-colored letter right away. It impresses me enormously, of course, that my little sister already has such regal stationery. But see here, I with my lovely lavender paper am not going to be outshone. Today Uncle Wulf went to Pomerania to go hunting, and so I had to walk the three dogs. That was quite an undertaking, because when I let the mongrels out of the kennel they began to go wild. In a minute I had completely lost sight of them. And they're not permitted to go chasing around like that for fear they might go after the little deer. I couldn't even get out a whistle at first. But then I did finally manage a good shrill one, and the two big hounds dashed back, followed by the little white one named Nelly who pitter-pattered after them.

I wonder if I'll find a skating rink soon? The Schlachtensee already has a very wide crust of ice along its banks. I was able to give it a good chipping with my heel. Are they heating your "sunflower bedroom" on Sundays, and are you getting good heat from the stove? You must tell me all about that soon. Farewell, my little sister. Greetings to Henner. A kiss to you from your Paula.

**To her parents*

[Late November, Berlin, 1896]

[...] I have fantastic news to tell you. *Next week I start painting in oils!* I put great effort into my picture of corncobs. And then yesterday Dettmann came up to me and said, "Good, good, very good!" —And then he said that I could paint next week. My heart rejoices! Think about me Monday! And if I've painted something good, then I'll think about you and be happy for you. And if it goes poorly and sadly, then I'll hear your encouraging words of consolation in my mind.

How I look forward to working with oil colors!

Forgive my rush. I've been so serious about my work all day long that all this rush is rushing into my letters. [...]

To Paula from her mother

Bremen, December 5, 1896

[...] She will get two of our rooms, and I shall get three hundred marks a month for room and board, and now I can pay for your painting lessons. Hurrah! And that makes me so happy, because Father often accuses me of having "put my foot in it." [...]

My Paula, I think it is very sensible that you took along only the one brown winter skirt and no dress; then in March, you can copy Aunt Cora's light-colored

cheviot dress. Go with Aunt Paula and buy yourself some very good material; it must be very good because it has to put up with heavy wear. [...]

To Paula from her mother

Bremen, December 29, 1896

[...] Father and I were overjoyed as we solemnly withdrew into his *fumatorium* [smoking study] with your roll of drawings. There was the head of a woman, which you drew twice, a young woman with a whole history in her face and she captivated me. And the life studies are splendid; I almost think the best of them is the tender and gaunt figure of a woman whom one sees from the side. I sense that these are things which interest you primarily, dear Heart, and that your teachers are satisfied with you, and that the stern Fräulein Hönerbach is praising you. What good fortune! But do you know what I would do, for absolutely certain, every evening if I were in your place? Every evening I would take a pencil and a piece of paper and, even if I failed a hundred times, I would try every evening to capture the likeness of Uncle Wulf and Aunt Cora. In your whole life you will never again have a chance to live with such a beautiful pair of human beings. Seize the opportunity when Uncle Wulf is reading aloud. Sketch his nose, his eyes, a hundred times, and when Aunt Cora is knitting, draw her magnificent face over and over. And don't be discouraged, even if you fail a hundred times. Believe me, Child, there is much to learn from heads like theirs, which are so beautiful and right. It would be refreshing for you, after all your Calibans, to draw such a couple whom God so obviously created in His own image. [...]

**To her parents*

Berlin, January 10, 1897

Dearest Family,

My Sunday letter has turned into a Monday letter. There was nothing I could do about it. There are too few hours in my day and too few days in my week.

I can only write you the same thing over and over: that everything is going well for me and that I am so grateful to all of you. And the weeks go flying by; it really frightens me. By this time I have a vague little notion about painting in oil—not much more than that. I shall surprise you with a few paintings on Papa's birthday. But until then you will have to put it out of your minds. They are really not all that beautiful, not yet. But I love doing them, even though I don't work and paint with half the pleasure under Uth as I do with Dettmann. Uth is not nearly the serious artist that Dettmann is. He doesn't care whether he is fooling the public, just so long as his work looks pretty. He is the typical social butterfly in school with his "pretty miss" here and his "pretty miss" there, and while he goes on chatting with

you he has painted half your picture for you. So I told him that I was going to finish my own picture the next time, my third one. He was half impressed by that, and half irked, too. He looks, by the way, like the caricature of an artist from the *Fliegende Blätter*. His forte is watercolor, which he handles with considerable style and ease. I plan to work with him in that medium soon.

Recently I have progressed nicely under Alberts. He sees to it that I don't get too big for my boots. If he praises me one day, I can be fairly sure that he'll find fault with something the next day. I am growing more and more fond of drawing in charcoal.

So far every Friday Körte asks me to submit a red chalk drawing to show the class. That's the hour of my weekly triumph—but it makes me very unpopular with the other people in the class, and brings out a slightly haughty air in me which greatly amuses me. Now, Father, don't let my confession trouble your paternal heart. Just let me be. Inside I am still just as nervous and anxious as I was when I was young. And I can get over that best by sticking my nose in the air a little bit. At that, it only helps me to steer clear of a few of the "vulgar" females here.

Things are going smoothly in the life-drawing class. Hausmann praised me yesterday and said that what I was doing was the work of a proper painter, and that I had some good chiaroscuro effects—even if they were still somewhat vague.

There you have another litany, my week's calendar. If I carry on too much about my drawing lessons, just tell me honestly and I'll try to turn my thoughts in another direction for you. For example, I can tell you a lot about the question of women's suffrage. I'm very familiar with the catchwords already. Last Friday after life-drawing class, for instance, I attended a lecture: "Goethe and Women's Emancipation." The lecturer, Fräulein von Milde, spoke very clearly and very well—and also very sensibly. Nevertheless, some other modern women have an indulgent, rather scornful way of speaking about men as if they were greedy children. And as soon as I hear them speak, I am immediately on the men's side. I was just about to sign a petition protesting the new *Bürgerliches Gesetzbuch* when Kurt gave me such a persuasive tongue-lashing that he strengthened me in my original position. I guess little Paula is going to let the great men of the world carry on and I'll continue to trust in their authority. Still, I have to laugh at myself and the world.

To Paula from her father

Bremen, January 11, 1897

[...] Now let me tell you some details about our meeting with the painters. Modersohn, von Emden [*sic*], Odeleben [*sic*], Vinnen, and Vogeler turned up. Mackensen is in the midst of work on a big three-part picture and announced that it was impossible for him to come. Modersohn, a good Westphalian and not Semitic as one might guess from his name, has the soul of a child who winces and dives

under the table at every little joke, no matter how innocent. Von Emden makes a solid impression, Odeleben reminds one at first of Donndorf. Vinnen, who is really not a Worpsweder but owns an estate three hours away in Beverstedt, was unfortunately ill for quite a while after he fell from a horse, and has only recently recovered enough to begin to paint again. He seems to be a well-bred man from Bremen. Vogeler, also from Bremen, is the youngest, and a fantast with the large eyes of a visionary. He is primarily involved with black art. [...] I sat between Vogeler and Vinnen. The former baffled me by declaring that he never read anything, he wanted to concentrate on himself, within himself, so that he would not be led astray. Now I ask you, [...] what else could the man do during the evening in Worpswede? There does not seem to be an intimate fellowship among the painters. As they say themselves, they almost never talk about art. If they go on working in such a one-sided way, then one can hardly be surprised that they seem to be more or less eccentrics in the world of art. Vogeler's engravings are odd in the very highest degree. They are supposed to impress one as being archaic and "Old German," but they do not have the thorough workmanship of master engravings and the subjects are also mostly so curious and unfinished that it is impossible for one to understand him. [...] Vinnen, who sat on my other side, entered into a political conversation with me. Strange how people who are so extreme in their art can remain so conservative in other areas. It is probably mostly because, caught up as they are in outmoded prejudices, they feel no need to adjust or broaden their horizon. They have an *idée fixe* which puts the brakes on them, just the way a chalk line drawn on the ground in front of a rooster will hold him captive because he thinks that it is tying him in. I'm not at all surprised that their thinking becomes mired. Here the mire is only the Worpswede Devil's Moor. Lenbach's remark occurred to me at the time: Nature in itself is not a work of art and vice versa. What I saw by the Worpswede painters, except for Mackensen's, did not seem to me to be works of art. I did have to admire the veracity in Modersohn's work, but these glimpses of landscape are without any further charm. Von Emden paints snapshot pictures. I recall one of a landscape in a rainstorm. In the foreground, in front of a few houses, stood fully rounded birch trees, while the background was completely purple as if a bottle of Kaiser ink had been poured over the picture and smeared into it. Now, I admit that for a moment, in a certain light, such color effects might have appeared to him like that, but does one want to have that in a painting before oneself forever? Just as little, I think, as I would like to have a face staring at me contorted in pain. I feel that sort of thing shows a lack of taste in our newer artists. The Byzantines also painted their saints writhing in death agonies on the rack, but don't we all acknowledge the advance made by the Trecento and Quattrocento artists in toning down the horrifying aspects and in locating the principal charm in the beautiful organization and coloration of the work as a whole? [...]

To Paula from her father

It is nice that you have been making new acquaintances through Fräulein Ritter; otherwise you would be exposed exclusively to your aunts, who are such great advocates of women's rights. But it can't hurt you to attend some of their meetings. Although one cannot view all they say as incontrovertible truth, at least there is justification in much that they discuss. What I find distasteful is all this talk about equality. [...] Open competition can only result in science and art becoming public property more and more and consequently losing value. For the general public that is an advantage, but for the individual it is certainly a disadvantage. Certainly egotistic motives influence our judgment, but up to now there has never been anybody who does not value his own skin higher than that of others, and in the future it will not be different. One thing is certain: the women are working toward social democracy, even if perhaps they may not be conscious of doing so. Seen from the higher perspective, their claims must be justified; yet despite that, we shall defend ourselves against them as long as it is possible. When we are forced to, we shall surrender; so far, however, no one has ever voluntarily given up his rights. But I am losing myself in sociopolitics and since you have probably already heard enough of that I shall not bore you any further with it. Still, it is worthwhile to acquaint oneself with the viewpoint of all parties, so that one does not become one-sided and unjust. [...]

* *To her father*

Schlachtensee, January 27, 1897

Dear Father,

I have turned my back on the noisy city for a while and have come "home" again to our lovely, quiet, snow-covered Schlachtensee.

My thoughts are so much with you right now that you must almost be able to feel them. They are concentrating on you. Along with your five other children, I am trying to smooth away the wrinkles on your brow. It makes me sad to think that the wrinkles got there in the first place because of us. Do you think they can be smoothed away by the happy moments we have given you? Well, let's at least hope that in your New Year there will be enough happy moments so that no new wrinkles will join the old ones. At the stroke of eight on the morning of your birthday you must think of me. My thoughts will be concentrating on you at the same moment. Pay very close attention and see if you don't feel the breath of a kiss on your right cheek.

I am sending you more drawings of heads. I hope this whole business is not boring you. I keep sending you essentially the same thing over and over. The drawing in color of the little girl is my first attempt with pastels. It is not exactly over-

whelmingly beautiful. At first it was very hard to capture the little imp; she wouldn't hold still for a minute. So far my treasure trove of pastels consists of only five colors. The little girl had blue eyes, but unfortunately I didn't have a blue crayon. Just as I was pondering fate's bitter blow, I heard two people in front of me arguing about whether her eyes were really blue or brown and so (for obvious and practical reasons) I joined the brown party.... The next day I quickly finished the portrait of the laughing girl. That's why it's a bit smudged. And as to my three landscapes—you must not show them to anybody! They still look a little too much like lobster salad.

To Paula from her father

<div align="right">Bremen, February 7, 1897</div>

Dear Paula,

Tomorrow you will be twenty-one years old and come of age. That is, you can now emancipate yourself completely from us and live your life according to your own tastes. You will now be responsible and accountable to the external world alone. Those are very fine attainments which your majority will bestow upon you. Use your freedom always for your own good, and may it rest lightly on your shoulders. For honor brings obligation; it is often easier to be less independent and have a safe port in the storm. I know, of course, that you are not going to become unfaithful to us and that our former relationship will continue, and also that your good understanding with us will not come to an end. Nevertheless, I had to mention to you the legal aspect of your coming of age. Now after this preamble let me hold your sweet head and plant a paternal kiss on your forehead and wish you every good thing on your birthday. May you remain healthy. May you progress in your art and find full satisfaction in it. If you do, then we may hope that everything else will take care of itself. If one has one's calling and one's work, then one is happy even when living on a shoestring. For the present, things with you continue to be as good as you could wish. Your years of apprenticeship have been relatively carefree. They have not yet come to an end; let us hope that soon they will be followed by years of mastery and that these will make your life equally free of care. You will be spending your birthday with Mother, a pleasure which you probably did not expect at all. Have a good long talk with her; you will have a chance to speak to her about everything in your heart which you have not yet confided in us. And if there is anything we can do for you, we will certainly want to try. For your birthday present you are getting mostly good wishes from us. In addition, we have commissioned Kurt to buy you a box of pastels after you have conferred with him about your preference. It will probably be best if you buy the box together. . . . Adieu, dear child. Remain our dear good daughter and bring us happiness.

<div align="right">Your old Father</div>

<div align="right">On the train, February 13, 1897</div>

My Dears,

A quick note to you from the train—just enough to give you my short weekly report.

First of all, of course, the ball at the Frombergs'. It was simply perfect! Beautiful arrangements of flowers all through the house. The dark paneled hallway looked enchanting with its evergreen wreaths, cheerful, fire-red poppies, and garlands of fresh white roses. The music room, which is decorated in delicate yellows, was smothered in mimosa. And you should have seen the tables in the dining room— fresh white lilac on one, wallflowers on the other; on still others, violets, lilies of the valley, tea roses.

Max Grube and [Amanda] Lindner performed a prologue to the "Consecration of the House." We three lady painters were merrily escorted by two gentlemen painters and two sculptors. The painter Müller-Kurzwelly asked me to dance the Française—but imagine the plight of my poor heart! Practically through the whole dance, with his face all aglow, he kept on praising the beautiful eyes and the beautiful gown of the young wife of Petschnikoff, who was also dancing nearby. I thought it was very amusing. But the three of us were in seventh heaven until three o'clock; we kept saying good-bye, but they wouldn't let us leave.

Now I'm writing in school. It is between classes and the buzzing and humming around me sounds like a beehive. Right now we are planning a class trip. All of us are eager to assert our own opinion about where we should go. I keep insisting on Schlachtensee, because that is where I live.

Recess is over and I must get back to my little model.

<div align="right">Berlin, February 20, 1897</div>

Dear Family,

Here I am in school, sitting in an empty classroom, and writing to you. Class has not yet begun. I wish I could multiply the days I still have left here by six. I feel I am really learning now.

The whole marvelous world of color is emerging—the relationships among colors, their character, many other things that you can only feel and for which there are no words. My new teacher, Jeanne Bauck, also says it has to do with a state of physical well-being. And now your little daughter is reveling in this feeling every day.

Fräulein Winkelmann is the most talented person in the class, and we seem to infect each other with enthusiasm. Whenever either one of us has a beautiful color on the palette or on our canvas, it has to be shown to the other. I am very much at

home in class now and happy that they like me. It is nice to hear somebody say, "Little Becker, what would we do without you!"

Between classes we carry on like silly fools. Afterward one can settle down to work so much better. All the girls here are interesting people. In one way or another you feel respect for each of them. . . . This is my life now and I'm attached to it with every fiber of my being. Even when I'm not here, my thoughts are. Maybe this has made me a little one-sided. But I believe that if I am ever going to get anywhere, I have to devote everything I have to it.

To her father

Berlin [ca. February 27, 1897]

Dear Father, after a morning of hard work it is such a pleasure to sit down and thank you for that beautiful box of pastels. I keep looking at the rows of magnificent crayons and can hardly wait to begin using them.

My model right now is a little Hungarian boy, a mousetrapper, who cannot understand a single word of German, so that it is impossible to scold him when he comes every morning half an hour late. But it is such fun drawing him.

Last Thursday after class I went to see the Kupferstichkabinett [Print Room] for the first time. I had stood at the glass entrance several times before, but the solemn gloom behind it always frightened me away. Yesterday I took heart and went in, feeling like an intruder in the sanctum sanctorum. An attendant came up to me and silently handed me a slip of paper on which I had to write down what I wanted to look at; "Michelangelo, drawings by". . . He brought me a gigantic folio. I could hardly wait to look inside. At the same time, being the only woman in the midst of this overpowering masculinity, I would have given anything to make myself invisible. But as soon as I opened the folio and could study Michelangelo's powerful draftsmanship, I could forget the whole rest of the world. What limbs that man could draw!

We had the most amazing model that evening in life-drawing class. At first, the way he stood there, I was shocked at how ugly and thin he seemed. But as soon as he began to pose and when he tensed all his muscles so that they rippled down his back, I became very excited. How strange and wonderful, my dears, that I can react this way! That I am able to live totally in my art! It is so wonderful. Now if I can only turn this into something good. But I won't even think about that now — it just makes me uneasy.

Let me tell you something funny that happened to me. Do you remember, Mother, the drawing of the nude woman with the beautiful black hair which you took back to Bremen? Well, I drew her [again] in Fräulein Bauck's class. She was wearing a black dress with a white collar, and so was I; only the style of her dress was a good deal more chic. And she stuck out a beautifully shod foot so smartly

that I felt obliged to modestly hide my rather clumsy feet. And later when this young lady with her gentle dove's eyes appeared for a second time, it turned out that in place of her black mane her hair was now a beautiful chestnut brown. She told us some sort of story about washing her hair and having gotten hold of the wrong bottle. But I thought to myself quietly, Oh, yes, *c'est la vie!*

To Paula from her father

<div align="right">Bremen, March 2, 1897</div>

[...] but I missed learning further details about the sketch which you call *Intermission*. Having let me into your secret a little you must go on and tell me something about its completion. The idea of representing an intermission comically as a drummer anxiously awaiting his cue to begin is very clever, but to carry it out as an image is certainly not easy. So, naturally, I am very curious as to how you solved the problem. Not everything that one can picture to oneself and then express in words can be represented. ... Whenever content and form do not coincide, it indicates that the equilibrium between concept and realization has not yet been achieved. In most symbolic realizations by painters of the new school, this dichotomy seems to me to prevail. ... This does not exclude the possibility that new artists are capable of creating altogether new things in a different way. But their task will continue to be the further development of the old with dependence on what is already there before them. For example, in religious paintings: I do not believe that a picture of the Madonna will ever be painted in the modern way of representation that can measure up to the paintings of the old school, for it is precisely the harmony of thought and execution that seems to me to have been completely attained there. [...]

It is certainly very good that you are taking time to study Michelangelo's engravings [sic]. I only wish that you would now make some drawings after them. One must absorb their form not only through the eye, but also have it in one's hand. ... You seem to place too much emphasis on the total impression and too little on details. [...]

**To her parents*

<div align="right">Berlin, March 5, 1897</div>

Dearest Family,

...First, the latest news from school. I have given up instruction in landscape painting and work all week long on portraits. In my painting class, besides myself, are the five other women who are best at portrait painting. Of course I want to go on with my drawing, because I can see from looking at my talented colleagues that drawing is still their big problem. Fräulein Bauck must see this herself be-

cause she has all of us energetically sketching now. I am very impressed by the control and determination which she instilled in a new class. You can imagine what a shock it was when we returned to drawing and none of our sketches of heads would turn out right. Our model had a rather complicated and difficult way of posing her head, a little to the left and at the same time tilted a little forward. None of us could express this subtly enough. It was wonderful the way the instructor then made a little sketch for each of us and showed us how to reproduce the essence of this particular pose. She is very much concerned with the fundamentals, anyhow. We really don't quite understand her completely yet. I think she wants to teach us to draw in a very different way. She didn't let us make a single line the way we thought we wanted to, but only what she wanted. Working this way with your hands tied, so to speak, is extremely tiring—one has the feeling that one can't do anything right. And so the results were naturally poor—most of our drawings ended up in the stove.

Do you want to know what she is like? First, what she looks like. Well, unfortunately she looks like most female artists: unkempt and a little shabby. She probably took care of her hair when she was young, but now it looks more like a mound of feathers. Her figure is large, fat, without a corset, and she wears an ugly blue-checked blouse. At the same time she has a pair of happy bright eyes which are always observing things, and with which (as she told me later), she always draws a grid of horizontal and vertical lines over any new face she sees. This almost convinces me that her genius for drawing must be greater than her gift for painting—because wouldn't she otherwise be thinking more about color than lines? But I really don't know anything about her yet. In a few weeks I shall be able to see some of her paintings at Schulte. Up to now she is still a book with seven seals to me.

*To her parents

<div align="right">Berlin, April 3, 1897</div>

My Dears,

Here I am and it is another Saturday again. So much has happened to me this week. Last Sunday I went to rehearse the play that I've promised to take part in. I would much rather have my free time back now—because I don't like Frau N., I don't like the play, and I don't like the lawyer, who is always trying to hug me.

Father, please don't start worrying now because I sound so negative. Actually my behavior is generous and even heroic—I smile at Frau N., I have already memorized my part, and I sweetly embrace the lawyer. Each time I have to embrace him, of course, I silently swear at him.

On Monday I was at the Du Bois Reymonds'. Lucy told me what she did in Bremen and showed me some of the stylized patterns that are made there. And then we

had a fine conversation about drawing and painting. They are not at all modern—they make too much of a point of defending contour.

In Jeanne Bauck's class I drew an old man. Her method is similar to Alberts', but the basics with her are much more thorough. Both of them studied in Paris and that is probably the reason for their similarity.

In Hausmann's class we have a very droll model now, a genuine Berlin janitor's wife who talks just the way you would expect. She never sat as a model before. We simply brought her in from the street for lack of someone better. When we asked her if she would sit for us, she looked down at her picturesque, faded clothes in horror and said that she would have to run home first and dress up. When she came back she was wearing an impossible bright new apron. It was so funny to watch how posing affected this irritable, breathless little woman. At the end of an hour she shouted, "God, I always thought sitting around was the greatest thing—but it sure is a lot harder than work." After the first day she vanished from sight with the immortal words, "I'd rather scrub three rooms!"

To her father

Berlin, April 30, 1897

I woke up to the most wonderful sun shining into my room and all day I have reveled in beautiful nature. The world is laughing and bursting into leaf and blossom. One has to laugh along with it. It has even gotten very warm suddenly, almost as hot as summer. Our naked model wondered naively if we didn't envy him his lightweight costume. I am happily using my free time now for sketching. It's such a pleasure to sit outside in this divine air—and to look at the delicate birch trees. And as if all this were not enough, I am being deluged with admiration. My principal patrons now are some railroad linemen. One of them recently was saying over and over, "Well, boys, now that's real art!"... In all honesty, though, I must admit that first he cautiously inquired whether those were supposed to be birches that I was painting.

Suddenly more models are popping up than I can use. Three cheerful workingmen were passing by my easel the other day, and one of them said, "Hey, miss, wouldn't you like to paint us three old crabs, too?" So I took one of them at his word, but such people don't have the endurance of a real model. It's not long before the whole thing begins to bore them.

Evening has come as I've been writing. But it is still so bright and clear that even though the sun has set, I can continue writing my little letter to you, Father. I have had such a lovely time working today, and it was interrupted only once when I went to the Print Room to look at those marvelous Botticellis. Did you know that the originals of his Dante illustrations were here in Berlin? There is a separate drawing for each canto. I find it so interesting the way Dante's strange fantasies

were interpreted by this great contemporary of his. Well, now it's a little too dark, my dear—as I look up at the beautiful evening sky, my thoughts are with you—but I cannot see to write anymore. The sunset is magnificent.

To her father

Berlin, May 7, 1897

[...] A perfect May day, everything in blossom, birds twittering everywhere. The magpies are the only problem—hundreds of them everywhere, but their days will be numbered after Uncle Wulf gets back. And the June bugs are whirring around everywhere, so many you wouldn't believe it.

I still look forward to my classes with Jeanne Bauck so much. Now that I am used to her rough-and-tumble appearance, I really like to look at her. Her features are just as interesting as her paintings. I keep looking at the funny little curve of her nostrils. And her mouth seems to stop so suddenly and nicely, just as if the Lord God had abruptly gone over it with a stroke of His brush. I continue to paint with her, loving the luscious colors of oil paints with all my soul.

I visited Jeanne Bauck in her own atelier recently. There is nothing I love more than entering an atelier—my thoughts are far more pious there than when I enter a church. I feel so serene and enlarged and marvelous inside myself. She had wonderful things there: portraits and landscapes—there is grand and simple understanding in each of her pictures and they are not mannered at all. Fine, fine!

From the Album

"Let the flowers root firmly in the earth, but let no earth fall into their blossoms!"—Jean Paul, quoted by Fräulein Bauck concerning idealism in art which must grow in the soil of realism. "Art is the earthly sister of religion"—cited by Fräulein Bauck.

"One must have a mental image and feel it, about everything one draws. The more vivid and powerful this mental image is, the more artistic the result will be." Fräulein Bauck.

To her parents

Berlin, May 14, 1897

My Dears. Here is another pencil sketch. I'm afraid you won't get to see anything better of mine until we hug each other hello again. I'm already thinking of painting portraits of you during my long vacation—and even planning the backgrounds for them, because they are so important. I love oil colors. They are so rich and

74

powerful, so wonderful to work with after those shy pastels. I'm thinking of using Herma as an experimental subject. Please try to instill enough patience in her so she can sit for me when I get there.

Yesterday I began working in oils under Hausmann, too. He has us work so differently from Jeanne Bauck. While she teaches us to work down from the brightest tones, taking white as the norm, he has us work up from the darkest tones, from shadows. The deeper the shadows, the brighter the saturated light must be. Rembrandt got such fantastic effects from light. All that came from the depth of his shadows. Living skin in daylight is so dazzling, so luminous, that it's nearly impossible to paint it bright enough.

Again, a fine day behind me. In the morning, my oil portrait of my little old man in Hausmann's class, lunch at the Gottheiners', and at four o'clock the three of us visited the young sculptor Wenck. He had made a clay model of a little faun for each of us and we went to get them. He is an incredibly simple person. It never would occur to him to meddle in anyone else's business. But that is just what I like about him. And now here I am at home, happy with my new little faun.

I hug you all,

Your happy Artist-Child

To Marie Hill

Bremen, Schwachhauser Chaussee 29
July 14, 1897

My dear Aunt Marie,

[...] I think Maidli's character is completely revealed in her beautiful eyes and sweet mouth. She has a very sensitive nature and I so enjoyed being with her. But I think it was almost too good for me—too much of a good thing, never being irritated or annoyed. I must rub elbows with the outer world even if in a very private way! If I don't, I am no good for the world. I become a kind of snail that is always pulling in its horns (or does a snail have feelers?). No matter, I have made up my mind to use my horns (or feelers) and not shove my way through life but proceed gently and quietly on my own path through life.

Paint, paint, paint—I never seem to get it out of my mind. It is the melody that accompanies my life right now. Sometimes it is soft, dreamy, sometimes like a fairy tale. I call it my Versunkene-Glocke [Sunken Bell] mood. Sometimes it is loud and fine and grand, and at times like that I want to stand on the top of a mountain and shout. But since I really can't do that, I stay completely quiet inside and out. It is almost as if I weren't really alive, or perhaps better, as if only my soul were alive. It's really very wonderful. I scarcely dare to breathe, for fear of frightening away the magic. It is a little like mountains at sunset—something that has always been the most beautiful thing I can imagine—when they lie there enor-

mous and solemn. And then something else comes to mind suddenly—those wonderful hours, sitting on my rock by the waterfall. When I was a child I used to sit there, thinking only about the blue sky and the white clouds.

Am I being egotistical by writing all of this to you? I thought you might like it. Do you? Well, you have to take my egotism along with the rest of me; I am never going to lose it—it's just as much a part of me as my long nose. Sometimes I think that if I had been born a cripple my whole nature would have been different. If that had happened to me, I think I would have renounced my joy of the world from the very first breath I drew. But born as I was, I find there are so many desires that my heart listens to and thinks about in its own self-seeking way, that it forgets the desires of others. I wonder if this selfishness improves with age? That's my only hope. [...]

*Journal

Worpswede, July 24, 1897

Worpswede, Worpswede, Worpswede! My Sunken Bell mood! Birches, birches, pine trees, and old willows. Beautiful brown moors—exquisite brown! The canals with their black reflections, black as asphalt. The [River] Hamme, with its dark sails—a wonderland, a land of the gods. I pity this beautiful part of the earth—the people who live here don't seem to know how beautiful it is. One tells them how one feels about it but they don't seem to understand. And yet one doesn't need to have pity. No, I really don't have any. No, Paula Becker, better take a little pity on yourself for not living here. Oh, not even that; you are alive, you are happy, your life is intense, and it all means that you are painting. Oh, if it weren't for the painting! And why take pity on this land at all? It has men, painters, who have sworn fidelity to it, who are devoted to it with the enduring and solid love of men. First there is Mackensen. He's the one with the golden medals from the art exhibitions. He does character portraits of the land and its people; the more characteristic the head, the more interesting. He understands the peasants completely. He knows their good aspects, all of them, and he knows their weaknesses. I think he could not understand the peasant so well if he had not grown up in humble circumstances himself. It is harsh of me to say it, almost cruelly harsh, and there is arrogance in what I think, too, and yet I have to say it. This "growing up in humble circumstances"... is his flaw, and he can't do anything about it. The fact is that a person can finally never get over it if he had to grow up fighting for every penny, even if he has more than he needs later. At least not a noble person. This battle always leaves its scars. They are almost imperceptible, but there are many, many of them. The practiced eye will discover a new one every minute. The whole person has been bound and tied up tight. The lack of money chains one to the ground; one's wings are clipped, but one doesn't notice it because the shears make only a

little snip very cautiously each day. It's astonishing how this cruel, cruel fate slowly but surely cuts human beings down. Greatness, openness, independence, impetuous rage, the Prometheus in us, the titanic strength of a man, elemental power—all that is lost. Isn't that hard?...But that is the way it is with Mackensen. He is a wonderful man, enlightened in every way, firm as a rock and energetic, sweet and kind to his mother. But greatness, the indefinable quality of greatness, that is gone, he has lost it. Not in his life, but in his art. What a shame, what a shame.

The second in this circle is little Vogeler, a charming fellow born under a lucky star. He is my real favorite. He's not nearly the realistic man that Mackensen is; he lives in his own world. He carries Walther von der Vogelweide and *Des Knaben Wunderhorn* around with him in his pocket. He reads them almost every day. More than that, he dreams them every day. He reads each poem so intensely, trying to dream for himself the meaning of each word, that he finally forgets the words themselves. And so, despite all his reading, he doesn't know a single one of the poems by heart. In the corner of his studio is a guitar, propped against the wall. He plays all the old tunes on it. And when he is playing, it is marvelous to see how his large eyes seem to be dreaming the music. His pictures move me very much. His models are the old German masters. In form and style he is very strict, almost stiff,...his image of spring: birches, delicate young birches with a girl in their midst—she is dreaming of spring. The girl is very stiff, almost ugly. And yet I am so touched to see how this young man can translate his urgent dreams of spring into such balanced form. The severe profile of the girl is seen contemplating a little bird; it is almost a masculine contemplation—at least it would be that if it weren't so reserved and dreamlike. That is little Vogeler. Isn't he a delight?

And then there is Modersohn. I've seen him only once and then just for a short time—and I did not get a real sense of him. All I remember is something tall, in a brown suit, and with a reddish beard. There is something soft and sympathetic in his eyes. His landscapes, the ones I saw exhibited there, have a deep, deep mood about them—a hot, brooding autumn sun—or a mysterious, sweet evening light. I should like to get to know him, this Modersohn.

And now comes Overbeck. I have tried to be sympathetic with him and his work. But I was not able to understand him properly. The colors in his landscapes are very daring—but I don't think his work has the depth of feeling of Modersohn's.

And Hans am Ende—I don't know him at all.

There is also a man named Schröder in Worpswede now, but I don't believe that he is one of the "Worpsweders"; I've heard he is supposed to be a very "musical" musician.

At the lunch table was a painter from Berlin named Klein, a handsome fellow with soft almost feminine features and delicate nervous hands—in a brown velvet suit. I don't know his work. There is probably some sort of relationship between him and Fräulein von Finck—they say "du" to each other. I had been prepared for her arrival and so I was not terribly astonished to see her come to lunch in trou-

sers. She interests me. She seems to be intelligent. She has seen a great many things and, I believe, with perceptive eyes. She studied in Paris—I wonder how long? And how successfully? I don't know, but I am extremely anxious to see some of her work.

And so, Worpswede, those are the priests in your service.

To her parents

<div align="right">Worpswede, July 1897</div>

This morning I decided to leave my brushes at home and give them a rest. I strapped a rucksack to my back, packed my lunch, took along Goethe's poems, and walked to the moors, past lonely farmsteads surrounded by pine trees, through the unbelievably green meadows along the Hamme, through heathland covered with red heather, past slender nodding birches. Whenever I got to a spot that I thought must be the most beautiful one, I lay down and watched the clouds; once, I fell asleep. And then I would walk a little farther. I was full of happy songs—I felt so peaceful, and felt the peaceful world around me.

When I got back, I set up my easel outside, but by that time the heavens had decided that I'd had enough beauty for one day and sent down a pouring rainstorm. So we [?] decided to go visit Hans am Ende, whom we knew only slightly. He showed us many of his sketches and some splendid etchings. Among them some things by Klinger, a beautiful Dürer, and work by am Ende's friends in Worpswede. He could describe a whole person in a few words. I liked everything he said. The gentle way he talked to his young wife won me over completely—I had a feeling that she was in his thoughts every second, and I can still hear him say her name, "Magdalein."

The evening before last we spent a few wonderful hours with Heinrich Vogeler in his studio—and Sunday we shall be at Mackensen's.

Life is almost too wonderful for

<div align="right">Your Child</div>

To her parents

<div align="right">Worpswede, August 1897</div>

Dear Family,

I am happy, happy, happy.

Only a few lines, just to tell you this, because it is late, already ten o'clock. I was outside awhile ago and I simply could not abandon the moon. Yesterday and today we have been painting alongside a very blue canal in Südwede. In the evening we went punting with the three Vogeler brothers on the Hamme. The evening light

illuminated the lush meadows along the banks. Now and again one of those somber black sails with a motionless man at the tiller glided by. And then the moon floated up very gently. I thought about you, and then I thought about nothing at all; I just felt.

Today we went on an excursion to Schlussdorf. Some people were holding a religious service out in the open. There were many wonderful men's faces to see, but the women in their garish city clothes were ugly. Nevertheless, the whole thing made me think of Mackensen's *Sermon on the Heath.*

All of Worpswede is asleep, except for a few restless spirits still making a racket at the bowling lane across the way. It is a beautiful, clear night, filled with stars.

Today I painted my first plein air portrait at the clay pit, a little blond and blue-eyed girl. The way the little thing stood in the yellow sand was simply beautiful—a bright and shimmering thing to see. It made my heart leap. Painting people is indeed more beautiful than painting a landscape. I suppose you can notice that I am dead tired, after this long day of hard work, can't you? But inside I am so peaceful and happy. [. . .]

*To her mother

[Ca. August 20, 1897]

Mother, the package of provisions was heavenly! "And the cupboard was no longer bare." Now we have enough to the end of our days. My Sunday? Sunday morning I painted my sweet blond girl, Anni Brotmann, who posed again out at the clay pit. That afternoon there was a rendezvous with the cousins and we all took a hike and found rich booty: blackberries and things to paint.

An evening walk through the village. We hear dance music at Welzel's. We look in and what do we see? The children's dancing class is having its final big fling—a charming picture, everyone in a white suit or white dress. The instructor, who looks for all the world just like a fox, stands there in a dainty pose about to lead the roundelay.

We amble past. And again we hear the rhythmic beat of a band. We peer through the doorway—a peasant wedding. The bride has practically fallen asleep under her garland. The groom is yawning. At the other end of the hall some farmers are dancing the quadrille. In the background, awful music—and on the right, cows sticking their heads over the stall partitions.

When the next waltz strikes up I dance with the bride's father. He bellows in my ear happily, "Pretty good, ain't we?" I only nod up at him. Later my friends had a big laugh at us for dancing there. They told us that the bridal couple was a little "simple"—that they had lived in the poorhouse the winter before and were planning to return there next winter. After that we paid one more evening visit to the cottage opposite the Brotmanns'. They are terribly poor people, but today their

eyes shone with happiness. Their oldest son, eighteen years old, had just returned home from a sea voyage. He was a bright and alert blond fellow. He was telling the wide-eyed family all about the foreign places and people he had seen. His brothers and sisters were crowding around him, all of them blond and blue-eyed.

Mother, would you perhaps have a few things for these people? The ages of the girls are fifteen, twelve, and nine, the little boy is four, and then there is a baby. I should like to take something to the good woman. [...]

*To her parents

[Undated]

... It is night again, beautiful, silent, and solemn. Another day for the gods is behind me. This morning I was painting an old man from the poorhouse. It went very well. He sat there like a stick with the gray sky as background.

The midday meal at our women's table is devoured with hearty appetite. The ladies in trousers (by the way, a second one has arrived) are proving their masculinity by assuming the ravenous appetite of young boys. It's fun to study the inner workings and the outer behavior of these individuals. I believe they really imagine that they are not vain and that they don't care a bit what they look like. And yet they are just as proud of their trousers as we would be with a new dress. I join the sages: all is vanity.

I am basking in the world's sunshine and in your love! [...]

*Journal

[Undated]

Worpswede, Worpswede, I cannot get you out of my mind. There was such atmosphere there—right down to the tips of your toes. Your magnificent pine trees! I call them my men—thick, gnarled, powerful, and tall—and yet with the most delicate nerves and fibers in them. That is my image of the ideal artist. And your birch trees—delicate, slender young virgins who delight the eye. With that relaxed and dreamy grace, as if life had not really begun for them yet. They are so ingratiating—one must give oneself to them, they cannot be resisted. But then there are some already masculine and bold, with strong and straight trunks. Those are my "Modern Women.". . . And you willows, with your old knotty trunks, with your little silvery leaves. The wind blows so mysteriously through your branches, speaking of days long gone by. You are my old men with silver beards. I have company enough, indeed I do, and it's my own private company. We understand each other very well and nod friendly answers back and forth.

Life, life, life!

To her mother

Thank you, dear Mother, for sending all those clothes! Let me tell you, there was quite a celebration at the Brotmann house! It did me good looking into all those shining eyes; the good woman would not stop squeezing my hands.

I painted all day. First, Becka Brotmann with her loose yellow hair and just a suggestion of dahlias in the background. Then I painted Anni Brotmann at the clay pit, where the sun nearly baked us. In the afternoon I painted Rieke Gefken holding red lilies. I think it is the best thing I've done so far—I'll show it to Mackensen tomorrow.

I spent another hour with Vogeler yesterday. That's always as much fun as reading a fairy tale. He's really a charming sight with his dreamy eyes. He showed us a sketchbook full of his ideas for etchings, from the time he first started up until now—many really fine and original things. Time flies and flies and it's all such a joy for

Your Child

To her parents

Berlin, October 28, 1897

The very latest news is today's opening of our school exhibition. Jeanne Bauck described for me her feelings whenever she enters an exhibition hall where some of her own works are being shown:

One sneaks restlessly from one room to the next, looking furtively to the right and then to the left, with the bad conscience of a criminal.

And finally—the shock! One has discovered the offspring of one's suffering, and immediately runs away, if only to avoid being discovered and pursued. That's just the way it was with me. I looked at the pictures on one of the walls very calmly. And then my glance fell on Rieke Gefken and the red lilies—and I ran away.... During recess our whole class visited the exhibition. Everyone is friendly and kind in criticism of all the others, out of fear of being attacked by some colleague. I had a happy reunion with my old friend of last year, Körte. He gave me all kinds of pleasant news and was very much the cavalier toward me, to my great pleasure and to the envy of a number of others standing around us. He did, however, have a few scolding remarks about my drawing of the heads. No sooner did I wriggle away from him, than Fräulein L. grabbed hold of me. (She is the young painter whose studio I worked in last year.) She wants to paint me. She said that I was the inspiration for one of her color sketches last year—lilac merging into a kind of brown (my good old velvet blouse)—with my hair the high point. I smiled and was flattered. To tell the truth, her proposal gave me a lift—but I decided that I was

not going to pose. I have no time for that. And even if I did, I would use it differently.

Inflated by all of this, I walked into my quiet painting class. Unfortunately, there was too much of the vanity of the world in me to be able to get myself into the right and proper mood for painting. And we had such a wonderful model! An old woman with a yellow face and a white linen kerchief on her head—she was sitting before a golden background. The effect of it that first day was so beautiful, in fact, so magnificent, that I could scarcely work because my heart was pounding so hard.

In the classes with Hausmann and Bauck we are working more and more toward extremes. I'm still very happy working with both of them.

Hausmann projects the feeling of a true artist—a very finely developed, perceptive faculty; he seems to have it down to the tips of his fingers. One notices it when one speaks with him. But he's extremely impractical. He can't translate his feelings into something straightforward and tangible. He can't collect, or even control himself. This seems to be the case with so many people who have everything—except that little extra bit of energy.

Jeanne Bauck, on the other hand, is extremely practical. Everything she says, in fact, is practical and at the same time wonderfully subtle. She is very modern, which means, in the good sense of the word, nothing more than youthful effervescence. She is in remarkable condition for someone fifty years old. I love her very much. Speaking with her gives me a feeling of great comfort. She is so charming and innocent, has that kind of innocence that simply disarms you.

With that same innocence she told us how Dr. Lahmann ordered her to paint without any clothes on so that her skin could breathe. She regretted being unable to introduce this regimen into our whole class. Everything is said with complete seriousness. It was really touching. It makes me happy, this kind of generosity that is not always finding treason and conspiracy in everything—and it makes me feel as if I had a black soul myself.

My whole week consists of little more than work and feeling. I am working with a passion that excludes everything else. Sometimes I think that I am nothing more than a cylinder in an engine in which the piston is frantically going up and down.

We went to the theater twice, both times to comedies. The audience was howling. I secretly buttoned myself up one buttonhole higher, feeling very alienated from humanity. I thought the people around me were all so hideous—I didn't even want to think about anything at all. When Cora is in moods like that she does her thinking. That must make one feel simply wretched inside. I am playing the ostrich here in Berlin more and more. I wouldn't be able to stand it otherwise.

Berlin, November 1, 1897

My Mother,

Here I am, with you in my thoughts—happy, completely happy. I have had a wonderful day of painting. It is not that I have accomplished anything in particular, but it's the thought of all I could do that makes me almost crazy with joy. The piston in the cylinder is going like mad. We had a marvelous model: a blond, pale girl with wonderfully formed, elegant hands. She was against a light gray background in a light blue-green dress, and leaning against a very blue-green table. Fine! My fingers begin to tremble when I think about it. So fine!

But what about you, my one and only Mother? I think about you so often. I am getting to understand you more and more. I sense my nearness to you. Whenever I think of you, I feel as if the little restless person I am is clinging to something firm and indestructible. But the best thing is that this firm and indestructible something has such a big heart. Thank you for continuing to be such a wonderful mother to us. I hug you long and tenderly. [...]

*To her parents

Berlin, November 7, 1897

[...] The family is discontented with me—is that what you are saying? But I don't feel guilty about anything. I have to go through dreary times, and you have to get dreary letters from me—that's obvious and natural.

It looks as if I have to put up with pages of scolding in your otherwise kind and fatherly letters. You are scolding me for living in the frenzy of this world, when the only frenzy I am involved in is hectic rushing from class to class.

Well, let's be generous now and forgive each other. Today, on *Buss- und Bettag*, the three of us went out again to visit the sculptor, Wenck, in his studio. He has finished the monument for Körner and is now working on a group for the base of the monument to the Kaiser. I especially liked a beautiful model he was doing for a fountain. Wenck was in a very jovial mood. He made all three of us take off our hats to see if any of our coiffures was good enough to model. But none of us was plain and modest enough for the head of a German Mother.

My latest distress: Warfare in the school again. Women! Women! Women! Sometimes they are fine and great. And then sometimes they're just rabble in arms.

The director, Fräulein Hoenerbach, is a wonderful person. She devotes herself completely to the school. But at the same time she wants to be its absolute monarch. It seems now that there must have been an explosion with my teacher, Jeanne Bauck. She will stay on only to the end of the year—and then set up a private studio of her own. The whole thing was announced yesterday. I hid in the corner be-

hind the smocks and wept. Fräulein Hoenerbach is an important person, to be sure, a person of considerable virtue. But she has been very unjust to Jeanne Bauck. It was almost as if I had been present at the birth of some invincible lust for power. It was like *Wallenstein*. Jeanne Bauck seems to have gotten too great a hold over her own class, but also over Fräulein Hoenerbach's creatures. So the director set up a parallel class in which she herself is the instructor. For political reasons most of the pupils went over to her. As far as I am concerned, there is no doubt at all that as an artist Jeanne is incomparably better than Fräulein Hoenerbach. They can't even be mentioned in the same breath. The artistic vision that Jeanne wants to awaken in us is on a higher plane and infinitely more difficult to acquire. Here is where the injustice lies. The director must know that Jeanne's instruction is better than hers. She simply could not endure Jeanne's having such power over her pupils.

I don't say any of this aloud in school. We are surrounded there by a band of eavesdroppers and informers. In fact, nobody says anything, yet everyone knows that everyone feels clearly either one way or the other. It's a sad way to get to know the world. But that's the way it goes in our little community. How do you suppose it goes in a big one? In a state? In a nation? It's disgraceful! Disgraceful!

Jeanne Bauck behaved with dignity. When I saw that everyone had left her side, I felt that I should take her hand. When I did, she was very sweet and kind. Not weak at all; she remained calm and controlled. She spoke as if not a hair on her head had been touched, half from pride and half because it was impossible for her to be small. But we understood each other.

I'm at the post office now, and here's a quick little greeting from the counter. Between the time I began this letter and today I have had three pleasant classes with Hausmann and done a fine nude drawing.

<div align="right">Your Child</div>

To Henner Becker

<div align="right">Berlin, in school, November 13, 1897</div>

My Henner,

School is over. All the girls have already gone home. Only the worn-out janitor is running back and forth straightening up the classrooms. I'm sitting here in a secret corner to write to you. I thank you many times for the beautiful nut-bars which you sent me from *Freimarkt*. I took them along with me to school, and together we gobbled them up between classes, eating them "to your health." — This morning in the horse trolley I sat next to a real Chinaman with a long pigtail. But he can already speak very good German. In fact, one sees so many foreigners here. Recently I saw a sweet little Moorish boy on a bicycle. And you must realize that bicycling is very hard here in Berlin. One must pay very careful attention. Otherwise one will be run over. This is only a short letter today. But I have to leave for lunch now at

the Gottheiners'. If I don't, I may get there too late and there will be nothing left to eat. So a very quick kiss from

<div align="right">Your Paula</div>

To Herma Becker

<div align="right">Berlin, Perleberger-Str. 28
November 13, 1897</div>

My dear little Herma,
Here I come, finally, to thank you for the beautiful nut-bars. They had such a wonderful taste of *Freimarkt*. I was so proud of my rich little sister who bestows such charitable gifts upon me. We won't have to wait much longer here for ice skating. The other day there were already frost flowers on my window. A pity that we can't practice our figures together. I wish you could be with me just for a minute so that I could show you my school. We have even bigger classrooms than you do in your school, with big, big windows. But there are no desks in it, nothing but easels. All along the walls hang the paintings that have to dry. And that makes the whole thing look so cheerful and colorful. Between classes, when we eat our breakfast, we are just as jolly as all of you. We even waltz sometimes. How are your dancing lessons going? Have they already begun? And how about your Latin? You have to tell me about everything. You should also write a letter to Kurt, when you have the time. He has so much to do now. It will make him very happy.
A kiss from your Paula.

** To her parents*

<div align="right">Berlin, December 10, 1897
[Written on the train]</div>

Here comes your traveling child, back home from a wonderful trip. Things are going almost too well for me. Scarcely does a beautiful today come to an end, when I am already looking forward to a beautiful tomorrow. This time it is a combination of Vienna and Jeanne Bauck. Before my departure I put everything in order, and tomorrow I shall return to school in the happiest of moods.

But Vienna, Vienna! I was captivated by its beautiful buildings and its glimpses of history everywhere. Every baroque house has something to tell. I relived the age of the Congress of Vienna when there was so much intelligence and creativity on this little piece of earth. I am always inspired in such places. History, a feeling of contact with great people of the past—there is always something fascinating and magical about that for me. There is so much about history that attracts me, a sort of unconscious understanding of a personality. It is the same thing that excites me

when I am painting rapid and gentle vibrations of feeling. It's what attracts me so powerfully when I look at a great work of art.

I wish that Herman Grimm had written a history of the world. He would have always placed at the center of the stage the great personality, the one who really brought events about and who gave them their true value. That way of seeing things is much closer to my ideal than the assumption that events shape individuals. Perhaps that's the case for the average person, but not for the giants.

But I'm beginning to daydream and my great thoughts have used up the last drop of ink I have left. So back to my letter, in pencil.

I saw such magnificent pictures in Vienna. I don't think I'll ever forget Moretto's *Divina Justina* and the wonderful colors of Titian's noble portraits, and the magnificence of Rubens.

I was captivated by the Old Germans. Dürer, with all his power and virility, is still so touching and gentle. And then, Lucas Cranach with his half-childlike, half-coquettish Eves and his sweet Lord God who is so earnestly admonishing the Children of Paradise with His finger. I was enlightened by Holbein in a very special way, too. He provides an instructive illustration to Bauck's text: the grand effect of noble simplicity.

In the Liechtenstein Gallery I was bewitched by Leonardo's little portrait of a head and by the dazzling Van Dycks. I literally feasted on them. Being there made me stand in awe of the human being, the human figure. And that does me good because unfortunately in the big city this feeling of awe for humanity often shrinks to a minimum. But I fight against such feelings because that doesn't make other people very happy. And it makes me unhappy, too.

But now to the main point, to the wedding. It was a joy to see Lili in her white bridal dress. Her quiet brown eyes had a gentle, womanly expression. The composure of her mouth gave her face a soft and peaceful look. She is an unusually calm creature. She came up to the groom in all her array, showing no inner emotions at all. All the time she was in the church she maintained the same balanced, peaceful, and friendly face. It must have been reflecting the peace in her soul.

Her composure must have been heavenly balm to the nervous groom.

Here is Berlin!

To Paula from her father

Bremen, December 10, 1897

Dear Paula,

I trust that we will receive news of you tomorrow and hear more about your trip and your arrival in Berlin. [...] As for the rest, the pressures under which we are living here remain the same, and just now at Christmastime are even more noticeable than usual. My funds are coming to an end and I am no longer able to delight you with the little things that I used to be able to afford for you. You will have to

accept the fact that we shall celebrate the holidays without song and mirth. The times are too serious and not very gratifying, and it seems to me that the veil of the future will reveal only difficult problems. You, too, my dear Child, must think of the future. As soon as your painting course is finished next year, you must make yourself independent. Unfortunately I cannot give you children through self-sacrifice what I should like to be able to give. By Easter I shall be completely dependent on my pension and shall have plenty to think about just paying for partial education for the twins. You older children must help yourselves through life on your own. Naturally, it is still a bit early for you to make positive steps in that direction, but don't lose sight of the fact that you must get a job in June. Begin now to inquire about the best way to earn your own living. It is useless to hide these facts from yourself. It is always best to look fate straight in the eye and make the best of it. You are brave enough not to be petty about this or lose courage. So then, courage and onward. [...]

*To her father

Berlin, December 17, 1897

My dear Father,

Here is the answer finally to your latest letter. As soon as I finished reading it, I sat down and wrote you eight long pages. Aunt Paula said she would mail it for me, but unfortunately she lost it.

First of all let me give you a hug and a kiss. It makes me so terribly sad to think of you carrying your worries around with you for so long, while I was in Vienna enjoying everything so much. I can feel the depressed mood in your letter — but I really thought it was partly a result of your old rheumatism. Please, dear Father, don't worry about me. I am going to get through life perfectly well — I am not afraid of it. What else is the point of being young, of having all this energy? Up to now you have made my wonderful education possible, and it has made an entirely different person of me. Now I begin to see what sacrifices were involved, and that makes me very sad. This year [in Berlin] — I can live on it for a long time. It has planted so many seeds in my mind and in my heart, and they are only now gradually beginning to grow. For that reason it will not be so hard for me to stop for a year and become a governess. It will give me a chance to sort out many things for myself. Meantime, I can put a little bit aside to help me to resume my studies again later. Please, all of you keep your eyes and ears open and see if you hear about a good position somewhere. I must earn at least a thousand marks. If I don't, I'm afraid I shall regret the time I'll have to spend. It is not very likely that we can find something in Germany — maybe England, Austria, Russia? It's all the same to me. Just as long as it fills my pocket. But something overseas is out of the question. I do not want to commit myself for longer than a year.

Father, don't let your thoughts about me make you even slightly sad. In the com-

ing year I'll be able to continue painting in my mind and in my daydreams. Just happily thinking about it will keep it alive. It should help me get through a year of work. I shall endure—and very well, too. In my free time I can draw, so that my hands won't lose their touch, and I will be able to develop my mind a little more. If only I could take some of the burden from your shoulders! We young people, we always have our heads full of plans and hopes. Life doesn't really affect us yet. At least not in this way. Let us just stand side by side and love each other and hold hands. Even if we haven't much money, we have so much else that cannot be bought. We have two loving parents who have devoted themselves to us. That is the best thing we possess. As for me, I have never had any desire for money and I never shall. I would only become superficial. I just wish that you could be relieved of some of your worries.

Father, promise me one thing. Don't sit at your desk, staring into space or at that picture of your father. That is the one way to invite worries in and then they will cover the eyes of your soul with their dark wings. Don't let them do it. Let your poor soul enjoy the few rays of autumn sun still left—it needs them. When you feel gloomy, seek out Mama's or Milly's company and enjoy their love. I send each of you a loving, earnest kiss.

To Paula from her mother

Bremen, December 20, 1897

[...] My good, brave Child, you have no idea what support and consolation you two girls give to my life. God bless you. I know for certain that no matter where life may take you, the two of you will stand the test. But your courage and your joyful strength, may they never be tested too hard. For the present, my sweet Child, do not permit any worry about the future to steal from you joy in your work or the concentration necessary for it. Try to deal with the difficult double task of solving the great challenge that life poses: how to plan your life with an eye on the future, and at the same time take a powerful grip on today with its work and its joys, as if there were going to be no tomorrow. The first of July is still far away. Until then, continue your studies and rejoice in your life. Then, if an interruption must occur, you will be able to put up with it bravely and still not lose sight of your goal. You will never in your life give up your art, and you will share the battle against material obstacles with the majority of those who struggle along with you. When we begin to look around in the new year [for work for you], I believe we must think first of all of a position in France. [...]

To Paula from her father

Dear Paula,

Our best thanks for the sketches you sent us. I will not presume to give them a definitive judgment. You are the one to decide whether you can be satisfied with your achievement. As you know, I share the view that all art is a skill, and that technique and draftsmanship cannot be regarded as mere incidentals which can easily be ignored. Despite all the efforts I make to evaluate modern paintings, I am unable to find that they satisfy this fundamental principle. [...] If it is today's fashion to quickly dash off an oil sketch, then it will be very hard for a disciple to fight against this. Only the mature person with independent ideas will persevere. The great majority will confine themselves to this fashion, but fashion as you know is fickle; and I also fear that today's style of painting will not last very long.

I have decided to leave Bremen at Easter and have put in a request for a little apartment for the two of us and the twins in a suburb of Dresden. It will naturally be very difficult for Mother to leave the Bremen she cares for so deeply. But there is no other way, I can no longer afford this expensive household, and in new circumstances it will be easier for me to cut down expenses. [...]

*Journal

January 2, 1898

They are wondrous, these two people with whom I live, strange in the highest degree. They are people who are not suited to one another. Both are noble. She is strong, he is weak. They walk their path next to each other. Their closeness often oppresses them. Each of them sees that the other one demands the impossible. Neither one can give up his innermost self. Thus they remain separate. Sometimes they reach out to one another and walk along, hand in hand. It is an almost shy contact. It is unusual, unusual — as if they were two young lovers. They do not remain holding hands for long.

She looks out into the universe. Her great eyes swim with sadness. She is pale. Her lips show neither life nor love and are unearthly narrow. A strange energy lies in them. A heavenly goodness lurks at the corners of her mouth, and yet like the gods and without batting an eyelash, she will condemn the guilty one. Her white, unearthly little hands have the same trait but in a higher degree. They are enchanting. They have fine wrists and delicate fingertips. But the way they move fills one with fear. They are cruel, these hands. They are the hands of a fanatic.

And then suddenly they are as if transformed. They are all helping love. They gently bind up the wounds. They become very soft. She would like to help all. In her heart stands written the suffering of the world. It stands written there in great fiery letters which burn day and night. In her beauty she bends down to the filth

and washes it clean. It cannot cling to her as it does to us other earthly mortals. It falls from her to the ground. She stands there in a halo.

She loves with a passionate heart, but her loving is not of this world.

She can also hate, hate unforgivingly, hate cruelly. I shudder.

He gazes up to her as to a divine image. In his heart he is pious. He folds his rigid hands. He bends his knee. He bends it before no other. He gazes up to her. He wants to look more closely at her. He wants to seize her. He wants to press his lips on the hem of her dress. He does not love in an unearthly way. He loves her beauty, loves her delicate limbs, but he does not touch her. He conquers himself for her sake.

It has cost him many years, this self-control. He still does battle with himself. For he loves her beautiful soul, but he cannot grasp it. And he loves her beautiful body passionately. But because of its unearthliness he may not grasp it.

Life, how strange you are. Up to now you were like a dream to me. I went along as in a dream. Dreaming like this was sweet to me. But time marches on, slowly, year by year. Gently, almost imperceptibly, it opens my closed eyelids.

I gaze into the world. I see great, great passions which battle there in the hearts of human beings. It is a battle with gigantic forces. Oh, let me dream on. This heart explodes in the great battle of the great world.

Journal

[Cannot be dated]

How fascinated I am by this girl!

From within she creates her own powerful, beautiful world, a world like that of a young boy who enters life with great plans. And yet she remains a virgin.

She hates pettiness in woman. She loves man in his magnitude. She loves him with quiet generosity and humble heart.

She sees herself as small and the others as big. And yet she is greater than all of us.

She is still a bud. She still awaits development. She doesn't know what it will be, but she awaits it with beating heart.

She speaks as the good man, without guile, without malice. I love this simple greatness. It refreshes, it calms, like antiquity. And yet it is far more natural than that, more pulsating with life. For it is reality. It is life, modern life.

Is there anything more beautiful than a noble human being?

To Paula from her father

Bremen, January 26, 1898

All bark and no bite! Don't look a gift horse in the mouth. Take people as they come. Nothing so bad that it isn't good for something. A bird in the hand is worth

two in the bush. Penny wise, pound foolish. If not by the bushel, at least by the peck.

I could write down a hundred more proverbs for you. But for the time being I advise you to memorize this little group, and when you can recite them without stumbling, you may read on. Several days ago I received two documents in the mail, along with two letters from a court bailiff, one for you, one for me. I was not very edified by this receipt. I smelled a rat at first and was afraid that you had had some kind of trouble in Berlin which might have led to litigation. Thus it was doubly agreeable for me to learn from these documents that you and I have been summoned to attend the reading of Aunt Pauline Falcke's last will and testament. At first I thought this would eventuate merely in our both receiving some useless memento from our late relative. But no, our old auntie made each of us a legacy, six hundred marks for you, fifteen hundred for me. And so, if you should want, you can now devote another year to your art studies. In spite of all her eccentricities, our aunt had a great sense of family. I am all the more grateful to her final disposition because I can now support Kurt and because you have been given the opportunity to use this small capital as you wish. You have become a "good prospect" overnight!

So, I congratulate you now on your promotion to capitalism. Your fortune will be transferred to you on the fourth of June. Dispose of it as you will. It would be best if I were to deposit it in the savings bank here. Then you could make withdrawals whenever you wish. Or do you want to speculate? Sugar steady, but weaker; coffee, slack; tea, slow. Now do what you want. Farewell for now. Pity that I don't have more aunts like that. It is probably the first and last inheritance I shall ever get in my life. *L'appétit vient en mangeant*. But too bad, there's no more for nibbling. [. . .]

To Paula from her mother

Bremen, January 26, 1898

Child of my heart, I congratulate you a thousand times! Six hundred marks suddenly thrown into your lap as if from heaven! What an unheard of delight! [. . .] All at once everything is crystallizing in my optimistic head. Drawing lessons with Mackensen from the first of June and benefiting from his wonderful and precise criticism. And then I will look for an au pair position in Paris for you, beginning October 1. Mornings must be yours, afternoons and evenings you must place at the disposal of the family. [. . .]

My old darling, I am so very happy that this has been granted you! Now plant yourself down firmly and force yourself to be pedantic and precise in drawing hands, eyes, and noses. Mackensen recently spoke about a "loveless ear" when he was looking at your sketches. He didn't say that humorously, but as solemnly as a

judge of the dead. He pointed out that there is no "conventionally loveless ear" like that in all the world, but that people's ears are just as individual and just as varied as their eyes and their hearts. [. . .]

Berlin, January 30, 1898

My dear Father,

Let me kiss your brow and hold your hand and look into your dear eyes. Don't you feel the great love your children have for you? Of course, at first we can't do very much for you except love you. But doesn't that make up just a little for all the worry we are causing you?

Once we are out on our own, dear Father, when our little ships are well under sail, then things will be better for both of you. Surely the inheritance must have lightened your burden a little. I can't tell you how much it amuses me to be an "heiress." But already one has to resist even more temptations than before. Just yesterday I went past a secondhand shop where all kinds of beautiful old things were for sale. I instantly felt unnecessary cravings I would never have had when I was poor. That's the way it is, wealth brings worries.

As a surprise for your birthday I am sending you some of the work that I have "perpetrated" on paper this month. You'll see how hard and conscientiously I am trying to draw.

These drawings are based on a principle different from the ones I did under Herr Alberts in school. Those were meant to have an impact. These new ones make no such claims at all. I am just supposed to learn from doing them, and I hope I shall. I'm trying hard to render contours with precision, to suggest them with lines. But drawing lines is really contrary to my nature because in reality lines don't exist. If you look closely at your hand you can see that it is not surrounded by a line.

But I realize that for me to learn properly, lines are necessary. It forces me to observe things very carefully.

Farewell Father. I send you a loving, loving kiss.

Your Child

To Paula from her father

Bremen, January 31, 1898

Dear Paula. You really are a lucky girl. Just imagine what Uncle Arthur sent for my birthday! For the next two to three years he wants to give you six hundred marks annually for your further training. Beginning with the first of April you are to receive from him and Grete fifty marks a month. In addition, he wants to take

over the management of your six-hundred-mark capital and add to it, according to the need, so that after your training you will be able to take a journey for further study. Now, what do you say to that? They surely are lovely people and the way in which they want to help you is particularly considerate. I am happy for you and I hope that this present will be to your best advantage. If you continue to be a hard worker and to the best of your ability spare no pains, then we can hope that your talent will be sufficient to accomplish something above average. Accept only good advice and do not trust your little thick skull too much. That is something you have inherited from me, along with your contrary nature. You will shed both of them in time, or at least you will learn to temper them. [...]

To her parents

Berlin, February 8, 1898

My dearest dear People,
I have been shouting for joy up here in my little room. Life is too beautiful to live it out in silence.

Well, that's the way I seem to feel now that I am twenty-two years old. It suits me wonderfully, simply wonderfully.

A hug for all of you for the love you have heaped on me and for all your sweet letters. I have just been reading through them again, one after the other. You can guess how I was hungering for them all afternoon until I got back at five o'clock. I leave my room at the crack of dawn, you know, and I don't get anything from the postman until I return.

The life-drawing class this morning went well, but no differently than usual. That is, up until the midmorning pause for second breakfast, when the big corrugated iron door opened with a clatter and in marched Paula Ritter, Fröhlich, and Meyerlein with beaming faces.

The first one was carrying a birthday cake with twenty-two candles, the second a bouquet of pussy willows and anemones, and the third a charming picture of the Mona Lisa.

The easels were quickly pushed together and a festive table arranged on top of them. My big bouquet of violets was divided in four and arranged in the curls of our hair. And in this gay mood we all enjoyed the chocolate cake.

Later we went back to our brushes with redoubled zeal. After drawing for so long it is always such a joy to get back to painting.

I am surrounded by a great deal of love here. I hope it won't spoil me. Somehow I have won the hearts of these marvelous girls without any effort at all.

And now it's possible for me to go on working and learning. I can only hope that my happiness won't make me too presumptuous. I shall try to wear it with humility. I'm reading the letters and biography of Stauffer-Bern just now. There is a kind of holy striving in his art without any suggestion of pretense or nonsense. He once

taught at our school. It was a terrible tragedy, a confusion of circumstances which broke him at the height of his powers.

Thank you all again for this generous bundle of love from home. You are practically smothering me in love. It's too much. My little heart and I cannot bear all this happiness.

Often I feel like crying out with Stauffer-Bern, "Lord, what is man that Thou art mindful of him?"

Your Paula wishes you all a good night.

From the Album

[February 1898]

"If one works and creates so that the sparks fly, one can hold oneself in a much higher regard; one thinks that one has much more right to exist; in short, one feels much better."
"The deeply hidden well of Truth speaks only to the Serious one / who blanches not in the face of tribulation"—Schiller, quoted by St.-B. [Stauffer-Bern].

To her parents

Berlin, February 19, 1898

My Dears,

Well, the great day has come and gone. The Women Artists' Costume Ball will surely remain one of my most wonderful memories. I can still feel the excitement of it, and just remembering all my different "suitors" makes my heart leap with joy.

We sold two thousand eight hundred tickets. Unfortunately only a small part of that large crowd was able to take advantage of the variety of clever entertainments that were offered.

I went costumed as Rautendelein and I wore Mother's garland of roses in my hair.

Karla A., who looked handsome enough in her minstrel costume to fall in love with, acted as my escort for the first part of the evening. She played her role charmingly and now and again played a few chords of an enchanting medieval *minne-sang* tune. Arm in arm we strolled through the crowd and then danced all sorts of steps we invented ourselves.

If I became the object of a too amorous glance from some Faun or Devil or Dandy, then my Cavalier dealt with the impudent rascal; and as soon as the foe was vanquished "he" would sing me a tune of springtime love to the accompaniment of his mandolin.

A jolly Pierrot, seated upon the head of a Sphinx, called out to me, "Paula Becker from Bremen!" When I met him a bit later, I made him give a full account of him-

self. He turned out to be Anna Stemmermann, also from Bremen, a student at Helene Lange's *Gymnasium*. She will graduate in a year and then study medicine. She has sweet, merry eyes and danced a wonderful Boston.

My train of suitors grew by leaps and bounds. A black little Chimney Sweep, a sweet soul if ever there was one, helped out when no one better was in sight. A jolly Jockey and a Lucky Hans then took turns dancing with me.

A Hungarian band marched in, at its head a charming violinist with a lively smiling mouth. Four couples were dancing to their music. A little dark-haired Magyar had by this time also joined my list of partners. He confessed to me half in confusion and half in embarrassment that he was from Frankfort on the Oder.

Then all at once, up jumped a crazy little Imp and tried so hard to kiss me. It was only after much effort that I was able to escape from his arms. I fell unluckily in love with Hermann the Cheruscan. Such a fine tall fellow, with the arms and legs of a giant and a head covered with red curls which spilled out from under the eagle-winged helmet. From the knees down, his legs were wrapped in furs. He was a magnificent sight.

This Hermann had actually wanted to come as a Centaur, with the body of a horse from the waist down, but his mother wouldn't permit it. His heart, alas, had already made its choice: a delicate, pale maiden, who was a strong contrast to his immense strength. So I had to console myself with a little, green, elfin Moss-Man, who looked quite funny with a red toadstool on his head. We danced with a passion. The *Kehraus*, which I danced (or whirled, I should say) with my little Hungarian, was an appropriate finale. When the musicians, modestly hidden under a green gauze net, finally finished playing, I could really notice that my feet were killing me—as the Berliners would say. But it was wonderful, really wonderful!

You will have to appreciate my dedication: I've written this entire epistle at the post office, standing at the counter, just so that you can receive your Sunday greetings on time.

Your Paula

To Paula from her father

Bremen, February 20, 1898

[...] In your previous letters you spoke of a family by the name of Arons to whom you were recently introduced. I forgot to ask you whether that is the same family whose son, or close relative, is a university lecturer and the same one whom the government wants to discipline because of his Social Democratic views? [...] It is the same old song: one believes that one can suppress viewpoints by reprimands and prohibitions and one forgets that every pressure produces a corre-

sponding counter pressure. We in Germany have had sufficient opportunity to learn that police management does not hold back progress in the long run. That which was violently suppressed at the beginning of the century later returned all the more explosively; take, for example, our most conservative government officials; they would have been imprisoned without further ado under the old regime and regarded as the most rabid Democrats. Thus do times change. It would be more reasonable not to draw the bow too taut even now. We are, unfortunately, caught up in a powerful reactionary movement, which of course will not prevail, but which is creating dissatisfaction and embittering the people. It is not likely that I shall live to see the turnaround, but for those of us who stood on the peak of the wave it is very depressing to be falling back into the valley again. [. . .] It is strange to see how the educated have been changing their opinions and views. In my time, every young person was liberal, but now that appears to be altogether socially unacceptable. I doubt whether that is progress. Youth must refresh the old spirit, not dilute it. And if they do not, they have not met their task. I find, indeed, that the quality of our young people has declined. They do not have the ambition to create but let themselves be blown with the wind, and they manage to turn up wherever the power is at any given time and wherever they can hope to be promoted with the least effort. [. . .]

To her parents

Berlin, March 1898

It is evening. I'm alone and have just finished painting another portrait of myself. I have had a very long day and so I'm granting myself permission to be dead tired. You must not demand too much of my soul, which is still too involved in the painting.

Von B. has invited me to go to the Pépinière Ball this evening. But I'm not going. I have been too wrapped up in my drawing and my oils all week long, and it has made me stingy with my energy. I don't like to waste it on other things. [. . .] My latest model, a pretty girl with curly black hair, a tempestuous little creature, hasn't come back. She has left us in the lurch. Some handsome painter has probably lured her away — that's life!

Did I write you that I have entered a competition? We were asked to submit a series of six small [post]cards, each about seven by fourteen centimeters. I sent in six heads of girls with backgrounds of stylized flowers. Then I read in the newspaper that they had already received seven hundred submissions. They are all going to be exhibited in the old Reichstag Building. A major step into the public eye! With such tremendous competition I have naturally given up all hope for a prize. But one can learn from such an exhibition how one could have done it better. [. . .]

[Ca. March–April 1898]

Dear Father, I have read to both aunts here what you wrote regarding my severe judgments about people. I was happy to hear them say that I have improved in the last couple of years, even though I haven't noticed much improvement myself. Time is going by for me as if it were all a dream. I am still very busy with contour drawing. Sometimes I am convinced in my soul that I am now getting a slightly stronger grasp on form, and that makes me very happy.

I feel so comfortable and peaceful when I am drawing. I try very calmly and thoughtfully to put down on paper what I see. Today in class we had an old woman whose head and neck were wonderfully structured. I loved quietly following with my eyes the almost imperceptible flow of the lines. I don't think that I ever understood it quite so well before.

Do you really want me to send you more of my things? I would actually prefer to show them to you when I come home for the holidays. There are so many things about them I would like to explain. And I can speak about all that so much better than I can write about it. It's really strange; I live my days so intensely that when I write you in the evening I always sense a reaction in myself. It's quite true, the most beautiful thing about my life is much too fine and sensitive for me to be able to get it down properly on paper.

And so what I write you is really only details and trimmings. It's no more than a container for the fleeting fragrance of exquisite moments.

If only I could convey a little of the peacefulness that fills my soul. My life is so beautiful! The hardest part is that I am enjoying it without you and without having earned it.

There is an extremely interesting exhibition of graphic work in the Gewerbemuseum [Museum of Arts and Crafts] now, with marvelous etchings and color prints from a great many countries.

And at Gurlitt there is an exhibition of Ripple-Ronais [sic], a remarkable Frenchman, a latter-day disciple of Botticelli.

At Schulte there is a show by the Eleven; Leistikow, in his beautiful and his serious moods. All I have to do is make the effort, and straightaway I have something wonderful to see here. Outside, an early spring storm. Good night. The whole house here is already fast asleep. [...]

To Paula from her father

Bremen, April 5, 1898

Dear Paula,
You are in the midst of preparations for Paul's wedding and I don't wish to disturb you. My letter will therefore be rather short. Your lines came yesterday to tell us

that you are studying busily and getting to know the painting treasures of Berlin. But don't demand that we become "modern," too; we are too old for that. I looked around for the *Studio* but I couldn't get hold of the March issue as yet. We shall be happy to learn something more about your Fräulein Bauck. When you are in Leipzig at Easter perhaps you can visit Klinger's atelier and get to know him yourself. I don't know how long you wish to be away, but if you have time, do visit poor Baring. [...] his eyesight remains poor. [...] There is no end to misfortune in the world, and it strikes all the harder when it is undeserved. Baring endures his harsh fate through his faith in God. Religion is his anchor and without it he would probably give up. It is not given to everyone to have such faith, but it is indeed a blessing for many. While I used to proudly ignore all orthodox believers, I now envy them for the support they have found. I cannot yet nor shall I ever be able to follow in their footsteps, and yet I readily admit that they are often happier in their faith than others who do not believe in anything transcendental. [...] You will also be visiting the museum there, of course. Even if you already know most of the paintings, you will doubtless be happy to see them again, especially since you will look at them now with new eyes. Make the most of your stay in Leipzig; you can always reserve your evenings for the family. [...]

*To her parents

[Ca. April 1898]

[...] It's Saturday again, and very early in the morning. I hear the birds singing outside my window. From every nook and cranny there is an enchanting sound. We have had fun counting ten different kinds of birds which nest in the garden. A gentle rain is falling and washing away the dust of the past few days from the tender young foliage. The smell of earth is coming through my open window and makes my heart even happier.

Over the past few days I have been sketching hands, a pair of elegant, bony, nervous woman's hands with slender wrists.

Everything else is like a minor accompaniment to the main theme of my life. We did, though, have a fine evening musicale at Regierungsrat M's. Hans Hermann sang *Lieder*, something I always love to hear. [...]

To Paula from her father

Bremen, May 3, 1898

[...] I have some particularly happy news for you. Mackensen has offered you his support and advice while you are studying painting during your summer holiday. It will certainly be a pleasure for you to be able to draw under his guidance. [...]

[Norway, ca. June 10, 1898]

It is nine thirty in the evening and still daylight. After a few wonderful days' travel we have reached our hotel in Christiania.

Sunday noon we boarded the steamer *Melchior* in Stettin. *Melchior*: I have locked all this into my soul. How wonderful to stand at the bowsprit and look up at the blue sky through the spray. A veil descended over everything, thick and sweet, and let my spirit flow out and hover over the water, not thinking, only vaguely feeling.

From time to time this veil would lift to reveal the shape of a Norwegian woman, about thirty-five years old, a real original. She was returning to her native shore from a trip to Hungary. Brimming over with her own experiences, she looked for victims to whom she could pour out her stories, speaking with the lightning speed of a rattlesnake. And it was quite true that she really had had a wonderful time. Through her stamp collecting she had begun a correspondence with a young Hungarian girl. Then photographs were exchanged, and then finally there came an invitation to visit Hungary. Hardly knowing what to expect, this little Norwegian lady bravely set out only to land amongst the highest Hungarian gentry and magnates, and was passed from one prince to another. She became well known in Hungary; in fact, she was exhibited everywhere as a cultured Norwegian and was written up in four newspapers. She is the daughter of an army chaplain at the garrison in Christiania, and typical of the advanced state of women in Norwegian society, she earned all her own travel money by working as a secretary of a large trade firm.

My second acquaintance was a young man of the legal profession. "Kgl. Fuldmaegtig" [Royal Solicitor's Clerk] was printed on the card he pressed into my hand as we parted at midnight after a magnificent sunset. Our conversation must have seemed rather funny in its three languages, German, Norwegian, and English. Even despite our amazing variety of tongues, however, I am afraid that our best jokes were lost on each other.

Number three was a couple from Christiania. She, born a Swede, either really was or was acting the role of a grande dame. He had an intelligent, bearded face. The signs of the gourmand could be seen at the corners of his mouth. His eyes wore the expression of somewhat supercilious disdain for the outside world. He became even more interesting to me after I found out, from a couple of typical Philistines from Christiania, that he was well known in their city, not well liked, very rich, and a spendthrift. I think, however, that he must be from a narrow, pedantic background, has cast off his chains, has lived to his heart's content, and has arrived at the point where he can laugh at the world. And the world, not to be outdone, laughs back at him.

It was such fun to pin down these characters who, like comets, sped past my own little skiff of life and to make little mental sketches of them for myself. If I

have any gift at all for painting, it's certainly clear that I must concentrate on portraiture. I feel this again and again. The loveliest thing I can imagine would be to learn to express figuratively the subconscious feelings that at times hum easily and gently in me. But that I'll leave to the coming years.

I slept none too well in my little narrow bunk. Whenever I woke up, I would stick my head out of the porthole. The sea and the sky glowed in faint red and lilac. The only thing that seemed real or substantial was the dark black wave which the ship kept concealing from me as it sailed along over it.

In Copenhagen we took a pleasant walk along the boulevard, the avenue along the shore where the elegant people promenade in the afternoon. On the whole, the city made a rather sleepy impression on me, perhaps because the hectic tempo of Berlin is still too much with me.

The entrance into Christiania Fjord was heavenly! On either side the blue mountains soared into the sky, closer dark ones intervened, little jagged islands lay in the foreground, and in front of them white sails filled with the breeze. My heart couldn't help from laughing with joy.

After the most beautiful crossing you can imagine, we entered the harbor, passing the good, old, weather-beaten *Fram*, aboard which Sverdrup will embark on another expedition in the next few days. All around us lay the great steamers with their mighty reflections distorted by the waves, and among them bobbed gay little green and blue fishing smacks.

*Journal

June 16, 1898

Bright as daylight, in misty rain, two o'clock in the morning on the small steamer between Bergen and Namsos.

We boarded. A narrow wooden gangplank led us onto the little green steamer. An unpleasant odor of fish assaulted us. It came from the great barrels of fish on deck. It came out of the cabins and the pilothouse. It clung to everything.

White sea gulls flew in great arcs above my head, their wings touching the clear reflection of my spirit and clouding it.

Melancholy sat on the distant shore playing mighty chords on her harp. I listened to the somber minor notes of life's symphony and became sad.

People were standing along the shore to watch the ship depart. They looked over at us with empty eyes. Their posture betrayed lives without content.

I gazed at the sea. It lay smooth and gray before me, terminated by stony cliffs in the distance. Their dull blue gazed back at me. A streak of gold was the only reminder that the sun had once shone here.

Mists rose and wrapped long veils about the cliffs. And the world stood there, silent and sad.

The little thing on which we were traveling made the only sounds to be heard, a voice emitting frightful warning noises. And I heard the pounding of the propeller and the rushing of the waves. Everything else lay in total silence.

Now and again the lonely cry of the sandpiper reached us from the water's edge, monotonous, sad, gray.

*To her parents
<div align="right">Lilleon, Norway, June 20, 1898</div>

...We have been at our "manor house" for three days now and already feel very much at home in our little room with its brightly painted paneled walls, its low ceiling, the friendly white curtains, and the handwoven rugs.

We feel even better outdoors. We take walks up and down the bright green grassy hills where happy little birches are growing. They stretch out their arms, laughing up at the sky. Above, whenever we have particularly fine weather, a transparent blue sky laughs back where soft shimmery clouds dance along. Everything that nature speaks here is in tones of green and blue. One can't really call it speaking—it is singing, fluting, rejoicing. Looking at it literally makes one's heart leap with joy. Or sometimes, which is even lovelier, one's heart drifts along gently and softly, scarcely audible, and dreams of the landscapes of Böcklin.

In the distance lie blue mountains covered with fir trees which the setting sun robes in a brilliant golden brown. This gentle mood lasts from about nine in the evening to eleven. Everything happens here with incredible calm. It is not like our sunsets which vanish before they have hardly begun. And way in the distance the white snow glitters in the sun. Sometimes, today, for example, it is very, very cold.

All in all, the two days' travel to get to Lilleon was a bit difficult. Wednesday noon we left Christiania. We traveled as far as Trondheim on the train and arrived at seven in the morning. My soul was not impressed by the charm of this place. Smoking chimneys, fog, ugly wooden shacks, German waiters, that's what I remember about it.

But the old Gothic cathedral shines like a star in the midst of all this gloom. Its beautiful strong contours reconciled me completely with the world again. It is being renovated now; they are working on it so meticulously that all the old decorations, mostly dating from the very beginnings of Gothic architecture, will be preserved.

At nine that same evening we continued on to Namsos. A hideous little green monster of a trawler was our transportation. It fouled the air with the smell it trailed behind. This fishy stench was sweet anticipation for Uncle Wulf. I cursed it more than a hundred times. The next afternoon at five we arrived at Namsos, nothing more than a group of little half-finished wooden houses. Last summer the

town burned down completely in a matter of two hours. After three hours' travel by carriage and our friendly encouragement of the eighteen-year-old Lilleon mare, we were finally at our goal. The innkeeper and his wife are both nice people. She is a good housekeeper and cook, but an incredible gossip as well, and comes in to chatter after almost every meal.

The local farmhouses cannot be compared with ours. Each is a complex of wooden structures. Whenever the people want more room they simply build on another one. They have all the wood they need right outside their door, and generally there is also a stream nearby which is hitched up to a little sawmill in springtime. Uncle Wulf and I have five rooms and two private entrances, and with all that we scarcely occupy a quarter of the main house. It's a puzzle to me what they could possibly do with the remaining three-quarters. Across the way from the main house are two barns standing on mushroom-shaped wooden posts, designed to keep out the rats and the moisture from the ground. Then the stable is next to them—and then a small milking shed. All of these buildings, as seems to be typical in Norway, are painted a warm red, which blends in beautifully with the greens and blues of nature.

That appendage to the house, which we must all occasionally visit, really makes me laugh. But funny as it is, it has made such a deep impression that I have to describe it to you. The entire structure is dominated by the number three, the trinity—immediately putting one in a pious mood. Three steps lead the "pilgrim" to the small white doorway which opens into a little hall. Its walls are sweetly adorned with fresh mountain-ash greenery, which sprouts from every cranny. Three little windows let in just enough light to cast the room into a magical and picturesque half-darkness. At the other end a long and immensely tall "bench" beckons, but you can get up onto it only with considerable difficulty. And there again the mystical number three, solemn and questioning: three lids—choose one.

Now at last to my main subject, the river, the Namsen. It is about as wide as the Weser and, when it is on its good behavior, crystal clear. But it has many bad habits and the weather can play the nastiest tricks. Besides that, the moodiest creature in the whole world seems to be the salmon. My soul cries out to Saint Peter, in supplication for success. Yesterday afternoon we brought home two salmon. But still I cannot help thinking that fishing is a particularly stupid sport. One is supposed to wait patiently three or four hours for a fish to bite, and then for ten more minutes frighten and torment the poor animal to death. It all seems to be a splendid way to get yourself into a bad mood. But so far, things seem to have gone all right. It is sweet to observe Uncle Wulf's boyish enthusiasm and his passion for the sport. Of course, I wisely keep all my antipathies to myself. But the unhappy time is bound to come when someone will force a fishing rod into my hands and spoil it all. I am maneuvering cautiously to avoid this.

Tell Father many thanks for his kind letter. Milly, won't you send me a book, please? My soul feels the need to get hold of some human grandeur in the midst of

all this heavenly nature. I can't yet say how long I shall stay. That, I believe, will be decided for me by Herr Salmon. [...]

To her parents

[Undated]

...We are leading a most contemplative life here. One day goes by as quickly as the next. Really I should not say that it goes *by*, because it really doesn't. Our stay has been three weeks of nearly continuous daylight. We have been greatly favored by the weather, at least from a human standpoint. That, however, is not always the same as the fishes' standpoint.

We have made three trips to a remote little lake in the woods. The bountiful results of these excursions were little red-speckled trout, some of which, I must confess with horror, were the victims of my own fishing pole. And now I'm haunted by the ghosts of these little fishes. My window blind, which has a design of dots surrounded by circles, stares back at me now like an endless pattern of fish eyes.

This morning, the cattle from our farm were driven up to summer pasture. It is a long way, and so the drive was carried out in stages. It was led by two horses loaded with sleeping blankets, milk pails, and all kinds of household equipment and utensils, and driven by a picturesque and dirty young cowherd. We went along with them for a while and came upon more of the village livestock at the edge of a forest, where there was a happy confusion of sheep, cows of many different pretty colors, and spry little goats.

Following along behind at a deliberate pace were an old shepherdess and the little red-haired daughter of our farmer.

You know already about my diet of salmon and trout and plenty of lovely *flöde*. But have you ever dined from a proper shank of a valiant elk? It really sounds better than it actually is. We came close to rousing two of them ourselves the other day.

We were walking through the moors and bog, practically up to our ankles in the muck, but one gets used to that around here. Suddenly, right in front of us, the two animals started and dashed away. We could hear them crashing about in the bushes. The boy ahead of us was just able to see them. But all we got from the elk was their terrible legacy; a huge swarm of flies that had been feasting on them now attacked us. It nearly drove me out of my mind. I raced away from them straight into a swamp, while my companions poked fun at my flight. But it really was horrible. I'm surprised that Dante did not include swarms of flies in his *Inferno*.

My days are flowing by now like a quiet little brook, silver in the sunshine. The sun here has an incredibly magical effect. After two gloomy days of rain it came out yesterday with all its warmth and golden light, a glory and a splendor. I wandered around happily as if bewitched, as if in a fairy tale.

The little birches were rejoicing and making music on their green hills and the little white woolly clouds laughed in the blue sky. And the gentle gray alders seemed to look even more gentle.

I walked out to a promontory over the water and sang down to the foaming and swirling water. Huge spruce logs came swimming down the river, diving beneath the surface and leaping up again, and seemed to send their reflected light to me.

The white tongue of the water lapped up to where I was sitting. I had to laugh because it couldn't catch me. So I played games with it. A little wagtail flew over to me with its black cap and its little black breast and bobbed its tail up and down and chirped, and we forgot the distrust between man and beast and, for a while, sat quietly next to each other and were happy.

In the evenings Uncle Wulf reads aloud and I sketch and everything is very cozy. The leitmotif of our days is salmon fishing! It pervades everything more, and more, and more!

Yesterday Uncle Wulf lost his bait, today it was his line. The consequence was the loss of two big fish. The river hardly ever seems to be right for fishing. Either it is muddy or the water is too high or the water is too low. The weather is never right: it is too warm, it is too cold, it is too windy.

Herr Salmon sets many conditions before he even thinks about taking the bait. But when he finally deigns to bite, Uncle Wulf is as happy as a little boy playing games, and he describes every last detail to me afterward, about where and how the great event occurred.

I am drawing and painting a great deal. At first I tried landscape, but one would have to study it for at least a year to be able to capture the magnificent simplicity of its form and colors to avoid making it seem merely crude. Instead, I've been painting our little calf and the chickens. And I'm doing a great deal of sketching.

The unfortunate thing here is that one can't take very long walking tours. The river hems us in on two sides, and on the other two sides there are mountains and moors. One can walk for only about fifteen minutes in one direction before coming to the end of our little world. The confinement is just a bit terrifying.

But it is not nearly as cold here as you might think. Whenever our bones begin to freeze, there is always a cheerful fire crackling in the stove. And when the sun shines, it actually burns more penetratingly than it does at home. That's because of the thin, clear air.

I think that I'll be coming home in two weeks. Uncle Wulf plans to stay on for a while to hunt grouse.

[Lilleon]

I lay under the buckthorn tree. My soul was enchanted. I looked up through its leaves. The sun was coloring them a brilliant yellow. They stood out from their delicate red stems, laughing at the sky.

And the sky was deep blue with one small cloud. And the blue was a glorious contrast to the yellow of the leaves. And the wind came and played with them, turning them over so that I could see their shiny upper surfaces. And the wind came down to me, too, bringing me armfuls of sweet fragrance.

The buckthorn was in blossom and that was the prettiest thing about it. Its scent filled the soft air and covered me in a dream, tenderly, and sang to my soul a tale of times before I ever was, and of times when I shall be no more. And I had a strange and sweet sensation. I thought of nothing. But all of my senses were alive, every fiber. I lay that way for a long time. And then I came back to myself again, to the wind and to the sun and to the happy buzzing of the insects around me. They loved the buckthorn, too, and its blossoms, and they whirred round about it. There were bees there also, with their busy buzzing, flying eagerly to and fro. And there were golden brown bumblebees droning over my head, content in their little brown fur. And many, many flies — sticking out their little black snouts and rubbing and whetting their delicate little legs. And some gay gnats whined about, joyfully playing their little high-pitched fiddles.

And in the warmth of the summer blossoms, dragonflies hovered and cradled themselves, and darning needles, too, with their wiry bodies and iridescent wings.

From time to time bits of fluff would float down from the willow tree on the riverbank, laughing, shimmering white against the blue sky like tiny clouds.

Yes, before I forget it, I heard the great river, too, because it was there behind the willows. It was not its great silent flow I heard, but the noise it made when it splashed against a rock and sprayed up, or when it rippled among the bright pebbles in the shallows along the bank.

And it was all such a charming concert of joy, peace, and bliss that my soul spread wide its wings as far as it could stretch them and was borne along by the great universal joy of creation.

From the Album

Lilleon, June 26, 1898

"When people are in love, the one who loves the most is the one who must always humble oneself." — *Frau Fönss*, Jacobsen

"For to walk about in rapture demands so much discretion." — Jacobsen

Lilleon, July 3, 1898

At last I'm with you once again, at least in writing. In my thoughts I am often so close to you, perhaps a bit too often, because I'm so looking forward to coming home.

I've escaped with my pen and paper and am sitting here beneath the flowering buckthorn. It is a happy little spot. The whole air is saturated with its drowsy fragrance. The trusty little birches are adding their spicy aroma, too. This mixture is something extremely pleasing, something I never tire of breathing in. My buckthorn trees are visited by hundreds of different insects, so that I am constantly surrounded by their sweet summertime humming. There is hemlock here, too, and spirea and dandelions with their dream-spun heads. Straight ahead stand the willow trees in late blossom, now and then sending down to me one of their snow-flakes on the wind. Behind these willows is the river, the Namsen, which has been behaving very badly, flowing much too fast for us to be able to catch anything at all for the past week. The first six salmon, unfortunately, have already gone the way of all flesh. And I had hoped (in vain) to be able to bring along a whole smoked fish for you. Papa, how I would like to relinquish my whole share of trout and salmon to you!

This fishlessness has depressed me, even though Uncle Wulf has swallowed down his sorrow sweetly. But he has little else to do. Right now, with a burst of excess energy, he is painting the window frames of our little castle green. Or we stand on the riverbank together skipping stones. It makes me think of the time when Mother used to go with us to the *Gehege* [preserve]—and then I get completely wrapped up in the sport.

Or sometimes we roll back into the current the big spruce logs which the river has pushed up onto the bank. That is the way it is done here; there are very few logging rafts on these wild rivers. The tree trunks are simply slid into the river upstream and then fished out when they arrive down at its mouth. Because of the marvelous honesty of these people nothing is ever lost in the process. And so at times the whole river is jammed full of these huge logs. The sun paints them a golden yellow in the evening and then they gleam wonderfully against the blue of the river.

I was so pleased with the books you sent. The coincidence with Jacobsen was remarkable, wasn't it? Having read his six stories, I was just then longing to get to know his work somewhat better. So far, I have read only *Marie Grubbe*. I am entranced by the images the book conjures up. I read it very, very slowly, intoxicating myself with small doses, partly here under my buckthorn tree and partly at my little cliff near the waterfall—another of my favorite places. I can sit there completely quiet and tiny, surrounded by the roar and passion of the elements, and still feel only the power of the book.

I shall wait a few more days before beginning *Niels*. I think we shouldn't read books like these too quickly, one right after the other. I'm surprised to hear that Vogeler is illustrating Jacobsen. I can understand, of course, that he is tempted to draw the images which the books arouse in him, but I also think there are few authors who need illustrating less than Jacobsen. I believe it is a thousand times more artistic, in the author's terms, that is, to leave these images up to each individual's imagination. Still, I look forward to seeing what he has done with Jacobsen. I am sure that in their own way, as separate works of art and independent of the book, they will be magical.

I look forward to returning to Worpswede so much and seeing everything that has been done there during the past year, just as I look forward to seeing you again, each one of you. And I look forward to being back in my studio and to the new plans I already have for it. I hope that this fishless river here will drive Uncle Wulf away into fish-infested waters. Then I can sail for home. Right now I don't have the courage to abandon him. I've discovered that in payment for all the beauty I'm enjoying here, I must do a little dangling on the line myself.

We have a few neighbors here to be sure, a couple of English anglers, a quarter of an hour farther upstream, but we see practically nothing of each other, which is fine with me. My progress with Norwegian is so-so. I can make myself understood by the people here, but this part of the country is a bad place in which to learn the language. They speak such a harsh and horrid dialect that they can hardly understand the pure Norwegian spoken in Christiania.

Just this very minute Uncle Wulf revealed his plan to travel even farther north through the Lofoten Islands all the way to Tromsö. He wants to take me along, the good man. But he says I don't have to make up my mind quite yet. There is no question of my answer: a definite "No." And so I'll be coming home soon.

Kisses to all from

<div align="right">Your Paula</div>

To Cora von Bültzingslöwen

<div align="right">Worpswede, September 7, 1898</div>

My dear Aunt Cora,

My first evening in Worpswede. There is happiness and peace in my heart. All around about me the precious quiet of evening and the pungent smell of hay in the air. Above me the clear starry sky. Such sweet inner peace fills me and gently takes possession of every fiber of my whole being and existence. And one surrenders to her, great Mother Nature, fully and completely and without reservation. And says with open arms, "Take me." And she takes us and warms us through with her full measure of love, so that such a little human creature completely forgets it is made of ashes and dust and shall return to ashes and dust — This morning I walked

out here with Kurt through the misty landscape, the green meadows, and the radiant fields of mustard. And the landscape grew more and more "Worpswedeish"; then came the shining canals which reflected the blue sky, with the black peat barges slowly and silently gliding past. And finally came the brown heath, with happy, sparkling birches here and there, a strange mixture of melancholy and frivolity. We had a merry picnic under the open sky, and then in the afternoon a dreamlike hour with the painter Vogeler, who paints fairy tales, and lives fairy tales, and who offered us dream chairs in his fairy-tale hall. And there Kurt and I peacefully and happily entered a new existence. And then we returned deep into the moor, along shining canals, past laughing birch trees. It was the loveliest, purest atmosphere, straight out of Böcklin.

—And now a word about the practical side of this world. Would you be a friend and send me fifty marks and write me how much money I still have? I am savoring my life with every breath I draw, and in the distance Paris gleams and shimmers. I truly believe that my most secret and ardent wish is going to come true. I never even wanted to utter this wish before, it seemed so daring. But I cherished it in my heart all the more so that it would thrive, and finally it became the greatest of all the wishes that grew there. For the present, it is only half a year away but a half year has many days, and I plan to profit from every single one of them.

The mist is rising. It's becoming damp and chilly. I had better withdraw to my little chamber, which is really nothing more than a bed. Greetings to my dear Aunt Paula and my dear Uncle Wulf (and tell him that every waking moment my thoughts are still "in Norway"), and to the little bride whom I would so much like to meet face to face. And receive a tender kiss from

Your loving niece Paula

My address: c/o Frau Siem, Worpswede near Bremen.

Note to her parents delivered by the messenger Bernhard Barnstorf

[Undated, probably September 7, 1898]

My Dears,

I have found l....... [illegible because of ink blot—lodgings?]. Hurrah! Next to Bolte's villa, a nice bright sitting room, bedchamber being built on. I'm very happy. Nice proper people. Peaceful. I believe I am in Abraham's bosom. Rejoice with me. I left my clock on my night table. Please be kind enough to put it in the safe hands of good Bernhard. Dear Mother, would you perhaps have a square table for me? Maybe the one from the sewing room. And I also find it rather a pity that the newcomer [boarder] downstairs should have two sofas. Later I think it would be very fine to have one of them; right now I have hardly any more space in my one little room. Heartfelt greetings, I am very happy!!!!

Your Child

Worpswede, September 18, 1898

My Dearest Ones,

Well then, everything continues to be fine with me. I missed my chance last Monday to say good-bye to you, my dear Mother. I had been taking a walk from the poorhouse over to Vogeler's, thinking I would find you there. Instead, I walked right into total chaos. Vogeler's whole roof seemed to be lying on the lawn next to the house and he was dreamily climbing down a ladder from the rafters. Then, when I continued on my way, up past the sand pit, I suddenly caught sight of your little carriage down below me in the valley. But all my shouting and arm waving couldn't bring it to a standstill. I was able to console myself by saying that, after all, our separation was not forever.

Since then I have been going faithfully, mornings and afternoons, to old Mother Schröder in the poorhouse. I have spent some very strange and unusual hours there. I sit there in a large gray room with this ancient little woman, and our conversation goes something like this. She: "So, you comin' agin tomorrey?" I: "Yes, Mother, if it's all right with you?" She: "Yep, all the same to me. . . ." A half hour later this profound conversation begins all over again. But in the meantime some extremely interesting episodes take place. The old woman has a sort of hallucination. And later she will begin to tell stories about her youth, but in such a dramatic way and in dialogues with herself and with such changing intonations that it's a delight to listen to her. I'd like to be able to put it all down on paper. But unfortunately I don't understand everything. And I don't dare ask anything or interrupt her, because it breaks her train of thought and then she returns to complaining about her miserable existence in the poorhouse. And the scenes at night, too, which she has with the ancient and decrepit Olheit, when the latter falls out of bed and wails. They are worthy of being published. And now and then [while she is sitting for me] the poor old soul has to go to "the pot."

Besides this sibylline voice another happier twittering is heard. This is a little five-year-old blond girl whose mother practically beat her to death and who is now permitted to take care of the poorhouse geese as part of her "recuperation." By now this dear little creature has wrapped herself in a web of dream and fantasy and holds enchanting conversations with her white flock. Occasionally she will slowly crow the words to "Freut euch des Lebens" while she whacks one of the smart-alecky chickens with her stick. I feel very strange in these surroundings.

*Journal

October 4, 1898

I walked through the darkened village. The world lay black around me, deep black. It seemed as if the darkness were touching me, kissing, caressing me. I was

in another world and felt blessed where I was. For it was beautiful. Then I came back to myself and was still happy, for everything here was also beautiful and dark and soft like a kind and grown-up person. And the little lights shone in the houses and laughed from the windows out onto the street and at me. And I laughed back, bright and joyful and grateful. I am *alive*.

My model, old Jan Köster, after he had sat for three hours today, said to me in an ironic tone, "So, sitting's sure some fun—my ass has gone blind."

And old von Bredow from the poorhouse—what a life he has behind him! Now he lives there in the poorhouse, taking care of the cow. Years ago his brother tried to get him to return to the normal, orderly world. But the old fellow had grown too fond of his cow and his dreams. He is never going to leave them again. He holds the cow by its halter, walking with it out to the yellow-gray pasture, giving her a little poke with his stick at every step, and philosophizing. He once was a university student. Then he was a gravedigger during the cholera epidemic in Hamburg. And then a sailor for six years, and in general probably lived a crazy life, then he turned to drink to try to forget it all, and now he has found a kind of peaceful twilight in the poorhouse. He enjoys a certain reputation at the poorhouse and is thought to be some sort of secret millionaire. With bashful reverence, the old women there confide to me in secret, "Oh, Fräulein, he is rich!!! He has a hu-u-u-n-dred marks!!!"

Journal

October 18, 1898

Today I drew a ten-year-old girl from the poorhouse. She has been there for eight years, she and her little sister. She has lived under four different superintendents— and now her playmate is little Karl, the son of the present one, who loves her very much, and says, "If I had children, she could play with them, too." She can't bear to listen when another child is being beaten, and so she runs out into the garden. And she is never a tattletale either, except when Meta Tietjen takes away her knitting needles: "That's not nice," or if Meta says that people in the poorhouse have lice, when they are really always so clean and neatly dressed. And she says she can allow herself to be happy because she came to the poorhouse when she was a small child and has known nothing else. She has it so good, she says, and she says it with a little beaming face. How content a good heart can be with so little.

And how well off I am by comparison. Today I had a big window cut into one of my walls, and now there is a wonderful light in my little blue-green room. Gradually everything is being put into order. The things that only yesterday were still exciting and new are already sweet and familiar, and I live quietly and peacefully. I'm sure this is the atmosphere in which I can work and learn. Every few days Mackensen comes over to give me his excellent critique. It is good for me to be

around him. There is such a passion for his art in him. Whenever he speaks about it, his voice has a warm, almost tremulous sound, and it sets up the same kind of vibration in me. And when he quotes Dürer, he does it with a solemnity of tone and gesture, as if he were a pious child reciting the Bible. Rembrandt is his god. He sits in admiration at Rembrandt's feet and fervently follows in his footsteps.

Vogeler will be going to Dresden in the next few days. I'm sorry that he is not staying here. The man has a magical effect on me. Recently I visited his Martha. She is in all of his paintings. He began drawing her first while she was still going to school. When she grew older, Mackensen wanted to teach her how to enlarge [enhance by tinting] photographs with crayon so she could earn some money. But Vogeler said that was not for her—that she should draw flowers. Now she is embroidering screens and mats for him and seems to be living deeply in the spirit of his art. Sometimes she will sit for long hours in his studio while he makes one sketch after another of her. Or he will sit quietly next to her in her mother's living room and draw her. Soon she will go to the Kunstgewerbeschule [School for Arts and Crafts] in Berlin. I wonder what will happen after that? He has had his house enlarged. I think that their relationship is too tender and dreamy for it to ever end up in such an everyday way.

*Journal

October 24, 1898

I spent an evening recently at the am Endes'. He had that effect on me again like warm, mild spring rain and sunshine. The tender love that these two people have for each other fills their whole house with a rosy light. It seems that anybody invited to share this atmosphere would have to become soft and gentle, too. He has a combination of the tender soul of an artist and a strict, pure sense of form. The ones he loves are Dürer and Donatello, and Botticelli. He has [reproductions of their work] hanging on his walls in attractive, somber frames. He seems to sense the vibrations from other people's souls. He understands the unspoken and responds without speaking. Such a silent dialogue sets up charming vibrations in him. And then there is his little wife, with a heart one would want to kneel before. She hates spiders. There is something contemptible about them for her. And yet whenever she finds one in their little jewel box of a house, she picks up the enemy with tender adoration and sets it outside the window so that it can go on living happily.

October 29, 1898

Mackensen was at the Rembrandt exhibition in Amsterdam. He is filled with a holy ardor for "this giant, this Rembrandt." He loves what is healthy, the old Germanic strain, with all his body and soul.

He saw the sea for the first time in his life. He and some others saw a horseback rider in the distance who rode up to them, stopped, dismounted, and adjusted something on his saddle. And they asked him, "Where is the sea?" And he raised his hand and said, "You can hear it roaring."

He saw a man sitting in the evening twilight, sitting on white birch chips and carving little white wooden shoes. He said that if someone could paint that, he would be greater than all the others.

He is often hard and egotistical. But confronted with nature, he is like a child, soft as a child. At such times he is touching to me. He seems like an old proud warrior on bended knee before the Almighty.

I sketched a young mother with her child at her breast, sitting in a smoky hut. If only I could someday paint what I felt then! A sweet woman, an image of charity. She was nursing her big, year-old bambino, when with defiant eyes her four-year-old daughter snatched for her breast until she was given it. And the woman gave her life and her youth and her power to the child in utter simplicity, unaware that she was a heroine.

Mackensen saw a man chopping down a birch tree that was golden with autumn. And he walked closer. The man shouted, "Watch out!" And the tree fell. All the gold lay there at his feet. It was beautiful.

*Journal

[Undated]

I have drawn my young mother again. This time outside in the open. She is a joy no matter how she poses. I should like to paint a hundred pictures of her. If only I could! This time her brown hair stands out against a red-brick wall. Later I must paint her once with the white clay hut as a background, the one built by old Renken himself. She will stand out dark and warm against it. And then once with the dark pines as a background. Oh!

[Undated]

I feel as if I were seated in eternity
And my soul scarcely dares to breathe.
It sits with tightly folded wings
And wide-eyed it eavesdrops on the Universe.
And a gentle mildness comes over me
And over me comes a feeling of great strength,
As if I wanted to kiss white petals
And to battle mightily beside great warriors.
And I awaken trembling, full of wonder...
So small, Child of Man! And yet so very huge,
The waves that kiss your soul.

From the Album

November 9, 1898

"Most people spend the greater part of their time working for a living, and the little bit of free time that is left over makes them so frightened that they will do anything to rid themselves of it. Ah, human destiny!" (*The Sorrows of Young Werther*, May 17)

"Let us treat our children as God treats us, Who makes us happiest when He lets us tumble along in happy delusion." (July 6)

"Are we merely fantasizing when we feel happy?" (July 18)

*Journal

November 11, 1898

I'm drawing nudes in the evening now, life-size, beginning with little Meta Fijol and her pious Saint Cecilia face. When I told her that she should take all her clothes off, this spirited little person said, "Oh, no, I ain't doin' none of that." So at first she got only half undressed. But yesterday I bribed her with a mark and she complied. I blushed inside, hating the seducer in me. She is a small, crooked-legged creature. But I'm still happy to have a chance to study the human figure at my leisure again.

I am now reading the diary of Marie Bashkirtsev. It is very interesting. I am completely carried away when I read it. Such an incredible observer of her own life. And me? I have squandered my first twenty years. Or is it possible that they form the quiet foundation on which my next twenty years are to be built?

She was eleven and still dreaming the fervent dreams of a child. She had not yet awakened to what we grown-ups call life. She loved to sit in the garden next to the flower beds. She spoke with the wallflowers and with the mignonettes. They smelled sweet to her, she understood their language, and she smiled at them. And the flowers rejoiced in her brown eyes which were still covered by the blue veil of dreams. They blossomed and were more fragrant than ever, and in their own language they told enchanting tales. The little maiden had an impish ringlet curling over each ear, and her hair rippled like golden streams down her back, soft and gentle. And the sun was delighted in her curls and played sweet melodies upon them.

The child sat in the garden beside the slender white narcissus and talked and whispered with them. They swayed on their gray-green stalks, their narrow leaves like fans, and spoke their own language. And the air was pregnant with their aroma and wafted around the little maiden. And one of the narcissus, the best among them, with the snow-white brow, asked her sisters to hold back their seductive fragrance and not to arouse the maiden's senses. And they scented the air softly and sweetly. But the little maiden turned to the large golden-brown bumblebees and spoke with them. She took them between her fingers and set them into blossoms rich with honey, making them droop under the added weight. The big bees buzzed gratefully. They told of their queen, and completely forgot that they had a sting.

Beside the narcissus bed, however, there lay a yellow path. And all along the farther side of the path glimmered fragrant pink and lilac stock. Behind them stood a high wooden fence that separated the garden from the next one. The child had never looked over it, nor had she ever considered what might lie beyond. But something was there on the other side. It was standing on tiptoe trying to peek through a knothole into her garden, which smelled so sweet.

And he saw the child through the flowers, and after that he often peeked in. Often he would stand for hours, breathless before the little hole in the fence. And it seemed to him like a fairy tale and overcame him like a dream, like a holy seizure from within, and he did not dare move. Once, though, he could not restrain his curiosity and he whispered fervently through the little hole, "You, you." The little girl looked up out of her dream. But since she saw no one, she thought it was the flowers playing hide-and-seek with her. But for the boy on the other side of the fence it seemed as if heaven itself had opened and he had looked in on all its splendor. His heart suddenly stood still with joy. He dared not say another word. But her eyes had burned into his soul like two suns, like suns from southern lands where people do not have war nor must they wrestle with the earth for a little bread, and where they wander and dream and make up verses like children. The

boy could not forget those eyes like suns. He held them in the purest recesses of his heart, cherished them, and rejoiced in them.

Years passed. The stock and the narcissus no longer grew in the garden. The bees that buzzed over the other flowers were different bees. And other dreams were dreamt. My soul was filled with sorrow at the sight of these new gardens. I stole away. I went into the city. I stood at the entrance to the art exhibition, where I hesitated a moment before I stepped in. I walked through many great halls. My eyes passed fleetingly over the pictures, but my heart was with the old stock and the narcissus and with the old dreams. Suddenly I stood before my picture. A pair of sun-dream eyes were looking at me and brought spring back to my soul. They belonged to a solemn, quiet maiden. An impish ringlet hung over each ear. She held a slender white narcissus in each hand. My soul began to tremble. And beneath this painting in delicate letters was written the word You. The people walking past, everyday people, shook their heads and did not know what to make of this You. But the brown bumblebee that flew in through the window, . . . it knew. It was a sad story. The bee's grandmother had often told it to the bee when it was still small. . . . And I? I knew it, too.

*Journal

November 15, 1898

The journal of Marie Bashkirtsev. Her thoughts enter my bloodstream and make me very sad. I say as she does: if only I could accomplish something! My existence seems humiliating to me. We don't have the right to strut around, not until we've made something of ourselves. I am exhausted. I want to accomplish everything and am doing nothing. Today Mackensen was confused and dissatisfied during his critique. If the little woman from Bergedorf hadn't been there, I would have cried afterward. And so I simply tormented myself for two long hours—and did the same thing again this afternoon. The result: less than nothing. And now I am placing all my hope in my little nude model this evening.

The world is gray all around me and the sky looks gloomy. The water murmurs, gently, dreamily. It makes my soul restless. I wandered beneath the birch trees. There they stood, chaste and naked. Their bare branches stretched out to the sky, praying devoutly, begging for happiness. But the sky looked down in gloom, and they stand still now and mourn, gently, gently, with their little hands folded in piety. Living—breathing—feeling—dreaming—living.

I am wrapped in the riddle of the universe. And I sit down and say nothing. The water rushes along, the sound making my soul ill at ease. I tremble. Brilliant drops of water hang in the pine tree. Are they tears?

November 25, 1898

Dearest Family,

[...] in the meantime I go on living and drawing, drawing, drawing—and long for the time when I can accomplish the things I would like to do now. I certainly have a gigantic bear of a hangover from painting, the biggest one I have ever had in my life so far. Such creatures seem to thrive in this climate and proliferate wildly. Still, it is considerate enough to permit other very special moods to develop alongside, moods which make life rich and full for me: a sunset with the ringing of church bells, a visit to a little old woman with one foot already in the other world whose thoughts flash up bright and clear once more before they flicker out in the final catastrophe. She told me recently in the wonderful strong words of these people, but struggling a bit for breath, about birth and marriage and death. Whenever these people speak their real thoughts, one listens spellbound. Usually, though, they tend to speak in a kind of cliché, only empty words, just for the sake of talk. When that happens it's terrible. It makes them so inferior.

It's the season when all the cottagers are doing their spinning. The little old women are now going from house to house with their spinning wheels. And then the men knit the woolen yarn into stockings. Even my Garwes knits now in his free time.

Most of all I like to go see old Renken who lives "behind the fir trees" (which are really pines). There he makes his brooms, chattering pleasantly, rocking his grand-child on his lap and forever singing to her in two repeated notes, "Oooh, aaah, oooh, aaah." And when the young mother gives him a teasing look and says, "She knows that song already," then he quickly invents something new and sings, "Aaah, oooh, aaah, oooh." Those people really have a deep affection for each other, a rarity around here. And they just go on letting the world be the world, which to them means letting Worpswede be Worpswede.

I like sketching my little nude in the evenings. Although the girl is knock-kneed, she moves with such a naive grace. Today Mackensen had her pose in at least twenty different ways. I wanted to capture every one of them.

I am reading Bismarck's letters. The great man really has a very human effect on me. When he speaks about hunting, or women, or his impressions of nature, he almost seems to blend into Uncle Wulf. Bismarck, Werther, Marie Bashkirtsev, Worpswede—all of that in one little head. I seem strange to myself here. I look at the bustle of the world as if I were in the dress circle and, as befits my seat in the theater, I really don't think much about it. Up to now one has been playing a rather large role on one's tiny stage. The playing has come to an end now. We are simply ourselves. One stretches out and then pulls oneself back in, without being embar-rassed in the least before the audience. Only rarely does vanity wish to be spurred along, and that only the world can do. Even if it is just a little kick, at least one feels

important enough to be kicked. But that happens only seldom, and never in those sublime moments when one doesn't wish for anything at all.

Journal

<div align="right">November 29, 1898</div>

That was a terrible hangover, like some beast with its tail wrapped around my throat, almost throttling my soul. Marie Bashkirtsev, she's the one I accuse. I was working feverishly—but all I accomplished was uninspired handiwork. The "ingenium" (to use Frau P.'s phrase) was lacking.

Now the tail of the beast has let go and my throat is no longer constricted. I shout hooray! and have been singing all day long and sketching happily. So life is beautiful again, entirely beautiful.

This little Worpswede tragedy came to its conclusion at a merry dance held at Dreyer's. To be sure, I was only a spectator. When they were dancing the waltz it was hard for me to sit there quietly. But there was so much else that stimulated me.... The moonlit patch in the breeze, the birches against the blue evening sky. And then inside the house, the women's heads red in the glow from the lamps, and then again by an open doorway lighted from behind by the glow of the evening sky. Really, *anything* against the sky!!! And finally, the six musicians on their platform, four lighted candles in front of them illuminating those dark fellows so wonderfully. I absorbed that little scene in particular and when I got home made a little sketch of it. I wish I could do etchings. That would be just right for such a scene.

Today I did another drawing of His Highness, von Bredow, and half listened to the flow of his chatter. Things are a bit topsy-turvy in that old head. Many a weed in that wheatfield. He keeps drawing parallels (for himself) between his own life and the greatest men of all times. Schiller, he said, would have lived longer if he hadn't drunk three hundred talers' worth of champagne while he was writing his great drama, *Die Glocke*. Poets and such people, he said, they need to do that sort of thing. They have to be half crazy when they are writing. "Yes, and Johann Gutenberg, he died in the poorhouse. Dr. Faust lent him a huge amount of money, then foreclosed and took over the printing press, went to Paris, and sold his Bibles cheap there. He almost lost his life while he was there; the priests were after him. It was the waitress in his hotel who finally saved him." Then stories about his dreams and his critical years, a very strange vision in one of his dreams which disappeared like fog when he awoke, a vision of "sonnamblists," he thinks they must have been women. "That couldn't be no man." —His constant refrain: He who wants to love must suffer; one cannot escape his fate.

[Undated]

In the mornings a model with an unusual head sits for me, really one to study. And afternoons for "dessert" I go over to my dear Renkens. I have grown very fond of these people, particularly the little wife with her childlike but feminine charm, and with that simple capacity for sacrifice (which she is totally unaware of) such as one finds only among good-natured peasant women.

If I ever get to the point where I can paint, I would like my first portrait to be of her.

Her old father, with his sixty-nine years, still goes out into the *Blockland* at six o'clock every morning with his wheelbarrow and sells his brooms all day long. One day recently he came home in a rage. His worthless son had spread the rumor among all his customers that his father had died. So they bought their brooms from the son and the old fellow was cheated out of his earnings.

*Journal

December 12, 1898

I'm doing a drawing now of Anna Böttcher in the morning — extremely fine coloration and with a wonderful shape to the head. And this afternoon I'll be picking up old Adelheit Böttcher, "old Olheit," who will pose. There is something of a rivalry among the old women for my posing fees. "Big Lisa, she put on her good bonnet and now she's thinkin', now you're goin' to be fetchin' her. She always is jabberin' such junk at me, 'bout the boys and the girls and what happened here and what happened there. Don't even listen to her — from time to time I give her a little yes and a nod, but all my thoughts is somewhere else." That's the way the little woman talks at me. There is still a lot of life in the old thing, passionate likes and dislikes — but already a little bit childish again. If she feels the need to repent for having done something, she will say to the younger woman, "Mother, forgive me, I done wrong." I find that quite touching.

Fräulein Westhoff's model complains about her earache: "Tried everything. Done everything they said to — everything, except cleanin' 'em out."

*Journal

[Undated]

I am not satisfied with my sketching now. I'm out of breath. I want to go further and further. I can hardly wait until I am a real artist.

And then I long so for life. I've only begun to get a little taste of it. I didn't have the real mind for it earlier. And here there is no life; it is a dream here.

I'm reading Nietzsche now, *Zarathustra*. Among so much that is confused and obscure, such pearls! His rearrangement and re-creation of values! His sermons against false brotherly love and self-sacrifice.

False brotherly love, that certainly gets in the way of great goals. Many great minds would not have been chopped into little pieces by everyday concerns if they had been armed with his way of thinking. The next generation should have this concept born into it.

From the Album
[Thus Spake Zarathustra]

[Undated]

"At least be my 'enemy,' thus speaks true reverence which does not want to ask for friendship." ["On the Friend"]

"One ought still to honor the enemy in one's friend. Can you still approach your friend closely without trampling him? In one's friend one ought to have one's best enemy. You should be closest to him in your heart when you resist him." ["On the Friend"]

"Your friend should be a master in guessing and keeping silent. You must not wish to see everything. Your dream must betray to you what your friend does when awake. May your compassion be a guessing correctly, so that you may know whether your friend wants compassion. Perhaps he loves in you the unbroken eye and the gaze of eternity. Let compassion with your friend hide under a hard shell so that you should break a tooth on it. Thus it will have its delicacy and its sweetness. . . .

"Are you a slave? Then you cannot have friends. All too long a slave and a tyrant were hidden in woman. Therefore woman is not yet capable of friendship. She knows only love." ["On the Friend"]

"I do not show you the neighbor, but the friend. May the friend be the festival of the earth for you and a premonition of the superman. I show you the friend and his heart filled to overflowing. But one must understand how to be a sponge if one wants to be loved by hearts filled to overflowing." ["On Love of the Neighbor"]

Journal

December 15, 1898

Old Olheit told me the novel of her life today. "Worked in Bremen," she told me, "on the Besselstraten. Then she got herself married. Had to live somewhere, she did. Went along pretty well, all in all. Only thing is, he's dead now."

I am drawing Frau Meyer *aus dem Rusch*. She was in jail for four weeks because she and her man mistreated their illegitimate child so badly. A voluptuous blonde,

a marvelous specimen of nature, with a throat gleaming like the Venus de Milo. She is very sensual. But isn't it true that sensuality, inborn and natural sensuality, always goes hand in hand with this kind of ripe and robust energy? For this sexuality contains something of a great Earth Mother with full breasts. And sensuality, sexuality, to the very fingertips, when it is united with chastity, that is the single, true, and proper concern of the artist.

*Journal

<div align="right">December 16, 1898</div>

My blonde was here again today. This time with her little boy at her breast. I had to draw her as a mother, had to. That is her single true purpose. Marvelous, these gleaming white breasts in her fiery red blouse. The whole thing is so grand in its shape and color.

In the afternoon, my old woman: "I said to Big Lisa, I got to live a good life so I can get in an honest grave like my man. I ask our good Lord every day for that, so He will stop me from whoring and stealing. You can be safe and sound for sure, only if He sees to it."

I had to shake my head and smile to myself at this innocence. Half blind and half withered away and nearly in the grave and asking the good Lord not to let her go whoring.

One hears a pure Lutheran dialect out here. Every day one hears the coarse and common expressions that really call a thing by its name. When I take the old woman by the arm and lead her up to the door, she says, "First I have to take a piss"—or, "First I have to let my water." Then up comes the dress, and I flee in my virgin chastity.

I think I'm getting into the real mood and atmosphere of Worpswede now. What I used to call my Sunken Bell mood, the spell I was under when I first got here, was sweet, very sweet—but it was really only a dream, and one that couldn't last long in any sort of active life. Then came the reaction to it, and after that something truer—serious work and serious living for my art, a battle I must fight with all my strength.

I am filled with the sun, every part of me, and with the breezy air, intoxicated with the moonlight on the bright snow. It lay heavy on all the twigs and branches, and a deep silence surrounded me. And into this silence the snow fell from the trees with a gentle and crisp sound, and then there was peace again. An indescribably sweet web of moonlight and soft snow air enveloped me. Nature was speaking with me and I listened to her, happy and vibrant. Life.

Journal

[Undated]

Nature is supposed to become greater to me than people. It ought to speak louder from me. I should feel small in the face of nature's enormity. That is the way Mackensen thinks it should be. That is the alpha and omega of all his critique. What I should learn, he says, is a more devout representation of nature. It seems that I let my own insignificant person step to the forefront too much.

I became aware of something today when I was with Fräulein Westhoff. She had just finished sculpting a bust of an old woman, intimate and heartfelt. I admired the girl, the way she stood next to her sculpture and added little touches to it. I should like to have her as a friend. She is grand and splendid to look at—and that's the way she is as a person and as an artist. Today we raced down the hill on our little sleds. It was such fun. My heart laughed and my soul had wings. Life—

To Marie Hill

Worpswede, January 15, 1899

Dear Aunt Marie,

It's Sunday evening and I'm snug and cozy here in my little room. I've fed some dry Christmas tree boughs into my stove, and now it smells dreamy, of resin and Christmas. All day long I was far out on the moor in a storm, with clouds racing by. I'm still discovering new beauty in this landscape. Today, walking through a snarl of birches, I came upon ancient farmhouses, green with old moss, with venerable junipers in front of their doors. Here and there stood a few gnarled old pine trees, huge and grand, looking almost as if they belonged to a different world. And the deep dark brown, saturated ground of the moor, and the brilliant color of the winter wheat. Oh, yes, it was fine. And on top of all that, the battle with the elements, the wind wantonly grabbing at everything and blustering and laughing mischievously.

So the effect of my cozy little room on me is so sweet now. I have your letter in front of me. It makes me feel as if I were back on old Friedrichstrasse. How strange it is that I was once a child, with nothing to think of, just living, living quietly, and now all of a sudden grown up. Strange. It would be hard for me to say what I've done with my first twenty years. All at once they seem so far away. Perhaps I'll have more to say about my second twenty years. At least now I live with a full awareness of things and am sipping slowly from the cup of life. My lot is a blessed one. [...]

From the Album
[*Thus Spake Zarathustra*]

[January 15, 1899]

"Oh, that you would get rid of all half desires and be resolute in indolence as in action! Oh, that you would understand my word: do in all cases what you want to do—but at least be such who are capable of wanting." ["About the Virtue that Belittles"]

"One must learn how to love oneself—this I teach—[with a sound and healthy love:] so that one can bear to be with oneself and need not roam about." ["About the Spirit of Gravity"]

"'That, then is *my* way—where is yours?' Thus I answered those who ask me 'about *the* way.' *The* way, you see, does not exist." ["About the Spirit of Gravity"]

From the Album

January 18, 1899

> Give my soul the noble ecstasy
> It needs for work! For as the hand
> Must labor with tongs and hammer
> To split the marble and guide the chisel,
> As this thing fails and that one will not thrive,
> And the smallest thing demands my greatest pains—
> So also are thrill and spirit lost.
> The breast will oft contract, the gaze grow dim,
> The soul's clear image disappears.
> Not to lose this heavenly gift,
> Amongst the day labor's bric-a-brac,
> This gift which, like the perfume of the sun,
> Knows no restraints,
> Is hard.

[Hauptmann, *The Sunken Bell*, act 4]

**Journal*

January 19, 1899

While I was bathing today, the sentence occurred to me: Here in solitude the human being is reduced to oneself. It's a peculiar feeling, the way all the confused, superimposed, theatrical qualities that were in me fall away and a vibrant simplicity takes their place. I'm working on myself. I'm reworking myself, half consciously, half unawares. I'm changing—becoming better? At least I know I'm pro-

gressing, becoming more conscious of my goal, more independent. This is a good time for me now and I'm aware of a fine young energy that makes me rejoice and exult. I'm working very hard. I don't get tired, and even after work, in the evening, my head is still clear and can absorb and learn. I'm proud now and yet more modest about my accomplishments than ever, not particularly vain—probably because I haven't much of an audience here. Life seems to me like a crisp apple which I enjoy biting into—young teeth conscious of their strength, happy. Mackensen says strength is the finest thing of all. In the beginning was strength. I think about that, and I recognize that it is so. And yet I know at the same time that strength will not be the keynote in my own art. The feeling I have inside me is like a gentle weaving, a vibrating, a beating of wings, quivering in repose, holding of breath. When I am really able to paint, I shall paint that.

Outside, nature is putting on the grand fine dance. The wind is roaring. The rain is beating, hail is showering down—ancient and primeval might. One feels tiny in the face of it all—and then laughs, ready to measure one's strength against that nameless spirit of nature whose smallest atom makes up this little defiant creature, irrational in its struggle.

It's too bad to have to go to bed at night. My feeling of strength wants to fight on as it grows more and more conscious of itself; it wants to stay awake, not rest. Oh, don't leave me! My life will be like the flight of a young eagle. I delight in my wings, I exult in my motion, I rejoice in the blue air of heaven. I am alive.

*Journal

January 24, 1899

Another lovely day behind me. My soul is happy again. I stretch out my arms and am filled with life's rapture.

My model, my woman out of Rubens, couldn't come today. So I took a walk in the twilight, and went out to the flooded meadows. My soul was overcome with the power exuded by this hour of dusk—it pressed down upon me, robbed me of my breath. And I felt blessed. It's a gift, isn't it, to be able to feel this splendor. And I thirst for more and more, and I am determined to strive with all my strength for it, untiringly. So that finally I can create something I can pour my entire soul into. It will not be anything grand, but something graceful, virginal, austere, and yet something demanding. And when will it be? In two years. May God grant me this. I say God, and what I mean is the spirit that flows through nature, of which I, too, am a minute particle—the spirit that I feel in a great storm. It was like powerful breathing.

> Oh, holy spirit, enter and dwell with me
> And let me be your homestead
> For constant bliss and joy.

Sunlight, happiness,
you will bestow on me
heaven's life now.

I reach out with my arms for that and again am filled with awe.

Journal

[Undated]

I am reading *Elective Affinities* and find myself warmed through by the charm of this book. For the first time I have a feeling for Goethe as a human being. I sense him to be a thoroughly aesthetic person, inwardly and outwardly. The charm of conversation, the grace of his women — all this speaks from a heart that has deeply felt these things. I feel good in this atmosphere. It affects me the same way that Aunt Herma and Maidli do. And the book has an educating effect on me. We modern women who dismiss grace and chase after other things — we should unite grace with our other goals. In fact, we must. I must let this into my flesh and blood more: I should dress attractively, and my movements should be graceful for the sake of grace itself. This principle has been mine ever since I was a young girl: for the sake of grace itself and not for the sake of the public. For the public could be absent occasionally, as in my case, for example. In addition, the cultivation of grace and charm is infinitely superior to the cultivation of one's audience.

From the Album
[Goethe, *Elective Affinities*]

"In marriage one must fight sometimes; in that way people learn something about each other."

"All people should take their own advice and do what they cannot help doing. If it turns out well, then may they rejoice in their wisdom and their good fortune."

"Business demands seriousness and rigor; life demands free will. Business demands the purest logic; life often needs inconsistency, indeed it charms and enlivens it. If you are secure in the former, you can be all the freer in the latter, quite contrary to the assumption that in a mixture of the two security will be torn asunder and abolished by freedom."

"For Charlotte was of the opinion that one could not get acquainted quickly enough with the character of the people with whom one had to live in order to know what one could expect of them and what capacity for development they had; or what once and for all one had to confess to them, or for what one had to forgive them."

"The new and fashionable clothes enhanced her figure; for to the extent that the

attractiveness of a person is also conveyed by what she wears and has about her, one believes her appearance to be ever more charming whenever she imparts her innate qualities to a new surrounding."

"I find it a very pretty trait in women that they continue their devotion to any given man for so long; indeed, that they do not let it be disturbed or destroyed by any kind of separation."

"Married women, even if they are not particularly fond of one another, nevertheless stand together in silent union, especially against young girls."

*Journal

[Ca. February 12, 1899]

A week in Berlin. So happy to be back in Worpswede. Getting myself back into work, painstakingly.

*To her parents

Worpswede, February 12, 1899

Dearest Family,

I am back again at my country estate and so happy to be here. I am surrounded by the splendor of early spring. The sky is laughing in its exquisite blue, and the waters of the spring thaw reflect the sky and laugh back even more exquisitely. The larks sing and the hazel bushes are covered with catkins.

My heart rejoices in all this beauty. Just walking back out here was glorious. As soon as I left Bremen behind, the very moment I abandoned the unpleasantness of my old ragged and shabby self, and the minute I buckled my green, homemade sack on my back and took off my jacket and my little fur cap, I became a whole person again and rejoiced in my humanity. Merriment at the coming of spring, cheerfulness with no particular reason or goal, filled my soul and nests there still. By the time I got to Lilienthal I wanted to have a drum to beat or a harp to play mightily and in a voice of praise to sing Schubert's "Allmacht." But since I had neither drum nor harp nor a voice for proper singing, I just surrendered to the whole feeling. I let myself be used as an instrument and someone played on me so that my strings gave off wonderful sounds and reverberated for a long time afterward. The most wonderful thing was the blue-green water running through the green meadows. Gradually the excitement of it all made me tired. I walked a few steps off the road, put my sack under my head, and took a fine nap. Then I dreamed along the rest of my way until I reached my dear little nest here.

And here it turns out that everybody either has had, is having, or is about to have influenza. Nevertheless, I was received heartily and tenderly. Some of my

friends were even crying a little. Now I am back at work again and enjoying it with all my heart.

Thursday evenings have been christened community bowling evenings. To tell the truth, I don't think particularly much of bowling, that is, not for us little women—but we do need some kind of tangible bond to bring all these sensitive souls together. They are so absorbed in their isolation. So when we go bowling they let themselves relax, join in merrily, and are pleasantly drawn together. Whenever their pleasures are too aesthetic, they tend to stay in their separate, sensitive cocoons and inevitably irritate each other—they are all too alike and at the same time too different.

That's the only fear that I have for my own little person here.

I believe that I'll grow away from here. Those with whom I can stand to speak about things close to my heart and feelings are becoming fewer and fewer. I suppose they vanish entirely with age, when the glimmering light of subjectivity is extinguished and the cold electric light of objectivity is turned on. When that happens, everyone, I suppose, can speak with everyone else about everything. And that will be a state of affairs to fill me with horror.

*Journal

February 19, 1899

I seem to have my great thoughts when I get up in the morning. Today: the complexity of a character grows in direct proportion to the refinement of one's understanding of it. In this case, not being understood by people who are not inferior simplifies things. At least that's the way I feel it to be out here. [...]

Goethe's *Elective Affinities* loses its grip on me just as soon as the plot begins to thicken. It's the same as in *Tasso*, where the first act is also the most beautiful. One can feel later how the artist tormented himself by having to complete the design. Modern writers have made progress in this regard. Their works develop so smoothly and logically. One doesn't sense the birth pangs. That is refreshing. Hauptmann's *Fuhrmann Henschel*, for example. The work simply stands there, grand and solid, and lifts the audience. Splendid!

Helbeck of Bannisdale by Humphry Ward.

The book fascinates me as a novel. A not too farfetched love story always seems to have something engrossing about it—at least for me. As a work of art in itself, I wouldn't rate it very high. The flesh and blood of Rembrandt are missing without its being on the other hand sentimental and fleshless, like an old German master painting. That seems to me to be the failure of English art in general. It suffers from false idealism. [...]

From the Album
[Thus Spake Zarathustra]

March 2, 1899

"The God who saw everything, even Mankind, this God had to die! Man could not bear the fact that such a witness might live." ["The Ugliest Man"]

"For happiness, how little is really needed for happiness! Thus I once spoke and thought myself clever. But that was a blasphemy; *that* I have now learned. Fools speak better than that."

March 3, 1899

"It is precisely the very least thing, the quietest, the lightest thing, the rustling sound of a lizard, a breath, a whisper, the blinking of an eye—It is *little* that makes the *best* happiness." ["At Noon"],

**Journal*

[Ca. March 3, 1899]

Finished [*Thus Spake*] *Zarathustra.* A wonderful work. It intoxicates me with its Oriental language of the Psalms and its tropical profusion of glowing images. Its many dark aspects do not bother me. I simply overlook them. Do we understand everything in life anyhow? Nietzsche with his new values—yes, he is a giant. He holds his reins taut and demands the utmost of his energies. But isn't that true education? Shouldn't such striving be the basis of every love, to inspire the beloved to realize his or her most beautiful potentials? It seemed strange to see so clearly expressed my own thoughts and feelings, which rested unclear and undeveloped in me. I feel happy again, as a modern human being and as a child of my own age.

**Journal*

[Ca. March 6, 1899]

I am reading *Niels Lyhne* for the second time, and very intensely. It intoxicates all my senses. It is as if my soul were wandering at the height of day through an avenue of linden trees in blossom. The fragrance is almost too much for me.

It is a strange book, with a subtle psychological development. And at the same time so simple, so alive. Life with glowing colors, with sunshine, nights with nightingales—and now and again a delicate murmuring music that the human ear can hear and sense but not understand.

Never has anybody created so perfectly for me the magical atmosphere of a sin-

gle room. One can sense in advance what kind of thoughts must develop in this air, what kinds of people must grow in this environment. Jacobsen. I can feel him in all my nerves, in my wrists, the tips of my fingers, my lips. It envelops me. I read him physically. [...]

*Journal

[Undated]

Little Berta Garwes told me very seriously, "Karl Schröder has a book and he writes down all his misfortunes in it." Yes, most people are like that. They inscribe on their minds all their bad luck and diligently memorize it. But their luck, all the good things that happen to them, they don't pay any attention to that. For them they are merely transitions from one bit of bad luck to the next. Poor, poor world. Things are better than that for me.

From the Album

March 6, 1899

"We women can perhaps tear ourselves away for a while whenever someone has entered our lives and opens our eyes to the need for the freedom that dwells in us. But we do not endure. We have, once and for all, in our very blood a passion for the quintessence of what is correct, up to the most brittle point of what is proper. In the battle we do not side with what has been assumed by the general public. In our innermost being we believe that general opinion is right, because that is what judges, and in our hearts we bow down before its judgment and suffer under it, no matter how bold we may pretend to be. It is simply not within us women to be exceptions; it makes us so strange, perhaps more interesting. But as for the rest ..."
Niels Lyhne, Jacobsen.

"Yes, our nature grows with our knowledge; it is clarified and comes together through it. It is just as beautiful to learn as it is to live. Do not be afraid of losing yourself in other spirits who are greater than you yourself are. Do not sit and brood anxiously about the special quality of your soul; do not exclude yourself from that which has power, out of fear that it could sweep you away and drown your dear inner specialness in its mighty roar. Be calm; the special quality which was sloughed off in the process of healthy development, that was only harmful; it was only a defenseless sprout, and it was only "special" as long as it was pale, suffering, and afraid of the light. And you should live from what is healthy in you; it is health from which greatness comes."
Niels Lyhne, Jacobsen.

Worpswede, March 9, 1899

Dear Father,

Today I'm going to tempt you. I shall need a new model Monday and would love to have you sit for me on my little throne. Would you be able to give up Bremen for a week and rush into my arms? And I promise you won't have to have just pancakes to eat—I'll feed you something sensible. Incidentally, I've never had a passion for pancakes myself. The weather is superb out here right now, just perfect for long walks.

Last Sunday I ate at Welzel's, just to get a chance to visit with the other women there. It was very pleasant, and I plan on doing it every Sunday now so that they won't think I'm avoiding them. We had a cozy conversation over coffee and then a lovely walk through the springtime landscape, still half covered with snow. All in all, I'm converting to a more sociable policy. Quite without intending to, I seemed to have steered my little ship into foolishly isolated waters, which happens to be good for study and work, to be sure. So now I've made a point of visiting the Overbecks and the Modersohns. The Overbecks are both very reserved people—there's a great deal there, but everything is under lock and key, and unfortunately I'm not an aggressive breaker-down of barriers, at least not by design. Once repulsed, my arms go limp and I retreat. And so I don't believe that I'm going to get very far with them. Modersohn, on the other hand, I found immensely appealing. He's pleasant and comfortable through and through, and he has a kind of music in his nature which I can accompany on my little violin. His paintings alone endear me to him. He's a gentle dreamer.

*Journal

March 23, 1899

Snow and a shimmering moon...
Slender trees inscribing
the image of their
soul, lying on winter's white shroud,
searching, trembling.
In piety they lay their lovely essence
down upon the simple ground...
When will my day come
that I in all humility
can cast upon that pure
and chaste same ground
a shadow of myself...
A shadow of my soul.

Worpswede, March 30, 1899

Carl Vinnen was in Worpswede for two days. He's a lovely person and an artist, body and soul. He has a whole group of pictures on exhibition in Bremen now. Beautiful large things which have grown out of his devotion to nature and which put the human and personal elements in the background. And yet one can sense from them that for him human beings are more important than things. That's what gives him this great and simple viewpoint.

Yesterday he gave a little celebration in Otto Modersohn's studio. It was the loveliest evening that I've spent out here among the artists. I loved seeing Modersohn's birches and canals everywhere. And then the space itself had something so pleasant about it. Dim light from paper lanterns. Two tables, one set for the grown-ups and one for the "children." At the latter sat Fräulein Westhoff and I, Vogeler, young Mackensen, and Alfred Heymel, the former owner of our dog Caro. He amused me a great deal. Vogeler had just lent me some of Heymel's poems, but I didn't like them enough for their spirit to affect me. They have that youthful power which is self-conscious and would like to establish itself. He lives in Munich, pickled in the same brine with all our finest and most modern artists. With his cousin Rudolf Alexander Schröder and Otto Julius Bierbaum, he publishes a magazine there, *Die Insel*, among other things.

Afterward Vogeler sat down with his guitar and sang "nigger songs." And after that the tables were shoved aside and we all danced. Heymel was an inventive dancer. He made up round dances so well that I couldn't get enough of them. Besides, my feminine instinct told me that my new green velvet dress looked pretty and that several people there were delighted by me.

This morning Vinnen visited me and had a look at my work. I was immensely happy that such an artist takes me seriously. He liked many of my things and praised the way they were painted and my colors.

I heard a nightingale, a nightingale in the Boltes' garden. One evening recently a cricket was chirping and a bat swooped over my head. Life is becoming more and more beautiful.

To Marie Hill

Worpswede, April 20, 1899

My dear Aunt Marie,

It's midnight and the moon is shining, a worthy moment for me to reflect and to repent my sins. The occasion of your birthday also gives me a kind of moral push, so that I find it impossible to persist in my beloved state of silence. For by virtue of enormous effort I've now arrived at a state of silence, which is said to be

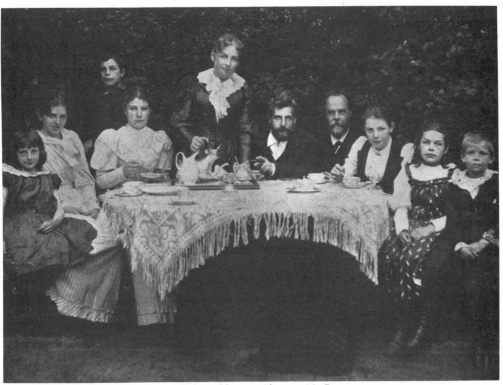

2. *A family party in the garden at Schwachhauser Chausee 29, Bremen (Paula Becker second from left), ca. 1893*

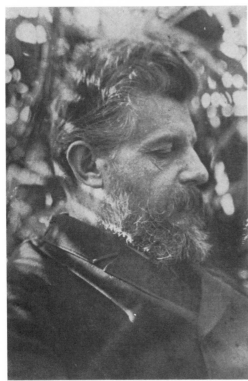

3. *Woldemar Becker, Paula's father, ca. 1895*

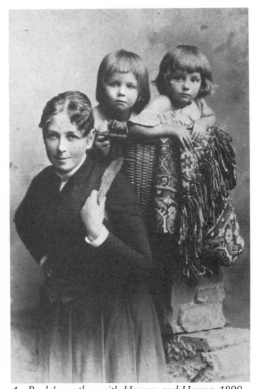

4. *Paula's mother with Henner and Herma, 1890*

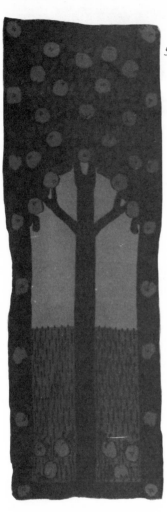

5. Wall hanging, ca. 1900, woven from a design by Paula Becker

6. Nine rue Campagne Première, Paula's first studio in Paris, 1900

7. Entrance to the Académie Julian

8. Class for women painters at the Académie Colarossi

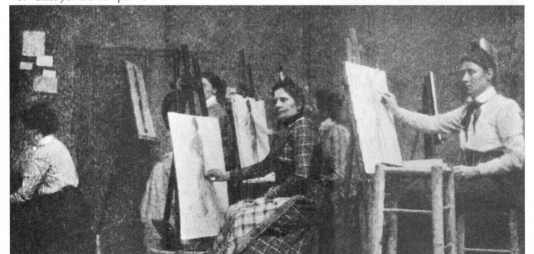

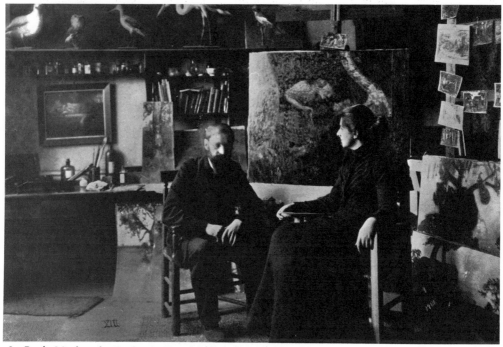

9. *Paula Modersohn-Becker in Otto Modersohn's studio, 1901*

10. *Paula Becker's studio with the skylight*

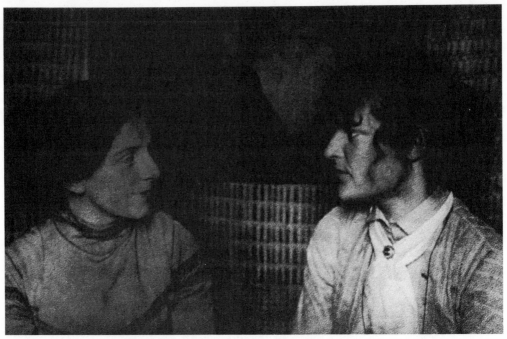

11. *Paula Becker and Clara Westhoff in Paula's studio, ca. 1900*

12. *Rilke in his workroom in Westerwede, 1901*

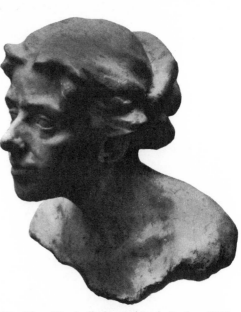

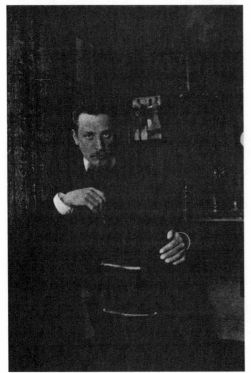

13. *Clara Westhoff's bust of Paula Becker, 1899*

14. *Heinrich Vogeler:* Summer Evening (Concert at the Barkenhoff), *1905. Left to right: Paula Mo-dersohn-Becker, Agnes Wulff, Otto Modersohn, Clara Rilke-Westhoff, Martha Vogeler, Martin Schröder, Heinrich Vogeler, Franz Vogeler*

15. *Outside the Barkenhoff, ca. 1904; Rilke's blessing for the house on the beam above the door (Paula Modersohn-Becker at the right)*

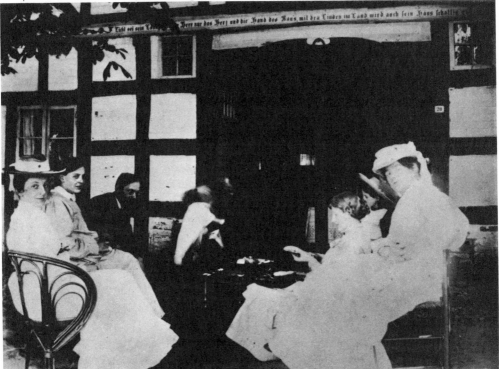

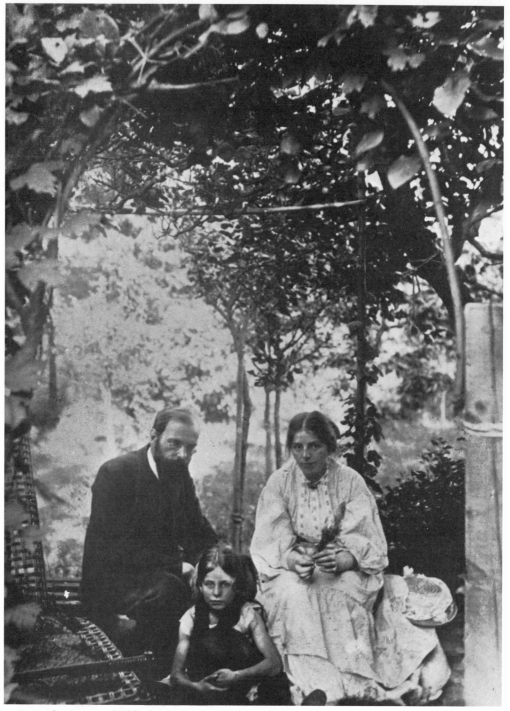

16. *Paula, Otto, and Elsbeth Modersohn, Worpswede, ca. 1904*

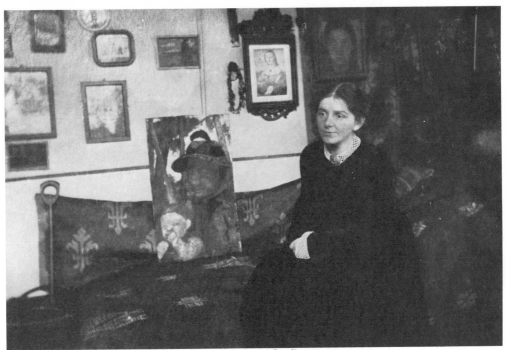

17. *Paula Modersohn-Becker in her studio at the Brünjes', ca. 1905*

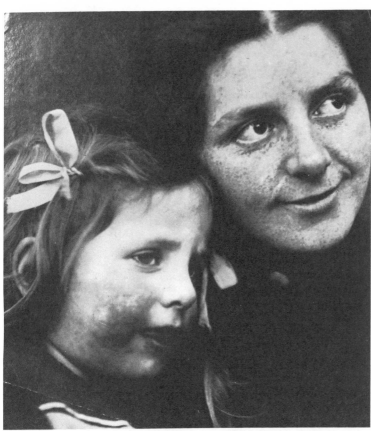

18. *Paula Modersohn-Becker and Elsbeth, ca. 1902*

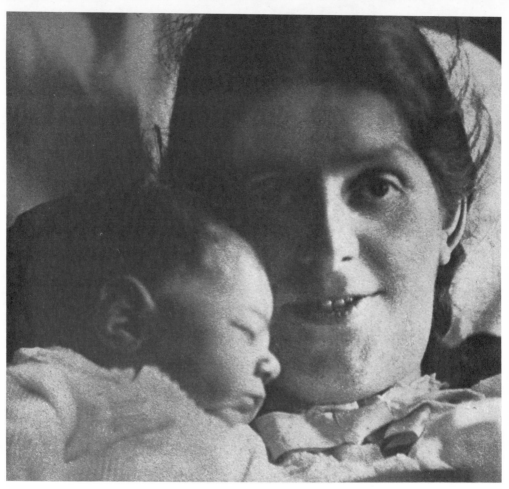

19. Paula Modersohn-Becker with her daughter, Mathilde, November, 1907

golden—though up to now I don't seem to have received much of that gold. Still, I continue to believe in the truth of that old saying.

I have little news to tell you about myself. I'm working rather hard, thinking a lot about it, and sometimes my sky is full of violins, and sometimes none at all. At present, Mackensen is at the dedication of an exhibition in Dresden where the Worpswede artists are beautifully represented. The twins were out here visiting me at Easter. It was wicked fun for me to have these little visitors in my lodgings. We were packed like sardines in my miniature room, cozy together, little man and little woman. It was a delight to have the scoundrels around me. I'm getting to the age now when it's fun, at times, to be a child again with children. In contrast to earlier, when childishness was the usual thing and acting my age the rare thing for me.

Please excuse this letter; I seem to be suffering badly from a lack of wit and warmth. My only excuse is the late hour. I have just come back from bowling, where I used up my meager physical and psychic energies. Finally spring seems to be here. Beside me on the table is a branch of blossoming pussy willows, not coaxed forth by the sun, to be sure, but by the strong heat of my peat fire. The pussy willows may love it, but not I, and not my purse.

My eyes are literally three-quarters closed. Dawn is creeping up and our cat Mimmi and her four kittens are meowing like fury. I flee now to my big feather bed.

* *To Kurt Becker*

Worpswede, April 26, 1899

My dear Kurt,

This letter greets you in your new home with a heart full of good wishes. May you now, as "a man standing on his own two feet," have a fine new appetite for life. Just thinking about this whole matter of achievement is exciting enough in itself, and I can hardly picture how I shall be able to express my own joy once I have really attained that peak, too. You men are all so composed about the great things in life, which in part must be very fine. But it's also wonderful to completely lose one's composure out of sheer happiness. I think that sort of thing happens to you men very seldom. In any case, I wish you a barrel full of happiness; with or without composure, that's up to you to decide.

It seems such a long time ago that you were out here on a visit. Yet it's not much more than four weeks ago. Things are going well; we pass our days slowly and seriously, we make progress in our struggles and, I hope, also in our abilities. Mackensen has been in Dresden for such an eternity as a member of the exhibition jury that I'm already longing to see him again. He's being deluged with honors, has already been twice to tea with Princess Feodora (which has gone to his mother's head, to say the least), spent a marvelous first week visiting people and objects, and now can hardly wait to get back home to his heath. Vinnen was

awarded the "big golden medal" in Dresden. I'm enormously happy for him in particular. The last time he was here he gave a charming party in Modersohn's studio, then sought me out the next day and looked at all my work; he had all kinds of good things to say. It made me very happy that such an artist even stopped to bother about me.

I was in the city to see our new home on Sunday. Mother has arranged it all very comfortably. The living room looks very much like the one on the Chaussee, only it seems infinitely more calm and larger; one can really appreciate the high ceilings. Sunday morning the twins and I put on our coats and climbed up to the flat roof even before the church bells began ringing, each of us snuggled up against a chimney. The constant view of the Weser is a joy to behold. And while up there I made good use of the closeness to old Bremen and took great delight in the variety of little gables and the everyday poetry of this little neighborhood—There's no end to the things that can make one happy in life. One only has to know how to find them and to maintain the strength to be able to seek them out.

I'm afraid my pen is fighting me in a hopeless way. It's nearly midnight. After more than its share of spring air, the eyelids of my little soul are snapping shut.

<div style="text-align: right">

Good Night

In Faith

Your

Sister

</div>

From the Album
Maurice Maeterlinck: *Wisdom and Destiny*

<div style="text-align: right">

April–May 1899

</div>

"The more an ideal refines and improves itself, the more reality it lets in."

"Seeing without loving is the same as staring into the night."

"When a disappointment overwhelms you, do not sob to yourself, 'Alas, life is not as beautiful as my dream!' Say to yourself, 'There was something missing in my dream, for it has not found the approval of reality.' In the last analysis all the so highly prized strength of great souls consists only of disappointments that have been taken in stride."

"Renunciation cannot be avoided considering all the general and unavoidable facts of life; but in every instance where a battle is possible, renunciation is only faintheartedness, ignorance, or disguised laziness."

"Is not worrying oneself and worrying others the same as refusing to learn to be as happy as possible?"

"We never know whether a thought is deceiving us or not, but the love with which we loved it will return to us without a drop of its clarity or power missing.

What constitutes and nourishes the ideal nature we all struggle to create within ourselves is not so much the totality of the concepts which determine its inner contours, as it is the pure passion, the honesty, and the selflessness with which we surround these concepts."

From the Album

Hölderlin, *To the Young Poets*

> Dear brothers, perhaps our young power will ripen soon—
> since youthlike it has been fermenting long—
> soon ripen to the stillness of beauty;
> only be pious, as was the Greek!
> Love the Gods and think kindly of mortals!
> Hate drunkenness as you hate the frost, neither preach
> nor describe!
> If your master makes you fearful,
> ask great Nature for advice!

**To Kurt Becker*

Worpswede, Thursday, June 1899

My dear Brother,

It's evening again, another one of my beautiful evenings again. When they come, I feel as if the whole world were standing open before me. I sit down in my comfortable chair, the one you know; I don't think very much, and not too little either, but this little thought I think intensely, feel intensely, and am very quietly happy about being Paula Becker.

After I've indulged myself enough in these happy thoughts, it's time to choose how I'm going to bring my day to its conclusion. Should I read? Right now I'm in my Ibsen period. Since I place such great demands on my feelings when I'm working, Ibsen, who in great part must be absorbed through the intellect, is just the right prescription to conclude the day with. He interests me very much. So far I've read *Hedda Gabler*, *Lady Inger of Östrat*, and *The Wild Duck* (the one that always makes me think of Aunt Cora), you know, the play about being robbed of the illusions that seem necessary for life. I believe that I learn a great deal from reading, especially the way to observe people, and that eventually this has its effect on my art. I have a rather good knowledge of human nature, but also a tendency to idealize, probably through Mother's influence. The close union I have

with nature has convinced me, however, that naturalism is the only true approach, if only because naturalism assumes and demands a much greater diversity of individual types, something that is impossible in idealism. Idealism generalizes. I used to do that, too. I think the most important bit of progress this winter is the fact that I don't do it anymore, or at least that I have the will not to do it anymore. A great deal more clarity has come into my work. And that makes me happy.

But I'm still thinking about what I want to do with my lovely evening. Should I perhaps go visit one of the splendid people here? Slowly but surely the rough edges between us are getting smoother. We are beginning to find what they call in this area "contacts." One has "contacts" with one another. Recently I've found a few with Modersohn. I have many of them with Fräulein Westoff [*sic*] and with Frau Bock. We like each other, and esteem each other, and learn much from each other. I've come to like the rapport that has developed among us very much. There's something serious and something grand in it, fine, earnest conversations about art with Heinrich Vogeler, who is the fourth in our little union, or the simple pleasure of an evening bonfire and the sound of mandolins on the Lartusberg [?]; or a boat ride with Chinese lanterns against the blue evening sky. There are two new stars in our constellation. Number 1: Dr. Carl Hauptmann, the brother of Gerhart Hauptmann, also a writer, has come here to work. I've observed him being very open in a conversation with Modersohn. He's a fine human being. And once I saw him very close up in a larger social gathering. I very much look forward to seeing more of him. Number 2: Dr. Büttner, a Mystic; we three little women still have no opinion of him since he even seems to keep us in the dark about his mysticism. But he must have something because Dr. Hauptmann sent for him and uses him as an adviser for his own work.

Or should I do some etching? It's such a great joy to slowly, slowly discover my way into this art form. Right now I'm working on a plate of another old woman, this time with enormous hands dangling from her short arms.

So that's the way my evenings are spent. And during the day I work, doing a great deal of life drawing. In a few months Mackensen is going to let us work by ourselves. Then I'll probably begin painting. All over again, from the very beginning. But I believe that I'm going to make something of myself, and he, at least, is becoming more and more certain of it. And that gives me an inner happiness, which naturally does not guarantee there will be no black and gloomy times.

Farewell for today. I've got to go to sleep and collect a little strength for tomorrow.

In sisterly love,

Your Paula

*To Marie Hill

Worpswede, Wednesday, June 1899

Dearest,

Why do you tempt me? I really *cannot*. It's *impossible*. *"Be happy?"* The only thought I have in my mind now is to immerse myself in my art, to merge completely with it until I can begin to express what I really feel—and after that to be consumed *even* more by it. Even if I wanted to, I could not leave here. Or maybe I should say that I am unable even to *want* to leave. I couldn't bear it down there in the Alps, in spite of your company and in spite of the mountains. It's not ingratitude. I was excited by the thought of being together with you for so long; we really need something like that. And the sweet way in which you thought out the whole plan! It warmed my heart, but I really didn't hesitate for a moment. I knew all along that I couldn't do it. The only traveling I'm willing to treat myself to is a week in Dresden where I can visit Uncle Arthur and Aunt Gretel and see the exhibition. Aside from that, I want to live here. I want to *live*—and develop further as a person and as an artist. I'm getting closer to all these fine people and feel that I'm learning a great deal from them. I want to strive to make of myself the best I possibly can. I know it's egotistic but it's an egotism that is great and noble and that subjects itself to the one big cause in my life. That's the way it is with me. Can you understand this? I think you can. And do you approve? I hope so. In any case, I can't do anything different, and I don't want to do anything different. I feel energetic and happy, and I work, work, work, so that I won't neglect my obligation to my own destiny. And, after all, what could be more beautiful.

Farewell. Have a restful time in your beloved mountains. Enjoy your holiday as much as you can. And please believe how happy your love makes me and how it honors me, even if right now I'm unable to think much about accepting love or doling out my own. "Only one thing is needful."

Your Paula

*To Marie Hill

Worpswede, June 1899

My dear Aunt Marie,

Did you receive my second letter? I wrote it on the other half of my last piece of stationery. And since beggars can't be choosers, that's why I am writing you now on this nasty scrap of paper. My pretty blond landlady is convinced that I put that second letter to you into the stove instead of the mailbox. So, for precaution's sake, I'm sending you this duplicate which I will safeguard with all my maternal instincts.

I think it would be wonderful to go on a walking tour with you in the Alps for two weeks. For a backwoodsman like me, two weeks seems a gigantic treat. But

isn't it, in fact, a bit short considering the long journey we have to make to get there?

I keep on thinking that you ought to be able to find a better traveling companion, someone more cheerful. I don't know whether I'll have a happy effect on you, even though I'm convinced that I'm happier and more cheerful than most people are. But after three weeks out in the great world, I will really want to get back to my beloved Worpswede.

I've just taken a long evening walk in the shadowy fields with the brilliant sky above. Now it is night, silence, with only the occasional sound of a dog barking. I'm quiet inside, and I'm now quietly going to bed.

With love,

Your Paula Becker

*To her mother

Worpswede, June 1899

My dear Mother,

I've been planning to write you for two days, and now at this late hour I finally have time. First, let me send you a kiss for your "gray one." When I got back Saturday evening at ten thirty from a long and beautiful expedition with my sketchbook, it was lying there on my Abruzzi blanket. As soon as I saw it, I thought of going into Bremen the next morning as a surprise, but I was afraid of the heat in the city. Instead, I spent a pleasant afternoon and evening with the Modersohns. I like him especially. Beyond his smile and beneath it there lies much that is fine and serious. She is a small woman with an intuition for things and people, and with good natural judgment and sensitivity. At ten in the evening Fräulein Westhoff came riding up on her bicycle and took me to the dance, the festivities following the *Schützenfest*. The two of us, Heinrich Vogeler, Dr. Carl Hauptmann, and the Mystic made up the group. Waltzing is so wonderful, but not with the Mystic.

This afternoon Fräulein Westhoff and I punted far up the Hamme, she doing all the work. We picked golden iris, swam, felt blissful floating in the liquid element, and stuck yellow water lilies in our hair.

I have the skeleton with me now in my atelier and study it a great deal, since my grasp of anatomy is still pretty weak. I'm doing etchings, and drawing outside a lot, and reading.

Milly's letters take me back to last year. I can hardly believe that only one year has passed since my trip. The time in between seems so much longer and fuller to me. I think that must come from intense living.

Worpswede, July 8, 1899

My dear Aunt Marie,

Your sweet little letter opened up golden prospects for me. From where I sit here, it seems strange that all the things you write about actually exist. At present the whole world outside Worpswede lies shrouded in a veil of mist, as far as I'm concerned. But now with your letter at hand, little towers and great battlements and mountains rise up all at once.

Am I supposed to choose between staying in the Engadine and a general tour? Both of them seem so wonderful that it will be very hard to make a choice. Is one really just as good for you as the other? Personally, I think that an open-ticket tour would be better for me. I mean, better for my character which, at least to judge from the way I feel now, might otherwise stay a little too North German and solemn, a bit ponderous and awkward in one place. It seems to me, perhaps, that a little bit of bouncing hither and yon would be a good cure for me. After my quiet life here, two weeks of new impressions might seem more like eight and have the equivalent effect on me. Or do you think, perhaps, that staying in the Engadine would be better for Father? I still hope so much that he can join us.

A day in Munich is a dream. And I should also love to spend a day in Nuremberg so that I can finally get a real feeling for Dürer, for he is one artist of whom one can never see too much.

By the way, I've made up my mind to travel fourth class. I know the local trains around here and have already traveled twice on them, out of necessity. So now I don't see why I shouldn't choose fourth class of my own accord. The people in fourth seem to me to be just as proper and elegant, or inelegant, as in third class. Besides that, it's interesting to hear the constantly changing dialect of the people as one gets farther from home.

*Journal
[Written during the summer trip with Aunt Marie and W.D. through Switzerland.]

[Undated]

Am I not a little girl,
Walking through the fields of spring?
Am I not a little girl,
Whom good fortune is embracing?
I am glad that flowers grow,
And that the fleecy clouds can flow.
I am so totally contented,

Good alone seems for me destined.
I know that at the gardens' edges,
Good fortune lies amidst the hedges.

To her parents

Worpswede, September 10, 1899

You dear People,

Here I sit in my beloved little nest again, working hard and thinking of the past and of things to come, of all the future holds. I think it did me good to see things from the outside for once, and not always from the inside. I mean, from inside our little village with all its goings-on.

I'm now confronting both the bright and the dark sides of my present life with a good deal more awareness, both what happens inside me and outside. And that is progress.

When I returned, I found that a great deal had changed. The lighthearted crowd seems to have moved in. A good number of lady painters have arrived on our hilltop, while the regular inhabitants all seem to be off on trips—Mackensen, Modersohn, Vogeler. But I really see nothing of other people. I'm trying to dig my way back again into my work. One absolutely has to dedicate oneself, every bit of oneself, to the *one* inescapable thing. That's the only way to get somewhere and to become something. I've made use of the beautiful weather to sketch and paint outside. I had been staying away from color for such a long time that it had become something quite foreign to me. Working in color was always a great joy to me. And now it *is* a great joy again. Still, I have to battle with it, wrestle with it, with all my strength. And sometimes that's not so easy, a battle one has to fight all by oneself. And one must be victorious. But if it weren't for the fight, all the beauty of it wouldn't exist at all, would it?

I'm writing this mostly for Mother who, I believe, thinks my whole life is one constant act of egotistic ecstasy.

But devotion to art also involves something unselfish. Some people give their lives to others, and some give their lives to an idea. Does that mean that the former are to be praised and the latter blamed? People must do what nature demands of them. Excuse this defensive letter of mine. It comes from an instinct for self-preservation. [...]

To Milly Becker

<div align="right">Sunday [September 1899]</div>

Dear Milly,

[...] I often have sudden memories of my girlhood these days. A noise woke me up this morning, for example, and I thought I was still in the old family house on the Chaussee, in our bedroom with the wisteria wallpaper. The noise was exactly like those creaking sounds you and I used to hear every time someone opened or shut the door into our little three-cornered room. I had the feeling that Papa was about to appear in our doorway and wake us up. But he didn't. Then I realized that I was lying in my little snug, white room, a good six leagues further on in my life.

I'm still constantly hard at work. Modersohn was here the other day. He said so many good things about my work that it was hard to believe it was my own. It was lovely. Modersohn's opinion, more than anyone's, is worth a great deal to me. Afterward, however, one gets a little frightened by the possibility of delusions of grandeur. Well, I'll tell you more about that when I see you. It makes me happy most of all because of our parents. As for me, I've already received my share of happiness.

To Milly Becker

<div align="right">Worpswede, September 21, 1899</div>

Dear Sister,

A word before I go to sleep. I've just come back from a walk in the moonlight. It was very beautiful. Is the fall just as beautiful for you on the Weser?

I'm going through a strange period now. Maybe the most serious of all my short life. I can see that my goals are becoming more and more remote from those of the family, and that you and they will be less and less inclined to approve of them. And in spite of it all, I must pursue them. I feel that everybody is going to be shocked by me. And still I must go on. I must not retreat. I struggle forward, just as all of you do, but I'm doing it within my own mind, my own skin, and in the way I think is right.

I'm a little frightened by my loneliness in my unguarded hours. But perhaps those are the very hours that help me along toward my goal. You needn't show this letter to our parents. It's an attack of despondency which is really best left undiscussed. In case Ernst Horneffer comes to Bremen, please let me know right away. I could discuss a number of things with him. I think he's an ethical person.

October 22, 1899

When I awaken in the middle of the night, and when I get up in the morning, I feel as if something beautiful and dreamlike hovers over me. And then it simply turns out to be life standing before me with its beautiful arms outstretched for me to fly into.

*To her mother

Worpswede, November 10, 1899

Dear Mother,

I want to repeat what I could only shout to you from the omnibus: please don't worry about me, dear! There is really no need to, none at all, dear Mother. I have such a firm desire and determination to make something of myself, something that won't have to be afraid of the sunshine and something that will shed a little light itself. I am tremendously determined and this determination will amount to something. Please, please let it struggle where it must go; it cannot do otherwise. Don't try to change it because that only makes it sad and gives my heart and tongue a harshness which is painful. Be patient, wait for yet a while. Don't I have to wait, too? Wait, wait, and struggle? That's the only thing that such a poor little person can do: to live the way that its conscience says is right. We cannot live any other way. To realize that the people closest to us disapprove of our actions is the source of great sadness. But we *must* remain ourselves, we *must*, in order to have the self-respect we need to live this life with happiness and pride.

Those are some of the solemn minor chords that resound from the distance through the jubilant major key of my life. May this jubilation be the stronger and the festival of my life be greater than the minor key — so that a resounding harmony can sing out, a harmony that is more alive than the world's false smiles I see passing over tired lips and exhausted hearts. I'm still young and I feel strength in myself, and I love this youth and this life too much ever to give them up for that joyless smile.

Just wait a little while. Everything must turn out all right.

*To her parents

Worpswede, November 15, 1899

[...] I go on living my life. There is not really much to write about it. The things I would describe are all those small details that have little to do with life. And I surely do not want to write about life's great and living soul or about art. It is much too fine to do that to it. And so the point of this letter is simply to assure you that I'm still your old Paula, even if a new Paula is on her way. And if this new Paula doesn't please you, take consolation in the thought that there will soon be a

time when the new Paula will be replaced by an even newer one. They come and go like the seasons outside. And it's impossible to tell which season is the best. It's also impossible to leave one out. Whoever loves the spring must calmly wait a year until the next spring comes. The old earth always remains the same. And so it is with each of its little people. The important thing is to be able to wait. I believe that half our happiness is in being able to wait. I'm not sure of that, but it seems to me true, since I really have that ability to wait more than many another: I have love, softness, radiance, a shining clarity at the bottom of my soul. Laughter, you see, is not the same as happiness. Nor is speech. But that is probably different with every person. It's simply that the dear Lord, or whoever else it might be, made me like that—end to the *affaire*!!! [...]

Review from the Weser-Zeitung *(Bremen)*
No. 19073, p. 2, Wednesday, December 20, 1899
A. F[itger], "News of the Kunsthalle"

Unfortunately we must begin today's notices with an expression of deep regret at the fact that such unqualified work as the so-called studies of Marie Bock and Paula Boecker [*sic*] has succeeded in finding its way into the exhibition rooms of our Kunsthalle; indeed, that an entire section has been put at their disposal, a section from which treasures in our permanent collection that one is accustomed to seeing there were removed. That something like this could be possible is most regrettable. The vocabulary of pure speech is not adequate to discuss the work of the two above-named ladies, and we are reluctant to make use of impure speech. If a similar capacity for work in the realm of music or theater had had the audacity to venture into the concert hall or onto the stage, a storm of hissing and whistling would have instantly put an end to such coarse nonsense. One does not hiss or whistle in the Kunsthalle, and thus it is all the more the duty of a critic to speak clearly. We are fully aware that it is always our duty, and most particularly at this moment, to apply considerate and thoughtful formulae and never to take recourse to those expressions that would most closely correspond to our outrage. Confronted, however, with work like this—and since it is not extracted with the modest blush of a primitive beginner from its hiding place in a portfolio and laid before a teacher or adviser, but instead now covers the walls of two rooms in all its demanding bulk as objects for exhibition—we cannot spare our sharpest words of rejection.

If one has had the misfortune of having to listen to some repulsive story told by an uncouth person, one does not wish to consider eating or drinking for a long time. Likewise, the thought of our Kunsthalle has become so repugnant at this time that we were unable to suppress the lively desire to rid our minds of it as soon as possible and turn our attention to something more edifying. In the same sense,

however, our desire to deal with the extraordinarily rich exhibition of drawings by Hans Thoma was thoroughly spoiled. Involuntarily the question arose: what is the point of anyone's still being a richly gifted artist of the good old solid school, whose inexhaustible imagination (even if it occasionally drifts off into lack of taste) nevertheless has enriched the true art treasury of the German people with costly gifts, whose hand (even if on occasion his hand fails him) nevertheless does so clearly and vigorously what its lord and master wants it to—we ask: why then does one bother to be one of our good or, indeed, one of our best artists, when at the same time such wretched lack of talent is permitted to spread itself over wall after wall [in our museum]?

He who has been seasick looks upon the first square meter of terra firma as a paradise; and so, too, even we were brought to that point after turning our backs on that exhibition room, of declaring any other painting, even if it might be the most commonplace landscape, as a masterpiece. Thus, in order to obviate any such injustice, we wish to confine ourselves only to a very few remarks that we had previously set down in our notebook. Gripping in the mood and atmosphere that gave it birth, but in its artistic qualities more ugly than beautiful, is the great triptych by Count Kalckreuth, the pessimistic elegy on the difficult labor of human life. A breath of *Germinal* wafts over these three pictures; we admit that life does have such hard, gray, joyless, ugly periods, but a *great* artist elevates hideous reality as he himself rises into Olympian heights and suffuses them there with immortal tragedy. Where the former is satisfied by a Maheude, the latter creates a true Hecuba. That a painting has given me cause to indulge in such a diversion is testimony to the depth of Kalckreuth's perception. [...]

Particularly to be recommended is *The Alsatian Mill* by Franz Hoch, a beautiful, solemnly harmonic painting; and we wish to express our jubilation at the little beach scene by Bochmann: what accuracy, what refinement and truth! An objective, serene representation of things as they are without any subjective poetry in oils, a proof of the heart-cheering power of the painter when he is all painter and nothing but painter and attempts to burst in upon the realm of neither the philosopher nor the poet nor the historian nor the representative of any other discipline which has either nothing at all, or only very little, to do with painting. Thus did the old Netherlanders paint their immortal little panels, and thus, too, *mutatis mutandis*, did all those painters who created immortality paint their pictures. First and foremost, painting! First and foremost, the objective fulfillment of the law! Whatever then of prophetic divine revelation was added to the picture was a matter of loftier, subjective idiosyncrasy. But to begin with lawless subjectivity— that has never yet entered the mind of a great artist. This unassailable truth we should like most particularly to draw to the attention of the very productive and imaginative and technically gifted Hendrich; this law should find a firmer foundation in his work, and then the figures of his imagination would become more believable. See Böcklin! [...]

Review from the Courier *(Bremen)*
December 24, 1899
Carl Vinnen, "Harmless Marginalia to Fitger's Art Criticism"

Whoever has learned to value a newspaper on long winter evenings in the country will be able to sense with the author of these lines the cozy feeling with which he again found one of Mr. Fitger's reviews in issue no. 19073 of the *Weser-Zeitung*.

After reading the many terrifying war dispatches, it does one good to stroll peacefully in the realms of art under the guidance of an experienced aesthete. But it was with a vivid sense of regret that we discovered that Herr Fitger, too, had brought out his big artillery, so that even here it was at first not possible to enjoy anything in peace. And for whom was this Olympian thunder meant, at whom was this artillery of violent rage aimed, what enemy of art had dared to raise its wicked head under the very eyes of the great knight defenders of the old? Alas, it was only two young women pupils from Worpswede, whose entire crime consisted of exhibiting below-average and immature schoolwork and for whom—which only exacerbated the problem—the administration of the Kunsthalle had chivalrously set aside one of their side galleries. The poor Worpswede ladies! Quite recently our compatriot Fräulein Westhoff also had the misfortune of being reprimanded for the very work about which Max Klinger in Dresden, in the presence of the author of these lines, not only expressed himself in the most glowing terms, but which also convinced him to accept her as his student. May we hope that this recognition might compensate her at least a little for the reception she was given in her own native city. It seems to us, however, who always read the reviews in the *Weser-Zeitung* with honest pleasure, that this new case in particular is probably worth some consideration. Whoever has had as much experience as an art critic as Herr Arthur Fitger really ought to know that inferior student work (and we do admit that we, too, do not evaluate this questionable exhibition any higher) is encountered all too often and almost everywhere. A retrospective glance at the history of our Kunstverein [Art Society] will remind him that, in general, we have not been particularly spoiled by the work of local women artists. Why then suddenly this ferocious attack which goes far beyond all the bounds of objective criticism? If we might interpret this zeal as an oblique recognition of the fact that, since the new directorship, the artistic level of exhibitions has so improved that immature work like the present can call forth such a revolution in the temper of a friend of ours, then that would be in itself a promising symptom. I speak of the zeal as such, but not of the way in which it makes itself felt; it is precisely this that compels us for this first and we hope only time to abandon that reserve which we commonly exercise vis-à-vis an artist of criticism. [. . .]

We personally are just as removed from this sort of work as Herr Fitger himself; only we do happen to know that both exhibitors have remained true to their study with great and serious devotion and also by renouncing the amenities of life in the

city throughout this winter. These honest intentions do not guarantee a higher evaluation of their work, but serious perseverance might triumph over failure. And if the fact that it is a modernist who is Fitger's opponent in this affair has made it appear to many, and perhaps to Herr Fitger himself, that all this rhetoric is a mere *oratio pro domo*—then no matter! The impartial person will perhaps recognize that the artist, too, has a certain claim to what we generally call proper social conduct vis-à-vis the critic. And should perhaps these lines move Herr Fitger in the future to accommodate his feelings, or at least his expression of them, to the demands of common social parlance, then he would again make feasible, perhaps for many but certainly for the author of these lines, the unclouded pleasure in the reading of his reviews.

To Paula from Maidli Parizot

Vienna, December 27, 1899

[...] Just now your letter to Mama has arrived in which you speak of your upcoming trip to Paris. [...] How happy I am for you that your dearest wish could come true. Your stay there will be of incalculable value to you. Of course, a year would be better than three or four months, but Carl Bernewitz was there for only three weeks and insists, despite that, that he was enormously stimulated. Much luck on your trip! You know that I believe in you because you have the firm will to achieve things through force and struggle. [...]

To Otto Modersohn

Bremen, Wachtstrasse 43, December 30, 1899

Dear Mr. Modersohn,

I am returning your Pauli lecture to you with many thanks. Reading it in Lilienthal during the half hour I had to wait for the omnibus shortened the time most agreeably. New Year's Eve, at half-past one, I begin the great journey. That will be a lovely little moment when I shake the dust of Bremen from my feet. Hurrah! Right now my poor head is in chaos: packing, saying adieu, talking about Fitger!!!, my plans in Paris, and Mozart arias which my sister is singing in this very room. And so for now, very happy New Year's greetings to you and your dear wife. And in the new century when I am in Paris, the great pit of sin, I shall often think of your sweet and peaceful little house, and not only in connection with Jules Dupré and the candelabra. [...] So, once more, looking very much forward to seeing you again.

Your Paula Becker

The Weser is thawing. One can see again the living water and no longer the dead ice.

1900

If we consider the year 1892–93, the year in which she took her first painting lessons, as the beginning of Paula Becker's artistic development, then 1900 marks the midpoint of the brief career granted to her. It is a year of decisive steps and of fulfillment, and the fact that such decisiveness and fulfillment are in harmony with each other gives it its splendor. She herself will later call it the year of hope (April 2, 1902).

What Paris meant to her and how her stay there benefited her is told in the letters. She was silent about only one experience, her trip to the art dealer Vollard on the rue Laffitte. One day she took her friend Clara Westhoff to the gallery to show her what she had discovered there on previous visits: pictures by Cézanne, which had made such a strong impression on her and in which she found something of what she herself was striving for. In the letters and journals she permits this extremely important Cézanne experience to retreat behind her enthusiasm for Charles Cottet, whose native Breton art allowed her to go on living in a Worpswede ambience, while Cézanne forced her away from it. She probably did not as yet feel strong enough to follow this call. In her last letter to Clara Rilke-Westhoff in October 1907 she reminded her friend of that trip to Vollard together in 1900, and Clara later set the event down in words.

Other things are confided to Paula's Paris journal; it is here that she talks about the "kindred soul" she seeks. The phrase is borrowed from Marie Bashkirtsev, whose remembered image probably accompanied Paula through Paris—the sister soul, the Thou that unites itself with the I, the fundamentally sympathetic, understanding Other. Clara Westhoff was close to her, but her desire for the human being who would understand her as an artist was now united with the anticipation of fulfillment as a woman with a man. Heretofore there is no trace in the letters and journals of a relationship with a man; at most there is an occasional suggestion of a little social flirtation. That is surprising, for the erotic element in her was in no sense stunted. In 1901 Otto Modersohn writes in his journal that before her union with him she had always laughed at men and not taken them seriously. This type of behavior on her part hides, more than it expresses, her relationship to the opposite sex. Now, from Paris, the excess of feelings released by her impressions there is poured into the letters to Modersohn, the admired Worpswede master, which overflow with candor and spontaneity. It is not surprising that the human being in the artist was touched by so much girlish veneration. During the days when the Worpswede painters were in Paris for the World Exhibition—Modersohn, Vogeler, Overbeck, Frau Bock—the two of them were drawn together. One may say that the death of Helene Modersohn on June 14, 1900, spared them an ordeal.

Paula Becker returned to Worpswede at the end of June 1900, and moved into new quarters in the house of Hermann Brünjes in Ostendorf. It was her room there which was to remain forever her true home. She did not know how her life was to proceed now, for the three-year stipend from her uncle was already used up and no further aid was expected from her father. A letter from him alludes to Paula's plan to set up a handweaving shop together with Frau Bock which was to provide money for their livelihood, but the whole project evaporated. Because she had returned in a weakened condition from Paris, where she had probably fed herself on scant rations, and because the doctor had prescribed a rest, she was now granted a further period of indulgence, and again she allowed her little ship to go with the breeze. In July, fearing that she had a serious illness, she wrote in her journal of the possibility of an early death, adding in the same breath, "and if love should now blossom for me?" Otto Modersohn wrote later that he often visited her at the time and would read aloud in order to shorten her hours of recuperation. On September 12, 1900, because so little time had passed since the death of Helene Modersohn, they were engaged secretly. Paula Becker was twenty-four, Otto Modersohn was thirty-five. To the members of the artist colony that was almost the equivalent of a generation's difference.

Two weeks before this secret engagement, visitors had come to Worpswede, two poets of contrary natures: Carl Hauptmann, Otto Modersohn's friend and brother of Gerhart, the famous Silesian dramatist, and Rainer Maria Rilke, a guest of Heinrich Vogeler.

The former brotherhood of the Worpswede painters had long since slackened. There were tensions, little jealousies beneath the surface, and harsh but hidden criticisms of one another. Women had arrived who were not always compatible with each other and they accelerated this slackening of the bonds. Vogeler and Modersohn had drawn closer together, and at this time a circle was formed which felt itself to be so united that it called itself a "family": Modersohn and Paula Becker, Vogeler and Martha Schröder, Clara Westhoff; and a little on the periphery were Marie Bock and Paula's sister Milly. In this circle now appeared Hauptmann and Rilke. During this September the old Worpswede dream blossomed once more: a community of "us" such as the Romantics had once striven for. Vogeler's stylized Biedermeier house provided the frame for their meetings. Rilke's sensibility was heightened by association with the artists who had initiated him into their creative circle. What really inspired him, however, were the two women, Paula Becker and Clara Westhoff, who were receptive to the thoughts that he brought to them. If one reads his journal notes, it is clear that Paula made the stronger impression on him, and he may well have hoped to win her for himself. It was assumed by some that Paula Becker's decision was partly determined by the fact that Modersohn was in a better position to offer security than Rilke. However, completely apart from the course of events and from the strength of feeling which can be read in the letters and journals of Paula and Rilke, this as-

sumption is not valid since Paula Becker gave Otto her consent only a short time after Rilke's arrival. Her receptivity is simple to explain: nothing is more natural for a person who is borne along by happiness, but who must conceal this happiness, than to open herself to a third person, and for the latter to receive what the other is not yet permitted to receive in public. Nothing is more natural for a woman in her happiness than to show herself receptive to great thoughts, thoughts that are new to her, and to be prepared to think about religious questions, ultimate questions, that are expounded to her. These were new ideas that Rilke brought to Paula Becker, and he spoke about them to her in a language she had never heard before. Thus they enhanced each other. He wrote in his journal on September 16: "Then I was in the 'Lily atelier.' Tea was awaiting me. A good and pure communality in conversation and in silence. Evening came on wondrously; from it grew our words: about Tolstoy, about death, about Georges Rodenbach and Hauptmann's *Friedensfest*, about life and about beauty in all experience, about being able to die and wanting to die, about eternity and why we feel related to one another in the eternal. And about so many things that reached out beyond the hour and over us. Everything became mysterious. The clock struck much too late an hour and rang very loud and long in the midst of our conversation. Her hair was of Florentine gold. Her voice had folds like silk. I never saw her so slender and gentle in her white maidenhood."

Just as Paula Becker was carried along by her love, in the same way Rilke, still an uncertain seeker for his own identity, was carried along by the affection which was offered him. One can read in his Worpswede journal how he enjoyed the communal trip to Hamburg (to a performance of Carl Hauptmann's play, *Die Breite*), how he enjoyed the days there and himself as the center of the circle and as a spiritual benefactor. A serene and lofty feeling, such as occurs in rare moments of a beautiful union, must have filled these nine people (Rilke, Paula and Milly Becker, Clara Westhoff, Marie Bock, Otto Modersohn, Heinrich and Franz Vogeler, and Carl Hauptmann). Even the usually objective Modersohn wrote words of enthusiasm about this Hamburg excursion in his journal; he wished he could continue to have such stimulating experiences over and over again. They were all together in the Hamburg Kunsthalle where they raved about Böcklin; directly afterward they visited the private collection of the banker Behrens, where another Böcklin, this time a sleeping Diana and two eavesdropping fauns, occupied their attention, while Rilke was busy discovering Corot for himself. Again there is nothing about this to be found in Paula Becker's journals and letters—insofar as they still exist—with the exception of two tiny notes, one of which contains an amused and naughty jab at Rilke and which lets us see that the latter's solemnity, despite the friendship and admiration he enjoyed, also provoked their urge to laugh at him.

Despite that, a relationship between her and Rilke was formed in those September weeks which matured only years after both of them had found their way as artists

to their own style and form. Why it was that Rilke, who immediately after he had expressed his decision to spend the winter in Worpswede, left for Berlin and did not return cannot be answered. Between October and the end of the year 1900 there was a lively correspondence between Rilke and those in Worpswede, especially between Rilke and Paula Becker. It was to Berlin that she wrote him of her engagement.

On the train, January 1, 1900

You Dears,

One hour from Paris and my heart is full of anticipation. Time hasn't gone slowly for me despite the hour I gained when we had to set our watches back at the Belgian border.

From the time we all waved good-bye to each other, I began to think once more of each of you; I thought of the glow of the candles on the Christmas tree, then of the song we sang when the New Year was rung in. And then I slept the sleep of the righteous.

The sight of Cologne and the Rhine was enchanting. Unfortunately, I was shown out of the cathedral by a hardhearted sexton in red robes as I was delightedly studying the stone lacework and letting my gaze wander all about. When I asked him when the New Year's services were going to be over, this red angel with his fiery sword answered me laconically, "Tomorrow morning, five o'clock." So I began to look at the cathedral from the outside. One cannot help admiring it enormously, every refinement. But I must admit that its elegance did not speak to my heart. A few of the little early Gothic cathedrals that I saw this summer in Switzerland were much more to my liking.

From Cologne on I shared my ladies' compartment with a Mademoiselle Claire—at least that's the way she was addressed by a young man with Negroid features. For six hours the two of them were jabbering together about nothing. The whole time he stood in the doorway, but didn't dare to come in, probably because of my stern German glance. They turned out to be variety-show entertainers on their way home from a tour and were telling each other everything that they had been up to. When the wellspring of their conversation finally ran dry, she began singing in that peculiarly nasal voice of theirs, swaying with her body and making dancing motions with her hands and feet. She also managed to change her costume three times during our journey, etc.

In Belgium I thought of Meunier and Maeterlinck and about how the two of them had their roots here. The whole country seems to be sown with little red-and-white houses, all occupied by workers—Paris approaches.

So, here I am now, happily on my boulevard Raspail. So far I still have a horror of the big city, and a hideous feeling of being an ant stirs inside me. As I sat in the clattering carriage and the coachman kept on driving and driving, I was convinced I would have to spend the rest of my life traveling along in that bumpy carriage. But finally I landed. I was welcomed by a red-cheeked concierge in a black dress,

who impressed me right away by her humanity and warmth. Five narrow flights of stairs led me up to my little room. It is not much longer than a bed and about a bed and a half wide. Everything is covered with flower patterns and, at least by the light of my little paraffin candle, it doesn't seem to be too dirty.

Good night.

*Journal

[Undated]

I am in Paris. I departed on New Year's Eve. I listened to the New Year's bells from our dear old rooftop overlooking the Weser in Bremen. Then my family accompanied me in a great procession to the station. My trip lasted seventeen hours. And now I am living here in the bustle of this great city. Everything rushes and swirls around me in a damp and foggy atmosphere. It's filthy here, very filthy — an inward filth, way down deep inside. Sometimes it makes me shudder. It seems to me as if I needed more strength than I have to live here, a brutal strength. But I feel that only sometimes. At other times, I feel blissfully clear, and serene. I can feel a new world arising in me.

I should like to create pious figures with soft and blissful smiles, figures wandering through green fields, along riverbanks. Everything should be pious and good. And I *love* color. It must submit to me. And I *love* art. I kneel before it, and it must become mine. Everything around me glows with passion. Every day reveals a new red flower, glowing, scarlet red. Everyone around me carries them. Some wear them quietly hidden in their hearts. And they are like poppies just opening, of which one can see only here and there a hint of red petal peeking out from the green bud.

And others carry them in pale, soft hands, walking slowly in their trailing garments and keeping their gaze fixed on the ground. They are waiting for the wind that will come and bend their red flower, so that it will kiss the neighbor blossom and make the two flowers entwine in one flame.

And there are others. They swagger along with their heads held high. They strip the blossoms and break them, and go on their drunken way.

Which of these is life? the true life?

*To her parents

Paris, boulevard Raspail 203
January 4, 1900

I'm sitting at my French hearth! After I mailed my letter to you Monday I went to bed, rather exhausted from the train trip, only to be aroused from my sweet dreams

by a knock on the door. It was Clara Westhoff, and we talked until daybreak. She is so full of all kinds of news.

Later that morning, the Louvre. And in the afternoon, the Luxembourg. The nobility of Titian was a revelation to me. And two wonderful Botticellis are there. And for the first time I saw the work of Fiesole. So moving. He speaks to me so strongly. And Holbein's beautiful, solemn portraits. Down below in the sculpture collection, glorious examples from the early Renaissance — della Robbia, Donatello, and sweet polychrome Madonnas in bas-relief.

When one comes out of this colossal structure, the Louvre, one walks directly across the Seine and is captivated by an enchanting view, bathed in golden or blue mist. All along the quai there are row upon long row of secondhand bookstalls, where one can search and rummage as much as one wants to.

An acrobat performs on the sidewalk. A circle of spectators who do not take their eyes from him. Wherever one goes, whatever one does, there are things to see and learn.

Wonderful old two-wheeled carts with even older white horses tucked up in their short harnesses. Long, narrow beer carts, also with two wheels, but with three horses harnessed in tandem. Colossal omnibuses with three horses harnessed in troika.

Three Horses Harnessed in Tandem, *Paris, ca. 1906*

And the buildings! The Musée de Cluny on the boulevard St. Michel, an old Gothic building. Next to it, the ruins of a Roman bath. Everywhere one goes there are things to see that one can use. One must work constantly at them inside oneself. Because if one grows too tired and can't do it anymore, then one simply senses a great *dégoût*. For the world here is much, much, much too filthy. Hideous stench of absinthe, and faces like onions, and a depraved collection of women.

I have never had a higher opinion of us than I've had in the last few days. Up to now, I was clearly conscious only of our faults. But now I sense with all my might all the things we do have, and that makes me proud. Yesterday I heard a lecture on art history in the Sorbonne. The content was mediocre; I went to hear the language.

Instruction begins Monday. I need this week to collect and orient myself. Paris is perpetually playing forte on the piano of my nerves. I will first have to get accustomed to that.

The secondhand shops here are enough to make your heart sing! Every fourth building contains a jumble of interesting old objects. Every time I walk up to one, I am amazed all over again, and say to myself, like that little boy, "If I only had a leash, I'd attach my squirrel to it. If I only had a squirrel."

Eating is very expensive here. And the portions are extremely small, too. One can just manage to get one's fill for a franc. But since my school is only two minutes away, I'll mostly be able to enjoy the pleasures of my own domestic hearth. Everything tastes better to me on my own Olympus.

Clara Westhoff and I are next-door neighbors and we often dine together in intimate company. I've lighted my fireplace for the first time today. Supper and afterward an evening stroll on the grand Parisian boulevards. The Christmas fairs are still on, and of course the Parisian night life. [...]

To Paula from her father

Bremen, January 8, 1900

[...] At least for the beginning [of your stay] it is very good that you have found a sympathetic neighbor in Fräulein Westhoff and can spend your free time with her. But for the long run I would advise you to emancipate yourself from her. You ought to be in a completely new milieu, and so it is only to your advantage to rid yourself as far as possible from the whole Worpswede group and devote yourself completely to new impressions. You are permitting yourself, without noticing it, to be influenced by her stronger personality, and I do not think that is in keeping with your stay in Paris; at least it is not desirable. In my opinion your stay in Worpswede, where all of you were subjected only to reciprocal criticism, was a bit fatal for you because everyone entered into a kind of life that may perhaps

have been understandable among you "prophets" and even beautiful, but that for other mortals was just a little hard to digest. [...] All of you ended up with a kind of thinking and feeling that was flattering to your own personalities and any sensible perspective fell by the wayside. [...] It is as if you were growing in a hothouse, and so it is no wonder that you all become stunted, that you are not living a natural life, and that you will collapse in the slightest breeze. [...] The more you can shake off Worpswede and the less stock you put by that foolish word "modern," the more progress you will make. [...] Try to get the very best from your stay there. Don't work too much, for that is stultifying and people are not meant exclusively to study and learn but must also enjoy life so that they can continue to be fresh and receptive. Throw away all prejudices and do not look at the world with blinders. Life is ugly only to those who demand that the world accommodate itself to them, and not vice versa. Take in everything that is beautiful, and develop your feeling for form. That is where the French are superior to us. Beauty is in enjoyment. The little bloated bellies of your Worpswede models, at least, will be replaced by prettier ones at the painting academy. May you learn much from them. You will soon realize that these neutral and expressionless bodies in their refinement are much harder to capture than those bony and sinewy ones of yours, and that they have a charm which is revealed in their delicacy alone. And one more thing, dear child. Don't walk around in the boulevards too much at night. What you see there is not beautiful. Farewell. [...]

*To her parents

Paris, blvd. Raspail 203
January 11, 1900

Each of you at the round table gets a Sunday kiss from me, and you, dear Father, are to receive a very special one for your two long, dear, wonderful letters.

Milly will laugh, but I have to say it anyhow. I already feel as if I had been in Paris for months, because of the thousand impressions I've experienced here.

For me, the Louvre is the alpha and omega. One can immerse one's soul there to one's heart's content. And I do very often. That seems to me the only thing in Paris without a catch. Really, almost everything here has its barbs and hooks. One gradually gets accustomed, of course, to not seeing or feeling them, either involuntarily or by applying effort. But the barbs are there, assert themselves, and are determined to remain. Only the Louvre has none. Hallelujah!

On Monday classes begin at the Académie. Cola Rossi, with his black bangs falling over his brow, scooped up the tuition money and taught the nude model how to strike some kind of pose or other. Unfortunately all the models here are "posers." All of them have a half-dozen "positions" for which they gradually manage to find takers.

155

Everybody in the class works very hard. The critiques seem to be objective and good. One does not work life-size here, but in the same format as in Berlin. I hope to learn a great deal, particularly from the wonderful instruction in anatomy offered free at the École des Beaux-Arts. It will certainly improve my deficient familiarity with the human anatomy. Yesterday the knee was explained to us in an illuminating way, with the use of schematic blackboard drawings and laboratory specimens. We girls can get instruction like that only here.

I spent Sunday with Clara Westhoff at the Uhlemanns' in Joinville near Vincennes. They are an enormously interesting family, but they don't make a very cheerful impression. They are more like a play by Ibsen.

The mother is a widow, and completely deaf, and therefore she leads her own very separate life. When the others are having sophisticated conversations, she will interrupt with little naive questions. It's very touching. Then she will read the answers from our lips with eyes that life has rather sadly dulled. All the livelong day she is busy in the house. She cannot sit still, because if she does she is overcome with sadness and begins to cry. In the center of the family is the twenty-three-year-old son, Alexander Ular, a person of much talent. He speaks eight languages fluently and works for a newspaper. He has a liaison with a forty-year-old woman here in Paris. He is one of those who complain about everything and aren't content until they have picked everything apart. But underneath they all have that soft and childlike personality of which they are almost ashamed and which they rarely permit others to see. One can catch it in their eyes sooner than anywhere else.

We also met a twenty-year-old daughter, precocious, intelligent, sober, but with a gloomy outlook on life.

And then Paula Uhlemann arrived this week; she studies music in Munich with Frau Erdmannsdörfer — and is very sensitive, almost bloodless. Clara Westhoff, with her healthy coloring and her gigantic size, made a very comical impression. Every time she moved, she either actually knocked a table or a chair over, or it seemed as if she were about to.

Joinville lies on the Marne, which rolls its yellow waters through tired, gloomy meadows. Along the banks, stern poplars. We saw it under a rainy sky. In clear blue air, the effect must be very much like Böcklin. But it rains all the time. The atmosphere here has something enormously picturesque about it, something that shrouds and veils all objects. That probably comes from the high humidity.

All in all, Paris puts me in a serious mood. There is so much sadness here, and the things that the Parisians seem to enjoy the most are the saddest things of all. I often long for a walk through my moors. Still, I'm having a fine time, absorbing everything, and progressing.

On Monday I'm going to move into a little room which I'll furnish myself, rather the way Mama makes furniture out of crates. Then I won't have to get angry any

longer with the houseman, who never tidies up my room until five in the afternoon. In my own little room I'll be able to do all of that myself.

We've also struck up an acquaintanceship with a few young men who are art students. But they are still not the right ones. They haven't got a really serious approach to art yet.

The street life has an incredible fascination. Women with colorful hats. Wonderful strong white horses hitched up to their carts and carriages. All sorts of vagabonds and picturesque rabble.

When my French gets better I am going to see Sarah Bernard [sic].

This letter has turned out a little confusing. Paris does that to me. There is a skin here, you know, which one can't grow into right away. It repels you for some time. I'm struggling with it. But I will not let thee go, except thou bless me.

<div align="right">Your Paula</div>

To Otto and Helene Modersohn
<div align="right">Paris, 9, rue Campagne Première
January 17, 1900</div>

Whenever I have felt most helpless here in Paris, I always let my thoughts wander back to Worpswede. That is always a splendid remedy. It disperses the chaos in me and brings a kind of gentle repose. Of course, Paris is wonderful, but one needs nerves, nerves, and more nerves—strong, fresh, and receptive nerves. To keep them under control in the face of these overpowering impressions here is not easy. That's why the people here are mostly so blasé, or at least look as if they are. For the moment they can be witty or lively, but that simple, deep, and great feeling that we have, that's something that they know little about. I have noticed that in their art, too. There they have no trouble producing fireworks, and have more esprit than they know what to do with and that tingling in their fingertips; but what they don't have is simplicity and depth. I don't think Paris allows one to really get to the very bottom of feelings. It is always offering new and beautiful things with full hands. Or am I to blame? I wonder if I am too slow and awkward in working out my separate impressions? I still don't know the answer myself. You probably think that I don't like it here? On the contrary, if Mammon has nothing against it, then I plan to stay here until long after spring, for it seems to me that one can learn wherever one goes and whatever one does here. The Louvre! The Louvre has me in its clutches. Every time I'm there rich blessings rain down upon me. I am coming to understand Titian more and more and learning to love him. And then there is Botticelli's sweet Madonna, with red roses behind her, standing against a blue-green sky. And Fiesole with his poignant little biblical stories, so simply told, often so glorious in their colors. I feel so well in this society of saints—and then the

Corots, Rousseaus, Millets that you told me about. There are wonderful pictures by Millet to be seen now at the art dealers'. The most beautiful one to me was of a man in a field who is putting on his jacket, painted against a brilliant evening sky. Well—and the Luxembourg—and then the air here! I have so often wished that you were here, Herr Modersohn, and really felt it to be an injustice for me to be seeing all of this, and not you. The air, when one walks across the bridges over the Seine! There seems to be a shimmering and mixing of subtle gray, yellow, and silver tones which completely shroud the branches of the trees. And the beautiful buildings are set off with a wonderful depth against this atmosphere. The gardens of the Luxembourg at twilight—oh, just twilight here! Once I was in Joinville on the outskirts of the city. The Marne flows nearby. It was a dreary day. The air grayish yellow, the water even more so, gloomy meadows and tall leafless poplars. The scene had a special charm about it—

And the street life! Every moment there is something new to see. Over there a fellow sits down on the ground and writes something in chalk on the pavement. Soon a crowd has gathered around him and he begins to pull their leg in a friendly way. Another time an acrobat performs his feats on the open street. And then almost every laborer digs into his pocket and throws him a sou. In the *crémerie* where I was eating today with all kinds of happy, friendly riffraff, an old man was singing *chansons* and accompanying himself on the guitar to the great delight of his audience who would join him in the refrain with laughing voices. Mornings I go to an academy (Cola Rossi). I have had some very fine critiques there, especially by Courtois, who has a fine feeling for *valeurs*. Collin, who does the more practical criticism at the start of each week, is more concerned with accuracy—

For two weeks I put up with the dirty housekeeping in a dirty atelier. But since last Sunday I have been living in a dollhouse atelier with my own furniture, i.e., one bench, one table, one chair. Everything else is made of boxes covered with cretonne. It must be grand to have money and to be able to furnish one's home here. There are so many fine secondhand shops here, and thousands of fine things. Often I get into a rage and then I go into the shops and ask what the things cost. After I've taken a good look around then I calm down and saunter away—

There are as many painters here as there are grains of sand on the beach. And among them one sees some fairly eccentric phenomena. When one is in a good mood, one can be amused by it all. But when one feels weak, one is easily overcome by the creeping malaise. "All humanity's misery lays hold of me." One sees so frightfully much misery here, much that is corrupt and degenerate. I do think that we Germans are better people.

And with this thought I close. Do excuse me if I run on so frightfully like this to you. You already are familiar with this weakness of mine. If you have the time it would make me *extremely* happy to receive a few lines from you. And so goodbye until spring, or fall or next spring.

Your Paula Becker

Clara Westhoff lives in the same house with me; she is doing over-lifesize sculpture here in Paris and sends her best regards.

If you have any plans at all to write to me sometime, then please do it on February 8. That, you see, is my birthday.

*To her father

<div align="right">Paris, 9, rue Campagne Première
January 18, 1900</div>

My dear Father,

Many thanks for your two long letters. Don't look at the world and me so darkly. You will feel far better, and so will the two of us poor abused people, if only we could be left with that little bit of rosy hue which does, in fact, exist. In the end, though, it doesn't make that much difference to us.

So you are upset by my recent move? As far as order is concerned, it's a step forward. The old *hôtel* furniture and carpets were worn and filthy beyond redemption. Where I am now everything is clean. Fairly empty, but pleasant. As to expense, both places are about the same.

It's almost like spring here now. I am sitting at an open window. Outside a friendly sun is shining. I am happy that we are being spared your cold weather, because the fireplaces here tend to tease much more than they actually warm us.

A few words about the Académie. Today I had my critique from Courtois. He hits the nail on the head, short and to the point. He has an eye for what I want and doesn't want to push me in another direction. I learned much from him today and am very happy. I have registered for a morning course in life drawing. At the beginning of each week Girardot and Collin come and criticize the accuracy of our work. Toward the end of the week, Courtois comes and criticizes primarily the more picturesque aspects of what we have done, our tonal values, etc. This double-teacher method here has proved to be successful; the Académie Julian also has this arrangement. And it's very agreeable to me, too.

In the afternoon there is a course in *croquis* also from the nude in which for two hours we draw models in four different poses. This is very instructive for understanding movement. Each of us pays a fee for this course every afternoon. That way we are not bound to it, and every so often can take a trip to the Louvre instead. The Old Masters there also do their part in helping me along.

I am taking different courses than Clara Westhoff is. In fact, my style of living is totally different from hers. Enough for today. Your two letters did depress me a little. They made you sound so thoroughly dissatisfied with me. I, too, can see no end to the whole thing. I must calmly follow my path, and when I get to where I can accomplish something, things will be better. None of you, to be sure, seems to have much faith in me. But I do.

Paris, 9, rue Campagne Première
January 22, 1900

Today I will concentrate on telling you all about the atelier. Not about fundamental ideas, about the seriousness of art, or about the work itself, but about all the little details. And there are many of them, much to laugh at, and much to be astonished about.

Well then: the rue de la Grande Chaumière is a little street with little houses. In two of them Cola Rossi has set up his atelier. He's king on this street.

Formerly a model, he is now the complete "gentleman." Dressed very smartly, and very chivalrous with the ladies, he strives to maintain the appearance of a *grandseigneur*. He is very like his father. The difference is that one can tell from looking at the latter that he has had a considerable acquaintance with the seamier side of life. The two of them seem to get along very well and to have been through a lot together.

The janitor of the building, who sees to it that the ateliers carry on in their now venerable filth and that the stoves burn badly, this same factotum, himself moldy, dirty, bent over, and sly as a fox, is called—Angelo.

Angelo is the good fairy who rules over everything here. It is he who first interviews the models. Most of the time he is being hexed by three or four charming little ladies so that he will put in a good word for them. With a smirk on his face, he goes along with everything.

And then there is the whole courtly array of students, male and female, but among them a remarkable lot of swindlers, too.

All in all, so many painters here in Paris look the way people used to think artists were supposed to look. Long hair, brown velvet suits, or wearing strange togas on the street, with enormous fluttering bow ties—altogether a rather remarkable bunch.

Even normal, sensible people, nonpainters, wear great black or dark blue capes whose hoods they pull over their heads when it rains. That looks nice. The same sort of outfit, only a little bit shorter, is also worn by the soldiers and the gendarmes.

Some of the female students are very good looking. Most of them do incredible things with their hair and have added all kinds of clever touches to their clothes. On the whole, the artwork here is rather poor. However, I have met a few nice and talented people.

My household runs along smoothly. Sundays, a *femme de ménage* gives the place a good scrubbing for thirty centimes. My maidenly and domestic virtues are thriving. Just about my first piece of equipment (actually, the first was my bed, and so, the second) was a broom. Dustcloths, dish towels, and polishing rags are in constant use, each according to its function.

I have discovered a *crémerie* where I eat with a great variety of simple folk.

The simple folk of Paris are really rather different from those at home, they're more like our own important people, at least in some respects. Well then, I am the poor little orphan among these sophisticates. But they are quite sweet with me, except sometimes they are inclined to make fairly ambiguous puns out of my French. I don't understand them, but I'm not letting it give me gray hairs.

One simply cannot let things turn one's hair gray here. There is such an incredible multitude of things going on everywhere. Soon one stops being astonished.

I have just now received your sweet letter, Father. Thank you so much for all the detailed news from home.

I have three teachers: Courtois, Collin, Girardot, who take turns with instruction. What you have heard is quite true. The professors here are not salaried. They teach in order to make a name for themselves and because they learn through teaching. Incidentally, this arrangement is just the sort of thing you would expect from a business genius like Cola Rossi. Every day I sense how much I am learning here. There is a great deal to be said for an academic approach to drawing.

I get enormous pleasure from looking at street life. There are many extraordinary individuals here who seem to worry neither about God nor the world around them, but who dress according to their fancy. For example, nearly every time I go to school, I walk by a sweet old man who is always wrapped in a brilliant purple quilt and has a dog of some curious breed on a leash.

In anatomy class we are now learning about the construction of muscles in the human body. Two live models and one cadaver are used for demonstration purposes. It's extremely interesting, but unfortunately the sight of the corpse never fails to give me a headache.

Everything is in such close proximity here: laughing faces, *amour*, *amour*, and wretched poverty. Whenever it gets to be a little too much for me, I pick up my guitar and play on it. It is the David to my own soul.

All the pensions and *chambres garnies* here are going up in price because of the Exposition, but not my little atelier. I'm very satisfied with it. Several times a day I am pleased by the big piece of sky I can see.

The only drawback is that certain neighbors make a terrible noise slamming doors, when we good middle-class people are supposed to be sound asleep. They jolt me out of my sweet dreams, a blow to my Achilles' heel.

At the atelier six languages are going all at once, enough to make one run away.

<div align="right">

Paris, 9, rue Campagne Première
January 29, 1900

</div>

I pray that life will become easier for you. At least not be quite so gray, so gray. I pray, too, that you will be able to rejoice in what you have, and that you will not keep longing for things that you do not have. These are only things you keep wishing for us children. But for that very reason you ought to stop because in our own way we are already happy enough. The little bit from the outside that could add to it is unimportant. It has nothing to do with true happiness. That is something each of us keeps quietly inside and which is there to warm us up when we come in from the great outdoors with cold feet. Some people have enough inner happiness to warm up others along with themselves. But that is nothing more than a gift they were born with. So, my dear, see to it that you get your feet warm, too. You need it. Let some of the warmth and sunlight of our love come through to you. Let peace into your soul. What is the good of advancing years without peace?

Here is a little kiss for you, dear Father, and please excuse my grandmotherly advice. It comes from my childlike heart.

I saw Notre Dame yesterday. What an experience! My Baedeker had not said very enthusiastic things about the cathedral, and so I went there somewhat blasé.

All at once, there it was before me — hovering over the golden waters of the Seine. The heavy humidity recently had darkened its stone. It stood there against the heavens, stern and solemn. In spite of its spires and peaks the whole effect is solid and enormous.

A service was being held inside. There were the most wonderful light and color effects through the green and warmly glowing red windows. A little monk in his colorful robes was hopping around, preaching against the Russian Orthodox Church and against us Protestant heretics. I find it more and more incredible that intelligent and honest people find anything at all in this kind of belief.

Then I devoted my afternoon to reading. I should love to know French well, because the people here are all so bright and witty.

There is such an enormous amount of esprit here that it sometimes stops my poor little peasant brain and tongue dead. And there is much esprit also in the art here. Simply the way they apply paint to canvas is extremely ingenious. But they do lack the fundamental, the deepest, and finest qualities. It's just that which I instinctively felt missing in *Cyrano de Bergerac*.

In two weeks there is to be a *concours* for a medal here at school. Placement will be awarded after this week's work. At the Académie Julian there are money prizes. Considering the financial situation of the students, that seems to me much more sensible.

For my birthday I'd like to have a book, *Wisdom and Destiny* by Maeterlinck.

You mustn't be suspicious of the title. It isn't anything "mystical" this time, but something quiet and comforting.

What you call my student housekeeping is really not bad at all. It is perfectly neat and orderly. Right now I have a bouquet of narcissus and mimosas on my table. Flowers are ridiculously cheap here. And necessary. All last week my delight was a lovely bunch of roses, eight of them for fifty centimes. One needs a little bit of real nature around one—the complexity and decay of the city constantly make me dizzy. My spirits are often restored by the sight of a dog or our big, long-tailed house cat. Now a quick supper, and then from seven to ten my evening drawing class.

Clara Westhoff and I are trying hard to ignore each other's existence as well as we can. We feel we must get our stimulation from very different sources sometimes.

I enclose a little sketch of a nude. As a contrast, it would be very interesting for you to bring down from the attic some of the nudes that I did in Berlin. You'll find that everything is now more where it ought to be, and that there is a lot more to what I am doing!

This Paris!!

To Paula from her father

Bremen, February 5, 1900

Dear Paula,

If one really wishes someone else well, then in my opinion the best thing to do is to let that person formulate his own wishes alone; for all wishes more or less are so very individual that they are probably appropriate enough for the person who puts them into words, but not adequate to the desires of the one they are meant for. I am all too aware of how different my feelings are from yours to be able to believe that my wishes could match your notion of what is desirable for you. And so I must be satisfied to give you a quiet kiss for your birthday and to ask the gods to be good to you, to keep you healthy, and to give you insight into everything that is good, right, and beautiful. What they consider good, right, and beautiful, however, I do not know, and I leave it to their superior wisdom. For my part, I am too old to completely reshape my views and my knowledge; so you must simply take me as I am and you must not demand that I be unfaithful to my lares and penates. But that ain't no reason to be enemies! Naturally I would prefer us to feel alike, for our thoughts to complement each other's, and for you to build on them from there. But as we all know, no one can jump out of his own skin, and he has to be served up as he is. Therefore, let us walk along side by side and not try to convince each other that we have found the philosophers' stone or have a private lease on truth. The more you come in contact with a variety of people, the more you will realize that the superior person will mature only together with another

one, the way a diamond can be polished only by other diamonds. And thus, my wish for you is that you get together with solid and capable people more and more and that you follow their example. Look here, it was altogether wrong for us to agree to your going to Worpswede. You, my dear Diamond, didn't land in the proper polishing shop. You were too hard for it and you got polished only on one side. That does not make you sparkle or shine. The more facets and angles a diamond is given, the more beautiful it becomes. It must, of course, sacrifice part of itself, but in the very act of doing that, of being prepared to sacrifice not only external but also internal parts of itself, that is what turns it into a true gem. Do you think your stay in Paris will help you along in this direction? [. . .] May you have much joy and may you be able to say: Life is beautiful and it is work that makes each day more beautiful and pleasurable. The rest of the family will be sending their own greetings. And so, *a dio!* Your old

<div align="right">Father</div>

To Paula from Otto Modersohn

<div align="right">Worpswede No. 17, February 7, 1900</div>

Dear Fräulein Becker,

How charming of you to sit down and sketch for us a little mood picture of Paris. It did give me a certain satisfaction to read that your thoughts occasionally flee the wild life of Babel on the Seine for the peace and quiet of our country life in the moorlands. [. . .] I wish I had answered you sooner and now I am almost afraid that my epistle will not be in your hands on the blessed "8th." Yesterday was a wild day and that's to blame. My studio had become so crammed with canvases that I finally had to clear out and straighten things up. [. . .] But now I've almost forgotten the point of the letter. For your birthday, dear Fräulein Becker, I wish from my heart all the best for your body and soul, for your life as an artist, and as a person. May you progress in Paris on the paths of art, and may you grow in the recognition of what is necessary, what is necessary for you. Getting things clear is the most important thing in getting ahead. From the perspective of Paris you must certainly see Worpswede with completely different eyes. It would be lovely if these clarified feelings would lead you back into the arms of Worpswede with renewed strength. Because (I have to tell you even though I hardly believe that it's necessary) because it really is beautiful in Worpswede. [. . .] I would like to be there with you and share your pleasures. Take a good hard look at everything and write it down and tell me about everything, and that way I'll have a little bit of it, too. Please write me sometime what pictures by Rembrandt are in the Louvre and which ones by Velázquez. I don't think that there are many special things there by R. If you stay and if we come to the World Exposition (perhaps in an extra train full of Worpsweders), you could offer us your services as a cicerone. But that is

not for a while yet. Are there perhaps paintings by Turner in the Louvre; what are their colors like? [. . .]

To her parents

Paris, 9, rue Campagne Première
February 8 [1900]

You Dears,

First of all, a quick kiss for each of you for remembering my birthday with your letters. It was so sweet having each of you with me that way and being able to talk to each of you. Dear Father, your letter was so beautiful. I read it slowly and in silence in my little green room, sometimes glancing up over the lines out into the sunlight with a feeling of gratitude in my heart for you and for your words. And from you, Mother, I have two lovely "gray" letters. Another kiss for them. And Sister Milly, and my dear Twins, to each of you an extra kiss, too. All morning, I was walking around in my studio as if you were there with me. I had all your letters in my hand. Milly, the notification about the five [marks]? Do you think you can manage it, my dear?

So then, another February 8 celebration. And so many letters!!! And then Clara Westhoff played a little lullaby for me on her Pan's flute at my chamber door. Then handed me a budding hyacinth in a pretty green bulb glass, an enormous orange, and an intoxicating bouquet of violets. We had coffee together. And this evening, after life-drawing class, the main celebration with half a bottle of champagne!!! This afternoon I bought myself the Knackfuss volume on Klinger. I thank you for that, too. This giant of a man overwhelms me again and sends shivers and sunlight through me. The reproductions in the Parisian folio make the effect twice as beautiful and grand and serious and intense. It is his earlier art that speaks to me most of all. There is the unbroken, unfalsified Klinger. I feel that he is now much too much under the influence of ancient art. He seems now to look at the world more with the objective eye of antiquity, whereas earlier he was so subjective and still his own special man. Ancient art leaves me cold. But in the Louvre, standing before the Venus de Milo, that was something else. That is a wonderful woman. And then, too, walking past the long rows of statues, I did find much else that was beautiful. But when my eye suddenly and unexpectedly fell upon a glorious fresco by Botticelli, an enormous weight was lifted from my heart. The Ancients oppress me with their icy objectivity. One cannot feel the personality coming through.

Well then, I ought to give you a complete description of my little room. I'm enclosing a plan of this enormous Paris, Mother. And yet it's strange; it doesn't seem so very big to me at all. One keeps meeting the same faces in the street, and when I return to the Latin Quarter I always get a very homey feeling. So: your child lives in the big atelier apartment, the rue Campagne Première, number 9, entrance

number 6 at the rear, four flights up, room 47. To the right, as soon as you come in, is a rather hard bed in which, however, I have grown accustomed to dreaming the most beautiful dreams. During the day the bed is chastely covered with Milly's red Abruzzi blanket. [End of fragment. The following is written in a margin.]

Even Grossmann has written me. Tell me, what is her address? ...Soon Milly will receive a letter of her own....I received such a beautiful, solemn letter from Maidli.

To Paula from her father

Bremen, February 12, 1900

Dear Paula,

Now that you have sent us the plan of your *buen retiro* I have something of an idea of where to picture you. A hideous building, gray and filthy—the wooden steps that lead up to your aerie are worn out and greasy. The indescribably sickly-sweet smell of a hospital accompanies me into the corridor. Finally in the semi-darkness I have discovered No. 47. I knock. *Entrez!* And here I am with my Fräulein daughter. Here things already look friendlier. The green room with all the little ornaments on the wall is most inviting. No place for me to sit, if you are in your armchair. Permit me to rest my poor limbs, weary from the climb, on your martyr's bed. Well then, many greetings from home and a nice how-do-you-do from everybody, and please do grant yourself a little more rest and take care of yourself. Do not be too stingy with the fuel, especially since it has now gotten cold again. Impractical fireplaces are fine for good circulation, but it seems that they are also made to give people colds. On the one side one roasts, on the other one freezes. And now the old influenza is going the rounds again. Be very careful not to do without the necessities. Who are your neighbors, and is there nobody in the whole building to lend you a hand and take care of the heavy housecleaning? It's not bad for you to polish your own boots sometimes, but if you could leave that to more accustomed hands, it wouldn't hurt either. And the same for scrubbing the floor.

How do you arrange your morning coffee or tea? Does someone bring you bread for breakfast or are you still used to day-old bread ever since Worpswede? In either case, don't spread the butter too thin or you will not get your necessary fuel. A piece of cheese or smoked meat or two eggs could not hurt, because you need that for your mornings. And now pretty yourself up a little before going out. A fresh ruche, clean white cuffs, and a coquettish bow lend a more refined appearance to one's looks, and since cleanliness is the only luxury that one can afford, you must above all see to it that you get hold of a good laundress. That is not easy in Paris. I can still remember how I used to swear at my gray shirt-fronts. So now put your hat on and we will take a little stroll together.

Careful going down the stairs. I recall one fine morning sliding off a slippery step

and finding myself one flight down with a few black-and-blue marks, and how my beautiful top hat (a Gibbon's English Guinea-Topper) rolled down into the court-yard. Oh! this damned new law of inertia; what a wretched fool gravity made of me! But what else could I do? I had to limp after my crazed headgear, found it cooled off in a puddle of water, and returned to my lofty garret in order to repair the damage done to the two of us. Since that time, I have had a horror of Parisian staircases and I advise you to learn from my experience. Now we go through the courtyard and a filthy corridor leading to the *première cour* and then through the *porte cochère* past the dragon of the house (the *portier's* wife) whom we naturally greet with reverence (*tirez le cordon, s'il vous plait*), and out into the street. Well, it doesn't look too lovely and clean here. It's still early in the day and one can still see the heaps of rubbish or *poubelles* in front of every house which have not yet been carted away. An awful, sour smell pursues us and we hurry on to the Lux-embourg. It is lovely there, even though the still bare trees only give a hint of the charms of the coming spring. [...] So, you do your landscape studies here in the Luxembourg? That is all well and good, but how would it be if, as soon as spring comes, you were to devote yourself to these studies under the supervision of a ca-pable painter? [...] If you plan to earn a living later by your paintbrush, then I still think that you will get more as a landscape painter than as a portraitist. [...]

To Milly Becker

<div align="right">Paris, 9, rue Campagne Première
February 29, 1900</div>

My dear Sister,
Today you get the first family letter, so kisses for everyone at the round table, members of the inner circle only, naturally.

Now a quick transition to the order of the day, because once again time is short. Last Sunday, Clara Westhoff and I took another fast jaunt to the country. At the Louvre we climbed into one of the steamers and boated up the Seine. Past the great Exposition Palace, which I got to see for the first time. When the steamer stopped, we disembarked and walked on along the riverbank. The region here has a special charm. Despite its closeness to the city, the landscape still has something un-touched about it. They don't have our devilish German compulsion for order. Finally our walk took us uphill, past hedgerows, to a beautiful, solemn church-yard gate. Then we stopped and had a merry chat with a Frenchman and his wife who were headed for the city with a cartload of cabbages. And then a cozy evening by the fireside, an evening that left me with cheerful, natural, and simple impres-sions. Here in Paris it's the simple and natural things that one has to seek out with a lantern more often than not. The cheerful offers itself to you every day, sponta-neously. Or perhaps it's really more frivolity than cheerfulness, something to help cross many a dark abyss.

My art is going well. I have a feeling of satisfaction about it. Afternoons I stroll around the city, taking a good look at everything and trying to absorb it all. Or else I work here in my little atelier. On my last stroll I saw many pictures but most of them seemed terribly sweet and poorly done. The best things are being kept aside for the Salon.

I went back to Notre Dame again. Such wonderful Gothic detailing, those monstrous gargoyles, each one with its own character and face. And spring scurries across everything. It's in bud in the quiet little churchyard where the old men sun themselves on benches. It laughs down at us from the blue sky and fat white clouds, a sky almost as beautiful as in Worpswede, just not as blue. It fills everyone's heart with laughter. Well, maybe not everyone's here in Paris. Directly behind Notre Dame, almost encircled by the Seine, lies the morgue. Day after day they fish corpses from the river there, people who didn't want to go on living, or sometimes someone who was robbed and thrown into the water. Under the colorful surface of this laughing city there lies a great deal that is black and horrible. I sometimes fear it will tear my heart to pieces.

But on the table before me are violets, breathing the springtime. It must be magical here in Paris when spring has really come and everything is green. I'll still be here when that happens. My purse will hold out long enough for that.

In the evening we have life-drawing classes with male models, and I'm not the only female present. Four or five girls, advanced in drawing, are there with me. One can learn more with others around. Better work gets done there. Besides, it's an interesting experience to see something of these little people. You don't have to be intimate with them right away; as you know, that's not my way.

Hatred of the English is very great here now. Wherever we go they taunt us the way a red cape taunts a bull, and shout, "Boer, Boer!" at us. As far as they're concerned, we're English, too. I don't like being confused with them at all. That nation is beginning to seem disagreeable to me. Wherever I can, I turn on my *allemand*—but the people still think I'm a fraud.

The people here know almost nothing of our German artists. I watched a few Frenchwomen recently looking at my Knackfuss volume on Klinger. His peculiar style seemed to amuse them. The only praise they could come up with was, "C'est joli." Whereupon I replied indignantly, "C'est beau, pas joli." But that was only wasting my ammunition. They didn't mean to insult him. They say "c'est joli" about their own artists, too, even about Rodin, etc. They simply have nothing more profound to say.

One simply must grow older and older, quieter and quieter, and finally create something.... Good night to you all.

Paris, 9, rue Campagne Première
February 29, 1900

Dear Frau Modersohn and Dear Herr Modersohn,

I'm finally getting to the letter [I owe you]. Here in Paris, you see, one "gets" to thousands of things and even that is only half of all the things one would like to do. So, as one of these thousand things, I shall immediately sit down and write you from my soul. First of all, many thanks for your dear letter on the "blessed 8th." It made me so *very* happy. I was filled with feelings about Worpswede. Now with the approach of spring, outside as well as within, I often find myself thinking how much purer it appears in Worpswede than it does here. Of course, one feels spring here, too, wherever one goes. But in this gigantic orchestra of Paris there are thousands of little violins playing, so it's difficult to hear the sound of one single instrument. That's the way I feel about spring, too.

Moreover, I'm surrounded by the fragrance of real violets (not to speak of the many artificial "violets," for most of them are very inartistic). Flowers here are one of the few aspects of nature that people cling to. And at that, they don't feel about flowers the way we Germans do, but think of them more as something that has a nice smell and a pretty color. We Germans are probably somewhat ponderous in our views, somewhat stolid, not nervous enough; but at least one can sense somewhere a warm heart beating. The only thing about these people that really speaks is their nerves. That appears everywhere in their art, in a fine and sometimes in a not so very fine way. And wherever it shows itself to be fine is where we Germans have much to learn from them. Very little new painting can be seen here now. The newest things are being held back for the Salon and for the Exposition. Of the things I have seen, I was *very* interested in a few figure studies in color by Bonnat, simple and profound in effect and magnificently held together. Then there is Degas; it would be nice to finally see something of him other than his ballerinas and his absinthe dens. It seems to me that he strives too hard for naïveté of line and that makes his work mannered. But he does indeed have the technique of an artist.

In several salons (a la Schulte), where one trips over the long gowns of elegant Paris, there were many things to be seen, much shallow, sweet, and bad stuff. But I keep thinking that somewhere hidden treasure must lie.

There is much beauty and depth in Puvis de Chavannes. He is someone who suddenly stands quite alone among others. Naturally all the older ones are wonderful, Rousseau, Corot, Daubigny, Millet, Courbet. Do you know Monet? I had heard his name in Germany. I saw a number of paintings by him recently. Even here the concept of nature seemed superficial. I would so like to have your opinion. In the Louvre there are only two things by Velázquez, two little blond Spanish princesses, in grayish white dresses overlaid with a dull rose color; colossally fine and contained in their hues. There are two fine little paintings by Rem-

brandt there: Christ with His disciples at Emmaus and a Holy Family. I don't believe Turner is represented there—

Now just a little about my life. Cola Rossi has his academy buildings on the little rue de la grande Chaumière, by which I mean small, ragged, dirty, comical barracks which nevertheless have a kind of poetry of their own in the form of a staircase all overgrown with wild grapevines, a real balustrade which one goes out to during the recess to get a little air, and portieres which fill us full of awe with their age and filth. After Julian, Cola Rossi has the best academy. He was formerly a model himself, but now plays the role of the *grandseigneur* and has his clothes made by the best tailor in town. He is a patron of the arts, of his professors, and of the students, or at least he acts as if he were. On most Mondays he wears a face that makes him look as if he were paying for something he did on Sunday, and that he probably does all week long as well.

In these hallowed halls I do life drawing, in the mornings with the "little women," and in the evenings with the "little men." One can also paint here. But that gives birth to such monstrosities that I can forgo painting without difficulty. It's all so thick and soupy, with attention paid only to the modeling. Among the women in the morning one sees much unkempt hair and unpolished boots, together with a few very clever heads and not much talent. They labor like beasts of the herd with little idea of what really matters. In the afternoons, I wander around and take a look at the world around me, or I work here in my own little green atelier. At seven o'clock in the evenings I'm with my "little men." With them things are even funnier. They are such comical figures! Not a single one of them, really, looks as sensible as the men at home. Velvet suits, long hair, in shirtsleeves, with towels used as neckties, and other peculiar attire. Such is the appearance of these budding artists. Gala performance: bombardment with bread crusts, crowing like roosters, caterwauling, and general good-natured horseplay. Many Yankees, many Spaniards, Englishmen, some Frenchmen, and Germans. The conversation of these gentlemen is often unusual. The point around which everything revolves is *elle*. Whenever one of them suddenly sighs during his work, someone immediately asks, "Est-elle gentille?" The fact that it is possible to sigh for, and about, something other than a "she," they either have not yet learned or have already forgotten. On the whole, better work is done here in the evenings, not with much understanding, to be sure, but more correctly than in the women's class. There is more health and strength behind what the men are doing. And what seems simply rowdy in the men immediately appears unattractive in the girls. We do have it harder, I think. *But in spite of everything, life is beautiful,* and I feel that I'm making real progress with my art and I'm happy. I'll stay here as long as I can. And then perhaps I'll be somewhat *accomplished.* And then I'll come back to Worpswede. For I can really feel here, so far away, how *very* much I love that place—

On Sundays, Clara Westhoff and I take little dashes to the country. How *very*

fine it is there. Hilly, and with tall bare poplar trees at the river's edge, soft earthy grass. That is, when the sky is cloudy. When the sun shines, the turf seems much too bright for me, and immediately I want all the colors to be deeper and more saturated, and I get very angry at all this brilliance. Sometimes I walk along the boulevards in the evening. There are many comical things to see there, things that one would hardly get to see in Worpswede. And now, finally, many thanks for the little church and the chocolate address. End of the epistle, and a hearty greeting from

<div align="right">Your Paula Becker</div>

I would love to have seen the pictures. When you have the time someday, Herr Modersohn, do write and tell me what you're painting now; all of that interests me very much. And Elsbeth as a great traveler.

Recently I saw Heinrich Vogeler at a window on the Weyerberg, another reminder of home.

To her parents
[Postcard]

<div align="right">[Postmarked Paris, March 1, 1900]</div>

Picture Puzzle/Solution
Your daughter with decoration. In the *concours* I won the medal.

* *To her parents*

<div align="right">[Ca. March 3, 1900]</div>

[...] So, I have a medal and am now a top dog in the school. All four professors voted for me. Of course, the medal has nothing to do with what I've learned so far or with what I still have to learn. That's much deeper. But I'm happy inside. I can feel that I'm stronger and I know now that I'll be able to get up and over the mountain. And when the mountain is behind me, I'll give it a little glance over my shoulder and say, "That wasn't easy." Of course, there will be new mountains in front of me, but that is what life is all about and that is what one has one's energy for.

How very grateful I am for this stay in Paris! It is really only a continuation of Worpswede: constant work and thinking about art. But new perspectives have opened up for me, completions and clarifications of what I've done in the past, and I feel that I'm getting somewhere. And spring is just about to arrive here.

*Postcard to her mother, March 1, 1900, showing self-portrait
of the artist with "the medal"*

By Clara Rilke-Westhoff
"A Recollection"

[...] One day she insisted that I accompany her on a walk to the Right Bank, so that she could show me something special there. She led me to the art dealer Vollard. And in his shop, since we were left to our own devices, she began to turn the pictures around that were standing against the wall, and to choose with great self-assurance a few of them that were of an altogether new simplicity and seemed to be close to her nature. They were pictures by Cézanne which we saw there for the first time. We did not even know his name. In her own way, Paula had discovered him and this discovery was an unexpected confirmation of her own artistic search. Later, I was surprised not to have found anything about this in her letters. Perhaps it was impossible for her to articulate these things in a comprehensible way—indeed, this experience was perhaps so inexpressible that it could only be transformed in her own work. [...]

**To her parents*

[Between March 18 and March 25, 1900]

[...] Awhile ago, spring came to every bush and shrub. It hovered in the air and nestled into people's hearts. The Parisians seem to have a real understanding for spring. When I came home from school at noon everyone on the street seemed quite happy. But now that's passed, and spring is hidden again under winter coats and furs.

But before it did, I was able to spend a sunny Sunday with Clara Westhoff in Joinville last week. The Marne flowed broad and grand in its bed and played around the feet of the ancient and stern giant poplars. But up in the branches the birds sang and twittered. Spring arrives here with an intoxicating profusion. It captivated us totally and we recited and sang all our dear old German songs of spring.

All along the riverbanks lie enchanted old gardens, with blueberried ivy spilling over their gray stone walls. In the greenery behind them one can catch glimpses of ivy-covered urns from the time of the Louis's. It has a startling effect, all this luxuriant wilderness so close to the great city.

Paris is just like its inhabitants. Along with endless corruption, there's a childish joy in living, in letting oneself go the way nature seems to like it best, without much concern about whether it is good or bad. We Germans could not put up with such behavior the way the French can. After such self-indulgence, we would perish from moralistic hangovers. But the people here seem to have no idea about such things. Each day they begin life anew. That, naturally, has its dark as well as its sunny sides. [...]

To Paula from Otto Modersohn

Worpswede, March 25, 1900

[...] You asked what I have to say about Monet. I do not like him. Monet is one of those who draw the ultimate consequences from Naturalism, I think, who paint outdoors with their watches in their hand, calculate precisely the shift [in illumination] by the hour and day, and then never paint longer than half an hour because the sun moves too much. It is an art which no matter how good in observation is completely external and leaves me totally cold. Puvis de Chavannes — that is a man made of different stuff; I would like to see things of his sometime. In general, I like to look at French art, old and new, even if in the long run it makes one return all the more emphatically to one's own work. For it is a great pleasure to be a German, to feel German, to think German. [...] How are you doing with your "chocolate pictures"? [...]

To Frau Marie Bock

Paris, 9, rue Campagne Première
April 8, 1900

Dear Frau Bock,

I hope you and the loom and the rug and Fräulein Höbel haven't been waiting for this letter. But life, you know, life! One simply doesn't get to letters today. And then, then when there is time, one has to take a rest from life and still cannot get to them. Today for once I have set aside a whole Sunday, have been looking at my Worpswede sketchbooks, and thinking about what I will be doing when I return home. And so I am in a fine, hopeful mood and have time for this letter.

Gooseboy with Flute, *a design for Stollwerck Chocolates, 1900*

Peasant Woman with Two Geese, *a design for Stollwerck Chocolates, 1900*

So once again (to get to a completely new subject): the rug. I also think it would be better to put a border around the leaves and apples. Only I believe that then the field has to be much darker so that the leaves and apples stand out brightly. If there is a much darker olive color, that would probably be the best. If not, we shall have to use a dark blue; but I believe the olive will do. You know I really still don't have the colors exactly in my head. Hence this vague answer.

The Salon has opened: a few, a very few good things, and much rubbish. I haven't seen it yet. But recently I did see a small private exhibition at Georges Petit, which was fine. Everything there had personality and stood all alone on its own two feet, and stood splendidly. Seeing something like that keeps one's head above water in these gloomy days.

I bought myself *Wisdom and Destiny* and have been reading it, as much as I have time for, for one's head is really always too occupied with thoughts and plans. And I am also not going to hold out much longer on such meager rations. I'm getting very ugly and skinny in the process as far as I can tell from looking in my little green mirror. Well, all that is only temporary.

The Exposition—there will still be some wonderful things to see there, and then I'm returning. Probably in June. By that time it will also be dusty and hideous and hot here. And the Worpsweders are not sending anything to the Exposition. If they did, it would let others see what they are up to. Klinger is not sending anything either. They gave him too little space. But Rodin, you know, he really is a giant. We saw photographs of things, of creations—they captured one's whole being with their greatness. Cl[ara] W[esthoff] also sends her best wishes. And you, dear Frau Bock, what are you doing? Write and tell me what you think about the world.

Your Paula Becker

To Paula from Heinrich Vogeler

[April 1900]

[...] Dear Fräulein Becker, believe me it's simply demoralizing here. The way people think here in general is not even human, everyone is separately turning into an eccentric. Their horizons are shrinking and they sit on their own sofas and anxiously protect their small-minded feelings. Moreover, everything has become disconsolate here. Worpswede is turning into a colony of separate houses. The Overbecks are the same as always and never share any of their secret, spiritual possessions. Am Ende skulks around, grumbling and saying hello in a gloomy way and—he's my neighbor. Modersohn is very nice but completely blind to the terrible condition of his poor wife. [...] Maybe I'll soon have to tie up my little bundle and trek into a distant valley where there are no people, for you're probably already thinking from reading above: just take a look at him, it's gotten to him, too, all that stuff about demoralization. Sometimes a bad thought attacks me and

I can't protect myself from it; that never happened to me among the other people, out there in life!

In spite of all this ill humor I am probably the most inflated of anyone here. I would simply like to lift the world off its hinges; I've turned into such a great braggart. Feel as exalted as a king. Had a few bad experiences in Munich, lost many old friends, and in my isolation I'm standing stronger and stronger on my own two feet. Maybe I'll still lose everything here, too, maybe just because of my only beloved — but what does that matter to me? I get all my strength through her. As long as this faith is not taken away from me, I'll go on living as an artist. But if this one were to crumble, too, then my time would be up. [...] Dear Fräulein Becker, it's really just a fluke that it's you who is getting this letter, but I just happened to be writing and have a lot more to get off my chest which I hope you will regard as absolutely holy. Not that you shouldn't speak to anyone about these things which are big and important to me, but one message for everybody who gets near me is: absolute respect for the best in me. [...]

And by the way, during the past years here you've changed enormously, for the better. You're so free of old-fashioned poetic trappings, and anyhow, never before could I have written you such a crazy letter from the kind of mood I'm in right now. [...]

To Heinrich Vogeler

Paris, 9, rue Campagne Première
April 12, 1900, Maundy Thursday

Dear Heinrich Vogeler,

There are one or two things that I have to say in answer to your letter. Even if you don't want to be bothered with letters at the moment, you will have to listen to this. And I mean to make it short. Well then, I was *very* pleased about your letter. First of all, about standing on your "own two feet." It's so good to see that one's neighbor is standing firm. That gives me such happy encouragement for growth. And my own two feet are growing, too. As a person I'm almost at the point of being able to stand alone; and my artistic feet, well, they must now grow like the lilies of the field. Their time is coming. I'm certain of that now—

Your life can become a good one, must be a good one, and will be a good one. Continue drawing your art from this pure and inexhaustible spring; keep what is deepest in you pure, those things that we have in common with children, and with the birds, and with the flowers. It's good that you have said what was on your mind, and I thank you for it. It's better to live in clarity and truth than in the darkness. A thousand other things remain dark. And where we can bring a little light, we should. This is a hard time for Frau Bock. But she will fight her way clear and get rid of her ugly feelings. And then she'll be one step further, and we who stand beside her will be happy for her. Be gentle to her. And another thing. Talk to Mo-

dersohn sometime on a human level. The man can use it and he's worth it. We don't know whether the man is completely blind to the awful things that must be affecting him. He has a pure, delicate, sensitive soul. In all his simplicity, there is something great. The self-control that he has about his wife is rare in men, I believe, and even among us women can really be found only in the old-fashioned ones, like my sister. The thought of Worpswede makes me sad. I can sense the heavy atmosphere. Nevertheless, I'm going to land there in the summer. Only I'll not be living in Worpswede, but half an hour away. I wonder if I, too, will be sitting on my sofa and protecting my small-minded feelings? I don't know, I hope not. I picture myself looking around with open eyes.

And now, a strong friendly handshake. Paint spring and love, to your heart's desire, freely and joyously. Last year I had a slight feeling that you were stubbornly following just one artistic idea. You are probably over that by now. Everything smells of spring rain and freshly plowed earth.

<div style="text-align: right">Your Paula Becker</div>

To Paula from Maidli Parizot

<div style="text-align: right">Vienna, April 12, 1900</div>

[...] And just now the Maeterlinck arrived. I'm not sure whether I should be happy—or whether I should also be concerned, when I think of the barley coffee which Paula Becker occasionally prepares as her luxurious dinner, and of the fireplace where there is not very often a fire, and of her lost sensitivity to the cold. But what's done is done, and so I kiss you and send you thanks. Milly has been sending me your letters. [...] You can tell that from the above. [...]

In the big painting exposition you'll see Klimt's *Philosophy.* It was the sensation of the winter here. You will be very enthusiastic about the painting in it, but please don't be enraged by its graphic subject matter. Maybe that's the way people look when they've been disfigured by illness and vice; nature does not create bodies like that; they are revolting. [...]

**To her parents*

<div style="text-align: right">Paris, 9, rue Campagne Première
April 13, 1900</div>

It's evening and time to stop work. I am sitting in my little room. In front of me in a green pot is a bouquet of dark pine and powerfully fragrant stock.

In the distance I hear the bustle of Paris. And now and then the singing of blackbirds and twittering of sparrows. The gentle evening sky with little cream-

colored clouds. And in the treetops which I can see from my window (from my lofty height I have a distant view) spring is hard at work. The spring I wrote you about a month ago stole away and hid itself from view. But now it's back, enrapturing the hearts of our city. Yesterday, Maundy Thursday, we listened to the first half of the *Saint Matthew Passion,* sitting on the hard steps of a sacristy. The many pillars between us and the choir made the music seem to be coming from far away, as if from another world. But at the same time there was a wonderful openness about it.

The Salon is open. The average is no better than that in the Munich Glass Palace. And among German exhibitions the Munich Glass Palace is no more than third best.

But the great Exposition will really have wonderful things. That will be a feast. It opens tomorrow and everything is in a fever of activity. So are the poor little sculptors' apprentices from the evening life-drawing class who are doing the stucco work.

Being here is good for me. Everything is more settled now, and I'm beginning to get an idea of the value of things.

We don't have any Easter holiday. The world here continues undeterred, and whoever wants to work on Sunday will always find a model available at the academies. I never do. That is one of the few Christian things I still observe.

My letter upset you? My dears, I'm not like that. But that is one of the characteristic aspects of Paris. That is what contributes to the great mixing pot. There is no such thing as pure gold here. To be able to accept this alloy for what it is, that is what is fine. To be strong enough to look the shortcomings of a friend and the defects of the universe frankly in the eye, the same way one looks at one's own faults, that is truth.

Rodin has set up a school for sculptors and Clara Westhoff has enrolled there. To be sure, she can only get one or two critiques a month from him. The rest of the time his own pupils come. But she's a person who learns under all conditions. When all's said and done, I'm not really very sure whether Paris is the right thing for her just now. To my way of thinking, she often seems too big and cumbersome, inwardly and outwardly. But she has such a powerful nature, too, the kind that seizes on everything that approaches her and unwittingly twists and turns it until she can make use of it. People like that can never be unhappy. Whatever happens to her will always turn out to her advantage.

Did my Easter bouquet arrive with at least a little fragrance left? I simply couldn't resist sending you some of our spring abundance. Happy Easter to all.

And when will I be getting another "gray one" from my mother? You're giving me short shrift, my dear. Must I lose my virtue before you bother to write? That's not so difficult to do here, you know.

You know, whenever I walk along the boulevard in the morning and the sun is shining and there are throngs of people about, I say in my heart to them: Oh, chil-

dren, all of you together don't have the wonderful beauty I have to look forward to. And then I love life all over again.

*Journal

[Ca. April 13, 1900]

If I could really paint! A month ago I was so sure of what I wanted. Inside me I saw it out there, walked around with it like a queen, and was blissful. Now the veils have fallen again, gray veils, hiding the whole idea from me. I stand like a beggar at the door, shivering in the cold, pleading to be let in. It is hard to move patiently, step by step, when one is young and demanding. Now I'm beginning to awaken as a human being. I'm becoming a woman. The child in me is beginning to recognize life, the purpose of a woman; and it awaits fulfillment. It will be beautiful, full of wonder. I walk along the boulevards and crowds of people pass by and something inside me cries out, "I still have such beautiful things before me. None of you, not one, has such things." And then it cries, "When will it come? Soon?" And then up speaks art, insisting on two more serious, undivided years of work.

Life is serious, and full, and beautiful.

*To her parents

Paris, 9, rue Campagne Première
April 19, 1900

Spring is springing everywhere! And it's so tempting that I think we'll have to begin our summer trip next Sunday. The nightingales have not begun to sing yet, but it's time to set out for a week among the apple and peach trees and restore the spirits.

No, I am not a skeleton yet; the roses in my cheeks are still in full bloom.

Last Sunday I had an intoxicating day with Clara Westhoff. It ended in Vélizy, a little village where we sat down in a spring bower by the light of a lantern and wrote postal cards to the great men in our lives, to the painters in Worpswede, and to Klinger and Carl Hauptmann.

The whole mood was magical. The moon was shining over the little village pond, the tavern, and the little ramshackle cottages next to it. And out of the twilight we could see the shining white ducks. This peacefulness and quiet countryside, so close to the great city, that is the great charm of Paris.

Our summer trip won't begin until next week. We would both rather do another week's hard work and then be able to enjoy the holiday all the more. Give Father

a kiss for his Saint-Simon letter. Incidentally, Maeterlinck never seems to speak directly about the latter's teachings, but he does praise him as a noble and happy person. A springtime kiss for all of you.

To Kurt Becker

<div align="right">Paris, 9, rue Campagne Première
April 26, 1900</div>

My dear Brother,

I jumped out of my so-called bed this morning extra early, conscious of the fact that this difficult and demanding daily event should always start on my right foot. This precaution guarantees a good mood, for the whole day, something I value highly. And that is why I've been careful to protect my precious right foot ever since our idyllic youth in Dresden's Friedrichsstadt right down to my turbulent period in Paris now.

It is strange how certain things from my earliest days have stayed with me! For example, every time I see a bumblebee I think of their playground in that bed of stock and mignonette out behind our exercise bars. It's wonderful how a child's mind can seize on something, be completely filled with it, and submit totally and unconsciously to the impression it makes. And then to carry over this impression into our adult and conscious life; that is something miraculous. It's still like that sometimes for me. Then there are hours when being and nonbeing seem to blend together for me, the way it was in our old garden. I don't think you and the family notice that much. Those are hidden, fleeting things which shun the light of the sun. But my life consists of those very things. Compared to them, everything, everything else seems small and ridiculous, the external events that happen and which for so many other people seem to make the difference between happiness and unhappiness. But not for me. It is the other things, the other moments which make up my art, my life, my religion, and my soul.

I write all this to you on your birthday, first, because I haven't written to you for such a very long time, and then because whenever we speak to each other we never really get down to what matters deep inside. Now and again I have to talk to somebody about the flower that blooms inside. I yearn for us to understand each other, so that you won't think that I have turned into something foreign and strange. I haven't.

What happened was that after this life of dreaming and sleeping, a sudden development took place. I can understand how it might have shocked all of you. But what it did for me was to give me the feeling of life and happiness and youth and freedom. And something fine is going to come from it all, and you are also going to share this joy.

I think a lot about you here and often have questions to ask you, so that I can learn from you. A young woman like me is still an ignorant creature. I have also

heard bells ringing the news of many things, and I don't know in which tower the bells are. That is a feminine vice. Whether it is inherited or learned, that is something our grandchildren will have to decide. By that time, we will no longer be oppressed by such matters; instead we will be gone from this beautiful earth.

Are you reading much now? And are you reading a lot of the modern things? You see, what I am wishing for you is that you will live with your own times and with the best and the wisest of your times, with the strugglers and the creators, and not with those people who only look forward to their Sunday rest after their week's work is done. You are too deeply rooted in the ideas of the previous generation. But that is not you. Your nervous system is part of our generation, and if you don't come along with us, that is nothing but weakness and apathy and something that you have to overcome.

Think about Niels Lyhne. He didn't manage it. But you can. You have the stuff in you. But you have to send the best that is in you out into the battle. I believe that you have to fight for an idea, by which I don't mean that you are just supposed to argue about our legal system at our parents' dinner table. That is nothing more than squandering your vitality. But to embody an idea, to live, that is what I wish for you and what I wish for all our German men. They lose their feathers much too soon on the field of battle and become Philistines.

Be idealists until you are old men. Idealists who embody an idea. Then you will have lived. And the world will progress. And the great swamp will dry up and turn into a fertile garden. We are still stuck too deep in the swamp.

That is what I had on my mind and in my soul to write you today. Accept it like a brother, dear, and don't grumble and don't smile at me or shrug your shoulders. It is much too well meant for any of that.

<div style="text-align: right">

With love
Your Sister

</div>

*Journal

<div style="text-align: right">

[End of April 1900]

</div>

I have been depressed for days. Profoundly sad and solemn. I think the time is coming for struggle and uncertainty. It comes into every serious and beautiful life. I knew all along that it had to come. I've been expecting it. I am not afraid of it. I know it will mature and help me develop. But everything seems so serious and hard, serious and sad to me. I walk through this huge city, I look into a thousand thousand eyes. But I almost never find a soul there. We acknowledge each other with a glance, greet each other, and then continue on our lonely way. But we have understood each other. Kindred souls embraced for an instant. Then there are others. With them one speaks many many words and lets the little brook of their talk flow over oneself and hears the wellspring of their laughter, and one laughs

along. And beneath it all flows the Styx, deep and slow, knowing nothing of these brooks and wells of ours. I am sad. And all around me are the heavy, pregnant, perfumed breezes of spring.

From the Album

<div align="right">May 1, 1900</div>

"One should never want to paint simply color, but only the form of a body and then fit all the color in after it. When one, for example, paints a bright cliff against a blue sky, one thinks first of the form of the rock and then cautiously gives the sky a breath of color until it appears blue in contrast to the rock. One should always paint only in contrasts."
"In deepest shadow and in the brightest light, only a few details."

<div align="right">Arnold Böcklin</div>

** To her parents*

<div align="right">Paris, 9, rue Campagne Première
May 4, 1900</div>

You Dears,
Everything has been going fine for me. And now I am in good spirits. Two of your dear "gray ones" came and a dear letter from Father. A thousand thanks. Thinking back, I am very sorry for having written you such a long and tearful letter. But I have to tell you that just now I am in a grave mood and it's probably going to last several weeks. I have run up against some obstacle in my painting. After I have gotten over that, I'll regain my spirits. It isn't as if something unpleasant had happened to me. And, yes, I feel perfectly well. And thanks for the iron [pills]. Whenever I want to give myself a bit of a lift, I buy myself a bottle of French red wine for sixty centimes. But Mama dear, the story about Brandes and the anecdote doesn't fit me at all. For despite this gigantic fit of depression, I'm outwardly very jolly and laugh a lot. The trouble is that the inner person can't take part in it much. That part of me is going through some dark and difficult hours which have to do with art, and wrestling with the Angel of the Lord: "I will not let thee go, except thou bless me."
We have gotten to know a whole crowd of young German artists. Every week we go on excursions with them to the country. We dance, go rowboating, and sing German songs in the twilight, acting as "German" as can be, which from time to time makes us feel good here in France. They are a splendid sort, dependable, poor, and like children; very different from the young Frenchmen. What they do, they do with zest. And they reveal all kinds of natural, healthy ways of looking at the world. It refreshes and delights the heart.

You know, compared to the French we are barbarians, and I can understand why they think we are. But energy and youth are behind it. Now and again we talk about the ways of the world, and a word about politics and history. And so it really is fun being together. And we leave our problems at home.

Saturday and Sunday we were out at the Uhlemanns' in Joinville. The deaf old lady has only one thought: to do something nice for other people. This time she let us enjoy the luxury of a genuine feather bed and insisted on feeding us with her own loving hands. That was really a treat after our "seven lean years."

Then we went rowing on the Marne, with the nightingales and the trees in bloom above us. Spring is mightily at work here now. If it weren't for the occasional breeze, its thousandfold fragrances would be stupefying.

Do you know Klinger's series of etchings called *A Love?* It's the one in which he has drawn himself in several of the prints, together with an alluring woman, in the midst of a great mass of chestnut trees in blossom. The very passion on those pages and the atmosphere heavy with perfume, that's the French spring. When one takes a walk through the Jardin du Luxembourg one sees a couple on every bench, billing and cooing. It's a different kind of courting than in Germany, more laughter, less sentimentality, even a bit casual. It looks as though each of the parties is already looking forward to another rendezvous with someone else.

I have seen yet another beautiful thing in Paris. Montmartre. It is tremendous the way the hill dominates the city. One climbs up through steep streets, winding among little houses. Old women sit in their doorways mending clothes, and one can see the young men constantly casting their glances this way and that, for this, too, is a painters' quarter. Finally one gets to a little marketplace with chickens running hither and thither. Suddenly one is standing before the beautiful Sacré-Coeur which gazes solemnly down upon the teeming city. It was eight thirty in the evening when we entered the church. Vespers were being held. Here and there a little candle, the reddish glow of a lamp, and deep silence. We ate supper in the refectory with no one else there but a group of old nuns. One of them was named Valentine, eighty years old, who had an awful face and mannerisms, and she even tried to convert us. Only when nothing else seemed to work did she begin to use her piety on us. She inquired about our *petits noms* and said she would never forget us and would love us in spite of everything. She took both of our hands in her two big fleshy hands, and then shuffled away.

I'm beginning to master Paris. I'm rediscovering myself and my capacity for inner peace. During the past week I have had beautiful, deep, full days. I am beginning to sort out my impressions and get closer to them and absorb them with composure. During the first few weeks each new impression chased out the previous ones. There were so many of them they frightened me. Now they have gradually become like old friends who are no longer confusing. I have the good feeling that I'm making progress, developing another side of myself, and growing. It's a feeling of deep and serious happiness.

Many thanks for the money. It came at just the right moment, half an hour before our holiday trip. Clara Westhoff and I together had only two sous in our pockets. So benevolently did fate intervene.

To Otto and Helene Modersohn

Paris, 9, rue Campagne Première
Beginning of May 1900

Dear Modersohns,

Now my silence is becoming too much for me. I *must* talk, really talk. I've been to the Exposition, you see, and it is simply *stupendously* fine. I believe that there will not be anything like this soon again. All nations are wonderfully represented. I was there yesterday, and today again, and these days have simply created an epoch in my life in Paris. You simply *must* come here. You *may* not let this chance pass by. Especially you with your colors. I think you will find colossal inspiration. *Dear* Frau Modersohn, can you come along? There are so many wonderfully beautiful things here to make you happy. I should so much like to show you everything. How is your strength now after this cold, horrid winter which brought influenza and sickness everywhere? Can you manage such a long trip so soon again? And even if you couldn't manage it, send your husband away by himself. Naturally he won't want to go without you, but be unrelenting and stern. Do not give in to him. One week will suffice. And then he will come home to you again full of new impressions. Herr Modersohn, write me by return mail when you are coming. It won't cost very much.

I shall then rent in advance some kind of a room privately from a woman painter who will be taking a trip. For lunch we know some inexpensive *crèmeries* where we can get a good meal for one franc. The most beautiful for me are the French artists. Cottet said to me, "The nature of our people is one of decadence, but in this decadence several are able to live independent of it. And that is what shapes their art into such a unique one." And that is true. Now I can feel how we in Germany are far from being liberated, that we do not rise above things, and that we still cling too much to the past. I sense this now about Liebermann, Mackensen, and consorts. All of them are still stuck too much in the conventional. All of our German art is. Of course, I can't give my final judgment, but today's impression was sad. Too, too bad that you don't have any paintings here. I believe that could still have been arranged. I would so love to have seen all of them here. Do you know that you are one of the people who have worked their way through this mountain of conventionality? All the others fall by the wayside. I have huge hopes for your future. Excuse me for saying that directly to your face. But I just had to get it off my chest. I have thought about it so often. You, perhaps Heinrich Vogeler, when he can get up over his mountain, and a painter from Meissen, Zwintscher, who is very different—I have a high regard for you all. Perhaps I don't know the

others, or don't understand them. Perhaps I don't try to. Probably because a little creature like me, who at the present moment is so caught up in her own growth, must first think about her own two arms and legs. I have spent some rather difficult weeks, but they are now behind me. Perhaps because of the torture I was submitting myself to, it seemed like a bit of salvation to be at the Exposition yesterday. And now I believe in art again with all of its greatness. And I think, too, that my own little flame will give off a little heat eventually. I am painting now, as you know, at the academy. Do you have any idea how difficult that is? I don't know if our German academies are also this way, but this one is terrible. We paint using almost no color at all. The alpha and omega here are the *valeurs*. Everything else is incidental. I have been frightfully scolded about mine. I thought that *valeurs* were my strong point. Now I notice how much I still have to learn. I shall probably stay on until the first of July. For two weeks I have been working at a half life-size nude (that is, I have been adding and subtracting highlights and shadow in the proper *valeurs*. One really mustn't call that painting). But I believe that my feeling for form is being refined in the process. Short and sweet: I will endure. On the whole, I think more of the independent individuals who consciously reject conventionality. I think that they must first have possessed it and practiced self-discipline and moderation. *Then* they can turn away from convention. But if someone speaks against it who has *never* practiced it, then I am tempted to think: sour grapes! It seems to me it's that way in art, too. It's a tricky business, this so-called "free and full life." We will have to speak about this sometime. If you can make something out of these fragments of unpolished ideas that I've been scribbling down here, then I give you a very high grade—

But more about the Exposition, also in fragments, because everything is still whirling and tumbling before my eyes, like looking into the kaleidoscope we had as children. Well then, the French were, for me, the finest. Most of all, Cottet. He exhibited a triptych, *Au pays de la mer,* which was bought by the Luxembourg. In the center section, lit by a hanging lamp, there are women and children at supper with sad, expectant faces. The evening sea shimmers blue through the window. In the left panel, one sees part of a boat and its crew on storm-tossed waves, and on the right, the shore at evening with women and children waiting for the return. It all has a depth of color and ornamentality of design paired with a gentle spiritual conception. Another Cottet: a white horse in a meadow at evening. A third: three black figures of women on the beach. Cottet himself is a fine fellow—red hair, red beard, full of life. Unfortunately I haven't seen him again. Unfortunately, when he came to see me I was not at home. But perhaps next week. Yet I scarcely have the courage anymore now. Another fine fellow is Lucien Simon, with a strange, naive, but healthy feeling for form who paints in black and white tones like Velázquez. Then there was a large painting, another seascape, with men, by Jean-Pierre. There is a little moment in one corner that expresses what I am striving for: a profound energy, full of color and light at dusk, colorful light within the

shadows, a light without sun such as we see in the fall and spring in Worpswede. Blue sky, enormous white clouds against it, and no sun. How I look forward to coming home—I can hardly tell you. Those things that for me are the most beautiful, depth and saturation of color, I don't see here. This is a brilliant, lighthearted, graceful country.

Inside me I have a very close feeling for the Nordic people, not so much because of the way they express themselves as because of the spirit in which they work. Finland is also represented here with works of a most original understanding for form. At the same time, to be sure, I am now a little disturbed by the lack of a sense for construction in all these Nordic people. Disturbed is not the right word, but I am aware of it now, whereas I never saw it before. That's a bit of progress that I have made in Paris. For "construction" is also one of the slogans here—

Segantini is represented by large, beautiful, and somber canvases, a little severe but the creations of a deep soul. The great Sculpture Hall only makes me dizzy so far. But that Rodin—he is a titan. *What* a sense of form he has, and the movement of every limb, and how the whole thing just reposes there, calm and isolated. Yes, one is lucky to be able to look at such things. But one has to earn it, too, by many difficult hours. I'm also beginning to get something from the paintings at the Luxembourg now; at the beginning they seemed foreign to me—they come out of such a different feeling from the way we Germans feel. Life in general here is full and beautiful, and I have a wonderful feeling about the future. And so I will gladly work my fingers to the bone, as long as my soul can now and then have a song to sing at twilight.

That was a long epistle so please, both of you, be good enough to excuse it. And also this terrible handwriting. My wicker chair is on strike and will no longer bear the weight of this sinful frame of mine. I am practically sitting on the ground by now. As far as the comforts of life are concerned, on the whole I have happier tales to tell about the past than I do about the present. I have a little blackbird now, too, and it twitters outside my window. And I also had a thunderstorm after a hot and sultry day, and now the fragrance of spring and rain is in the air again.

We were also on Montmartre recently where the church looms solemnly above the great city, admonishing us with its wonderful tolling of bells to atone for our sins. And we also have some little German painters here now, with whom we go dancing and rowing and sing German folk songs.

It's a good thing that it is getting dark or else I would go on telling you a thousand more things, for this Paris *is* a city and I am not here for the *last* time.

I also want to go back to the northern countries again. I never dreamed of such a lush spring before, air so saturated with fragrance. Everywhere chestnut trees with their thousands of bright torches, lilacs, wallflowers, wisteria, hawthorns— and women in their finery.

But really now, farewell. By this time my little lamp is lit.

Please tell the Overbecks how beautiful the Exposition is, how colossally excit-

187

ing, although I don't believe it's really Herr Overbeck's cup of tea. But see it he must. And Heinrich Vogeler, and Frau Bock. They must come, too. Tell them all about it. Frau Bock will be getting a letter herself in the next few days. And there is a Hungarian band that plays *waltzes*!!!! It defies all description. They can even play our Worpswede "Dreyfuss" and "O komm Karlineken."

It was hard to stay seated. Twice we have been dancing at night, right out on the pavement. Whenever they feel like it, the people here start dancing. They don't wait for some official occasion, like our *Schützenfest*. And with this in mind, farewell. Your letter made me so very happy, full of the sounds of dear Worpswede. And I look forward to the next one. And you must come.

<div align="right">Your Paula Becker</div>

But soon, before it gets too hot.

**To her parents*

<div align="right">Paris, 9, rue Campagne Première
[Ca. May 11, 1900]</div>

So then, I've been to the Exposition three times. It is even more beautiful and more instructive than I had imagined it would be, enormously instructive. The paintings by the French are the most beautiful. Cottet, Simon, Jean-Pierre. What they have in common is an enormous depth of color. They show us Brittany, and how wonderfully!

Beside them we Germans seem a little bourgeois and Philistine. Lots of zeal and enthusiasm, and too little real study.

I paid Cottet a visit. A fine, redheaded, red-bearded man, the picture of health, full of deep feeling. He once came and knocked on my door, but unfortunately I wasn't at home and found only his name written on a card. But I shall go visit him again.

You know, the few great French painters here are totally without convention. They dare to see things naïvely. There is no end to what one can learn from them.

It is wonderful how I can now see the country and its people with different eyes.

In the evenings at life-drawing class the little Frenchmen are filled with spring fever and high spirits and sing one *chanson* after another. They're like champagne. The trouble is, they seem to lose their bubbles so quickly.

The corner of the Jardin du Luxembourg, where students live and congregate, is splendid to see now. The couples sit cheek to cheek and spend the whole afternoon there. And because there is such a tremendous number of them, each couple can feel alone and unobserved. They sit there under the blossoming chestnut trees, not saying much, not thinking much, not dreaming much, but *amour, amour—*

I've just come back from my evening class in life drawing. These moonlit spring

nights intoxicate me. The whole *rapinière* is shouting spring! I can hear a mando-
lin and a violin, even a cello. And somewhere a German is singing, "Auch ich war
ein Jüngling mit lockigem Haar." The scene is lit by the white blossoms of the
chestnuts in the garden next door and by my dear old moon. In front of me, a
bunch of sweet lilies of the valley. But even with all this glory, I look forward to
coming home. Everything is so full of light here that it sometimes makes me impa-
tient. The whole tone of life at home is deeper and fuller and more serious.

To Paula from Otto Modersohn

Worpswede, May 20, 1900

Dear Fräulein Becker,
Your last letter, which we had long been looking forward to, caused quite a storm.
At first I was firmly resolved to follow your call and send a telegram asking you to
secure me a place to stay. Later, however, after further reflection, other thoughts
and considerations gained the upper hand. And so I shall probably not be coming
to the Exposition after all, as tempting as it would be to enjoy it in your company
and with your guidance. The reasons are these. At present I feel so fresh and in-
spired and my head is so full of ideas that I am afraid of being torn away. I'm afraid
of being unsettled, and I'm afraid of possible influence. I believe one must be quite
cautious in these matters. The moderns, in general, simply seem to see too much.
And that easily robs one of freshness and individual feeling. It is finally the value
and charm of our life here in this country quiet that none of those modern move-
ments can draw us into their orbit. It is only in the distance that one can see and
hear the surging and crashing. No, I prefer to stay here; I prefer to become more
and more inward, to say in my way the things that move me, no matter what else
others do. One can only get real joy and real profit from the feelings, etc., that
come from one's own breast. [...]

To Milly Becker

Paris, 9, rue Campagne Première
May 27, 1900

Dear Sister,
Your letter deserved an immediate answer from me last Sunday. I meant to write,
but time is getting shorter and shorter with every day. I'm beginning to stay up far
into the night, and am hanging on to peace of mind and soul only by the thought
that this will soon come to an end and I'll be enjoying a period of seclusion and
tranquillity in Worpswede again.
 I'm now leading an irregular life, you see. On several recent evenings A.T. led us
along bygone paths of his bachelor days in Paris. We have also spent several days
with our young Germans who have become warmly and faithfully attached to us

and have pledged their undying friendship. They seem equally happy to have found two dependable and steady companions after all their little Parisian *amours*. There is a party planned for next week at the studio of the little sculptor Albiker and the Swiss cow-painter Thomann. The two of them are leading a true marriage which they laughingly assure us is kept intact only by virtue of an occasional battle. This goes on in four almost empty rooms, a kitchen, and an alcove. That is to be the playground for the party. The girls will bring sandwiches, the male contingent will bring the wine. Candles and Chinese lanterns for light. Mandolin and guitar music and a cake that Thomann's sister is bringing. Clara Westhoff and I will go over early in the afternoon to decorate the rooms.

Our group has made a new acquisition in the person of a painter named Hansen. By birth and nature the son of a Schleswig farmer, he worked for a long time as an artisan before he got the clever idea, when he was in Switzerland, of picture postcards with views of the Alps, the Jungfrau, Mönch, Eiger, and so forth, each one with an expressive face. Have you ever seen any of them? They were published once in *Die Jugend*. Being the sly little peasant he is, he published them himself and in one week he earned ten thousand marks. Now his banner is emblazoned with the sign of True Art and he has serious aspirations. At the same time, he is withdrawn like all people of the North.

The Exposition continues to offer more and more glorious things. When one stands on the hill of the Trocadero, with the Grande Roue before one, and the Eiffel Tower, and the huge globe of the world, with all the towers of the city forming the background, one feels like paying homage to all of it with torches and bonfires. You would never believe the profusion of it all, its never-ending abundance. This Paris has an immense personality. She can give everything to everybody. You must come and have a look for yourself sometime, dear. But not for a mere fortnight, that would be pointless. You can't possibly get a feeling or understanding of it in two weeks. You wouldn't be able to get over the feeling of being foreign and separate. All you would bring back with you would be a muddle of bad impressions about the ruined state of mankind. I felt a complete stranger even to the art here at first, though seldom to the French. There is so much in Paris foreign to the blood of us little Teutons, and we bristle and resist it. It's interesting for me to observe how my judgment has gradually been formed, even though I am still far from saying that it is complete. What is complete? When is one complete? Never, I hope. That's the way I feel about all fixed points of view. And if at the moment you and the family feel that I'm being contrary, just hope that in a year, maybe only half a year, much will have changed. [...]

To Otto Modersohn

Paris, 9, rue Campagne Première
May 31, 1900

Dear Herr Modersohn,

I'm so *enormously* happy that you are coming. *What a treat that will be.* And then we shall both shake the dust of Paris from our feet and return homeward, and that will be *even* lovelier. I just have to write this to you quickly; I don't have any more time. Tomorrow I shall rent a little room; more news later. Now I have to curl my hair quickly for a costume party this evening (private, German, twelve people) and make a hundred sandwiches for the same reason. Puddings "with al-mond flavor" and with "strawberry flavor" are already prepared, ready and waiting for their purpose in life. We are becoming versatile in this little town. But the most splendid thing is your visit. Viva Modersohn! Hooray!

A *lovely* greeting to you, dear Frau Modersohn. I am still looking for roses and very much want to send you a nosegay of them again.

And so, *auf Wiedersehn.*

Your Paula Becker

**To her parents*

Paris, June 3, 1900 [Whitsunday]

Well then, let me tell you about the party. From beginning to end it was a happy and blissful affair, full of high spirits. We made all the major arrangements the af-ternoon before. Clara Westhoff and I fabricated, right in the party rooms, two puddings, one with "almond flavor" and one with "strawberry." In the kitchen we set out all the utensils and other things for the party with proper domestic concern.

Meanwhile, the noble male contingent was busy painting a wall frieze. In the sa-lon, fully lined with a covering of white paper, there appeared a splendid centaur frieze. In the alcove, where various mattresses and cushions were heaped up, they produced a frieze of the Elysian fields. There were no chairs. In addition to the party rooms, there was a reception salon and a dressing room with a full-length mirror.

Such was the playground for our grand fete. Our whole little world came in cos-tume. And it came in a good mood, or perhaps better, in a mood of highest antici-pation. Then there was dancing with guitar and mandolin accompaniment. Twelve wall sconces had been artfully fashioned of heavy wire. And so the room was resplendent with candlelight. Glowing Chinese lanterns in the alcove. The next morning, after Milly's coffee machine had done its duty, we counted the five bottles that went into our punch bowl, and it turned out that we had consumed only about one and a half of them. Everything else was provided by youth and in-

toxication without wine. I liked that. Then we walked home in our costumes through the early dawn of Paris. By the time I reached my little ladies' bower it was fully light. Outside, a mass of blossoming locust trees, morning bird songs, and cooing doves. I stayed up for a long time, even though I felt carefree and certainly did not have a heavy heart.

By eight o'clock I was holding my *grand levee.* Off to the Académie. At noon we held our "hangover" breakfast in our party rooms, where we merrily chatted away.

I have saved my major news till last. On the tenth the people from Worpswede are coming, Modersohn and the Overbecks. They will be staying for ten days to two weeks. And then we are all going home together. Hurrah!

A kiss for all of you.

To her parents

[Ca. June 8, 1900]

After a sunny Whitsunday walk following church and after considerable inconvenience on account of bad omnibus connections, I got back here feeling rather exhausted. At a time like this, the city seems frightful. One feels so powerless before it. What it is not willing to give with overflowing hands and of its own free will cannot be gotten from it in any other way.

Several new galleries have been opened in the Louvre, which was shut for quite a while because of rehanging the paintings. Now I can again wander like a drunkard through all this splendor. I rejoice that the past half year has brought me closer to an understanding of the Old Masters. I am able to measure my own inner progress against that standard.

The sculptor Rodin has opened a special exhibition, the great, profound lifework of a sixty-year-old. He has captured life and the spirit of life with enormous power. For me, he is comparable only to Michelangelo, and in some ways I even feel closer to him. That such human beings exist on earth makes living and striving worthwhile.

Thursday evening, a dance at Bullier. Do you know that big dance hall in the Latin Quarter, dear Father? It's a colorful picture, so very much to see: students and artists, handsome and merry in their stunning velvet suits and floppy slouch hats, and with their girls, some in their cycling bloomers, others in silk robes, and still others in summer blouses. They are mostly *couturières* and *blanchisseuses,* and revel in a kind of vain and childish gaiety. At half-past midnight the gas is turned down and people go home. Café life here actually does not last all that late into the night. By two o'clock nearly everything is closed.

And on Monday the people from Worpswede are coming! That is what makes

me happiest of all. Quite honestly, my mind is always there. I can tell you, sometimes I thirst for home.

Paris, Friday [June 15, 1900]

You Dears,

Frau Modersohn died very suddenly. The poor man has gone home with the others. After so many years of caring for her with the most unselfish devotion, heaven was cruel enough to take her when he was away. Even now he doesn't seem able to comprehend it. He followed everything happening around him, gave his instructions, made arrangements, but he is not able to grasp the horrible truth. [...] I shall come home as soon as possible. Perhaps I can be with you by Sunday. This is a very sad ending to my stay in Paris, and my next period in Worpswede will also be sad and difficult. I have gotten so much from being with Modersohn these days.

Auf Wiedersehn!

Your Paula

Journal

Worpswede, July 2, 1900

An evening walk through Schlussdorf. The Ottelsdorf mill against a somber, glimmering sky, in front of it the moors, a waving field of wheat. Don Quixote on a white horse, red bearded.

People at work in peat bogs. Evening mood. Everything deep. Brown and blue, with dark bits of white and red set in. The girl at work cutting peat, with a hunched back and very visible pelvic bones.

Garden of love. Evening mood. Brilliant red fritillary. Young couple. He dark, she white.

I am living now with the Brünjes in Ostendorf; lovely here in the quiet. I am trying to slough off all the vanity I brought here with me from the city and make myself into a real person and a sensitive soul and a woman.

Journal

Worpswede, July 3, 1900

All morning long I was among the trees around Boltes' factory.

Blue sky and great ballooning clouds. I felt every bush. Perhaps I shall also paint an abandoned factory sometime.

To Paula from her father

[...] You seem to be satisfied with your new lodgings and landlords, and I hope that the new friendship will last. But I cannot approve of your plunging into new expenses in connection with it. In general, I must ask you to be reasonable about your future and to make a plan for yourself which is not adventuresome and one which you can really follow through. Nothing you have told me can convince me that you are altogether clear about what you are going to do after Uncle Arthur's funds have been used. I believe that I can deduce from certain things I have heard that you would like to return to Paris in the fall; however, I see absolutely no possibility of that. Naturally I cannot advise you to borrow money, for I believe that you are not in any position to pay it back and would otherwise encumber yourself with a debt for a long time, which would depress you morally and physically. [...] What I think is that you must look around for a position. If you inquire about one in time perhaps something appropriate will turn up, something in which you might also continue to pursue your studies, and yet at the same time save a bit so that you might work on your own later in Paris or Munich. But you must come to some decision and the earlier the better, because if you do, you will be able to make a choice, and if you don't, you will have to take the first thing that comes along. And so think the whole matter over and do not go on living day to day. Trusting that something will turn up and that everything will somehow be arranged is unjustified, and you will not be able to take care of your own future in time. [...] Be sensible and mature, then, and consider what you have to do. From my point of view, your [and Frau Bock's] plan to earn your subsistence from weaving will not be successful. [...]

Journal

[July 5, 1900]

Father wrote today and told me that I should look around for a job as a governess. All afternoon I had been lying in the dry sand on the heath reading Knut Hamsun's *Pan*.

Journal

Worpswede, July 1900

I listen in the dark corner of my chamber;
As if with great still eyes, it looks back,
As if with great soft hands that stroke my hair.
And benediction flows through every fiber of my being.

This is the peace that lives here along with me...
At my side my lamp burns cozily,
Purring its song of life, as in a dream.
Out of the dusk, white flowers shimmer,
Trembling, shuddering, for they can sense the future.
With gentle wing strokes, a bat flies round my bed.
My soul observes life's riddle,
Quivers, is silent, and watches.
And next to my bedstead the lamp purrs
Its song of life.

*Journal

Worpswede, July 26, 1900

As I was painting today, some thoughts came to me and I want to write them down for the people I love. I know that I shall not live very long. But I wonder, is that sad? Is a celebration more beautiful because it lasts longer? And my life is a celebration, a short, intense celebration. My powers of perception are becoming finer, as if I were supposed to absorb everything in the few years that are still to be offered me, everything. My sense of smell is unbelievably keen at present. With almost every breath I take, I get a new sense and understanding of the linden tree, of ripened wheat, of hay, and of mignonette. I suck everything up into me. And if only now love would blossom for me, before I depart; and if I can paint three good pictures, then I shall go gladly, with flowers in my hair. It makes me happy again as it did when I was a child, to weave wreathes of flowers. When it's warm and I'm tired, I sit down and weave a yellow garland, a blue one, and one of thyme.

I was thinking today about a picture of girls playing music under a cloud-covered sky, in gray and green tones, the girls white, gray, and muted red.

A reaper in a blue smock. He mows down all the little flowers in front of my door. I think that perhaps I, too, will not last much longer. I know now of two other pictures with Death in them; I wonder if perhaps I shall still get to paint them?

*To her mother

Worpswede, August 13, 1900

My Mother,
It was a beautiful evening. I did some painting, and then lay down in a haystack with my copy of *Auch Einer,* but I really looked away from it more often than into

it, because the evening was simply too beautiful. And then, from time to time, I would burst out laughing because I was thinking of the funny thing that happened yesterday. I want to tell you all about it so that you can laugh along with me.

After spending a rather respectable Sunday, Clara Westhoff and I are strolling through town together. We think that the day shouldn't end on this same note. We want to go dancing. But where and how? The next moment we're talking about art again, about Clara's angels for the church.

So, off to the church. It's locked. Only the door to the tower is open. We climb up together, the first time for either of us, and now we're sitting together on one of the beams in the belfry. Suddenly we're inspired. We must ring the bells. At first we dally with one of the clappers, but the temptation is too much. Clara grabs the rope of the big bell, and I get hold of the rope to the little one, and they begin to go up and down, and then we begin to swing along with them, way up off the floor, and everything begins to ring and sound and resound out across the Weyerberg, until we're tired.

Just at that moment one of the tallest schoolmasters you can imagine appears at the top of the steep stairway, draws himself up to his full height, and starts to scold us; but when he catches sight of us two young girls in white dresses, he turns right around and goes down.

We follow him—and—there's the churchyard, swarming with people. We'd been ringing the fire bell! Everyone had thought there was a fire. Farther down in the village they had hooked up the hoses. We wanted to escape as fast as possible but were stopped by the village pastor. Pale and panting, he hissed the word "Sacro-sanctum" several times at us. Later on we made a special visit to calm him down.

After a stop at the newspaper printer's, with the purpose of keeping our names out of the press, we finally went home. The two good Brünjes were waiting for me, terribly worried. He: "Oh, Fräulein, what a shock we've had. Probably a hundred times came lookin' for ye at the door. Thought they probably locked ye up."

And Frau Brünjes: "Kept telling everybody all along that the big one, she could take it, but our little miss, she'd catch her death for sure in the clink." The neighbors had been trying to console them by saying that we had gone to Bremen for certain. But now the evening conversation everywhere was about the bells ringing over the Weyerberg. "Heard the ringin'?"—"Yep."—"Ye know who done that?"—"Nope."—"Fräulein Westhoff and Fräulein Becker."

Clara was received in Westerwede with jubilation. And Martin Finke said he would "give five groschen if only he could have been there." And a little hunchback kitchen girl, who belongs to the household and who grumpily peels potatoes the whole day long, suddenly became cheerful and lively when she heard about our scandalous deed.

*Clara Westhoff and Paula Becker ringing church
bell, 1900*

Worpswede, September 3, 1900

And it [life] will be going on for a long time, after all. I am healthy and strong and alive. Hail!

Dr. Carl Hauptmann is here for a week. He is a great, strong struggling soul, someone very much to be reckoned with. A great seriousness and a great striving for truth is in him. He gives me much to think about. He read from his journal, *Gedankliches und Lyrisches.* German, hard, a difficult and stolid text, but great and profound. Put vanity aside and be a human being. Vanity erects walls between you and nature. You cannot get through to it. Art suffers because of it. Go deeper into yourself, live from the inside out, not from the outside in. For me, therefore, a refutation of Paris.

In contrast, Rainer Maria Rilke, a refined, lyrical talent, gentle and sensitive, with small, touching hands. He read his poems to us, tender and full of presentiment. He is sweet and pale. In the end, the two men were unable to understand each other. The battle of realism with idealism.

To Otto Modersohn

[After September 12, 1900]
Monday afternoon

My Dear,

I was thinking about the two of us, and then I slept on it, and now I am clearer about everything. We are not on the right path, dear. You see, we must first look very, very deeply into each other before we give each other the final things, or before we even awaken the demand for them. It is not good, dear. First we must pick the thousand other flowers in our garden of love before we pick, at a beautiful moment, the wonderful deep red rose. And to do that, we must submerge ourselves even more deeply in one another. Please let your "hot-blooded iconoclasm" slumber a bit longer, and for a while permit me simply to be your little Madonna. It's meant to be for your own good, do you believe that? Keep your mind on art, our gracious muse, dear. Let us both plan to paint all this week. And then early Saturday I shall come to you. And then we will be good and gentle with each other. "A gentle rustling," as you once quoted. Good, well-behaved children, "for there is a need of them as well," if I may change your words around a little.

Farewell, dear. Think and feel beautiful thoughts. We have reached out to each other so that with our common strength we can become *finer,* for we are both still very short of reaching our highest potential. I still have a l-o-n-g way to go, and you do too, dear. And thank God for that. Because growing is the most wonderful thing on this earth. Isn't that so? Both of us have such good things to look forward to. I

send you a quiet kiss and stroke your beloved head. "I am yours, you are mine, of that you may be sure."

<div align="right">

Auf Wiedersehn
Your Me

</div>

Dear? Please sleep well, and much. And eat heartily. Won't you? You!!

To Otto Modersohn

<div align="right">

Wednesday evening

</div>

Dear,

I've done fine work today. That is, considering the circumstances, and I'm extremely happy. I thought to myself, if I can persevere and not suddenly come up against a stone wall, then someday you are going to get a wife that people can look at and admire. I long for that with all my soul, for both of us. Until then, however, I believe that I'm the only one who is convinced of that. Well, if you believed in me just as much, perhaps it would be too much good fortune for me and I'd be likely to have my head too much in the clouds. That is the weak point in my character, you know; I become arrogant too easily. This morning I was right on the edge of that. But I must not let myself become arrogant in matters of art, because if I do, it means an end to art. That is why I must be *serious*. So please, stop trying to make me laugh whenever you catch me being serious. Keep in mind that the few serious moments I can manage are needed for the health of my soul. I must become a *deeper* person, all parts of me. The only part of me that's deep enough is my sense of humor—

In the meantime I have been doing a lot of hard philosophizing about that other matter and have accumulated so much practical wisdom, that now I hope for both our sakes that I can sleep it off again before next Saturday. Otherwise it might be too overwhelming for us.

Let things go well for you, my dear. Don't think about the stupid old world at all but a lot about art and a little about me.

<div align="right">

Your Pilgrim for Life

</div>

**Journal*

<div align="right">

[Beginning of October 1900]

</div>

I have rented Fräulein Reyländer's studio at Ranke's the tailor. That girl is extremely interesting to me. All the little things in the studio I have inherited from her have so much personality. A wooden birdcage stained green and kept locked with a feather; a whole collection of colorful and cracked and sleepy little vases and

crocks; a portfolio with her childhood drawings, *The Field Where the Bench Stood,* and endless variations on the theme of her sisters crocheting, holding books, holding nothing. Then up in the attic, hanging from a nail, a few charcoal drawings from last year with much character.

I feel good surrounded by all this debris. I daydream a little, and I'm beginning to work. Mornings I am painting a life study of someone naked from the waist up; afternoons, Herma. And wonderful moonlight nights. Last night when the Brünjes were out dancing, we jumped naked out of the window and danced ring-around-the-rosy. Today I've been reading parts of *Die Versunkene Glocke.* Gerhart really is quite a person, no matter what they may say. And his song isn't finished yet. I don't believe it.

It's lovely to have Herma around. She is like poplar leaves quivering in the wind. There is such sweetness asleep and dreaming in her. And a loveliness is already awakened in her. Whenever she recites poems by Goethe and Heine, an atmosphere of light and warmth flows from her whole being.

I'm reading Ibsen's *Emperor and Galilean.* I find myself completely under the influence of this great man again. I hadn't remembered from last year how really great he is. And there is something noble about him, and such depth of thought. Mother has misjudged him badly, too much according to the cut of his clothes.

A letter from King Red, with all-encompassing love and glowing with life. He makes me feel pious.

**Journal*

[Undated]

I entered the Land of Desire. It was sweet and lovely to behold. The Sun looked down from her golden throne in the firmament and her silken gold hair twined about everything she gazed upon. It flowed around and snuggled at the feet of the great, gnarled pine trees. And the old fellows were pleased by this attention. They felt young and happy in this affectionate embrace. They didn't stir, but stood quietly as if they were afraid of frightening away this sweet magic if they moved. The locks of the Sun gilded their branches and twigs. And they reveled in their beauty. And the light flowed along the shores of the lake and played with the dry reeds. It cast golden threads out upon the lake, so far out that I could not see the ends of them. It encircled my breast warmly and softly, so that my heart beat slowly and reverently, happy to be alive.

I glanced out over the surface of the lake. My eyes followed the golden threads of the Sun. Far in the distance they seemed to disappear. They were submerged in a grayish-blue mist. It was not water. It was not sky. It was a tangle of gray veils that received them. And the Sun's threads could not illuminate them with gold. It

made me sad to see it. I looked again at the reeds and rushes and heard their gentle whispers of love.

But something forced me to look out again into the distance. Again I saw the gray veils billowing softly. And behind them there was something like a pair of huge deep eyes, and they penetrated to the bottom of my soul and would not turn away their glance. My soul grew sad. And it asked the old pines, "To whom do these deep eyes belong?" But they would not make a move, from fear of frightening the golden magic of the Sun away. And I asked the reeds. But they would not listen and kept on whispering among themselves.

And again I looked into the distance. Into the deep eyes. My soul cried out and called, "Who are you?"

Then the first of the veils quietly lifted and let three white swans swim forth. They swam slowly across the golden waters, slowly and sadly. And as they approached the place where I stood, each of them cast up to me one white feather. And when I took the first of them I recognized the deep eyes in the distance. They were the eyes of Longing that looked at me as if they would never let me go. I was forced to stare at them. And I forgot the world round about. I forgot everything that I loved, and looked into the deep eyes.

And I took the second feather. It seemed as if the scales fell from my eyes. And I saw standing next to me a crowd of people of all ages. With sad gestures they looked out into the eyes of Longing, just as I did.

And I took the third feather. My ears were opened and I heard talking all around me and mournful sounds. The voice of each person sadly uttered one wish, the wish of the heart. And the deep eyes of Longing were upon each of them, so that they were unable to forget.

There was a woman there who cried out for the heart of the man she loved. And the eyes of Longing were upon her. Just like me. She had forgotten the world, just as I had, and everything she loved, and thought only of the heart of her beloved man. There was a youth. Boldly he cried out into the distance, "Fame and honor!" The eyes of Longing were upon him. And he forgot everything else, everything that he loved. And he cherished only this one thought.

I looked into the distance, and I shuddered. My wish was in my heart and I caressed it. I thought of nothing else and I cried out for my heart's wish.

Then I heard the gentle sound of a voice, growing louder and ever louder. And the golden hair of the Sun wafted around me in the breeze. And I was able to look away from the deep eyes of Longing and I looked up at the Sun.

But she called out to me, "Go home to your own house and create. Think of the people who live around you and love them. And you will be healed."

The hair of the Sun blew sweetly around me. And my heart beat slowly, reverently. A great strength came to me. I went, and I created. I cast the wish of my heart far out into the lake. It glowed there from the depths.

But I am surrounded by the Sun's golden hair. And peace lives in my soul.

To Rainer Maria Rilke

Worpswede by Bremen, October 15, 1900

Dear Herr Rilke,

Actually, we all wanted to write you a Sunday letter together. And then all of us were no longer there and I planned to do it alone. And then the mischief of the inanimate object took over, as I first upset my little inkwell all over my red Abruzzi blanket, and then I couldn't find a pen that would write properly. I wonder whether this little note will get to you? If not, all the better. Because that means that you'll soon be back sitting pleasantly on our heath. And that's the nicest of all.

You have brought me beautiful, contemplative hours through your sketchbook during, and in spite of, your absence. It was the only thing that I wanted to read during this period. We had wonderful moonlit evenings. And I sat in my little room with the golden lamplight and outside the blue moonlit night was breathing. And when I had enough of looking and thinking, then I would reach for your little book—

Today it's almost wintry. It has snowed, and a wild storm is testing the courage of the little birch trees. I ran through all the tumult and the pelting rain and sang in jubilation, but I could scarcely hear my own voice in the great battle of the great elements. But that didn't depress me at all. It was so natural.

Come back to us soon again. It is good to be here.

We all look forward to your return and to being with you.

Auf Wiedersehn
Paula Becker

To Rainer Maria Rilke

Worpswede, October 25, 1900

We waited for you at twilight, my little room and I, and on the red table are autumn mignonettes, and the clock has stopped ticking. But you do not come. We are sad. And then we are grateful and happy again just because you exist. It is nice to be aware of this. Clara Westhoff and I, we were speaking recently and saying that you are an idea of ours that has become real, a wish fulfilled. You are vitally alive in our small community. Each of us turns to you in gratitude and should so much like to make you happy again. It is so lovely making you happy because one does it without noticing it, and without intending to. You are with us on our lovely Sundays, and we with you. It will stay that way. For you are an event for each one of us, and what you have silently and gently placed in our hands lives on in us—

And now I thank you for the new happiness. Your Sunday poem made me calm and pious, and Clara Westhoff read it and sat there quietly for a long time in meditation. Sunday morning brought me the books with your own personal touch.

They lie before me. I stroke them in my thoughts. And your sketchbook is a dear part of yourself which I leaf through gratefully in the quiet evening hours. The "Annunciation" and "To my Angel" entwine themselves sweetly around my soul. "But you are the tree." I cherish the little book, and I will return it to you by registered mail on the first of November. Do you know, I have the same feeling I had a few weeks ago when you were reciting beautiful new things to me almost daily, and when all I did was to return your red pencil. And you had even given me that—

A cousin and an aunt of mine live in Berlin, Maidli and Frau Herma Parizot, two gentle, sensitive women whom life has not treated gently enough. Whenever you are in one of your overflowing and generous moods, then perhaps you might go to see them. I think that might make you happy, too, for there is something very gentle and very noble there. And if you might wish to request something for yourself, then ask Maidli to play you Beethoven. She has her own special interpretation. And it is beautiful. Maidli's older sister, when she was eleven years old, was playing with six other children (I was one of them), and was buried in a large sand pit near Dresden. The rest of us were able to save ourselves. [The death of] this child was the first real event in my life. Her name was Cora and she grew up in Java. We got to know each other when we were nine years old and loved each other very much. She was very mature and intelligent. The first glimmer of self-awareness entered my life with her. At the moment of her death, Maidli and I were hiding our faces in the sand so as not to see the horrible thing that we sensed was happening; I said to her, "You are now my legacy." And that she has remained. And because she is my legacy I ask you to bring a little beauty to her life. I shall write you the address soon—

—Herr Modersohn was made *very* happy by your letter. He has painted a beautiful picture, a girl with sheep, coming down a slope in the evening sun, returning home. You would love the picture. A new one is completed almost every day. It is the beginning of a wonderfully rich creative period for Modersohn. I always feel as if I should be shielding him with my hands. Doing something like that makes me feel good. On that afternoon you saw into the hidden waters of the man's soul, but it is deep and beautiful and whoever can see it is blessed—

It is evening again and my little yellow lamp is lit. Outside it is very still and very black. The only sounds are an occasional drip from the wet thatched roof and the sleeping cow jingling her chain.

And in this peacefulness, let me reach out my hands to you. I often think of you.

<div align="right">Your Paula Becker</div>

Worpswede, October 28, 1900

My dear Father,

[…] Now please don't start worrying about any celebrations. You know that Otto and I are both very sensible people. Heinrich Vogeler did bring a bottle of red wine over to celebrate our engagement with us; he had only just understood what it was all about and was very charming about the whole thing. Otto had told him very briefly about it awhile ago, but it seems that Vogeler was so embarrassed that it might be a delicate matter, that he didn't pay any attention to him until now.

Both of us are busy with our work. Otto has begun three new paintings, one right after the other. Evenings I go over to his studio where we look at them together. I'm still working outside most of the time in my wooden shoes and letting the wind blow through my hair. We must pay attention and enjoy these last few golden days.

*To Marie Hill

Worpswede, October 1900

My dear Aunt Marie,

Yes, I am deeply and gently happy, and life wafts sweetly around me. It seems as if everything is a dream. In fact, my whole life has been a dream until now, and now it is even more than that. I believe that evenings such as I am enjoying are had by very few other people in the world, like this evening, for instance, when the two of us met at dusk at our favorite place. We stood there together among the trembling fir trees which were creaking in the wind — he is like a man and like a child, has a pointed red beard and gentle sweet hands, and is seventeen centimeters taller than I. He has a great intensity of feeling. His entire personality is based on that. Art and love, those are the two little tunes that he plays on his fiddle. He has a serious, almost melancholy nature combined with a great capacity for cheerfulness and a love of sunshine. I can mean much to him. That is wonderful good fortune. In matters of art we understand one another very well; one of us is usually able to say what the other is feeling. Nor am I about to put my art on the shelf. We both intend to continue working and striving together. His great simplicity and depth make me feel pious. I am such a complicated person, always so trembling and intense, that such calm hands will do me a world of good.

I carry happiness in my heart.

Your Paula Becker

To Arthur and Grete Becker

<div align="right">Worpswede, November 1, 1900</div>

My dear Uncle Arthur and my dear Aunt Gretel,

You haven't heard from me for a very long time, have you? And what must you have been thinking of me, you dear people? But things just turned out that way and the story has its sweet side. Something wonderful was happening in my life. But first I had to wait for things to calm down. And now there is something in me and all around me and it's called happiness. Of course, happiness has been with me for a long time, as long as I have been devoting myself to art. But the new thing that has come to me is in the shape of a dear, serious man with whom I shall share my whole life. The painter Modersohn and I are of one mind; we want to marry next year. Last spring he lost his wife, to whom he devoted a rare love during the last three years of their marriage when she was ill. After her death, he longed again for life and love. And then all at once we found each other. We had always had a deep understanding with each other in art, and the evenings that I spent with the Modersohns are among the most beautiful I have known. I have an understanding for his art and he has an understanding for my aspirations. You will love him when you get to know him. He has a serious, deep nature which opens up completely in his art. He absorbs the beauty of creation so sensitively, and he devotes a heart full of love to everything and everyone. Things shall go very well for me by his side. I am truly happy, and inwardly calm. He has a little blond daughter to whom I shall be a mother. For the time being, our engagement is to remain a secret. But I had to tell you about it, you who in such a loving way have assured my being able to stay with my art. I reach out to you and thank you for all the good things that you have done for me. It has all fallen on good earth, for I can probably say that ever since I was twenty I have lived every day of my life with joy. And now, every day is even fuller and more beautiful. I am calm and grateful. Heartfelt greetings from

<div align="right">Your Paula Becker</div>

To Rainer Maria Rilke

<div align="right">On Thursday [November 1, 1900]</div>

And now you have your sketchbook once again. It often sang beautifully to me. And here, also, is a little hint of our autumn. The chestnuts fell from the yellow trees outside my window and rolled onto my lawn, and then I strung them in a row for you. There is another little brown chain of them hanging on my wall. And now I reach out to you and thank you for your second Sunday song. Continue to be our dear friend.

<div align="right">Your Paula Becker</div>

To her mother

Worpswede, November 3, 1900

My Mother,

Yes, I must write you, I must write often. I have been thinking so myself. In fact, the thought had already hatched. Even if I hadn't received your "gray one," I would be writing to you now. Or perhaps your letter was my inspiration, after all. Initiative is my weak point now. In fact, it never was my strong side. And now the little that I have I must divide between Otto Modersohn and myself. He even has m-u-c-h less than I.

I'm often surprised how gentle and understanding I am with him. That probably comes from love. I believe that I'll become quite a good wife. I have even been concerned, lately, that I might completely lose my old obstinate head as time goes by; and because it's already a quarter of a century old, it has antique value. So, the philosopher in me says I really mustn't let it completely get away from me. But the man is so touchingly good, like a child, that whenever he hurts someone, he does it with such divine naiveté that one must kneel before him in humility. It's the same naiveté I used to admire so much in Maidli when I was a child. We who are aware of things, we really have it twice as hard. We are not permitted to hurt anyone, just because we're aware.

I'm very busy with my painting, making use of all the bits of time I have. And he, he keeps on shaking beautiful pictures out of his sleeves. I want to make the best use of the bachelorhood I have left, to learn everything I can. For just because I'm getting married is no reason for my turning into a nothing.

Dr. Carl Hauptmann has published his journal, and I've just now gotten hold of it for the first time. I was never able to warm up to his plays, but in this book the fine person he is is revealed truthfully and clearly. One can sense his strong desire to make the profoundest and most serious qualities of the human being ring out and drown all shallow overtones. He has a youthful tender idealism, a godlike belief in the world. He looks at every living creature with love. The passage of time has not ossified him as it has so many others. A wall of deep and pure ethics guards and protects him. I want to send you the book after I've finished reading it, so that you can get to know him, too.

Otto saw Klinger with Pauli. There is something wonderful about such a totally dominating personality. Klinger is one of these sovereign types, and at the same time kind. When I think of that look he gave me three years ago as he was saying good-bye! I was so very immature, so very unprepared, and contributed so very little. The look he gave me, it was as if he were gently stroking my hair.

To Rainer Maria Rilke

<div align="right">Worpswede, November 12, 1900</div>

Dear Friend,

And you say your letter wasn't a letter for me, and really wasn't a letter from you? I hope it was for me and to me, and that it was also from you. I think that we shouldn't always demand a Sunday mood of our poor souls. And I think further that every act we perform is a part of ourselves and that one should have respect for it. I don't recognize any sort of norm, neither a Rilke norm nor a Becker norm, etc.; rather I accept human beings humbly in their many-faceted change of hues, or I try to do so, and I respect all this and I also respect your letter. I should like very much to tell you this in person by the yellow lamplight in my little warm room. Perhaps what I mean would be more understandable there. I say that because you are able to listen so beautifully with your eyes. And then I'm not at all aware of this empty space in me which, in other people, is where logic and clarity reside. Whenever I write, this black abyss yawns up at me.

My soul is not celebrating any Sunday today either. It doesn't even know what it's celebrating or not celebrating today. I really never know that. My soul is under a veil today. A fog covers it and makes it motionless. And still I'm writing to you. And you will permit me my everyday soul's day, won't you? And put up with it and not think too poorly of it?

—I have rented Fräulein Reyländer's studio for my work, on the second floor of a house next to Otto Modersohn's. I am working there now and seeing to what extent my brush has learned its language from an apple tree with red apples, against the blue sky with great white clouds, and around it girls dressed in white are dancing a happy ring-around-the-rosy. And in another one a mother sits with her child, and a cow is resting, and it is evening. In another one there is to be a white-gray, glimmering sky and part of a red church blending deep and harmoniously into this damp, autumn mood. And out of the open doors, in a black stream, comes the devout congregation, all simple, aged figures. It was the communion for the old people. I shall probably not be able to say all of that the way I should like to, but who can? And I, I'm just a beginner.

Much of the spirit of the other girl who lived here is present in my studio. And I love this spirit. Here and there is still a bright little pot that she must have decorated herself; here a piece of gray moss, there a bright piece of lichen. Next to me, under a pile of things, is a portfolio of her very original drawings of children. Her six brothers and sisters appear again and again or *The Field Where the Bench Stood*, or some kind of merry group of farm animals. Every fragment, every scrap of hers has individuality and personality and makes me happy. And then I have been reading your Rodenbach and he interests me very much. However, may I give you my opinion? In spite of all sensitivity and feeling, isn't it brutal to rob a dead woman of the adornment of her hair? Should not the sweet love of material things be ennobled in life against a broad, open spiritual background, like "Red roses in the

evening air"? It's against this love cult in death which clings so to material things, it's against this that something in me screams out and was even screaming at the time you told me the plot of this play. And yet I didn't want to render my verdict then. You'll permit me my point of view, won't you? In fact, please do permit me everything.

— — —

And all of this, all of it is only incidentals and little trivia and things with which one kills time. The one thing for me, the whole thing, the great thing, the thing that stands firm for me is my love for Otto Modersohn and his love for me. And that's something wonderful and it blesses me and pours over me and sings and makes music around me and within me. And I take a deep, deep breath and walk along as if in a dream. You know about that, don't you? It happened long ago; even before Hamburg. I never spoke to you about it. I thought you knew. You always know, and that is what is so beautiful. And today I had to tell you that in words, to baptize it and place it piously in your hands so that you could be its godfather. For your hands bring goodness. And you love the flowers. They really are so beautiful. And they make us better. Yesterday we had another Sunday of songs and you were among us.

And my sisters are made happy by your greetings.

But I, I'm happy that we live together on the same beautiful earth, and I stretch out my hand to you from afar.

<div style="text-align: right">Your Paula Becker</div>

To Paula from Rainer Maria Rilke

<div style="text-align: right">[Schmargendorf, November 14, 1900]</div>

Wednesday

It is so strange; being young and giving blessings.
And yet I thirst to do so:
To meet you at the edge of words,
and to rest in your hands at evening
my hands which turn the pages
of books I have laid aside...

This is the hour when hands will speak:
the day's work still resounds in them.
They tremble slightly and truly know
every thought which the lips need only speak;
and if keys were beneath them,
if the air laden with the echo ascended into night,
and if they dwelt at the edge of a cradle,
the child in it would smile and awaken—

with eyes, huge, as if it were keeping silent
that which imbues every spring with might.

And now that my hands are in yours,
listen to the blood which gently speaks,
invent a good face to join
these hands which are within yours.
A wise face, which grew worthy of life,
a still one, which understands whispered things,
a deep one which, framed by his beard,
remains so calm, as behind crowns of the oak
through which a storm is speaking, a very quiet house
in which you will no longer fear to dwell.

For behold, my hands are much more
than I in this hour in which I bless you.
As I raised them up, both of them were empty;
and since I grew ashamed of my light and empty hands,
with a fear which lamed me,
there, hard before you, someone placed
such beautiful things within these poor shells,
that they have become almost too heavy for me and radiate
almost too much, overflowing with a great brilliance...

So take then what an overrich one
bestowed upon me, enshrouded, at the last moment—;
he garbed me, that I am like an equal
amongst trees: the winds grow softer
and rustle in me, and I bless you.

I bless you with every kind of blessing
that one sees at evening in the spring:
after days of whispering, frost, and rain,
comes a stillness, simple as a song.
The trees already know what is afoot,
the fields in consultation fall asleep,
the nearby skies have broadened out,
so that the earth has space to grow.

No word is soft enough to say it,
no dream is deep enough to dream it,
and all fairy tales are like empty cupboards,
for everyone has now put on the clothes
which rested fragrant in their darkness...

Written upon the receipt of your dear letter. In gratitude, trust, and friendship, your:

<div align="right">Rainer Maria</div>

Cordial greetings to Otto Modersohn

From the Album

<div align="right">November 26, 1900</div>

"For truly, Art is to be found in Nature; he who can extract it from Nature, he has hold of it.... The more your work accords with Life in its forms, the better it appears. From this it follows that no man can make a beautiful portrait from his own mind, unless it be that he has first filled his spirit with Her through much counterfeiting of Her; but that, then, can no more be called a man's own property, but has grown out of Art as handed down by Nature and learned from Her, an Art which fructifies itself, grows, and brings forth fruit of its own kind. Thereby the whole secret treasury of the heart will be revealed through the work and the new creation which he produces in his heart in the shape of a thing made."

<div align="right">Albrecht Dürer</div>

From Otto Modersohn's Journal, 1900–1902

<div align="right">November 26, Monday [1900]</div>

Oh, what great fortune it was for me that I found my Paula, a fortune for me that cannot be treasured highly enough. How I need just such a young woman. [...] Paula is a mature, abundant young woman with a hundred interests, with real and true aspirations, with a fresh and vibrant mind. How often when I am with her I feel as if I were growing wings, as if I were made lighter; everything becomes alive in me, becomes so light and joyous. That is worth so much to me! There is no question that I am inclined to be ponderous and brooding; how often I am like that when I am alone. For this, Paula is a true balm. She brightens, refreshes, enlivens, rejuvenates.

To Rainer Maria Rilke

<div align="right">Worpswede, December 1, 1900</div>

I have been at Clara Westhoff's. Now I have come home through the damp evening, past the birch trees, in the distance the twilight shadow of the scrub pines. And

the moon is shining again. And Max Klinger is probably coming tomorrow. And that is why we were sitting on Martin Finke's roof and cutting ivy to make a wreath for the door, old ivy with little green fruits, and ivy with clusters of little yellow flowers. And then we sat for a long time next to the chimney on the thatched roof, looking down at the little grain fields beneath us and the little apple trees, amazed at how different the big world looked from up there.

And Klinger is coming tomorrow — perhaps — I saw him once, three years ago, in Leipzig. I was in his atelier with several aunts and an elegant cousin. The cousin was a good conversationalist and had a gray suit on with lavender bows and hat, and she had a slender figure. I was insecure about the way I looked at that time and very shy about myself. I walked among all this splendor and glory and opened my soul wide to receive this great human being. And I was no longer embarrassed and felt that I was alone among these treasures, for the thought that I was permitted to or even able to say anything was far from my mind. I made my own rounds through this huge atelier and experienced everything privately. Only when I shook hands with Klinger as I was leaving did I look at him, the man in the brown jacket with the red beard. And with this glance I had the feeling that I was placing my whole being in his hands. He could have done with me whatever he might have wanted to. And he looked deep inside me with a long loving look so that everything began to tremble inside me. As I left I went past the gigantic frieze of Christ on Olympus, through the hall with the remarkable green walls and the gray lilac ceiling and the portrait he did in Rome. In the entryway where the walls of the stairway were covered with little white starflowers, I had to cry quietly. At that time I was very much like a child, so unprepared for any great event. Since that time, Klinger has receded further from me with every day that passes. Rodin had emerged. I began to see the weakness of the other. But at this moment his personality with that all-embracing look stands so vividly before me, and I sense a human being who strives and suffers enormously. Will he come, I wonder?

As for the rest? I have a great bouquet of white autumn berries on the table before me, those berries that say pop! when one steps on them. They are gleaming in the yellow lamplight and I caress them with my eyes. Next to them lies *Marie Grubbe* — I have wrapped it up with old ribbons and filled the binding with cotton batting so that it is soft to the touch. And next to that lies Walther von der Vogelweide. Under him lies *The Green Henry*. Do you know *The Green Henry*? It's very long and very tender. All the wisdom and the love of an entire German life is in this book. I love it very much. It is one of "my" books. This morning before work, when the fog was still enshrouding the earth, I read "Kennst du Pan?" How beautiful —

And after Christmas, or even better, after New Year's, I'm coming to Berlin for several months and will look at many beautiful things there and learn some things, too. Will you still be there?

Now won't you please write me something about *yourself*? I have the feeling I haven't heard anything for a long time.

<div align="right">Your Paula Becker</div>

Your blessing was so very beautiful. Let me reach out my hand to you.

To Carl Hauptmann

<div align="right">Worpswede, December 3, 1900</div>

Dear Dr. Hauptmann,

I have been living a great deal with you and within you these days. I read your journal for the first time. Its profound and beautiful sentences came to me and are now with me on my wanderings. And a great and serious happiness is inside me when I think that something as beautiful as your book exists in the world and that you gave it birth. Your wonderful faith in the good principle in humanity put me in such a solemn mood; and then this search of yours for the deep sound, the deepest sound. After reading this book one has such a clear feeling for the few important and true things in this life, and for the many unimportant and untrue things. And that is good. Let me reach out my hand to you, dear Dr. Hauptmann, to thank you for having given all of this to me.

And then let me reach out a second hand to you for being one of the very few people who have seen the hidden depths of Otto Modersohn's soul. There blossoms such an overflowing of simplicity and sweet naiveté and a gentle goodness of heart down there. The soil in which these flowers bloom is the true spiritual garden of an artist. But so few people find the key to this little garden of paradise. You have found it, dear Herr Doctor. And I believe I have found it, too. It makes me happy, to the very depths of my heart.

Have you told your dear wife about how our whole little group was a bit disconcerted in Hamburg, or at least very preoccupied with itself? All of us reproached ourselves afterward for having behaved so inconsiderately. But it was really more appearance than reality; we were really quite different deep down inside. But the great city and our pleasure in being there caught us by surprise.

There is a shining, singing moonlight night outside. *Very* beautiful. Everything's asleep, except for the goat bleating in the stable. And here indoors my peasant clock on the wall is ticking so loud it almost scares me—And now farewell. I reach out a third hand to you. Life is wonderful.

In heartfelt admiration,

<div align="right">Your Paula Becker</div>

To Otto Modersohn

Bremen, December 5, 1900

Dear,

Now I'm here, and for the time being I won't be getting away again. What are you doing during this gloomy weather? Shouldn't I really be with you, and you with me? I feel as if the world were turning over and over, making me slightly dizzy, so that I have trouble standing on my own two little legs. If I hadn't practically fought off the family tooth and nail, I would now be sitting in the theater for the second time since I arrived. Their intentions are all so well meant, but I fear that my poor little soul is being frightfully mistreated by all their love. I still *must* go along to *Così fan tutte* with them tomorrow evening before I can get back to Worpswede again early on Friday. It is something I look forward to very much. It's a bad thing not being where one belongs. And I do not belong here in the city. I kiss you, my man. And Friday afternoon I'll come to you in your studio. How do you suppose it was possible for Velàzquez to paint *such* pictures while he was at court? At the same time I'm writing this I have to help Herma with her English composition and listen to Henry's aimless banter. My little personality is totally extinguished here. Strange. I have nothing to say, and I feel nothing. That's just what I told you. I don't have terribly much endurance. But you are mine and you are fine.

A fervent kiss from your Love

From Otto Modersohn's Journal, 1900–1902

December 20 [1900]

Even though Paula has qualities and views that run contrary to mine, she does have two things in a way that no one else has, two of the best qualities that exist. One of them is her genuine artistic sensibility, a true understanding and a seriousness about art that I noticed earlier, especially in Paris and Hamburg; in front of my paintings and compositions, in reading Böcklin and Vogeler's stories; about her own work; and closely connected with that, a real sensitivity to nature. [...] The other thing is a happy disposition, cheerfulness, freshness, liveliness, a sunny nature; that is just as precious to me and just as important as her artistic side. And like the latter, it is a rare gift that nobody can give to oneself. For me these two things are her dearest and best aspects. And even if little peculiarities sometimes come, they arise out of the good artistic intentions of this twenty-four-year-old. And so, let them be. She tries to avoid all gloominess, [...] and hates in me certain ill humors. [...]

Bremen, Wachtstrasse 43
December 23, 1900

The family is gathered around me again, and all of them are in the pre-Christmas spirit. Just now they are in council, deciding what they want to give me. But I told them I already have everything I want from my husband-to-be. And now they want to dictate this letter for me. Altogether they are acting a little crazy. Kurt is in a wonderful mood, as happy as a boy looking forward to the holiday, and we're singing all the Christmas songs we know. And you, dear, are you at home and being good? Be sure to go often to Saint Christopher in your cathedral and let his golden leaves rustle over you. And when you're there think of me, as I shall be thinking of you. And the little yellow nightshirt, did it make you happy? So far things are going well for me here, and I can still manage to put up with the city. This morning Henry woke me, put Papa's heavy fur robe over my nightgown and the two of us climbed out onto the flat part of the roof, fed the pigeons, and listened to the great cathedral bells. I should love to ring them myself someday. That would be fine, wouldn't it? This afternoon I walked in the twilight through the city, and there stood the old boy, my cathedral, so solemn and venerable, with his two great towers standing out against the blue sky. And then suddenly one final ray of light struck the lower part, the golden portico, and the light on the market stalls shimmered a golden red. I am the complete observer, studying everything. For instance, it was such a pleasure today studying the lines in Father's cheek. It would be one of the most wonderful things I can imagine, to be able to do a proper painting of a face like that. To place it in space in a new way, fine and intimate in character, color. If I could only manage it.

Now it's night. Everyone is asleep except our parents. And I can hardly keep my eyes open, either. But I wanted to be sure to visit with you before I go to bed. It's fun to walk around in the city in my furs. And you, dear? Don't be sad when you think of me or yearn too much, but be happy that we belong together. I feel that this separation will deepen our love and make it stronger in spirit.

And now just a word about Pauli. I think his letter to you was nice, but that is no reason for you to change your answer to him. Once one has principles which come from the bottom of one's heart, they cannot be simply overturned.

To Otto Modersohn

Bremen, Wachtstrasse 43
December 24, 1900

You, it's still Christmas Eve, or already Christmas morning. The smell of pine and candle wax is in the air and in front of me stand empty green wineglasses. The five candles of the candelabra on my Christmas table have almost burned down. The

light flickers once more over the surface of a thousand lovely things. Many amusing presents for our home. A *wonderful* old mirror, and next to it snuggles my dear mink, which I lovingly let curl around my shoulders.

Milly surprised me with a wonderful traveling bag. And I'm sitting here among the Christmas greenery in a fiery red velvet blouse. I wonder if you will like me in it. And then, on my table is a dreamy little cloud puff of a bridal petticoat. You? I wonder, will the two of us one fine day walk over the hill to the little church? I felt *very* close to you all day, dear. At noon, without a word, my father pressed your letter into my hand. Then I walked through the city at twilight while the bells were ringing. Isn't it funny? Just this morning I told Milly the same thing you wrote me this afternoon. The forms and colors in a city like this have so much originality. I haven't even begun to exhaust the possibilities. In fact, it seems as if I hadn't even made a start yet.

I am so very deeply happy that I'll see you again before I go to Berlin, and also that you will be comfortably together with my family once more. You, my dear, they all love you so.

Vogeler popped in for a minute on Christmas afternoon. He was in town looking for wedding rings for Martha and himself—You do realize, don't you, how very lucky the two of us are? I carry around a great and quiet feeling of gratitude in my heart all the time. Everyone in the family sends warm greetings to you. I'm with you with all my love, and all my love embraces you. Do you feel it?

I would be very happy if you could come here on the second of January. I'd like to get off to Berlin early so that I can get back that much sooner. But if that isn't convenient, of course I'll wait until the third.

—Do you think we'll be celebrating next Christmas in *our* own home? I don't even dare think of such happiness, dear. And you? —I send you a loving kiss.

<div align="right">Your Girl</div>

To Otto Modersohn

<div align="right">Bremen, Wachtstrasse 43
December 25, 1900</div>

Dear,

This morning when I finally managed to descend to the lower regions of the house, about ten o'clock, where coffee was being served—we three sisters had again been celebrating the caroling of the bells up on the flat roof—I found your cards from Münster and in my mind's eye I ran along the little gabled street toward your beloved cathedral, and I thought to myself, there he actually is, walking along in his brown overcoat with the big collar. My man, you are spoiling me; Bismarck letters and Andersen, such an abundance of pleasures. This afternoon Herma's three *Jungbrunnen* books arrived and she was beaming with pride. I thank you

for being on this earth, even if you are far away, my dear, dear King Redbeard. In spite of everything I have immodest plans which I must quickly tell to you. Could you perhaps be with us on New Year's Eve? It is always quiet and intimate here then with all of us together. For my parents' sake and for yours, and don't forget me, for my sake too, for the sake of the whole family, I wish with all my heart that their new brother, son, and my future husband can be with us. But you yourself must know, dear, how you feel about it and what your parents might think about it. How are you spending your days? I am fine. Everyone here seems to be on the wings of a joyous holiday, and the inner sunshine that everyone seems to be filled with is building golden bridges among us. This little piece of Christianity warms me and I accept it for the fairy tale it is. And then, you know, it is such a celebration for women in particular, because these tidings of motherhood go on and on, living in every woman. All that is so holy. It's a mystery which for me is so deep and impenetrable, and tender and all-embracing. I bow down to it wherever I encounter it; I kneel before it in humility. That, and death, that is my religion, because I cannot comprehend them. This is not meant to make you depressed. You must love it too, dear. For those really are the greatest things on this earth. I love the Bible, too. But I love it as a beautiful book that has brought so much loveliness to my life. Now, don't let all this trouble you. When I am in Münster I won't say these things. Only to you, just to you. In the next room Milly is singing love songs, and my soul is gently lulled by the sound of them. Life is gentle and soft and tender and smiles at me from eyes veiled in dreams. And I kiss them and love them—Kurt said just now, slapping his leg, "You're writing *four* pages to him?" I made a face at him and said, "Yes!"

Yes, dear, and now I have to go to bed, and I kiss you one thousand times.

A lovely Christmas greeting to your dear parents.

<div align="right">Your little Bride</div>

To Rainer Maria Rilke

<div align="right">Bremen, Wachtstrasse 43
Still Christmas</div>

Dear Friend,

I have been feeling so Christmasy this whole time, and so I must come to you and tell you about it. It's such a wonderful celebration and is so alive and warm. It's a celebration for mothers and children, and also for fathers. It's a celebration for all humanity. It comes to a person and lays itself warmly and softly upon one and has the fragrance of fir trees, and wax candles, and gingerbread men, and of many other things that once were, and of things that are going to be. I feel that one must grow with Christmases. I feel as if the barricades are falling which one has built up wearily and small-mindedly against so many things and so many people; as if

one were progressing, and as if the vase could contain more and more, so that with each year a new white rose could bloom in it and beckon to the others, shine into their midst and stroke their cheeks with its shimmer and fill the world with beauty and fragrance. And that is life, a life like a prayer, a pious prayer, a jubilant prayer, a lovely and smiling prayer which descends deeper and deeper into the meaning of life, whose eye grows greater and more serious because it has seen so much. And when it has seen everything, the final thing, then it may no longer look, for then death comes. Perhaps in this sense I can reconcile myself with death, because I, too, must suffer it someday. Then it will be better this way—I'm looking forward to talking with you again. You listen so well and in such a friendly way, and I'm not shy about speaking of things the way they are inside me.

—We have a beautiful green Christmas arbor in the living room. My little brother built it. It is a beautiful corner in which to read your *Stories About the Dear Lord God*. I put the book under the Christmas tree for Milly, and she is very happy and sends you her greetings. And I also send dear greetings and look forward to seeing you and am happy because of you. In Berlin you will be my only piece of Worpswede, and that's a great deal. It is growing darker. I'm sitting in the bay window over the river and letting the water glide past below me. Usually this water makes me so sad. It's so slow and soundless and patient and the long barges rest upon it as if they were quietly crying. Really all the other things around the water here are crying, the great red warehouses and the little white buildings, and when they are reflected in the water they tremble and cry even harder. But I think they are not crying today. Because it is Christmas. The houses, I believe, are not crying today nor is the water, but the water is still and old and sad and good, and smiles very seldom and as if in pain; for life has made it yellow and murky. It is like my dear father. Life has also been too hard for him, and the days too many, and they extinguished the little lights and candles and torches in him. Someday I must tell you about him. He is someone who once made me think that growing old would be terrible. But now I don't believe that any longer. Farewell. I must break off here. It was only a short, quiet hour which came into blossom. Now the world with all its demands is back again. And so I shall now try to meet some of them. For things are going so well for me.

<div style="text-align: right">Your Paula Becker</div>

To Otto Modersohn

Bremen, Wachtstrasse 43
December 27, 1900

My Rex, my King, my Beloved, Dear, You Best of All,
my Knight with the little dog,
What a sweet letter, you. It was like a soft caress of your hands. I held myself out
to you and gladly let it happen.

How strange a thing is love. How it lives in us, rests in us, and takes possession
of every fiber of our body. It envelops our soul and covers it with kisses.

Life *is* a miracle. It overpowers me so, that often I have to close my eyes as if you
were holding me in your arms. It flows gently over me and shines through me and
lights up rich and subtle colors within me, so that I begin to tremble. I have a won-
derful feeling about the world. Let it do what it wants. It can hobble along instead
of dance, as much as it wants; and screech instead of sing, as much as it wants. I
walk by your side and I lead you by the hand. And our hands know one another
and love one another and are content.

> When two are in love with all of their heart,
> They can suffer the pain that comes when they part.
> When two are in love with all of their soul,
> They must suffer whatever the heavens will dole.
> When two are in love with Divinity's ardor,
> A miracle happens and brings them together.

And that miracle is happening to us. We will be seeing one another again, in
spite of our good-byes in Vogeler's little library. And soon, my treasure, soon.
Come whenever you want, my dear. Come on New Year's Day or come on the sec-
ond. Do just exactly as you wish. I'll like anything you do.

I have the wonderful feeling that this period of separation is purifying our love
and making it more spiritual. The thought of it fills me with a feeling of great
goodness toward the universe. My King Redbeard. I am the maiden who loves
you and who gives herself to you, whose modesty lies in pieces before you, melted
away as in a dream. That is my humility, dear, the fact that I give myself to you as
I am, and place myself in your hands and shout, here I am.

Let it be thus to the end of our lives. Let me gently stroke your red beard and give
you a kiss on each cheek. Raise up my soul and drink it. Drink it in a hot kiss of
love.

I am forever,

Your faithful Woman

To Otto Modersohn

<div align="right">Bremen, Wachtstrasse 43
December 28, 1900</div>

My Own,

It's midnight and I really ought to go to bed. But I long for something deep and clear and complete. In spite of night and darkness I want to be with you for a little. This city is now beginning to overwhelm me, press in on me, and squeeze me to death. These little half-people are gradually beginning to cut me in half, too! Soon they will chop me into little pieces; and I don't even want to be *half* a person, I want to be complete. I can't get to myself here. I can't hear my soul speak and I can't answer it. Beauty can no longer find the path to it. Beethoven's Fifth Symphony, for example. It took such powerful hold of me in Paris and stirred up the deepest chords of my being. When I heard it today, it scarcely penetrated deeper than my skin. My nerves would not, could not react. And I hate myself in this half-life and lameness. My little being yearns to be back at the time when it didn't limp about, and it looks forward to the time when it won't limp again. To trump that thought, here's an inkblot.

Things are not going any better for Clara Westhoff. She staggers along with her own crown of thorns, hoping for a quick end to this year 1900. Tomorrow the two of us, and Heinrich Vogeler, are going to the Rassows'. I wonder what that will be like. I'm happy for you that you won't be there; because all this dabbling and meddling with art, none of it has any point at all. What's the point of it? But as a matter of fact everyone meddles here anyway—I wonder if a note from you will be here to greet me along with my morning coffee? It is always such a delight to feel a letter crinkling in my pocket all day long. Today I showed Clara Westhoff your droll caricatures of the little folk of Münster. They had the same [amusing] effect on her, she said, "as Rilke's talk in Hamburg." And you, my dear? Are you and the world still getting along happily together? Can you still smoke your little pipe in peace? I certainly hope so for your sake, and for your family's. But now I must jump into bed. This was just supposed to be a little epistle, a little epistle filled with sighs and exhaustion. Dear, I have my copy of the Bismarck letters now and am reading them. How beautiful they are! Really too beautiful to read alone—we shall have to do it together. I can't stop yawning. Good night, my Redbeard. I'm thinking tenderly of you and kiss you.

<div align="right">Your Girl</div>

Bremen, Wachtstrasse 43
December 30, 1900

My Dear Aunt Marie,

[...] I'm overflowing with happiness because of my dear man. Life is quiet and lovely. I sit here, little me, without stirring a muscle and hardly complain at all, while fate caresses me with its gentle hand. I have the feeling of living with great ease, and of gently enjoying every moment. I find it so wonderful whenever objects and sensations come over me, and not the other way around. It is always bound up with a kind of brute force, I'd say; I mean the latter case. That is the way most social activity in the city appears to me. People are reluctant to wait even a moment for the slightest little thoughtful spring to well up out of their hearts. They can hardly wait to kill everything with cliché words and cliché feelings. We have no desire to visit much here in the city, except at home, of course. It doesn't work out well. One gives nothing, because the superficial way we have of conversing makes us very careful to keep to ourselves the little we have. And so what we receive is really only a sad, distant sense of things.

Otto Modersohn is celebrating Christmas and New Year's with his parents in Münster. I don't know when we are getting married. We really have the feeling that we could any day we wanted. It will probably turn out that we'll make a sudden decision and one beautiful summer morning walk together up the hill to the little church.

Out in Worpswede our little community leads a quiet life: Vogeler and his little bride, Otto Modersohn and I, and Clara Westhoff. We call ourselves "the family." Every Sunday we're together, enjoying each other's company and sharing a great deal. It would be wonderful to live my whole life this way.

Farewell, my dear. I don't think that I have written you anything sensible here. I always forget to, feeling as I do that what I'm experiencing inside is so much more valuable and important than what goes on outside. And as long as that doesn't threaten to knock me over, it really doesn't matter to me that much. As for the rest...oh, well [...]

To Otto Modersohn

Bremen, Wachtstr. 43
December 31, 1900

My Red,

The thought of a letter from you made me jump out of bed early this morning. The domestic side of me submitted with quick eagerness to its tidying-up chores and then slipped into its little green dress. But the twins received only their cards, and were joyful and proud about it. Herma is especially beaming about her future family relationship with you. All of us are *very* much looking forward to your arrival.

You will then be able to spend the night here, won't you? And then when you go out [to Worpswede] I shall accompany you so that I can pack up all my things. And perhaps there will also be time for a lovely walk, if the new mushy snow hasn't turned the moor into too much of a morass. On the morning of the first, Clara Westhoff and I plan to take a little hike over to Worpswede. And then on the second, for your sake, I'll return to the city so that I can wait for your arrival at the station there. My dear, that will all be lovely. I cannot put up with this town *very* much longer; better Berlin. Day before yesterday Vogeler and the two of us girls were at the Rassows', further confirmation that we little people don't belong in this city. And yesterday evening, *Die Meistersinger*. I believe I've grown quite a distance from this opera; when I saw it three years ago in Berlin I liked it a lot better. Perhaps I was less critical about it then, perhaps the performance was better—

Dear, the world is swirling around me here again. Henry is cracking his whip; in the background they are conversing around the copper table. And inside me I'm very restless because of this city. *Auf Wiedersehn,* my man.

<div align="right">Your Paula</div>

Please squeeze your dear parents' hands heartily and wish them, for me, a New Year without worry and tribulation, and a quick recovery to your sister.

To Otto Modersohn

<div align="right">Ritterhude, January 10, 1901</div>

Dear, dearest,

Well, now we are really apart. It all happened so quickly and suddenly. I think that character in the church with his broom was an angel who wanted to sweep away the gloomy moment of our parting. And now, so soon again, we must say *auf Wiedersehn* to each other. Each of us is going to have to try to remain brave now and work hard during the two months we must be apart. For you, my King, it will be beautiful, beautiful pictures—for me: soups, dumplings, and stews.

I wonder if your trip home was as wonderful as mine? From Ritterhude I ran back to our little church again, and then back to Ritterhude. First in the company of an old seaman of thirty years and his cargo of eggs, and then alone, alone in a wide world of yellow and blue colors which descended deeper and deeper and embraced me lovingly and kissed me. I felt very pious during those moments, in the face of this nature at prayer. Oh, my man, how wonderful it is to have a heart that beats and lives and stirs in our breast, to be part of the great universe—a flock of wild geese flew past overhead. I love this breed of birds and their whistling high above me. I can understand so easily that people with pantheistic religions were able to read the future in such things. It has always been something that I have loved very much, something very still, very beautiful. I remember one silent evening in Norway when the rush of a hundred wings sounded very close above me. I

looked up, and above me was a trembling carpet of many, many starlings whose wings were bronze in the light of the setting sun. That sight spoke to me in that silent hour.

And now a kiss for you, my Otto. A cordial handshake to your family. Have fun skating now, and don't keep looking down all the time.

Your little Bride

To Rainer Maria Rilke

Ritterhude, January 10, 1901

Dear Rainer Maria,

In great haste, a word from the train station. We have again spent wonderful days together, we the "family." We had a wonderful time skating. And today they took me past the little lonely church to which people can come to pray only on ice skates. It sits in this almighty splendor of winter like a prayer itself, like silent supplication. And then we rushed over the yellow ice under a blue, a night-blue sky. And then a little way on foot. The river cracked beneath me, and above me a flight of wild geese cried.

And so I am coming to Berlin now. Friday or Saturday. Shall I visit you at your home Monday at twilight?

Please write me an answer at Eisenacher Strasse 61. Please excuse this ugly scribble. I look forward to seeing you again.

Your Paula Becker

1901–1905

In accordance with her parents' decision, Paula Becker spent the first two months of the year 1901 in Berlin in order to learn how to cook; they did not wish to visit upon their future son-in-law an incompetent housewife. She managed to get through the course cheerfully but reluctantly. The tedium of the cooking school was lightened by being with Rilke frequently and by visits to museums and exhibitions. At Gurlitt's gallery, Böcklin's exhibitor, she saw many of the painter's works; the experience was powerful. The news of Böcklin's death (January 16, 1901) moved her deeply. On the ninth of March after a short visit with relatives in Dresden Paula Becker was back in her little lodgings in Worpswede.

On the twenty-fifth of May, the Saturday before Whitsunday, Paula Becker and Otto Modersohn were married, not, as they had wished, in the little church in Worpswede, but at the sickbed of her father whose health had been a matter of continuous concern from the beginning of the year. The ceremony was performed by Otto's brother Ernst, a pastor "of very strict observance" according to Frau Becker's observation, which did not fit in with the liberal attitudes of the Beckers at all.

Their wedding trip took them from Berlin to Dresden and Schreiberhau, where the couple were guests of Carl Hauptmann and his wife for about a week. After further short visits in Prague, Munich, and Dachau they returned to Worpswede on the nineteenth of June longing for their own four walls and for the quiet of the country.

Several architectural changes had meanwhile been made on Modersohn's house, and with gentle but firm determination the young wife had also carried through changes in the interior. She was fond of handcrafted and unusual objects and old furniture, and she was able to win her husband over to her taste. It was never Paula Modersohn's intention to become a typical housewife, and she also casually assumed that it would not be expected of her. "[...] They got up at seven in the morning, and a few domestic things were taken care of by nine o'clock. Then she would disappear on her little path through the meadows behind the clay pit and head for her atelier, avoiding the road and its inevitable encounters with people. The noon meal was at one o'clock. After a ten-minute nap she would appear at afternoon coffee, fresh and ready for work, and at three o'clock her painting began again and went on until seven. [...]" This according to her sister Herma.

Her evenings belonged to Otto or to the Worpswede society. Sunday was a day of rest. Despite the highly structured days, Otto's child Elsbeth was not neglected and the new mother quickly won her heart. Everything was orderly and peaceful— nevertheless, the young wife began to experience if not disappointment, at least disillusionment. The union of body and soul which she had expected from her

marriage remained a dream. To that was added the unfulfilled desire for a child of her own. A marriage without children was unnatural to her highly developed maternal instinct. And another sorrow caste its shadow over this first year of her marriage: the loss, or what she interpreted as the loss, of her friend Clara. The Rilkes, who had been married on April 28, 1901, cut themselves off from the Worpswede "family." Paula Modersohn had been expecting an even greater sense of community. She accused them of abandoning her, and after the receipt of Rilke's corrective answer to her letter to Clara (February 12, 1902), Paula withdrew, wounded and hurt. She interpreted as arrogance what was in fact the concealment of a distressing situation. For Rilke was unable even to feed his wife and child; a daughter, Ruth, had been born in December 1901. But Paula Modersohn felt only that she had been deprived of the human contact with Clara, of the communication that was necessary for her, and of the bonds they had in common, for which even her husband Otto could not offer any compensation.

Paula Modersohn was without any trace of radical feminism but the fact that twice she had chosen women to be her closest confidantes, Jeanna Bauck and Clara Westhoff, is an indication of how strongly creative women were thrown back upon their own resources, and how difficult things were for them to assert themselves and to gain a sense of security. The word *Malweiber* ("painting females"), which was current at the time among men painters, is further indicative of the situation. In question and answer, in criticism and encouragement, Paula and Clara had sought their different artistic paths together. One gets the impression that since Paula Modersohn was now bereft of this close communication, her journal entries during the period of alienation from Clara are all the richer in written thoughts on art. Otto Modersohn, sharing his wife's indignation, did nothing to smooth things over. Together they looked for reasons for their sudden antipathy toward Rilke, and they found them in his Slavic foreignness—he seemed to them "undeutsch." There are echoes here of Langbehn's Germanophile and potentially dangerous book, *Rembrandt als Erzieher* [*Rembrandt as Educator*].

Paula Modersohn gained her husband's consent at the beginning of 1903 for another stay in Paris. It was probably not very easy for him to understand that she needed not only artistic inspiration and the comparison of her art with what was being produced there, but that she also had a simple need for the colorful and lively activity of that great city. Shortly before Paula's departure Otto wrote a letter to Rilke, who was finding Parisian life difficult to bear at that particular juncture in his life. The letter vividly illustrates the difference of temperament between husband and wife: "That dreadful wild city is not to your taste—Oh I can believe that. Nothing, nothing at all is more important to me than my peaceful, serious countryside. I could never endure living in such a city—I should look at and enjoy the art that is stored up there and then quickly return to my peace and quiet." That reads very much like a protestation against the wishes of his wife.

Together they left Worpswede on the sixth of February 1903, making a stop at

Münster in order to celebrate the birthday of Otto's mother. On the tenth Paula arrived alone in Paris where she first took lodgings at her old address in the boulevard Raspail. She moved, however, on the sixteenth into an atelier at 29, rue Cassette.

Her weeks there were highly productive; she spent much time in the galleries. With the Rilkes she saw the Hayashi collection of Japanese woodcuts which were going up for auction and which impressed her; she experienced Rodin, his personality, his work, above all his sketches; she found a connection with the Classical art she saw in the Louvre; she occupied herself with the Fayum portraits which she knew from reproductions; she gained a deeper insight into Rembrandt and learned to admire more and more the older French masters—and everywhere she went she took her sketchbook.

She was frequently with the Rilkes. Externally the breach seemed to be healed, but in her heart the bad feelings smoldered, and Rilke's personal situation continued to give sufficient reason for misinterpretation on Paula's part. And she saw her friend Clara suffering and being transformed into someone she did not know.

Letters full of love were sent to Worpswede; Paula's happy mood found expression in the amusing way she addressed and decorated the envelopes which she casually entrusted to the French postal system. Her bond with her husband never seemed to be closer or more heartfelt or self-evident than in this period of separation and distance. Finally, impatient for a reunion, she returned home somewhat earlier than planned.

In July 1903 the little family traveled to the North Frisian island of Amrum; for Paula Modersohn this was a welcome change from the metropolis of Paris and one which she enjoyed heartily. Indeed, her whole life is marked by a rhythmic alternation between periods of absorbing stimuli and quietly working them out in her art.

In contrast to Otto Modersohn, who was painting a great deal, she thought that the winter 1903–4 was not productive for her; instead of painting she read many French books—the next trip to Paris was being planned.

In April 1904 Otto Modersohn visited his parents for several days; his wife happily took advantage of his absence to live the life of a single woman again. She moved into her beloved little room at the Brünjes' household and enjoyed her independence and solitude with an intensity which she confirms with surprise, but also without feeling uneasy about it.

From Otto Modersohn's travel journal we learn that they were again on vacation in July 1904; from the second to the fifth of July they were with the Vogelers and her sister Milly and brother Kurt in Fischerhude, a village near Bremen off the main thoroughfare to Hamburg. There they enjoyed swimming in the little Wümme River. On the seventh of July the couple traveled via Berlin to Dresden, groaned about the heat there, but in spite of it hiked in the sandstone hills along the Elbe and returned by way of Kassel and Braunschweig. Otto Modersohn had

long promised to show his wife the Rembrandts in these two cities. On July 30 they once again traveled out to Fischerhude where they met Herma, and also the Swiss painter Louis Moilliet, August Macke's friend, who stayed in Worpswede frequently during that time.

There is very little written evidence from the year 1904. It is clear from Paula's Christmas letter to her sister Herma, who was in Paris, that the winter days in Worpswede were particularly depressing to her. It was a damp, gloomy, and warm winter which prevented Paula from ice skating and ridding herself of her excess energy. Physical activity was essential to her. It was in this mood that she made plans for yet another stay in Paris which she was to succeed in carrying out, even though Otto Modersohn did not give his consent enthusiastically.

To Otto Modersohn

<div align="right">

Berlin, Eisenacher Str. 61, Entry 3
c/o Frau Herma Parizot
January 13, 1901

</div>

My Man,

Well, now I'm in Berlin and feel very tamed and very confined and would like to blow up these walls so that I could see a little bit of the sky. I think I'm going to have a very hard time of it for the next two months. I don't fit into a city like this, and particularly not into this elegant district. I fall right out of the frame. It was quite a different thing being in Paris, in the Latin Quarter. The people around me here are sweet and friendly. But they live their lives in such strict adherence to their social status. And yet there are delicate, vibrant, sensitive women here. Garden flowers. But where I have to flower is in the field. Everything will turn out all right. Only my poor little soul is marching right into a cage. If I were to give it the freedom it had in Worpswede, it would lash out like a bull in a china shop.

I haven't seen anything yet. Just a lot of faces. Many of them interest me and attract my attention. But mostly I have this strong feeling of having had my wings clipped. Yes, things will get better, but not until I've sorted out my life into art and cooking. Nearby is a twofold cooking school, both simple lunches and roast turkey. Dear, wasn't our last day on the ice together really wonderful? And did you have just as beautiful a time afterward with your family as I did with mine? I think of that with longing. And isn't Worpswede simply beautiful? I wonder if all of you are on the ice there today. I would be so happy for you. It brings such life and health and joy.

This afternoon I am going to see Rilke and thank him in your name, too, for the *Stories About the Dear Lord God*. Unfortunately, I don't really like *all* of them. It will be hard talking about them. Well, we shall see. He is, indeed, a person who makes things easy. When Herma visits you again, have her recite "Ich denke Dein" for you. I send you a kiss, my Red. I am yours with all my heart and my soul and all my mind.

<div align="right">

Fervently your Paula

</div>

Journal

At dusk I went to see Rilke. I entered a quiet, industrious life full of beauty and tenderness. He was not as happy as in Worpswede. He lived in creativity there and in the fullness of his art. Now he is catching his breath for the new things to come.

He read one act of the new Hauptmann play to me, a play in which the author has descended to the depths of the world and has brought wonderful things back up into the light with him. As a drama it may have its shortcomings, but a great soul speaks to us through its lines.

That spirit that is related to everything that unites the human being with art and nature, for me that is God. And Hauptmann has recognized this God and struggled with him and one is awed in the face of such a struggle. But naturally the press has no idea of such struggling and such awe.

Whenever I walk home along the lonely canals I rejoice in the misty beauty of this part of the city with its black and red hues. Only I must not go to the Tiergarten, for there I begin to yearn too much to return to my real nature. Here the poor girl is gagged and suppressed and altogether different from the way she would like to be.

To Rainer Maria Rilke

Berlin, Eisenacher Strasse 61, Entry 3
January 14, 1901

Dear Friend,

I'm grateful to the electric tramway for having guided you home so gently and so maternally; and that we are to see each other again so soon is a great joy to me. Your great work and the number of your Russian volumes lay so heavily upon me. I thought that the books would turn into a barrier that I could not hop over. (I now have quite a respect for barriers.) But it now seems that there will be a path. And I'm happy at having a view through to it—

—Well then, Cassirer and Daumier? Very, very beautiful. Will you be coming before noon? That will be lovely. I greet you. And on some Sunday soon you will read about the pale child to *me,* won't you? It's been a long time since I was supposed to hear it again. Today I can put up with Berlin a little better. One just grows older and more sensible in the first forty years.

Well then, *auf Wiedersehn*
Your Paula Becker

To Otto Modersohn

Berlin, Eisenacher Str. 61
January 15, 1901

I was at the museum today and heard the angels in heaven singing. It was so beautiful I had to come to you by letter right away and reach out and offer you my beak for a kiss. Art really is the most glorious of all things. Here in Berlin, with all these feathered hats and these dreadfully noisy trolley cars, art is my sweet and loving mother and a shelter in my distress. Then I sit very quietly in the midst of all this noise and curl up inside myself. I have a smile inside and my soul dwells in the Elysian fields —

— Your Rembrandt *is* a great and mighty figure, indeed, a king. I don't like all of his paintings. Many of them seem very far away from me and beyond me; the *Consolation of the Widow*, for one. He has color tonalities that I first had to adapt to and that weren't sympathetic to me at first glance. But then I saw that you were right. There is great vibrancy there. The little sketch of the angel in the stable at Bethlehem with Joseph and Mary is wonderful. The light on the angel's wings and partially on his arms, and his hands, and Mary with a blue mantle and a remarkable touch of red, and the cow's head. It's all so moving and human and so very, very deeply felt.

— Oh, these depths in our hearts! For such a long time it was hidden from me in the mists, and I hardly could know or sense it, and now it seems to me as if each of my inner experiences were lifting the veils and as if I could look into this sweet, trembling blackness that contains everything that makes life worth living. I have a strong feeling that everything I have dreamed about my own art up to now has not been nearly deeply enough felt. It must penetrate the whole person, into every fiber of our being — One of the little angels that sang a particularly sweet song was a photograph I saw at Keller & Reiner of a Böcklin painting. Otto, it was marvelous. You know it? Three girls walking along the shore at evening. The one in front, a brunette, walks along shrouded in a dark veil, and behind her, an enchanting blonde with floating features. We have to have it, it's *so* wonderful. I like to think of Böcklin in a very, very gentle way to myself, because all of Berlin is jabbering loudly about him. Why is it people have to blather on about everything, even violets and roses —

— At the end of my tour I saw Velázquez. He had a very refined and cool effect on me, almost too moderated an atmosphere for me, I think. A house with central heating is no longer right for me anymore. It should be cool in the hallway but warm in the main room, and whoever touches the stove has to get burned. And there should be life everywhere. No controlled palace temperatures for me, thank you, for that would mean I'd have to get high heels and little silk stockings and froufrou dresses, and I certainly don't want to commit your future to expenses like that. I so love the old German masters and their lamentations of Christ. But

the Dürers I saw today seemed a little too well-nourished and self-satisfied. I like to hear what hungering, searching souls have to say — I saw wonderful old wood carvings and fine relief portraits made of colored wax, period of Charles V. I saw so many beautiful things and I'm still living in their midst.

Dear, I still haven't received a letter from you. But when I was looking at all these glories today and all that splendor, it seemed to me as if you had written or as if I had been speaking with you. Our two souls would have resonated and harmonized at much of what I saw —

Sunday with Rilke was lovely. Listening to his voice was like a little piece of Worpswede after the earlier anxiety caused by the roar of this huge city. He read me the final act from the latest Hauptmann play. It made shivers run down my spine. There is such wonderful depth to the play. It's like looking at life from the very center of things. I also saw a picture of Hauptmann as a young man. It was very much like his Hannele. When Milly comes to visit you again have her sing "Und meine Seele spannte weit ihre Flügel aus." That's the way I often feel whenever I'm aware of how much happiness has been showered on this earth —

— As to my cooking? So far I've simply taken a look at some cooking schools, but I haven't been able to come to a final decision. There is a catch to every one of them. But it will all work out —

And now here is a quick kiss, a bridelike kiss, for your red beard, my King.

<div align="right">In love forever and ever
Your Girl</div>

And how is the ice? And how about your pictures? And my greetings to the others, too.

To Otto Modersohn

<div align="right">Berlin, Eisenacher Str. 61
January 17, 1901</div>

My Dearest,

How wonderful to get your note yesterday sailing under Clara Westhoff's colors. I carried you around with me all day. And when I was tired of looking at the museum I sat myself down in a quiet corner next to Verrocchio's enchanting lady, the one who holds flowers in her slender hands against her breast. There in the presence of so much beauty I read you through once again, and I spoke with you. I spent some time with Böcklin's work and had never found it so beautiful before. Just that springtime painting alone of the Three Ages of Man. The many details in the grass and the flowers are so moving. And in the distance, particularly on the right, the bewitching silhouettes of the leafless trees. The little brook is so simple and dear; and the lovers, the silvery light-blue girl, so charming, with a delicate veil around her hat. I'm so happy to have a much stronger feeling about all of this

now than I had before. In his book Böcklin speaks against a too dominant blue. And yet the sky in this picture seems to me too blue. I believe it would have a more gentle and springtime effect on me if the blue had been toned down. In the *Elysian Fields* there is a little corner on the left which seems wonderful to me. A couple in love drinking life from golden bowls, so deep and colorful and grand and simple it all is, and the dark lawn, too, on which they are seated, and the silent water before them. But Dr. Meyer is quite right, his painting doesn't age well; this picture and one more, I think it was the *Pietà,* have many cracks. In the Sleeping Nymph and Fauns I found many happy details. The overall impression of its color was not very satisfying to me. The great brown massing of the fauns' bodies probably called for more blue to balance the whole effect. At least I think that's why the painting seems really rather disappointing to me. But the silvery veil covering the nymph, that is something. The way it lies against her flesh and reveals the body beneath it, and the way its silvery points sparkle. And the ivy is so wonderful, too, and the stones covered with lichens and the urn against which she is resting.

Otto, there are so many, many, many wonderful things in life. So often I feel as if I should simply sit down quietly and reverently in their midst and hold my breath so that none of it can escape—Dear, it's evening now. I'm sitting all by myself up here in my quiet room and all kinds of sweet thoughts come to me. I must hug you once more, very gently, as if with my soul. Just a moment ago Maidli was playing on her piano so wonderfully in the darkened room next to me. And then she left, too. I wish you could hear her sometime. It's something extremely soft and tender, very sad, painful. She gives herself completely, but when she speaks to others, her shy soul holds itself back. Now I have to go, too, dear, away from you and me and out among the others. (Today it's to be Lilly Stammann, from Hamburg, who is married to a sculptor from Berlin named Bernewitz, formerly a pupil of Begas; both of them good people—she is even touchingly good—but bad musicians.) Farewell, sweet dreams, my dear. Soon the nightshirt will be arriving, too. Saw Wilhelm, too; but he—was freezing.

To Otto Modersohn

Friday [January 18, 1901]

Arnold Böcklin is now no more. Dear, the news fills my mind constantly. I keep thinking of him, the great man. It was a beautiful death. What I mean to say is that he still had so much within him. He was not one of those who were gradually hollowed out by the power of time. I know little about his son, the family tragedy. But I believe that it was a cause for great bitterness in him. And yet, the fact that a seventy-three-year-old man can still feel such powerful bitterness is a wonderful thing to me—Dear, I'm happy that we read his book together, before he died. It makes me feel as if we were able to press his hand before he parted. This death

makes me feel very solemn, almost pious. When a tree drops its leaves in the fall we look up at it and give our blessing to the will of nature. For energy does not die. In the spring a new green magic comes to life. And spirit, the spirit of Böcklin? Where do you suppose it is now? Do you suppose it will appear to us again in flowers and trees? Perhaps I shall see him next spring again, blossoming on the Weyerberg. Thinking about that makes my humility and love of every blade of grass grow a thousandfold. And even before this, I adored them so. I do think, by the way, that I'm becoming more pious, perhaps just because of this impious city. You know, my dear, that I don't mean this in a Christian sense; there are plenty of churches here for that. But I see so few truly pious faces. In the room next door, Maidli is accompanying her brother Günther. He's singing Schumann lieder, about the nut tree and the maiden: "Das dächte die Nächte und Tage lang, wusste selber nicht was." —I have recently had such a strangely gentle quivering and dreamy feeling about life. In the spaces between these big, cold, old-new buildings I see so little sky, but I know it's there and I carry it with me. These are days of gentle rustlings.

<div style="text-align:right">

From my heart, from the very depths of my heart
Your Most Beloved

</div>

To Otto Modersohn

<div style="text-align:right">

Berlin, Eisenacher Strasse 61
Monday, January 21, 1901

</div>

My Red,
Your letter accompanied me today to my first cooking lesson. I kept it in my pocket, and along with me it learned how to boil peeled potatoes, and potatoes in their jackets, how to make mashed potatoes, bouillon, and gravy and roast beef. Since the two of us were together in this, I think we were luckier than the others. Here's a kiss for you, dear—

My little room is long and narrow. The main thing in it is a wonderful soft bed. But there's a desk in it, too, at which I am now writing and a cupboard and a washstand. Over the bed hangs your sketch, dear, and every morning I awaken to rosy clouds, study them a little, and dwell for the first five minutes of every day in Worpswede. Next to your picture hangs the portrait of the three of us, Clara Westhoff, you, and me; and so I can look you in the eyes every morning. Have you been noticing? And then I turn to my cyclamen plant on the nightstand on the other side of my bed, which I worry about because it doesn't seem to want to blossom properly, and it hangs its little head. Then all at once I spring out of bed. Well then, cooking today was fun and the cook herself is a splendid person who keeps everything in her head—all us girls, and everything we are roasting, boiling, and

stirring. She seems to want to take me under her wing in particular, for she was touchingly kind to me.

A word now on Vogeler's behalf. Rilke and I visited his room at Keller & Reiner. It was finally opened only last Saturday. The architect told us that he has another one to build just like it in Potsdam. I liked it very much. Especially the decorations on the walls with the green garlands, which were then continued in the bench; that was especially pretty. Also wonderful was the silver looking glass with the bird and the candlestick with the wax candle by Heymel. Tell Martha Schröder that I was enchanted by the tulip pillow—those waves of flowers. I have rarely seen anything like that so beautiful; do you remember it? When you and I saw it, the little blue border was not on it yet. But we begged her hard to add it; and it's really now the dot on the *i,* and turns the whole seat into a cheerful and ingenious spot. It would also disturb me if it lacked the greens of the birches and of the bench. At the next opportunity I want to write Heinrich Vogeler to ask whether he will be coming here—On the desk before me stands a wonderful picture of Gerhart Hauptmann. So deeply and humanly gentle and mild, a face that understands the pleasures of this earth in such a lovely way. It is still the Hauptmann of the period of Hannele. Now they say his face is very, very lined. But he is still a fine human being.

—Yesterday (Sunday) I went with Maidli to the Neue Gemeinschaft, the group founded by Heinrich Hart in Friedrichshagen, you know. We went in the morning. There was a lot of talk about Nietzsche and much reading from his work, and concern with the present condition of things, and declaiming of poems by Herr Hart. There seemed to me an awful lot of vanity there, artists with long hair, lots of powder, and too many women without corsets. Not that I'm keen for that particular item of clothing, but on the other hand, it shouldn't appear as if one were without one. If only each of those Samsons had his own Delilah, willing to shear his locks; I believe the world would not be much worse off, even if their strength were to vanish. This evening I went to the Gottheiners' for supper in a white, low-cut silk dress with violets. Girls I knew when I was a child in Dresden were there. The older one, a cool, tall brunette, studies economics, has a sharp tongue, but interests me anyhow. The younger fat one has a good heart—So you were in my little room at the Brünjes'? Did you start the clock ticking, too? —Oh, yes, art. Farewell, my Otto. Let your girl embrace you and gaze long into your eyes.

My mother has just written me that my father is in bed after an asthma attack. I'm worried about him.

To Paula from Otto Modersohn

W[orpswede], January 22, 1901

[...] I suddenly found a whole packet of sketchbooks, and I began to pour over them. Now then, tell me, Paula (seriously), how could you have kept these sketchbooks away from me, I ask you, how did that happen? These books were enormously interesting to me, and not just because they happen to have been done by my fiancée; no, it was because they contain such very fine and artistic work. Well, I'll let you know more about this when you have landed here again. Then my revenge for your sin of omission will be visited upon your head; just how — I'll leave that up to your imagination. [...]

To Rainer Maria Rilke

Berlin, Eisenacher Strasse 61
Wednesday [January 23, 1901]

I have just sent flowers to the Worpsweders. And now you shall get something, too; just a little thing again. In fact it's even less, just something I'm lending you. First the Worpswede Sunday note and then this little piece of my past. You mustn't be alarmed by the size of the envelope. You must look through the thick book, this childlike book, starting only at the yellow flower. The first part is not me at all, and in a few parts it is too much me. So you don't have to read those. Your [photo of] Hauptmann is in front of me and is *very* beautiful. I think I have not even thanked you properly for it yet. Everything is always piling up on me so, and then I don't seem to do anything properly. I believe that is what other people call my coldness. But *you* understand, don't you? — And Sunday? Naturally I would *love* to come, only it won't be too early since I have been asked for dinner.

It really is already spring today and I ought to be in Worpswede. Things like that often make me sigh a little. I wonder how the clouds looked from the Weyerberg this evening. Well, even this century of culinary art will probably come to an end.

Auf Wiedersehn
Your Paula Becker

To Rainer Maria Rilke

Berlin, Eisleben [*sic*] Str. 61
Thursday evening, January 24, 1901

Maidli and I got tickets for an evening reading at Keller & Reyners. Isn't that something? Do you perhaps have one, too, then we could all walk there together. Or must the foot slumber because again blackhearted me didn't inquire?

In great haste
Your Paula Becker

To Otto Modersohn

My dear, I have just now taken my letters out of my brown traveling case, for that's where I keep them, and sat down with each of you in my little room, and we have been talking about many, many things together. We had a fine time of it. And then it was the Brünjes' turn and we started telling all kinds of *Plattdeutsch* jokes—But that's not what I want to tell you about. Here I sit in Berlin, four floors above the street, but even with that I can see very little sky. Beneath me, from the courtyard, I hear the regular thumping of some sweet pretty thing, beating her carpets down there. I lead a strange life here, an inward and very solitary one. I try as hard as I can to communicate with my relatives here, for they are fine, dear women. But this communication only goes to a certain point and then it just stops. And what is left over sings and hums privately inside me and lulls me into a dreamland within the realities of this huge city. I gladly put up with this arrangement; it all seems to go well, and this way I can dream my way through the two remaining months of our separation. And then I hear music all around me, not from a concert hall but in the room. And then feel you close to me and look into your eyes and feel your soft hands stroking my hair and then my cheeks and neck.

I spent a remarkable evening yesterday at Keller & Reiner. Maidli and I were given passes and went there expecting not very much. After entering, we walked through several exhibition rooms, past elegant slender mirrors and the most wonderful Böcklins, and finally arrived in the salon at the rear. It was festively lighted by candles and shaded electric lamps which gave off a soft glow. The *crème* of Berlin was assembled there. We sat in great comfortable armchairs, all arranged quite casually. Maidli and I scurried into a quiet corner from which we could spy on the others but not be seen ourselves. For the first time in a long while I could sit quietly and enjoy looking at clothes, and in particular at one wonderful black velvet hat. Then the electric lights were extinguished, and we sat in soft candlelight. There was a great cluster of candles standing on the piano, illuminating a lovely Verrocchio lady holding flowers in her delicate slender fingers. We then heard a reading from a piece by a Frenchman named Gobineau about Michelangelo and Vittoria Colonna. And the spirit of these two great people came over me, to the extent that it could come to a little thing like me. Do you know the love sonnets of Michelangelo? This hard man, strong as a giant, is as gentle as a child in them. He was a vessel which love was nearly able to burst open. How it shook him! He gave himself to love with every nerve and fiber, and was gentle as a lamb. And even then, in each of these fibers, there was more strength and warmth and humanity than there usually is in a whole person. And still he remained silent. When Vittoria died in his presence, this giant of a man dared only to kiss her forehead and hands, not her mouth. Just knowing this about him fills me with humility and piety. And so I

sat there at Keller & Reiner listening to music and to the voices of a man and woman intertwining and singing their love. I stared into space, then at the walls with their blue tapestries and at the beautiful candelabra, and then paintings by pupils of Rysselberghe, whom I don't particularly like but got along with well enough during the reading. It was then that I felt almost close enough to touch you, dear. I curled up completely in my quiet corner where no one could see me, and I was with you. Every evening and every morning I conduct a quiet dialogue with you. Evenings I read one or the other of your letters by candlelight.

And in the morning I look at your sketch and at the picture of you. I have added a little portrait print of Böcklin to the collection and I look into his eyes, too, eyes which saw the deepest pain and the greatest joy of this world. And above, on the other side of the bed, hangs a little yellow wreath of *immortelles* I bought from a little old flower lady near the Potsdamer Bridge and wove into a wreath for myself during one quiet hour. After it has shed its glory over me for a few more nights above my bed, I'm going to send it to you, dear. And my cooking school? Well, I'm learning, I can say that. I can already do a meat loaf, and a veal fricassee and have almost learned how to do carrots. Most of the time I'm with a class of future cooks who, consequently, aren't the type whose intellectuality would get on my nerves. The head cooking instructor told the others that I have beautiful hair. And one of the assistants began to call me *Beckerchen* the moment she learned that I had the simple and honest name of Becker. I take it all with a grin and with a sense of humor—

I have seen Rilke every Sunday so far. I visit him in his large room in Schmargendorf and we have lovely, quiet hours together. He thanks you very much for your letter and asks me to say hello, even though his [handwritten] addresses on my new envelopes, which were a present from him, were meant by themselves to be greetings to you, as he said. And Clara Westhoff? Is she coming here soon? How lovely, dear, that you see each other so much. It gives me a nice feeling about the future to know that the two of you get along so well. She is such a splendid creature. Also give my greetings to the dear people at Barkenhoff.

Otto, have you asked Fräulein Boysen to send you photographs of Elsbeth yet? If not, do it right away. I should so like to have some. Please, please.

One more thing. I should very much like to have a bright and pretty dress, and it's so easy to get one in Berlin. Could you afford to buy me one? About fifty marks? But you know, if you can't, I won't be sad—

Farewell, now, dear. I'm going to read Hauptmann's *Lonely People* to Maidli and Aunt Herma.

With great and deep love. Greetings to you from far away,

Your Bride

To Otto Modersohn

Berlin, Eisenacher Str. 61
Thursday, January 31, 1901
My father's 60th birthday

My King Redbeard,

I had just been thinking that I didn't want to receive white stationery anymore and that from now on I wanted to have blue, gray-blue, paper. And then came your big blue letter, and blue it was! It seems that our two minds are joined even at a distance. And when one of us thinks "blue" then the other simply has to conform. Isn't that lovely? And now Clara Westhoff is here and told me so much about you and how wonderful it is in your studio, you dear. And your letters tell me about it, too. But then they are so silent about almost everything else that I *really* look forward to seeing the new paintings you have done, in all their beauty. There is such a gentle, wonderful breath that always streams from your letters; each time I get one I'm aware of what a bad time I'm having here. I mean, I wouldn't feel so bad if I were not me—or maybe I do just because I am me. In any case, there is so much of the moon's atmosphere and the beauty of the birches and the grand power of nature in your letters. Yes, Otto, how I look forward to the pilgrimage to our little cottage on the moor, and to the time when we can do a thousand other things again. That will be wonderful—By the way, didn't you receive a big envelope about a week ago with the nightshirt in it? You don't mention it—

So, now to Clara Westhoff. We have gotten *so much* from each other: a solemn hour yesterday in memory of Böcklin. Our ball was less enjoyable. Women's emancipation here is indeed very unattractive and unpleasant when it comes together in mobs like this. A quiet evening in Schmargendorf with Rilke. And now we're just about to leave for the museum. It's so early we haven't even had our morning coffee. But I just felt that I hadn't been with you for such a long time [that I simply had to send you this note]. With all of my love I hug you and very gently stroke your soft hair, and then I look deep into your eyes and remain

Your faithful Woman

The talk by Lichtwark was wonderful, not in the slightest bombastic or effusive, and he used the right words for everything.

To Otto Modersohn

Berlin-Schmargendorf, February 3, 1901

Dear,

"The family" will be writing to all of you. In this letter I'm coming once again all by myself to you, to sit on your lap and gaze into your eyes. I am still filled with the poem, "Annunciation," which Rilke read aloud to us, "Du aber bist der Baum." And that will happen to the two of us also, dear, and I fold my hands si-

lently. All I have to do is keep very quiet, then it seems as if my breath came sparingly and I can utter only a few words. But they come from my deepest depths, and they have things to tell you about what they have seen. Those, then, are *my* love letters. I don't know if I have told you what I wanted to say. And I'm also tired, you know. It's just I who am tired. And are you coming for the eighth, are all of you perhaps coming? There are so many beautiful things here, and then there is something else here — your Love. To answer your two questions: no, don't take her on as a pupil. And the picture? I would not give him the forty marks until I knew that I had to. And as for the rest, come, just come. And then I can show you the many Böcklins, too, and it will be beautiful.

Did you get your little wreath in time for last Sunday? Where do you have it hanging? And I kiss you and bless you, and tomorrow I'll write you a letter, you.

To Otto Modersohn

<div align="right">

Berlin, Eisenacher Str. 61
February 4, 1901
</div>

Dear,

Is it true that all I ever write you about is painting and nothing else? Isn't there love in my lines to you and between the lines, shining and glowing and quiet and loving, the way a woman should love and the way your woman loves you?

Dear, there are no words for my true feelings. They hide in me timidly and are afraid of the daylight. But then they sometimes venture out in the twilight or at night. But you know how strange the world seems to them. Slowly but surely a time will probably come when you can feel that I don't have to express them in words — a time of silent hours when you have flowed over into me and I into you. Do I seem stingy and miserly to you? I believe that it's my virginity that holds me back. I want to carry it with me, quietly and devoutly, until the time comes when the last veils will be taken away. And then? —

But here in this city I don't think much about that. Sometimes in the evening I do, when I am lying in bed and your little drawing shines down on me, or sometimes in the morning when I wake up, or in a quiet, pensive moment. Otherwise, I don't let myself think about it here in this city, because the things that connect my ideas with this most sacred thought are not pretty and not pure. When spring comes to the Weyerberg and green veils cover the little birch trees, and when every little tree prepares itself for its season of fruit, when the smell of young life flows out of the earth, then it will also kiss me on the forehead and blissfully flow through my entire being, and the urgency I feel toward you will grow and swell until one day it reaches fulfillment. But I don't let myself think more than just a little bit about that, and I don't want to talk about it anymore. Dear, leave your little future bride to her hibernation.

All of the above I wrote last evening. This morning I'll tell you quickly only about

beautiful things. Sunday, Clara Westhoff and I went to a wonderful concert: Beethoven's *Eroica* Symphony, the one with that marvelous funeral march which breaks through again and again, solemn and subdued. After that movement comes the next, full of sunshine and optimism. It has a sweet effect on the sobbing soul. Dear, listening to the music I was suddenly determined that you must be here for my birthday. Can you, are you coming? I don't want to torment you about it, and I'm not going to say another word about it. You're the one who knows best, of course, what your situation is and how your work is going and whether this little trip will disturb all of that or not. I would love so much to be able to look at the Böcklins with you. And besides—my aunt sends you her best. She is sweet to me— and I can buy myself a little dress? Thank you very much. That makes me very happy. I'll tell you all about it after I buy it.

Clara W. and I went to see *Michael Kramer*. It was *very* beautiful. You and I will also go when you get here. Dear, I have not even had my coffee yet, and have to close quickly. Also, my fingers are still cold from my bath.

A warm embrace
From your fiancée

Did the card from Rilke [and me] recently make any sense to you? Suddenly I was so tired I think I wrote the same thing over and over. You didn't take on that pupil, did you? Let's not get ourselves in any more of a bind.

I got a good laugh from your card recently.

And do tell the Vogelers that they should come along.

To Rainer Maria Rilke

Berlin, Eisenacher Strasse 61
Thursday, February 7 [1901]

Dear Friend,
It seems that it's going to be a family excursion out to Schlachtensee after all, and so I should like to disinvite you since you really are not one for an abundance of apparitions. In the evening send a little thought out there to me, or in the morning, or whenever you feel like doing so. And then I'll be happy, too. I really am sorry, for it would have been beautiful. Do you know "The Great Window" that overlooks the Wannsee? I wanted to show it to the two of you. And then there is a beautiful outdoor fireplace there. It would have been beautiful to hear you read there.

Auf Wiedersehn
Your Paula Becker

To Paula from her father

Bremen, February 7, 1901

Dear Paula,

Tomorrow is your birthday; unfortunately we cannot bring you our felicitations personally, and so we must do it by letter; but since words can never completely express what one has in one's heart, you will have to add most of it through your imagination and complete the letter in your own way. It is most natural for us to wish you even warmer and more heartfelt wishes than usual, since now you are celebrating your birthday as a bride-to-be. You are leaving your father's house not only in fact, but also in spirit, for no matter how firmly attached you are to your brothers and sisters and parents, in the future they will no longer be the ones closest to you. Your duty will now be to merge with your future husband, to dedicate yourself completely to his ways and his wishes, to have his welfare constantly in sight and not let yourself be guided by selfish thoughts. For the most part it will certainly be easy for you, because you surely love Otto and seem to agree with him in most matters. But there will also be times when it will be difficult for you to subordinate yourself to him, and to bend to his will. Only then will you really be put to the test and I hope that, guided constantly by love, you will find the right note and words that lead to harmony. Whenever two people live together they must always try to draw on the strengths of both partners without one trying to dominate too much, or without permitting occasional arguments to destroy their equanimity. You both have your strong points and your shortcomings because you both are simply human beings. It is the task of the wife, however, to practice consideration in marriage, and to have an alert eye for everything that is good and fine in her husband and look upon his little weaknesses, which he also has, through a diminishing glass. I have known so many marriages which turned out unhappily because the couple put their mutual shortcomings under the magnifying glass, studied and turned them on all sides until they became bigger and bigger in their imaginations, and finally seemed to them to be insurmountable obstacles. That is no way to keep the peace at home. One must not consider the good to be self-evident and the bad to be something abnormal and monstrous. Both of them are joined in our natures, and judging them depends solely on whatever yardstick one measures them with. Nature knows no good and evil, no beauty and ugliness; to Her everything is completely neutral. It is only Man who judges all impressions of the external world according to the way they please or displease him. If one tries as hard as possible to suppress one's subjectivity, then one will judge life dispassionately and be able to maintain a balance when destiny comes to test and try one. May you always have the strength to do that; then your marriage will also be an eternal source of happiness for you and your husband. Learn to discipline yourself, and do not seek satisfaction in outward things. You know that Otto loves you and that you will find him prepared to do anything in order to make you happy and comfortable. He is, insofar as I know him, perhaps too good-hearted and, as

an artist, also too impractical and might permit your free will too loose a rein and trust too much to your leadership in many areas; and so you must be all the more moderate and keep in mind that thrift is the best gain. Otto seems to have a very nice income at present, but an artist is dependent on the times and the whims of the public and must therefore prepare for the future, and it is up to you to keep your goods and chattels together, and not to strive in good times after too much in order to be all the more prepared to give up necessities in bad times. Do not think yourself to be more clever than your elders, and believe that when Mother and I give you a piece of advice we do not give it for our own sake, but on the basis of experience and out of our love for you children. And so I should not like you to convince Otto now to sell his old home and to move into that farmhouse. I hear that you will have only small rooms where you are, to be sure, but it is a healthy atmosphere, especially for Otto's child from his first marriage and that is a major consideration. I can assure you that living in that farmhouse, which you seem to have so fallen in love with, will not be nearly as healthy as in our modern houses. [...] You must take your future little daughter more into consideration than your own wishes. Otto loves the child and he would certainly eventually regret having done something, which in the opinion of the experts, could harm the child. [...] And then your desire to furnish an old country house with old household things is just a completely selfish idea. Up until now, Otto has felt happy in his domestic life, and then you came along and inoculated him with the notion of copying Vogeler. In Vogeler's case, living in that particular manner was perhaps a necessity, but in your case it is merely a passing urge to imitate. [...] Therefore, my dear child, be sensible and do not let your fancies turn into follies which you would certainly regret. Move into the old home and through your personality and the touching way you have of creating and managing things, turn it into a place of joy and peace. [...] Look here, I shall certainly not interfere in your domestic lives; the two of you together must work everything out, and it would be absolutely criminal of me to want to be so meddlesome. But it would also be false of me not to want to help you out with my experience. That is the only thing that I have; and as you well know, as much as I might like to help you out with the material things in this world, I cannot; I can only give you the absolute necessities. [...]

Farewell, dear child; once more my warmest wishes for happiness on your birthday. Celebrate it in joy and do not take my words amiss. They come from a full heart, and out of the abundance of the heart the mouth speaketh. On this occasion it is only my pen. [...] A heartfelt kiss.

<div align="right">Your old Father</div>

To Otto Modersohn

Berlin, Eisenacher Str. 61
February 8, 1901

My birthday today, dearest, and your little bride is now twenty-five years old.
 You dear, dear man of mine, you good and loving person.
 When I opened up the wooden box, love, love, and more blissful love flowed out of it, and it made me shiver. You have scattered so much beauty and goodness upon me—and a sad letter. You must not do that, my dear, you must not get upset about a postcard I wrote when I was too tired. I'm so sick of this city and cooking and the people here and the thousand concerns I'm expected to keep in mind. I long for freedom, for air, and for other people, and I yearn for you. But I will be brave and stop complaining. Except I think that I will probably be unable to endure it past February. Is that all right with you?
 —Dear, your little picture was like sweet music from another world, your world and mine. I can hear so much rug beating and door slamming here, and I keep wounding my poor little knees and elbows by banging up against sharp corners. Oh, I can hardly wait until I'm back with the rosebush, and my two people, and the little flowers and the birch tree. Here there is nothing but walls, walls, and more walls, and overblown, fake Renaissance decorations, no matter where one looks. It's a blessing to think about you in your simplicity. No, dear, you are not complicated. I know that. I knew it before and I shall know it tomorrow. And I thank you for being that. I don't know whether I'm complicated or not. If I am, then I probably have to be that way. In which case I wouldn't call being complicated a flaw. (If I were with you right now, I would have said that last little sentence very quickly and then stuck out my big fat tongue at you.) Well, well, well. That's it: I have to be with you soon again, isn't that so? Should I? I'm cooking five times a week now and learning quickly, and soon enough I'll be able to cook for both of us. You know that otherwise you'll start daydreaming and getting crazy ideas, and I'll perish here from lack of air. Well, Clara Westhoff will soon be able to tell you all about me—
 —Yes, your picture is so beautiful, so very, very beautiful. Those quivering birches against the evening sky and those peaceful flowers. Yes, dear, that's the way it looks at home—
 —And the Böcklin photograph. Yes, dear, that's the one I meant. Isn't it wonderful? Isn't it a whole wonderful world of young girls? How could this great strong man have found the pathway into this most delicate world? I kneel before him in humility. If only I could once have kissed his hands. It was sweet, dear, for you to have guided me to this evening dream along such secret pathways. And my little dress? It will be lilac. Sweet and soft. And perhaps in three weeks it will be sitting on your lap.
 —Write soon. Write me immediately. We will spend my birthday today out in

snowy Grunewald. I need a little nature again. In just a few minutes we are setting out for Schlachtensee. The house where I lived for two winters stands empty now. (You know, with my aunt and uncle who are in Australia now? The Norwegian uncle is the same uncle.) Can you feel that I am with you? I am really always with you—Or at least in my best moments. Whenever I see something beautiful I see it in connection with you. And whenever I listen to music it seems as if you were near me, as if I were breathing you in with every breath. I give you a warm hug.

<div style="text-align: right">Your Paula</div>

To Rainer Maria Rilke

<div style="text-align: right">[Berlin], Eisenacher Str. 61
The evening of my birthday [February 8, 1901]</div>

Dear Friend,

I was inundated with love today, warm and soft and gentle. Now it is evening, and I sit here in the silence at that old yellow desk of Grandfather Bültzingslöwen. In the kitchen next to me the clock is ticking and telling me not to be afraid, that I am not alone here, because it is still awake, too. And I'm not lonely. Truly not. I am a lucky little human being, and wonderful gentle hands are rolling one ripe red apple after another to me. And I receive each one of them as a new wonder from heaven, and I sigh with happiness. I give thanks to those hands for having taken you by the hand, too, and leading you to me here on my green meadow. And I throw you one of my red apples, and you lay such sweet flowers into my lap, even a sweet bouquet of lilacs today. *Spring is coming*—And then you came yourself, not just to my green meadow, but all the way up to my tower, which is so hard to do and is so very exhausting. I reach out both of my hands to you with thanks and look into your kind eyes, and as the one who receives, I ask you to remain so for me. The book on Oldach is my heart's delight. Isn't it remarkable; only last evening at nine thirty I was so intensely thinking about him and telling my relatives about it. Did you wrap him up in that beautiful white paper yourself? And the confections!! *It is too much.*

<div style="text-align: right">In dear friendship
Your Paula Becker</div>

[On a separate sheet]

I have a garland of immortelles in my hair, and a wonderful big tortoise shell comb, and a yellow silk lace handkerchief. They were presents from my grandfather once, to my mother, when *she* was still young; and I have yellow immortelles in my sash. That's the way one looks when one is twenty-five years old and Otto Modersohn's fiancée. Hallelujah. And he painted a sweet little picture for me.

Journal

Notes on building a house. I really mean, obviously, something for Otto Moder-
sohn and me and our children. Stairways are to go everywhere, up and down, here
and there; rooms, if possible at various levels, so that little alcoves and funny nooks
and crannies will be formed. Some of the windows on the second floor ought to
go right to the floor. On the ground floor, a conservatory with French doors lead-
ing outside. A few windows with low, wide sills so that we can sit on them. Some
windows broad and generous, almost square, with a suggestion of the same thing
in the corresponding doors. The roof, a mansard with dormers at intervals. If pos-
sible, a tower room with a flat roof. Pretty lanterns, like the ones in Berlin on the
Wilhelmstrasse, if there is anywhere they could be put. Unusual, small-flowered,
brownish or gray wallpapers.

To Otto Modersohn

Berlin, Eisenacher Strasse 61
February 12, 1901

My Beloved Man, that was another beautiful letter. Now you are happy again and
I am happy again. And now you must promise me not to grow sad again. Or may-
be it is true that sadness is something natural. Perhaps it is merely like catching
your breath before happier things, a preparation of the soul. There is one thing I
don't want you to do: I don't want you to think that these sad times have something
to do with me or come from my letters. No, they come from within *you;* they fol-
low upon a happier mood the way February follows January.

It seems to me as if I were being a lady philosopher today; or, to put it in good
German, as if I were skating on thin ice. I better summon all my energy and head
for the shore before I fall through—

I received a happy and almost embarrassed letter from Kurt yesterday. And dear,
your gift of the pictures was a sweet thought. Papa wrote me a touching birthday
letter. He elaborated on the subject of my dowry and says he wants to give me a
thousand marks, and that I'm supposed to talk this over with you. But I wrote him
that I need only two hundred marks. That will make for a pretty enough dowry
and then I hope you will be satisfied with me. The twins ought to have the rest of
the money for their education. Dear, I have bought another little thing for our
house, another mirror, made all of glass but quite small. It was so enchanting that
I couldn't resist buying it. I bargained for it one night from a most unusual little
Jewish woman. She also has a gray glass tea tray with a decanter and two drink-
ing glasses decorated with turquoise dots and gold. They are wonderful, too, and
we must get them. And, dear, the "little dress" you gave me for my birthday is go-
ing to be my wedding dress. Just imagine. I shall have it made here. When that's

done I'll be just about all ready. I can't stop thinking that by this summer we'll belong to each other completely. I shall be your loving wife. We have to be careful and prepare everything well in advance, and arrange everything inside and outside ourselves. If we do, time will never weigh heavy on our hands. I have gotten hold of a few inexpensive squares of old-fashioned wallpaper samples, covered with little flowers; gilded picture frames will look beautiful against any of them. And today I've been making notes about the way a house should probably be when we build one in ten years. I always like doing things like that, and you must, too. So many nice thoughts occur to one while doing something like that. And if one doesn't, by the time one is ready to build, one has forgotten all one's ideas. And I've been thinking about a portrait of Elsbeth with her golden curls and have been planning how the three of us will flop into some great lonely haystack in haying season, and how we'll play like big children. Oh, I keep imagining all these beautiful things to do. Do you, too?

Again I have seen so many interesting things at the museum. That Goya really has temperament and great creative power. His fingertips must have been tingling with energy. I find that Daumier has something of him here and there, and sometimes Manet, too—You, I really didn't like your French postcard very much. You mustn't take it amiss, but you know that I can't go along with things like that. And —I'm sorry that you took on that pupil, after all. I thought that was just what we did not want to do. Such a little bit of money and such annoyance and time taken away from your own work. Can't you cancel it and tell her not to come?

Yesterday I ordered a little gold frame at Köster's and one to put around a wonderful picture of the Deposition by Böcklin. It was such fun and such a pleasure to speak with Köster about you and your frames. He has a wonderful white lamp which goes all the way back to his grandmother's time. I've been looking these days for one just like it at the secondhand shops. I have to go see Aunt Paula now. I have put aside the last page because I would prefer to write Kellner by myself rather than together with you. Thank Vogeler for his birthday letter. I look forward to seeing Martha Schroeder's dress. And you say Hektor is dead?

<div align="right">Your Paula</div>

You know, you really ought to address your letters yourself from time to time. H[einrich] V[ogeler] can't always be writing me these letters and sending me packages.

To Otto Modersohn

Berlin, Eisenacher Str. 61
February 16, 1901

Dear, I have been with you so much today, every day in fact. I'm with you all the time. I want to write you just a little note so that you'll have something to read for Sunday. And then Clara Westhoff will be returning there and can tell you all about me and Berlin. And the last weeks of our separation will go by more quickly for you. For me, things are really beginning to get quite difficult. At first, all my impressions were still new and my spirit was fresh. But by now all these tired people around me are making me tired, too. They don't seem to know anything about that other life, the life of victory that smiles back at one if one smiles at it. And all I can do is tell them what I know about it, as if it were some fairy tale, because they don't know it themselves. Even then I have to describe it in a much paler version and suppress its deep colors. If I didn't, I'm afraid it would make them sad because their own eyes can't see them. But as for me, I love the depth of color as much as I do my life. I need it for my life, just as much as I need air—

Well, only a little while longer.

So then, dear, set yourself down right away and write me on a little piece of paper if your birthday is on the twenty-first, so that your little bride will arrive on the right day. And next year? Next year there will be another head with a thick auburn braid lying beside you on a big white pillow, saying good morning. I still have to write my Sunday letter home now, and that's why you are getting the short end of the stick today. I have also received a letter from your mother to whom I had written on her birthday. One more thing. Dear old Papa, the good man, simply will not calm down about the dowry. He says that I should get everything now because I'm in Berlin now and have the time. And I'm supposed to ask you whether you think we need more linen for our household. So please don't forget to write me what you think about that because Papa, with his paternal thoroughness, is trying to take care of everything for me.

Oh, if only I were further. Oh, if I were only at home. I've already learned to do all sorts of things, you know. As far as you and I are concerned I could come right away. I'm only staying here to please my father. Well, *auf Wiedersehn,* sometime soon, you dear man, you.

You write that you are painting a nude. Tell me, do you have a model? Tell me more and more.

I send you a kiss.

[Undated]

I think I should like to paint an Annunciation. In a garden with many flowers, more gentle. She is walking or sitting. There must be water there, too, and several pious animals that are under the holy spell of this pious moment.

And Saint Christopher carrying the Christ Child across the Hamme. Maybe it will be O[tto] M[odersohn]. Atmosphere gray gloomy; the red beard in it, dressed in black and white. The landscape very open and lonesome.

I sit here in the Kupferstichkabinett [Print Room] in Berlin, middle of February 1901. And I have a *very* great longing for Worpswede and for my work. And little Elsbeth, I think I should like to paint her, too.

To Rainer Maria Rilke

February 16, 1901

Dear Friend,
When I stood with the two of you in the room yesterday I was far, far away from you both. And I was overtaken by a great sadness which was still with me today, dampening my high spirits. But during my nap it left me, and I began to feel that it was just a small sadness. Now it makes me happy that it has left and I'm happy for myself and for life; and I wanted to tell you this and that I am happy for you, too, and reach out to you. Your little tree has shot up and has grown. And whoever sees it rejoices in it.

And so:

> Here are greetings from one
> who sees it and is made happy

To Otto Modersohn

Berlin, Eisenacher Str. 61
February 19, 1901

Dear, dear, dear, Today I bought myself chemises and drawers and nightgowns, and all just for you. And they certainly are sweet and Circe-like. I believe that you will like me in them. I made a point of selecting the pretty ones, the sort of thing you like. And then yesterday I received one of your letters on blue paper, and another one today, and I keep on thinking that the difficult cooking school examinations will soon be a thing of the past. And all that and much, much more gives me a feeling of rapture and jubilation. You are so right. Life is wonderful and we two little people are so fortunate. Or at least I will be at the end of my "process of refinement" in Berlin. And, you know, I can't stand not painting much longer.

To think how happy you are with your art! Hallelujah! Just to be able to invest the human being, the human form, with the artist's concept of things—yes, that seems like a dream to me, too.

— You, if you should happen to get a package in the mail before the twenty-second you mustn't open it yet. I'm sending it to Otto Modersohn for the day on which he is thirty-six years old, and not before then.

And now good night to you, dear—I'm sitting here in the nude with only my bathrobe over me. And my little tummy is freezing.

Oh, let me tell you, you are going to be getting something fine for your birthday. Until we see each other soon.

<div align="right">Your jubilant Bride</div>

To Otto Modersohn

<div align="right">Berlin, Eisenacher Str. 61
February 20, 1901</div>

It's evening now and I come to you and enfold you with all my love and pour it out over you, you dear, dear man. I sit on your lap and stroke your soft hair and feel your hands gently, gently on me. And we love each other very, very much; we are completely one and yet two. Let me hang this little amulet around your neck on its blue cord—wear it always above your heart. [...] The little golden thing came from Aunt Linchen, and who Aunt Linchen was my mother can tell you, for she belongs to the images of her youth.

And what do you say to the three schnapps? Your little woman brewed them for you herself and will be able to brew you more in the future. So don't tell me Berlin wasn't worth it.

The Velázquez is a present to you from my mother, or rather, she gave it to me for *my* birthday so that I could give it to you for yours. Isn't it beautiful? That is my dear little lady from the Louvre which I love more than all the Berlin Veláz-quezes put together. And now once more, here is a gentle and loving kiss, which I give to you with a gentle rustle. Do you feel my love, my huge and silent love which lives inside me? I close my eyes and feel that I'm close beside you and I remain in you and around you with devoted ardor. And now I gaze into your eyes for a long time until we both have to quietly look away. Farewell and *auf Wiedersehn*.

<div align="right">Your Betrothed</div>

To Otto Modersohn

February 23, 1901, Saturday evening

My dear Otto,

In great haste, just a word and a request. My father has once again had one of his bad, frightening asthma attacks and is so weak that he has to stay in the house. Dear, would it be possible for you to visit him on Monday or Tuesday? That would be the nicest thing that you could do for him at the moment. I know, of course, that it will be a great sacrifice for you to be pulled away from your work; but please do it as a favor to me. Remember, I have been making an eight-week sacrifice myself. Just announce your arrival with a note or telegram and say you'll arrive at *noon*. Then you two men will have your dinner served in Papa's room, as I've already arranged for by letter, and you can have a comfortable chat. After dinner let the good old man rest a little. He will naturally not agree to do this but then you should say that you have to go out with Milly and cash her Christmas check. And then you can also take a little rest or do whatever you want. Just confide in Milly. You can also go to the Kunsthalle and that way the afternoon at our house will not seem so long. If you feel like it you can either take Herma along or not. And you can also steal away in the evening by pretending that you have some purchases to make, and then go and buy yourself a little octavo pad and write your journal at the station. I am so looking forward to the letter from you, which I shall certainly receive tomorrow, and kiss you tenderly as your bride.

To Otto Modersohn
[Postcard]

February 26, 1901

Dear Mr. Modersohn, I have sent Clara W. a package with flowers in it and a Böcklin but I hear that she has left. Please be good enough to take the other Böcklin, which I'm sending to the Vogelers, out of the package and also a little box and letter for the Brünjes, and forward the package to the Tyrol. Things are fine with me. There is a great deal of snow here, and spring simply will not come. In three weeks I think I shall be leaving this nest. Have you been painting beautiful pictures? Well then, I thank you very much for taking care of the package for me. With hearty greetings,

Yours P. Becker

Berlin, Eisenacher Str. 61
February 28, 1901

Dear,

Today, after I had been busily wielding my little kitchen spoon to make desserts, and had bought us a beautiful brass foot warmer on my way home, I found your beautiful portrait-postcard when I arrived, and it gave all of us a good big laugh. Well, dear, you really did visit my dear father. I thank you. I thank you also for the photographs. The one of Elsbeth is creating a sensation here. Are the ones from Fräulein Boysen also coming, then? Because they are really the prettiest of all. I'll probably take a little three-day journey to see my relatives in Dresden on Saturday. If you write me, the address is: Herr Landesgerichtsdirektor Dr. Arthur Becker, Tieckstr. 23, Dresden North. Those are the relatives to whom I owe thanks for the last years of my study and my trip to Paris, my father's brother, dear, good people; now I have to tell them all about you. I should so like to do something nice for them and make them happy. Please do me a favor and go to the Brünjes'. Near the window there you will find my big portfolio with the drawings of the heads; there is another small portfolio of the same color, either behind it or in the chest in the shed. In it you will find a watercolor which I did when I was first in Worpswede, a rear view of Struss's smithy as seen from the hill. Could you take that to Netzel and have him frame it in a narrow gold molding. I think the one I have in mind is what he uses as liners; and then send it to me in Dresden in care of the above address; but everything has to be done in a hurry, otherwise it won't get to me there in time. And would you also ask Frau Brünjes to wash my little white sack dress, you know the one that I sometimes wear in the evening? Tell her also about Clara W.'s engagement. That will amuse her.

I'm at home now a great deal in my thoughts. I long from my heart to get away from all this heavy molded oak furniture and be back in the quiet of my little room and wake up gently in my little canopy bed. Well, I'll be there soon. Tell Frau Brünjes to get it ready for me. And ask her also if my lamp is still burning well, and if not, to tell Bernhard Barnsdorf in town to put a new wick in it. Lilienthal's wicks are too small. Can you imagine, the frame for my picture of you is still not ready. Köster got sick.

And in your studio spring has come and it's blossoming and beauty abounds. Dear, I must see it soon. I can hardly wait. Clara W. and Rainer told me about it yesterday. Yes, yes, the new couple. By the way I didn't say anything about it in my last letter because I knew nothing about it myself. A loving kiss from Your Paula.

Rilke will probably not be writing you another letter now for quite a long time.

To Otto Modersohn

Dresden, Tieckstr. 23
March 4, 1901

My dear, I feel like that couple we saw together in Hamburg in *The Magic Flute,* the pair that had to pass such and such a number of ordeals in order to attain final happiness. In that sense, this trip to Dresden, combined with my feeling of home-sickness, is simply one more ordeal. I'm being showered here with so much unde-served love and goodness. But you know, I'm tired of the world and long for my quiet little room and for an activity other than cooking and traveling around. Well, this thing, too, will soon come to an end and I'll be back again with you and in my own element. A fish simply belongs in water and I belong to a life of solitude. I know that now, again. Well, I have probably, at least inwardly, profited by certain things aside from learning how to cook. Yesterday I happened quite by chance upon your painting of a little old woman here in the Dresden gallery. It made me so happy to suddenly hear those familiar and dear notes ring out. But do you know, your recent painting is even riper, especially in a technical sense. You probably painted this picture on a different ground, didn't you? It gives it a certain uneven-ness in color, and the hut does stand out more solidly against the sky than the way you have it here. But it's still an Otto Modersohn, and that makes me happy.

The trip from Berlin to Dresden was glorious. Spring was everywhere, behind every bush, and I could feel it forcing the fresh buds. The little brooks were swol-len by the melting snow and were hurtling downhill. The meadows were covered with great pools, and the pools were shouting back at the blue sky. Spring was everywhere. I had to think of Zwintscher. The train was traveling through his re-gion of vineyards and orchards and round towers on the ridges of the hills where the wine is pressed. At intervals I read Michelangelo's poems. Their grandeur and simplicity and humility made such an impression on me. What a man he was. And the starlings are back again, too. And next Sunday? Next Sunday at eight in the morning I shall jump aboard the little local train and rush to you and cast the world and all its glitter behind me. And then a lovely, quiet, serious life will begin again for me, a life like a ship that draws deep water, as Dr. Hauptmann would put it. Here and in Berlin I always wanted to plunge deeper than other people were will-ing to go. And that always set up a constant friction.

I've heard nothing from you for a long, long time. But then I imagine, as I always do, that you are painting something beautiful, and as a humble woman I sense your silence is natural. My relatives send you hearty greetings. I've received friendly in-vitations for us everywhere. Do you think I'm writing even fewer "love letters" than before? I have been reading *King Lear* and am again cast completely under the spell of its magnificence. That is where I also read: "What shall Cordelia speak? Love, and be silent." I find that a familiar feeling. For the rest, my spirit is exposed to too much dust and too much conventionality in this city air. A deep kiss from

Your Girl

Arrange your Sunday so that you can eat at my place and we can have the whole day together.

To Otto Modersohn

<div align="right">

Berlin, Eisenacher Str. 61

March 6, 1901
</div>

Dear,

Hurrah, today you're getting your last letter from Berlin and I'm moving back to the Weyerberg with my quiet little Brünjes family. I can't tell you how happy I am. I long to leave here so much—it almost makes me feel ill. Sunday, then, will bring us back together again. Today you are receiving your last "business" letter and then you'll have me back again. You dear, dear man. I'm your Cordelia. You know that my whole life of thinking and feeling has withered and frozen completely under the pressure of this huge city. And now it will slowly thaw out in Worpswede. Oh, how I look forward to it. To have a heart of stone like this is not beautiful, and it makes me tired and sad.

Funny, from the very beginning of marriage it's we women who are put to the test. All you men are permitted to stay simply the way you are. Well, I don't really take that amiss because I do like you all so very much. It's only that in general the masculine nature is bigger than the feminine, more connected, and more as if it had been made from one mold; that is probably why it is the way it is. By that I don't mean to refer to the two of us in particular, for I consider myself made from the same mold, too. But I'm speaking in general about male and female. See, my cockscomb is growing again—that's a happy sign or omen for my Worpswede days —A deep kiss for your loving favor in sending the Struss picture. They liked it in Dresden, even if they did laugh a little good-naturedly at the blotches of color. But they are dear, simple people and all of them send you hearty greetings. They already have you locked up in their heart just because I chose you. It's true, you are going to be received with much love and much expectation in my family. Only they all hunger for a pretty picture by you. Is Fräulein Boyson already back? Have you received the Rossetti? I ordered it a month before your birthday. And it simply didn't arrive. And then when it finally did come, it was at a time when it was ebb tide in my cashbox and you had to pay for it yourself, you poor man. How lovely that you have felt so comfortable being with my family. They have nothing but your very best interest at heart. Receive a kiss, my dear King Red Beard, from

<div align="right">

Your little Wife
</div>

I'm coming to you Sunday on the eight o'clock train. Hurrah.

To Otto Modersohn

Berlin, Eisenacher Str. 61
Friday [March 8, 1901]

My dear Otto,

I am sitting here next to my packed luggage but held up by a telegram from Mother. She says that I should not come back yet and that I should go on cooking, cooking, cooking. I cannot do that anymore, and I will not do that anymore, and I am not going to do that anymore. That is demanding more of a person than she is able to do. That would be squandering the springtime to hold me prisoner here behind high walls and have me hungering to be outside. And so I *am* going to leave Saturday. I hope that things will not be unpleasant when I get home. Sunday I am coming to you. *I am indeed.* In spite of everything.

You know, I must see all your pictures. I can no longer endure having so many other eyes look at them and not mine. I tell you, it seems that I have to battle my way through the fires of purgatory before I can regain my peace. But this peace is worth the battle.

So it is to be Sunday!

I kiss you! My soul *hungers* for something profound, for something absorbing, and warm, and beautiful. There is nothing like that here. A city like this makes everything superficial, at least it does for me. And I will not be superficial. I haven't the slightest desire to be and I see no pleasure in it at all. Do you know this little Bierbaum? Accept my kiss.

*To her mother

Berlin, Eisenacher Str. 61
March 8, 1901

My dear Mother,

It makes me very sad that my return will be so unwelcome and upsetting for the family. I am very sorry to disturb Father, especially knowing as I do that he is more nervous these days than ever. My dears, how can I explain in words to you that there is no other course for me than to come home now? I so wish our reunion not to be a gloomy one. That is hardly an occasion to be sad and gloomy. From the beginning I firmly set my stay in Berlin at two months. I have used my time well, Mother. But now that cannot continue. Something in me cries out for air. And that cannot be silenced. I have already written that to you in a letter which you evidently thought I meant to be a joke. The life I lead here is not my own life at all. My truest and innermost being hungers, it hungers for something deeper and for peace. The way I approach art here and that which is most important in my life are made totally superficial in these circumstances. They depress me so, that my soul cannot function happily or with any of the stimulation it must have. And now my soul

demands its freedom and I'm going to give it that. I am not going to hold it back any longer.

It is not only my longing for Otto Modersohn that compels me. It also happens that I can no longer endure this rug-beating environment and all these tall buildings. And why? I have learned a great many things here that I shall need for my domestic life. And I know without being told that I am not perfect. But that I can learn only when I am back in my own element.

Dear Mother, I'm writing all of this to you because I know that you are also able to recognize the voice in us that wants something. That is our truest voice. I am giving in to it. Don't think that it is ruthless or heartless. I cannot do otherwise. I must. The very fact that this is part of my nature makes me happy. For it is instinct that guides me.

Dear Mother, my letter is very confused. But it upsets me that I am causing you such distress. I'm writing to you in the hope that you can translate my words into your sweet and gentler language and tell them to Papa so that our reunion will not be upsetting. It's so sad that what I'm doing angers you. There must be something now and then about me to make you happy, and I mean something besides my engagement.

Read this letter through with Milly and discuss it with her, and try to sympathize with my soul which is thirsting for freedom and is casting off its chains. It is not evil. It is not weakness. It is strength. It's good to get rid of circumstances that rob a person of air to breathe.

Here I stand. I cannot do otherwise. Amen.

<div align="right">Your Paula</div>

*To Marie Hill

<div align="right">Worpswede, March 23, 1901</div>

My dear Aunt Marie,

It's impossible for me to write what I am experiencing now, so that's one of the other reasons I haven't sent you a letter. We really must see each other again. Would that work out? But then, of course, you know that even if I saw you I couldn't tell you about it. But maybe you would see and feel how the atmosphere here is filled with happiness, a wonderful and enormous happiness. So couldn't it work out?

My dear, what a surprise your generous gift was. The mailman thought that I had sold a picture. But it wasn't that. It was my first wedding present. But isn't it too much, dear? I found it completely overwhelming. This evening I shall have to have a discussion with my dear Otto about what we are going to buy with it. But don't fear, we won't buy guitars and other frivolities like that. We are completely rational people, that is, so far as our natures will let us be. Thank you very, very much, dear Aunt Marie.

Oh, how lovely it was to get home again, and just being here is wonderful! One

completely forgets about the rest of the world. My sweet, brownish-red sitting room and my little blue bedroom with the white, white canopy are filled with a thousand pussy willows. He and Clara Westhoff put them there to let me feel every hour that spring has come. And I do feel it.

I'm constantly going in and out of his house and we are making plans together about how we're going to redecorate it, and all the time our little girl twitters and laughs and laughs. And then we all hug each other and sing a happy Indian song.

Our love has had a wonderful effect on his art. Suddenly many veils that lay over him have fallen, and now everything is coming out into the light in a great variety of forms. New images seem to form constantly inside him. I wish that you could see the splendor of them and him working among them, simple and childlike, and like a young boy in his happiness. And I, a reflective type, just stand there, humble and even pious before the simplicity of his soul. His life is nature. He knows every bird and its habits and he tells me all about them carefully and lovingly and about the butterflies, and everything that has life in it.

Our whole neighborhood consists of happy things. Heinrich Vogeler is returning any day now from his wedding trip with his slender blond girl, and in a few weeks Clara Westhoff will be married to the poet Rainer Maria Rilke, a friend of all of us.

And on top of all that, it's spring.

To Marie Hill

Worpswede, April 22, 1901

Dear Aunt Marie,

The nightingales are here. It continues to get more and more beautiful. One can hardly believe that it could keep up this way. I can actually see the blossoms of the chestnut tree opening up outside my window, and we two redheads are getting ready for our wedding. Painting and hammering are going on all the time in the house, and we are happy as can be. We shall be married at Whitsuntide. [...]

To Clara Rilke-Westhoff

Worpswede, May 13, 1901

Dear, dear Clara Westhoff,

It's a hot and summerlike day. I have just come home from the Tiebrucks' with my sketchbook. It's just fine there now. In among the shining yellow dandelions and the touching little blue gill-over-the-ground, little children and little goats and Voge's little geese are sitting and kneeling and lying and standing and tumbling. And in the distance blossoming trees and young birches are laughing. It was good being there. In the last few days I have again been thinking very intensively about my art and I believe that things are progressing for me. I even think that I'm beginning to have a liaison with the sun. Not with the sun that divides everything up

and puts shadows in everywhere and plucks the image into a thousand pieces, but with the sun that broods and makes things gray and heavy and combines them all in this gray heaviness so that they become one. I'm thinking about all of that very much and it lives within me beside my great love. A time has come when I think that I shall again be able to say something [in my painting] one day; I am again devout and full of expectation. There is also so much that is new in Otto Modersohn during this time. I am so amazed at the way things emerge from him. For six weeks he will just walk around with his little pipe in his mouth and on the forty-third day it suddenly appears. Right now he rejects nearly all of his newest pictures. I don't know if he is right to do it. But what hovers before him is a deeper and deeper penetration into nature. And with a shout of joy I understand these revolutions, because even if I have no idea where they might be leading, it's enough for me just to see that so very, very much is going on in my dear man. And everything in such a calm way, everything as if in nature itself. *Dear* Clara Westhoff, I'm almost beginning to get used to not seeing you and being able to talk about all these things with you. But not yet completely, and I feel how much remains unspoken within me because you are not here. Your letter was a big part of you. It was lovely to read. Yesterday, Sunday, I read some of it to the others on the Vogelers' terrace and we were thinking very much of the two of you, as indeed we often think *very* much about you and about the fact that our Sundays no longer have their full sound without you two. It's always sweet and dear being with the two Vogelers, and little Martha is blossoming wonderfully. I've been noticing more and more that beside her flowerlike quality and purity there is also what we would call a real person there. When the two of us are alone together I don't yet dare to get too close to her. I believe we are shy about each other. But then she's fragile and spring makes her tremble, and her senses are so keen she can smell the rainwater after she's washed in it. We must take very gentle care of her. Are you coming home soon? Oh! How wonderful that will be. But if you will be staying in Dresden until Whitsunday, do wait for the two of us to get there. For we are coming, and perhaps the Vogelers, too. Or would it be better on our trip home from Prague? Then the six of us will celebrate Hamburg all over again in Dresden. Oh, wouldn't that be beautiful?

We are probably getting married the Saturday before Whitsunday. Now that the time is here we simply cannot believe it. We had gotten so used to waiting. And now I shall be his wife. You'll be pleased by the many changes in the little house. The greenhouse has become a little white garden room. It's charming to sit there in the evening twilight. And you must also get to love my little girl. Please do. It should be easy for you, with the great abundance of love that you lavish so nicely wherever you go. We've been having a difficult time this past week. Father was suddenly tormented by frightful pains in his kidneys and nothing seemed to do any good. One night he said good-bye to all of us and to his life and put everything in the hands of my oldest brother. But he stayed alive for us. He's a very good hu-

man being. During the night when he thought he was going to die he said so many wonderful, loving things. I can feel it again now: love never ceases even when everything else comes to an end. In that sense [Otto and I] have pledged our lives to this love. For isn't art also love? Dear Clara Westhoff, it will be lovely when we are back together again. There are so many loving things that I should like to say to you, but then so much is impossible to put on paper. And it's probably best for the two of us that many of these basic things remain unspoken out of shyness. Affectionate greetings to your husband. And is he singing [i.e., writing] again? I am your,

<div align="right">Paula Becker</div>

[Written at the edge of the letter]
 This faded coltsfoot was growing next to the brickyard. This is what will happen to the little yellow stars that I sent to my father's sickbed.

From Otto Modersohn's Travel Journal

May 25 to June 19, Wedding Trip: To Visselhövede—Berlin—Schreiberhau—Prague—Munich—Dachau—Worpswede. The days in Schreiberhau with Carl Hauptmann were very stimulating; got to know also Bruno Wille and wife, Bölsche

Paula Modersohn-Becker: Postcard with Otto Modersohn sitting next to kerosene lamp, May 27, 1901

Otto Modersohn: Postcard with Paula Modersohn-Becker in Berlin,
May 30, 1901

and wife, Gerhart Hauptmann and wife (in Agnetendorf) and Prof. Ploetz. Made a major excursion to the Schneegrubenbaude. We liked Prague as a city very much —in Munich it poured rain—the tour to Dachau was fine.

To her parents

Schreiberhau, June 1901

Dearest Family,

It's June, isn't it? But what year? Who knows? The waves of another world are breaking over us, and a considerable part of our time is devoted to tugging each other's sleeve so that neither of us gets run over. And then out came the sun whose intentions for us were not of the best, and we thirsted for a good thunderstorm. In Meissen we didn't seek out the poetic places; instead we looked for the little shade we could find.

All in all, it has become completely clear that our honeymoon is like one of the ordeals in *The Magic Flute*. That's just the way it seems to be. The arrangements that are made for most people are simply not made for us. For example, this round-trip [excursion] ticket of ours is like an iron collar that evidently is going to suffocate us little by little by dragging us off to Prague and Munich.

Just now, though, we are living in solitude and peace with a group of fine people,

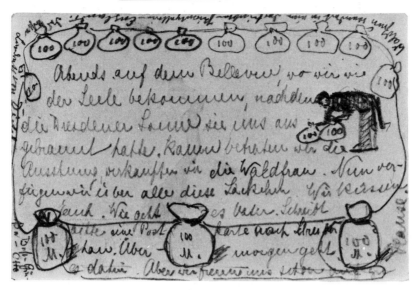

Postcard announcing the sale of Otto Modersohn's painting,
The Woman of the Forest, *May 30, 1901*

and are enjoying a divine and redeeming rainstorm. Everywhere the mind and spirit of the great Gert [Gerhart Hauptmann] suffuses and overpowers everything here. A few days before we arrived he was here with his sons. But when we arrived the whole house was empty again, the birds had flown to Dresden and our letters and telegrams brought them back to us only yesterday. Meantime, however, their friends took good care of us.

I haven't quite sorted things out within myself, and so I can't evaluate everything yet. So occasionally I take a little walk by myself and pick a bouquet of Queen Anne's lace, and try to put things in order and smooth out the wrinkles in my head. But I won't completely succeed with that until we get back to our Weyerberg. Bless it a thousand times and everything that lives there.

To her parents

Schreiberhau, June 1901

My Dears,

It's Sunday and everyone else has taken a trip to Warmbrunn to see Dr. Hauptmann's mother whom he is very devoted to and visits every Sunday. And tomorrow we are going to Agnetendorf to see the great Gert. But how imperfect everything in the world is. On the dark side of our thoroughly humane Dr. Hauptmann is the fact that he suffers so from the fame of his brother. It seems that everything is full

of conflict. When one is close to even the greatest people one can observe how these conflicts cast shadows on them. One learns so much here in the world of the great. One learns to be very patient. We two often find ourselves singing songs of praise to the pure, innocent, and simple atmosphere of our Weyerberg and to all the people on it.

We shall probably leave Tuesday or Wednesday and then stay one day in Prague and three in Munich, and then probably be back with you Sunday or Monday. We'll set ourselves down beside our dear father's bed and then tell you all there is to tell, in proper order. And then the two of us can look forward to our work which we shall greet with open arms.

The people here are unusually kind and charming. And what makes me particularly happy is that they seem to sense and understand something of Otto's nature. First of all, there is our dear Dr. Hauptmann, full of knowledge and earnestness and striving for the highest things, and full of love for them. He would be a complete person if he were not his brother's brother. Then his wife, a warm-blooded and intelligent creature, with a quick sense of her husband's work, full of good advice and immediately in control of any situation. She was brought up with five sisters in a Moravian convent. And after she returned to the splendid, but motherless, home of her father in Kötzschenbroda, the three Hauptmann boys came one after the other and married her and two of her sisters. The world she then entered neither astonished nor frightened her. Calm and secure, she has followed her path

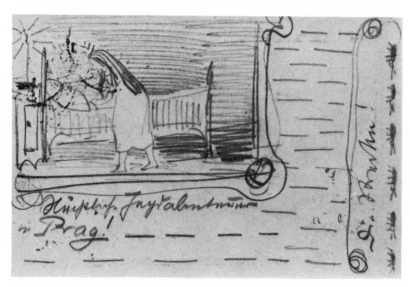

Otto Modersohn: "a nocturnal hunting expedition in Prague!"
June 13, 1901

up to the present time, a path that has often not been easy. But she does it as if it were the most natural thing in the world.

All in all, the landscape here leaves us rather indifferent. And to our taste Schreiberhau is too much of a resort town. To be sure, up near the snow basins it was impressive. But this vagabond life is not for the two of us.

The little spirit in us needs a calm and secure foundation with peace and quiet. It also needs our own landscape in order to be at home with itself.

Otto is lying on the bed studying the timetables with furrowed brow, figuring out our trip to Prague. Kisses from your two children.

To her parents

Schreiberhau, June [12], 1901

My Dears,

It's our last day in Schreiberhau. Tomorrow we will travel on. Our gentle hosts won't let us go until then, but I'm restless to be on our way, to you. I very much want to see my dear father again and find out if he's better than when we left. It seems as if that were months ago. And I have also had my fill of mountains and yearn for the flatlands where my little hermitage is.

In the midst of all these talkative people I sense what a calm and clear talisman resides for me in Otto's heart. There is none of the will-o'-the-wisp about him; he is calm, resolute, and complete, and the ground beneath him is well tilled, and one feels that it's good to be here. At this very moment I think he is in the hands of Dr. Ploetz, the phrenologist, and it will soon be established whether he is a member of the glorious caste of the long skulls or whether he is condemned to live his life with the sad realization of having to struggle on as a round skull.

To Martha and Carl Hauptmann

Worpswede, June 24, 1901

Dear Frau Dr. Hauptmann and dear Herr Dr. Hauptmann,

We have already been back home for five days, and perhaps it's just because we *are* at home that we haven't got around to writing you before. But we speak and reminisce so much about you and our days in Schreiberhau. Were your ears ringing last Saturday evening and Sunday? Saturday evening we were sitting at home while the little carnations were giving off their fragrance and we spoke so much about you, and then Sunday again at the Vogelers'. Nature had changed her dress considerably while we were away. And now the roses in our little garden are having a blossom competition. Coming home was wonderful. Someone had strewn the path in front of our house with flowers and there was the fragrance of others everywhere inside. Little Elsbeth came running toward us with her loud hurrah. And we? We felt as if we were in heaven. We are having wonderful weather now,

that deep blue sky with huge clouds beneath, where everything is swimming in joy and color. It's that deep tone which you, dear Dr. Hauptmann, also love so much in this part of the world. We greet every person, every familiar bush, every little cottage with shouts of joy. It is simply wonderful, and both of us are waiting very quietly to return to our work and to dedicate ourselves to it in humility. The zigzag trips we took from one city to another after we left you are now far, far behind us. In Prague we found the aspect of the city interesting; in Munich there were many beautiful paintings; but compared to the way our Worpswede has got hold of us now, nothing else in the world has such a firm grasp on us. When I got home I found my dear father much improved. Of course, he will be confined to bed for quite a while yet, but that entire first morning we were able to sit by his bed and chat with him.

And how are you? Are you painting a little, dear Frau Dr.? And how is the *Bergschmiede* doing? I wonder if we'll see each other again this summer on the Weyerberg. All of us very much hope so.

It's evening again and I must bring this short letter to an end. Once again our heartfelt thanks to both of you for all your goodness and friendliness.

Your Paula Modersohn-Becker

To Otto Modersohn
[Postcard]

[Postmarked Hannover (illegible) rode]
September 3, 1901

My journey has been wonderful under the sign of cows and clouds, and blue water and cloud shadows, and your wife has told me that for Christmas she desires a spacious rowboat. *Je t'aime.*

To Clara Rilke-Westhoff

Worpswede, September 30, 1901
Dear Clara Westhoff,
Don't you sometimes feel compelled to walk into a little room at Hermann Brünjes' house in Ostendorf? Many things are waiting for you there, among them a young wife. But waiting is becoming very long and sad for her. I am

Your Paula Becker

Worpswede, October 22, 1901

For some time there have been three young wives living in Worpswede. And around Christmastime their babies will be arriving. I'm not ready for that yet. I must wait a little while longer to be certain that I will bear glorious fruit.

Clara Westhoff has a husband now. I no longer seem to belong to her life. I have to first get used to that. I really long to have her still be a part of my life, for it was beautiful with her.

From Otto Modersohn's Journal

December 5, 1901

On the night of the twenty-ninth of November my father-in-law died very suddenly of a heart attack. Paula happened to be there at the time, and so I rushed immediately to the city on Saturday, the thirtieth. During the short period that I was close to him I truly learned to treasure and to love him. The interest which he took in everything and everybody in our lives was moving, as was the joy we had when we visited him, when I would sit with him for hours on end and talk to him about all kinds of things. His joy at having me as a son-in-law was so great. A painful emptiness has come into our lives—a rich life has come to an end. His interests were very numerous and his inclinations were for everything that was noble and lofty; he must have had wonderful, happy years in Dresden with his family—I so much like hearing about them. Alas, it was never granted him to see our home once again, something I so hoped he could do. I shall have the highest regard and esteem for him in my thoughts forever. Henry and Herma were truly heartrending during this first great pain in their lives. He had so much understanding and love for all his children, and they all had their own special relationship with him. That has made me happy so often. And now all these bonds have been broken by inexorable death. He will live forever in my thoughts, and I rejoice that my dear Paula is his daughter.

To Marie Hill

Worpswede, December 20, 1901

Dear Aunt Marie,

I thank you for your letter and all your kind words. Yes, it will be Christmas soon again, and Christmas without him. Mother intends to stay very quietly at home and think about him and all the other Christmastimes of the past. She is very calm. There was something so transfigured about Father at his death. And there was the

last period of his life which he lived through without care. A half year ago he re-
tired from all work just for us. Those six months were a gift from him and we ac-
cepted each day in full awareness of it. But during the very last period there was
an intense inner calm about him, something we had not seen for a long time. He
stopped worrying about what would happen after his death. He was quiet inside,
preparing himself for the great silence. The night he died, he had a wonderfully
peaceful expression which gradually became noble. In the expression of his mouth
and brow, there was revealed to us a life without guile or falseness. I think we must
be silent. Thy will be done. His death has brought us all closer together. Love one
another. That was his last will.

To Martha and Carl Hauptmann

<div align="right">Worpswede, January 2, 1902</div>

Dear Herr Dr. Hauptmann and dear Frau Martha,
The two of us felt very comforted knowing that you were at our side with your
thoughts during this period. You can be sure that our thoughts, too, have often
been with you in your dear Schreiberhau and that our hopes for your work have
helped to guide you into the New Year. We were so sorry to hear that the last part
of the Old Year brought illness to your family. May the New Year be all the more
healthy and happy.

The first Christmas with my dear husband was very beautiful. There was so much
life and hope in our house, and little Elsbeth was jubilant. A short while before
[the holidays] I experienced the first death in my life. It was very gentle, as peace-
ful as sleep, and full of beauty. After my father's illness during the summer he be-
gan to recover slowly — Life was not easy for him. He always worried a great deal
about his six children. He had been brought up with the highest expectations and
ideals. But somehow he was not made for them. Life wore him down. He devel-
oped a rough outer shell over his tender heart. But then this last half year he re-
turned to us again the way we had known him as children. He had done his work,
done it for us; his soul was quiet and serene and full of care for everyone. He slipped
away from us so peacefully one night. I was home there at the time. He was very
great and gentle in his death and very beautiful. Seeing him that way was the most
devout religious experience of my life.

— And out here, new life has arisen at the homes of the Rilkes, and the Vogelers,
and the painter Paul Schroeter who has just arrived here. In every home a baby girl
is lying in the cradle and it's all so blissful. With his duties as a father Rilke has
suddenly become a strong man and looks ferociously courageous. Vogeler is taking
care of the duties of the lying-in room with gentle care and a blissful expression.
These two new tiny creatures arrived at their various parents' homes as complete
surprises.

And we are *so* looking forward to *Bergschmiede*. Most hearty greetings to the two of you. And to you, dear Frau Hauptmann, many more thanks for your very sweet letter.

<div align="right">Your Paula Modersohn-Becker</div>

To Paula Modersohn-Becker from Clara Rilke-Westhoff

<div align="right">Westerwede, February 9, 1902</div>

Dear Paula Becker,

This morning I was leafing through my diary and all at once read: February 8, 1901, Paula Becker's birthday—and suddenly I saw two yellow tulips on a desk, and the photograph of Gerhard [*sic*] Hauptmann, a little picture of Otto Modersohn above a bed, and a shimmering piece of voile—then I noticed many Böcklin pictures—and then—unfortunately—also a great group of aunts. But stop, I don't want to think too clearly about that, otherwise the little image of the little birthday celebration in that bedchamber will vanish. But again something else occurs to me: a bouquet of violets, an orange, and a Pan pipe, and then also a bottle of champagne, which did not pop.

February 10. I was interrupted yesterday and so in the meanwhile it has become even higher time for me to send my felicitations—if they are to have any justification at all.

I am (in this case, unfortunately)—so very housebound that it is impossible for me simply to get on my bicycle and pedal away as I used to do. I can no longer, as I also used to, simply pack up all my goods and chattels on my back and bear them off into another domestic arrangement and carry on my life there for a while—rather, I now have everything around me that I used to look for elsewhere, have a house that has to be built—and so I build and build—and the whole world still stands there around me. And it will not let me go. All my building blocks have to remain in the house if the house is to become solid and cannot be carried off hither and thither. Therefore the world comes to me, the world which I no longer look for outside, and lives with me in all the things that are round about me. And these things, which know well which paths lead me to them and which love them because they always lead me to them—these things which are so wise, like the ripest hour of my life—stood for a while and thought of your celebration and sent you a greeting—

And I come with them and send many good wishes for you and your house.

<div align="right">Your Clara Rilke</div>

Dear Frau Modersohn,

There was a lecture — and there was one job after another, the never-ending problem of staging *Sister Beatrix:* and thus it was that I, too, forgot the day which it is so natural for me to concelebrate. Please accept my sincere wishes and at the same time this little book of my latest work, of which I have already told you.

Many greetings to Otto Modersohn and to you all affection from your

Devoted Rainer Maria Rilke
Westerwede on the tenth of February 1902

To Clara Rilke-Westhoff

Worpswede, February 10, 1902

Dear Clara Westhoff,

Ever since that afternoon when I brought the money to your little room in the hotel behind the castle you have been very selfish with me. And I, who approach life very differently from you, I felt a great hunger. Isn't love thousandfold? Isn't it like the sun that shines on everything? Must love be stingy? Must love give *everything* to *one* person and take from the others? Is love permitted to take? Isn't it much too precious, too great, too all-embracing? Clara Westhoff, live the way nature does. The deer gather in herds, and even the little titmice at our window have their own community, too, not merely that of the family. I follow after you, a little melancholy. Rilke's voice speaks too strongly and too ardently from your words. Do you think that love demands that one person become just like the other? No, it doesn't, a thousand times no. Isn't it true that the union of two strong people becomes rich and rewarding by virtue of the fact that both are ruling and both are serving in simplicity and peace and joy and quiet contentment? I don't know much about the two of you; but it seems to me that you have shed too much of your old self and spread it out like a cloak so that your king can walk on it. I wish for your sake and for the world and for art and also for my sake that you would wear your own golden cape again. Dear Reiner [*sic*] Maria Rilke, I am setting the hounds on you. I admit it. I believe it is necessary for me to hound you. And I have every intention of hounding you with my thousand tongues of love, you and that lovely colorful seal of yours with which you stamp more than simply the elegant letters you write. Clara Westhoff, in that room of last year you write about where my husband and Gerhart Hauptmann dwelt, you dwelt, too. I believe that I have a faithful heart, a simple German heart. And I also believe that no power in the world gives you permission to trample it. And I believe that if you continue to do it, that foot of yours which does the trampling will not become more beautiful. And is that what love is supposed to demand? Think of the Ninth Symphony, think of Böcklin. Are those not feelings that overflow and flow on and on? Doesn't that speak out against your new philosophy? Don't put your soul in chains, even

if they are golden chains and no matter how gorgeously they might resound and sing.

I bless you two people. Cannot life be lived the way the six of us once thought it would? Whenever you are with us, are your souls not also united with us in this greater community? Can we not show the world that six people can love one another? It would be a wretched world, indeed, in which that couldn't happen! And is our world not wondrous and full of the future?

I am your old Paula Becker and I am proud that my love can endure so much and still remain the same size.

I thank you, my dear friend, very much for your beautiful book. And please, please, please, don't make up riddles for us. My husband and I are two simple people; it is hard for us to do riddles, and afterward it only makes our head hurt, and our heart.

To Paula from Rainer Maria Rilke

Bremen, February 12, 1902

Dear Frau Modersohn,

Permit me to say a few words about your letter to my dear wife. It concerns me very much, as you know, and if I were not in Bremen I would seek the opportunity to speak with you personally about the matter—which...indeed, about what matter? Will you believe that it is difficult for me to understand what you are really thinking about? Nothing has happened—or rather, many good things have happened, and the misunderstanding comes from your not wishing to let happen what has happened. Everything is supposed to remain as it was, and yet everything is different from the way it was. If your love for Clara Westhoff now wishes to do something, then this is the task and the work of your love: to make up for what it has failed to do. For your love has failed to see where this human being has gone; it has failed to accompany her in her broadest development; it has failed to spread itself out over the new horizons that encompass this human being. And it has not stopped looking for her where she was at one particular point in her growth. It stubbornly seeks to hold fast to one particular point of beauty that she has gone beyond, instead of waiting patiently and faithfully for the new and beautiful things that the future holds for both of you.

The trust which you, dear friend, placed in me when you permitted me a brief look into your journal entitles me (I believe) to remind you of how strange and distant and incomparable Clara Westhoff's nature seemed to you at the beginning, of how you were surrounded by a solitude whose portals you did not know... And you have forgotten this first essential impression so completely that you accompany your remarks only with blame and admonition now that this person, whom you began to love for the sake of her uniqueness and solitude, has entered into a

new solitude, the reasons for which you are capable of realizing even better than the reasons for that initial seclusion, which you at that time regarded not with reproach but with a certain admiring concession. If your love has remained alert, then it has had to see that the experiences that came to Clara Westhoff have retained their value precisely because they have bound themselves closely and indissolubly with the interior of the house where the future is to find us: we had to burn all the wood on our own hearth just to warm up our house and make it habitable. Must I be the one to tell you that we had worries, hard and anxious worries, which could no more be displayed in the open than could our few hours of deep happiness? . . . Are you surprised that the centers of gravity have shifted, and are your love and friendship so mistrustful that it constantly wants to see and grasp hold of what it already possesses? You must constantly experience disappointment if you expect to discover the old relationship unchanged. But why not rejoice in the expectation of the new relationship that shall begin when Clara Westhoff's new solitude will one day open the gates to receive you? I, too, am standing quietly and full of deep trust *outside* the gates of her solitude, because I consider this to be the highest task of the union of two people: that each one should keep watch over the solitude of the other. For if it be the nature of indifference and of the mob not to recognize solitude, then love and friendship exist for the very purpose of constantly giving such opportunities for solitude. The only true moments of human communion are those which interrupt rhythmically periods of deep isolation. . . . Remember that when you first knew Clara Westhoff, your love was there waiting patiently for a gate to open, the same love that now knocks impatiently on the walls behind which things are drawing to completion, things neither of us knows, I just as little as you —it is only that I have the faith that they shall touch me deeply and closely on the day they are revealed to me. Can your love not grasp hold of a similar faith? Only from this faith will joy flow to it, joy from which your love will live without hungering. Your:

<div align="right">Rainer Maria Rilke</div>

*Journal

<div align="right">February 24, 1902</div>

I put a wreath on the grave of the woman he once called his love. It was in the morning. Snow was on the ground, but a finch was already practicing his love song.

I walked for a long time, as if in a dream. My heart smiled. The snow was a coverlet beneath my feet, crisp and brittle from the frost last night, and my foot sank into it a little, making a gentle crunching sound. Off to one side was the green of winter rye. Its steady growth had conquered the snow. My smile made me feel strange. Perhaps I was thinking of where my feet were taking me.

I have often thought of my grave and how different from the other one I imagine

it will be. It must not have a mound. Let it be a rectangular bed with white carnations planted around it. And around that there will be a modest little gravel path also bordered by carnations, and then will come a wooden trellis, quiet and humble, and simply there to support the abundance of roses surrounding my grave. And there will be a little gate in the front of the fence through which people can come to visit me, and at the back a quiet little bench where people can sit. It will be in our Worpswede churchyard, by the hedge near the fields, in the old part, not at the far end. Perhaps at the head of my grave there should be two little juniper trees, and in the center a black wooden tablet with just my name, no dates, no other words.

That's the way it should be.... And I shall probably want to have a bowl where people can put fresh flowers for me.

*To Marie Hill

<div align="right">Worpswede, February 27, 1902</div>

Dear Aunt Marie,

I know I don't write you often, but the reason for that has nothing to do with our relationship. It has to do with my nature which, I think, is too reticent to express itself. Even if I had just become engaged, I think that I would write much less about it than most brides-to-be.

At the moment I'm sitting in my same little room of old, where I must say I have spent my happiest hours. I either do something here or think about what I'm going to do or about the things that have recently happened to me. Or I read. Recently I've been immersed in Gottfried Keller. I understand him even better because of the extraordinarily tender and tolerant friendship which Böcklin had with the writer in his last years. How very, very German Keller was. His last days were starkly overshadowed by his illness; but over and over again brilliant golden visions broke through his death agonies, for he had wonderful visions and hallucinations toward the end, which seem so much truer and lovelier when one considers his nature, which wasn't effusive or visionary in the slightest. Reading about his death made me feel very solemn and serious, and filled me with gratitude.

I'm happy that your young lady friend who paints makes you think of me. Otto and I have a very high opinion of her teacher Kalckreuth; he is one of the most sympathetic of the Germans. His portrait of his wife that we saw in Dresden last year was one of my most intense experiences. Just exactly the kind of portrait for a German to paint of his wife. A man like him has given wonderful things to the deepest layer of our consciousness as a nation. In this age of tourists and newspapers most of the others seem to have lost the little bit of Germanness they ever had, and no longer have an ear for its true sound. As a result, the top people in art in our beloved Dresden refused to purchase this very portrait. It had been proposed for acquisition

by the gallery. They said they had no desire to have "such an ugly old governess." In Munich there is a little picture of his, hanging way off in a corner of the Neue Pinakothek, of a little garden refreshed after a rainstorm where a mother is walking with her child. It conveys wonderfully the fresh crispness of color and feeling in nature right after a rainfall. Give your young painter lady my greetings and tell her that I hope something good will come of her. There is no sense in my sending you anything of mine right now. Let's wait a little while longer. I feel as if I were still developing; it's a feeling that makes me very happy, almost pious.

Spring began here today and one can hear the melting snow dripping from the eaves and trickling away. And high in the air was the most glorious song of a lark, the little bells of heaven.

A young musician from Dresden named Petri is living in the village now and has been playing the most heavenly Bach.

Journal

February 27, 1902

Drip, drip, drip, outside my window. That is the ice thawing, making a watery, swimming sound. And outside my window in the field where the apple trees are, the snow is now spread out like a white sheet. My soul senses that it will soon be melted and gone.

From Otto Modersohn's Journal
Beginning February 28, 1902

March 11, 1902

I have really been astonished at Paula's progress this winter. If she continues to develop like this, I am certain she will produce something very fine with her art. First of all, her style is very personal; nothing conventional and nothing traditional, unlike almost all women painters, in form, color, material, treatment—that for me is the best evidence of her truly artistic calling. And that is the way even her first little pieces of work are. Especially two heads of girls against the sky. That is really a fine and genuine bit of painting—free, naïve, with fine coloristic determination, intimate, and yet great in a painterly sense. I particularly like the larger one; a sweet springtime spirit is alive in it. Earlier, I valued her judgment, but now I also value her accomplishment. Then she painted several still lifes and a portrait of a head, both on slate board, all very original in coloration. Above all I am happy that she has become much more intimate, much deeper; earlier she painted very superficially. I am very happy about this development. Her judgment is extraor-

dinarily fine. So far she has always proved to be right. From the beginning she did not like my three pictures in Bremen, nor last winter my painting of the elfin dance; and now that is exactly my opinion, too. H. Vogeler keeps on being wrong. First he liked the forest witch, and I believe he still likes the stupid dance of the elves. How many correct judgments she has already made and how correct her advice to me has been! No one understands her—no one. In Bremen: her mother, her aunts, her brothers and sisters, they have all silently reached the same conclusion: Paula will never accomplish anything. They do not take her seriously. Fräulein von Steinsdorf—yes, she is something else. And here in Worpswede: Overbeck and Schröder naturally don't know her at all. The same for Mackensen and the Rilkes? Well, their behavior proves the point. No one ever asks about her work; Clara Westhoff has never visited her—she, who claimed to be her friend. What arrogance there is in Rilke's words that P. is supposed to wait outside the gates, until his lofty wife and great artist opens them up; that P. has failed to follow her into her higher regions. The fact that *she* is somebody and is accomplishing something, no one thinks about that. And it's the same with H. Vogeler. Art must be a very minor thing to that woman, he says; but for C[lara] W[esthoff]—yes, that's something entirely different, she must go to Florence, her works ought to be photographed, etc.—he never asks about P.; he never comes to the Brünjes'. He doesn't know her; he doesn't know how to value her—he thinks she is completely on the wrong track. His wife often feels very small—surely she has influenced him. Well and good. I rejoice in my Paula, who is a true painter. Even today she paints better than H[einrich] V[ogeler]. Yes, I think that head is better than Mackensen's *Fisher*. And my judgment is not dictated by my love for her. All by herself she will struggle along and one day she will astonish everyone (as I did then). That is what I look forward to. At the same time she is learning to be a housewife, and even today she certainly knows as much about that as Frau V[ogeler].

I rejoice in my Paula. Her song will celebrate the spring, things that are charming, sweet, gracious, fine, that is her world. Youth, love, buds, blossoms, stillness, peace. Also the serious things, veiled, muffled, deep, covered, gentle things, they belong to her, too. (Böcklin's Magdalene.) She has her own ideas about form, about color, about technique. She is an artist through and through. She is certainly the best woman painter who has ever been here. I now like her better than Reyländer who is too sophisticated, decorative. H[einrich] V[ogeler] also lacks all naiveté; he underlines everything, sky, clothing, grass, flowers, everything is filled with intention; everything is in quotation marks. With P. everything is naively and quietly there. She has a great talent for color. And perhaps even more, she has a great capacity for the large image. And it is here in particular that Paula is on a very sensitive path, the way she can weave her personality together with nature. She communicates intimacy on a large scale. Her things have their effect, seen in the large, as some of mine do. She gives less [detail], but what she gives is intimate and strong.

From the Album

Catkins were in blossom even *before* my birthday, when all the snow came which the sun is only now finally kissing away. There are just little patches lying now in the sunken lane. Hazel and poplar catkins.

And now *snowdrops* are in blossom in our garden and at the Brünjes'.

Titmice, starlings, larks, and finches are singing. Daylight lasts almost until seven o'clock. And five days ago, it was probably on the twenty-second, I found yellow *coltsfoot* near the brickyard. And now it's lovingly here in front of me in the green cup from old Frau Böttcher (the spinner). All day long yesterday Herma and I and Gefken were getting the garden ready for Easter. Gradually I'm getting to know every flower there, helping them along, and slowly we're beginning to feel that we belong to one another. Today I want to sow seed in my seedbeds.

**Journal*

Easter Week, March 1902

In this first year of my marriage I have cried a great deal and my tears often come like the great tears of childhood. They come when I hear music and when I am moved by beauty. When all is said and done, I'm probably just as lonely as I was when I was a child.

This loneliness sometimes makes me sad, and sometimes happy. I believe it makes me a deeper person. And it makes me live less for the sake of appearances and recognition. We live turned toward the inside. In the old days, I think, feelings like this made one enter a nunnery. And then I've had this experience: my heart has been longing for a certain soul, whose name is Clara Westhoff. I think we shall never again find each other completely. We are on different paths. And maybe this loneliness is good for my art. Perhaps it will sprout wings in this earnest silence. Blessed, blessed, blessed.

I welcome the spring outside with passion. It must consecrate me and my art. It will strew flowers on me as I work. I found coltsfoot out by the brickyard. I carried some of them around with me and held them up to see how the yellow stood out deep and shining against the sky.

**Journal*

Easter Sunday, March 30, 1902

My experience tells me that marriage does not make one happier. It takes away the illusion that had sustained a deep belief in the possibility of a kindred soul.

In marriage one feels doubly misunderstood. For one's whole life up to one's

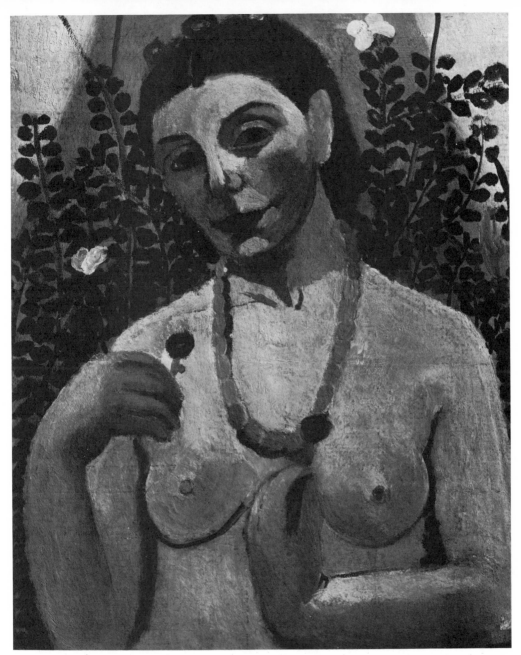

20. Self-Portrait with Amber Necklace, *ca. 1906*

21. View from the Artist's Atelier
 in Paris, *1900*

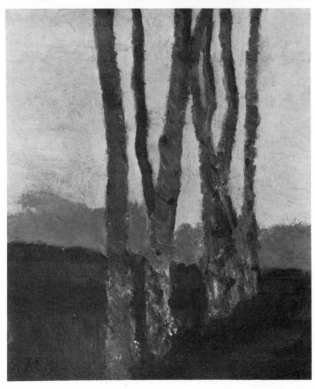

22. Birch Tree Trunks, *ca. 1900*

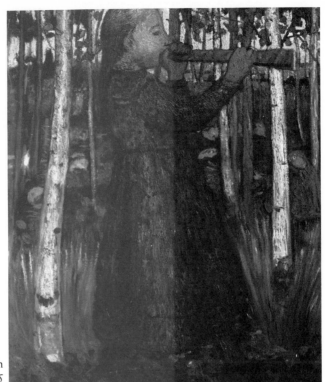

23. Girl Playing Horn in Birch
Woods, *1905*

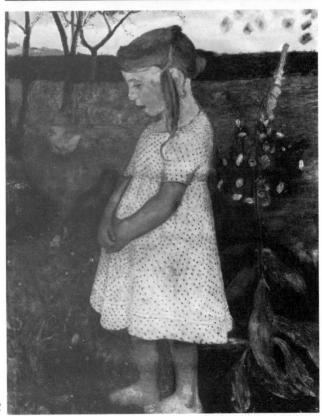

24. Elsbeth, *1902*

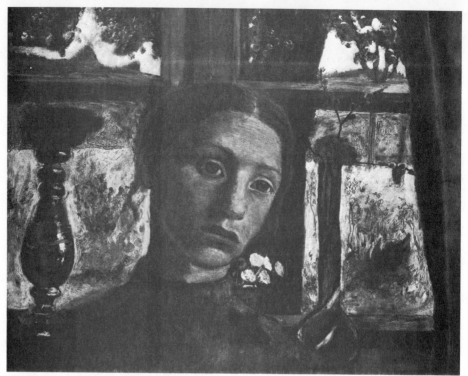

25. Head of a Girl at a Window, *ca. 1902*

26. Still Life with Venetian Mirror, *1903*

27. Still Life with Apples and Bananas, *ca. 1905*

28. Self-Portrait with Camellia Branch, *1907*

29. *Paul Cézanne,* Still Life with Apples and Oranges, *1895–1900*

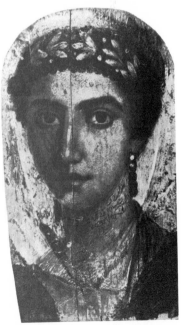

30. *Mummy portrait of Irene from Fayum, ca. A. D. 40*

31. Otto Modersohn with Pipe, *ca.
 1906–7*

32. Portrait of Herma Becker, *1906*

marriage has been devoted to finding another understanding being. And is it perhaps not better without this illusion, better to be eye to eye with one great and lonely truth?

I am writing this in my housekeeping book on Easter Sunday, 1902, sitting in my kitchen, cooking a roast of veal.

<div align="right">Evening of the same day</div>

It seems to me that Böcklin must have learned a great deal from Titian. He never mentions him, or only very rarely. I wonder if spiritually he was too close to him? That hand filled with flowers in Titian's *Flora* could have been painted by Böcklin. I am astonished with what ease the great Renaissance masters put their great pictures on canvas. I'm studying the Titian book. It seems to me as if great, voluptuous images like these, figures with landscape background, everything marvelously modeled, everything subordinated to the great concept of image, not realism at all and yet so full of the beautiful coloristic charm I connect with the modern way of seeing things — as if that were the art of the future. I wonder if it is in my art? Titian was a painter, a mind rich with temperament and the power to shape and to form. I should like to confront him once again. Of course, I'm speaking now from having been inspired only by reproductions. Perhaps the originals would have quite a different effect on me.

*Journal

<div align="right">April 2, 1902</div>

I believe that what makes me happy is the hope [expectation] that my wishes will be fulfilled. Once I have what I want in hand, it has already lost its excitement for me. It seems nothing more than one of the steps in natural process of growth, something that need no longer amaze or overjoy one.

It's like being a child who wishes to be big and grown up. By the time it has grown up, the fact of adulthood has long since lost its excitement. That is why my stay in Paris was such a happy one. I had such strong hopes.

In spite of everything and everyone this hope is what excites me. That is what gives such pride and strength to my entire being.

*Journal

<div align="right">April 1902</div>

How much Böcklin gave to the world! It is beautiful that my life was contemporary with his for a little while. It gives me the feeling that I belong to the epoch that produced him, and that I can understand him all the better for it.

Heinrich Vogeler often tells me how painful it is for him to have to give up his paintings and watch them leave home. For me, that is ultimately a sign of his sparse and constricted artistic flow. Art that is abundant and always giving birth thinks only of what is to come. That is the grand and hopeful quality I see in Otto's work.

Probably all young painters have faith in the future. And that is what gives them the strength for their first great flight. And then most of them freeze in place. They are not full enough of the future; artistically they live too much in what they have already done.

To be honest with myself, I must say that I have nothing in common with Overbeck's art. I don't feel its inner necessity. Or to put it better, he seems to me more like a sterile worker bee whose number is legion and who works with all its power simply so there can be another fertile queen bee sometime in the future.

From Otto Modersohn's Journal
Beginning 28 February 1902

April 9, 1902

In our opinions on art, in our taste, Paula and I are an excellent match. Both of us love the naive, the unusual (our house, Brünjes' atelier, my studio). She makes flower beds in our garden, everywhere; little intimate spots with benches, a glass globe. Mackensen's garden is laid out very economically; am Ende's is like a city garden, with its hedges and such; Vinnen is a big landowner; at Overbeck's, too, everything is so urbane, inside and out. Only Vogeler and we are different. And even then, Vogeler is more stylish and refined; we are more naive, more intimate, a bit more odd. In our passions Paula and I fit together superbly.

To Marie Hill

Worpswede, April 22, 1902

Dear Aunt Marie,
This is our time for building arbors. Together, Otto and Henry have hammered together three charming ones; one stands under an elderberry bush, the second under birches, and the third will be for growing gourds. And now we have plans for two more. You can imagine how cozy and comical our miniature garden looks with them. Right in the middle there will be a silvery glass globe like a shining jewel. These pretty spots make us very merry, most of all Elsbeth. I'm planting roses and all sorts of common flowers, tying up the invalids with pieces of cloth and rags, watering them when they get dry, hoeing weeds, and have black hands. . . .

Our old postman is bound to be here any minute, so I want to send off this little epistle with him. A quick kiss before I do.

April 25, 1902

[...] Paula's and my tastes in artistic matters are very closely related. We both love the primitive and intimate, the unusual and the particular. [...] P. has brought me back to my own ways (first of all to living à la Brünjes). I have learned to like her atelier at the Brünjes' more and more. The old times came to life again in me. And this spirit also moved into our little house; there, too, the primitive, unusual, and intimate now predominate and no longer the conventional, the materialistic. And so the spirit is now moving into our little garden. Paula and I have been working there for days. P. is making little naive pathways and benches surrounded by carnations, planted with farmers' flowers; I am constructing arbors. I have never been so active in the garden before. [...] The fat glass globe was the final touch. [...]

To Paula from her mother

Bremen, April 29, 1902

Dear Paula,
Set yourself down right away and paint the boy. [...] At the end of May he is enlisting; in the middle of June he is sailing away from us and won't be back for a year and a day. [...]

Journal

May 2, 1902

Rilke once wrote [me] that it is the duty of the husband and wife to keep watch over each other's solitude. But isn't a solitude that someone has to keep watch over merely a superficial solitude? Isn't true solitude completely open and unguarded? And yet no one can get close to it, although it often waits for someone to walk hand in hand with through the valleys and the fields. But waiting is perhaps only weakness, and the fact that no one comes makes the lonely person stronger. For this walking alone is good; it reveals to us many depths and shallows we would never be aware of with someone else along.

It seems to me terribly difficult to live one's life to its end in a good and great way. Up to now, still the beginning, that was easy. Now it is probably starting to get more difficult, there will be many inner struggles. Anyone can cast one's net—but the point is to make a good catch!

May 29, 1902

I stood in the grass with bare feet while my husband painted me. I first had on my wedding dress, and then a pink one, and then a blue, and finally a white satin dress edged with gold. The pink dress had an open back and was sleeveless. I stood in the sun. And when I felt the slightest breeze on the nape of my neck, I would smile a little and for a moment open my eyes, which I kept tightly closed because of the brilliant sunshine.... The grass around me was covered with little white star-flowers. I picked a handful and looked at them against the bright sky and at the play of their shadows on my arm. I was awake but dreaming and I looked at my life as though from a second life.

*Journal

June 3, 1902

Someday I must be able to paint truly remarkable colors. Yesterday I held in my lap a wide, silver-gray satin ribbon which I edged with two narrower black, patterned silk ribbons. And I placed on top of these a plump, bottle-green velvet bow. I'd like to be able to paint something one day in those colors.

We are reading a book now on Segantini by Franz Servaes. Otto is very excited by Segantini's technique of placing next to one another bits of color like a mosaic and thus producing a concrete, brilliant effect. He is enthusiastic about color in motion. And I am, too. I dream of movement in color, of gentle shimmering, vibration, of one object setting another in motion through color. But the means which I should like to use are very different ones. There is something almost tactile for me in the thick application of paint. And I should like to produce it by glazing techniques, maybe over a thick underpainting. A different kind of glazing than Otto has in mind. He really knows only the single-glaze process, and with a second application of paint he covers right over the glaze. I think that one can glaze ten times, one layer over the other, if one only knows how to do it correctly. And I think, too, that once I am further along I can achieve greater vitality in my pictures. But I'm going to attempt it by using an underpainting technique. And later sometime I want to try painting on a gold ground.

To Martha Hauptmann

Worpswede, June 5, 1902

Dear Frau Hauptmann,

Our plant will soon be in blossom; it already has fat round buds that will pop open on the next sunny day. We are rejoicing in its white and rosy colors already and thank both of you very much for giving us such springtime happiness this year

and for the seasons to come. The plant withstood the journey perfectly, and we had an extra cold May with rain showers every day just so the plant could endure the change of climate and send its roots down to take hold.

—But it is all at once summertime now, the rye fields have developed their heads in three days, and the tops of the birch trees are hanging heavy with greenery. We're finding everything so new and so beautiful once again. In our miniature garden we've built one bower after another and have been sitting there in the evenings. And my husband has been reading me a book on Segantini by Franz Servaes. It is wonderful getting close to the life of this serious and intense artist. And it was strange; both of us found a great similarity in spirit between your husband and Segantini, even in the way in which they sometimes express themselves; this idealizing of the light, of the sun and clarity and the love that lives in everything—I wonder when you will be coming here? There is so much conversation about the two of you, by everybody.

—And now Mackensen is also engaged—head over heels, almost to his own amazement—to a very little lady from Bremen, who might perhaps be nicer if she weren't so much a Bremer. He is painting a big canvas again, a Sermon on the Mount. And Vogeler is painting his wife and child who are seated under a rosebush—

—We are all fine. My husband is sailing full speed ahead again, and I'm full of curiosity about where his little ship is headed. Little Elsbeth plays in the sand every day and is completely browned by the sun. In fact, she's running toward me this very minute with the firmest intention of doing some sewing and I have to arrange things for her.

Many hearty greetings from my husband and me to the two of you.

<div align="right">Your Paula Modersohn-Becker</div>

Also greetings to Fräulein Teichmüller and Dr. Wille and his wife.

To her mother
<div align="right">June 10, 1902</div>

My dear Mother,
Tomorrow I shall be thinking of you two, my parents, on your wedding anniversary; for he, our father, lives in all of us and his presence is a blessing to all of us. Now you must receive all this love for the two of you, you who must represent both. And let your hand be kissed by

<div align="right">Your Child</div>

From Otto Modersohn's Journal
Beginning February 28, 1902

<div align="right">June 15, 1902</div>

It is really splendid to work and strive alongside my dear Paula. By evening the new studies are leaning against the plant stand on the veranda. Last evening P. really surprised me by a sketch from the poorhouse with old Three-Legs, goat, chickens — simply wonderful in its color, very remarkable in its composition, and with its surface worked over with the end of her brush, made all swirly. Remarkable how great these things are, everything seen as a true painter. There is no one else here in Worpswede, in fact, who interests me nearly as much as Paula. She has wit, spirit, fantasy; she has a splendid sense of color and form. When she has progressed to an intimate treatment [of subject matter], then she will be a superb painter. I am full of hope. At the same time that I am able to give her something of this intimacy, she gives me something of her greatness, her freedom, her lapidary quality. I always overdo things and so I can easily become small and fussy and I hate that; I want greatness. Paula stimulates me enormously in this. This reciprocal giving and taking is wonderful; I can feel how I am learning from her and with her. Our relationship is so beautiful; more beautiful than I ever thought it could be; I am truly happy; she is a genuine artist such as few in the world are; she has something absolutely rare — she is fundamentally more artistic than F[ritz] M[ackensen] or H[einrich] V[ogeler] or F[ritz] O[verbeck], not to mention C[arl] V[innen] and H[ans] a[m] E[nde]. No one knows her, no one appreciates her — someday that will change. I frequently have the effect of being too quaint, nice, pleasant, and so forth — while my ideal is greatness.

**To her mother*

<div align="right">Worpswede, June 27, 1902</div>

My dear Mother,

[…] Imagine ending your visit with us by stealing away at five o'clock in the morning! That was completely contrary to the rules of our Worpswede spa life whose first rule is to sleep late. It always makes me happy to realize that Otto can sleep the same deep, childlike sleep that I'm capable of, especially in the summertime after we've been out painting everywhere, all day long. Even after supper the two of us dash over to the poorhouse and do oil studies of the cow, the goat, and the old woman with her walking stick, and of the children there who, as far as I'm concerned, are the only people here who ever really sing. The only other singers one hears are the drunks. Song is not part of the nature of this heavy race of people.

It's very hot here today, which you can probably tell from the tone of my letter. But nothing is going to stop my master from coming to fetch me for another day's painting. Today: boys swimming. The perfect weather for that […]

From Otto Modersohn's Journal
Beginning February 28, 1902

June 28, 1902

[...] Egotism, lack of consideration is the modern sickness. Nietzsche, the father. Opposite of Christian love of neighbor. Think it is terrible, barbaric, brutal, just to think of one's self, take care of one's self, to kick other people. That's the way Rilke and his wife are. Related to that is superficiality, which characterizes H[einrich] V[ogeler] and his wife. One thing they have in common: the heart is superfluous. [...] Unfortunately, Paula is also very much infected by these modern notions. She is also quite accomplished in the realm of egotism. Whoever is not deep enough or fine enough in her estimation is pushed aside gruffly and ruthlessly. If this goes on much longer we will soon be alone. Another triumph. I, too, have already and frequently been the object of this gruff egotism. I wonder whether all gifted women are like that? In art, Paula is certainly gifted; I am astonished at her progress. But if only this were joined by more humane virtues. It must be the most difficult thing for a woman to be highly developed spiritually and to be intelligent, and still be completely feminine. These modern women cannot really love; or they grab hold of love only from the animalistic side of their nature, and the psyche has no part in it. How far they really are from any truly high objective. They stumble over their own feet. With all their intelligence, they get further and further away from any goal. They think that egotism, independence, conceit, are the best things there are; and no happy marriage can come from that. The husband, naturally, is caught up in medieval, tyrannical appetites if he expects his wife to do him favors, live with him, enter into his interests. To do that, of course, a wife would have to sacrifice her rights and her personality. That's the way they argue, and they make themselves and their husbands miserable.

To her mother

July 6, 1902

My dear Mother,
It's Sunday morning and I've taken refuge in my dear little atelier and am sitting all alone now in my dear little Brünjes cottage. All of its inhabitants seem to have gone to church, so that I had to force open one of the rickety windows to get in.

My Mother, I'm sorry this letter won't turn into the usual, punctual, Sunday letter it should, but there is a good reason for that, namely, the work I'm doing. It consumes me, heart and soul. There are times when the feeling of devotion to work and dependence on it simply has to slumber in me, times when I just read a lot, or make little jokes, or just live. And then suddenly those feelings are wide awake in

me again, and storm and surge so that the vessel seems about to explode, as if there were room for nothing else inside.

Mother, the dawn has broken in me and I can feel the day approaching. I am going to become somebody. If only I had been able to show Father that my life has not been simply fishing in troubled waters, pointless; if only I had been able to repay him for the part of himself that he planted in me! I feel that the time is soon coming when I no longer have to be ashamed and remain silent, but when I feel with pride that I am a painter.

I have just finished a study of Elsbeth. She is standing in the Brünjes' apple orchard. Here and there a few chickens are running around, and next to her stands an immense flowering foxglove. It's not earthshaking, of course. But in painting it, my power to shape and form and express things has grown. I have a clear feeling that many other good things are going to come after this piece of work, and that is something I didn't know last winter. And this feeling, this knowledge does my soul good. My dear Otto stands next to me, shakes his head, and says that I'm one devil of a girl, and then we hug each other and we speak about the other's work, and then we talk about our own again. Oh, as soon as I have become somebody, what a weight will fall from my shoulders. My relationship with Uncle Arthur, for example; I will be able to look him straight in the eyes and not have to console him with all kinds of promises. And he will be satisfied that the money with which he so kindly entrusted me was a good investment. And I can face all the other people, too, who are always treating my painting with such sympathy and tender understanding, as if it were some little eccentric obsession that they had to put up with along with the rest of me. You can see how my head is swelling.

And I think so often of the words of Solomon or David, "Create in me a clean heart, O God; and renew a right spirit within me. Cast me not away from thy presence; and take not thy holy spirit from me." . . . I don't really know whether these words fit the feeling I have when I say them. But it is strange. Ever since I was a child and whenever I felt I was running a risk of being too proud about something, I said these words to myself.

And what about you? The two of us have enjoyed your letters. But, dear, no staying up until one o'clock every night! You have to think of this trip primarily from the standpoint of your health, yours and the little chick's. Give Herma a kiss for me. I wish for her that in her life she will have feelings like those I have today. But the path is long, and one must have hope in one's heart that will sustain one. My dear Herma, pick out something to hope for! You are an intelligent girl by nature. So it should be part of your nature to see to it that you don't develop too early and become sophisticated too soon. A fruit that slowly ripens in the wind and the sun, that's what life must be. Stay away from too many books and from too much theater. It is better for you to find an active group of friends your own age. See to it that you get into the *Gymnasium*. And don't try to take too many steps at a time. Your health is not up to that. And besides, that's not at all necessary in this

life. Someone who has a long road in front of her doesn't run. Just create for yourself a quiet and simple milieu and think about things that suit your years.

Kisses for both of you.

<div align="right">Your Paula</div>

From Otto Modersohn's Journal
Beginning February 28, 1902

<div align="right">July 7, 1902</div>

My Paula is such a fine wench. An artist through and through. Her sense of color—no one else here has anything like it; I can't keep up with her now. I am simply bowled over by it. This has never happened to me before, except here and there with Fritz Mackensen, at the beginning. It is tremendously good for me. It shakes me up. "This little wench should paint better than you? The devil, you say!" Boy, I am really getting to it now! My eyes are open. That will be a race.

<div align="right">July 8, 1902</div>

After my recent upset over Paula's painting with the glass globes, I have finally, finally completely awakened from my seven years' sleep. [...] The scales are falling from my eyes. Thank God that I can finally see clearly, very clearly, what is at stake, what it is all about. I owe that to Paula, this bedeviled wench. [...]

<div align="right">July 9, 1902</div>

[...] In short, this is what painting is: seeing, feeling, doing. [...] Ever since my feelings have changed (since Paula's picture) I have sensed everywhere harmony, resonance, nothing separate—everything bound together. Air, light, the great unifiers.

I want to go deeper, pull myself together, and paint something profound and great. That is the only thing that occupies me. Paula is my comrade. Paula is a highly gifted woman, the most gifted one here, and rare anywhere; she alone has the great point of view, feels what is at stake, is an artist through and through. All the others are going downhill, all of them.

To Paula from her mother

<div align="right">Burgstall, July 11, 1902</div>

[...] How wonderful that you, yourself, have been feeling a "forward, march!" in your art; we have all had the feeling that this year has advanced you, but the happy awareness in one's own breast is worth more than everything else. [...]

August 7, 1902

> Warmly the evening
> Lets down its arms
> And at the edges of the world
> There its hands rest....
> The little gnats hum
> Gently in their brilliant way,
> And all creatures quiver
> And sing quietly of life....
> It is not great
> It is not broad
> It is a little space of time
> Eternity is forever...

(Written at my clay pit)

[On a loose sheet]

[Fall 1902]

I took a warm bath today. I felt so cozy. Little Elsbeth helped me. She touched my breasts and asked, "What are those?" Yes, my child! Those are mysteries...

And then I ran through the mild autumn wind in the glow of the half-moon. The bath had quickened my blood and invigorated me. In my throat was a song that wanted to be sung. Sometimes my voice does sing. When my soul and my senses are full.

Today I read that in its first stages the heart of a human embryo is located in the head and only gradually moves down to the breast. It is a sweet thought that they are born so close to one another, heart and mind. That confirms my feeling. In my own case, I can hardly ever tell one from the other.

Journal

October 1, 1902

I believe that one should not think about nature too much in painting pictures. At least not during the process of conceiving the image. An oil sketch should be made just according to the way one once felt something in nature. But my own personal feeling, that is the main thing. Once I have got that pinned down, clear in its form and color, only then do I introduce things from nature which will make my picture have a natural effect, so that a layman will be totally convinced that I painted my picture from nature.

Recently I have felt just what the mood of colors means to me: it means that everything in this picture changes its local color according to the same principle, and that thereby all muted tones blend in a unified relationship, one to the other.

To Otto Modersohn

Worpswede, November 4, 1902

My beloved Husband,

Well, this is the first evening of the first big separation in our marriage. It gives me a strange feeling. In the bosom of your family you are probably not conscious of such a feeling at all—I am reveling in it, reveling in my solitude, and thinking of you with love. Thinking of our love, I walked home this evening through the dark moist air and had a little inner conversation with you. You are my only beloved husband. I feel a great security in our love and for our love. And today as I walked along, I was suddenly breathless from a feeling of happiness. When I considered that the high point of the ultimate peak of our love is yet to come! Look, dear, there's no need for you to be sad or jealous of my thoughts when I tell you that I love my solitude. I love it in part because I can be quiet and undisturbed while I think good thoughts about you. Dear, I kiss you.

Coming back home to our birch trees was lovely. I saw everything through the gentle veil of your absence. I guess we really are, each of us, already a part of the other. I can feel how very much I live inside you. But I also love this separation because it transforms this living inside each other into a spiritual thing. I love it when my body steps back occasionally—I change back and forth from a brittle avoidance of your physical presence to the most passionate desire for the next physical union. Dear, love me, even if I don't make any sense. I really mean it well.

I shared my trip home with Mackensen, who was coming back from a week's stay in Hamburg. He was buying painting materials. It was a rather neutral atmosphere, not particularly pleasant and not unpleasant.

I enclose the letter from Frau B. Her request for a reduction in the price outweighs for me a little, or entirely, all the rest of her [flattering] twaddle. I'm surprised that such people aren't ashamed of themselves. I would hold off with an answer, if I were you, until you got back here.

Hearty greetings to your parents. Also to Laura and her family. I kiss you on your dear, soft brow and the soft place under your ear.

Your Paula

To Otto Modersohn

Worpswede, November 7, 1902

My beloved Husband, my King Redbeard, my Otto of the Beard, You of the Soft Brow and the Sweet Hands, You Painter, You Cozy Dear, My Intimate

Dear, I should almost wish our separation to last just a little while longer, for my heart would like to inscribe in itself more and more tenderness, and make it seem as if I were holding your dear head between my two hands and lying all entwined at your side. Dear, how I am living these days in our love. How remarkable that this separation makes our love so jubilant. When you return you shall have everything, everything. I shall lay everything in your hands. Except for the final thing, the most precious, the jewel—I shall wrap that in a silken cloth and bury it in the earth and plant a little flower above it and in May, when my flower blossoms in fragrant bliss, then I shall gently lift the cloth and together in devotion we shall gaze upon the holy of holies. When I write and think about that my heart beats from the happiness to come and my breathing grows louder, and I hear the beating of wings over my head. I kiss your hand.

—Yes, my love, we do live in the fields of the blessed. I felt that on Tuesday, too, when I returned home from Bremen. There is so much loveliness here that has still not been released. I wonder whether you will speak the magic words? And will I have a little word to say, too? Oh, whenever I think about all that I see such happiness and bliss for us in the future. Just now I was out in the Brünjes' apple orchard. The silver crescent of the moon was hanging behind the great fir trees. The days are beautiful now, but the air and the earth are beginning to look a little wintry. Cold. But here in my little room it's cozy and warm and a couple of baked apples in the oven are giving off a wonderful smell. And the cow is mooing and Bertha is washing the bed canopy.

This morning I began the painting of little Frau Vogeler with her child, dressed in white. I was there with them last evening. I think the two of them are going through a difficult period now. It seems to me that they suffer because he cannot talk to her about his ultimate concerns.

Have I written you that Mackensen is trying out tempera now and that he has ordered your paint and other things? So far he is infatuated with the technique. But while he is painting he keeps the other side of the canvas very wet. And Bernheimer, Munich, has sent wonderful samples of material, which are waiting for you. At Christel Schröder's I bought the most interesting buttons for one mark. I carried them around with me for a whole day because they were so pretty. I shall probably get the apples for two marks. If so, I shall get two bushels. I'm now busy as a bee working in the garden with Elsbeth, and have already sent three messengers on horseback to His Highness Gefken asking him to please spread manure on our little garden.

Elsbeth and I speak about you a lot. She with that compassionate tone in her

voice, I with a sort of bridelike feeling of happiness. Otherwise there is nothing else to report at all, except that we caught a mouse in the cellar. But I have so much to tell you. I'll do what you are doing, and store it all up in a little bag. Oh, how wonderful it will be when we're together again and can exchange them.

Many thanks for the *picture postcard* you sent with your family. It made me very happy, but a kiss to you for your dear letter. Let me have another one.

All my greetings to your parents, Laura, and the children. Ask Laura whether the children already have the second volume of *Gritli*. If they don't, they will get it for Christmas.

And you! I kiss you fervently and love you with all my heart, all my soul, and all my mind, and am

Your dear Wife

**Journal*

December 1, 1902

I was reading about and looking at Mantegna. I can sense how good he is for me. His enormous plasticity — it has such powerful substance. That is just what is lacking in my things. I could do something about that if I could add his substantiality to the greatness of form I'm struggling for. At present I see before my eyes very simple and barely articulated things.

My second major stumbling block is my lack of intimacy.

Mackensen's way of portraying the people here is not great enough for me, too genrelike. Whoever could, ought to capture them in runic script.

There is something like it in the Louvre, hovering before my eyes: the grave monument with the eight figures carrying it.

Kalckreuth has something of this remarkable runic quality in his old women. The women with the geese, and the old woman with the baby carriage.

Strange. It seems to me as if my voice had completely new tones to it, and as if my being had new registers. I can feel things growing greater in me, expanding. God willing, I will become something.

To Carl Hauptmann

Worpswede, December 15, 1902

Dear Dr. Hauptmann,

We were so anxious to hear something from you, and we received three things all at once. You do give abundantly. I have just finished reading *Mathilde*. I'm still completely wrapped up in it. There is something so strong and complete about it, like an old master, and also something Biblical and grand.

You have explored the depths of this human being with such kindness. Like nature herself. Your image of this woman, with her many intimate features, has a wonderful grandeur. The book affects me as powerfully as life itself. It's wonderful the way you have subordinated the background and incidental details. And the way you have built up the whole thing! It's all so clear, one thing after the other, with everything determined by what goes before.

And the language of this book has also made it possible for me to understand you better. This transparent clarity, breathing the air of the mountains. I felt remarkably close to the passage with the Easter hymns.

I'm happy for Otto who still has the book ahead of him.

I greet you and your dear wife and reach out my hand to you in gratitude.

Your Paula Modersohn

Merry Christmas!

From Otto Modersohn's Journal
Beginning December 21, 1902

January 15, 1903

[...] Spent this evening having a long conversation with Paula about me. She doesn't believe me when I say that I have now really had very important insights; she says it is only a phase, a transition, like all the times before when I used to make similar claims. It's like the old saying, "He who cries wolf..." I really can't blame her for feeling this way; I certainly have wavered very much and have often declared that now I have the answer. And yet, this time it is something completely different. She is right in saying that actions speak louder than words and that we must let time be the teacher. She considers me to be very hopeful, but says that I also have a very dangerous tendency in me, that I am filled with enthusiasm one moment only to reject everything the next moment; that whenever I talk about other people's low points, I always add that we are on the good and proper path. I insist that Paula is fundamentally wrong this time.

**To Marie Hill*

Worpswede, January 29, 1903

My dear Aunt Marie,

Milly told me a few days before Christmas that you were not at all well, that your heart was rebelling at the fast pace you insist upon living. At the same time she also told me about Frau D.'s plan to go to Italy, but that you were hesitant because of taking on a new retired lady boarder at Easter. Dear, forget all these ladies in retirement for now, completely. Pack up your bags and take a trip. Think of it as a

message from Providence which you should use now to get rid of domestic worries for a while. Put everything aside and concentrate on your health.

I wish that I could be with you even if only for half an hour, so that I could talk to you about all this face to face. I'm so afraid that the pace of your life has become much too fast and that you are fearful everything is going to stop suddenly and you will have no more responsibilities. You're being exactly like Father who denied himself all vacations just at the time when he needed them most. It is evidently my job to preach relaxation to everyone I know and to tell them to pull themselves together. I only wish they would listen to me. There would certainly be a lot more happiness in the world. And so I wish that you would also listen to my little words of wisdom. Why shouldn't I preach to you? Just because I'm half your age is certainly no reason to say that I'm wrong.

When I was a child I always thought that people got better and better year after year. Now as an adult, I think that as the years go by people get accustomed to their own mistakes. In your case, it's the fact that you work too much. It is my firm and devout conviction, not a joke at all, when I say that you must summon all your strength and fight against this shortcoming of yours. By working too hard you are really sinning against life, and sinning against work, too. You rob work of the wonderful, grand, and satisfying beauty which it sheds upon our lives like a gentle sun.

The two of us are quietly following our path and quietly waiting for something to become of us. Otto in his way, just as I in mine, for he, too, has a need for something higher in life. And then we tell each other about ourselves, what each one wants to do, and then each of us waits for it to happen to the other.

We found Fräulein Malachowski's studies interesting. Doesn't she ever do anything bigger? If one needs to express oneself in such a small format, I feel that the medium for it has to be different. She is seldom the same person in any two drawings, and reminds me sometimes of this, sometimes of that. All in all, I much prefer what I'm trying to achieve, not that that is something everyone needs to find. I'm telling you this only because, in a certain way, you are comparing the two of us.

If you feel that you have not gotten many letters from me this year, please blame it on a certain taciturnity in me which I think I've always had, in conversation as well as in my letters. Sometimes I hardly ever speak at all, and Elsbeth has to keep bombarding me with new and clever questions to get more than just a yes or a no. Perhaps it comes from the fact that my thoughts, consciously or unconsciously, are always directed toward my one goal. I can't explain it any other way.

To Elsbeth Modersohn
[Postcard]

[Postmarked Cologne, February 10, 1903]

My dear little Elsbeth,

Now Mother is sitting in the train! And has a dreadfully long trip until this evening, when you will be going to your little white bed. Then Mother will be in the great city of Paris. And just imagine, one no longer says *meine lüttje Deern* ["my little girl"] there, but one says *ma petite fille*. That does sound funny, doesn't it? Has your old cough finally flown out of the window again? I give you a sweet kiss and also one for dear Father, who must surely be back again with you by now. Greetings to Bertha; and who is your mother now? . . . [rest of postcard illegible].

To Otto Modersohn
[Postcard — on the trip to Paris]

[Postmarked February 2, 1903]

D[ear] O[tto]. Between Compiègne and Paris. Belgium was glorious. Hilly and white sandstone rocks, dark-haired, serious women who climb up to the top of the black dusty mountains of coal. I'm surprised that their painters paint anything else. Meunier is the one I feel closest to, but oh, painting, painting, painting. Now and then remarkable villas, covered with ivy and surrounded by white orphanage walls high as houses. And arbors. And there is always a river to see and one always has the feeling of Once Upon a Time. I greet our little wooden house.

Y[our] P[aula]

To Otto Modersohn

Paris, February 10, 1903

Dear Otto,

Here I am in my little Grand Hôtel de la Haute Loire, the same place I stayed three years ago, the same little room, number 53. The only difference now is that number 54, where I hear two German women painters I don't know talking to each other, was where Clara Westhoff had her red canopy bed. The concierge, who used to look as if she were going to give birth the next day, still looks exactly the same way. I bumped into her frontal projection accidentally again, just the way I did the last time. But I still believe that there is no child in there. I withstood all the perils of the journey and very much enjoyed the train trip through Belgium. I'm beginning to enjoy Paris again, even though I'm still very self-conscious and a little afraid of the people. When I was walking to the *crémerie* for supper, one of those well-known Spanish devils came right up to me. And as I entered, two Frenchmen

passed me and said, "Aha, elle est rentrée." Alas, I felt quite uncomfortable in my fur jacket in the midst of that arty crew and quickly ate my ham. I kiss you and bid you good night, my Redbeard, my haven, my treasure trove and King. Just imagine, I think that I'm going to be writing you in a couple of weeks, after all, to come to Paris. Wherever I go, champagne is in the air, not to speak of all the art one sees wherever one goes. Good night.

Wednesday

Well, I have slept my first night here. It went fine. However, I'm still a little absent-minded and too diverted. I feel just the way I thought I would. That old feeling of wanting to crawl into a mousehole is back again. Everybody seems to look at me and laugh, and I keep feeling that all those soft voices I hear around me are letting me know that I don't belong to their race.

But what a *city* this Paris is; it's only that there are still veils hanging between it and me.

I intend to go to the Rilkes' this evening after all. Eating out all the time tires me and makes me nervous. On the way home just now, where I have landed exhausted, I bought myself a few little things for the household. It was really my first lovely hour just now, cooking my own cup of cocoa with a bouquet of eucalyptus next to me. How I would like to hear from you, my dear Redbeard. You know as well as I that the reason I'm here is to learn to see Worpswede through more critical spectacles. It holds up its end well so far. And Elsbeth, how is her cough? I see her whenever I look at the children around here.

This was a short greeting and is meant just for you to get my address.

Fervent kisses to all of you.

Your little Wife in the big city of Paris

To Otto Modersohn

Paris, boulevard Raspail 203
February 12, 1903

My dear Otto, I mailed a letter to you only yesterday and here I am today writing you again. I plan to bombard you with letters just to prevent you from doing anything other than write back to me. I think so very much about you and Elsbeth, really all the time. And I still cannot quite realize that I have left the two of you. That is because so far I'm not quite ready for the pleasures of Paris. Still, today things are just a little bit better than yesterday. The main reason is that these strange folk don't get on my nerves and upset me quite so much as they once did.

Evening.

The Rilkes were just here, returning my visit. I was there last night. They are very

friendly to me. But Paris is plaguing both of them with strange anxieties. "There are voices arising in the night." The same unhappy feeling of doom still hangs over these two people. And their joylessness can be contagious.

My dear Redbeard, I wish that I could enjoy a quiet moment sometime to tell you in gentle and soft words how fine and grand you live in my heart. Just thinking of your work and your soft brow and your hands, that is so lovely. I feel a bit like a little ship whose sails are waiting for the wind to fill them. And the Louvre is about to fill my sails tomorrow.

To "Mademoiselle Elsbeth Modersohn"
[Picture postcard with five little kittens]

[Postmarked Paris, February 13, 1903]
My dear little Elsbeth,
These five kittens are supposed to say good morning to you next Sunday and tell you that your mother is thinking about her little girl very much in this big city of Paris. There is a big garden here where many hundreds of children are playing with their balls and dolls. You would also have a lovely time playing here, but it is loveliest of all to do it in W[orpswede]. I kiss you. Your Mother.

To Otto Modersohn

Paris, boulevard Raspail 203
February 14, 1903
Dear Otto,
I'm now beginning my third letter to you and am also feverishly awaiting the first one from you. I have consoled myself by thinking it will be in Sunday's mail tomorrow. Dear boy, I wonder what you are doing and how things are with you and what you are painting? Have you already framed the little paintings? I'm especially excited about that. I have noticed in general that one of the main things one can learn here in Paris is *impromptu* work. Today I was on the rue Laffitte where the art dealers are. There is so much of interest to see there. You know the things that you call "the artistic" in art. The French possess to a high degree this sense of not having to bring everything to a pitch of perfection. The mobility in their nature really comes to their aid here. We Germans always obediently paint our pictures from top to bottom, and are much too ponderous to do the little oil sketches and improvisations which so often say more than a finished picture. They often produce the most charming things in the tiniest format here. You ought to perfect such a technique. That sort of thing is perfect for your talents. The trouble is, though, that pictures like that are not for our public. And we have so very few really "artistic" art dealers. But despite that, go ahead and paint them anyhow. It's the same in drawing. How strongly we were struck by those barely sketched-out

things by Segantini. I'm afraid that Anton von Werner's perfectly rendered gleam on the boots has gotten a bit into all our blood. Today I was looking at works by Cottet and Simon. I much prefer the feeling in Cottet, even though Simon's color spectrum has a much more subtle range. On the other hand, I don't like the way Simon applies his paint. And furthermore, he paints faces and objects so flat; it seems to me there is something almost violent about it. Then again, the way Cottet applies his colors ought to be a little more serious, at least for my taste. In the Louvre there are a few still lifes by Decamps (is he in Muther?), tiny little things, but most remarkable and delicate. And then a few little pictures by Millet; technically they excite me very much—I am happy that I'm gradually becoming able to think with all this noise around me, impossible up to now. I have been carrying a miserable and forsaken feeling around with me. And the feeling tells me that if I want to learn something this time, it's going to cost me even more than it did the first time. The first time, I didn't have you and I didn't have a home. And still, I feel that it's very good to have the opportunity, at least once, to see everything from a distance. You come out pretty well, you know. Sometimes in all this confusion I would just like to sit down in the street and cry. All day long I was bitterly trying to find a little room with at least a view of one tree. No success so far. Lodgings are not expensive. Mine now costs thirty-nine francs, about thirty marks, a month. But a clanging electric tram that rushes by disturbs the dreams I need so badly. What I really wanted to do yesterday was go to the country. But the Rilkes want to visit a Japanese exhibition here, and I'll probably tag along. If only they were a little more cheerful! They trumpet gloom, and now they have two instruments to do it on. In the afternoons I do life drawing at the Académie. Every half hour a new position. I love doing that—I have had little of the Louvre so far. I haven't really been receptive yet. Soon I'll write you more about all these beautiful things here. The Rilkes were telling me about their enthusiasm for Brittany.

Everywhere I go people seem to assume that I'm a *Fräulein*. But I aggressively display my wedding ring. In fact, I feel chilly if I'm not wearing it—What does Elsbeth say about her traveling mother? Does she speak well of me? You must tell me everything, everything. Go to the Brünjes' sometime and tell me all about it. And please see to it that the mice don't gobble up my art. My regards to little Frau Vogeler. I kiss both of you tenderly.

Your little traveling Wife

I have also seen a wonderful little marble sculpture of a woman by Rodin. And Mackensen? I hate the boardinghouse food and wish that Bertha were here so that she could cook me something lovely—Have Herma cut your hair, not that cynical barber.

February 15, 1903

Today I saw an exhibition of old Japanese paintings and sculpture.

I was seized by the great strangeness of these things. It makes our own art seem all the more conventional to me. Our art is very meager in expressing the emotions we have inside. Old Japanese art seems to have a better solution for that. The expression of nocturnal things, of horrors, of sweetness, of the feminine, of coquetry, all these things seem to be solved in a more childlike and concise way than we would do it. We must put more weight on the fundamentals!! When I took my eyes from these pictures and began looking at the people around me, I suddenly saw that human beings are more remarkable, much more striking and surprising than they have ever been painted. A sudden realization like that comes only at moments. Our routine way of life tends to blur such realizations. But it's from moments like these that art must arise.

And now I come to the other insight that I had yesterday on the rue Laffitte: the ability to create from the moment at hand, something that the French have in abundance. They don't seem to care whether what they are making is a "picture" or not, or whether the public always understands them. The important thing to them is that it be art. They sometimes do things on the smallest scale just because they are enticed by the idea. Degas, Daumier, many little things of Millet. And in these things there is often the most charming way of applying color: sensitive, loving, and full of good artistic piquancy. Rodin said to Clara Rilke, "Rien à peu-près." This feeling is part and parcel of the whole nation, this ability to hit the nail on the head.

I didn't feel at home during my first few days in Paris and felt that it wasn't going to help me get anywhere. But now I think it will. This evening a cart stopped in the street. There was a barrel organ on it, and it was being pulled by a little scruffy, shaggy donkey. How the music made the people move their feet; this feeling for dance! There was a little shopgirl who was supposed to bring in the flowerpots from the street because it was evening. And she was doing it so charmingly, enchantingly, in a hopping step to the music. But the fact is that this was nothing unique to her. Every third person would have done the same. In an entryway two other people were dancing. They are an easygoing people, the French. If we Germans could only learn to combine our sense of virtue with such grace, we would be a more admired people.

To Otto Modersohn

Paris, 29, rue Cassette
February 17, 1903

Dear Otto,

I have moved. It was much too noisy for me on the boulevard. I was never able to collect my thoughts when I came home from all the hubbub, and you know how important that is for me. So now I have moved and am very happy. All around me, quiet. And outside my window, a tree, and behind the tree is a garden and behind the garden is something Catholic, but I don't know what it is yet. My building has its own little garden, a courtyard really, full of rubbish and love and where Madame promises me that the most glorious buds are about to burst — You can probably tell from this that Paris is gradually beginning to dawn for me again. All kinds of remarkable things from all directions are storming in upon me. And I'm getting the feeling that the trip is doing me good.

On Sunday I went with the Rilkes to visit a famous private collection of old Japanese art which is soon to be auctioned. I wished you were there. The pictures were not framed paintings in our sense of the term, but on paper or silk scrolls.

They were a remarkable mixture of form, color, and spirit. They can express a powerful atmosphere, something nocturnal, something sinister and mysterious, or then again, something very much of this world, sometimes even coquettish. And how lovely the pictures with flowers and birds are! One can sense how closely these people live with nature. I must tell you a lot more about that when I see you.

Ever since Rodin said to the Rilkes, "Travailler, toujours travailler," they have been taking it literally; they never want to go to the country on Sundays and seem to be getting no more fun out of their lives at all. But Clara Rilke is deep in work and trying very hard to get close to her art from all directions. Recently I visited her in her atelier where she was working on a little girl's thumb with great sensitivity. Only, as far as I'm concerned, she is becoming a little bit too wound up and speaks only about herself and her own work. Considering all of this, we shall see how she plans to avoid becoming a little Rodin herself. She already draws exactly in his most original way, but she has also accomplished some good things with it — Don't read this passage to little Frau Vogeler. In fact, don't read *any* of my letters in full to anyone and don't let them out of your hands. I am writing only for you —

Sunday evening I took a walk by myself. In a little side street there was a barrel organ on a cart being pulled by a little donkey, and an old woman was playing it. Her audience was electrified, in an almost childlike way. A little shopgirl carrying flowerpots into the store was swaying and dancing in time to the music. In an entryway two other girls were dancing. And a couple of fellows passing by seemed to be itching to dance, too. The whole thing was charming to see. It was an example of that childlike receptivity which can also express itself in art —

The Louvre today. I am getting closer and closer to Rembrandt, in fact, to all the Dutch masters. And on the other hand to the Venetians, Veronese. (I had to think of

Stuck.) Toward the end of my visit I saw some remarkably good copies of sketches by Ingres and reproductions of wonderful ancient portraits whose color must have been applied in a remarkably flowing manner. A very charming picture of Cleopatra.

You can see, my dearest, that I am drinking everything in with great gulps and that I am very receptive. Writing letters about this is a very inadequate substitute. Later you will have to ask me to describe the details. Imagine. I have not thanked Mother at all for the one hundred marks. Please, you do it. But also tell her that I shall be bringing back half the money for her. I tenderly kiss the two of you and think about you a lot and in great love.

<div style="text-align: right;">Your little Wife</div>

I have neither seen nor heard anything about the Rafaelli oil crayons. When my French is a little better I want to visit Cottet and ask him about them.

To Otto Modersohn

<div style="text-align: right;">Paris, 29, rue Cassette
February 18, 1903</div>

Dear Otto, my dear Red and King,

Today I am writing you your birthday letter even though it isn't for a very, very long time. It is strange how endlessly long the speaking tube between the two of us has grown. In fact, it seems so strange that I won't even be with you on your birthday, as I was the very, very first time in Berlin. It is really also strange that you weren't with me on my birthday, for neither of us considered that event in Münster the other day to be the real thing. In fact, you didn't even give me a birthday kiss because of my cold. Despite everything, though, I am probably more with you and within you than ever, live in you and sleep in you. You are my sweet shade, I enter you to get cool. You are the cool water in which I bathe my little round soul (which I feel must look like me with nothing on). You are my beloved, a great and silent forest where the leaves are gently rustling and whispering. And even though I have now run out into the meadow for a bit, I shall return soon and sit down quietly with you. You are my dear companion, and I think of you with deepest love and kiss your loving hands and your brow. Your two hands and gentle brow, where your art is born, look to me very much like your own pictures, red beard and all.

You know, I'm thinking a great deal here about your pictures. They must get much, much more striking. There must be a breath and a feeling of anticipation and something remarkable in them, as there is in nature as it appears when our eyes are unclouded and clear and can see things in their rare essence. One of your expressions is: "I have a feeling that there are spirits in the air." When you paint a picture now, the most important thing for you is to express that feeling in all its

strength. You must master all the means at hand, technique, color, the greatness of form. Those are your means, and now the point is to let your compositions come to life as pictures. The French certainly have a delicate charm about them, and a great sensitivity of expression. At the same time they manipulate the tools of their art with such great and loving neatness. It is strange; the more I learn to understand Rembrandt, the more I feel that they, too, have understood him. I'm happy to hear you are planning to try some things on a small scale, and I'm beginning to believe that no one can paint truthfully until one can express oneself on a small scale. Isn't it true that small-scale work is the more immediate and direct result of a productive hour? I am thinking of Millet, Rembrandt, Böcklin—

There are a great many Rembrandts here. Even if they are yellow with varnish, I can still learn so much from them, the wrinkled intricacy of things, life itself. There is a little thing here by him; I don't know if it is meant to be Potiphar's wife or not. It is of a woman in bed, nude. But the way it's painted, the way the cushions are painted, their shapes, with all those details of lacework, the whole thing is bewitching. And then the small *Holy Family* next to the charming open window. Then two pensive little philosophers sitting in some kind of Gothic building, where a bit of sunlight skips over the flagstones. The colors in the painting of *The Good Samaritan* must have been wonderful—They seem to have suffered greatly.

I think that Paris will have to become an imperial city soon again. The people are ruining everything. The parquet floor in the Louvre is going to rack and ruin, and in the hall of ancient art, which is fairly remote and quiet, there were ten drunkards of the worst sort today, and there I was, all alone with them. I'll tell you about those antiquities another time—I'm having a lot of experiences, am I not, my dear?

Now I kiss you fervently, my dear thirty-nine-year-old. They say that great art begins in your fortieth year. On Sunday I will drink three toasts to you with my chocolate milk. Kiss Elsbeth for me. I shall see to it that I send her some snowdrops with their roots. Give them to her in my name.

May our new silver-glass globe be preserved for us and our children's children. I enclose a photograph of [a painting by] Cottet. I find it very beautiful and solemn. Write me what you think of it.

Tell Elsbeth her letter was marvelous. There will be a letter from me to her soon.

To Otto Modersohn

Paris, February 19, 1903

My dear Husband,

My birthday letter is all finished and lying next to me, and already I'm beginning another to you. I am simply overflowing. When I returned home this evening from *croquis* I asked, "Pas de lettre?" And they told me, "Rien du tout, madame." That made me a little sad because I had figured out that now was just about the time for a letter from you to arrive. And just as I was having my evening cocoa, there was a

knock on the door and the *garçon* shouted, "Voici, ma petite dame! Voilà, tout ce que vous désirez!" and handed me your thick letter. With this same *garçon*, you see, I have one little point of contact. Just about all the French I can speak I speak with him. I hope he doesn't strive for any *big* point of contact, for if he does, we won't have any contact at all.

Paris is becoming more and more the Paris of three years ago for me. The faces of the same little old ladies who are still selling violets on the Pont des Arts; the same old shriveled people who display their books along the Seine, and still the same ones in the shops.

At the Académie everyone seems to think I am still the same person I was then, too, because they keep referring to me as mademoiselle. So, I told a gossipy Danish girl recently that I am married now and would she spread the word around. I was secretly somewhat angry that no one could tell from looking at me that in the meantime I have become your wife. And besides that I wear my ring. But in Paris nobody pays attention to anything like that.

—Well then, the Rafaeli crayons! Dear boy, I'm so happy for you. When I get home there will probably be many things already gone without my ever having seen them finished. My, my, you are shaking new things out of your sleeve all the time. How did the little legs on the woman cutting peat turn out? Get Mother's opinion sometime. An inexperienced eye often sees more than the trained one.

February 23, 1903

Well then, to continue on today. Do you know what I'm finding out? That art, your beloved sweetheart, is enticing you away from your lover in Paris a little. And she would like to get another love letter from you sometime soon, like the one from Münster. But just let it be, dear. Happiness and blessings to your dear hands so that glory and gleaming and brilliance may blossom under them. That is what is by far the most beautiful thing as far as I'm concerned.

—Well, the monograph has been published. Rilke brought it to me yesterday, although he had forgotten that it was your birthday. So far, I have only leafed through it and can't form a judgment yet. Only one thing is obvious to me: if you painters are not yet clear about things, then this book is not going to clarify things for you either. Otherwise it seems to me that many good and kind things are coupled with much that, artistically speaking, is quite awry. By the way, Clara Rilke has received a fine commission. She is to do a sculpture of Björnson's daughter, the wife of the publisher Langen, full figure but on a reduced scale. She also said that there is nothing of the father in the girl, really nothing Nordic, but she is an original: capricious and very Parisian in all her gestures.

Carnival, with all its confetti, has made the city very colorful. Three years ago I was part of it, wading up to my ankles in this multicolored snow. This year, all I got to see were a few Pierrots from a distance—Incidentally, I now have a very cozy

relationship with my concierges and I went with the two of them, mother and daughter, down into the city yesterday to see the students' parade. They listen with rapt attention when I tell them about you and Elsbeth. They are genuine Parisian *petites bourgeoises* and amuse me greatly.

My *hôtel* consists essentially of one enormous entryway. The building itself seems tiny by contrast. Sometimes a huge rabbit runs around in the courtyard. Everything is cozy and funny here, and the people live in such a naive way—I am receptive to so many good ideas about art here. I'm more and more convinced that intimacy is the soul of all great art. It suffuses little Tanagra figurines just as it does Rembrandt and Millet. I am happy about my stay here for that reason alone. It has helped me very much toward that realization.

— Thank Mother warmly for her two dear letters. How did the silver globe come out? Are you happy? I should so much like to hear somebody here talk about the Rafaelli crayons. I'm so happy that you're happy. I kiss you all with love.

<div align="right">Your little Wife</div>

*Journal

<div align="right">February 20, 1903</div>

I must learn how to express the gentle vibration of things, their roughened textures, their intricacies. I have to find an expression for that in my drawing, too, in the way I sketch my nudes here in Paris, only more original, more subtly observed. The strange quality of expectation that hovers over muted things (skin, Otto's forehead, fabrics, flowers); I must try to get hold of the great and simple beauty of all that. In general, I must strive for the utmost simplicity united with the most intimate power of observation. That's where greatness lies. In looking at the life-size nude of Frau M., the simplicity of the body called my attention to the simplicity of the head. It made me feel how much it's in my blood to want to overdo things.

To get back again to that "roughened intricacy of things": that's the quality that I find so pleasing in old marble or sandstone sculptures that have been out in the open, exposed to the weather. I like it, this roughened alive surface.

These people here have such quick spirit and they like playing with words. I asked a dealer near the Temple today for the price of a piece of gold trim that he had for sale. He gave me the price and then I said, "Mais si chère, monsieur, elle est vieille." Whereupon he answered smiling, "Ah, mademoiselle, c'est le contraire comme chez nous, qui sont chers, quand nous sommes jeunes." Then I climbed to the first floor of the Temple, which I had read all about in Baedeker. There, all those silk skirts, which have performed their dubious services, are once again reunited. It's a marketplace for colorful satin shoes tattered from dancing, for faded artificial flowers, silk dresses, and lace skirts. There they are bought by the poorest girls to deck themselves out with.

When I'm out in the street I sometimes feel the same mood I felt three years ago. I feel like a queen hidden behind veils, with everything rushing and roaring past me.

To "*Little Elsbeth Modersohn*"
[Postcard]

[Postmarked Paris, February 22, 1903]

My little Bettine,
Today is Father's birthday, and because it's also Sunday many, many bells are ringing here in Paris, for there are many, many churches here. When all the big and little bells ring together it sounds simply beautiful. Here in Paris there are a vast number of white horses, you know, like the ones Mother is always painting. I always look at them good and hard. Many of them are very fat, and tall, and have a blue hat with red tassels sitting way at the back of their neck. It looks beautiful. Yesterday evening I saw a bicyclist who had tied a red torch to his bicycle, and I thought, when it is summer again then you will also be able to ride along with your lantern and sing as you go. I kiss you devotedly. Your letter was so lovely. I thank you many times for it. Your dear Mother.

**Journal*

February 25, 1903

I am constantly observing things and believe that I am coming closer to beauty. In the last few days I have discovered form and have been thinking much about it. Until now I've had no real feeling for the antique. I could find it very beautiful by itself. But I could never find any thread leading from it to modern art. Now I've found it, and that is what I believe is called progress. I feel an inner relationship which leads from the antique to the Gothic, especially from the early ancient art, and from the Gothic to my own feeling for form.

A great simplicity of form is something marvelous. As far back as I can remember, I have tried to put the simplicity of nature into the heads that I was painting or drawing. Now I have a real sense of being able to learn from the heads of ancient sculpture. What grand and simple insight went into their creation! Brow, eyes, mouth, nose, cheeks, chin, that is all. It sounds so simple and yet it's so very, very much. How simply the planes of such an antique mouth are realized. I feel I must look for all the many remarkable forms and overlapping planes when drawing nature. I have a feeling for the way things slide into and over each other. I must carefully develop and refine this feeling. I want to draw much more in Worpswede. I want to draw groups of children at the poorhouse or the A. family or the N. family. I look forward to work so much. I believe my stay here will have been very good for me.

To Otto Modersohn

<div align="right">

Paris, 29, rue Cassette
February 26, 1903

</div>

My much beloved King,

Dear, you made me wait for a long time. It has been exactly one week since I re-
ceived the fat letter with the postcards. The Raffaeli crayons must certainly be very
marvelous to work with, if they can overshadow me like this. But how happy I
am for you that you are so hard at work. Please let me know; do you still plan to
come? If so you must come soon. It would be so lovely for me; we would be able
to do all sorts of things together that are hard for me to do as a single lady. But *I*
don't want to play any role at all in your decision. It must depend completely on
whether it will fit in with your art and the rest of your schedule.

There is almost too much beauty here in Paris. I should also very, very much like
you to experience the art of Rodin. He is probably the greatest living artist now.
A French magazine recently printed some conversations on art that he conducted
with a few young women students—which is to say that they are really more in
the nature of monologues on art. They are expressed very simply and can be ap-
plied to all great art; it was a great pleasure for me to read them and I look forward
to discussing them with you. Dear, I'm so *very* happy, so happy, that you let me
come here. And I'm grateful from my whole heart, and I believe that after certain
intervals I'll want to keep coming back to Paris again and again in my later life.
But now to all your questions.

Well then, I get up at eight o'clock in the morning, open my windows and look
out into my garden where the lilacs already have big green buds, and I take a look
at the weather. Then I make my cocoa. My bread is delivered to my door and I
still have milk left over from the previous evening. And then my adventures begin.
First of all, the Louvre. My midday meal I eat either at a Duval or I make a couple
of fried eggs here; then I nap and read, and then at four thirty I make my pilgrimage
through the Luxembourg Gardens to my *croquis*. The gardens are swarming at
that time with the little children of Paris who are supposed to be breathing in the
so-called fresh air. After *croquis* I make my way home and brew myself another
cup of cocoa and spend the evening very pleasantly with writing and reading and
thinking by an open window, all the while keeping an eye on the Carmelite convent
whose little eternal lamp glows at the other end of my garden. I also frequently
spend evenings with the Rilkes. In general though, I'm not much interested in com-
pany right now. I'm so full of thoughts and impressions that I want to work out
alone. When I do this, time doesn't lie heavy on my hands. Those are my days.

Fräulein von Malachowski came to visit today, but I wasn't at home. I shall make
a date with her to tour Versailles so that I'll get to see the wonderful palace and the
park once again—

The Luxembourg Museum has opened again. It was being cleaned. And what
wonderful things are there: Manet, the nude with the Negress, the scene on the

terrace (in Muther), Renoirs, but not as beautiful as the one we have. Zoloaga [*sic*], two dark ladies, a gentleman, and a fallow greyhound against the sky, and then a dwarf holding a silver globe like ours, absolutely fabulous colors. But the most wonderful thing for me was seeing the great Cottet triptych again. The panel on the right where the women and children are anxiously waiting in the evening, is truly great in form and color—

Then the pastels of Degas. Very interesting in form, very artful and capricious in color. But you know, I'll have to tell you about all of that later, because writing about things like this is no good. Or are you perhaps coming after all? And now this annoying subject of money. Mine is all gone. Would you perhaps send me another 180 *soon*. That way I'll have enough for my train ticket. Haven't I been writing you a great deal or does it just seem that way to me? I kiss you all tenderly and think of you with love. You know that I am aware of you there in the background and that makes my stay here so peaceful.

And Worpswede! In the Louvre recently I saw our Rousseau landscape with the cows. Without realizing it, I suddenly found myself with tears in my eyes, quietly feeling how lucky I am to have such a home.

My sniffles are completely gone and I feel very well.

<div align="right">Your Paula</div>

I'm not familiar with Cottet's colors. I think of him as using almost black tones. I find that Overbeck comes in for the harshest treatment in the [Rilke] monograph— do me a favor and send the *Mathilde* to the Rilkes.

To "*Mademoiselle Elsbeth Modersohn*"
[Postcard]

<div align="right">[Postmarked Paris, February 27, 1903]</div>

My dear little Elsbeth,

Today I have seen some wonderful animals again. There were birds which were very pink, and just imagine, they are as tall as Father and completely pink. And their legs are as long as Father's walking stick and their necks are as long as your little rake. There were five of them and they were all eating together out of one dish and not even fighting. Are you still taking lovely walks with your dear grandmother? It's probably lovely. Have you seen Fritz's little sister yet? Ask Grandmother sometime if it isn't time to take the wrapping off the roses near the front door. I think they would like to have some air now. It is so very dark in those burlap sacks. They probably don't want to have them on very much longer. A lovely kiss: X, and one for Father and Grandmother from your

<div align="right">dear Mother</div>

Paris, 29, rue Cassette
March 2, 1903

My dear Spouse,
Just listen, I'm getting the feeling more and more that you must come here, too.
There are so many reasons why you should. But I'll tell you only one, a great rea-
son, the greatest: Rodin. You must get an impression of this man and of his life's
work, which he has gathered together in castings all around him. I have the feeling
that we shall probably never experience anything like this again in our lifetime.
This great art came into full blossom with incredible determination, silently, and
almost hidden from view. The impression Rodin makes is a very great one. It is
hard for me to talk about any single work of his because one must keep coming
back to it often, and in all one's various moods, in order to completely absorb it.
He has done the work almost in spite of the rest of the world, and it exudes such a
wonderful feeling—he doesn't care whether the world approves or not. Instead he
has one conviction, firm as a rock: that it is beauty itself which he means to bring
into the world. There are many who pay him some heed, although most of the
French put him into the same pot with Boucher and Injalbert and whatever the
names of all those other dim lights are.
　But I want to tell you everything chronologically.
　Armed with a little calling card from Rilke, which referred to me as "femme d'un
peintre très distingué," I went to Rodin's studio last Saturday afternoon, his usual
day for receiving people. There were all sorts of people there already. He didn't
even look at the card, just nodded and let me wander freely among his marble
sculpture. So many wonderful things there. But some I cannot understand. Never-
theless, I don't dare judge those too quickly. As I was leaving, I asked him if it
would be possible to visit his *pavillon* in Meudon, and he said that it would be at
my disposal on Sunday. And so I was permitted to wander about the *pavillon* un-
disturbed. What a wealth of work is there and such worship of nature; that's really
beautiful. He always starts from nature. And all his drawings, all his compositions,
he does from life. The remarkable dreams of form which he quickly tosses onto
paper are to me the most original aspect of all his art. He uses the most simple and
sparse means. He draws with pencil and then shades in with strange, almost pas-
sionate, watercolors. It is a passion and a genius which dominate in these draw-
ings, and a total lack of concern for convention. The first thing that comes into
my mind to compare them with are those old Japanese works which I saw during
my first week here, and perhaps also ancient frescoes or those figures on antique
vases. *You simply must see them.* Their colors are a remarkable inspiration, espe-
cially for a painter. He showed them to me himself and was so charming and
friendly to me. Yes, whatever it is that makes art extraordinary is what he has. In
addition there is his piercing conviction that all beauty is in nature. He used to
make up these compositions in his head but found that he was still being too con-

ventional. Now he draws only from models. When he is in fresh form he does twenty of them in an hour and a half. His *pavillon* and his two other ateliers lie in the midst of strangely intersecting hills which are covered with a growth of stubbly grass. There is a wonderful view down to the Seine and the villages along it, and even as far as the domes of Paris. The building where he lives is small and confined and gives one the feeling that the act of living itself plays hardly any role for him. "La travaille [*sic*], c'est mon bonheur," he says.

I went to Meudon early in the morning with Fräulein von Malachowski. We wandered in the country and picked yellow coltsfoot, and today I made a little garland out of them. You must tell Herma that they are already in bloom here, our little yellow flowers from the brickyard. Fräulein von Malachowski is a dear, innocent, intelligent person, quite different from what I expected. She is only twenty-two, still a little immature, artistically also, but there is so much of life's joy behind it all. The countryside around Paris has a wonderful, magical charm with enchanting views and landscapes; one must know these too if one wants to understand the people here. By contrast to our north country, everything here has such a gentle and passive effect. I had to put the touch on Fräulein v.M., because my money was all gone.

I wonder how things are with the two of you, and what you are doing, and what you are painting? I kiss you fervently, my dear Redbeard, and am your

Little Wife

It's been storming and simply pouring rain these past days; only Sunday morning was sunny and bright.

To Otto Modersohn

Paris, 29, rue Cassette
March 3, 1903

My dear King Redbeard,
This morning I awoke in my mahogany bed feeling like a bride, because last evening as I was getting ready to go to bed and had already put out the lamp so that I could take an air bath at the open window, your and Herma's letters were pushed under my door. Dear, it was a blessing for me. I read all your words very slowly, each one by itself. I let them flow over me gently and sweetly, I bathed and sunned myself in them, laughed at them and rejoiced at the thought of you. And I felt so cozy falling asleep. Yes, my King, everything I am belongs to you, and to you I dedicate it. Take everything in your dear hands. When spring flows over our beautiful hill, our love will unite us again. Dear, I felt the same way you did. I didn't want to write so much about our love either, just so that our separation would not be made more difficult. But it's wonderful now and again to talk to each other about our love, because after one does, it is so much easier to keep one's peace—

you know, I talk about you just as often as I can. When I'm with the Rilkes, though, it's rather hard to do because they only half listen and are much too preoccupied with themselves. But I do tell my *garçon* from Brittany a lot about you and tell him what beautiful pictures you paint. The other day I particularly wanted to impress him, and so I showed him your picture in the monograph. He didn't think you were handsome at all. And so I got angry and told him that your beard was red and that your face really does look fine with it. And to myself I thought quietly and fervently of your sweet hands and your soul. But I didn't tell him anything about that. I was suddenly beginning to realize that I had knocked on the wrong door, and that I was beginning to dislike him a little—My dear, dear, dear. Yes, I look forward to coming home very, very much. We'll have a blissful Easter together, for I'll be with all of you again by then. I don't dare really think about that at all yet. And what about your trip here? You know I don't intend to make up your mind in any way for you, but I must say those watercolor drawings of Rodin would be a marvelous thing for you to experience, too. Just to see how far one can go without concerning himself about the opinion of the public. You know, Rodin's courage is very much like the courage Rembrandt expressed during his time in his etchings.

Herma wrote that you would like to hear more about the [Rilke] monograph. It becomes clearer to me by the day that this is not the right way or manner to write about art. Let your way of speaking be a simple "Yea, yea" or "Nay, nay." He knows nothing about that. These precautions, this anxiety of his about spoiling things with anybody who could possibly be useful later in life! For example, one notices in the essay on am Ende that he does not value his art very highly. There is a lot of talk and beautiful sentences, but the nut is hollow at its core. Un-German. I save my praise for Muther who could calmly say that he liked you and didn't like Vogeler so much, and said everything in more or less simple terms. Gradually I can see a great emptiness behind this sweep of rhetoric. I'll be able to explain what I mean better when we can talk about it. In my estimation Rilke is gradually diminishing to a rather tiny flame which wants to brighten its light through association with the radiance of the great spirits of Europe: Tolstoy, Muther, the Worpsweders, Rodin, Zuloaga, his newest friend whom he will probably visit; Ellen Key, his intimate friend, etc. All of that is impressive at first. But the more one looks into life and into the depths of human feeling and into the rushing waters of art, the more shallow his life seems to me. Much more about this when we can talk. They have a very nice relationship with me, but when I'm with them I don't feel very comfortable. You have probably received my letter about Rodin. I had just stuck it in the mailbox when I got your sweet and lovely Redbeard letter. I'll be reading it frequently here in Paris. Herma's letter was charming and dear. Thank her warmly for it.

And now I sit on your lap and give you a long kiss full of yearning and love. Until we spend a merry and blissful Easter celebration,

Your little Wife

Why don't they leave old Fitger in peace. I think that they could lock horns with someone else besides him. How good that you are quite a different person, a quiet one.

To Martha Vogeler

Paris, rue Cassette 29
[Postmarked March 6, 1903]

Dear Martha Vogeler,
I sent you a little basket of violets as a Sunday bouquet so that they would fill your little brown sitting room with their fragrance. And now I hear you are staying in the city, so the flowers will no longer be fresh by the time you get them. So instead I send quick greetings with this little card. There are so many beautiful things to see here, and I'm absorbing them even more than I did during my first stay in Paris. This time I see everything with different eyes. I believe a trip like this does me much good. I should like to see Paris every few years, despite the fact that the first time I was here I was quite uncomfortable. Paris is truly a city of beauty. Every day I have something to add to my storehouse. Spring is far advanced here. The blackbirds are singing in the Luxembourg, and on the table in front of me I have a vase of lovely yellow coltsfoot. I could have kissed them when I found them out in Meudon, where Rodin lives. I'll tell you about him when I next see you.

Your Paula M.

To Wilhelm and Luise Modersohn

Paris, 29, rue Cassette
March 6, 1903

Dear Parents,
I have been meaning to write you a letter for a long time, but I have never been able to get to it. Today I find I have a free evening and I will put it to use. Otto has probably already told you that everything is going very well for me. But I wonder if he also wrote you that his plan to come here is now in doubt. He has found another new kind of paint again. He likes using it so much that he does not want to interrupt his work. That makes me very sorry, for it would have been so beautiful if we could have shared all these many impressions and then been able to talk about them afterward in Worpswede. I still have a secret hope that he will be coming. Otherwise, I think that I will be traveling homeward soon again myself—

—I think that I am still able to learn all kinds of things here and that makes me very happy, for I do so very much wish to become a good painter one day. And I also continue to think that if I am still able to learn new things, I can understand Otto better and better in his art. Every day I go to the Louvre where an enormous

number of art objects from all periods are on exhibit: paintings and sculpture from the Egyptians down to our own time. I do a lot of drawing there. Surely Otto has sent you the monograph on Worpswede by Rilke; I also received it. It was so lovely to see pictures by good acquaintances and by my dear husband here in a strange land.

Little Elsbeth sometimes writes me a letter under the guidance of her grandmother and in each one she assures me that she is being very good. I see the Rilkes very often, and I have also made the acquaintance of a very nice German girl, so that I'm not alone much. Dear Mother, I'm sending you a little bouquet of violets as a "sample without commercial value"; masses of flowers are being hawked here now on every street corner. For Otto's birthday I also sent him flowers which bloomed for a long time in his vase; I hope the violets will also still be fresh when they reach you—

—Now farewell, dear Parents. I still want to write to Otto. This letter is supposed to be only a little sign from me that I am thinking of you from far away. [...]

To Otto Modersohn

Paris, 29, rue Cassette
March 7, 1903

My dear Husband,

I've just written your parents a little letter so that they will know a bit about how things are going with me in this foreign country, and now I'm quickly rushing to you to give you a kiss. I'm thinking to myself that it's now midday there and that you have just come from the studio in your brown overcoat, or is it already so warm that you only have to wear your "armor"? Well, in any case, you've come into the house and found my letter lying on top of the *Bremer Nachrichten* on our chest in our little dark-yellow entry. I know you are happy. What I don't know is whether you have sat down on the veranda or in the living room to read it, because I don't know whether the veranda at present is under water or not. And then, when you've finished reading, Bertha will bring you something lovely to eat. I hope you'll enjoy it. I know that I, at least, shall enjoy my food when I come home again. I'm sick to death of the meals in my restaurant, and I'm bored sitting alongside so many people who mean nothing at all to me. I compare this with our quiet noontimes together, when we sit next to each other on the little bamboo bench and you hardly say a word because you are enjoying your lunch so much; or at the most you give Elsbeth a smack on the head with your napkin when she jabbers too much and eats too little. Yes, I look forward to all of that again—

—But in one very concentrated way I'm happy to be here. I'm using my time well. Almost every day I sketch paintings and sculpture in the Louvre. My sketchbooks will be a fine accompaniment to our talks about them. In general, I'm enjoying sketching enormously now. And in Worpswede I want to go around much more

with my sketchbook than I have up to now. In fact, I hope that my stay here will result in progress for me. Well, we'll have to wait patiently and see.

Rilke has had the influenza for a week, the third time this winter. He cannot endure Paris and he really should leave, because that would perhaps be better for his wife. You probably are noticing that I haven't many good things to say about him, although we are very sweet to one another when we're together; for example, I brought him absolutely wonderful tulips to his sickbed. But suddenly I can't stand him anymore. I no longer have a high opinion of him. He holds [court] with each and all. One cannot make any judgment about her at all. She's in a state of mind that cannot go on; one must simply wait to see what happens. Only I do believe that a good portion of self-worship has fixed itself firmly inside her, and that it's probably going to stay there. All of that leaves me completely cold, to the point that I'm even astonished at myself. Even when I first went to see them I wasn't affected by their behavior in the slightest. They can express the craziest opinions now and I just sit there quietly and think my own thoughts, think of you and your good health and of how untainted and sane you are; and I secretly kiss my wedding ring, with which I have formed a most remarkable relationship here so far from home—although I'm very frightened that I may lose it sometime because it's so loose on my finger.

—Otto, do send as a "sample without commercial value" a little swatch from your "armor" and ask Meyerdierks the tailor how much is needed for a jacket. I believe I can locate the material here. Yesterday the postman brought me 223 francs, for which I thank you from the bottom of my heart and which will bring me back to you again in two weeks. Dear, that will be a celebration. Did Elsbeth's orange arrive in good condition? I sent her one today. My loving greetings and kisses to all of you. In spite of distance, and my desertion, and all my painting, I am

Your little faithful and dear Wife

To Martha Hauptmann

Paris, 29, rue Cassette
March 9, 1903

Dear Frau Hauptmann,

You are in my thoughts now and so I want to write you immediately and thank you for the letter you wrote me at Christmas. A long time has passed since then, to be sure; and it seems even longer than it really has been, for I've been in Paris a month now. Suddenly (or to be accurate, gradually) I felt such a longing to look at old works of art. And my dear husband allowed me to take the trip. Looking—I can do that best of all here. One gets submerged here so beautifully, submerged in the great mass of people, and one has no obligations at all and can let everything take its effect with no other interference. I also find it so interesting and fine to come

back and stand in the same spot time and again, just to see what different opinions I have about the things I've seen before. This time it seems to me as if the Louvre has grown even larger. The world of ancient art has opened up completely to me for the first time, a world that had seemed so cold to me, perhaps because of all those false imitations and the worshiping and the way people always carried on about it. It's becoming clearer and clearer to me that antiquity and the sense of the classic have a powerful closeness to nature. This proximity to nature, and the one who preaches getting closer and closer to it, that is Rodin. Dear Herr Doctor, I know how you love Rodin. I had to think of you often these days, hearing and seeing such beauty and such simplicity coming from him. The impression he and his work make, I can't write you about it in words. I hope we'll have a chance to see each other this year so that I can tell you many things about him. It is remarkable how he has revealed himself to me in his drawings. He showed me many, many portfolios filled with them. They are very quick outline sketches, life drawings, which he then washes in with remarkably simple and impressive light watercolors. They can be compared best to old Japanese pictures or those simple, colored frescoes left by the Egyptians—

—Your husband once told me awhile ago that I should not go back to Paris. I so much hope that it will be useful to me after all. And I hope that it will be so when I return here again. For it is my great wish and my most compelling desire to be granted the ability to express in my art that little message that is my whole being. And I still hope to get there someday.

—I'm also interested in that easy impressionability of the French people in contrast to us. They have something childlike and are closer to nature and art than we are. With what devotion the French vagabond will study, for ten minutes at a stretch, the marabou at the Zoological Garden. I believe the German vagabond would never do anything like that—

Clara Rilke is sadly and gravely taking in the dismal side of Paris right now. That probably comes from having had to separate herself from her home and child. I wonder what you will think about the monograph on the Worpswede painters. As for me, I really think there is more of Rilke in it than there is of Worpswede. They are all so much simpler [than he makes them out to be].

—I have used this Sunday, my day of rest after all my looking around, to take an excursion to the outskirts of the city with a little German [woman] painter. We picked spring flowers and pussy willows and took a rowboat trip on the Marne. The countryside around Paris is so varied and charming, hilly and somewhat primitive in spite of its closeness to the great city. In fact, its closeness to the city is often its charm, for example, when one gets a view through to the towers of the Panthéon or to the dome of Sacré-Coeur—and I'll be celebrating Easter in my quiet happiness back home again.

I greet the two of you from my heart and from far away.

Your Paula Modersohn

Paris, 29, rue Cassette
March 10, 1903

My dear Red,

[...] I look at little children with love, and when I'm reading I look up words like swaddling and nursing and so on with great understanding. I have been very aware how these two years at your side have gently turned me into a woman. When I was a girl I was always full of jubilant expectation. Now, as a woman, I am also full of expectations, but they are quieter and more serious. And they have also rid me of the vagueness of my girlhood. I believe that there are only two very definite expectations left in me now: my art and my family—My dear husband. With all the things that are going on inside me here, I'm having an odd and wonderful time. It often seems to me incredible that I really have you and Elsbeth and our little house. And then when I think about it all, I know that it is the wonder of these secure possessions that gives me peace of mind to approach things here with composure and happiness. You know, I don't feel erotic in the least right now. No doubt that comes from all the mental concentration inside me. But if such a thing is possible, I love you more recklessly with each passing day. I love every fiber of your being. I am so very proud of you, my dear Red. [...] But if Easter isn't until the twelfth of April (at least that is what the concierge's calendar says), then I am not staying away from you that long. I've had it in my mind all along that it was on the thirtieth of March. Isn't that what your little book with all that information says? No, my idea is to come between the twenty-fifth and twenty-seventh of March. My dear Red.

Last Sunday, Fräulein von Malachowski and I had another outing in the country. We went boating on the Marne. The scenery along the river was so grandiose in its shapes and forms, and the rowing was so healthful and made us feel so strong, after all our pounding of the city pavements. Fräulein von M. is a dear, natural, and bright human being, and not without talent. She does life drawing with Cola Rossi and paints with Blanche. I wonder if something good is going to come from her work? She has since done things better than the ones you and I saw, but she is not conscientiously pursuing any one goal. How can someone go to Blanche after having studied with Kalckreuth? And then, unfortunately, there is the aura of something messy and unattractive about her, as there is with so many women painters. It's so ugly in her room. She is nicest by far outdoors, in nature, where she responds directly and happily to everything going on around her. Rilke has lent me a beautiful book, *Notre Dame de Paris* by Victor Hugo, a novel in which the author fervently and with the most sensitive understanding supports the preservation of the old Gothic buildings. You know, I must come to Paris sometime with you. I really think that a great deal of what slumbers in you, which you express now only instinctively, would be awakened in you here. What I mean has primarily to do with form. For example, I would so like you to acquire a different

standpoint vis-à-vis the art of antiquity. I sense that those early things are very close to our way of feeling. All of that is what I want to show you.

To celebrate the day I have had them make a little fire in my fireplace. It's crackling and sparking cosily—just think, I saved half of the *Mettwurst* from Mother just so that we could dine on it together. Now I'll have to eat my way through it alone. And your paintings. Mother is ecstatic about the large one. Thank her for her letter. What did Mackensen and Overbeck say? It seems so strange not to be seeing them. And what are you up to, then?

Kiss my little Bettine [Elsbeth]. I am and shall be

Your little Wife

To Otto Modersohn

Paris, 29, rue Cassette
March 12, 1903

My dear Red-Rex,
Just now your dear letter arrived with the great big *Paris* [on the envelope]. Your letters always arrive after nine in the evening here. That way I have plenty of time to ask myself all during the day whether I am perhaps getting one that evening or not. My dear fellow, this time I've fallen behind you as far as love letters are concerned. But my head and my heart, you know, are so hard at work just to absorb the thousand things here in such a short time. And you know, I've so very much to tell you, about David, Delacroix, Ingres, and consorts, and about a certain Chardin and many, many more. I have such a high respect for these people, and I'm beginning to believe that the judgment we have about them in our country is rather askew. When all is said and done the majority of our population is also superficial, only it expresses itself in a different way. But in their work they are not superficial, that is absolutely certain—You know, after we've had our real fill of kissing when we see each other again, we can then spend the next ten days and ten nights in uninterrupted conversation. As you can imagine, I'm so full of things to tell you that I could nearly explode. But I'd rather spare our health. And I also am very much looking forward to my little bed at home, although my little mahogany bed here isn't bad either—

There's a full moon here now, silver and blue over the city. How it must be shining in our little garden, too; and when you close the bedroom window this evening you will love the color of Dreyer's stable and barn—

—I've been looking at Goya's etchings. You probably know them too. What great composition they have, and a remarkable sense of space and atmosphere. In the Louvre there are three paintings by him, the little piquant lady in black in front of a landscape, a half-length portrait of a lady with very rosy skin, probably rouged, in a very subtle gray silk dress. (3) A gentleman in uniform who doesn't please me so much. Zuloaga builds so very much on him and on Velázquez. My opinion

about Zuloaga is much more definite now, having compared his pictures with the great Cottet triptych. Zuloaga will never have the remarkable things that are in those side panels; with him I have the feeling that we get all his beauty at first sight, compared to Cottet whose picture opens itself up to me gradually, deeper and deeper. Such subtle reserve in his colors. Do you remember the left panel, the men? Blue and brown. The sea, blue. The men in the boat, brown. But what browns. These rich nuances. Besides, there is much more atmosphere in his work than there is in the other.

Fräulein von Malachowski is a dear, but primarily for Sunday outings. During the week I'm really mostly alone; at least this was true last week when the Rilkes and I were unable to get together. But I really prefer it that way. I'm so busy with my own thoughts. And then I've been reading a wonderful book by Victor Hugo which I also want to tell you about. He was a great man. And it's also interesting for me to delve a little further into the language and its *littérature*. As opposed to Rodin, who took a trip to Italy with the firm intention of speaking not a word of Italian. He would get into the horse trolley, and then when the people addressed him so that he would have to speak, he would get out again. If everything went smoothly though, he would just stay aboard—my convent clock has just struck ten, dear. And you know how conscientious I am about going to bed. Good night, good man. You are probably already lying flat as a poster in your little snow-white bed, for your clock is already an hour later than here. Are you still sleeping under the big feather comforter? Throw it out, spring is coming. I've been thinking today that when I come home I want to wash your hair. I wonder what it will look like then? Do send me Vogeler's letter, and do send Rilke the *Mathilde*. You are certainly having elegant feasts in my absence. Herring with cream sauce is something I've never eaten at my table. What luck, old fellow, that all of you are getting along so well. But when I return, you know, you are going to kick all of them out of the house, because at first we want to have a little time by ourselves. Then they can come on Sundays. But calm Milly down beforehand. Otherwise that's such a boring business. I kiss you tenderly and I let you give me a kiss and I kiss you back. And even though my love does not jump out in writing on this paper, you'll certainly get a taste of it when I come home again.

<div align="right">Your little Wife</div>

To *"Little Bettine Modersohn"*
[Postcard]

<div align="right">[Postmarked Paris, March 14, 1903]</div>

My dear little Snow White,

When Mother comes home again she will be able to tell you a whole heap of things. Just imagine, I was on a steamship, just like the ones you have seen on the Weser in Bremen. We passed under five bridges. And each time when we came to one,

the steamer made a very loud "Toot." It was lovely. And then I saw a donkey today. He stood before a wagon and looked at me and said, "Hee-Haw." And then I looked at him. But I didn't say anything to him. And then all the trees here are getting their dear little green leaves. And the birds are singing. Are they doing that where you are, too? You must show me everything when I am back. A lovely kiss from your dear Mother.

X X X X X X X X

Journal

[Undated]

I have bought myself Delacroix's journal. It's written in a colossally spirited way and is full of a painter's experiences.

To *"La petite Mlle Elsbeth Modersohn"*
[Picture postcard: Paris, Théâtre du Vaudeville & (illegible) des Italiens]
[Postmarked Paris, March ?, 1905]

My little Elsbeth, there are so many people walking in the streets here and so many horses and so many velocipedes, you couldn't possibly go out all alone; Mother would have to look out for you. The little birds here in the city sing so beautifully and many people throw bread out for them and feed them. That looks so pretty. A kiss from your Mother.

To *Otto Modersohn*

Paris, 29, rue Cassette
March 17, 1903

My King Red,
I'm coming home. It suddenly took hold of me and I have to come back to all of you and to Worpswede. Dearest, Saturday evening, maybe even Friday, I'll be with you. I must see to it that I leave Wednesday or Thursday evening; I'll stay a night in Münster and then fly to you. Your father wrote me a charming letter which he began in French, and now I want to send him a postcard and inform him of my arrival—unfortunately, I won't be able to wire him the exact time until I'm in Cologne. I was with Cottet today. He's quite a fellow, too; he is constantly progressing and that's the main thing. Now I quickly want to tell the Rilkes and Malachowski about my sudden decision. A thousand kisses to you and little Bettine. More when we see each other. Oh, my King Red, how beautiful that will be. Just open your arms wide and see to it that we will be alone. You can simply say that it's more appropriate for such occasions. I love you, as you do me.

Your little Wife

To Herma Becker

My dear, big, little Sister,
Your dear letter was such a great joy to me and brought with it a little piece of home atmosphere, and I could feel the peace and joy of early spring which has arrived for you there, back home—meanwhile I'm still taking in so much beauty here. It sometimes seems as if Paris is getting deeper into my bones than the first time I saw it. Or perhaps in these three years I've been developing more marrow. I wonder when you will possibly get to see all of this? I have the feeling that a person's soul grows from being near these things as it does when one is close to another human being in a good way. At present, Notre Dame is having a strong influence on me through a remarkable novel by Victor Hugo, *Notre Dame de Paris*; it's almost become a living thing to me. This book makes it clear that almost all thoughts of beauty that flowed through the individual served the work of the community; and that architecture was the artistic expression of the Middle Ages; and that after the invention of printing the expression of the individual was gradually directed to the word, to the book. I don't know whether you have ever seen a church similar to Notre Dame; it sits there filled with remarkable figures, dwarfs who hold up pillars, ravens, dogs, birds. The eaves troughs have wonderful little devils and animals which spit out the water. The whole structure lives and intertwines and brings us a thousand stories about superstitions and folktales. And still the shapes were conceived so simply and grandly. Well, I'll have to tell you much more about it when we see each other—really, I wasn't planning on telling you anything at all; really, I just wanted to tell you on a postcard how happy your letter made me. And now the postcard has gone and hid itself! Continue to walk your path with modesty and in sacrifice to your goals, and then much more beauty will come your way. I love you with all my heart,

Your Paula

To Otto Modersohn

[Postmarked Münster, March 19, 1903]

M.d.O R-R.,
So far I've made it as far as Wanne with no problems and have shaken the French dust from my shoes. I'm happy and surprised that I seem to understand everyone so well, and particularly happy about their sincerity and their good solid ways. And tomorrow, Friday evening, the mail coach will deliver me to our little garden gate. And you, dear, will be waiting for me and step toward me out of the darkness.

I'm afraid that the day in Münster which you've prescribed will seem pretty long, considering the joys that await me. I've been spending the last two days in a

great flurry of travel and am unable to realize suddenly, tomorrow, I'll be sitting next to you on our little white veranda. I really meant this letter to be just a post-card, but I fear that its tone got a touch too warm for the Worpswede postman and Johann Kellner. I wanted to temper the style but it wouldn't work out. My anticipation burns right through. Is yours burning, too? During my last day in Paris and the last night there, my thoughts about Worpswede were overwhelming. I wonder how all of you will look? Has Elsbeth grown? Have you? And has any-thing begun to stir in our garden? Well, I'll have the answers to my many questions soon. I'm a bundle of questions. Kisses, kisses, kisses.

Paula

From Otto Modersohn's Journal
Beginning December 21, 1902

March 23, 1903

My dear Paula is back from Paris and has brought me the most wonderful things: on the one hand, a deepening of our love, which is wondrous; I live as if in a dream, true rapture flows through me. And then, as to art: she does not like the pictures that I somewhat hastily did in Raffaelli crayons. She points with the strongest and most insistent emphasis to nature. For her my pictures contain all sorts of things, but they lack one thing: study, nature. Oh, I have told myself that a hundred times and yet I always make the same mistake. I am always tempted by my pro-lific fantasy and then I fall prey to its charms, and nature retreats, becomes stan-dardized, and turns into a cliché.

It is remarkable: art is like love (that's what Paula said this morning); the more one gives, the more one receives. One must open oneself completely, admire and worship every detail of nature, and then it will reward one wonderfully; one will receive the blessing of the gods. [...] So it is in marriage; if both partners insist upon their own points of view, love cannot reign, nor can it bless them, or unite them.

**Journal*

April 1903

I'm getting close to our people here again, sensing their great biblical simplicity. Yesterday I sat with old Frau Schmidt near the Hürdenberg for an hour. With earthy philosophy she told me about the death of her five children and her three winter pigs. Then she showed me the tall cherry tree her daughter had planted, the one who died when she was eight. "Well, as the saying goes:

When the tree is grown,
The planter is gone."

From Rodin, Cottet, and Paris I brought back a great craving for nature. And that is probably the healthy aspect of the whole trip. Something urgent burns in me: in simplicity to become great.

To Marie Hill

Worpswede, April 20, 1903

My dear Aunt Marie,

Our little house huddles in the midst of a wintry storm, and for a while all sense of springtime is being blown away, snowed away, and hailed away. All day long I circulate among our little fruit trees and brood about which ones the night frost may have harmed. Last fall I filled our garden beds with tulip bulbs and the tulips were just about to open, but now, of course, they can't. Because of the cold, Elsbeth doesn't play in the garden very much, and so it's been quiet enough for a pair of robins to build their nest there. So you can see that this stubborn and wintry spring has its good side, too. We can see our two robin redbreasts hopping about outside our windows.

How are things there, I wonder? I'm thinking of you on your birthday and pray that life's problems don't lie too heavily on you. I wish peace for your soul.

My life glides along day by day, and it gives me the feeling that it is guiding me somewhere. This hopeful, soaring feeling is probably what makes my days so blissful. It is strange; what people usually call "experiences" play such a small role in my life. I believe that I have had some of them, too, but they don't seem to be the most important things in my life at all. What lies between these so-called experiences, the daily course of events, that's what makes me happy. And that is also why I seem to have so little to say in my letters—for these small, mostly private things can probably be captured in writing only by a more knowing hand than mine. In that same sense, my trip to Paris simply passed by, and now I really don't think much about it. I am often amazed about it myself. But while I was there it did bring me new insights, and now I'm already busy again building on that foundation. I believe that I live very intensely in the present. [...]

From Otto Modersohn's Travel Journal

1903—From July 9 to August 5 we traveled with Elsbeth by way of Husum to Amrum. We stayed in Steenodde at the Sign of the Merry Seal, and then at Ricklefs'. [...] We painted and drew a great deal in the Frisian villages (fog, etc.). The sea, with its seabirds; the inhabitants, melancholy, distinctive in their native dress. Often stormy weather; Paula would boldly go swimming on such days. Elsbeth became ill and got the measles, went to stay with Mother Becker.

Postcard to her mother, July 26, 1903: Elsbeth, Paula, and Otto, "The three tidal-flat runners"

To her mother
"Open letter to the Family"

July 29, 1903

Background to the drama: Shoals and sandbars — Completely empty — With mud flats and stench. On the horizon the three church steeples on Föhr. Heat of the sun — In the middle ground the shipping channel, like a river; on its banks, two skippers busy with their nets — Pebbles — mud — heat of the sun. From endless space — from the heights and the depths — come the sounds of the birds: teeuuu-eee, teeuuu-eee, teeuu-eee — vow, vow, vow — kaitch, kaitch, kaitch — kaahk, kaahk, kaahk — peep-ee, peep-ee, peep-ee — toodle-ee-ee.

In the foreground, the family: daughter barefoot, trying to hack the naked rubber doll to pieces. Father in the hooded wicker beach throne of the last Frisian chieftain; Mother looking for the only shade along the whole coast, Father's shadow — sunburn —

Thank God that Father has recuperated! One whole night long he wanted to die in our room at the Seal Inn, like that pair of Nordic artists, Heinrich and Martha Vogeler, in Rome's sacred marble halls. During that long, long, long night he didn't know why, but he felt he had to die — until toward morning, the liberating realization and with it the act of salvation both occurred with demonic force: Mother Hansen had done him in with her too rich meals. And a Worpswede stomach simply could not deal with them. He ate from a feeling of duty in the good sea air,

317

and as long as a crumb was left on the table. But his fate soon drew near. Anxiety —cramps—the torments of repentance, the sighs of his spouse—"Newspaper, newspaper!"—Oh, freedom that I love—"Better dead than a slave"—We shall be leaving the Seal today because of the great racket. And three houses farther along in the old Frisian farm of the good ship pilot Herr Ricklefs we will bed down our weary bones until the hour of departure and return strikes. The gracious hour— oh, that gracious hour! Sea and island—nothing can be a substitute for my home. Everything here is as if it were on the edge of Paradise—no bird sings—not a one— not even those who ought to by their nature—everything accommodates itself to this silent island. The larks flutter up but only peep a little; the starlings in their sullen mood encircle the skinny island cows, waiting for the arrival of the only nourishment that makes them happy—But you also must understand me correctly. Charm, there is much charm for us to find here. The Frisian villages, with their architecture and palette so full of character, are very exciting to us. And the people! The slender, graceful Holbein women with their solemn Frisian headgear, the blue stripe on their black skirts, their silver ornaments on Sunday. They are glorious to see. And the men! With their ponderous and serious seamen's ways they are no less so. Something else precious are the flowers that bedeck the cropped meadows with rosy and lilac pillowy clumps in all hues. Swimming is different than one had imagined. So far only Mother and Daughter have been bathing. Father observed. We have just provided him with bathing breeches from Frau Schamvogel at the Beach Bazaar. And now he has no excuse. He has to go swimming, too. Unfortunately, up to now the weather has been miserably cold and rainy, weather fit only for dogs. One does see other people, marring the island's landscape with their white head-coverings of every tasteless description. One does not see them bathing. There is a family from Itzehoe with six boys which is the laudable exception. They make one's heart jump for joy. We are now living together with this family at the home of the excellent Pilot Ricklefs, with whom one can go on the most wonderful sailing parties. One must pay attention to these people, honest and good. Despite all the stormy weather, life here seems to be doing us good. Mother is gaining superhuman strength. I don't need to be ashamed of her when she's out bathing, the way Vogeler was in Helgoland once, when his wife stepped out of the bathing cabin looking so thin. All of us look more or less like North American redskins. The sun is getting higher in the sky. Father's shadow is getting shorter and shorter. The sandbars are flooding over—No mud flats anymore—no more stench—One is plunging into the waves—Sunburn!

From out of the waters, a thousand greetings to all of you. And to the Modersohns—also to Frau Rohland and Tony.

Set down at Steenodde upon Amrum
in the dwelling place of the excellent Pilot Ricklefs
on 29 Julius 1903

Hintergrund des Dramas: Wattenmeer — Völlig leer. —
Mit Schlamm und Gestank. Am Horizont die drei Kirch-
türme auf Föhr. — Sonnenbrand. —
Im Mittelgrund die flußartige Schiffahrtsstraße, darin zwei
Schiffer mit Netzen beschäftigt. — Kies — Schlamm — Sonnen-
brand. Aus dem unendlichen Raum — aus Höhen und Tiefen —
dringen Vogelstimmen hervor: Tiü — tiü — kiss — Wau —
wau — wau — Rähtsch — kak — kak — kak — Pip — pipik —
pipik — pipik — bedelik — liük — liük.

Im Vordergrund die Familie: Tochter
barfuß, versuchend die nackte Bade-
puppe zu zerhauen. Vater im Strand-
korb des letzten Friesenhäuptlings.
Mutter im einzigen Schatten der Küs-
te, Vaters Schatten ausgenützt. —
— Sonnenbrand. —
Gott sei Dank, daß Vater wieder wohl!
eine Nacht wollte er sterben im Sär-
(mund)

viel Ruhe ist hier für uns zu finden. Die Friesendörfer mit ihrer charaktervollen Architektur und Coloristik regen uns sehr an. Und die Menschen! Die zarten, anmutigen Volksinnraue mit ihrem friesischen ernsten Kopfputz, ihren blauen Strick am schwarzen Rock, ihrem Lieber schmuck am Sonntag. Die sind prächtig anzusehen. Und die Männer! Mit ihrem schweren ernsten Seemannswesen nicht minder. —— Ein Köst liches sind die Blumen, die mit ihren rosa und lila Riesen in al len Schattierungen die kurzgrasigen Wiesen bedecken. Das Baden ist etwas anderes als man es sich dachte. Bei uns badet bisher nur Mutter und Tochter. Vater soll zu Soeben ist ihm eine Badhose bei Frau Schamvogel im Strandbazar besorgt worden. Und nun hilft das nichts. Er muss hinein. Bis das

war es meist leider heute kalt und regnerisch. Ande re Menschen soll man wohl mit weißen Kopfbedeckun gen jeglicher, geschmacklo ser Art die Insel verunzie ren. Baden sieht man sie nicht. Nur eine Familie aus Tyho mit sechs Jungens macht eine rühmliche Aus nahme. Die machen einem das Herz im Leibe lachen. Mit dieser Familie wohnen wir jetzt zusammen bei dem famosen Lootsen Ricklefs, mit dem man die

ersten Segelpartien machen kann. Man rennt mit diese Leute merken billig und gut. Bekom men thut es uns sicher bar gut nach allen Stürmen. Mutter ge winnt übernatürliche Kräfte. Senieren brauche ich mich nicht für sie beim Baden, wie einst Vogeler in Helgoland, als seine Frau ihm zu dünn aus der Badkabine kam.

Wir alle sehen mehr oder weniger wie nordamerikanische Rot-
häute aus. Die Sonne steigt. Vaters Schatten wird immer kürzer.
Das Watt hat sich gefüllt. — Kein Schlamm
mehr — Kein Gestank. —. Man
stürzt sich in die Flut

Gezeichnet zu Steenodde
auf Amrum
im Hause des Bruders
meiner Lossen-Ricklefs
am 29 Julius 1903

Bremen, Wachtstrasse 43
August 11, 1903

My dear Husband,
I was unfortunately prevented from writing you yesterday by a discussion, as long as a tapeworm, with Tony Rohland. She was celebrating her birthday here. And so I'll make up for it right away. After a good and normal night, only slightly interrupted by coughing, Elsbeth is now sitting happy and content in her bed, playing with the collection of silk patches which Mother gave her. While I was away, Mother and Kurt had quite a time with Elsbeth. All at once she began having terrible earaches which caused the child to scream for hours and cry for me, so that they almost wired me to come. Kurt put carbolic acid drops in her ear and now there seems to be no more trace of the pain. Even by the time I got here yesterday she was already cheerful and happy about my arrival. To add to all the family misery, Kurt now has got the lumbago, spent a sleepless night, and has an urgent need for fresh air. Perhaps he'll visit you today or tomorrow. Just leave a message at the house saying where you are. Although Elsbeth is almost back to normal, Kurt does advise keeping her in bed until next Sunday, just to be sure that no cold sets in again. And so I shall very patiently wait out the time here; and then I hope, I hope, that you can fetch us on Sunday from the station in Kück's coach.
My dear!

Your Paula

To Otto Modersohn

Bremen, Wachtstrasse 43
August 14, 1903

My dear Husband,
The way to describe my mood right now is: "And they sat by the waters of the brook and wept when they thought of their homeland." I couldn't stay here in this banishment any longer than Sunday. A hundred thousand conversations and yet not one of them a really thoroughly satisfying one. How I look forward to my journey back to our Worpswede paradise. Tomorrow is going to seem very long to me. I wonder what you've been doing all this time, you lucky Adam? Kurt will probably be there with you this evening and let you know that things are fine and dandy with Elsbeth. But we must be very cautious at first when we get back to Worpswede.
I gave your kiss to Herma and she is now able to walk and hobble along and will probably accompany us to Worpswede on Sunday to get a little fresh air out in the country. *How* I long to get back. You know, this business of wasting time with things that are not going to get us into heaven is frightful. I would ten thousand times rather have taken care of Elsbeth out there.

I think that one droopy eye of mine has slid down onto my cheek in the meantime. Say hello to Else and tell her that I forgot to write her to please wash my white dress (the one in the dirty laundry) and, if she has time, to iron it. I've brought you some birch tonic for your hair. Tomorrow, to make your beautification treatments complete, it's your collars' turn. I'm really anticipating the poems of Wenzelau. Things are in a pretty sad way for them, but they really are for us too if the mother is planning to plague the Weyerberg. I thank you for your dear letter, and I'm sick from longing for our little quiet house and garden. If only I could sleep right through tomorrow.

I love you with all my heart and thank you from the depths of my soul that you are Otto Modersohn of Worpswede.

<div align="right">Your Paula</div>

You know I have that "sick-bird feeling" again. I recently met "Black" Garmann on the street. My existence is so melancholy now that even he had a buoyant effect on me. And so until Sunday with Kück's carriage. Leaving on the 10:30 from Bremen.

From Otto Modersohn's Journal
Beginning June 25, 1903

<div align="right">September 26, 1903</div>

[...] Paula has more intellectual interests and a more spirited mind than anyone else. She paints, reads, plays, etc. The household is also in very good hands—it is only her feeling for family and her relationship to the house that are too meager. I hope that it improves. But I am very happy about these intellectual interests of my Paula—she could never play the simpleton—I only wish that our lives were a bit more together and with one another, then I could call it ideal. [...]

Paula hates to be conventional and is now falling prey to the error of preferring to make everything angular, ugly, bizarre, wooden. Her colors are wonderful— but the form? The expression! Hands like spoons, noses like cobs, mouths like wounds, faces like cretins. She overloads things. Two heads, four hands crammed into the smallest space, never any fewer than that; and children at that! It is difficult to give her advice, as usual.

**To her mother*

<div align="right">Worpswede, November 2, 1903</div>

My dear Mother,
To think that I am so close to you and yet not with you! I don't know how I can steal away from my little house without making glum orphans of the three other

occupants. These days Otto seems to need my face to look at several times a day. Elsbeth makes much too much noise for him and consequently he is not very sympathetic to her presence. And so I must be the oil that calms the waves. Last but not least, there is our new un-"familiar" household spirit [maid] here. I do not yet have the courage to let her navigate all by herself on our little domestic sea. And so all I can do is write my love to you, which considering my nature and temperament is only to say that I have written it between the lines.

Dear Mother, may everything around you become happy and harmonious so that your years and days and nights are free of concern. Sometimes I have the feeling that I should make you a little happier than I seem to. But I don't know how to go about it. It seems to me as if I have been doing things mostly for myself, and for Otto.

Next week we'll all come and spend a lovely evening together with you.

<div align="right">
With tender love

Your Paula
</div>

To Milly Becker

<div align="right">
Worpswede, November 30, 1903
</div>

My dear Sister,

Winter has come now. It's really freezing and in a few days we shall surely be able to go skating. I'm sitting here in my cozy hermitage at the Brünjes'. It is twilight. The moon is bright in the sky and outside my window lies our beloved hill. Elsbeth and I have just gobbled down a baked apple together. We can already feel Christmas coming.

Dear, I would so very very much like to have you here with us for the holidays. Do you think you might like to be with us? You can pass right through Bremen and just spend a quiet Christmas in Worpswede with us. We won't talk about things from the past; we can just be quietly happy that we are together. You know, if your heart tells you that you would like to come here, then don't be concerned about the money. Maybe you could even come fourth class; it never bothers *us*. You make up your mind.

We are now especially grateful to be back again in our own dear surroundings. Maybe Mother wrote you that the two of us took a trip to Münster. Both of us tried so hard there and had so little success. Otto's old parents were either stubbornly silent or loudly opposed to every single thing. Poor Otto was practically obliterated by them in a few days. When he's like that I call him "my little pastor," because there is something so solemn and washed out about him. Unfortunately, this autumn he was suffering from palpitations which made him nervous and a bit frightened. He is, in general, an anxious person and such things make him very insecure about his health. But now he feels much better again and goes flapping

through the wind wearing his brown overcoat and is back in his studio painting. He has regained his proper balance by getting back to his little sketches and compositions. As far as I'm concerned, these small studies are the most beautiful, the most direct, the tenderest, and the most powerful thing about his art. They are the most immediate expression of his feelings. He has looked them through again and again, separated them by size into three groups, and now we are mounting them with great love and attention. I think there must be seven hundred of them. To me there is something so touching about them. They are his most beautiful things. Most of the people here have never even seen them, and the ones who have, have paid very little attention.

To Carl Hauptmann

Worpswede, December 30, 1903

Dear Herr Hauptmann,

How lovely of Christmas to have placed your *Harfe* in our hands, bound and printed and in its jacket. We thought so much of the autumn days when you first brought it to us and unrolled the images of this kingly soul before our eyes. Many, many thanks for it. And dear Frau Hauptmann, how very happy you have made our little Elsbeth, in three ways. The little rings are much too beautiful for our child, you know. We parents were astounded when we opened the box. Our little Daughter of Eve jumped for joy; she found a use for all three right away. She plans to wear one on Sundays, the second on Christmas, and the third when she grows up — and the book and the board game!! But she intends to dictate a letter to me telling you personally how happy she is —

— Unfortunately I am a very delinquent correspondent and am often aware of my shortcoming in not having written you once again about your very lovely visit. I hope you sensed how much your both being here pleased Otto and me. And for your letter, dear Frau Hauptmann, many thanks, too.

— We go on living our life very quietly here, a life which you now also know is very constant and regular. Our pleasures consist of the moods of nature and the moods of our souls and there is very little that one can say about such things. One can only repeat that the person whose soul is in tune and plays along must be in a good mood. Otto and I feel indescribably well at home here in our part of the country. We often feel best when the fewest things are "happening."

Our Christmas was very beautiful. Christmas Eve I went to our little village church with Elsbeth where two big Christmas trees had been set up and their candles were lighted. Little candles were also arranged on the pews in front of the people. The children sang down to us from the balcony "Glory to God in the Highest." And then the Gospel was read. I saw many an eye gazing upward with pious questions. Then we made our way home across the quiet churchyard through the clear and starry evening —

Afternoon.

I have just come back from skating where the ice is beautiful and smooth. Twenty village boys were skating along behind me to see how fast I could go. The ice cracked and the water splashed up onto the banks. What fun that was—

Oh, you wonderful insect life! One can sit for hours in front of it [this book] as in front of nature herself. This Rösel must have had a fine soul.

Elsbeth is pestering me. She wants to write you now, too. So I'll quickly bring my letter to an end. I wish the two of you a happy and blessed New Year and am most heartily

Your Paula Modersohn

[Dictated by Elsbeth]
Dear Frau Hauptmann, I got three beautiful finger rings from you and a board game and a picture book. *Many* thanks. Come out here soon sometime. I got a white kitchen; there are two fat coffeepots in it and a little milk jug. And I was at the Vogelers. Hansel and Gretel were there, and where the witch comes. We have been out sliding on the ice. Friendly greetings. I can't slide very well. Father Christmas has been here; he has a long white beard and puts golden nuts and silver nuts into my apron. I went to church with my mother. All the children were singing there, all the children. Friendly greetings.

Your little Elsbeth

Mother, Father, Elsbeth, and Aunt Herma [send] friendly greetings. Kisses!

* *To Milly Becker*

Worpswede, January 18, 1904

My dear Sister,
... Otto is working on beautiful paintings. Paintings of the fall and of springtime and all sorts of fine things. Besides that, during the evening hours he has once again been revising his "Ideals" and carefully copying them into a notebook with a green binding and yellow paper, something he is very proud of.

I, myself, haven't been really painting much recently; instead, I've been busily reading, mostly in French. I should like to get even closer to that language. At present I'm reading George Sand's *Lettres d'un voyageur* which interest me, in part, very much. Not really so much the letters themselves, as the various relationships she had (with such a variety of great men) and which are revealed in the letters. I cannot yet judge her as an artist, but it does seem that her style suffers a little from a lack of feminine restraint. It seems to me that, in her case, less would be more. I have been foolhardy enough to try writing this letter in our little brown living room. I really should write only while I'm at the Brünjes'. My thoughts and feel-

ings come more together there. Here, Elsbeth comes in every minute with one thing or another, and I'm afraid that this letter is full of gaps and holes. [...]

To Luise Modersohn

February 6, 1904

Dear Mother,

It has been just a year now since we were all together and having a lovely time celebrating your seventieth birthday. This year we Worpsweders will have to send you our wishes in writing. But our thoughts will accompany you in a heartfelt way on your celebration today. May the dear Lord continue to sustain your health in your new year; may you continue to have joy undiminished from your children. That is what I wish you from all my heart, dear Mother.

We have been enjoying true spring weather here. The sun was shining so friendly and warm that the birds all let themselves be fooled and started singing their spring songs. No doubt snow and ice will be returning, however, and will silence these rash songsters—

I don't know whether we wrote you that my mother now has a large and worrisome swelling on her arm which, thank God, is now much better, so that this evening for the first time in a long while she will be coming to visit us.

I must close now so that I can help Elsbeth compose her little letter to you. I send hearty greetings to the two of you and to all the Bohlwegers.

Your Paula Modersohn

**To Milly Becker*

Worpswede, March 2, 1904

My dear Milly,

I've been carrying a letter to you in my heart for a long time. It would have been a sad and tired affair, however, if I had written it, for at the same time I was carrying the influenza around in me, too; and it held my spirits in bondage. Now it's left me and I can come to you. First, let me thank you for your dear birthday letter. We were immodest enough even to be expecting another one for Otto's birthday, on the twenty-second; but you probably thought that would have been too much of a good thing. And so I know little about you, about the very most recent you, since there has also been no news from Mother. I hope you are well and I hope that bad little bump on your neck has not made a reappearance.

I wonder when your stint down there will be over? I really have no idea. But I do so look forward to having you near us again. And so many other people are looking forward to you, too. [...]

You will probably be getting here too late to be able to cast a glance into Otto's

crammed studio. All the pictures will probably already have gone off to the exhibitions. This year especially he has produced many beautiful things and is so happy and his spirits are lifted and borne aloft that it's pure rapture for me just to see it happening. In two weeks, after they have all been sent off to their various addresses, we plan to take a little art trip to Kassel and Braunschweig where some of the most beautiful Rembrandts are hanging. Maybe we will also have a chance to see Hildesheim and Goslar because of their beautiful architecture. We are both looking very much forward to this; since this winter wasn't any winter at all, things were downright ugly and unpleasant, and the human heart does yearn for spring. A trip like this will be the best way to get us over this period until spring arrives. Elsbeth is cheerful and has recently gotten a little jacket made out of the velvet dress which once adorned Aunt Cora, then Ella, and then me—and she looks absolutely fetching in it. She is developing her domestic qualities more and more, seeing to it that the maid gets enough to eat and that everything in the house is orderly; and recently, after I had tried to alleviate a certain shortcoming in our domicile by the application of a colorful hall-mat, I received a reprimand for having placed my new mat in such a place! In addition she is inventing new hairdos, and half of her little brain is filled with new clothes and new underthings and new shoes. But I'm happy to let her alone now. After all, she has a little bit of a real daughter of Eve in her; and then I think, too, that opposition to her would only increase these tendencies rather than diminish them.

You are certainly also thinking a lot about our Henner. If he were only back again with us now. It's so sad that we have no letter from Australia so that we would know how things are with him.

Farewell, dear Sister. I'm so happy when I think of our reunion. Otto sends you many greetings, and Elsbeth is sleeping or else she would surely want to cover the rest of the page with kisses for you. It will certainly be hard for you to leave the two boys, but all kinds of things are waiting for you here, too, and they want your love.

<div align="right">Your old Paula</div>

To Otto Modersohn

<div align="right">At the Brünjes' in Ostendorf
Monday, 11 A.M., April 15, 1904</div>

Dear,

When I said *adieu* to you I nearly felt the way Elsbeth does whenever she sees us off in the coach for Bremen and happily realizes that she will now have one or two whole days when nobody is there to say no to her. I feel so divinely free! And as I walked over the hill and listened to the larks, I smiled to myself and felt the same feeling I often had as a girl, and said: "Well now, I'll take the world today. How

much?" Do you know what makes my freedom so beautiful? It's because you are there in the background. If I were free but didn't have you, then it would all be worth nothing to me. Now I'm figuring out how I can spend these few days doing what I want to do. The first thing I did was to order a particularly tempting dinner for myself: cold rice with sugar, sliced apples, and raisins. Elsbeth was not coughing very much this morning. I hope that her cold does not get worse. I have brought out all her dolls' clothes for her, and now she's having fun dressing the whole crowd of them in different costumes. It isn't even raining now. And the laundry is merrily flapping in the wind. Then I took a walk and dug up some anemones and planted them in our little woods. They should be in bloom when you come back. I also went into your studio where I said to myself, proudly and very quietly, "This is the atelier of my husband." That new painting still has a way to go. There is, for me, still something a little uncertain about its mood. What I mean is that, instead of being grand, it is pompous. I think I would like to stand in front of it and discuss it with you again. I like the idea behind it very much and you have produced something marvelous with the old woman's head. It makes me think of our old "Empress" from the Klinkerberg. Have you ever thought of that, too? Now I must say farewell and write to your father.

Saturday, 16 [April 1904]

Dear, guess where I slept last night? At the Brünjes'. It was enchanting. I boiled eggs on my little oil stove—like the old days. Then I sat there until ten with my two windows wide open. At first the blackbird sang and then the robin. After a while they stopped. Through the evening air there was a gentle sound, the voice of nature awakening. Now and again the distant barking of a dog.

I'm as devoted to this little room as you were to your bachelor's quarters at Grimm's. Sleeping here, waking up here, the jingling of chains in the cow shed at night, and in the morning the voices of the roosters and chickens—it all makes me so happy. This morning I walked to the Gartenberg, sat myself down (on my sketchbook) so that I couldn't see the Villa Mackensen, and had another glorious hour by myself. We are having wonderful weather—

Well, Elsbeth did get her cold after all. I'm keeping her in the house, giving her Kurt's medicine, and wrapping her throat at night. I hope it passes soon. The papers from the Berlin Secession have arrived.

Now farewell my dear, dear, dear. I wonder how you are and when you will be coming back to

Your little Wife

You will be amazed at how the past two days have made the world magically green—

My many greetings to your family in Münster.

Worpswede, April 15, 1904

Dear Sister,

My husband has gone to Münster to be there for his father's birthday. And I have moved to the Brünjes' where I am playing Paula Becker. I have just now boiled up tea water on my little oil stove and am letting the soft spring night flow through all my windows and through all my pores into me. I've also brought along my copy of *Goethe's Correspondence with a Child;* when I am in a good mood, only a few pages of that book are needed to put me in an even better mood. And that's what happened to me today. I'm feeling so marvelous; half of me is still Paula Becker, and the other half is acting as if it were. No matter what, there was and there still is, a great portion of my happiness under this thatched roof. I have probably never in my whole life loved a house so much as this one.

Do you happen to know the *Bettina?* Along with Victor Hugo's *Notre Dame de Paris* it's my favorite modern book (modern in a very generous sense; I mean in comparison with the Bible, etc.). Spring is really coming here now. What that means for our souls is something you Italians down there can scarcely imagine. Just to feel that what one has been secretly starving for is about to come, this makes for the most blessed moments in life. But it's really not the possessing of these moments that makes one so joyous, as it is the moments which bring us to that point. Once here, it brings new duties and new desires. Perhaps one can also apply this to the spring, but perhaps that's not a good comparison. In any case, this spring is coming suddenly and sweetly and gloriously after long, stubborn, stormy days, and a little person like myself opens up her arms and heart and tries to catch as much of it as she can—I'm not a person to just sit by the lamplight. Of course, I can put up with a few more days like today when I sit and write by the lamp, but all the windows are open and one does have the feeling that Creation is gently rustling outside. This sweet rustling is then sliced in two by the barking of a dog or by the poignant waltz tune which the swelling heart of a farmer boy whistles into the still of the night—only an hour ago Nature was playing the flute through the robin and the blackbird. And in four days the nightingales will be singing, singing, singing, for they arrive on the twentieth. But by then I shall probably have already left these dear, dear bachelor's quarters. It's so strange, I am happy almost every time Otto and I are apart. One has the rare pleasure to look at oneself and each other from a distance, mentally; and then one can look forward to getting back together again, and in the meantime we can also write letters to each other occasionally. And I can also do certain things now that I can't do when Otto is around. For example, this noon I ordered up for myself cold rice and cold apple compote. And tomorrow there will be *Bierkaltschale,* all the things that I really childishly enjoy but are not nearly enough to keep Otto alive. As you can see I'm having a little noonday festival at home with my Elsbeth—and she's another thing that Paula Becker never had in her life.

—And you are in Florence. I've only read one letter so far, the first one you wrote from there. It seems to me that you are having a beautiful time. Rich and full of impressions. I can imagine that the language alone, which you are so good at, is ecstasy for you. And you must also be seeing many adorable and interesting people and much art. Go past Böcklin's villa sometime. And can't you also manage to visit Hildebrand's atelier through your connection with Römer? And can you possibly send me, as a "sample without commercial value," a piece of a lemon branch? They smell so wonderful. When Mother was in Italy she sent me such wonderful fruit that their fragrance is still completely alive in my memory.

I greet you warmly. *Auf Wiedersehn.*

Your sister Paula

*To Marie Hill

Worpswede, April 30, 1904

My dear Aunt Marie,

...I've been trying to imagine what it is like to be where you are now. I can imagine you now as the spiritual and physical center of a very large circle of people. Your birthday will become a general festivity at which each of your disciples, male and female, will take turns demonstrating his or her love for you. I wonder if you will all go on a little excursion in the countryside? I suppose everything is in blossom there. It must be wonderful in the orchards now.

Spring comes a little later to us than it does to you, but even here it is already miraculous. The birch trees are putting on their tender green veils and on the ground are cushions of white, star-shaped anemones. And then the pussy willows. Each time it happens it is so new to me, and each time it fills me with a happiness that I had completely forgotten. Right outside our bedroom window the starlings jabber in the morning and a redstart has also built a nest under the eaves.

Otto has returned from a four-day visit in Münster with his parents. While he was gone I played the role of Paula Becker and slept under the thatched roof in my little white bed. I had such fun. At night I heard the cows rattling their chains in their stalls, just the way they used to. And in the morning the clucking chickens woke us up. At noontime I went home for a visit and ordered all kinds of silly little things to eat.

Another game we play here now is dancing à la Duncan, Herma, Frau Vogeler, and I. It's such great fun. We are practicing all kinds of steps. Mother is a most enthusiastic spectator. Otto once used to play the flute but he pawned it when he was in need of cash. We have instructed him to devote his earnest attention to this instrument again so that he can accompany our dancing. He's grumbling about it, still. About playing the flute, I mean.

And yesterday I heard the first nightingale. [...]

1904

July 2 to 5 with Paula and the Vogelers in Fischerhude. Stayed at Berkelmann's; Paula's bed collapsed. Rowing boats, children swimming. Milly and Kurt are coming out. Swimming in the Pastorensee near Otterstedt; back by way of Bremen.

July 7 to 18 to Berlin, Dresden, Kassel, Braunschweig. In Berlin we visited the Wintergarten and the zoo. While we were in Dresden the weather was very hot and the Elbe was almost dried up; stayed in the home of Uncle Arthur. We visited him at the White Stag. Made tours to the Sächsische Schweiz, to the Bastei, etc., with the mail coach to Kipsdorf, to Lauenstein, where Paula's grandmother and Aunt Friedchen (her daughter) live.

July 30 to 31 we were back in Fischerhude. Herma and Moilliet were there. Great bathing parties with Herma, Paula, Heinrich Vogeler, and Moilliet, Frau Rohland senior. Afterward, breakfast in the nude (Frau Vogeler was not present); walked back over the Grasberg with Heinrich Vogeler; big quarrel between H[einrich] V[ogeler] and Paula.

To Herma Becker

Worpswede, December 24, 1904
Christmas Eve

My dear Herma,

Your thoughts about everything were quite correct. We did sit together in the arbor on the little brown settee and read your long-awaited letter, which I had kept hidden until then from Red; otherwise he would have opened it earlier. And so we read it together and from Elsbeth's "sample without commercial value" there came forth these *Nouveauté de Paris* knife and fork, the little bowling game, and for me that dream in rosy gray silk. All of us were so pleased in our own way—but more than anything we're happy that Paris is so enriching for you, even if your purse is limp and empty. What would make me happiest of all is if it were granted to the two of us to enjoy that beautiful city together before you return. I have strong hopes of arriving there at the beginning of February. Otto, to be sure, has not given me a definite yes about this; but he certainly is noticing that I have such great longings for my city that one cannot possibly put up a barrier against them. And also, this is the way my marriage is now: in many little things I give in, and it's not very hard for me to do that; but in a few big things I could almost not give in even if I really wanted to. And in this case, naturally, I don't want to give in. This winter—which hasn't even been much of a winter yet—has been a bad time for my work; in fact, I haven't gotten anything done. For that reason it's a very appropriate time to get a little stimulation from the outside. And that's really what I'm living for right now. In your letter you write some mystical words about an uncertain plan for Nice, if one only had some money in this world, and naturally I won't be getting very much

either. Well, we will have to wait and see how everything turns out. And above all, don't go to that pastor's family of yours in Bordeaux before I arrive, and even then don't go unless it's absolutely necessary.

I'm sure that Mother has given you all our news — the Duncan evening which we enjoyed again in our Olympian way. Otto is again frightfully deep into things, all taken up with the construction of a new "Ideal"; he always carries the notebook about with him and adds a little word here and there; even on Christmas evening he kept taking it out of his pocket constantly. He exhibited nine paintings in Bremen. The people there act very lukewarm about his art. He received two paltry offers from people who were prepared to pay half of what Otto was asking. At first we were outraged, and said no, but then we began to feel that a bird in the hand is worth two in the bush. No, we'll just have to wait and see what happens. Frau Overbeck is back again but must continue her convalescence. I believe that things are not very much better with her; her lonely recuperation puts her in a depressed mood. Other than that, Mackensen is still in Constantinople, and old T., Frau Rohland's friend who is seventy-five and whose heirs could hardly wait for him to die, has taken a wife and just a few days ago became the father of twins. And then, Rilke's back in the country again according to the newspapers — And one cannot even talk about the possibility of skating or sledding so far. Our weather keeps gently changing between March and April — Do you know where my amethyst beads have gotten to? I brought them home to the city, together with a pair of silk stockings, so a choice could be made for your birthday. Mother is coming this evening, the siblings tomorrow, and the day after tomorrow, alas, we have to go to Münster for a few days. And then I hope to be able to work a little bit again, and how I look forward to that; for when one has done nothing for such a long time, one really is starved for activity.

I received a very beautiful present from Otto. He's having a copy made of the little cupboard at Berkelmann's in Fischerhude; a local cabinetmaker is doing it. In addition, we are turning our dining room into a library, and the door connecting the guest room with the kitchen will be walled up, and the bed will have a canopy. We think all of that will be very beautiful, and we've also seen a big grandfather's clock at the antique dealer's; Adam and Eve are eating an apple a minute on its face — it's become the object of our desire. And we also have an aquarium now, enlivened by a crab, a carp, a bouncy and energetic white dace; and there is a goldfish bowl with four charming occupants, and a tree frog couple. Most of that Otto got from me for Christmas together with a fox fur cap, which he is christening today. A big magic box arrived from Hauptmann full of wonders, filled with splendid old plates and remarkable, comical pictures. Milly has bestowed upon me a wonderful copper kettle for the stove. You can see that things are getting more and more beautiful here at our place. And so I remain

Your sister Paula Modersohn

You must arrange some kind of fun for yourself with our ten marks, perhaps just staying there a few days longer.

To Herma Becker

Worpswede, January 2, 1905

Dear Herma,

A very short and sweet letter to you just to ask you how things stand now. I could probably come as early as the fifteenth of January, and with my money we could probably arrange things so that we could have a fortnight together there. However, I would prefer to come the beginning of February and that way my stay would get just a touch more of the Parisian spring, because by that time the days are no longer quite so dark and also because it seems we are about to have the most glorious skating-ground which I would like to enjoy before I go. I also have something like a skating tour to Amsterdam in mind, and then I could leave from there for Paris. I hope it isn't all a dream—so then, please let me know what you think. If we only knew of some source that would make it possible for you to stay somewhat longer in Paris. What about your Rohland Foundation; isn't it just about time for a little [money] from them again? I believe that we will enjoy it very much and in any case something must come of it. And I'm also completely of your opinion that we must put our youth to good use. Later, as elderly ladies, we can play some other sport—or even the same one.

Hauptmann has invited us to slide down the Riesengebirge on sleds with him. Maybe another year. This year my soul cries out for Paris.

And Milly's engagement—how lovely, how lovely, how lovely.

So, write me by return mail. Can't you find any little French people at all thirsty for knowledge whom you could drill in our beloved German mother tongue?

And so, *adieu* and *auf Wiedersehn*.

Your Paula

To Martha and Carl Hauptmann

Worpswede, January 3, 1905

Dear Dr. Hauptmanns,

That was another wonderful Christmas sitting there in that big box from you. Where did you find all these splendid things? After we had unpacked and set everything up the whole room looked simply beautiful. The caps and the pretty plates, the beautiful drinking glass and the *King of Italy with His Consort.* You made such a beautiful selection and everything fits in so well, and you have made us very happy with your friendly remembrances. Otto has probably already written you all of that, and I would have, too, if we hadn't taken a trip right after Christmas to see Otto's parents in Münster. Now we're very happy to be home again in our lit-

tle house. Winter arrived just as we got back. All the canals are full of sparkling ice and I have just now been skating along through that world, with the thatched roofs and the birches dancing past me. Elsbeth also received a pair of skates this winter and is supposed to try out the ice. Right now she pictures it as something very beautiful and has no idea that the whole thing is not nearly so easy as it looks. Dear Frau Hauptmann, her magic yarn ball was filled with such imagination. Now Elsbeth is sitting busily knitting her first washcloth, but out of curiosity she has already discovered the calendar and picked it out of the ball with her sharp little fingers; but to soften my look of reproach and to cancel her sin with a good deed, she immediately decided to give the calendar to her father for Christmas. Our holiday was wonderful and our Christmas room, which we kept quite cool while we were away, has stayed fresh longer this year than others. We always make a bower of Christmas greenery and I like to sit in it rolled up in a ball and read my Christmas books—

— And now we are to take a trip to see your snow and your magnificent Silesian winter? I think that will be another wonderful experience for me. Winter is so fine, and here where we live it never really reaches a point of perfection. We're too close to the sea. But just think, I am hungry for Paris this winter. I want to be right in the midst of life for a few months so I can see and hear everything. I'm still too young to have to sit here forever. That will be very beautiful for me; Paris is *my* city. Beautiful and bubbling and fermenting and one can dive right down into it. —And for me to be able to combine both of these, Schreiberhau and Paris, cannot be arranged either. We don't live that way these days; we do only one thing at a time and then let it go on working inside us. I hope you will feel how *very* much I would like to come for a visit, only right now I need something else. I don't know whether Otto will be coming to you alone. We haven't spoken about that yet, but I hardly think so. It's very difficult for him to make up his mind to take a trip without me.

And now I wish you many more good things for the New Year, many accomplishments and much satisfaction. As for me, I hope each year will bring me a little more ability to express myself in my art.

I am happy that the two of you are so dear to us. I am

Your Paula Modersohn

[Dictated by Elsbeth]
Dear Aunt Hauptmann, The magic yarn ball is beautiful. I have already begun to make something with it. I've already knitted a square. I thank you many times for the beautiful magic yarn ball. Is there also a party favor in it? I got a kitchen for Christmas and I have already cooked something lovely. I also got a beautiful Christmas tree. I also got a schoolbag, there are two pencil boxes in it, there are also slate pencils in them. I was in the cathedral in Münster. I also send you greetings. Come back sometime again soon.

Your little Elsbeth Modersohn

To Herma Becker
[Appended to a letter from Elsbeth]
<div align="right">Worpswede, January 11, 1905</div>

Dear Herma, It will be a long while before there is any chance of a skating tour to Amsterdam. The weather here is perfectly awful; there was a little snow yesterday, but today it's all gone again. I believe that you are colder in Paris than we are here. I'll wait until January is up and then, *auf Wiedersehn*.
<div align="right">Your Paula</div>

**To Marie Hill*
<div align="right">Worpswede, January 13, 1905</div>

My dear Aunt Marie,
[...] winter simply refuses to come this year. We have had nothing but spring weather, either violent spring storms or gentle spring rain or mild spring sunshine. I can't get used to this confusion of seasons. I yearn to do some sensible skating and pump my lungs full of pure air. On the other hand, Otto is content in any kind of weather and so he's better off, as far as that goes. Did I write you from Bremen that I shall probably go to Paris at the end of January? I look forward to it tremendously. My inner thoughts are really always headed in that direction. It is odd that from time to time I feel such a huge desire to go back to Paris. I think it must be that our life here is made up mostly of purely inner experiences, and so one frequently has a powerful desire to be surrounded by external, active life from which one can always escape if one has a mind to. [...]

To Clara Rilke-Westhoff
<div align="right">Worpswede, January 29, 1905</div>

Dear Clara Rilke,
Here is the Brandes book back; thank your husband for it. I did not want to send the two Millets and the Cottet; perhaps you could take them along with you at some convenient time. Would you send the Bojers' address to me in Paris, 29, rue Cassette? —Such rain after the beautiful ice!
 Looking forward to seeing the two of you again.
<div align="right">Your Paula Modersohn</div>

To Herma Becker

Worpswede, February 9, 1905

Dear Herma,

I am counting the days. And two weeks seem to me to be a very long time, but I'm beginning to notice that they are drawing to an end. And you can just imagine how happy I am, and how I look forward to seeing you, so that I can talk over your life with you and enjoy things with you. The big Worpswede get-together in April seems to me, just as it does to you, too beautiful ever to come true. The first big danger that I can see so far is that every person who hears about this trip already wants to go along. We have received all kinds of offers which we must cleverly shunt aside, and that is going to be very difficult. For example, Otto's brother Willy and his wife, who would not fit into our circle at all — well, we'll have to just wait and see about all of that. The most immediately important thing in my world view, of course, is that a certain Paula Modersohn remove herself to Paris during the night from Tuesday to Wednesday, where she intends to fling herself into your arms at the booth of the ticket puncher on Wednesday. In case you should not recognize me, let me tell you in advance that I shall be wearing a gray jacket and a riding hat on my head, which most of the people here cannot stand; but I have very great hopes for your good taste —

I thank you very much for your birthday letter. In reading it I had a powerful sense of that expectant atmosphere before the Concert Colonne begins which I experienced many times when I was there. In fact, I can't even begin to tell you how I look forward to it all; even though I must say in advance that I have to get used to things again, and at first I will not be quite so ambitious. The only unfortunate thing is the enormous distance that separates our lodgings there, but we must somehow cleverly bridge it. Any news I have to tell you I shall save up for an oral report. I shall be living at 29, rue Cassette, very close to the Luxembourg. Red is very apprehensive this time about our separation; his thinking about it is worse than he will actually feel when it happens. And the reunion afterward will be all the more beautiful. I'm curious whether you have possibly gotten to know something in Paris that I don't know myself yet? Imagine, I have actually never yet been in the Bois [de Boulogne]. In fact, I tend to avoid the whole western part of the city.

And now *auf Wiedersehn* in love and in joy.

Your Paula

1905–1907

On February 14, 1905, Paula Modersohn left for Paris for the third time. Frau Becker was entrusted with the care of those who stayed at home. This time Paula's stay in Paris was heightened by the fact that she was frequently together with her sister Herma, whose alert intelligence matched Paula's. Herma had earned her *Abitur* in October 1904, and was preparing for advanced study of the French language by taking on au pair positions in Paris. Apart from small stipends Herma was obliged to earn her way and attain her goal through her own efforts, a quite different situation from that of her sister Paula.

As before, Paula Modersohn had to go through a period of adjustment to her change of scene, but one can sense from the letters with what great pleasure she threw herself into the life of Paris. This was especially true during *carneval*, which she celebrated with her sister. At home, Otto Modersohn was even made a little jealous by reports of a small flirtation. She worked very assiduously, spent time with her sketchbooks in museums and exhibitions, captured in drawings what she saw on the streets — but this time one learns from her letters less about art than formerly, for enjoyment of life in the great city dominates her letters home.

She was introduced to the Norwegian writer Johan Bojer through Rilke; she found Bojer's wife Ellen particularly sympathetic and cultivated the relationship.

In the midst of the pleasures of Paris the news of the serious illness of Otto's mother reached her; soon after, she was informed of her death on the eighth of March. Paula Modersohn felt very close to her husband, but she never sought out an intimate connection with members of his family. With the exception of her own family, she permitted very few people to get close to her. And in Paris she was so caught up with a strong impulse for life and activity that, although she did offer to return home for the funeral, she was easily convinced by Otto to remain there. She wished that he would come to her in Paris; she wished that he could take part in the vibrant life there; she wanted to show him the landscape that made her rejoice, and wanted to share with him something of the buoyancy she felt there. And she probably hoped as the result of such a reunion that she would have the child she so longed for — many things in the letters point to that.

Her husband gave in to her wishes and came, together with Milly Becker and three Vogelers. But the great pleasure she expected in being together with them did not materialize. It was asking too much of Otto Modersohn to think that he would be able to shift his mood suddenly to a festive one so soon after the death of his mother. Their temperaments and their moods at this time were very far apart. It would appear, however, that Paula Modersohn got over this disappointment easily, and her husband eventually managed to do the same. But it is also quite possible that this break in the relationship never again healed completely. Even after

their return to Worpswede Paula expressed her desire and her intention to continue trips to Paris "as a completion of my somewhat one-sided life here" (April 11, 1905). Otto Modersohn's suspicion that Worpswede was not enough for her was indeed justified. She had long since gotten over his misgivings about the great city of Paris, which fundamentally had less to do with the city itself than it did with her financial dependency on others while she was there. Paula's way of ensuring that she would have enough energy for the one great task of her life, her art, was to avoid whenever possible such constraints on her freedom. In Paris she never really thought of the noise, the congestion of people on the streets, the great masses of buildings as an unbearable burden, for when she was there she was free of daily obligations to others, free to follow only the demands of her own artistic and personal development.

Her 1905 stay there remains longer than usual in her thoughts and in her letters to her sister Herma after the return to Worpswede; she asks her to send catalogues and magazines and asks about exhibitions. All of that was for the purpose of constantly remaining in touch with the Parisian art world. After the return her chief interest was in Gauguin. She and Otto, according to the latter's journal, had had the opportunity of seeing the great Gauguin collection of Fayet. They had also visited the massive exhibition of the Artistes Indépendants, which contained a Seurat retrospective with forty-four paintings, forty-five paintings by van Gogh, and also eight important Matisses. These encounters left visible traces in Paula Modersohn's work.

Otto Modersohn realized that he had to do something about the monotony of life in Worpswede. At his suggestion, the two of them, accompanied by Heinrich Vogeler, took a trip of several days to Westphalia in early November 1905. For Paula the high point of the little trip was the visit to Karl Ernst Osthaus's Folkwang Museum in Hagen, that seminal collection-point of works from the most modern art movements and one in which Osthaus had invested his entire fortune. If Paula could have had her wishes she would have lived among people like the Osthauses, exchanging thoughts with them and being close to such a center of modern art. Instead, "hibernation" in Worpswede was awaiting her. Paula Modersohn was evidently no longer prepared or no longer in a position to mount any opposition to this. It may be that at home with her husband she suppressed this beckoning call to the great world outside; but with her friend Clara who was again living nearby, mostly without Rilke and consequently completely available to her again, she made no attempt to conceal these longings. Rilke came to visit his family in Worpswede just before Christmas, and now, probably for the first time, he looked at Paula Modersohn's paintings. They surprised him, impressed him, and he said things about them which did her good. With the right word at the right moment the old friendship was renewed and on a higher plane than before. Paula discussed with the two of them her plans to leave Worpswede for an extended period, and probably also of her thoughts about separating from Otto

Modersohn and freeing herself for the sake of her art. Rilke, who was convinced that this step was necessary for the development of her powers, offered his assistance in Paris and together with his wife also helped her out on an immediate and practical level by buying one of her paintings.

The negative judgments about his wife's work that surface now and then in Otto's journals are always counterbalanced after a few days by expressions of approval. But Paula Modersohn-Becker's plans and intentions no longer had much to do with occasional misunderstandings or indeed even a total lack of understanding between herself and her husband. What was at stake for her was to get back to her own self and to her painting. In order to do that she had set her thirtieth birthday as a goal, and no power was strong enough to deflect her will from that goal. Once before, in September, 1899, she had written her parents, "But devotion to art also involves something unselfish. Some people give their lives to others and some give their lives to an idea." She had committed herself to the idea, to art.

Paula was happy to accept Carl Hauptmann's invitation to Schreiberhau as a diversion before taking her decisive step. The circle of stimulating people she met there had the usual vitalizing effect on her, and the sparkling personality of the sociologist Werner Sombart in particular attracted her. He, like the Modersohns, was a guest of the Hauptmanns. Otto's journal also notes his happy agreement with the plans to visit Schrieberhau, and Dresden and Berlin afterward; there is not the slightest suggestion of any bad feeling between himself and his wife.

Nevertheless, after their return home Paula went ahead with preparations for her departure — a departure forever. She took her own personal effects to her beloved little room at the Brünjes'. Her husband seems to have noticed nothing about these preparations. She spent February 8, her thirtieth birthday, with Otto and Elsbeth. During the night after her husband's birthday on February 23, 1906, she left. The reason for the delay was her mother's and brother's trip to Italy. She wanted them to be en route so that they would not give up their plans in order to remain and act as intermediaries in this affair.

For Otto Modersohn such an inexorable and uncompromising action was a blow that he could scarcely bear. He was thrown totally off balance and directed all the means at his disposal to win back his wife.

Paula's situation in Paris was just as difficult as his at home, especially since her beloved sister Herma, whom she met there, took Otto's side. Even though her mother after the return from Italy reacted in a measured and intelligent way to what had happened, it is more than clear during these months of crisis how distant the entire family was to Paula's struggle for her development as an artist and how little they understood her work. Indeed, the disappointment at the breakup of a period of happiness which had bathed all of her family in its reflected glow even caused them to be unjust to Paula as a person. They found the tone of her letters to be "too smiling," that is to say, frivolous. All their efforts were directed toward the resurrection of the old arrangement. Otto could be assured of the whole-

hearted support of all the Beckers in his struggle to regain his wife. They pitied him as the victim of Paula's egotism and saw him a martyr to her whims. Only her cousin Maidli Parizot-Stilling steadfastly refused to let herself be swayed: "... must not all of us who love Paula and have always known her to be a fine, proud, good person, must we not dare this leap of faith and believe in her, no matter what? Must we not believe that despite how ugly things may appear there are perhaps very beautiful and noble hidden motives, and a suffering and despairing heart? Do not let yourselves be misled by a smiling facade...."

Paula Modersohn intended to justify her decision through hard work. Like a beginner she enrolled in drawing classes in an attempt to overcome the shortcomings that she was constantly accused of. She had mustered sufficient self-confidence to risk this step toward freedom, but deep inside her there was insecurity about herself and her art, and this had to be overcome through positive action. This impetus came in the middle of April 1906, when she visited the sculptor Bernhard Hoetger, whose work had impressed her when she had seen it a year before in Bremen and now again in Paris at the Salon des Indépendants. A little journey with Herma to Saint-Malo (paid for by a gift of money from Otto) temporarily interrupted this new acquaintanceship, but it was taken up again at the end of April or the beginning of May. In his cursory notes about his first meeting with Paula Modersohn, Hoetger writes that she concealed the fact she was a painter. Only a chance remark by her revealed the truth, whereupon he insisted on seeing her paintings. He was surprised at her talent and encouraged her to continue following her own path. Recognition by an artist whom she admired had the effect on her of a sudden spring shower on parched ground and released a veritable orgy of production. Her gratitude to the person who had guided her to her own freedom was unlimited. In the weeks following, she painted the portraits of Hoetger's wife and of Rilke.

Rilke had come to her aid with encouragement and attentiveness; he often invited her to eat with him and take little trips—to Chantilly, for example, with the Bojers and Ellen Key. In his company she took part in the unveiling ceremonies in front of the Panthéon on April 22, 1906, for Rodin's *The Thinker;* also present on this occasion were the sculptor Artistide Maillol and the wife of George Bernard Shaw. This may not have been the first time that Paula met Maillol personally, an artist whose work was not without influence on her own. Except for happiness in her work, Paula's situation in Paris grew progressively more painful, for she constantly had to write her husband, from whom she wished to be separated, for money simply in order to live. She felt humiliated by this but she could find no other way out. For the first time in her life there was no way around the necessity of earning money herself if she wanted to maintain her freedom.

At Whitsuntide (March 6, 1906) Otto Modersohn came to Paris to talk things out with his wife, and they agreed that he should return there in the fall and stay for an extended period in order to find out whether a life together was once more possible. On the third of September she asked Otto to give up that plan, saying in

the strongest possible terms that she wanted to remain by herself—and on the ninth she changed her mind again, saying to both Otto and her sister Milly that Hoetger was the one who had advised her to make this final decision. Hoetger very likely realized that Paula was in no position to earn money and that without the presence and willingness of a third party to provide for her, she would not survive mentally or physically. She was not ready to give up her art, even for short periods, in order to be practical. And so they arrived at an understanding and decided to spend the winter of 1906–7 in Paris. Only for a brief Christmas holiday did the two of them go to Bremen to visit her mother and the child Elsbeth who had been under the care of Frau Becker during this entire period.

Even before the critical summer months of 1906 Otto Modersohn took pains to see that his wife's art was exhibited. His first attempt was a failure, as we may gather from a letter of Fritz Overbeck to Modersohn on the second of January of that year. The jury, probably members of the Northwest German Artists' Association to which Overbeck belonged, refused Paula's painting *Still Life with Apples* as being "too closely imitative of Cézanne." Later that summer Paula herself suggested that four of her canvases be offered to an exhibition of the Worpsweders, which was to be shown in Bremen in November and then later at Gurlitt's in Berlin; they were *Still Life with the Bambino, Still Life with Apples, The Sleeping Child,* and *Head of a Girl with Black Hat.* Gustav Pauli, the director of the Bremen Kunsthalle, wrote something of an introduction to this exhibition for the *Bremer Nachrichten.* In it he solicited understanding for Paula Modersohn's art, and thus Pauli's article functioned as a form of compensation for the injustice that had been done to her in 1899 by Fitger's attack in the same newspaper.

Pauli's intervention smoothed the way for Paula's return. In March when the long-awaited news of Paula's pregnancy reached her mother in Bremen, Paula herself now yearned to go back to Worpswede. What now kept her together with Otto Modersohn was no longer the great love of the early days of their marriage or the happiness that we have seen in her letters from Paris in 1903; it was a new relationship built upon a mutual understanding to which both partners contributed.

Her final great impressions before leaving Paris were of the paintings of Cézanne in the Pellerin Collection. In October 1907 Paula thought longingly of the great exhibition of Cézanne's paintings that was then being shown in Paris. Rilke's letters from Paris about Cézanne, which Clara sent to her, were among the very last things Paula ever read.

On November 2, 1907, a daughter was born, and faithful to Becker tradition she received the name of the grandmother, Mathilde. As was customary at that time an extended period of bed rest was prescribed for the mother. What then happened on November 20 was written down by Clara Rilke following Otto Modersohn's description of Paula's sudden death:

"Paula was given permission to get out of bed and happily prepared herself for

this occasion. She had a large mirror placed at the foot of her bed and combed her beautiful hair, braided it, and wound the braids into a crown around her head. She pinned roses which someone had sent her to her dressing gown and when her husband and brother were preparing to support her on either side, she gently walked ahead of them into the other room. There, candles had been lighted everywhere in the chandelier, on a garland of candle holders around the body of a carved baroque angel, and in many other places. She then asked for her child to be brought to her. When this was done she said, 'Now it is almost as beautiful as Christmas.' Then suddenly she had to elevate her foot—and when they came to help her she said only, 'A pity.'"

To Otto Modersohn
[Postcard]

February 15, 1905

Dans Aix-la-Chapelle
Je suis très fidèle
De Herbesthal
Des baisers sonder Zahl
À Verviers
Encore un baiser
De Liège à Namur
Je pense an das Tantengetier.
à Charleroy
an die Grossmama,
à Paris
freu ich mich wie noch nie.
Je suis la tienne
Ta petite parisienne
Avec son chapeau rond
Elle va voir la [sic] monde
Avec un chapeau gris
Sans soucis.

[Second postcard]

February 15, 1905

D. O. Je suis à Paris. Enfin, mais je n'ai pas vu notre petite Herma malgré mon télégram et je n'ai pas ma jolie petite chambre rue Cassette, qui a la vue sur le jardin. Demain nous verrons. Maintenant je pense de faire un bon someil. Mille choses pour vous trois.

votre P.

To Otto Modersohn

Paris, 29, rue Cassette
February 16, 1905

Dear Otto,
You know, I am always unhappy when I first get here—and that's the way I feel now. This big city still gets on my nerves, but most of all, things aren't in order yet

in the rue Cassette, my quiet haven. Sad to say, my pretty room with the view of the garden and the tree is occupied. I have a little, uncomfortable room, and I haven't quite made up my mind yet whether to move out or not. This morning I'll visit Herma. Her job seems to be a really nice one. She has great freedom, can take long walks with her girls, etc., so that we will probably be able to see each other frequently. Herma looks well and is very content in her work. In May she will be taking a trip with her employers for a month to Avignon where the older members of the family live. The people are very well-to-do and aren't at all the type to expect Herma to be dressed to the nines all the time. She's in a very good mood, and tomorrow evening she is coming to have tea with me. At the Luxembourg I was happy to see that Cottet's triptych is still for me his *great* thing. It's the one you know, too. And then there was a 1904 portrait by Roll; very interesting in its treatment of flesh, but not successful as a picture. Incidentally, Meier-Gräfe is right when he complains that the Luxembourg's new acquisitions are not always what they should be—

Greetings to the three of you. I'm writing this letter just so you can read my mood, which is still somewhat below the freezing point, even though it's so warm outside that the pussy willows are in blossom.

Friday [February 17, 1905]

My mood is still in a somewhat minor key, and I can't get around to doing anything yet; I am depressed by many things, but mostly because I haven't got a sensible place to live. When I try to picture you, it's as if I were looking through fog, as if into another life. I hope the weather will be good by your birthday. Tell Mother that a birthday package for you will be arriving and that she is supposed to sit on it to keep it warm until the festive day. I'm expecting Herma for tea and I have set my little table *à la française*. Farewell, my dear Redbeard. I'll send you a better letter soon.

Your little Paula with the — — —

Please send me as a "sample without value" the oilskin bag. It's in the chest next to the stove.

To Otto Modersohn

Paris, 29, rue Cassette
February 19, 1905, Sunday Evening

My dear Husband,

Now I will write you my birthday letter. I am with you, together with all my hopes for art and life, and life and art. Enclosed are a couple of amusing Daumiers and a

little Japanese picture book. I wish I could send you larger and prettier things, but I'll have to wait a few years for that until you, or I, or the two of us, will have saved up enough golden sovereigns. I hope that the old copy of *The Arabian Nights* also got to you from Nuremberg, and I hope you like it. If you don't, it can easily be exchanged—I wonder how you are spending your birthday? I hope the weather is nice. Is there still snow on the ground? If Mother plans to make you a punch, she will find pineapple in the wine cupboard—

I am still here in my little cage in the rue Cassette and that's why I don't feel very cozy. Tomorrow I'm moving to 65, rue Madame, sixth floor, where I shall have the great sky above me and Paris at my feet, both of which will be nice. Here, all I have to look at is a wall and that does not make my Worpswede soul rejoice. The new apartment is not very far from here. Today Herma and I took an all-day trip to the country and had lunch under an arbor in the sunshine. We had a lovely time together. The landscape still fills me with enthusiasm, with its bits of ruins of earlier grandeur here and there and with the view of the great city from the hills. The farms and the haystacks are very reminiscent of Millet. When we returned, we fixed a lovely tea and ate bread and butter and preserves and had a bouquet of pussy willows and coltsfoot, which is now already in blossom, here on the table—

I have registered at the Académie Julian for a month's session in life drawing, from eight to eleven each day. Since the museums are never open until ten o'clock, I won't waste my mornings this way, and it's not going to hurt me in any case. It seems the Académie Cola Rossi, where I used to be, went to the dogs soon after I left. Maybe that's why it did. Julian has an added advantage. There aren't so terribly many of those loud Englishwomen there, whose commanding presence I really don't care for very much.

I believe that Aunt Cora has altogether false notions about England. And there is also what Herma has heard from the little governesses who have had a peek behind the English scenes—the people who are so good and pious in the presence of others but have their whiskey bottles in their bedrooms. Herma's position can be seen as an especially favorable one; there are some au pair positions to be had here in which one can be very exploited. Several of her acquaintances have gotten into highly improper households, and that can't be very pleasant for them. In her new job she is still permitted to take her two previous girls for walks, so that she can continue to have that little extra bit of pocket money—I'm not ready to write you about any other experiences because I haven't yet become acclimated; and that won't happen until my living arrangements are in order.

I give you a tender kiss and say good night to you.

Greetings to Mother and *ma petite fillette.*

<div style="text-align: right;">

With love
Your little Wife
qui t'aime avec tout son coeur

</div>

Could you please send me my birth certificate or some other legal certification of my right to exist? Can Frau Vogeler perhaps locate at the hospital the address of the Munsees from Heudorf; and can Milly perhaps see whether that might result in something for us?

Herma and I will be celebrating your birthday together.

To Otto Modersohn

Paris, 65, rue Madame
February 23, 1905

My dear King,

I have just finished my supper, have put away all my pots and pans, and am now sitting surrounded by flowers under a sweet little lampshade at the fireplace. Now that sounds different from my first letter, doesn't it, and it is, too.

I finally left my little prison in the rue Cassette and am now enjoying light and air and space on the sixth floor on the rue Madame. Pretty soon I shall be adjusted to my new surroundings. I've already had some lovely moments and can tell now that I'm back in Paris. Here is something that will amuse you and the family. My *petit chapeau gris* was a "flop." Paris, which can (and must) put up with so much else, could not put up with my little hat. Everyone stared or laughed at me. Even the coachmen shouted witty remarks at me as they drove by. It was right between noon and one o'clock when all the little shopgirls and apprentices were standing around in clusters on the street. I was pursued by gales of laughter. At Durand-Ruel I heard the *portier* whisper to someone, "She's an anarchist." Finally I fled to the rear of an omnibus where only relatively few eyes could observe me. I rode as far as the Bon-marché and there I bought a *chapeau* which people can now accept, but which I, naturally, cannot endure. I was so proud of my *petit chapeau gris,* and now the wicked world forces me to pack it up and put it away.

People in general are terribly flippant here. In the atelier, too. The girls keep glancing at each other and giggling like children. There is something thoroughly childlike about these people. They love to squabble. And immediately afterward they make up. They can chatter as much as Elsbeth, so much that their mouths never seem to shut. And they have such a preference for the naive and for life's pleasantries, and so on, and so on. Then again they can be as helpful as the Good Samaritan. For example, as I was walking along the street today my paint box opened up and every tube of paint tumbled in a different direction. Suddenly there was a lady beside me, helping me pick everything up, despite snow and dirt everywhere. Many people here would do the same.

It is very comical at the atelier. Nothing but Frenchwomen, who are very amusing. Yet I'm still very afraid of them because they laugh so easily. They paint the same way they did a century ago. It's as if they hadn't seen anything that has been done since Courbet. And most of them don't know anything about it either; they

Men, women, and children among trees, Paris, 1905–6

go only to the exhibitions for the Prix de Rome and what is there is probably the same sort of rubbish, maybe of a slightly higher quality. But I've found a kind of canvas here which I'm sure will become my absolute favorite. The other students study my painting very skeptically and during recess, when I have left my easel, they stand in front of it six deep and discuss it heatedly. A Russian girl asked me whether I really see things that way, the way I paint them, and who on earth taught me that? And so I lied and said proudly, "Mon mari." Suddenly it dawned on her and she said, enlightened, "Aha, so you paint the way your husband paints." They don't seem to conceive of the possibility that someone can paint the way one sees things for oneself. But I'm very happy that I put my morning hours to such good use and that painting on this (so far) wonderful canvas is a great pleasure. To celebrate your birthday yesterday I painted a still life here in my room. Oranges and lemons, very tempting. In the evening Herma and I went to a concert. The loveliest part was the overture to *The Magic Flute*. We had a good laugh at your cabaret-style letter and also about Lina's high jinks. Just keep on holding the reins tight, don't leave keys lying about, and do nail the window to the kitchen shut so that she doesn't hear every one of your conversations. I wanted to do it myself, but forgot. Then you write, "more about the other things later," which you shouldn't have done because now I'm racking my brains about what that could all mean, whether I did something wrong, etc. Did you get the two postcards I wrote

on the trip? I'm asking because I didn't mail them myself. Do have Marnken make some dear little birdhouses like the ones that Mailman Welbrock has hanging at his house. Tell Elsbeth that there are nothing but charming little girls with ringlets here for her and sweet to look at. And how is Mother? Is Lina keeping the little room warm for her?

And now, I am yours with my whole heart and thinking of your red beard here in this great city. And yet I'm still happy to be a little apart from you because things will be so much lovelier later. With all of her love here is a kiss from

<div align="right">Your little Wife</div>

When I arrived here it was spring, and now it's a late winter thaw with a little bit of snow.

To Herma Becker

<div align="right">[Postmarked Paris, February 24, 1905]</div>

D. H. I have just looked at the concert programs and they don't seem very tempting to me. At the Comédie-Française plays by Victor Hugo will be put on in honor of his birthday; I would like to see them very much. One probably has to get tickets in advance. Please write me instantly whether you can come by and pick me up tomorrow morning if we are going to the theater in the evening; but perhaps it would be better not to do it until after lunch, at three o'clock. Today I visited the Bojers; they are very charming people, particularly the wife. They also gave me permission to bring you along sometime. Do you perhaps have a little box for flowers, "sample w.v."

<div align="right">Many greetings, Y. P.</div>

To Otto Modersohn

<div align="right">Paris, 65, rue Madame
February 28, 1905</div>

My Red-Rex,

I've just read your beautiful long letter through for the second time. I received it this morning just as I was leaving to go to the Louvre; what a beautiful beginning to my day. Things continue to be fine for me and I'm having some lovely experiences. On Friday I visited the Bojers, the Norwegian couple who are both writers; got their address from Rilke. I found her to be a fine and sympathetic woman, someone to whom I immediately felt humanly close. You know how happy I am whenever I find someone I like, since most people really don't matter much to me. She is so graceful, beautiful, and feminine and is completely open and honest. She expects her third child in the spring and is worried that it might be too much for

her husband and for herself. That's the way it goes; too fast for some, too slow for others. Her husband arrived just as I was leaving. He impressed me as being someone robust and healthy. He has a head of hair like a hedgehog. He asked me right off if I was also a vegetarian. Rilke's meatless diet seems to have gotten on his nerves. They gave me permission to bring Herma along sometime, so we have made plans to visit them on Thursday evening.

—Sunday evening the Théâtre-Français gave *Hernani* in honor of Victor Hugo's birthday, a play that ended in a terrible row when it first opened. How can that have been? It is something hard for us to imagine now. The play seemed to simply prance around on stilts. It was impossibly pompous. At the final curtain the "spirits of genius," one black and one white, appeared on either side of a bust of the poet. They recited several verses with exaggeraged rhetoric and sweeping gestures which seemed to captivate the audience. The people here are absolutely intoxicated with their own language! It is really remarkable—

On Monday evening we visited Mathilde Dörstling. She is a very nervous old spinster who chases around Paris all day long giving lessons just to earn her little bit of bread. When she had relaxed a bit she had a lot to tell us about Father. The two of them were young together. She was one of nine sisters. She showed us a little [picture of an] inn in the forest where Father had once invited her for coffee. And then she has an old picture, a painting of the Becker factory in Chemnitz; there is a house next to it where they lived, and she showed us the windows behind which Father and his brother lived when they came for a visit. They had a living room with nine windows, windows on three sides. I wonder what that really looked like? She has all kinds of antiques piled up around her and seems to be something of a sad antique herself. She had praise for the future of the human race because it has already developed the rapid underground *métro*. She said that she sometimes spent as much as five hours on the omnibus just to get to the places she gives lessons.

—Cottet now has a great exhibition of studies he did in Spain, Constantinople, and Africa. I prefer his Brittany to his countries in the south, and also I don't understand these southern colors because I'm not familiar with them—

—The butcher's bill? There's something wrong with all of that. I know nothing about it and have always forbidden having anything charged on credit. Ask Lina.

How glorious your postcard, dear fellow. Had a marvelous laugh at it and tacked it right up on my wall. "But Worpswede sits there in amazement," is splendid—

My room costs me 45 francs a month. It is very proper and has everything I need, above all a splendid, comfortable canopy bed, a wardrobe, table, chairs, fireplace, and two big French doors with a little balcony on which Herma and I love to sit. Even though it is not yet quite spring one already sits in unheated rooms. Many afternoons I go to drawing class. You must also go with me a few times, for there you will get to see a few naked models for a change—

Many thanks to Mother for her letter. Tell her I'll write in a few days. She had a

migraine. Just don't have too many festivities. Is Lina heating her room, too, so that it is nice and warm? Tell Mackensen I'm frightfully happy he wants to paint Elsbeth — and the little cupboard looked so lovely? Is it already painted? I'm so anxious to see it. Have you nailed the window between the dining room and kitchen shut? Please do it so that I can rest more easily. Now I have to get your letter to the post office quickly and then crawl into bed. When you come we will probably have to move into a room with two beds. This house is bigger and I shall be able to accommodate all kinds of people. I give you a kiss behind your ear and am your

<div align="right">Little Wife</div>

A sweet kiss to Elsbeth. Many greetings to Mother and Frau Vogeler. Don't pay the butcher's bill until I return.

To Otto Modersohn

<div align="right">Paris, 65, rue Madame, March 6, 1905</div>

My dear Husband, Otto, Red, Master Canvas-sizer,

I think this must be our first real spring evening here and it makes me feel very cheerful. The only reason I carried my fox muff today was to take it for a walk, but for the past few days I needed it to keep me warm. Like the other poor wretches, I would go into the Louvre and the Luxembourg and stand there, with my legs spread out over a heat register, and let the warmth rise up under my skirts.

We had a jolly foretaste of Mardi Gras last Sunday. We walked along the great boulevards where they were already enthusiastically throwing confetti around. It is such fun to watch these colored snowflakes drift through the air, and the people are having such good-natured fun. Sometimes two of them would get into a regular confetti battle, the one bombarding with green and the other with red — and finally a big, tall fellow emptied his whole bag over the head of a little girl. If one really inspects the confetti one can sometimes find tiny bits of shredded newspaper. Some inventive head of a household obviously set his whole brood to the task of snipping them up and thus cheated the world out of maybe four sous. And now he's having a grand time throwing it around. Herma and I sat down outside the door of a café where we had a fairly safe place and could observe everything without being bothered. Then two females with guitars, singing with powerful tremolos, came along, one of them ugly and sleazy, cursing, and then suddenly in a good mood again; the other, a tall skinny Spaniard whose cape hung casually and romantically over her shoulders as she strummed. That evening Herma and I went to a vaudeville performance. It was not all that innocent, even though there were many children in the audience. (They certainly seem to give them a fairly spicy diet here right from the beginning.) In the first little sketch everybody who came out on stage immediately got undressed, men in underdrawers and women

in bewitching *dessous*. Then a concierge in a nightgown and nightcap appeared on stage (the nightgown was cut in the same style as Mother's). Let me tell you, that would have been something for you to see. The second sketch was a little bit too much for me. The stage was constantly full of the most wonderfully constructed beds. The man was already lying in one and when the woman came out she had just about nothing on. I was really afraid that they were going to get to it right there and then. [. . .] (Naturally you must not read all of this aloud to the others.) I really rather regret that Herma is being exposed to this aspect of life so soon. Well, she's in it now and she'll simply have to deal with it —

I have hung your Worpswede *Festival Day* on my wall with thumbtacks, and it makes me happy. It's hanging next to the three women by Cottet, who don't have quite the same happy effect on me that they used to. When I was about to visit him (for the first time), it so happened that a dark-haired young man was just going into his house, so I decided not to go in. And today I ran into Cottet not twenty paces from the house just as he was leaving. He fixed me with his eyes and greeted me with a half-nod, the way one greets a person one can't quite place but whom one is sure one knows.

On the wall at the Académie Colarossi way up beside the clock, in Rilke's elegant handwriting so that he must have been standing on someone's shoulders, are the words, "I love Clara." But maybe he didn't write it himself. Have you seen the Rilkes at all, and where are they staying since they had to leave their other place? (You know, you have to come with me a few times to my afternoon drawing class. At least you will get to see a few naked models.) Herma and I have already figured it out: you should come here on the thirtieth; *Mi-Carême*, mid-Lent, is on the thirty-first, when all the confetti storms are on the boulevards again. You really must experience that. This week I'm at the Académie Julian again, working on my nude. I really enjoy painting and being with the other girls. There is a Polish girl there who dresses like a man. She wears a man's smock and has masculine gestures. Quite a few coquettish and sloppy French girls are there, too. Julian has another atelier, for ladies, on the other bank of the Seine. It costs twice as much to study there — that's where one sees marquises descending from their carriages. Bashkirtsev also studied there.

Believe it or not, you won't get any potatoes to eat here; instead, one eats nothing but bread —

Mother's snowdrops arrived today. So they are also in bloom at home? In this great colorful city it made me think of our little quiet house. How is Mother now? Better, I hope; otherwise I'll have a bad conscience staying here. And how far along is the business with the maid? Speak with Frau Overbeck sometime about Mine Marnken. My porter is Swiss and he has, or so I imagine, a sweetheart who is also far away; which is very nice. But what isn't so very nice is that he seems to have stolen all my writing paper. I can't possibly have used it all up myself, and you certainly haven't received that many letters from me yet. Oh, do you know

how very much I look forward to your being here, my dear Red. Let's use our time here in a wonderful way. I thank Mother for the thoughtful bouquet, I kiss my little girl, and hug you very, very tenderly.

Your little Parisian

Very special greetings to the Vogelers, too.

To Otto Modersohn

Paris, 65, rue Madame
Wednesday, March 7, 1905

My dear, dear Husband,
Your postcard brought me such sad news. And now you, my dear Husband, have the care and worry of that alone, without me. You are very much in my thoughts, my dear, dear boy. I do hope that the illness will take a turn for the best, as it did the year before we were married. Your poor, dear father. He must certainly be completely beside himself. It will be a comfort for him to have you there. Please write news by postcard every day and let me know how your mother is. Just before your postcard arrived with the news that she was worse, I sent her a picture postcard and a few violets. How did your mother get the chill? Your parents are always so cautious. Give her very heartfelt greetings from me and tell her to have a very quick recovery. And greetings to your dear father and to Laura. You will probably also get to see Willy when you are there. My dear boy, yesterday I received your charming and dear Sunday letter. Herma and I had such a wonderful laugh over it; it seemed to come out of such a cheerful Sunday mood. So I hope that by next Sunday your mind will be at rest again. I wish it with all my heart. I hug you and am in all love

Your Paula

Journal

Paris [ca. March 1905]

The intensity with which a subject is grasped (still lifes, portraits, or creations of the imagination) — that is what makes for beauty in art.

To Otto Modersohn

Paris, 65, rue Madame
March 10, 1905

My beloved Husband,
All of a sudden grief has entered your life and I'm not there with you to hold your hand. How quickly everything comes in life. And how good and comforting for

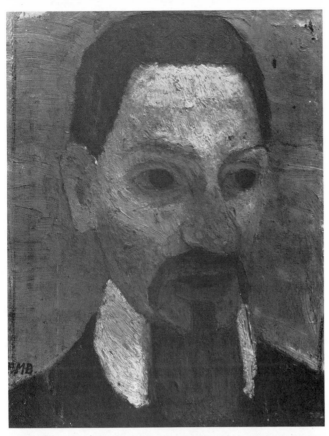

33. Portrait of Rainer Maria Rilke,
 June 1906

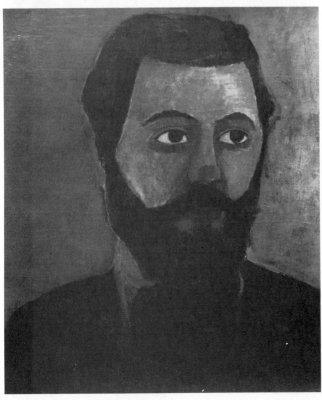

34. Portrait of Werner Sombart, *ca.*
 1906

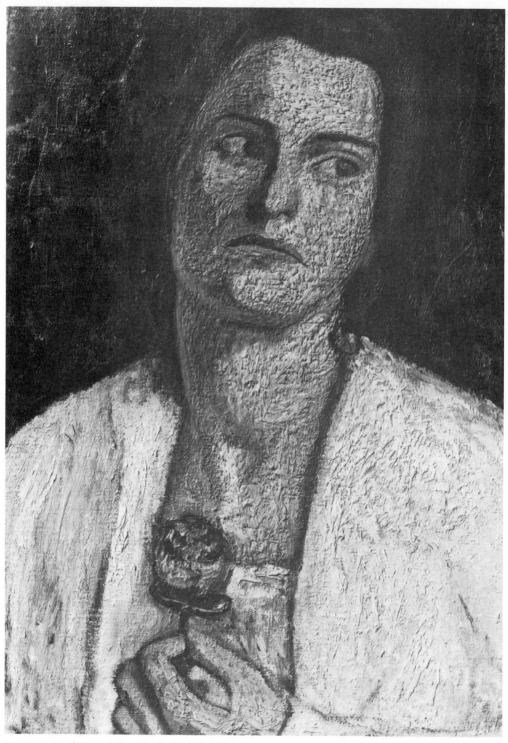

35. Portrait of Clara Rilke-Westhoff, *fall 1905*

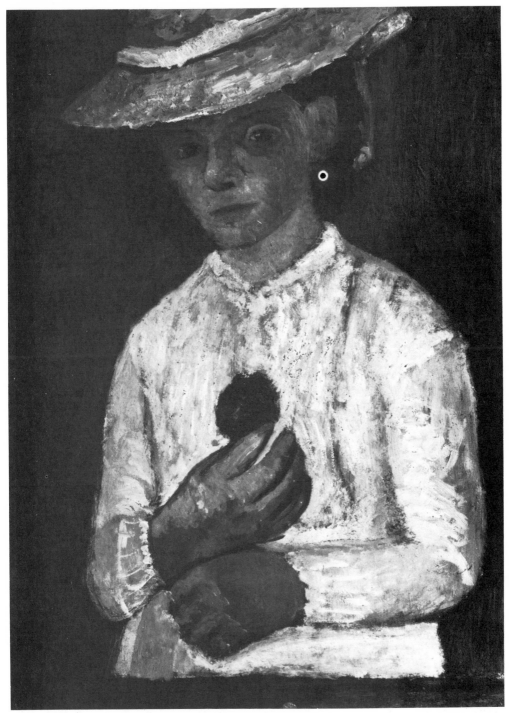

36. Self-Portrait with a Red Rose, *ca. 1905*

37. Old Poorhouse Woman, *ca.*
 1906–7

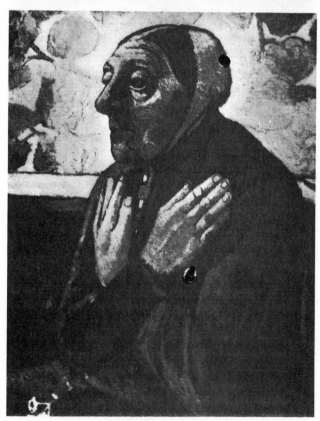

38. Old Peasant Woman with Hands
 Crossed at Her Breast, *ca.*
 1906–7

you that you arrived while your mother was still alive. Did you have a chance to speak with her? And did she herself sense that the end had come for her? How empty and meaningless life will seem to your poor father now, without the one who was the center of all his thoughts. One cannot yet imagine how lonely he will be. How good it is that Laura lives so near by and that Willy and Ernst can often see him, too. How odd they are waiting so long for the burial. My dear, dear husband. These are difficult days for you to live through. Please, you must write me in all honesty whether you have the feeling that I should come home, too. If you think that you will feel lonely without me, then write and tell me so, please. I have just been seeing many beautiful and rewarding things here and feel that there is still so much of great interest for me, and I really want to ask you not to give up the trip here after all. And if you are not in the mood to have the Vogelers along, then come alone — or perhaps with them, if you want. I was in Cottet's atelier. He does not seem to sell well; the whole atelier is full of the most beautiful and interesting things. I would love to show them to you. I asked him whether you might also be able to see his things sometime. I believe you would find them extremely stimulating. It's strange, this time the old masters are not the ones who have the strong effect on me; rather and above all it's the very most modern artists. I plan to look up Vuillard and Denis; it's in the atelier that one gets the real impression of an artist. Bonnard is in Berlin at present; I saw two things of his here but I didn't like them very much. You can see that I have seen much during these past few days.

My dear boy, please write me everything about how you feel things should be arranged. I'm sorry that you will be in Münster for such a long time. These sad days will be a very heavy burden on your soul. I kiss you with all my heart, and with love

<div align="right">Your Paula</div>

I'm enclosing a little note to your father.

To Otto Modersohn

<div align="right">Paris, 65, rue Madame
March 11, 1905</div>

My beloved husband,

I've been thinking a great deal about you today, every day. Can you sense it? It seems so odd that we two, who are really one, have such different lives now. You are serious and depressed there with your dear and grieving father and in spite of it all, here I am in this great city full of hope for the future. This past week I have again been completely under the spell of Paris. The astonishing, incredible variety of life here, the foreignness of the language and the people whose meaning a stranger can really never enter into, it all fascinates me so. Today, at the very hour

of your mother's burial, I was at Montmartre near the still unfinished Sacré-Coeur, looking down at Paris below me. I am shattered by the impression every time I'm up there: the teeming sea of houses, all this endless striving and chasing after things.

Human beings are such strange creatures. What compels them to all this endless activity? How strange this voice in us that rules and guides us. How odd this hunger our soul feels and which can never be satisfied—What thoughts have you been thinking during this time, dear? Write me. I can see you with your white brow sitting quietly in the corner of the living room where your mother's empty chair is. My dear, I'll be happy when you are back again in our little house in your own surroundings. The friendship of Overbeck and Vogeler will surely be a great help to you. Please write me by return mail how you feel. What you are experiencing. Whether you think it is right for me to stay here, and don't miss me too much. And what you think about coming here. Dear.

Last evening I was at the Bojers' again, and we spoke about you a lot. I told them many things about you. Cottet visited me. He thought many of my things were good, "But the way you draw!" I shall really set myself down when I get home [and get to work on that]. I miss you very much, my sweet fellow, and I want to kiss you and hold you in my arms and make you feel good. I am from far away

Your little Wife

Journal

[March 14, 1905]

Life and death take each other by the hand. A smiling blond Frenchman handed me a bunch of violets during Mardi Gras. I sent them to Otto's sick mother in Münster. They put them in her dead hands.

To Otto Modersohn

Paris, 65, rue Madame
March 15, 1905

My Red,

Yesterday Herma and I were talking about the fact that we will all be together again in two weeks. That thought makes me feel wonderful. You, too, dear? Oh, I have so many beautiful things to show you and I've saved up so much lovely love, which I want to pour all over you and cover you with, and make you feel good inside and out.

You wrote me about the solemn week that you spent in Münster. I can really feel how your father's sorrow had such a truly gripping effect on you—isn't it strange

that at the very time this serious event was happening in your life, I was in the midst of profound experiences here? Tomorrow an exhibition opens at Georges Petit's: Cottet, Simon, Zuloaga. Mme Simon gave me an invitation to it so that I can meet most of these people face to face.

If I only had someone here who could guide me through it. You will get to see the exhibition, too; it's open until April 4, although we will naturally miss the summer exhibitions. Would you be kind and write down a few addresses for me from Meier-Gräfe? Mine are still in that famous wallet—

I hope so much that you, my dear fellow, are installed again in your studio, among your pictures and with your friends. All of that will do you good—

I wonder if spring has arrived there yet? Here it's crouching in every corner and hiding behind every bush. On the boulevards, of course, one can't quite yet detect spring from looking at the great pollarded trees. But in the Luxembourg and in the Bois everything is getting green. We took a walk in the Bois with our two Bulgarians, the ones we met during Mardi Gras. Herma's is a law student and mine is a sculptor.

It was terribly funny the way the four of us walked to our rendezvous in the Luxembourg at three o'clock. We have to converse in French, but they speak Bulgarian to each other over our heads while we speak German over theirs; none of us knows the other's language. The sculptor studies at the École des Beaux-Arts. It's always interesting and informative for me to see how almost everybody here is still influenced by the power of tradition and the Old School. There is a kind of military and masculine discipline about it. We go about the whole business much too pleasantly in Germany. We always start right off talking about personalities. Here it is the oldest professors who basically are the best ones because they're the ones who still teach fundamentals, the ABCs. If I were free I would spend at least half a year here at the Académie. It would be good for you, too, though I doubt that you would think so.

—Sunday evening we were at Bullier, the dance hall in the Latin Quarter. It seemed to me a little run-down. The male contingent was just the same as always, those pretty, lighthearted art-and-science disciples. And the females weren't pretty enough for us. But you'll have to see it anyhow—

This evening we're going to the Folies Bergère, a kind of Wintergarten. We're exploring everywhere. And then I still want to go to see Rodin and I'm afraid to. This week classes at the Académie end. It really makes me feel sad. I've only now gotten a little used to the surroundings there. But I'm very happy that I've done it.

Here comes Herma, my dear, and right now I have to rush down my five flights of stairs and fetch two *fromages doux* to which we are treating ourselves.

Au revoir, mon chéri, mon coucou, as the little girls in love say here. I kiss you lovingly. Keep on taking your air and sunbaths faithfully so that you can sparkle when we are back in Fischerhude again. I take a beautiful air bath now every evening and morning and enjoy admiring my curves and roundness in my full-length

mirror. [...] Greetings to the whole "family." How is Elsbeth?
Je suis à toi de tout mon coeur.

Ta petite femme aimante

To Otto Modersohn

Paris 65, rue Madame
March 18, 1905

My beloved Husband,
Rain today. It's been coming down gently since morning. Up to now we have had
glorious weather. And often as I ride along on the open deck of the omnibus, the
beauty of this city makes my heart laugh. This morning's surprise was Mother's
photographs. The view of our little quiet living room is like a scene from another
world. It made me feel very peculiar just now when I am standing with both feet
in the great swirl of Paris. And the photograph of Elsbeth dressed as a page was
darling. Please thank Mother very much for them.

Last Thursday I was at the opening of an exhibition at Georges Petit's to which
Madame Simon (whose husband I had missed seeing at their home) had given me
a ticket. It was all very Parisian, many fine ladies, some with long trains on their
dresses, and elegant gentlemen. The artists were there, too; I saw Cottet. Zuloaga
was pointed out—but his face didn't make any particular impression on me.
Toward the end I came upon a group of people from Bremen: Heymel and his
wife; Sparkuhle, who looked like a small-town traveling salesman in an imperial
cloak; and Wiegand. It seems that they all want to buy pictures here, and I had
the feeling that they will hardly be taking the good things back home with them.

And recently we were at a *variété* with our black-haired Bulgarians. It was neither
good enough nor bad enough to be very interesting, but we did have fun together.
We sat at a little table and as part of our own entertainment we introduced our-
selves to each other. Although we had already had several rendezvous, we still
didn't know each other's names. Everything we had been saying to one another
had to be said in mangled French, and so Monsieur and Madame were enough.
We now introduced each other by first giving our Christian names, which we
translated into a variety of languages in order to try to explain what they meant.
Then came our family names, which we wrote down for each other, and finally
our addresses. It was very funny, rather like the way children introduce each
other. You see, our two cavaliers have been very little influenced by European
manners. Mine, who is blessed by intelligence and good looks, spits. But Herma
and I graciously accommodate ourselves to everything that happens, and only
now and then feel obliged to drop little hints. For example, we asked them to
please not eat food with garlic in it before they meet us, and things like that—all
of which they obediently allow us to say to them.

—I finished my month at the Académie Julian today. The ancient one-eyed professor had some praise for me. Sometimes I have the slight feeling, however, that I'm in a theater here, as if I were a character from a completely different drama who has to take part in a foreign play, all of which sometimes makes for fairly stupid disharmonies.

You surely must be back in Worpswede by now. Is Mother perhaps ill? Herma hasn't heard anything from her in so long. Long live the newly certified doctor! Will he be coming here? Is he coming with you? Soon now you must send the full list of your traveling companions. Is Overbeck coming along? And have I already asked you for a few addresses from the Meier-Gräfe volume?

Farewell for now, my Red. I'm going to sketching class and in the evening to the Bojers'. Just ten more days and we'll see each other again. I'll be waiting for you at the Gare du Nord with my arms wide open. Have the "Poet" cut your hair before you leave so that you will be handsome; but do it right now so that it will have a little chance to grow back and so you'll be even more handsome. I will also make a big effort to make myself look as pretty as I can. I hug you and kiss you and let you give me a little spank in the rear, and with love I am

<div align="right">Your little Wife</div>

The little cupboard from Fischerhude looks charming in the photo. La Duse is coming next week.

To Otto Modersohn

<div align="right">Paris, 65, rue Madame
March 20, 1905</div>

My dearly beloved Red,

All hail to your dear letter and to its author. I received it today just as I was leaving the house and read it on one of those nice little boats surrounded by the airs of spring and all the feelings of spring they brought with them And at the end of the trip, as I was leaving the boat, a blackbird flew over and greeted me by letting one of its opinions fall on the envelope. My dear boy, how I look forward to your arrival. Everything here is adorning itself festively and getting ready to receive all of you. Over the past few days the leaves have come out on the chestnut trees. It was a rare view that I had today, sitting on the upper deck of the omnibus and looking at the bursting treetops in the sunshine. And yesterday even the peach trees were in blossom in Meudon. Oh, how much we thought about you yesterday. We took a trip to Meudon, which all of us will have to do again when you get here. It's an entrancing and lovable country, this France, and this gigantic city of Paris has nestled itself into the landscape with great charm. The valley of the Seine has magical fascinations, the river itself enlivened with little islands. It is remarkable

how the land and its people complement each other. This lighthearted and seductive landscape, in love with its flirtatious little folk who are always kissing each other. Our reserved spring and our even more reserved hearts are naturally what I much prefer and feel closer to, but it's delicious to see and to sense all of this here. It will make you very happy, too. There must be a full moon at home just as there is here now, where it weaves gently through the trees in the evening when I am walking home from my *croquis* and making one more quick tour through the Jardin du Luxembourg. I only wish so much that you were at my side, for at this time of year one needs someone to love and to kiss. Dear, let's take in this spring as if it were the first one we were experiencing together. I am so happy about the early spring news of the thousand marks, and I'm very anxious to see the settee. Is it the amusing one with the little wooden spindles? Do go and see Hatjen the gardener and have him plant a row of not too big pine trees, out toward the street; they can screen our little sunbathing bodies from the view of the passing crowd. Ernst and Gertrud amuse me, too. In a few years it will surely be considered improper *not* to sunbathe—

Thanks very much for the addresses, but no matter what, we'll have difficulties. We really ought to have a little letter of introduction from Liebermann or Cassirer. The people live in great palaces surrounded by servants and it is hard to get to them, even harder if one is not elegant enough—And in your next letter you must set down a list of all the people you're coming with so that I can rent rooms for all of you. Is Kurt coming along, and Overbeck? Oh, oh, how happy I am.

Last week we went to a variety theater of the second rank. All sorts of droll things were going on—a very sensual Spanish dancer with a figure like Manet's *Lola de Valence.* Toward the end there was a little singer who sang ten verses about her *nombril,* her belly button. One can always calmly listen to things like that in French, probably because one only understands half of it. When one then leaves the theater about midnight and steps out onto the great boulevards and all the other theaters are letting out, then the city is as lively as the middle of the day and one has a feeling that Paris never sleeps. [. . .] —Are Mother and Elsbeth healthy again? Tell Mother that I received the blue patches today that I asked for, and please give her my thanks.

You know, you must leave on the twenty-ninth so that you won't miss *Mi-Carême* [mid-Lent] here. It will amuse all of you. So you want to paint me in the nude, and naturally a view from the rear which you love so well? Very well, that's all right with me. And how then did Vogeler's nudes turn out, the ones he painted in Dresden; and what is Mackensen doing, and Frau Overbeck? Have you been to the Brünjes' at all.

I kiss you heartily behind your ears and in front of your ears and on your smooth brow and your dear hands which are soon going to be caressing and loving me, so that my round body will be happy and my *nombril* will be laughing.

<div align="right">Your little Wife</div>

I have also seen little figures by Maillol which I like very much. The Indépendants are opening their exhibition this week. We will get to see all kinds of things there.

To Otto Modersohn

<div align="right">

Paris, 65, rue Madame
March 22, 1905
</div>

My dear Husband,

The Salon des Indépendants is open. Much sentimentality. The walls are covered with burlap and there the pictures hang, with no jury in sight, alphabetically arranged in colorful confusion. Nobody can quite put a finger on exactly where the screw is loose, but one has a strange feeling that something is wrong somewhere. There are retrospective exhibitions of van Gogh and Seurat, but one leaves them no better informed than when one went in.

Again the Salon is Paris through and through, with its whims and fancies and childlike qualities. Stupid conventionality hangs next to eccentric attempts at *pointillisme*. But I still look forward to seeing all of it again because finally one is more left alone at the Salon than when looking at private collections. You should have seen the fellows with their floppy hats and their little women, running around at the opening of the exhibition yesterday. I always find them so funny. To me they look like little boys playing soldier. Here and there one of them emerges as a general. Paris is enchanting now with the happy new straw hats and its air full of the smells and mists of spring. All week long I have been driven through the streets on my omnibus and am so very happy because it is so very beautiful. As I said, it's only now that the city is really beginning to attach itself to my heart; one needs time to get back into it. I spent several wonderful mornings at the Bibliothèque Nationale with Bode's *Rembrandt* and Rembrandt etchings. In the evenings I was at the Bojers' with Nordic people and Nordic impressions. Also interesting. Their house is filled with a colossal sense of life and spirit. It has an almost mystical effect on me, like Maeterlinck—

— In the meantime I've received your letter. My dear, dear, dear, how lovely it will be together with you again. It makes me feel so good. I think it's fine that you're not waiting until the sixth. A week's delay would also have been very costly for me. So now we will be seeing each other on the evening of the twenty-ninth at six thirty. I can hardly imagine it! Tomorrow we will either hike or go on the steamer to Saint-Germain-en-Laye (without Bulgarians). They say it is very beautiful. And I also want to see whether I can have a chance to visit the atelier of Denis, who lives there; I saw an enchanting picture of it. Kisses, kisses, kisses.

<div align="right">

Your Paula
</div>

You must each bring a knife, fork, and teaspoon. And also bring your pipe and

*Postcard to Kurt Becker, March 22, 1905: Paula and Herma in the rain
in front of Notre Dame*

tobacco along and give Milly half a pound. I doubt very much if you will like the taste of the tobacco here.

To Otto Modersohn

Paris, March 24, 1905

D[ear] Otto,

As far as I can find out *Mi-Carême* is on Thursday, the thirtieth, and so you will have to leave on the night of the twenty-eighth–twenty-ninth; you will have a two-hour stopover in Cologne, and so you'll be able to see the cathedral. Your train, third class, leaves from there at nine and is in Paris at six thirty. Second class arrives earlier but you'll save the other way. *Mi-Carême* will be much fun for all of you. The people here are genuinely themselves then. That's something for the evening—in the mornings I'll have something else beautiful to show all of you. Hurrah!

D[ear] O[tto], do ask Mother to go over your blue suit once more very carefully and look for stains. For the journey, you can wear your gray one; your so-called "best one," my dear, is probably going to be too warm for you here.

I am sending you a key to the upper right drawer of my dresser. There you will find a little tin box filled with keys, and one of them fits the cupboard with the golden stars on it in the nursery. There you'll find the brown hat Milly gave me. Please bring it along. But I must ask Mother to freshen it up a little before you pack it. [...]

This letter is nothing but a business letter written in haste. Maybe I'll write you a love letter this evening, for my heart is full of love for you and it's counting the days. It does not wish to wait any longer without its bridegroom in this glorious springtime.

I am yours, you are mine, of that you may be sure. Just don't lose my little key (to the dresser).

Your Paula

From Otto Modersohn's Travel Journal

1905

From March 29 to April 7. Traveled to Paris with Milly, Heinrich Vogeler, Martha V., Marie Vogeler. We all lived in Paula's *hôtel* (rue Madame). We saw the Gauguins at Fayet's; and Buffalo Bill. The time [in Paris] was not pleasant.

Worpswede, April 11, 1905

Dear Mother, Coming back home was wonderful. I thank you so very much for the new white ceiling on the veranda with its green stenciled borders, and for the sumptuous new chair cushions. The bright little room pleased me enormously. I thank you for everything you did for me at home as my representative, while I was flying around the world. You helped make it possible for me to enlarge the content of my life. I think of these trips to Paris as a completion of my rather one-sided life here. I know for certain that after ten quiet months in Worpswede, escaping to an entirely different city, with all of its thousand sensations, is becoming something of a necessity of life to me now.

Nature seems to have been asleep here during these two months. The birch trees refuse to bud. The anemones are twinkling secretly down in the grass. Today I picked two little violets in the garden and pinned them to my dress. It's odd how the charm of spring this year comes precisely from its own frugal reluctance.

Today I looked up all the little children who used to pose for me and strange to say, in every one of the four houses I stopped at, a new Hinnerk or a new Metta had arrived while I was away. And I was really envious looking at all this squirming new life. [...]

To Herma Becker

Good Friday
Worpswede, April 21, 1905

Dear Herma,

I've just now finished picking our yellow coltsfoot at the brickyard with a group of children from Bergedorf and am going to make a garland of them, and I was thinking of you a lot and wishing you were here so that you could be walking by my side with a spring wreath on your head. I love being with you.

As far as the weather is concerned, I could easily have been spending these past two weeks in Paris. It has been snowing here, and storming, and hailing, and from the east a cutting wind came whistling through. But since yesterday spring has finally arrived, and very blissful it is. Yesterday there was a blue sky and soft light clouds. And today the sky is overcast and all the hues of the earth are dark in color, something I love very much. I like thinking back to my trip to Paris. They were rich and wonderful weeks for me, and the memories that we have together and that Paris gave us for our lifetimes are very dear to me. Let us always be very friendly to each other. The end of my stay, with Otto there ("Once upon a time there was a tomcat"), fell terribly short of our happy plans. It began with rainy weather which prevented us from ever riding on the *imperiale* of the omnibus. As soon as I had Otto over the border the iron band that had clamped around his sad

and grieving heart broke in two. He was very jealous of Paris, French art, French nonchalance, the boulevard Miche, the Bulgarians, etc. He imagined that I only preferred to stay in Paris and thought nothing at all of Worpswede. Well, you know him. He had completely submerged himself in such thoughts and wouldn't say a word, and really ruined the last week for me. As you can see, one's fantasies have their dark side, too. When he looks back on it, however, his fantasies will help him to brighten up this trip with charms and delights, so that he will eventually be satisfied with it.

Meanwhile everything here is back to the way it was before, with a few little nuances. Mackensen has put on a new face and goes riding on his beautiful white horse. The Overbecks have bought themselves a house and some property in Vegesack and are about to cut their ties here. Whenever he says good-bye to his friends here, he is seized by love for them and visits them every day in cozy intimacy. They plan to move in August. At the Modersohns' house Lina has charged approx. sixty marks' worth of things at different merchants, which we fortunately are able to deduct from her pay. On the first of May we are awaiting the arrival of a thirty-six-year-old widow woman with her two-and-a-half-year-old child and are in a state of anticipation about the new acquisition. The Vogelers are expecting, perhaps, a third child. Further new arrivals are: Heilbuth [*sic*], Köster, Scholkmann, Fräulein Rhone [*sic*], Reyländer; Frau Rilke, after a seven-week holiday at the White Stag, looking very refreshed, to all outward appearances, is staying with Emmy Meyer. The Brünjes family in Ostendorf has had my atelier newly whitewashed and has set out a garden with bench and table just beyond my windows — Besides that, they are planning to install an air-bathing facility in Beta Schröder's garden about which Beta knows nothing at all as yet. And then, Gefken has renovated the fencing around our carnation bed so that our garden now has a look of Easter about it. In the little birch woods, Elsbeth has erected a small bench single-handed on which mother and daughter sit very proudly.

And what are you doing? How are things with you and your Madame, to whom please give my best regards. I wanted to ask you, do you have something that you can lock your letters up in? If not, buy yourself a little box. I would not let them lie about open. When are all of you leaving on your trip? Have you seen the Russian girl again? And have you undertaken anything together on Sunday? I would love to spend another Sunday with you there sometime. Have you visited the Bojers, 47, rue Boulard? They still have my Rilke-Knackfuss *Worpswede*. Have you seen our swarthy Bulgarians again? Are the Hoffmann girls gone yet? You must write me a letter soon and answer all my questions. I think that you and I will someday want to go back to Paris again together. Have you already seen the Salon? Please do send me a catalog, the illustrated one if they have it. And then, please find out about the prices of the following magazines; I very much want to have some of them.

1. Noa-Noa by Gauguin, Edition La Plume.

2. The Biography of Gauguin, by Ch. Morice, Mercure de France, Oct. 1903.
3. Study about Gauguin in the Revue Encyclopédique, Feb. 1, 1904.
4. L'Occident 1903, No. 16, 17, 18 — Article by Signac.
5. Article by Montfreid in the journal L'Ermitage, Dec. 1903.

Can you please find out the prices of these various publications?

I greet you from my heart and wish you patience and endurance, wisdom and gentleness and a beautiful Easter Sunday. With love,

<div style="text-align: right">Your Paula</div>

To Marie Hill

<div style="text-align: right">Worpswede, June 7, 1905</div>

My dear Aunt Marie,

I intended to write you just as soon as I heard that you were sick in bed. But now I have postponed it so long that I can only hope you are up on your two feet again and heartily enjoying this beautiful first part of summer. I feel so strongly that health is the most important thing, and I'm very happy and grateful that we have been blessed with it so far.

The news about us is the usual; we are all fine. Elsbeth is now going to the village school and can already spell the most incredible words, recite the story of the Creation, and subtract 1 from 2. So the groundwork has been laid for her to become a civilized person, and so far she finds it fun. Besides that, she has a little white rabbit which she pulls around by its long ears and for which she constantly has to gather food. While I (when I am not painting, or sleeping, or eating) am stuffing food down the throats of two hungry magpies. Otto, meanwhile, goes about with a glass bowl full of tree frogs for which he has to catch flies, and another bowl full of salamanders, water beetles, and fish for which he is supposed to be catching earthworms. But he's not very good at it. And in our garden the roses and carnations are beginning to bloom, which is always a beautiful time of the year for us. And other than that, there is painting, a beautiful art, but hard.

That is just about the way things are here....

To Carl Hauptmann

<div style="text-align: right">Worpswede, June 14, 1905</div>

Dear Herr Hauptmann,

Is it possible for you to lend me four hundred marks for someone else? I have been approached for the money and I know no one else better to ask it from than you. I am supposed to get it back in half a year, but I can't make a firm promise since it doesn't depend on me but on the third party. I hope the fact that I'm coming to you in this matter is a sign of my confidence and my friendship for you.

This spring once again overwhelmed us with two beautiful books. Then later we were so happy for you and celebrated your having won the Schiller Prize. Finally, we hope your path will take you to Leipzig again as it did last year, so that you can then take a side trip to Worpswede. And if you do, we hope you will be able to let us have a little more of your time.

We are all busy and content with our work here. My husband is excited about his new pictures, Elsbeth is going to school, and I too am trying harder and harder to become someone. Clara Rilke is spending the summer here working. A few days ago her husband left on a trip in order to study something or other. The Vogelers are well. He has just finished installing a room with works of his own at the exhibition in Oldenburg and has returned very satisfied. Mackensen has brought a white horse back with him from Constantinople, and unfortunately the Overbecks will be leaving Worpswede this summer and moving closer to Bremen. His good-natured, boyish personality has had such a positive effect on us this summer that we are reluctant to let him go. His wife is still away and seems to feel somewhat better.

—If it is possible for you to lend me the money, please send it by registered mail to:
Herr Hermann Brünjes
Ostendorf—Worpswede
bei Bremen
Auf Wiedersehn, and I hope soon. (The *Schützenfest* is on the twenty-fifth.)
To you and your dear wife, heartfelt greetings.

<div align="right">Your Paula Modersohn</div>

I ask you please not to mention this matter to my husband. It would upset him.

From Otto Modersohn's Journal, 1903–1905

<div align="right">November 5, 1905</div>

Had a thorough and deep conversation with Paula. [...] Our life has become too monotonous, philistine. Paula suffers very much from that. It makes her feel so confined. At first I didn't accept that—but was not justified. Paula is right. The things that made our marriage so fine during the first period, an exciting active life, full of content, experience—we have fallen very far away from that. A great mistake. Worpswede: one gets stuck in the swamp, one turns sour too easily here. [...] Paula has brought so much into my life and how happy I felt: swimming, air bathing, trips to Fischerhude. Skating parties, etc.; how wonderful that was and Paula was the soul of all these things. Evenings in the "white hall," the rendezvous at the Brünjes' place, midnight, one o'clock, walks over the hill in all kinds of weather—how rich, majestically rich, I felt. What inspiration, human and artistic. During that period I didn't paint much that was good, but the fault lay elsewhere.

Now I've worked myself out of that state. [...] But my life must now become richer and more active, more full of experiences. I am following Paula in this; she has very good instincts. [...] I wish to take hold of every opportunity happily, and Paula will thank me for it with her love. I shall behave younger, and I shall only profit from that, humanly and artistically. I am also no longer against travel, when I have the money. [...]

To Herma Becker

Worpswede, November 8, 1905

My dear Herma,

So things are going well for you in your "convent," and you have lots to do with time left over to take a look at the beautiful world for yourself. I'm very happy for you; you have a rich life. If there is anything at all that I can get for your little household, please let me know by letter. Clara Rilke was here last evening and talked to me about Paris, Rodin, and you. Sometimes I do yearn a little when I hear how things are out there in the great world and when it's a bit too quiet and monotonous for me for any length of time. It's good that the prickly period, which you saw last summer between Otto and me, is now past. Now we are getting along very well with each other. It's only that in the deepest depths I have a great longing for the world, especially on those long evenings when he is comfortably nestled into a corner of the sofa with a pipe in his mouth—

—A short while ago Otto, Vogeler, and I took a three-day side trip through Westphalia. Soest and Münster were inspected and shown to Vogeler who was again in his best traveling mood. Little Frieg, who has had his beautiful hair shorn off as short as a rat's in order to beautify himself (and so his hat is propped up by his ears now)...well, little Frieg showed us Soest. He also showed us his paintings about which we remained somewhat silent. The most beautiful thing in Hagen for me was the museum owned by a Herr Osthaus. He has collected the newest and latest art around himself there: Rodin, Minne, Maillol, and Meunier, Gauguin, van Gogh, an old Trübner, an old Renoir, and many other beautiful things. The Osthauses themselves, with their four blond children, had a wonderful effect on me. He is a strikingly tall person between thirty and forty, with remarkably searching eyes. She is a figure of light—blond, graceful, and shining. She came walking toward us with her naked two-year-old child, and it was like a picture. They are the kind of people I would very much like to see more of.

Society here is now beginning to settle into its winter arrangements. First of all, a bowling evening is about to take place: Franz and Heinrich Vogeler with their wives, Mackensen, the Modersohns, and a new, not too famous painting couple named Hartmann. Frau Philine has hatched from her cocoon, and upon closer inspection, proves to be nice and charming. Otto, especially, finds her fun. I like her very much, too; however I must say I miss a woman here with whom I can speak

Postcard to her mother, October 14, 1905: Otto Modersohn, Heinrich Vogeler,
and Paula Modersohn-Becker on a trip to Westphalia

Die Elsbeth stolz zur Schule geht,
Martin Bernhard staunt und steht.

Pictures from Family Life, November 3, 1905

Sie wandert feldmarschmäßig
denn Kalt ist's, ich mein grässig.

Hier malt sie ein blasend Kind
rasirt von grausam kaltem Winde.

Die Malerin mit ihrem Bilde
Sie streitet aus wie eine Wilde.

about the things that interest me—Recently Otto and I went to Hamburg for a day to look at an exhibition of van Gogh's works, but unfortunately the pictures were no longer there. Our plan to visit the Warburgs was likewise a failure; they had left for Italy the evening before we arrived. But Hamburg as a city gave us much pleasure. The region near the harbor, with all its masted ships, has an absolutely magnificent effect. But the so-called "educated" people there make an extremely materialistic impression so that one feels that despite all the grandeur and wealth there, the city really has no intellectual life.

—The Rilke-Rodin visit is still ahead of you. Rejoice. The nude at the Salon that you wrote about is by Maillol, a sculptor whom I first saw last spring and whom I love very much. The figure is going to the museum in Hagen. Just to keep my imagination up to snuff I'm taking all kinds of journeys in my mind. A skating tour to Holland, and a trip to Paris by way of Normandy, Saint-Michel (where I will meet you), Chartres with its beautiful Gothic architecture, and then on to Paris. I send you tender greetings and wish, for you, that you will become somebody; and for me, I wish the same. You can probably tell from my letter that I'm in a slightly downcast mood. I have entered my period of hibernation.

With love

Your sister Paula

Naturally you won't be sending my letter around to others.

To her mother

Worpswede, November 26, 1905

My dear Mother,

The few hours of daylight, which is all we have now these days, are gone. I have sent my little model home and lighted my little lamp, and am determined to overcome my writing block. Your long letter, and then your second gray one, have aroused my determination to act. [...]

Mornings I am painting Clara Rilke in a white dress. It's to be her head and part of a hand holding a red rose. She looks very beautiful that way, and I hope that I'm getting a little of her into my portrait. Her little girl, Ruth, is playing next to us. She is a cuddly little creature. I'm happy that I can get together frequently with Clara Rilke this way. In spite of everything she is still, of all my friends, the one I care about the most. She was living very close to Rodin for about a month and is still very much under the influence of his personality and his great and simple way of expressing his thoughts. As Rodin's secretary, Rilke is gradually meeting the intelligentsia of Europe.

Otto paints and paints and paints. We have earned enough now so that perhaps after Christmas we can come to visit you there, and also take a little side trip to

Schreiberhau. That would be lovely. In general, my time for hibernation has come again, along with all kinds of longings. Perhaps that explains my reluctance to write. I'm secretly planning another little trip to Paris, and have already saved up fifty marks. By contrast, Otto feels totally content. He uses life only as a rest from his art and he always profits from it. From time to time I have a strong desire to experience something else. It really is rather difficult, being married and so firmly anchored to one spot. [. . .]

To Herma Becker

Worpswede, December 1, 1905

Dear Little One,
You say you are "worried" because of me? Why, what for, because of what? Sometimes life is harder than some other times, but one must simply deal with that. In fact, one must become a better person because of it. Perhaps one also becomes a little older because of it, and that is something I dread because it is so boring. For in spite of my thirtieth birthday, which is approaching, I'm afraid of being "grown up," which I identify with being "resigned." Sitting still here is sometimes very difficult for me. Nevertheless, I tell myself that the things that are hard are not always the things that one should avoid.

—Otto can also put himself in my position and is so touchingly good to me. When summer is here everything will be fine again; it's only my winter sickness. But you don't need to be anxious on my account. I shall grow through this. Just forge your own life for yourself, and forge it strong and great, and with all your forging don't forget that nothing exists or comes into being without strength; and so nourish yourself well—

—You have probably noticed that I love you, and you probably know it, too. I am

Your Paula

I enclose Günther's letter. He is not lying on a bed of roses. I wonder if he will make it through.

To Milly Rohland-Becker

Worpswede, December 6, 1905

Dear Milly,
We are leading an active life here. I'll give you a few indications of what we are doing. Well then, first of all you have to imagine us as regular customers every Thursday evening at Welzel's bowling alley. Present are the two Vogeler couples, Herr and Frau Krummacher, Herr and Frau Hartmann, and we two little redheads. I'm very proud of Otto's demonstrations of power, taking on that whole

"regiment" four times a day. By contrast, I behave much more discreetly. Ranke, the tailor, had patched the seat of Otto's gray trousers with a piece of material brighter than the original, and so I had to do a little artwork on them at the last minute before we went bowling. Now the patch looks almost identical to the rest of the trousers, a demonstration of my artistic talent, which cheers both of us.

Last week I spent two evenings at the theater in Bremen. Eysoldt (from Berlin) was the guest artist in Hofmannsthal's *Elektra* and in Wilde's *Salome*. Her performances were full of fine and original touches, very sensitive, highly cultivated. The others in the cast were terrible.

Frau W. has lent me the Wagner-Wesendonk correspondence from which I feel just as alien as I did when I saw *Tristan und Isolde* recently. My soul (or perhaps I mean my body and my nerves) resists this hypnotizing music. In spite of his German materials, I consider Wagner to be un-German. Please forgive this judgment of mine. It comes to me instinctively. Nevertheless, I've become old and wise enough to have learned not to say such things in public.

And in my painting I've been trying to put the few daylight hours which winter allows us to the task of attaining that eternally self-renewing goal of mine. Whether one is talented or not makes no difference; I find that art is a very difficult thing.

We received a telegram today inviting us to spend a winter holiday at Schreiberhau. Perhaps we shall slip over there after Christmas. Besides that, we are looking forward to seeing a Centennial Retrospective Exhibition in Berlin, with paintings by Leibl, Marées, Feuerbach, and others.

...Our weather: a gray December sky with fog and rain and then warm winds. Painstakingly but happily, Elsbeth is busily sewing a Christmas present for you. She believes in Father Christmas now more than ever.

Good-bye for now, my dear Sister. Otto is sitting for Clara Rilke....

From Otto Modersohn's Journal, 1903-1906

December 11, 1905

What Paula is doing with her art now does not please me nearly so much as it used to. She will not accept any advice—it is very foolish and a pity. A huge squandering of her powers. The things she could do! She paints life-size nudes, which she can't do, no more than she can paint life-size heads. And in this...she's just as addicted as I used to be about my fairy-tale drawings. She lets her glorious sketches just lie there. All she has to do is make drawings from them—learn technique—and she would be complete. A great gift for color—but unpainterly and harsh, particularly in her completed figures. She admires primitive pictures, which is very bad for her—she should be looking at artistic paintings. She wants to unite color and form—out of the question the way she does it. She doesn't like to restrain form—a

great mistake—she doesn't think enough about her own art—always works from the same points of view and doesn't progress.

Women will not easily achieve something proper. Frau Rilke, e.g., for her there is only one thing and it's name is Rodin; she blindly does everything the way he does it—drawings, etc. That is very false and superficial—what are her own qualities, does she have any? Fräulein Reyländer also wavers back and forth, arrogant like all talented women, and yet she will never achieve anything except little things; she won't progress; knows no modesty and without that no one gets anywhere.

Paula is like that. She won't budge either, and closes herself off to sensible insight or advice—she will shatter and destroy her powers, I'm afraid—if she doesn't soon change her ways.

To Herma Becker

Worpswede, December 18, 1905

My dear Herma,

I give you a loving kiss and tell you what you already know: that we will be thinking of you when we are in our little evergreen arbor on Christmas Eve. Kurt will be with us. Then we'll begin our trip to Schreiberhau-Dresden-Berlin between Christmas and New Year's. I look forward so much to the snow and sledding in Schreiberhau. These half-dozen teaspoons are for your bachelor quarters. (Yesterday a shooting star told me that sometime this spring I would be spooning down *confiture de fraises* with you in your "convent" home. Maybe it was telling the truth.)

About the colorful trousers, Otto himself will be writing you a merry explanation. He and I were full of fear that old Frau Viol wouldn't come across with them. But she appeared just before the closing of the portals.

And then there is the loan of my coffee machine which, in case I am going to be spooning up the *confiture de fraises* with you in the spring, I'll have to fetch back. You do know, don't you, that I have already saved up fifty marks?

What do you say to Otto's sketch? A bit of Worpswede glory for your little cell. Yesterday Rilke came home for the Christmas holiday—and so, a kiss and a greeting and a wish and love. May — — —

Your Paula

From Otto Modersohn's Journal, 1903–1906

December 20 [1905]

I am more than happy, for I know now, finally and completely, that we are on an upward path. [...] Paula has had an especially favorable influence on me. [...]

Summer was enormously profitable for me with all my painting and then the studies I did—and at Paula's side with her masterful still lifes and sketches, the boldest and the best use of color that has ever been made here in Worpswede. [...]

From Otto Modersohn's Journal, 1903–1906
December 28, 1905, to January 13, 1906

January 15, 1906

Took a trip exhilarating in every respect, probably the finest trip I ever took. First of all *nature* in Schreiberhau in the winter, magnificent, powerful, much finer than in the summer. Then the people: Carl Hauptmann, his wife, Sombart, Reicke and wife, Lotte and Miezi Hauptmann, Anna Teichmüller, fine company. First, Carl Hauptmann: a wonderful, rich, touching human being. We came closer to each other than ever before. He is certainly not in the highest echelon as a writer, but what inspiration, what riches he has in him; his wife is a touching human being, too, and the sister and nieces are also nice. But then there is Sombart, a splendid fellow; how delightful the debates were that he had with Carl Hauptmann. Reicke and his wife were also interesting, even though less significant; and Anna Teichmüller, I don't like her outward appearance, but she is fine, too. The evening in Dresden at Hauptmann's lecture was absolutely splendid, and then the people there: Nikodé and wife, Frau Bienert, but above all Otitschko Müller and wife, Helene Kosslowski, Frau Gerhart Hauptmann, Göllner. A fine artistic atmosphere was in the air. We visited Otto Müller the next day, and Göllner, with Carl Hauptmann; [the former] a remarkably gifted painter and sculptor. And the freedom of it all! He is constantly painting his wife (Miene) in the nude; she just stands there, a charming creature. How far we are from all of that in Worpswede. And then Frau Gerhart Hauptmann: tall, heavy, genuinely feminine; and then Fräulein Kosslowski, a tall, magnificent figure of a woman and as a human being she has such a good effect on people, simple, and she sings so gloriously, grippingly, with deep feeling.

Then the pleasures of art: the Rembrandts in Dresden; they are indeed fine here: the Entombment, Old Man, the man with the heavily painted chest. But then Berlin: next to Potiphar, Hendrikje Stoffels, The Brother, Tobias, small Manger scene. Carstanjen Collection: a portrait by Rembrandt, a small nude, and a self-portrait. The latter, indescribable; artistically perhaps the most powerful painting I have ever seen. [...] Also in Berlin the German Centennial Exhibition: Leibl, Trübner, Thoma, Böcklin, Feuerbach, Marées, V. Müller, Liebermann. Leibl, Trübner, etc., inspired by Hals and Velázquez—but not so free. I don't like Thoma. Of Böcklin, only a small landscape on a gold ground. Most interesting of them, Marées, but unfinished, groping, more interesting in intention than in ability.

Worpswede, January 17, 1906

My dear Milly,

Here we are back home again, sitting under the lamp in our cozy, brown living room.

We had a simply wonderful trip. Staying with the Hauptmanns in the Riesengebirge, we really learned what snow and winter mean. The landscape, which hadn't particularly impressed us last summer, was glorious this time! The snow-covered mountains lay there before us, grand and serious, partly hidden by a cloudy sky. The Hauptmanns had invited a charming and interesting group of people, among them Mayor Reicke and his wife, and the sociologist Sombart. At table and after meals there were always interesting discussions going on among the men. All these scholarly people have such a different effect on us than the painters we are used to. Many fine things came out of these discussions, especially when Hauptmann and Sombart were confronting each other. During the day we devoted a lot of time to sledding. Simply wonderful, dashing down these mountains!

On our way back there was a great and impressive array of paintings to see in Berlin. For the first time, Otto and I saw the Kaiser Friedrich Museum and found many treasures completely unknown to us. And there was also the exhibition of German painters from the last hundred years. It had not yet opened, but we were allowed to go in and look at the treasures, all still leaning against the walls: Leibl, Trübner, Böcklin, Feuerbach, Marées. There were some superb things.

And now we are back home again, where everything is going on as usual.

Is your Hans off on another trip? Put your time to good use. Read a lot and practice your music. Isn't it strange how differently life's pleasures are parceled out? Nothing could make me happier than being alone for six weeks now and again. Well, let each person patiently cope with what has been given.

With love and more love, I am

Your Paula

*To her mother

Worpswede, January 19, 1906

My dear Mother,

And so Frau Rassow has died. I was deeply moved by the death of this great and generous woman. What a thing, to be slowly, slowly and gradually, deprived of the energy of life. And that was something she had in such abundance. She was still a tree and ready to bear more fruit. And this sudden fall!

And stupid, mercenary, flat-footed people go on living.

How can we possibly understand life unless we see it as each person's refinement

of the spirit, one could almost say, of the holy spirit? Some do the refining with greater passion, others with less. But all people, even the smallest, contribute their mite.

Frau Rassow's gifts and the work she produced with them came from her energy and the many battles she fought. She worked hard in fashioning her spirit, and she did it consciously and with willpower. This woman radiated powerful self-discipline, and I valued it very highly. For me, Frau Rassow, of all women in Bremen, was the one I respected the most.

I believe I would have told her that someday. I could have, if she had lived longer, because I feel that the barriers that Worpswede erected between me and the world are now falling.

The simple rustic life that we were trying too hard to lead here was one of the major barriers, and whenever our life in Worpswede came into contact with city life, the superficial differences between them were always colliding.

I also wish that Frau Rassow could have lived long enough to see that I am becoming somebody. That would have been the easiest way of revealing myself to her.

Because I am becoming somebody. How great a person or how small, I cannot yet say, but whichever it is to be, it is going to be something complete. The most beautiful thing in life is the steadfast pursuit of a goal. There is nothing else like it.

If my love for you sometimes seems to be lacking, please remember that what I am pursuing is my own future; and if I occasionally rest, it is only to keep on rushing toward my goal. It is a concentration of my energies on one thing. I don't know whether this is still a kind of egotism, but if it is, it is the noblest kind.

I lay my head in your lap, from which I came forth, and thank you for my life.

Your Child

To Herma Becker

Worpswede, February 5, 1906

Dear Sister,

Just a few quick business matters today. I'm enclosing an entry blank for a competition in *Die Woche*. It might be fun for you to enter the contest. If you want to, fill it out with the few necessary details and then send the slip back to me. I also enclose a swatch of Manchester corduroy; could you buy this material *immediately* so that I can make a blouse? I think two meters will be enough, but it would be better to ask at the store once more. (I think at Bon-marché.) Be sure to let me know how much you spend.

I wonder how you've been spending your time? My intuition tells me things are not going very well with you. But always remember that good times follow bad, whether it is something small or big that is worrying you. Concentrate on your health so you can store up energy to face whatever comes, be it good times or bad.

Things seem to be going the same way for me, too. But we have a long life ahead of us.

I send you sisterly and motherly greetings—soon I'll be thirty years old.

Your Paula

To Paula from her mother

Pillnitz, February 5, 1906

My dear Child,

Did I decipher the message on the flap of your envelope correctly: "Make haste and get there at once"? That is just what I also told my carrier pigeon today, for my letter must be with you promptly on your birthday so that my arms can hold you in a motherly embrace and bring the loveliest of wishes to you and your home for your new year. It was thirty years ago today that you first saw the light of the world in our little house on Schäferstrasse in Dresden-Friedrichstadt. It was storming outside and the Elbe was clogged with ice, bringing floodwater down from the mountains. Torrents of rain alternated with snowstorms, and Father, conscientious as always, could not worry about you and me this time. Instead, he had to spend day and night outside working furiously. The new railroad embankments along the river were beginning to give way and millions were at stake, as well as his reputation as an engineer. We two girls (I was only twenty-three when I had you, my third child) were left alone with a stupid and impractical old nursemaid. I can still see that fat creature as if it were only yesterday. I was nursing you, and the little oil light was burning and sputtering in a water glass. The old woman wanted to warm up her coffee and had overfilled the alcohol lamp, which made the flame shoot up furiously. Huffing and puffing and screeching miserably, "Oh, dear Jesus!" she brought the flaming tea tray to my bed and *I* had to put out the flame. Upset by all this madness and the noise of the storm and Woldi's worried eyes, I became feverish, got an infected breast, and had to be lanced. To make a long story short, it was the only birth that took half a year for me to recover from. Nevertheless, my little hummingbird grew chubby and charming in spite of storms and flaming lamps and plunging embankments. And today she is celebrating her thirtieth birthday.

The other day I visited Father's childhood friend, the wife of Councillor Fraenkel, who, like us, keeps boxes of old pictures up in the attic. She brought down these two photographs of Father and his brother Oskar, taken about 1860 or 1861. I was so struck by the similarity between you and Father; it seemed to me almost a miracle, a resurrection in the flesh. [...]

Worpswede, February 11, 1906

My dear Mother,

Your dear gray birthday letter with its message of motherly love came just on time. All the family's greetings arrived punctually and are now together on my little birthday table. It was so sweet of you.

...I have finished reading a book about Napoleon and women. A remarkable man. The thought that he was still able to love, despite his incredibly active life and considering his necessary ruthlessness, is strangely beautiful. A monumental individual like him often has a rather touching effect on me in human terms. He seems so full of great yearning.

And Father's picture! Yes, I can also see a great similarity between him and us children. And we probably also have it in our characters, except that he was not as relentless as I am. I think I am tougher. It was probably the similarity between me and our very modest father that prevented him from ever having been satisfied with me.

I kiss you tenderly.

Your Paula

To Rainer Maria Rilke

Worpswede, February 17, 1906

Dear Rainer Maria Rilke,

I thank you for saying that you rather like my painting of "the little child." People are happy whenever someone else likes them, especially if there is not too much competition, as in this case. You have brought me the first touch of Paris with this phrase of yours about "liking and approving," and that alone is a great deal. I had almost begun to think that things would never again go so well for me as they now seem to be doing. I feel as if I had been presented with a new life. It's going to be beautiful and rich. If there is something inside me, it is going to be released.

It was so good of you to inquire about the various exhibitions for me. I thank you. I do not at all want to try for the Salon; the Indépendants next year. By that time I will probably have better things.

Will I be seeing you here before I leave? I really hope not. The ground is burning a little beneath my feet. But I'll stay here until the end of this month so as not to upset my family. They are getting ready to leave for Rome. Later, when we are apart, will be the best time to come to an understanding with them. Or not.

I wonder if your friend Norland [sic] could do me a little favor and ask around to find out if one of his colleagues might be selling any household furnishings? That often happens at the Académie and is a good way to get things at half price. This is what I need: a *sommier*, an easel, a table, and a chair, not too ugly. I'll

leave it entirely up to you to decide whether you want to approach the gentleman about this. But maybe it is asking too much.

I look forward to seeing you again soon, either during or after your tour. I look forward to seeing Rodin and a hundred thousand other things.

And now, I don't even know how I should sign my name. I'm not Modersohn and I'm not Paula Becker anymore either.
I am
Me,

and I hope to become Me more and more. That is surely the goal of all our struggles.

Tuesday, February 20

I am now leaving Friday night and shall arrive in Paris on Saturday. Write a line to 29, rue Cassette, where I plan to stay, and tell me if I can see you before you leave. I am so wrapped up in my thoughts that I simply forgot to mail the letter I wrote you on Saturday. But now I can greet you once more with this little postscript.

Herma Becker to her mother

February 22, 1906

Today is brother-in-law Otto's birthday. The good fellow will be happy to have his wife with him this time and not hopping around Paris the way she did last year. That wounded him deeply. Paula seems to have given it up for now. Being in her thirtieth year will give her a good deal to think about; she had set thirty as her deadline for her painting. [...]

*Journal

Paris, February 24, 1906

Now I have left Otto Modersohn and am standing between my old life and my new life. I wonder what the new one will be like. And I wonder what will become of me in my new life? Now whatever must be, will be.

To Otto Modersohn

Paris, 29, rue Cassette
February 27, 1906

Dear Otto,

I am sure you have been waiting for a letter to let you know that I have arrived here safe and sound. I have. I'm staying at this address for the time being, but since it's too expensive I shall move into a studio on Saturday. 14, avenue du Maine. Next week I begin to work at the Académie. In fact, that's when I begin my life. But first I have to begin the battle with Paris. It will be hard, now that I no longer have my cozy domestic surroundings.

I asked Herma over last Sunday. She was very surprised about my sudden trip. She was just here with me a little while ago. Tomorrow Lent begins. It was just a year ago today that we met those notorious Bulgarians. This time we two little women are sitting virtuously and modestly in our rooms. Neither of us feels very much like throwing confetti around. I really don't know what's wrong with Herma. It seems to me her shoe is pinching her somewhere. Perhaps, though, it's just one of those moods I was in when I was her age and one never quite knew what the future held.

—I was in the Luxembourg this morning. Considering the fact that it's the only official French museum for modern art, it's a bit pathetic. It's not here at least that one gets to know modern French art. Dr. Voigt wrote me that he had spoken with you. Did he make the same fine impression on you that he did on me? He said the same thing you did, that I should wait and be patient for the time being. I think that's reasonable and so I will.

Meanwhile I suppose Mackensen probably has been giving his talks for all of you there? It's good for you that something is going on. And now Heinrich Vogeler is coming back again, too.

Best greetings to you and Elsbeth.

Your Paula

To Otto Modersohn

Paris, 29, rue Cassette
March 2, 1906

Dear Otto,

I thank you very much for your dear, long letter. I cannot answer it right now and I really don't want to, because it would be the same answer that I gave you when we were in Worpswede. Your letter has all the same things in it which you have already told me. For the moment let us not even talk about this; please let it rest for a time. The answer, which will come by itself, will be the right one. I thank you for all your love. The fact that I am not giving in is neither cruelty nor hardness. It is difficult for me, too. I am acting the way I am because I know for certain

that after another half year, if I don't finally put myself to the test now, I would be tormenting you again. Try to get used to the possibility of the thought that our lives can go separate ways.

And now, let's not talk any more about this for quite a long time. There is no point to it.

—Naturally things are not going very well for me. Emotionally I was quite downcast when I first arrived here, and I am still not back to work; nor have I found the right place to live. Tomorrow I move to 14, avenue du Maine.

I have seen a beautiful Manet exhibition here at Durand-Ruel. I especially liked the *Man with Guitar,* which we saw illustrated somewhere, and a still life of a rabbit. Then in another room were things by Odilon Redon, but I can't get very enthusiastic about him. I feel there is a great deal of taste and caprice there, but the foundation is somehow too weak. He has many paintings of flowers on exhibit, mostly pastels. The colors have great radiance.

Dear Otto, be a friend and go as soon as you can to Hermann Brünjes. I would very much like to enroll at the École des Beaux-Arts, but I have to pick out six of the best drawings of nudes that I did in Paris and perhaps three drawings I did with Mackensen. They are in the big red portfolio hanging near the window. Would you roll them on a cylinder and send them to me at once (perhaps label the package no commercial value). Thank you very much. Are you beginning to work again? Please do.

Affectionate greetings to you and to Elsbeth and Johanne.

Your Paula

Herma Becker to her mother

March 8, 1906

[...] Paula is very content to be living within her own four walls now, and to be away from the conventional rooming house which depressed her. She has found a studio at 14, avenue du Maine and has already completely settled in. She's bought her furniture, which is to say next to nothing, because the Bulgarian sculptor from last year has very cleverly constructed bookcases and tables for her. She had brought along coverlets, etc., so that she could decorate everything according to her own taste, and we spent a very pleasant evening together yesterday. [...]

**Journal*

March 8, 1906

Last year I wrote: the intensity with which a subject is grasped, that is what makes for beauty in art. Isn't it also true for love?

To Otto Modersohn

Paris, 14, avenue du Maine
March 9, 1906

Dear Otto,

Your many long letters lie here before me. They make me sad. Over and over again there is the same cry in them, and I simply cannot give you the answer you would like to have. Dear Otto, please let some time pass peacefully and let us both just wait and see how I feel later. Only, dear, you must try to grasp the thought that our paths will separate.

I wish so much that my decision hadn't made you and my family suffer so. But what else can I do? The only remedy is time, which slowly and surely heals all wounds—

I am happy for you that you have sold two paintings; that ought to bring at least a little cheer to these difficult times.

I wonder if you have been good enough to mail my drawings to me? I should like to have them here for admission to the École des Beaux-Arts. Even with them it is far from being a sure thing. Everyone says it is a fine place to work and that it is also cheaper. However, in case you haven't sent them off, please don't bother now. They would arrive too late, and I can still enroll in one of the private schools.

I am beginning to settle in here. This past week the weather has been wonderful, warm enough to make one walk on the shady side of the street. It is very beautiful stepping outside in the evening after the drawing lessons and seeing the great city spread out in the blue twilight, punctuated with the lighted streetlamps—

Last Sunday, Herma and I went to a very beautiful concert. They played three Beethoven symphonies. After that I paid her a visit in her "convent." She has a cozy little nunlike cell where she has all the peace and calm she needs for her studying. The meal was very good. The company, naturally, was fairly mixed. On the whole though, I don't get together with Herma very much. She has much to learn on her own, and aside from that I seem to have a depressing effect on her, which is my fault. Next Sunday, however, we are taking a trip to the country.

Dear Otto, I squeeze your hand and send you heartfelt greetings.

Your Paula

To Otto Modersohn

Paris, 14, avenue du Maine
March 19, 1906

Dear Otto,

Professor Modersohn, that sounds terribly grand. But perhaps you like the sound of it; if so, then I gladly grant you the title.

I am really involved in my drawing now and it makes me happy to discover all

the things I can learn here. The folks at the school are so thorough and meticulous, two qualities that I really have to improve in myself. My paintings look so dark and muddy here. I must get much purer colors. I have to learn to modulate. There is so much more that I have to learn, and then maybe I'll become someone. You know that is my goal, the aim of all my wishes and all my work—

From time to time Paris is able to captivate me completely, just the way it used to. In the evenings it is often wonderful, like the most romantic backdrop to romantic plays. At such times it doesn't inspire me to paint so much as it does to go out and do things. On other days I feel depressed, as is natural under the circumstances.

I attend the excellent courses in anatomy at the École regularly, and I am also taking a lecture course in art history. I have even made a heroic vow to spend my afternoons there drawing from the plaster casts. It will be quite some time before I can get into life-drawing class, and I can learn modeling just as well from the plaster casts. But to do that, I have to have an identification card from our German ambassador, and so now here I am again with all kinds of requests that you must not take amiss. It seems that the embassy requires some sort of documents about me. I am afraid that I have stored all my papers at the Brünjes' house. If you happen to have any document at all, please send it to me; in any case you certainly must have the marriage certificate. That will do. II. Please send me the French book on anatomy which is in the bookcase at the Brünjes'. III. I am all out of money. Would you still want to give me some? I had a full day yesterday, Sunday. In the morning I went to Mass at Notre Dame, and then I walked along the Seine to the Jardin des Plantes. Everything here is already beginning to turn green. In the afternoon Herma and I listened to a very beautiful concert, and after that we sat at a café along one of the great boulevards and let the world promenade past us.

My atelier is healthy and bright. It has a few pieces of pine furniture, a large wardrobe, and a cot, very much like at the Brünjes'. It has one big drawback. I can't see the sky because the windows are made of a kind of dull glass.

Now farewell, dear Otto. I thank you for your long letter and for sending my drawings, and also Elsbeth for her pretty embroidery. Many greetings to you, Elsbeth, and Johanne.

Your Paula

To Otto Modersohn

Paris, 14, avenue du Maine
April 9, 1906

Dear Otto,
I have just finished reading your letter. It moved me deeply. I was also moved by the words from my own letters which you quoted. *How* I loved you. Dear Red, if

you can do it, please hold your hands over me for just a little while longer, without condemning me. I *cannot* come to you *now*. I *cannot* do it. And I do not want to meet you in any other place, either. And I do not want any child from you at all; not *now*.

Much of you was once a part of me but has now disappeared. All I can do is wait to see whether it will return or whether something else will come in its place. I have been considering over and over what the best thing to do might be. I feel so insecure about myself since I have abandoned everything that was secure in me and around me. I must stay for a while longer out here in the world where I can be tested by others and can test myself. Will you send me, at least for the immediate future, one hundred and twenty marks each month so that I can live? In fact, for this month I even ask you for two hundred marks because I have to pay my quarterly rent on the fifteenth. I have given up my plan to go to Amrum. I'll remain here in Paris as long as I can hold out. For the time being, I do not want to work on my own, but at a school. I've rented my atelier at the Brünjes' to Fräulein Wehl from May 1 on, for twenty marks a month (ten marks for the furnishings). I simply wrote her that I would not be spending the summer in Worpswede.

Thank you also very much for the anatomical study and the yellow coltsfoot from the brickyard. In fact I thank you for everything that you are doing for me. But you know that, and you know me well enough to know that I am not bad and heartless. It just happens to be a *Sturm und Drang* period which I have to get through, and there is no way to avoid hurting the people closest to me. It hurts me to cause you all this pain and suffering. Believe me when I say it is not easy for me either. But I must fight it through, to one exit or another—It has begun to be really beautiful here now. Probably where all of you are, too. I've seen wonderful Courbets; I'm sorry that he is now the latest mode. I think he is greater than either Manet or Monet. There was a colossal still life with hollyhocks, in every conceivable color, with a female figure in it. It was magnificently painted.

You certainly put a bee in Herma's bonnet by suggesting a trip to Brittany. The idea made her very happy. She is leaving this evening. I will then meet her somewhere during the Easter holidays, probably in Saint-Malo. It was so sweet of you to think up the idea. Would you perhaps send me my money right away so that I can pay the rent before I leave on the trip?

Stay close to Elsbeth and to your art.

<div align="right">Your Paula Modersohn</div>

To Otto Modersohn from Carl Hauptmann

<div align="right">

Schreiberhau
April 15, 1906
Easter Sunday morning

</div>

Dearest Otto Modersohn,
Let me say to you in haste,

<div align="center">

Be proud and hard!
What you are is what you are.

</div>

The brave man bears his wound in silence and laughs outwardly.

If you are cold, your wife will become warm.

At present your wife thinks she is hurting you. And for that reason she finds a certain pleasure in having left you.

If you accept that, the anger that your wife feels will dissipate and she will find the opportunity to come to her senses.

Perhaps then you will be prepared to be generous enough to overlook her offenses.

And in addition, someone so beset by restless yearning without goal is also more than ready to pursue adventures. Is that not a constant danger for a man striving upward in his demanding work! In our suffering many things first show us their dark side and only later reveal a shining face. Just set your mind in that direction—even if only as an experiment. At such times it is good to study the sentimental value of things and people in an objective way.

You are probably thinking that what I am saying is hard. But one must be hard when one sees another person's ego being consumed by wild flames. Otherwise one is threatened with destruction by such a fire from without. You should then burn from within and show the world that your inner fire is something completely different and holy, and not just the petty, perilous fire of a wavering egotism. Action and work, that is your life. That is more than egotism. That is what you belong to. And whoever is not with you is against you. Be strong and clear-headed!

In faithful friendship, and in the full hope that your wife may still come to her senses in time, always yours,

<div align="right">

Carl Hauptmann

</div>

To Rainer Maria Rilke
[Postcard with a view of Mont-Saint-Michel]

<div align="right">

[Postmarked April 19, 1906]

</div>

Dear Rainer Maria Rilke,
I've had a beautiful Easter holiday at Saint-Malo, and yesterday was introduced to the famous *Ommeles* and chicken on Mont-Saint-Michel. Today, back to Paris. I greet you.

<div align="right">

Your Paula Becker

</div>

To Carl Hauptmann

> Paris, 14, avenue du Maine
> April 22, 1906

Dear Dr. Hauptmann,

Please keep on liking me, in spite of everything. I cannot do otherwise. I put myself *totally* in Otto Modersohn's hands and it has taken me five years to free myself from them again. [...] And if he is now suffering, well then, for my part I have truly suffered too. [...] He is [...]repressed in every single way. And in spite of that, those were probably the five most beautiful years of my life, the ones I spent in Worpswede. And what will come now? I am writing you only these few words because I am incapable of expressing myself in writing about our relationship. If only I could see you I would open myself up to you as if you were my father confessor. But what would be the use of opening up? My love for him is all over.

I beg you from my heart not to condemn me because of your friendship for Otto Modersohn. In spite of everything I am a human being who is struggling for happiness, even if appearances are against me.

With heartfelt feelings for you and your dear wife,

> Your devoted Paula Modersohn

I am not getting along in Worpswede in my relationships with other people either. It is too confining there for me.

To Otto Modersohn

> Paris, 14, avenue du Maine
> April 25, 1906

Dear Otto,

Let me tell you about our trip to Brittany. It turned out to be even more beautiful than we expected. I thank you many times for your inspiration. At first I didn't even want to go along, because I thought it would be really unnecessary, but finally decided to go in order not to disappoint Herma. And now we are back, both of us very fresh and full of vigor and burned brown by the sun. I now have beautiful feelings and thoughts about the art which I still hope to do. This country of France is really a blessed land. Traveling to Saint-Malo, we passed through the most fertile orchard landscapes, with apple trees set in the midst of tall, dark-yellow broom of a sort that I never saw at home. All around, there are glorious, huge, light-yellow primroses, sprouting everywhere. As one enters the suburbs of Saint-Malo it's something of a letdown to find oneself dawdling along for twenty minutes past railroad sheds and billboards toward a very small, very smelly, boring city with tall buildings. But then, when you unexpectedly find yourself outside the city, walking along the narrow fortifications, suddenly the immense sea lies at

your feet with its rocky cliffs and rocky islands; and everywhere you can make out beautifully proportioned old military forts. Their silhouettes are wonderful to behold. We spent nearly an entire day on the seawalls and little islands, and we clambered around the cliffs and laughed when the sea sprayed our faces. During the following days we took a few lovely trips. Herma is splendidly ambitious. She invented all kinds of clever, well-thought-out plans which I usually had to curtail, because they began to be a little too much for our endurance. Have you any idea of how mild the climate is on Jersey and Guernsey? And the area right around Saint-Malo has the same climate, a southern lushness, roses in full bloom, stock, and an abundance of blossoming wallflowers. It is anything but the sober Brittany that Cottet paints. His part of the country was a little too far for us and would have cost that much more to get to. As it is, Saint-Malo is ten hours from Paris, the same as the trip from Bremen to Dresden.

The money you sent arrived in plenty of time; I was happy to be able to pay the rent for my atelier before we left on our trip. Now, would you please be so good as to send me one hundred and twenty marks on the fifteenth of each month? It's difficult for me to have to ask you for it. But if you plan to take care of me for the immediate future, then please do so without my having to ask you for money every month.

It is very, very important for me that you go back to your work. Accomplish great things in your art; there is greater satisfaction in that than in anything else life can give you. Before my trip I visited your compatriot, the sculptor, Hoetger, whose work made such an impression on me in Bremen. He's working on a wonderful reclining nude, simply monumental. The small head in Bremen is of his wife. Both give the impression they've suffered greatly from their straitened circumstances. He's probably in his late thirties. The Indian photographs interested him enormously. They have asked me to come to tea with them again later this week. As for the rest, I'm pursuing my work industriously at the Académie and in the afternoons I work by myself.

This afternoon I plan to write to Fräulein Wehl to find out when she is planning to get to Worpswede. I think it's at the beginning of May. But she is to let you know precisely when. Please ask the Brünjes to set aside some space for me in my room to the left of the door where my paintings and studies and sketches can be stored. Please, can you be present when the old dear puts them away to make sure she doesn't treat them too barbarously? I haven't yet congratulated the good Brünjes family on the arrival of their heir to the throne. Just tell them that I'll write soon and that I have sent a pair of [small] shoes. I think there should also be a new box of Wurm oils which arrived after I left. Would you be a friend and send them to me here?

This week Kurt will be coming home, and the week after that, Mother. I'm happy they have been able to enjoy a lovely trip without worry. I haven't written them a word.

And, dear Otto, be brave and strong, and work. You must remember that some way or other every difficult period comes to an end. Say hello to Elsbeth. I send the two of you my very best.

<div align="right">Your Paula Modersohn</div>

Have you seen anything of Overbeck?

To Bernhard Hoetger

<div align="right">14, avenue du Maine

April 27 [1906]</div>

My dear Herr Hoetger,
I hope your exhibition in Cologne was a success and that it made your trip enjoyable. It is wonderful to hear that I may come to see you again. Let me know by mail the day and the hour that would be best for you. I wonder how your "Frau Saga" is progressing? Recently I find myself thinking a lot about her and that great arch formed by her arms.
 With the warmest regards to you and your wife,

<div align="right">Your devoted Paula Modersohn</div>

To Bernhard Hoetger

<div align="right">Paris, May 5 [1906]</div>

Dear Herr Hoetger,
That you believe in me is the most beautiful belief in the whole world, because I believe in you. What good is other people's belief in me if I don't believe in them? You have given me the most wonderful gift. You have given me myself. Now I have courage. My courage was always behind barricades and didn't know which way to go. You have opened the gates. You are a great benefactor. Now I have begun to believe that I shall become somebody. And when I think about that, I weep tears of joy.
 I thank you for being on this earth. You have done me so much good. I was a little lonely.

<div align="right">Your devoted Paula Modersohn</div>

Your sister-in-law is simply beautiful.

To Herma Becker
[Postcard]

Paris [Postmarked] May 5, 1906

D[ear] H[erma]. Otto has sold five paintings, so write to him right away that we need money. When you come and if you have a pair of old boots for a model, bring them along. Took the *portemonnaie* to H[oetger]'s. Saw a very beautiful girl there. A rich life. Work. Couldn't sleep all night, kept singing to myself. Child, child, if only I can become someone.

To Herma Becker

Paris [Postmarked] May 5, 1906

D[ear] H[erma]. If you can, take your charges on their walk early in the morning. In the afternoon I want to do a study of you. I'm so consumed by my painting now. Maybe we'll go out in the evening. Y[our] P[aula]

To Paula from Carl Hauptmann

Mittel-Schreiberhau
May 5, 1906

Dear Frau Modersohn,
I had the most vivid dream last night about a good and peaceful return to Worpswede. May my dream be fulfilled! May that star once again watch over your old home, and may the wellspring of healthy, clear feelings flow again for that lonely, creative life which you, either from ignorance or weakness, call Philistine.

You speak of love! It has a thousand masks. The one you call love, who knows if nothing more than a straw doll is hiding behind it? But Life will instruct you in time if a healthy feeling has not already taught you about it. You have known many a tragedy. By the end of the play Lear, too, knows where love was, but he looks for it there in vain. You must also be careful!

I will continue to hope!

Your,
Carl Hauptmann

Herma Becker to Otto Modersohn

Paris, 87, rue de Tocqueville
May 6, 1906

[...] Right now Paula is in very high spirits because of her work. Höxter [Hoetger] looked at her things and was extremely impressed by them. "Magnifi-

cent, very fine," etc., he kept repeating things like that, very softly. And then he would encourage her, would give her that famous, sometimes necessary, push needed for painting. And now her little soul is liberated. I just happened to drift in at the time and watched and listened and rejoiced at seeing Paula's big eyes, so eager and humble, drinking in this revelation. Yes, now she is firm as a rock and has faith in herself and is working. New work simply pours from her hand. This very afternoon I have to go over and pose for her for a few hours. She won't even rest on Sunday. It's nothing but paint, paint, paint—something will come of this!

This remarkable discovery by Höxter [Hoetger] and his wife and her beautiful sister is really a fabulous piece of luck. They're all difficult people and they are all astonished at their mutual and quick agreement. Amazing how one's star sometimes leads us down winding paths! We must abandon ourselves to it and not ask where they lead. [...]

To Otto Modersohn
[Picture postcard of Côte d'Emeraude, Rotheneuf.
Les Rochers Sculptés]

[Receipt postmark:
Bremen, May 8, 1906]

D[ear] Otto. I'm getting there. I'm working tremendously. I believe I am getting there. Would you send me by return mail the Wurm oil paints which are at the Brünjes'? Please give notice about my atelier. I'm very happy about your success. How beautiful for you.

Hearty greetings to you, Elsbeth, and Johanne.

Your P.M.

To Milly Rohland-Becker

Paris, May 1906

I am becoming somebody—I'm living the most intensely happy period of my life. Pray for me. Send me sixty francs for models' fees. Thank you.

Never lose faith in me.

Your Paula

[On a loose sheet of paper]

[Ca. May 8, 1906]

Marées and Feuerbach.

Marées, the greater. Feuerbach took on a conventional form of expression.

Great style in form also demands a great style in color.

Zola says in *L'Œuvre*: Delacroix is in the very bones of us poor realists.

To Paula from her mother

Bremen, Schwachhauser Chaussee 253
May 8, 1906

My beloved Child, couldn't you have come to your mother once during all your difficult time? How often I looked for you and called out your name, and then thought I must leave well enough alone and not force you to talk about it. I had no idea how really heartsick you were, otherwise I would have let Rome be Rome a thousand times and come directly to you. The letter from Otto, which I am enclosing, justified your departure in such a gentle way that I had nothing to say about it then and thought, if the two of them are in full agreement about this then surely it must be all right. It did not even enter my mind at the time that something was seriously disrupting your relationship to one another.

[...] You poor child. In your solitude you must have piled up every disappointment, every wound, until you had built a pyre, and one day it just went up in flames! I cannot tell you how difficult it is for all of us to see how unhappy the two of you are. When I say that I was so looking forward to coming home, I didn't mean to Bremen, where in any case my most valuable friends are already dead; no, I meant to Worpswede. It was your house, your garden in blossom, the way you would welcome me there in your white dress, and your beloved shining eyes which can give so much blessing and sunshine. I have never known another person in my whole life who possesses the power to give such a warm feeling to her home, her table, and her guests, or one with such an abundance of life as has been granted you. [...] And for all that, your fire and light suddenly went out and you had nothing more to bestow on others. Oh, Paula, why didn't you come to one of us, to me, to Kurt, to Milly — and let yourself be loved and cared for awhile until you were better? There comes a time of inner poverty and terrible need, even to people with the richest resources. [...] You must have suffered dreadfully during these months, my Paula. Your body and your soul must be ill. May I come to you? Just say one word and in two days I'll be at your side.

Your husband is enduring this difficult and taxing time in a singular way; I couldn't have imagined such a thing. He has dragged your oil studies into his atelier and has surrounded himself with your still lifes. Heinrich Vogeler wants to buy your "Apples" for a hundred marks, but Otto can't bear to part with their splendor. He got your oils from the Brünjes and is painting the most remarkable things with them, pictures of stuffed birds and old jugs, and he's putting your still lifes next to them to compare whether he can duplicate the effect of your colors.

You wrote him about the stern and meticulous drawing technique of several Frenchmen. His two most recent Worpswede landscapes, painted from nature, seemed to be drawn and then painted as though with a compass and look like two mathematical proofs.

I rushed out to Worpswede right away. My heart compelled me to go. It was enchanting to arrive on one of the most beautiful of spring days.

Otto rode back to the city with me and stayed at the house for three days. His great and mighty love for you is very moving. It fills his whole being. He often says to himself, "Oh, when I have her back again, the things I will do!" It was almost as if he were wasting away and passionately clinging to us. "She will have everything. No more desolate winters. She shall have joy; she shall have Paris—everything, everything, if only I can have her back again!"

In front of my little house, right in the midst of the streetcars' noise, a nightingale is singing such as I have never heard. [. . .] Otto says that it is the male who is singing to the nesting female so she will not lose patience. We were unable to carry on a conversation because of the power of this night song. As we listened, now and then Otto, or Kurt, or Milly, or I would say, "If only Paula were here with us." The full moon was shining and all the trees were in blossom. If only our Paula were here.

Your faithful Mother

To her mother

Paris, 14, avenue du Maine
May 10, 1906

My dear Mother,
You are not angry with me! I was so afraid you would be. And that would have made me sad and hard. And now you are so good to me. Yes, Mother, I was not able to endure it any longer. And I shall probably never be able to endure it again. Everything was so confining and becoming less and less of what I needed.

I am beginning a new life now. Don't interfere with me; just let me be. It is so wonderfully beautiful. I lived the past week in such a state of excitement. I believe I have accomplished something good.

And don't be sad for me. Even if my life might not lead me back to Worpswede again, the eight years that I spent there were very beautiful.

I, too, find Otto touching. That, and the thought of all of you, were what made my decision especially difficult.

Let us calmly wait for time to pass. It will bring what is right and what is good. And no matter what I do, you must firmly believe that I do it with the desire to do the right thing. Tell Kurt I take him by the hand. He has been so good to me. There is so much of Father in him for me.

And you, dear Mother, stay close to me and give your blessing to what I am doing.

<div align="right">I am your Child</div>

To Otto Modersohn

<div align="right">Paris, 14, avenue du Maine
May 15, 1906</div>

Dear Otto,

I have been so hard at work that I've neglected writing you for what I'm afraid has been a long time. These last two weeks have gone very well for me. Night and day I've been most intensely thinking about my painting, and I have been more or less satisfied with everything I've done. I am slackening a little now, not working as much, and no longer so satisfied. But all in all, I still have a loftier and happier perspective on my art than I did in Worpswede. But it does demand a very, very great deal from me—working and sleeping in the same room with my paintings is a delight. Even in the moonlight the atelier is very bright. When I wake up in the middle of the night, I jump out of bed and look at my work. And in the morning it's the first thing I see—

Well then, Hoetger visited my atelier and tells me that I have great talent. He told me such good things, and everything he had to say he said with such a simple goodness. It's remarkable! Of all the pieces at the exhibition in Bremen, his were the ones that impressed me most. And now we seem to understand each other so well. It seems to me as if I'd known him for a long time. But no reason for jealousy. Last year he married a woman he loves more than anything. The little head in Bremen is of her. He dresses her to his taste and she, in return, is his heaven. She is utterly devoted to him. I feel very happy at having met these people.

Dear Otto, I thank you many times for sending my paints, and I thank you many times for telegraphing the money. They wouldn't give it to me for three days. After I had been at the post office with all my documents I finally had to ask my concierge and her husband to come along and vouch for my identity. Fairly primitive, wouldn't you say? This is the way I thought I would use the money: half of it to pay for the trip to Brittany, the other half for living expenses beginning on the fifteenth of May. Is that all right? I'm very happy for you that my family is back in Bremen. You won't be so alone that way. How far have you progressed with taking care of all my painting things? It certainly must have been a lot of work. I thank you so much. Many greetings to you and Elsbeth.

<div align="right">Your Paula Modersohn</div>

If it is convenient, could you send me the Knackfuss volume on Worpswede sometime?

Compositional studies, Paris, 1906

Sketch of the artist's last studio in Paris, showing paintings from the year 1906

To Heinrich Vogeler

<div align="right">Paris 14, avenue du Maine
May 15, 1906</div>

Dear Heinrich Vogeler,

Please don't take it amiss if I write you how content I am with my work and how happy I am in my freedom now. And please continue to be my friend, no matter what turns my life may take. I'm hoping that things will get better and better, and that *I* shall become better and better—

I have just a little request to make of you today. Don't you have one of those old, round Worpswede folding tables? I was speaking to the sculptor Hoetger about them. He would like very much to have one built for his summer place. Would you do me a favor and send me a little sketch of your table?

I wonder what you are doing now and when I shall see you and Frau Martha again? Whenever I hear a waltz being played I can't help but think of you both so strongly—and at other times, too, of course—

These past weeks I have been working harder than I ever have in my life. I think I'm getting somewhere. And that makes me feel wonderful—this is only a note. Quite soon I'll write you a long and proper letter. Please thank Frau Martha very much for hers. Whenever she wants to write me another, tell her that I'm always so very happy to hear from her. The chestnut trees in St.-Cloud yesterday were overflowing with blossoms, a scene from Paradise. There is such incredible fullness to life here—how beautiful.

Greetings to everyone and everything in your white house. I am your

<div align="right">Paula Modersohn-B.</div>

To Martha Vogeler

<div align="right">Paris, 14, avenue du Maine
May 21, 1906</div>

Dear Martha Vogeler,

I was so pleased to get your little letter. I can tell from reading it that you like me, and that's always a good feeling. Yes, we shall remain "family," in spite of everything, even if I'm not with you. I am not sick at all, despite what Otto Modersohn thinks. I am in very good shape and ecstatic about my work. I know that I'm doing the right thing, even though I naturally have sad feelings about Otto Modersohn and Elsbeth and my own family. They are now going through the suffering I went through earlier; only they are not getting anything out of it, whereas I have been having some wonderful experiences up to now. You shall see. Now that I'm free, I am going to make something of myself; I almost think before this year is over. Whenever I think about that, I feel very devout.

—I'm living here in a large, bright atelier. Even without much furniture it makes

a very comfortable impression and has become a little home for me. I love to fall asleep among my paintings and wake up with them in the morning. With faith in God and myself, I'm painting life-size nudes and still lifes. All last week I did not crawl out of my fortress until late in the evening. After working all day wrapped up in oneself, this huge city seems so strange in the evening, as if one were looking at a picture book—it would be so lovely if you and Mining could come here for a week. Couldn't you leave your new horses by themselves for a while? Is Gottlieb back yet? Do come. Paris is even prettier now than in April, because it's greener, lusher. But if you come, come soon, before it gets too warm—

What you wrote me about my oil sketches naturally made me very happy. I love hearing things like that. And if you really want to have these three little things you wrote about, then of course you know how pleased that would make me. Which little girl with the black hat do you mean? Does she have a flower in her hand? If you would give me a hundred marks for the three, that would be perfect. Otto Modersohn is good enough to keep sending me money, but I use so much of it paying my models. If I could only begin now to earn a little bit on my own, I would be so very happy—

May I hope to see you soon? Please come, you won't regret it. Will Mining be good enough to send me the drawing of the table quite soon? Do let me hear from you right away.

Hearty greetings to both of you. I am

Your Paula Modersohn

I wrote this letter right after I got yours and left it overnight in my folder. Next day I received Mining's letter. Dear Heinrich Vogeler, if you would only come to Paris with your little wife and if we could only have the opportunity of talking together, how lovely that would be. Then you could tell me all about what you are painting now. But if your two roans just won't permit it, then maybe it will work out next spring. And then, of course, we would have even more to tell one another. In any case, continue to be good to Otto Modersohn. For the second time.

Your P.B.

Hoetger is working now in a very severe style, different and more beautiful than the things you saw in Dresden. Both you and he think alike about Rodin.

*Journal

May 26, 1906

When I read Otto's letters they are like a voice from the earth. And I seem to myself like someone who has died and now dwells in the Elysian Fields and hears this cry from the earth.

Herma Becker to her mother

May 26, 1906

[...] Paula is continuing to work very hard and is finding satisfaction in it. The Vogelers want to buy a few of her studies and that pleases her, and her desire to have accomplished something by the time she is in her thirtieth year seems to be happening for her. If only so many people didn't have to suffer because of it!

Herma Becker to her mother

June 8, 1906

Otto will tell you everything. I cannot do it. This past week was very upsetting for all three of us, and I feel as if I had been at hard labor. It is good that Otto is leaving now and that he understands there is nothing to be done at present. We talked about all sorts of things and people, only to return again and again to the underlying problem; one could sense it lurking there even during the most trivial conversation. Otto was touchingly decent, tried everything, promised anything. Paula naturally knows all about that as well as we do, but nevertheless! What Kurt says I, too, feel very strongly: how unfair it is for so many people to have to suffer on account of one, that such power should be given to *one* person. The longer this stretches out, [...] the harder it will be, because it will become almost a point of honor for her to accomplish what she is about. And for her to have to come back to all the people who will suddenly stare at her severely in judgment and whose sermons she has heard before is a very difficult thing indeed. I wonder if it was right of Otto to tell her all of it so openly, so that suddenly she saw her home as if it were a joyless vacuum; I don't know. I do think I know Paula in many respects better than Otto, who always judges so subjectively. [...]

To Carl Hauptmann

Paris, 14, avenue du Maine
June 10, 1906

My dear Herr Dr. Hauptmann,
One must first listen to both parties before one makes a judgment. You did not do that. I hope in the course of time you may get a somewhat better opinion of my womanhood. Time will put all things in their proper light. [...]

But I do not *want* to return to Worpswede and to Otto Modersohn. That is my reason. Even with this reason, and it truly is a reason, it still doesn't make my position easy and surely I am not so frivolous and heartless that it doesn't hurt me to have to reject so much tender love.

Continue to like Otto Modersohn, and try not to reject me completely; there are many others who will take care of that.

With my regards to your wife,

<div align="right">Yours truly Paula Modersohn</div>

To Otto Modersohn

<div align="right">Paris, June 30, 1906</div>

Dear Otto,

The freight package arrived a week ago, and I have been meaning to write you a letter for some time. I know that you are waiting to hear from me, but it seems that something always interfered. I must begin with thanks for many things. First of all, for the trouble that the package must have caused you. I know how you hate wrapping things. And then, I thank you for your letters, and for the photograph of the *Schützenfest*. And finally, for the money.

After you left I unfortunately became very ill. I'm still not feeling as well as I did before Whitsuntide. But I am a good deal better now, and for a whole week I've been able to do some proper work. At the moment, that is the most important thing for me. The weather is still quite good. Even after the occasional hot day or two, it cools right off again. I think I want to stay here until August, and then I'll go to the country somewhere. Where, remains to be seen—either to Brittany or maybe simply stay in the outskirts of Paris. But before then, I want to make some progress with several paintings. As a matter of fact, I'm in the midst of tormenting myself about them right now.

—Your still lifes amuse me greatly, mostly the little one with all its humorous details. It seems to me that you have the knack with Wurm tempera. The funny thing is that I have now tried painting in oil, and discover that it also has its advantages. I took your things over to the Hoetgers who were very interested in them. They were particularly impressed by the picture of the man throwing his hat in the air, the nude lying on the slope, and finally the one in which a mother is sitting with her children under an apple tree. Both the Hoetgers have very positive impressions of you now and will definitely visit you in Worpswede sometime. Meanwhile, though, they will be staying in Paris, since he is not making enough progress with his large sculpture, the reason being that his model has been sick. They both continue to be so considerate and charming to me. His wife, who seems very quiet at first, opens up in company and proves to be a human being with very fine instincts. I still cannot help thinking how miraculous it is that I discovered them and that we have become so close so quickly—

Herma is leaving tomorrow evening. I expect that you will be seeing her soon, and then she can tell you much more about what the two of us have been doing together. Last Christmas I did buy the little doll's bed after all. I've decided that I

would like to give it to Ruth Rilke, and have already written C[lara] R[ilke] about it. Maybe Johanne would take it over to her in a free moment.

—I'm very happy that Frau Brockhaus has bought my still life. Unfortunately, I'll have to pass the money right along. When I first got here I borrowed a hundred marks from Rilke, but I'm glad to be able to repay him now. Would you be so good as to send me the Brockhaus money and the July money on the tenth, since I have to pay my rent. I do want to stay in this atelier until I can sublet it.

Are you hard at work painting? The large still life unfortunately arrived slightly damaged. I shall keep it here. Herma will take the other things back to you with her.

Lovely greetings to you all.

Your Paula M.

To Milly Rohland-Becker

Paris, 14, avenue du Maine

My dear Sister,
You spoil me. You are so dear to me. I thank you from the bottom of my heart. If only I could also be as good to you. You must remember that there was a time when I was good to all of you and I know that it will come again. All I can do is promise you over and over that I'm going to try to do what is right. Mother complains that I am not writing. What should I write about? What you all must now do for a while is love me, even if appearances seem to be against me.

I'll always be

Your sister Paula

Journal

July 20, 1906

The fleas of Paris. They're so quick and clever that one is lucky just to catch a glimpse of one. One has long since given up any hope of catching them.

To Heinrich Vogeler

Paris, 14, avenue du Maine
July 30, 1906

Dear Heinrich Vogeler,
Everyone tries in one's own way to become someone. I'm trying to do that here in this big city, and yet I share your opinion completely. Yes, I really should be

spending the summer there in the country, painting the local people out-of-doors. But I hope to have many more summers in my future, when I can do just that. For the present, and as long as it is possible, I want to stay close to Hoetger. Even though he is a sculptor, he has wonderful things to tell me about color. He, too, wants to begin painting, whenever he can get back to the country—big things, maybe decorative things, but also powerful, he says, maybe something on the order of Marées.

My moods change often these days. Sometimes my art goes well, and that makes me happy. Sometimes it seems a bitter struggle. Right now I'm trying to work longer on each painting. That seems to me the only way to get anywhere. The only trouble is, that gives me too much of an opportunity to bungle the whole thing—

Thank you for saying that you want me to remain part of the "family." I hope and believe that no matter where and when I see you and your wife again, we shall be happy with one another. Things are sad now for Otto Modersohn. I know it. I have written him that as soon as his pictures are finished for the Gurlitt exhibition, he should come here and try painting out in the countryside somewhere. Then we shall see what we still have to give each other. No matter what, there will be a decision in the fall—

Try to see if you can pry the little still life out of him. I would be very happy thinking of it in your home. Maybe at the same time you can talk to him about the other two little pieces that you want to exhibit at Franz's. It seems to me, though, that they are still too incomplete. That decision I leave totally up to you. How nice to hear about the progress with their art gallery. My hearty greetings to Franz and Philine. And nice, too, that you are so hard at work, and that you finally have your clay pit. I'm certain that something wonderful will come of that. How does little Martha look now? More like Mikelies or more like Bettine? How they must enjoy horseback riding now. Sometime you must send me photographs of them on horseback—or even on foot. Either way, I should love to have a photograph. I have such pretty ones of your wife, but also one of you where your eyes are squinting.

My very best to the two of you. In friendship,

<div align="right">Your Paula Modersohn</div>

I owe you money from last year for a pair of Grünhagen shoes. Do you still have the bill, by any chance? Please just deduct the money from the hundred marks.

<div align="right">July 31, 1906</div>

It's suddenly so terribly hot here that I want to go to the country. I hope I can manage it on your hundred marks. Please don't think I'm being rude if I ask you to send it to me soon.

To Rainer Maria Rilke

Paris, 14, avenue du Maine
July 31, 1906

It is suddenly so terribly hot here that it's enough to make one dizzy. If you have discovered some nice place there, then I'll come.
 Best greetings to the two of you.

Your Paula — — ?

To Otto Modersohn

Paris, 14, avenue du Maine
August 3, 1906

Dear Otto,

Now the hot days have come that they say Paris is supposed to have but which, fortunately, I had never experienced until now.
 The fifth. I had to break off because the Hoetgers came. It was just about the most sultry evening of my life. The air was charged with electricity which then finally, at the very end of the evening, discharged itself in a series of thunderstorms. Since then the air is wonderfully fresh again, and my decision to leave Paris as soon as possible has weakened. Maybe I'll settle down somewhere in the outskirts and have models come to me from Paris. Recently I've been very happily at work again. Today I began the portrait of Frau Hoetger. The woman interests me, and I like her more and more. There is something very grand about her, and she is quite magnificent to paint. If only I can get something of what I sense about her into my picture. The Hoetgers remain just as affectionate and considerate toward me as ever. Recently they took me with them to the country for a few days. It was very beautiful and stimulating. Frau Hoetger's sister looked very beautiful in a white, closely fitted dress. I couldn't keep my eyes off her. Hoetger has a lucky life with two such models close at hand.
 — You have probably heard from Basel that Hans was here on Sunday. He was charming and dear, the good fellow. He even sent the money to visit Milly one fine day, and I'm going to do that when I can fit it into my working schedule — I have received a very sweet letter from Kurt but haven't answered it yet. Please thank him for me.
 If writing letters used to be difficult for me, it's even harder now than before.
 Are you doing some good things for Gurlitt?
 Painting is beautiful, only it is very, very difficult.
 One must only believe in oneself; that is the way one can produce something. I greet you affectionately.

Your Paula M.

To Heinrich Vogeler

> Paris, 14, avenue du Maine
> August 12, 1906

Dear Heinrich Vogeler,

I was happy to get my money, and I hope you are getting some pleasure from the apples. I still have not gotten to the country, but I might yet. At the moment, I'm painting Frau Hoetger's portrait. She can look absolutely magnificent, and grave; with an enormous crown of hair, blond, splendidly shaped—But what about the Grünhagen shoes? —

Really, the only point of this note is to tell you that I've received the money. And that I like the two of you very much. And that you must keep on liking me, too. It should have nothing to do with my relationship to Otto Modersohn. Basically I am a good chap, no matter how stupidly I may act sometimes.

One person lives this way, the other that way, each of us as decently as we possibly can.

When all is said and done, if people have something in them, then they can do what they want, and everything will turn out for the best. I hope that is true in my case and believe that it is; and that gives me peace.

Hearty greetings to you both.

> Your Paula Modersohn

**To Milly Rohland-Becker*

> Paris, 14, avenue du Maine
> August 12, 1906

Oh, dear Sister, don't torture yourself and me. I'll come to you, but I don't know when. Besides, I am more or less morally obligated to Hans to come because of the travel money he sent me.

The heat wave is over now. But even if it were still going on, why worry about a little bit of heat? You mustn't be impatient in your love. Let things take their own good time. Everything will turn out all right by itself.

"The struggle for strength," that all sounds so dramatic. One simply does what one can and then lies down to rest. This way one will accomplish something one day.

Guilty or not guilty. One is simply as good or as bad as one is. There is little point in trying to change oneself by fussing about. Find your path and pursue it in a straight line. I think that, by nature, I'm a good person; and even if I do something bad now and again, that's only natural, too.

Perhaps all this sounds hard or conceited to you. Some people simply think one way and others in another way. The main thing is to think consistently and with one's whole being.

Once one has realized that there is something "to" another person, as you do of me, then one must calmly leave that person alone in such a situation, like the one I am in now, and trust that person.

Yes, you can write me whenever your little guest room is empty. If it's empty now, I'll come—even if Tony is there and camp on the sofa.

Just now I'm painting a portrait of Frau Hoetger. In a few days she won't be able to sit for me anymore. Perhaps I'll be coming soon.

Greetings to you and your dear Hans.

<div style="text-align: right">Your sister Paula</div>

To Otto Modersohn

<div style="text-align: right">Paris, 14, avenue du Maine
September 3, 1906</div>

Dear Otto,

The time is getting closer for you to be coming. Now I must ask you for your sake and mine, please spare both of us this time of trial. Let me go, Otto. I do not want you as my husband. I do not want it. Accept this fact. Don't torture yourself any longer. Try to let go of the past—I ask you to arrange all other things according to your wishes and desires. If you still enjoy having my paintings, then pick out those you wish to keep. Please do not take any further steps to bring us back together. It would only prolong the torment.

I must still ask you to send money, one final time. I ask you for the sum of five hundred marks. I am going to the country for a while now, so please send it to B. Hoetger, 108, rue Vaugirard. During this time I intend to take steps to secure my livelihood.

I thank you for all the goodness that I have had from you. There is nothing else I can do.

<div style="text-align: right">Your Paula Modersohn</div>

**To her mother*

<div style="text-align: right">Paris, 14, avenue du Maine
September 3, 1906</div>

My dear Mother,

I know I have caused you much suffering this summer. I have been suffering, too. There is no way to spare all of you.

Mother, I have written Otto and told him that he should not come at all. I am now going to take steps to secure my livelihood for the immediate future. Forgive the troubles that I am causing all of you. I cannot do otherwise.

I am going to the country for a while. I'll now try to write you more often again. Do not take any steps; you can no longer stop me from what I am doing.

Your Paula

I love you all so much even if, at the moment, it may not seem so.

To Otto Modersohn

Paris, 14, avenue du Maine
September 9, 1906

Dear Otto,
My harsh letter was written during a time when I was terribly upset. [...] Also my wish not to have a child by you was only for the moment, and stood on weak legs. [...] I am sorry now for having written it. If you have not completely given up on me, then come here soon so that we can try to find one another again.

The sudden shift in the way I feel will seem strange to you.

Poor little creature that I am, I can't tell which path is the right one for me.

All these things have overtaken me, and yet I still do not feel guilty.

I don't want to cause pain to any of you.

Your Paula

**To Milly Rohland-Becker*

Paris, 14, avenue du Maine
September 16, 1906

My dear Sister,
Please, don't ply me with any more gold just to make me write to you in return. I thank you, of course, over and over again, for your goodness. But now you must start saving for Christmas and all kinds of beautiful things. I send you a kiss, and don't send me any more money. I have enough for the time being. The holidays with you in your lovely Amorbach are like a dream to me. Now I am here again, living my life and striving on. When I think back to the two of you, I am so happy that you keep things on an even keel. I think you are intelligent and reasonable. Stay that way. Everything good is difficult. I'm worried, however, about Hans's fever. Take care of it, both of you, please. Be careful about what he eats. And read over again what Nietzsche has to say about cooking. Hans also eats bread when it's still too fresh.

Otto will be coming to Paris after all. Hoetger preached to me one whole evening about it. Right after that I wrote him to come. You seem to mistrust the Hoetgers a little. They don't deserve it. They are better than many others and treat me as a

friend. Life has, of course, made me a little cautious, too, and so naturally I have yet to make a final judgment about them. But when does one know other people completely? That's the eternal question: "What is Truth?" And it appears to us every day in a different guise!

I thank you for all your love. Keep loving me, but without the gold. Write me a little note from time to time and let me know how you are. That is the main thing right now.

Loving greetings to you and Hans.

<div align="right">Your Paula</div>

And what about your moving? Should I help? Tell me honestly if you think you could use my help.

To Otto Modersohn

<div align="right">Paris, 14, avenue du Maine
September 16, 1906</div>

Dear Otto,

Today, a few practical questions about your stay here. Should I rent an atelier for you? If so, we must do it right away since this is the time everyone comes to Paris. Approximately when do you think you'll be here? It seems to me that you would be much more comfortable in a studio than in some dirty *chambre garnie.* In that case you will probably want to send some things ahead by freight, bed linen and such. And I still have some things at home that I could use, most of all my beloved feather quilt.

The Hoetgers are going to be spending the winter here, and I hope that you and he will become friends. Everything he says about you is very kind. It was on his advice that I wrote you that last letter.

This letter is not intended to be a real letter. All I really want to know is how you want to live here.

<div align="right">Heartfelt greetings
Your Paula M.</div>

To Herma Becker

<div align="right">Paris, 14, avenue du Maine
September 21, 1906</div>

My dear Herma,

The day after tomorrow, on your birthday, I shall be thinking of you. I wonder where your twin will be on that day? I really wanted to send you your Notre Dame angel, the one who blows his trumpet so impressively, but alas, it's nowhere to be found. And so I'll simply have to wish you a beautiful new birthday year, without

the angel. May your body and soul grow lovelier and lovelier, my dear little girl. Learn much and learn it well; but also take good care of your health and always try to avoid being harried because it is bad for you, physically and mentally. This is all the birthday letter I can write you this year. I just don't feel like writing anymore. And also, it's enough for you to know that I love you. Give Mother my greetings, and with a kiss to you.

<div style="text-align: right">Your Paula</div>

*To her mother

<div style="text-align: right">Paris, 49, boulevard Montparnasse
November 1, 1906</div>

My dear Mother,
I wish you happiness in your new year, just as much as possible. And I also hope that I shall not cause you much more sadness. Greetings and affection to all of you. At the moment I'm not really very happy. My moving, Otto's being here, and last week's partying with the Vogelers have taken me completely away from my work. But next Monday I plan to begin again. I don't like it when life takes me away from work too long.

Otto and I have had a talk about Elsbeth. No matter what, we agree that she should drop back to an easier class at school. Considering her delicate health and her high-strung disposition, I think that they demand too much of her. It won't hurt at all if she is kept back a year.

Greetings to the child and my brothers and sisters. I kiss you tenderly.

<div style="text-align: right">Your Paula</div>

To Paula from her mother

<div style="text-align: right">Bremen, Schwachhauser Chaussee 253
November 11, 1906</div>

Paula, what do you say to this fanfare! None other than our museum director is sounding his trumpet for you. Dr. Gustav Pauli is your Lohengrin. I believe that it was little Dr. Waldmann, the one who was so interested in your things, whose lantern lighted the way for him. I really cannot stand that portrait, but I am enormously happy for you that he wrote what he did. Frau Rohland read me the article at the table after our Sunday meal today. It took the place of dessert for me. I happily granted the others their cream cake, but was not permitted to touch a piece myself. Kurt has put me on a prison diet because I'm becoming increasingly plump. [...]

From the Bremer Nachrichten, *November 11, 1906*

[...] It is with a very special feeling of satisfaction that we are able to greet on this occasion an all too rare guest at the Kunsthalle, Paula Modersohn-Becker. Attentive readers of Bremen art news will still be able to recall the cruel treatment meted out to this extremely gifted artist a few years ago in one of our city's distinguished newspapers. Unfortunately, I sense that even now her serious and powerful talent will not find many friends among the public at large. She lacks nearly everything that is needed to win hearts and flatter the casual and untutored glance. And yet it is precisely when confronted with phenomena such as this that it becomes the duty of serious art critics to draw the reader's attention to matters of quality. It must be contemptible satisfaction for a critic to ensure himself a momentary success as the mouthpiece of ever-shifting majority opinion by tearing down excellent young talent—which in any case is always a favorite object of public ridicule. Whoever might choose to see Paula Modersohn's *Head of a Young Girl* as ugly, and then brutally decide to subject it to his scorn, can safely count on the smug approval of many of his readers. On the other hand, whoever would assert that this young woman artist possesses a most uncommon energy, an enormously developed sense of color, and a strong feeling for the decorative function of painting will have to be prepared for the opposition. Nevertheless, let it be said: we should consider ourselves fortunate to be able to lay claim to so powerful a talent as Paula Modersohn. This artist has been living for some time in Paris, and the influence of the incomparable culture there, especially that of Cézanne is evident in her work—and in no way to her disadvantage. [...]

Gustav Pauli

From the Bremen Courier, *Tuesday, November 13, 1906, morning edition*
Review of "Overbeck, am Ende, Modersohn in the Upper Gallery of the Kunsthalle"

[...] A newcomer to our Kunsthalle is Frau Paula Modersohn, and she proves to have a very interesting talent and a fine sense for color. The unusual juxtaposition of colors in her still lifes is very charming. However, one is quickly aware of a peculiarity of technique that often tends to give the objects in her paintings an untextural and stuccoed effect. In the highly stylized pictures, for example in the *Head of a Young Girl*, this effect is undoubtedly successful. But in the loosely composed, that is, the more or less naturalistic pictures, the effect is disagreeable. Indeed, in such work as the *Head of a Sleeping Child* this technique seems to us unhealthy or mannered. [...]

Anna Götze

To Clara Rilke-Westhoff

Paris, 49, boulevard Montparnasse
November 17, 1906

Dear Clara Rilke,

I shall be returning to my former life but with a few differences. I, too, am different now, somewhat more independent, no longer so full of illusions. This past summer I realized that I am not the sort of woman to stand alone in life. Apart from the eternal worries about money, it is precisely the freedom I have had which was able to lure me away from myself. I would so much like to get to the point where I can create something that is me.

It is up to the future to determine for us whether I'm acting bravely or not. The main thing now is peace and quiet for my work, and I have that most of all when I am at Otto Modersohn's side.

I thank you for your friendly help. My birthday wish for you is that the two of us will become fine women.

Please give my greetings to your husband when you write him. With affectionate greetings to you.

Your Paula Modersohn

I certainly hope that the misunderstanding between you and Otto Modersohn will turn into an understanding again.

Well, it seems that Ruth did not get the famous doll's bed after all.

To Milly Rohland-Becker

Paris, 49, bd. Montparnasse
November 18, 1906

My dear Sister,

You really seem to love me as a sister, and I thank you for it. I love you in my own way, with much reserve, but very deeply. If you feel a little cheated by me, heaven will see to it that you are compensated for that in some other way. I'm convinced that we are rewarded or punished one way or another for everything we do while we are still on this earth. The review was more a satisfaction to me than a joy. Joy, overpoweringly beautiful moments, comes to an artist without others noticing. The same is true for moments of sadness. That is why it's true that artists live mostly in solitude. But for all of that, the review will be good for my reappearance in Bremen. And it will perhaps also cast a different light on my reasons for leaving Worpswede.

Otto and I shall be coming home again in the spring. That man is touching in his love. We are going to try to buy the Brünjes place in order to make our lives together freer and more open. We will also have all kinds of animals around us. My thoughts run like this just now: if the dear Lord will allow me once again to create

something beautiful, then I shall be happy and satisfied; if only I have a place where I can work in peace. I will be grateful for the portion of love I've received. If one can only remain healthy and not die too young.

I'm so happy, my dear, that things are going well for you! I think about you and your little one very often. Just learn to be patient, and the happy event will soon come. And please make up your mind now that it is not important whether it's a boy or a girl. Do you think it mattered in our case; aren't we fine girls?

Right now Otto is at Hoetger's atelier. Hoetger is doing a plaster bust of him. I am to get a cast of it. The two of them have gradually come to understand each other very well. Otto has great hopes for his own art this winter. He has many new ideas, which is a great comfort to me.

I naturally indulged myself with the money you sent. I bought myself silly trinkets, something for the head, something for the feet. A pair of beautiful old combs, a pair of old shoe buckles.

Farewell, my dear. Be happy, be good, be careful.

To Martha Hauptmann

Paris, 49, blvd. Montparnasse
January 9, 1907

Dear Frau Hauptmann,
Your beautiful, beautiful cake tasted so wonderful, and before we ate it up it looked wonderful enough to paint, with its white frosting and little brown cookies on top. Everyone who tasted it was ecstatic. It was very dear of you to think of me. It made me very happy because I took it as a sign that you like me a little. Perhaps you know and sense that I like you very much, too, and your incorruptible way of dealing with human beings and the things of this world. I am still an incomplete person and should so like to become someone. I still lack things inside and out, but I have private hopes that someday I'll become something whole. Then again, I also feel that whoever thinks of me as incomplete needn't really bother to look in my direction. I hope and believe that you will let kindness reign—

It is probably very cold up in your mountains this winter. Even here it was only ten degrees sometimes. I wonder if you are finding a little time for your painting? The mountains look so splendid in the snow, a hundred times more beautiful and grand than in the summer.

I send you heartfelt greetings and take you by the hand.

Your Paula Modersohn

To Milly Rohland-Becker

Paris, 49, boulevard Montparnasse
January 29, 1907

My dear Milly,

I did not go and get the Turkish shawl. Even without that, I love you very much. In this past year you have been the person who loved me the most unselfishly and who believed in me. There are no words to thank you for something like that. But heaven, or fate, or whatever, rewards every good impulse one way or another. I find we don't need any heaven, or any hell. Everything seems to take care of itself with such simplicity here on our earth. Still, may a handsome portion of heaven be our reward. Your little bit of heaven is already alive within you. Milly, I won't chatter on any longer about this. I take you both by the hand. May the goodness which is in both of you be born again, for your joy and the joy of all.

Your Christmas brooch with the pretty little pin! I had always so admired its twin, the one you wear at your shining throat with your white toile shawl. I thank you tenderly.

What you write about Henry worries me. That boy has a morose streak in him. There is little we can do at such a distance. Actually he has a shy nature which must be dealt with in its own special way. Mother sometimes gives him too much, sometimes too little. I had a similar feeling toward Mother when I was between sixteen and eighteen. It's a pity that the boy didn't talk with me at Christmas. I'm very fond of him, and I have a strong sense of how fine he is deep down inside.

I greet you both tenderly.

Your Paula

To her mother

Paris, 49, boulevard Montparnasse
February 16, 1907

My dear Mother,

Kurt has just written us that you have erysipelas. That makes me very worried and sad. We are so far away from you here and have no idea how you are feeling right now. My dear Mother, if you think I could help you in any way at all, I'll make arrangements to come to you as soon as possible. I'll ask Kurt or Henry to send us daily news about your condition. It is so unexpected to learn that you are sick. That's why I'm so worried about it. You remember the time when you were sick in bed once and how terrible our dear Father felt about it. We have known you always as the one who can make the lame walk again, and now you yourself are lame, you love. That depresses me so. All three of your daughters are so far from you, one farther than the other.

My Mother, you were so dear and sweet to me on my birthday. One of your

lovely gray ones arrived the day before and made Otto and me so happy. There was no suggestion in it about this awful illness. Instead you were still filled with your impressions of the Artists' Society festival. My dear, my dear, how many people must have been there with outstretched hands waiting to learn their fate from you. Henry wrote us that you were completely surrounded by people.

— Tell Elsbeth that she will be getting her very own letter someday soon to thank her for the paintings. I enjoyed them so much. And the one with the potatoes and the miller is wonderful. I gave Hoetger one of Elsbeth's pictures. He gets such fun from her paintings. My birthday presents from Otto were a beautiful white shawl and a book with old Egyptian portrait heads which are most remarkable and full of character. I was so moved by the beautiful bracelet you sent, dear Mother. It beckons to me from its little case so charmingly and mysteriously. I think we will just leave it as a bracelet; it's so charming that way — I do wonder how you are? Dear Mother. I kiss you tenderly.

Your Paula

To Milly Rohland-Becker

Paris, 49, boulevard Montparnasse
February 21, 1907

My dear Milly,
Your birthday letter was like getting something warm and cozy from you, almost as if you had patted me with your sweet little hands. Thank you for it, dear girl. And God bless you. Thanks, too, for the gold piece. I haven't bought anything with it yet, but I promise to get something pretty.

And you, and the two of you? You are probably counting the days one by one until the middle of March. How eager one is for the arrival of such a little creature. How you must be wondering what it will be, whom it will look like, and whose personality it will have. I know you will be a terribly loving mother and Hans a splendid father. I intend to be a good aunt. But for the present, I can't do anything more than that.

Otto and I are still living our quiet lives here in this beautiful city. Our days are filled with work and reading. Next month Hauptmann and his wife plan to come here, and things will no doubt be more active after they arrive. We are now planning to come home at the beginning of April.

You say you are sad that I don't write you about my work. Dear Milly, art is difficult, infinitely difficult. And sometimes one doesn't want to talk about it at all. But that is no reason to make you sad.

To Elsbeth Modersohn

Paris, 49, boulevard Montparnasse
February 27, 1907

My dear little Elsbeth,

I have waited so long before thanking you for the lovely pictures you sent me for my birthday. They made me so very happy. I have already pinned the one of the windmill on the wall. And whenever I happen to glance at it, I think of you. And now it won't be very much longer before we're all together again and celebrating Easter in Worpswede. And spring will be coming, too, and the anemones will be in blossom and also the little yellow flowers that I always make garlands with. This year I'm sure that you, too, will be able to do that very well. Grandmother wrote me that you were first in your class. Are you still? That would be very fine. We have to learn when we are small, so that we will know things when we are grown up. Right now I am painting a little Italian girl. Her name is Dolores Cataldi. Isn't that a splendid name?

Now farewell, my dear Child. Say hello to Grandmother for me and to Uncle Kurt and Uncle Henry.

I send you a big kiss.

Your Mother

To her mother

Paris, 49, bd. Montparnasse
March 9, 1907

My dear Mother,

Perhaps in October you will be a grandmother again. I kiss you.

Your Paula

Don't tell anyone except my brothers and Frau Rohland.

**Milly Rohland-Becker*

Paris, 49, bd. Montparnasse
March 9, 1907

My dear Sister,

If all goes well, I'll be following your example in October. I hope this happy news will help to brighten your difficult days. I send you a kiss. My thoughts are much with you and Hans.

With love,

Your Paula

To Rainer Maria Rilke

Paris, 49, bd. Montparnasse
March 10, 1907

Dear Rainer Maria Rilke,

I am a bad correspondent; in fact I'm one of those people who move very slowly and make people wait for them, and who also wait themselves. Just don't expect anything from me. Otherwise I'll probably disappoint you, because it may still be a long time before I am somebody. And then, when I am, perhaps I won't be the somebody you thought I would be. I would so like to do something beautiful, but one must wait now to see if the good Lord, or fate, also wants me to. I think the best thing for one is to go one's own way as in a dream.

You sent me a beautiful thing. I had already seen with delight the new edition of your *Buch der Bilder* at Clara's during Christmas. It is a beautiful book.

The photographs of ancient art tempt me so much to travel south. They are very lovely. I look at them often. Have you ever heard or seen anything of a young painter named Carl Hofer who is staying in Rome? He has been inspired by these same things in a wonderful way. I've also heard that Maillol is in the south. Paris continues to be the same. Nevertheless, I'm happy to leave it at Easter. I shall return to Worpswede. I hope everything will be all right this way.

Please give my best to Clara. It is lovely that the trip is so rewarding for her. I think so often of her.

If only we can all get to heaven.

I wonder where you will be when next summer is in bloom.

I believe that I am satisfied with my life.

Your Paula Modersohn

To Rainer Maria Rilke

Worpswede, April 5, 1907

I am sitting again in my little studio at the Brünjes' with the green walls, and light blue below. I walk the same path to get here as I did in the old days, and everything seems wondrous to me. This is the room I love more than any other in my whole life. I have the desire to work, all the more so because I did nothing during the last months in Paris. Only I did see Cézanne during our very last days there, glorious things from his youth. The Salon d'Automne will be having a special exhibition of his works; you will be able to get a great deal of pleasure from that.

But now, to get to the purely practical—My atelier will not be anything for you I think, even though it does have its great advantages. By the time I left, it had not yet been rented. My landlady, Mme Vitti, is keeping the furniture for you until you get there. Please have the first *marchand bric à brac* who comes along take away whatever you can't use—walking along one day, I saw that the rue Vaugirard

114/116 (you must remember the object of our contention) has an atelier for rent. Unfortunately, I didn't ask which one. Perhaps you should inquire sometime.

I interpret the questions in your letter the only way they permit me to. I find it so disagreeable to answer questions. I believe that is intellectual laziness.

It's only people like Fräulein Reyländer, the ones who can pry secrets out of people innocently and with remarkable determination, who can get me to answer them.

But you're not as bad as that.

With a lovely greeting for your summer and for your Paris, I am

<div align="right">Your Paula Modersohn</div>

The Hoetgers are moving to Westphalia in the middle of May. He destroyed his big figure of a reclining woman.

To her mother

<div align="right">Worpswede, April 8, 1907</div>

My Mother,

Now the last of your brothers has died. The news made me think of Uncle Günther's death, twenty years ago. It must have been so hard for you this time when your brother closed his eyes. The bonds and the memories that held you together must have spoken twice as powerfully.

Blood is probably the strongest bond. It bridges the widest gaps, no matter how far apart you and your brother may have been. You had the same blood, and that alone was reason enough for you to be close. One must praise the Creator who creates these mysterious blood ties.

From her mother to Herma

<div align="right">Bremen, Schwachhauser Chaussee 253
May 10, 1907</div>

My dear Herma, I arose this morning at five o'clock and was driven home from Worpswede through the spring air and the fresh new green of the birch *allee*. Yesterday was Ascension Day, an absolutely heavenly Ascension Day! A year ago I would never have believed that I would be in my little Paradise [in Worpswede] again. But that distressed God, and so He made immediate plans to have it turn out the way it has! I surprised them by going out there on Tuesday evening. When I arrived there was a little explosion of joy. Otto and Paula were working together in the garden and came running toward me with delighted faces and Elsbeth, who had just gone to bed, dashed down in her nightgown calling, "Grandmother is here, Grandmother is here!" And then there was a happy supper out on the white veranda and everyone's bag of stories was emptied out for the others. And heaven

had sent weather such as is made only for the blessed gods, and I awakened the next morning in my canopy bed and felt the way old Gellert must have when he sang at sunrise: "Let my first feeling be one of praise and thanks." Again there was a happy hour at the breakfast table, after which Paula had to be alone a little, for in the morning she always feels a little faint and dizzy. Then Otto helps her out of her chair and because he can do nothing more to help, he sacrifices his greatest pleasure, his little pipe, because the tobacco makes her feel sick. Then Otto and I walked for an hour through the spring looking for possible garden sites, none of which will be planted until the Judgment Day. Then someone came flying toward us on his bicycle, with a freshly laundered Panama hat on his head — it was Kurt. And now all this quiet intimate happiness reached its high point, and we held a festive dinner which Johanna had prepared without a flaw. If only you had been there to eat my whipped cream! No, if only you'd been there for everything; above all I would have granted you the quiet harmony of our hearts which, even though no one mentioned it, filled our harmless chatter like music of the spheres. Have we all come through a terrible nightmare and are now awake? I can't explain it and sigh in gratitude, and don't complain. Kurt was transfigured and courted his sister Paula with all his might and main. She was altogether charming and exuded goodness and mischief. One never had the feeling that anything had been patched and put back together again here. Rather, you would have felt security and clarity everywhere. Kurt remarked quietly to me that he would never have thought such a thing possible, that somehow a miracle seems to have happened and one must simply accept it again in gratitude. [...]

To Otto Modersohn

Holthausen
Saturday, July 1907

Dear Otto,
I enclose the key to my bureau. Be nice and bring me a chemise, underdrawers, and a camisole, and the pink nightgown. I very much hope that you are still planning to come, even if we won't be staying here much longer. My dear, I'm so happy that I took this trip. Nothing ventured, nothing gained. Hoetger makes much the same impression on me here that he did in Paris; only his wife says that he is very nervous and depressed by a feeling that his liver is not healthy. It's probably true that he is an advanced hypochondriac. I think with your own experience you could be of some help in talking him out of this. He speaks warmly of you. The house here has many blank plaster walls on which we intend to paint all kinds of things. And we hope that you will come and help us out. I've already told them that you would be marvelous at doing some burlesque things, rather in the Ostade-Brueghel style. [...]

The postman is waiting for me to finish this letter. A thousand greetings. *Auf Wiedersehn.*

Your P.

Just come quickly. All is well with me.

From B. Hoetger to O. Modersohn

[Postmarked July 12, 1907]

Dear Herr Modersohn,

The female of the species is here, and all that is missing is the male! Please put on your big wings and fly to the little nest that we have prepared for you here. Your lady awaits you.

Please don't write and say that you cannot. There is enough to paint here, and I also believe that our local landscape will be to your taste. All of us look forward very much to your arrival.

Auf Wiedersehn.

Your Hoetgers

P.S. Please do come soon. It is so beautiful here. The house is absolutely marvelous, and afterward it would be so lovely when we can talk about it together. I'm healthy and cheerful and not at all exhausted. Do convince yourself of that and send a telegram saying when we are to fetch you. We all greet you.

P[aula]

Hoetger, Holthausen: Büren, Westphalia

To Rainer Maria Rilke

Worpswede, August 10, 1907

Dear Rilke,

Yes, it is a little bad of you to have forgotten my furniture, for now I must ask you to go and see whether any of it still exists. You must go to the blvd. Montparnasse 49 to Mme Vitti and inquire what might still exist of my estate: *sommier* with mattress, a large looking glass, two chairs and two tables; those are the most important things, and then all kinds of small equipment. Should the aforesaid furnishings still exist, then you will perhaps put them into the hands of a secondhand dealer and then if any money is forthcoming I should very much like you to buy me something beautiful. I lost a very beautiful [one word illegible] brooch in Paris,

about the size of a five-mark piece, of carved mother-of-pearl, and it cost only five francs. And so if you should see something like that . . . Or I might wish for myself a brass table bell in the shape of a lady, or Gauguin photographs [reproductions] at Druet, 114, Faubourg St. Honoré. I will let you know by letter, after you write me, whether any of my things are still alive. Will you be staying in Paris for the winter? And Cézanne, about whom you write! Now there's a real fellow. I wonder if many of his things will be in the Salon d'Automne? Unfortunately I have no time this fall to see all that for myself. And I still wait and wait for me to become somebody; I need few people and at the moment I'm not thinking or feeling much.

I send you hearty greetings.

Your Paula Modersohn

To Bernhard Hoetger

Summer 1907

I have not done much work this summer, and I have no idea if you will like any of the little that I have accomplished. In conception, all the work has probably remained much the same. But the execution, I think, is quite another matter. What I want to produce is something compelling, something full, an excitement and intoxication of color — something powerful. The paintings I did in Paris are too cool, too solitary and empty. They are the reaction to a restless and superficial period in my life and seem to strain for a simple, grand effect.

I wanted to conquer Impressionism by trying to forget it. What happened was that it conquered me. We must work with digested and assimilated Impressionism. Unless I am mistaken, something like this in part lay behind the cause of the tragic fate of your "Saga."

All we can do is ask again and again, "Dear God, make me good, so that I can get to heaven."

To Milly Rohland-Becker

Worpswede, October 1907

My Sister,

As Anna Dreebeen's relative said when everything was churning and growing inside of her, "Why, the kid knocked me right off the chair!" I'm feeling the same way. All of you must be nice and patient with me; otherwise he, or she, is going to get all frantic, too. And don't ever write me another postcard with words like "diapers," or "blessed event." You know me well enough to realize that I'm the type who prefers to keep the fact that I'm about to be concerned with diapers away from other people.

As for the rest, I give you a loving kiss for your sweet, maternal concern for me. You demonstrated this to me last summer, and now again this year. May God bless you for it, dear woman. You know that I never can, nor ever shall be able to, do the same for you. That's not from any lack of warmth in me. It's just that my warmth has its own special ways, and all we can do about it is wait and hope that it might be of some benefit. There are already enough people who condemn me for it. But you, I hope, will never be that way.

I knew it would turn out to be more pleasant at home in the Herbstgasse than you thought it would be. I hope that little Christiane's rejection of the bottle has disappeared by now, so that you can have a bit of peace and calm for yourself. Be sure to weigh yourself once a week on a good scale so that you can see exactly how much weight you are taking off. Be conscientious and diligent about it. You know you owe that to yourself for the future.

The autumn here is wonderfully mild and we are enjoying it so much. I'm good and patient, but only, please, none of you should hover around. One night recently, Anna Dreebeen got up three times because she saw a light on at our place, and in the morning she seemed terribly disappointed when I swept past her.

Here's a true story that happened here recently. Someone came into a farmhouse and wanted to speak to the farmer. His wife was standing on the hearth and said, "He's gone to lie down for a bit. We've had a bit of a restless night." The wife, you see, had just had a baby that night. I send you a big kiss. Keep me in your thoughts. My love,

<div align="right">Your sister Paula</div>

The other day I saw a snug little cradle which we might buy.

To her mother
[Postcard]

<div align="right">[Prior to October 8, 1907]</div>

Dear Mother,
Elsbeth is blissful about the invitation to visit her grandmother. I shall ask Hauptmann to take her with him to the city; he has been here for several days and is probably leaving tomorrow. I shall send you more precise information later. Also, since yesterday, the train schedule has changed. Things are going splendidly for me. Affectionate greetings to all.

<div align="right">Your Paula</div>

To Herma Becker

<div align="right">October 8, 1907</div>

Dear Herma,

Here are the photographs. We particularly like the two marked *x*. The profile views seem to have been taken when you were tired. I'll send the velvet tomorrow with Barnsdorf. I continue to be well, so none of you needs to get keyed up before the end of the month. Nevertheless I'm happy that Elsbeth is staying with you. Has she perhaps asked you yet to go to a man dentist, or perhaps a woman dentist? She must absolutely be looked at.

— Thanks for the swaddling clothes. I'm painting again and if I only had a magic cap to make me disappear, my wish would be to go on and on painting. Otto is devouring a new book by Meyer-Gräfe. Many greetings to you. Many thanks for Elsbeth's letter.

<div align="right">Your Paula</div>

To Rainer Maria Rilke

<div align="right">Worpswede, October 17, 1907</div>

Dear Rilke,

I have just finished reading your essay on Rodin in *Kunst und Künstler* and enjoyed it very much. I believe your work is more mature, simpler. It seems to me that the youth with his fragile exuberance is vanishing now and the grown man is beginning to emerge with fewer words but which have more to say — I don't know whether this is your opinion too, or whether it will remain my opinion only, or whether this is any opinion to your liking at all. In any case, it is not meant as an insult, as many of the things that I often said may have been, although they were not intended to be insults.

Will you perhaps be sending me the catalogue of the Salon d'Automne? I should like to see it.

And before you enter the mother-of-pearl garland of Venice, do go once again through the dark corridors of Madame Vitti. May the thought that Gauguin once ascended the same staircase illuminate your way. Even if he only did it for three months.

I send you kind greetings.

I've written these pages in a mixed-up order because I didn't have any blotting paper.

<div align="right">Your Paula Modersohn</div>

Worpswede, October 21, 1907

Dear Clara Rilke,

My mind has been so much occupied these days by the thought of Cézanne, of how he has been one of the three or four powerful artists who have affected me like a thunderstorm, like some great event. Do you still remember what we saw at Vollard in 1900? And then, during the final days of my last stay in Paris, those truly astonishing early paintings of his at the Galerie Pellerin. Tell your husband he should try to see the things there. Pellerin has a hundred and fifty Cézannes. I saw only a small part of them, but they are magnificent — My urge to know everything about the Salon d'Automne was so great that a few days ago I asked him to send me at least the catalogue. Please come soon and bring the letters [about Cézanne]. Come right away, Monday if you can possibly make it, for I hope soon, finally, to be otherwise occupied. If it were not absolutely necessary for me to be here right now, nothing could keep me away from Paris.

I look forward to seeing you and to your news.

I also send two lovely greetings to Ruth.

Your Paula Modersohn

**To her mother*

Worpswede, October 22, 1907

My dear Mother,

No, no, no! That won't do at all. I'm becoming a mother, not a grandmother yet. This great glorious beast belongs in your green parlor and I would hate to think of it missing from its proper place by the window. However, since it looks as if you will be away for most of the winter, I will give it a temporary home here until you get back. But when spring returns you to your little home, I'll dress the magnificent beast in his black stockings again and let it find its way back to you. Thank you for your sweet thoughts.

I expect that Kurt has probably told you all our other news. Unfortunately, not much has happened since then. And until it does, all of you are simply going to have to be patient. Anna Dreebeen has lost all interest in me by this time.

How I should love to go to Paris for a week. Fifty-six Cézannes are on exhibit there now!

Farewell. I hope the weather continues to be beautiful, even though it is almost greedy and immodest to hope, or to demand, such a thing.

Your Paula

In November I stood with my little daughter at the bed in which she lay with her little baby girl who was only a few days old — with the happiest and most peaceful smile that I have ever seen on her face.

From Frau Becker to Milly Rohland-Becker

Worpswede, November 5, 1907

Darling Child,

How I should like to give you the opportunity of being here in place of me for just an hour. From one wall to the other this artists' house is filled with happiness, and the little mother lies there holding her baby and her brown eyes are shining blissfully.

The birth was difficult. Late Friday night the midwife came into Otto's room and asked him to fetch the doctor; she was afraid that the child was dead, for there were no heartbeats to be heard. Dr. Wulf came and proved to be an excellent physician. Saturday morning the contractions stopped just as the child was about to be born. About two o'clock the doctor chloroformed Paula and drew out the child with forceps. Otto was pacing anxiously about outside looking for Kurt's arrival. Suddenly Dr. Wulf appeared from the house, flushed and streaming with perspiration, and extended his hands to Otto saying, "Congratulations! A splendid little girl!" "Is she alive?" asked Otto trembling. "And how. And she has a voice like a lion!" Indeed, that was quite a birthday celebration! Osten had already brought me the most beautiful roses, and I took them out to Worpswede with me and there found Paula "herself as young as a rose." Not a trace of a suffering new mother in confinement; all was joy and maternal happiness and gratitude for the safe delivery. [...] On Sunday Paula kept saying, "You ought to see her in the nude!" And Otto boasted as the proud father, "A very fine nude!" Now today, Tuesday, I am out here again and have seen her "in the nude." She surely is a splendid baby girl, large and developed as if she were three weeks old. She has a head of brown hair, shiny little eyes, and gesticulates energetically with her arms. The bathing scene today was a splendor! Paula reclines on snow-white pillows beneath her beloved Gauguins and Rodins. The winter sun laughs in through the little white tufted curtains, and red geraniums on the windowsill smile at her. Yesterday I cut all the flowers that were still blossoming in the garden, colorful sweet peas (Paula says that they look like happy summer dresses), and splendid single dahlias which shine in remarkable colors like gemstones. They are now on her little table in front of the tall brown corner cupboard, and at the foot of her bed there is a picture that Osten gave me for my birthday: [a reproduction of] Franz Hals, *The Nurse with the Child.* The nurse looks like Frau Osmer and the sweet little girl in her stiff baroque

dress is Mathilde Modersohn a year from now. [...] In the little "guest room" next to the lying-in room the tile stove is going; in front of it stands the little bathing tub and Paula can look from her bed directly through the open door and see her newborn baby "in the nude." After the bath she is laid at Paula's breast and takes hold as cleverly as an old hand, and nurses and feeds until she falls asleep, a little brunette next to a big brunette.

Otto has arranged for a photographer to come from Dresden, a very famous man, who has portrayed with his camera all the "big guns" of the aristocracy of the art world in Dresden. After photographing Otto for several hours, he came into the bedroom and made endless pictures of Paula with the little girl in her arms. You will be able to see them soon! —

From Frau Becker to Milly Rohland-Becker

Worpswede, November 10, 1907

Darling Child, it's Sunday and I'm out here again with the happy people. Just now I have witnessed the great bathing scene. Mathilde Modersohn swims with the same passion as her mother, and it is funny to see how she clamps on with both hands to Frau Osmer's fat arm so she won't sink in the sea of life. In fact, her arms and hands are in constant motion and reveal a personality filled with temperament. "Going to be a painter, too," says Frau Brünjes with real understanding, whenever the fingers on her little paws open and close as if she wanted to take hold of an invisible paintbrush and paint. [...] Unfortunately Paula has been having disturbing pains in one of her legs for two days. As soon as we heard about that, the first thing we feared was phlebitis. Fortunately, that is not the case; instead it seems to be a kind of neuralgia.

Sunday evening, home again. Kurt and I were out there the whole day and have just returned together. He is also deeply touched by Paula's appearance and nature. Before dinner Otto asked Kurt and me to go into Paula's atelier—but said not to say anything about it. There we saw an extremely original still life with flowers, sunflowers and hollyhocks, wonderfully painted, and several other good still lifes; also the big nudes from Paris interested us very much. But the brilliance of the hollyhocks made everything else seem dead.

From Frau Becker to Herma Becker

Sunnyside, November 18, 1907

[...] Paula's disposition is one of heavenly cheerfulness. Modersohn wants to enlarge the garden and either lease or buy [more land] from the Dreyers, for Paula has declared that in the future she wants to paint in the garden a good deal. (Thank God!)

From Frau Becker to Herma Becker

Sunnyside, December 4, 1907

[...] In her last letter Paula wrote to Fellner: "I'm not afraid of anything, all will be well — except death; that is the only ghost I am afraid of, that is the only true misfortune."

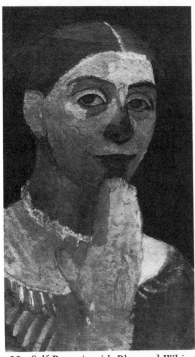

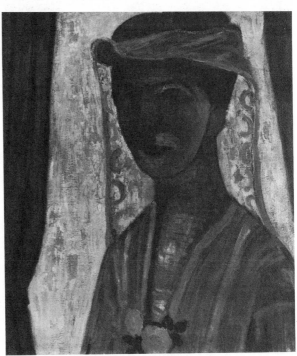

39. Self-Portrait with Blue and White Striped Dress, *1906*

40. Self-Portrait with Hat and Veil, *ca. 1906*

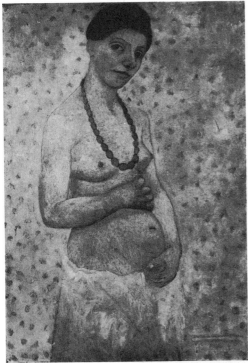

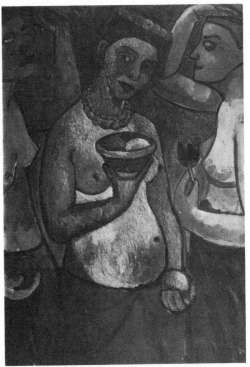

41. Self-Portrait on Fifth Anniversary, *1906*

42. Composition with Three Female Figures: *a self-portrait in the middle, 1907*

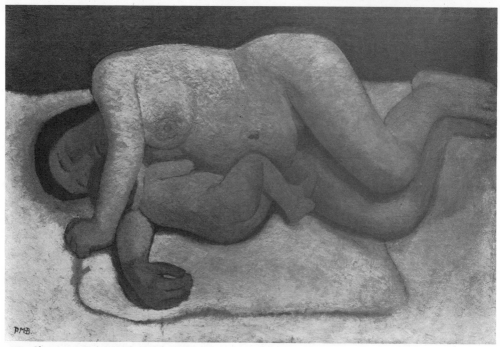

43. Sleeping Mother and Child, *1906*

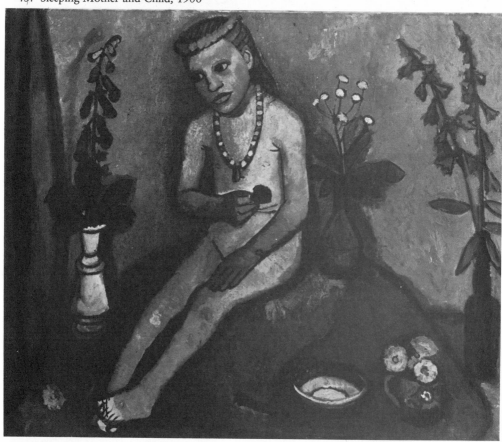

44. Nude Girl with Vases of Flowers, *1907*

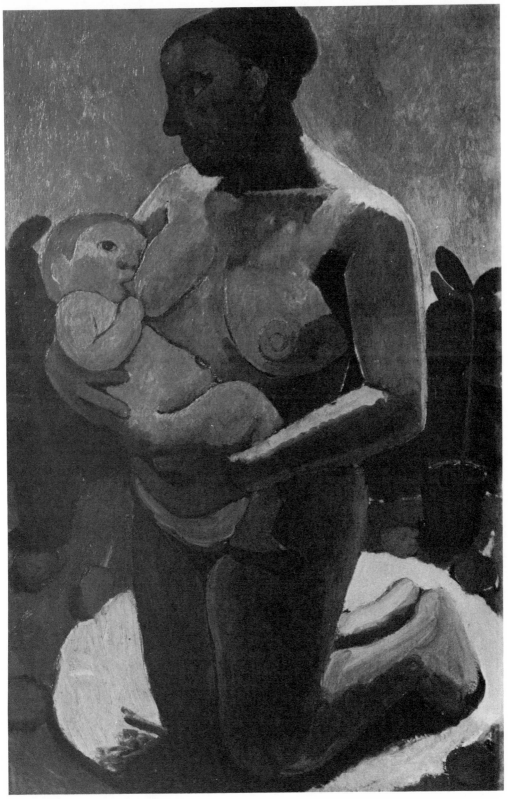

45. Mother and Child, *ca. 1906–7*

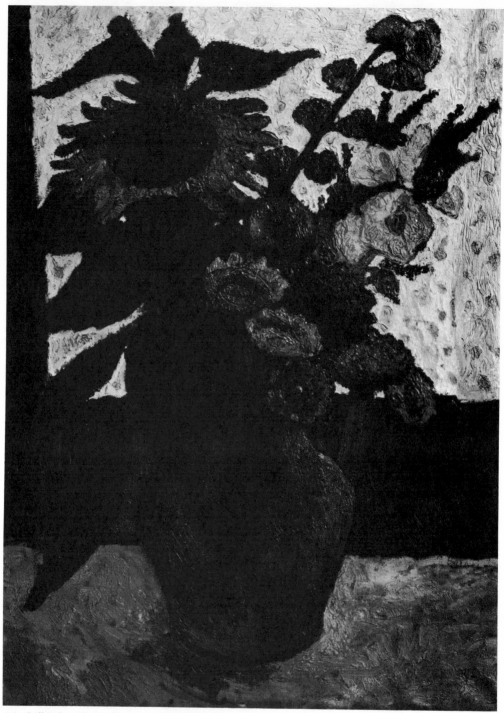

46. Still Life with Sunflower and Hollyhocks, *1907*

A Note on this Edition

The title of this greatly expanded new edition of the documentation of Paula Modersohn-Becker's life was intended to be kept as close as possible to the familiar title of the original edition. The only major difference is the change of the somewhat old-fashioned "Leaves from a Journal" to the more sober "Journals." This change is meant also to indicate that, for the first time, excerpts from the letters and journals of other persons are now included. This new edition is based on the following sources:

1. Three older publications:
 a) a selection of approximately fifty letters and journal entries written by Paula Modersohn-Becker which were published in 1913 in the literary magazine *Die Güldenkammer,* published by the firm of Kaffeehag in Bremen, vol. 3, nos. 4–8 (January–May);
 b) the first book edition, published in 1917 by the Kestner-Gesellschaft in Hannover, entitled *Eine Künstlerin. Paula Modersohn-Becker; Briefe und Tagebuchblätter* [*An Artist. Paula Modersohn-Becker's Letters and Leaves from Her Journal*]; second edition published in 1919 by Franz Leuwer, Bremen; it is to this edition we have adhered;
 c) *Paula Modersohn-Becker, Briefe und Tagebuchblätter*, the expanded edition of the 1917 publication, published by the Kurt Wolff Verlag, Leipzig, 1920; this edition went through many printings; we cite from the 12th printing.

 Sophie Dorothea Gallwitz, the Bremen writer, was engaged in the production of all the above editions: in *a*) as a member of the editorial staff of the magazine, and in *b*) and *c*) as the editor.

 Editions *a*) and *b*) contain passages which are lacking in *c*), and these were restored in our new edition.

2. The above sources were further expanded by newly discovered letters. Among them, those from Paula to her sister Herma from the years 1904–5 are of particular importance. Further, there are five letters from Paula Becker to her brother Kurt which exist in handwritten copies and a small cache of postcards from Paris to her stepdaughter Elsbeth. In addition, there are a good number of important letters (which are now published for the first time in their complete texts) to Otto Modersohn and one each to Clara Rilke-Westhoff and Rainer Maria Rilke, as well as eleven letters to Carl Hauptmann and/or his wife and two to Bernhard Hoetger. (According to information from Albert Thiele, Hoetger destroyed nearly all of the correspondence that he had carried on with Paula Modersohn-Becker.) We have also included the artist's letters to Heinrich and Martha Vogeler which were published separately about 1927 by Konrad Tegtmeier in a book on her published by the Angelsachsen Verlag in Bremen. With

the exception of the letter to Hoetger of May 5, 1906, all these documents still exist in handwritten form. We must assume, on the other hand, that the originals of Paula Modersohn-Becker's journals and the letters to her parents, which formed the basis for the older editions, were lost at the end of World War II at the relocation and evacuation center of Bunzlau in Silesia. All documents that were lost and that therefore cannot be rechecked for absolute accuracy have been designated in this edition with an asterisk [*] before the name of the recipient.

3. Paula Modersohn-Becker's entries in her *Poesie-Album* after the time when she first began to use it for copying down quotations from her reading.

 The above three groups contain the sum total of the written remains of the artist so far as they are known to us today.

4. The documents from the hand of Paula Modersohn-Becker have been supplemented by:

 —excerpts from the letters and journals of Otto Modersohn
 —letters and excerpts from letters from her parents
 —one letter each from Clara Rilke-Westhoff and Rainer Maria Rilke, as well as a poem by Rilke
 —one letter from Carl Hauptmann to Paula Modersohn-Becker
 —one letter from Carl Hauptmann to Otto Modersohn
 —sketches written by Clara Rilke and taken from the *In Memoriam* book edited by Rolf Hetsch (1932)
 —one letter from Heinrich Vogeler
 —four passages from letters of Herma Becker to her mother
 —two letters each from Frau Becker to her daughters Milly and Herma
 —a letter from Herma Becker to Otto Modersohn
 —two excerpts from letters written by Maidli Parizot-Stilling, a cousin
 —a note from Bernhard Hoetger to Otto Modersohn
 In addition, we have reprinted the text of an art review by Arthur Fitger and the response to it by Carl Vinnen (1899), and reviews by Gustav Pauli and Anna Götze (1906).

A comparison of the texts of the three older editions reveals that they often do not agree in a number of respects with the wording of the original letters. It is clear that they were stylistically reworked and "smoothed over." The original wording of a great deal of the material, primarily letters to her parents, cannot of course be restored. On occasion, formulations from the original *Güldenkammer* edition more characteristic of the artist were used in preference to later "emendations." The more obvious inconsistencies have been noted in the Notes that follow.

Different from the arrangement in all previous editions (where the letters were grouped according to recipients), the documents in the new edition are arranged chronologically.

Even as early as in the *Güldenkammer* publication one can note that sometimes

a series of letters has been printed as a single letter grouped under one date. This less-than-satisfactory editing decision was also perpetuated in the later editions. With the letters from her parents now available to us as a guide, it was occasionally possible to correct irregularities and imprecisions and to correct inaccurate datings.

Wherever we had the original letters before us, we have reproduced them in their entirety, with negligible exceptions. The few ellipses in brackets [...] indicate inconsequentialities in the letters from Paula Becker's youth. And in the case of the letters to Otto Modersohn they designate intimacies that the editors felt obliged to respect. In three places in the letters to Carl and Martha Hauptmann a few phrases were cut and replaced by ellipses in brackets at the family's request. These small cuts do not alter the sense of the letters but they do reduce the vigor of her expression.

Paula Modersohn-Becker's own spelling and punctuation were essentially maintained in the German edition in all those letters for which we possess the originals. It must be noted that these are frequently very willful, and the American editors have made an attempt to replicate this in their translation. The letters were often written in great haste or "on the wing" and consequently contain a good number of errors, which we have occasionally pointed out with a [*sic*].

The ellipses without brackets were frequently used by the editor of the older editions, even where Paula herself had used one or two dashes to designate a pause; this usage could be established from a study of the original. But whether Gallwitz was consistent in this usage, that is to say, whether the three dots did not on occasion also refer to omissions, cannot be established for certain—but it is to be assumed.

The full history of Paula's artistic genesis, cannot be thoroughly covered in this new edition. That remains essentially the task of art-historical research and investigation. However, the important finds that came to light during the preliminary work on this edition will help to clarify and reveal her artistic development in many essential details. And what formerly seemed to be nothing more than references and intimations in her letters (because their author could assume that the recipient was privy to her thoughts) has now been substantially elucidated by: (1) reference to contemporaneous exhibition catalogs, (2) the work on the new Modersohn-Becker oeuvre catalog, and (3) other similar, newly compiled source materials. The results of these investigations can be found in the Notes.

Wolfgang Werner of the Graphisches Kabinett KG, Bremen, not only placed at our disposal his extensive Paula Modersohn-Becker archive but devoted a great deal of time and energy to this project. He is also the author of the data pertaining to our illustrations, of the Checklist of Exhibitions, and of the Bibliography. May we once again express our heartfelt thanks to him.

L.v.R. (with additions by A.S.W. and C.C.H.)

FREQUENTLY CITED SOURCES
WITH THEIR ABBREVIATIONS

Andree Andree, Rolf. *Arnold Böcklin. Die Gemälde.* Basel: Friedrich Rein-hardt Verlag; Munich: Prestel Verlag, 1977.

Bauch Bauch, Kurt. *Rembrandt Gemälde.* Berlin: Verlag Walter de Gruyter, 1966.

Brachert Brachert, Adelheid. *Wesen und Werk meines Vaters. Lebensbild des Malers Graf Leopold von Kalckreuth,* with a catalog of the pictures. Hamburg: Hans Christians Verlag, 1967.

Bremen '76 *Paula Modersohn-Becker zum hundertsten Geburtstag. Gemälde, Zeichnungen, Graphik.* Catalog for the Centennial Retrospective Exhibition at the Kunsthalle, Bremen, and the Paula Becker-Moder-sohn-Haus, Böttcherstrasse, Bremen, from August 8 to March 3, 1976.

Busch Busch, Günter. *Paula Modersohn-Becker Handzeichnungen.* Bre-men: Angelsachsen-Verlag, 1949.

Chronique *La Chronique des Arts et de la Curiosité. Supplément à la Gazette des Beaux-Arts* (Paris). Vols. for 1900–1907.

Delteil Delteil, Loÿs. *Peintre-Graveur Illustré (XIXe et XXe siècles).* 30 vols. Paris, 1906–26.

Doede Doede, Werner. *Die Berliner Secession. Berlin als Zentrum der deut-schen Kunst von der Jahrhundertwende bis zum Ersten Weltkreig.* Berlin: Propyläen Verlag, 1977.

Exposition 1900 *Exposition Universelle de 1900. Catalogue Officiel Illustré de L'Ex-position Centennale de L'Art Français de 1800 à 1889/Catalogue Officiel Illustré de L'Exposition Décennale des Beaux-Arts de 1889–1900.* (In 1 vol.)

Fernier Fernier, Robert. *La vie et l'œuvre de Gustave Courbet. Catalogue Raisonné.* Vol. 1, 1819–65. Lausanne and Paris, 1977.

Gassier/Wilson Gassier, Pierre, and Wilson, Juliet. *Francisco Goya, Leben und Werk.* Edited by François Lachenal, with a foreword by Enrique Lafuente Ferrari, and translated by Alfred P. Zeller. Berlin: Propyläen Verlag, 1971.

Gerson Gerson, Horst. *Rembrandt, Gemälde. Gesamtwerk.* Amsterdam: Meulenhoff International, 1968; Munich: Bertelsmann Kunstverlag, 1969.

Gordon Gordon, Donald E. *Modern Art Exhibitions 1900–1916; Selected Catalog Documentation.* "Materials on the Art of the Nineteenth Century," vol. 14, in two parts. Munich: Prestel Verlag, 1974.

Güldenkammer Gallwitz, S. D., Hartlaub, G. F., and Smidt, Hermann, eds. "Paula Modersohn-Becker Briefe und Tagebuchblätter." *Die Güldenkam-mer.* Vol. 3, nos. 4–8 (January–May). Bremen: Verlag Kaffeehag, 1913.

Hamburg '76	*Paula Modersohn-Becker, Zeichnungen Pastelle Bildentwürfe.* Catalog for exhibition of the drawings, pastels, and oil sketches at the Kunstverein in Hamburg from September 25 to November 21, 1976.
Hetsch	Hetsch, Rolf. *Paula Modersohn-Becker. Ein Buch der Freundschaft.* Berlin: Rembrandt Verlag, 1932.
Knackfuss	*Künstler-Monographien.* Edited by H. Knackfuss and others. Bielefeld and Leipzig: Velhagen & Klasing, various dates.
Müller-Wulckow	Müller-Wulckow, Walter, ed. *Die Paula Becker-Modersohn-Sammlung des Ludwig Roselius in der Böttcherstrasse in Bremen.* Bremen [1927].
Muther	Muther, Richard. *Studien und Kritiken.* Vols. 1 and 2. 4th ed. Vienna, 1900.
1919 Edition	Gallwitz, Sophie Dorothea, ed. *Eine Künstlerin. Paula Modersohn-Becker Briefe und Tagebuchblätter.* Commissioned by the Kestner-Gesellschaft (Hannover). Bremen: Franz Leuwer, 1917; 2d ed., 1919.
1920 Edition	Gallwitz, Sophie Dorothea, ed. *Paula Modersohn-Becker Briefe und Tagebuchblätter.* Berlin: Kurt Wolff Verlag, 1920.
Pauli	Pauli, Gustav. *Paula Modersohn-Becker.* 3d ed., with expanded catalog. Berlin: Kurt Wolff Verlag [1934].
Petzet	Petzet, Heinrich W. *Das Bildnis des Dichters.* "Insel Taschenbuch." No. 198. Frankfurt: Insel Verlag, 1976.
Rouart/Wildenstein	Rouart, Denis, and Wildenstein, Daniel. *Edouard Manet. Catalogue Raisonné.* Vol. 1, *Peintures.* Paris, 1975.
S/A	Woldemar Becker's student album (1859–61), used by PB as her first sketchbook.
S/I-XXII	These sketchbooks still exist either in bound volumes (e.g., *The Bunzlauer Skizzenbuch,* no. XXI) or in loose-leaf form. The latter have been reconstructed by Dr. Anne Röver and Wolfgang Werner in preparation for the oeuvre catalog of the drawings.
Singer	Singer, Hans Wolfgang. *Max Klingers Radierungen, Stiche und Steindrucke.* Catalog. Berlin: Amsler und Ruthardt, 1929.
Uphoff	Uphoff, C. E. *Paula Modersohn-Becker.* ("Junge Kunst," no. 2.) Leipzig: Klinckhardt & Biermann, 1919.

Notes

The following names, which occur again and again in the annotations, Paula Becker/Modersohn-Becker, Otto Modersohn, Clara Westhoff/Rilke-Westhoff, and Rainer Maria Rilke, will be referred to in the following by their initials, PB/PMB, OM, CW/CRW, RMR. Works by painters which are only cursorily mentioned by PMB are given simply with their titles; for works with which she is more deeply engaged, precise reference details are given.

Frequently cited sources and their abbreviations are on pages 435-436.

1892–1896

Introduction

Gehege [*Preserve*]: See Casper David Friedrich, *Das Grosse Gehege,* painting. Dresden, Staatliche Kunstsammlungen, Gemäldegalerie Neue Meister [State Art Collection, Painting Gallery of Modern Masters], no. 208.

Lycée Richelieu: An institute of higher education founded by Armand Duplesis, Duc de Richelieu (1766–1822). He came to Russia as a refugee from the French Revolution. He was named governor general of Odessa by Czar Alexander I in 1803 and distinguished himself there by establishing a variety of cultural institutions.

"modest household": Gustav Pauli speaks of the "simple parental home" in which PB grew up. The description is somewhat misleading because of the language usage of the period. The intellectual milieu of the Becker household corresponded very closely to that of Pauli's home. The essential difference, the one that determined everyday life, had to do with the size of their bank accounts.

"our father's influence...": Herma Becker-Weinberg in Hetsch, p. 13.

The relatives of PB (parents, brothers, and sisters):
Carl Woldemar Becker (Odessa, January 31, 1841–Bremen, November 30, 1901), married June 11, 1872, to:
Mathilde von Bültzingslöwen (Lübeck, November 3, 1852–Bremen, December 22, 1926).
Kurt, M.D. (1873–1948), like previous members of this branch of the family, he added to his name that of his ancestress Johanna Christiana Benedicte Glauch (died 1793).
Bianca Emilie, called Milly (1874–1949), married in 1905 to the merchant Hans Rohland; daughter Christiane, born March 1907.
Paula (1876–1907).
Günther (1877–1928), merchant in various countries of East Asia and in Australia.
Hans (1880–1882).
Herma, Ph.D. (1885–1963), teacher in an Oberschule [upper school or junior college], married in 1913 to Moritz Weinberg. And her twin:
Henry, called Henner (1885–1949), officer in the merchant marine, later director of dockyards.

Relatives on the father's side:
Paul Adam von Becker (1808–1881), grandfather of PB, married three times, last marriage with Bianca von Douallier (1833–1909). His children:
Oskar Becker (1839–1868); see note for letter of February 28, 1905.
Arthur Becker, LL.D. (1854–1929), chief justice of higher district court, a civil and criminal court of the first instance, married to Margarethe Schindler (1861–1945).
Marie Becker (1856–1914), married to the plantation owner and merchant Charles Hill (1822–1894).
Friederike Becker (1859–1928).
Paul Becker (1864–1921), army officer, married in 1898 to Frieda Heller (1877–?).

Relatives on the mother's side:
Adolf Ludwig Heinrich Friedrich von Bültzingslöwen (1808–1882), grandfather of PB, married to Emilie Dorothea Sophie Lange (1815–1896). Children:
Günther von Bültzingslöwen (1839–1889), plantation owner in Java.
Paula von Bültzingslöwen (1841–1901), second marriage to Gottfried Wilhelm Louis Rabe (1837–1901), army major, PB's godfather; their children, Wulf and Ella.
Emilie, called Emma, von Bültzingslöwen (1843–1919), married in 1877 to Georg Theodor Schäfer, Ph.D. (1845–1911), Oberlehrer [senior instructor] at the Old Gymnasium in Bremen. Son, Edmund Schäfer, a painter and graphic artist (1880–1959); and other children.
Wulf von Bültzingslöwen (1847–1907), plantation owner in Java and Sumatra, and merchant, married in 1873 to Cornelia, called Cora, Hill (1852–1940), daughter of Charles Hill. Son, Fritz v. B. (1874–1943).
Hermine, called Herma, von Bültzingslöwen (1854–1940), married in 1873 to Gustav Wilhelm Parizot (1844–1907), merchant and plantation owner. Four children, among them Cora (1875–1886), suffocated while playing in a sand pit in Hosterwitz near Dresden; Mathilde, called Maidli (1878–1945), married in 1902 to Gerhard Stilling; and Günther (1880–1966).

seminary for women teachers: Seminar und Fortbildungsanstalt Janson, Bremen; director, Ida C. W. Janson (1847–1923).
Bernhard Wiegandt: (1851–1918), painter. Studied at the Munich Academy beginning in 1880 and settled in Bremen ten years later.
painters of the art colony in Worpswede: the following five painters are considered the "Worpsweders": Mackensen, Modersohn, Overbeck, am Ende, Vogeler. Beginning in 1889 they settled in the Village of Worpswede, about sixteen miles northeast of Bremen, in the center of the Teufelsmoor and at the foot of the hill, called the Weyerberg, attracted evidently by the quiet beauty of this austere landscape with its vast sky. They admired the masters of the Barbizon School and followed in their footsteps. Indeed, their life there as well as their work can be seen primarily as a reaction to the beginning industrialization of that part of the country. (See Robert Minder, "Lüneburger Heide, Worpswede und andere Heide- und Moorlandschaften" ["Luneberg Heath, Worpswede and Other Heath and Moor Landscapes"], in *Acht Essays zur Literatur* [*Eight Essays on Literature*], [Frankfurt am Main: S. Fischer Taschenbuch Verlag, no. 983, pp. 59ff.]; and Sigrid Weltge-Wortmann, *Die ersten Maler in Worpswede* [*The First Painters in Worpswede*], [Worpswede: Worps-

weder Verlag, 1979].) This central group of the Worpswede painters had already known one another from their period as art students together.

Fritz Mackensen (1866–1953), painter. Studied at the academies in Düsseldorf, Munich, and Karlsruhe. His first stay in Worpswede was in 1884; from the year 1889 he was a permanent settler there with the exception of the decade 1908–18.

Otto Modersohn (Soest, 1865–Rotenburg–Wümme, 1943), painter and graphic artist. Began his training in 1884 in Düsseldorf, Munich, and Karlsruhe. Trip to Paris in 1899. Lived in Worpswede, 1889–1908, following which he settled in nearby Fischerhude.

Fritz Overbeck (1869–1909), painter and graphic artist; studied from 1889 to 1893 at the Düsseldorf Academy and came to Worpswede in 1894 where he lived until 1905.

Hans am Ende (1864–1918), painter and etcher. Studied in 1884–86 and 1888–89 at the Munich Academy, 1886–87 at the Karlsruhe Academy; first came to Worpswede in 1889.

Heinrich Vogeler (1872–1942), painter, graphic artist, and designer. Studied at the Düsseldorf Academy, 1890–94; a trip to Paris, 1893; came to Worpswede in 1894 and studied under Mackensen. Bought the Barkenhoff (a large white house which for a while became the commune center for the Worpsweders). Had a close acquaintanceship with R. A. Schröder and A. W. Heymel in 1896. It was they who engaged him in the design and furnishing of the so-called "Insel" Apartment, and as a graphic collaborator for *Die Insel* in Munich. Returned to Worpswede in 1900. Traveled during the years 1911–14. Served in the army, 1914–18. In 1918 the Barkenhoff became a Communistic commune. Trip to Russia in 1923; settled there in 1932, died in a camp for political prisoners in Kasakstan, central USSR, and his grave is unknown.

July 29, 1892. To Grandmother von Bültzingslöwen
Willey: The Hills's estate near London which just at that time was being sold. The family was preparing to move into the recently purchased Castle Malwood, whose renovations, however, were taking longer than expected. For that reason the Hills moved frequently during the time that their niece Paula was visiting, from furnished apartments in London to visits with other relatives.

August 7, 1982. To her father
Professor Donndorf: Adolf Donndorf (1835–1916), sculptor, pupil of Ernst Rietschel; active in Dresden and, from fall 1876, in Stuttgart. From his period in Dresden he was friends with the Becker family, particularly with Maria Hill.

Christlieb: probably a pastor of the German Evangelical community in London. He was training there to become a missionary in Japan.

tomorrow [today?]: this is somewhat confusing; one must assume that this letter was written on two separate days. Instruction in sketching on a Sunday in England was highly improbable.

Käte: evidently the fiancée or wife of Pastor Christlieb, née Donndorf, daughter of the above and acquainted with PB from Dresden.

Durchleuchting: "Dörchläuchting," story by the famous *Plattdeutsch*, or Low German dialect, author Fritz Reuter (1810–1874); published in Wismar, 1866.

August 19, 1892. To her parents
little Ella: her cousin Ella Rabe.

Larssen children: evidently children of friends of PB's parents and relatives; further identification cannot be made.

Caro: the Beckers' dog.

September 2, 1892. To her parents

in the plural: Frau Becker had been visiting her mother.

Else: Else Bücking, born 1876. Daughter of chief construction engineer Bücking, she was a school friend of PB's. The Bückings lived on Schönhausenstrasse close to the Beckers.

Juist: one of the East Frisian islands at the mouth of the Weser in the North Sea between the islands of Norderney and Borkum.

Dr. Prate's family: possibly Poate, friends of the English relatives; further identification impossible.

Günther: PB's brother, very infrequently mentioned in her correspondence. He seems to have had a difficult time in life both within the family circle and later in his attempts to be a successful businessman in the Orient and in Australia, where he died by his own hand.

Rob Roy: novel (1817) by Sir Walter Scott (1771–1832).

cholera in Germany: in 1892 Germany was struck by its last cholera epidemic; Hamburg was especially hard hit.

September 21, 1892. To her sister Herma

Fritham Lodge: the estate of relatives of the Hill family.

two little sleeves: these extended cuffs, frequently made of celluloid, were worn by schoolchildren, shop clerks, and others to protect their shirt and blouse sleeves.

September 22, 1892. To Paula from her father

your oranges: a branch of an orange tree with fruit; watercolor, dated lower right "92." The Estate.

October 22, 1892. To Paula from her father

coram publico [*in public*]: Equivalent to the phrase *in coram populo.*

Aunt Falcke: Née Dörstling, was a sister of Woldemar Becker's mother and PB's godmother.

Kuntzes: Relatives of the Becker family; they lived in Hosterwitz, a village between Loschwitz and Pillnitz, southeast of Dresden.

Baring's: Adolf Baring, LL.D. (1860–1945), councilor of a superior district court in Dresden. As a student he lived at the Becker's home and because of his already failing eyesight he was the particular protégé of Frau Becker who would take him for walks and read to him.

Günther's epistle: PB's brother Günther had been temporarily sent to a boarding school due to his bad grades at school.

October 28, 1892. To her parents

Mr. Ward: Thieme-Becker, vol. 35, pp. 157ff., refers to several painters of this name; which one of them taught at PB's school cannot be determined.

[Ca. November 1, 1892]. To her Mother

This fragment has been taken from S. D. Gallwitz's introduction to the 1920 edition of the *Briefe und Tagebuchblätter* [*Letters and Leaves from the Journal*], p. vii. Our dating is

based on the fact that this is evidently a birthday letter and that in addition a reference to her father's letter of October 22 can be detected.

November 25, 1892. To her sister Milly
take my eyes from her: a play on the line "Ich kann den Blick nicht von euch wenden" ["I cannot take my eyes from you"], from *Die Auswanderer* [*The Emigrants*] by the poet Ferdinand Freiligrath (1810–1876).
Ellen Terry: the English actress Ellen Alice Terry (1847–1928), particularly famous for her Shakespearean roles.
Irving: Sir Henry Irving (1838–1905), English actor. His most celebrated roles were *Macbeth* (1888), Cardinal Wolsey in *Henry VIII* (1892), and *King Lear* (1893).
Dean: Also spelled Dien; she was a young relative of Uncle Charles Hill.

[Cannot be dated]. [Journal?]
This excerpt is likewise taken from Gallwitz's introduction, see above. This note must refer to the effect on PB of the reading in which she was engaged at the time.

December 7, 1892. To Paula from her mother
the Magi: a drawing, later inscribed by Frau Becker, "Drei Könige aus dem Morgenlande. Thema in London Winter 93" ["Three Kings from the Orient. A Theme from London Winter '93"], 1892. The Estate.

January 14, 1893. To Marie Hill
Frau Rassow: Christiane Rassow (1862–1906), daughter of the lord mayor of Bremen, Friedrich Grave, and wife of the merchant and later senator Gustav Rassow (1855–1944). She was a close friend of Frau Becker. She was actively engaged in the cultural life of Bremen and particularly in the creation of a humanistic high school for girls for which she recruited the famous German woman writer, Ricarda Huch (1864–1947) for a period. Since the latter was frequently a guest in the Becker home, as we can gather from a number of letters written by Frau Becker, it is very likely that PB got to know her. See Ricarda Huch, *Erinnerungen an das eigene Leben* [*Recollections of My Own Life*] (Cologne: Kiepenheuer & Witsch, 1979), pp. 245ff., esp. p. 247.
Rubinstein: Anton Rubinstein (1829–1894), Russian composer and pianist, whose ballet *Die Rebe* [*The Grapevine*] is subtitled "Poem for the Dance After Taglioni and Others" (1882); Paul Taglioni (1808–1884) was ballet director in Berlin beginning in 1869.
Tony Rohland, Minna Krollmann, Else Bücking: girlfriends of PB; Tony Rohland (1872–1945) later became the sister-in-law of Milly Becker.
Adolf von Wilbrandt: (1837–1911), German author; his comedy *Unerreichbar* [*Unattainable*] appeared in 1870.

January 22, 1893. To Marie Hill
Frau Franzius: Marie Elisabeth Caroline Uslar (1835–1902), married in 1859 to Ludwig Franzius (1832–1903), who was called to Bremen in 1875 as Oberdirektor or chief construction engineer. It was he who carried through the massive project of regulating the Weser River with its series of locks which made possible Bremen's connection to the North Sea. He was a gifted graphic artist as well.

Kea: maid at the Beckers'.

Frau Runge: possibly the widow of A. T. Runge, who lived at Mathildenstrasse 15, and therefore not far from the Beckers' home.

a picture of Herma: charcoal drawing, signed in an unknown hand: "Herma, Anfang 93" ["Herma, early '93"]; likewise, "Henner Anfang 93"; also "Zeus von Otricoli" ["The Zeus of Otricoli"]. All three in the Estate.

Grimm's Michel Angelo: Herman Grimm (1828–1901), art and literary historian, essayist, and son of Wilhelm Grimm (one of the two famous Brothers Grimm), he was also the son-in-law of Bettina von Arnim-Brentano. He was professor at the University of Berlin, 1893– . *Leben Michelangelos [Life of Michelangelo],* 1860–63.

Tony Roelecke [or Boelecke?]: Probably a school friend, but she cannot be further identified.

February 4, 1893. To Marie Hill

2½ d (pence) = approximately five cents then.

15 s (shillings) was about three dollars and seventy-five cents.

Prof. Bulthaupt: Heinrich Bulthaupt, LL.D. (1849–1905). He became the director of the Bremen city library in 1879 and devoted his life to his literary talents and inclinations. From 1878 to 1888 he was the head of the literary branch of the Bremen Society of Artists; from 1890 to 1904 he was its president and had a powerful influence on the cultural life of the city. In 1897 he inherited from the widow of his friend the composer Franz von Holstein the summer villa Burgstall near Oberstdorf where he entertained with a lavish hand. Frau Becker, a friend of his, spent numerous holiday weeks there, and Paula and Milly were guests at the villa for some days in 1899. In 1905 Clara Rilke sculpted a bust of Bulthaupt. His lecture on Wagner was delivered on February 2, 1893.

April 26, 1893. To Kurt Becker

The letter exists in a copy.

be feeling fine again: Kurt Becker was still suffering from the aftereffects of his rheumatic illness mentioned in the letter of January 14, 1893.

Herr Bischof: probably Paul Bischof, active on the Council for Railways. The drawing is inscribed "Regierungsrath Bischof, d. 31.3.93." S/A 5. On the same day Paula also dated the portrait drawing of her father, S/A 4.

my own faithful reflection: self-portrait inscribed "93." Hamburg '76, cat. no. 1. All three of these drawings are in the Estate.

de Tierys: G. H. de Thierry, an engineer in Bremen, was at that time a colleague of Paula's father.

May 5, 1893. To Marie Hill

Aunt Minchen: Hermine von Westernhagen, a relative on her mother's side.

My pride is my best possession: four years later while reading George Eliot's (1819–1880) novel *Middlemarch* (1870–72) PB still made a point of copying out the sentence: "Pride helps us, and pride is not a bad thing when it only urges us to hide our own hurts — not to hurt others."

February 25, 1894. To Milly Becker
Anna Streckewald: a friend from PB's grade school and seminary days. The family lived on
 Herderstrasse, very close to the Beckers.
"Grapevine Evenings": probably refers to get-togethers for practicing the Rubinstein ballet;
 see letter of January 14, 1893.

July 20, 1894. To Herma Becker
Spiekeroog: according to family letters PB was visiting this North Sea island with the family
 of her friend Anna Streckewald for the last two weeks of July. Herma was nine years old at
 the time.
Kea and Alwine: maids in the Becker household.

Spiekeroog [undated]. To Herma Becker
clamber in through the window: major renovations were being carried on at the Beckers'
 large house, Schwachhauser Chaussee 29.

April 27, 1895. To Kurt Becker
The letter exists in a copy.
"A brother and a sister...": PB is quoting from the poem "Treueste Liebe" ["Truest Love"]
 by the popular poet Paul Heyse from his 1872 collection *Gedichte* [*Poems*], 1872. It was
 set to music by G. Gramberg.

> A brother and a sister
> the world knows nothing truer.
> No golden chain binds stronger
> than the one holds to the other.
> Two lovers often part,
> for love is often fickle.
> Brother and sister, in pleasure and sorrow,
> hold to each other their lifetime through.
> As true as the moon and the earth
> circle side by side,
> as closely as the flames of the stars
> burn side by side all night.
> The angels in heaven point to them,
> rejoicing from the depths of their hearts,
> when brother and sister bend to each other
> and kiss each other on the mouth.

Mother's return home: Frau Becker had received sufficient funds from her brother Wulf von
 Bültzingslöwen to be able to take the long-awaited trip to Italy.
the last one [spring]: the family had to reckon with the loss of their official home on Schwach-
 hauser Chausee with the retirement of Herr Becker in 1896; however, the Works Council
 permitted them to stay on for a number of years longer, for the Beckers did not move to
 Wachtstrasse 43 until exactly four years later.
Sermon on the Heath: also called *Holy Service on the Moors.* Mackensen was awarded the

Gold Medallion in Munich in 1895 for this celebrated painting. It measures nearly nine feet by thirteen feet and is today in the Historisches Museum, Hannover. Besides this painting there was another by Mackensen at the Bremen exhibition, *The Infant*, also known as *Woman in a Peat Cart, Madonna of the Moors*, or *The Worpswede Madonna*, 1892. This painting was a gift to the Bremen Kunsthalle by members of the Art Society and cost at the time one thousand marks. Otto Modersohn's *Storm on the Devil's Moor* was also exhibited and bought by the Munich State Gallery, causing a sensation there. His *Autumn on the Moors* was presented by two friends of the arts to the Bremen Kunsthalle; its price was likewise the generous sum of one thousand marks.

glass wagon: this contraption no longer exists but was presumably a horse-drawn wagon with at least one side made of glass in which Mackensen could sit and paint and be protected from sun, wind, and rain. Other plein air artists in France and Germany used similar inventions for painting in the outdoors.

Dr. Hurm: Johann Gustav Karl Wilhelm Hurm, M.D. (1848–1896). "A man of great education and cultivation, Dr. Hurm possessed a noble and stimulating conviviality... and had great literary and artistic interests." *Bremen Biographie des 19. Jahrhunderts [Bremen Biography of the Nineteenth Century]* (1912), p. 231. Hurm put together the first scholarly catalog of the Bremen Kunsthalle.

[undated] Journal entry?

It is so heavenly to think: this must have been written following PB's examinations for certification as a teacher and was taken from the introduction to the 1920 edition, p. ix.

February 6, 1896. To Paula from her father

Leipzig: after his retirement, Woldemar Becker went to Leipzig where he looked for further work as an engineer at the railway construction sites in Saxony. He remained there for weeks, separated from his family and plagued by worry and concern that he would not be able to keep up his family's standard of living.

Your good uncle Paul: the relationship of Woldemar Becker to his youngest half-brother was not very close; there was a difference in age of twenty-three years.

two Langen patterns: probably patterns for making burnt wood pictures, a popular amateur art form at the time.

toujours perdrix: "always partridge," a humorous saying frequently used by Herr Becker. Henri IV of France (1589–1660) is said to have countered his father confessor, after the latter had accused him of carrying on too many amorous affairs, by directing his servants to serve the priest nothing but partridge for weeks on end, until the clerical gentleman began to complain, "toujours perdrix." The king answered that he had hoped in this way to demonstrate the pleasures of variety in appetite.

Wilbrandt: Adolf Wilbrandt (1837–1911), popular novelist. *Die Rothenburger* appeared in 1895.

Fontane: Theodor Fontane (1819–1898), one of the greatest German novelists of the nineteenth century. *Effi Briest* was published in 1894.

Ebner-Eschenbach: Marie von Ebner-Eschenbach (1830–1916), highly regarded Austrian writer of fiction. The novel *Bozena* appeared in 1876.

March 26, 1896. To her father

Walter Schäfer: one of PB's cousins.

Frau Dr. Hurm: Dr. Hurm had died two months previously. (See note to the letter of April 27, 1895.)

the letters of Mendelssohn: Felix Mendelssohn-Bartholdy (1809–1847), composer. His *Travel Letters 1830–32* and his *Letters 1833–47* were edited by Paul Mendelssohn. They appeared in a one-volume edition (Leipzig, 1882).

Kurt Bücking: M.D. (1878–1945), brother of PB's friend Else Bücking, and close friend of her brother Kurt.

1896–1899

Introduction

Society of Berlin Women Artists: this group was founded in 1867.

Alberts: Jacob Alberts (1860–1941), painter and lithographer, studied in Düsseldorf and Munich, and then at the Académie Julian in Paris, 1886–90. From 1894 on he taught at the Drawing and Painting School of the Society of Berlin Women Artists. The main themes of his painting were his native landscape in West Schleswig and the Halligen, small islands and sandbars in the North Sea off the coast of Schleswig-Holstein. He was a founding member of the Eleven (see note to letter of ca. March–April 1898) and later a member of the Berlin Secession.

Jeanna Bauck: Jeanna Maria Charlotte Bauck (1840–?), a painter of German-Swedish origin, studied in Dresden, Düsseldorf, and Paris (Académie Julian). In Berlin she was an instructor at the Drawing and Painting School. In the latter part of her life she lived in Munich. In Doede (p. 66) she is mentioned as a teacher of PB. PB seems always to have spelled the first name Jeanne, a spelling that Bauck may have adopted herself in France and later kept in Germany.

Paula Ritter: (1868–?), a native of Bremen, she was a pupil at the Drawing and Painting School in Berlin, and afterward in Munich with Peter Paul Müller. At the turn of the century she had several exhibitions in Bremen.

International Exhibition of Art: Internationale Kunstausstellung, Dresden, 1897. Catalog, May 1, 1897. The Worpswede artists were well represented. PB was also able to see works by the French Impressionists there (Monet, Pissarro, Sisley). She saw Kalckreuth's *Das Alter* [*Age*], which she mentions later; a Brittany landscape by Lucien Simon, whom she admired later in Paris; and three paintings by Oskar Zwintscher which evidently impressed her. In addition, she got to know the work of Constantin Meunier, who was shown in Germany for the first time at this Dresden group show.

Gewerbemuseum: [Museum of Arts and Crafts]. The guide to exhibition of lithographs edited by the General Administration of the Royal Museums of Berlin, March–April 1898.

Max Liebermann (1847–1935), German painter and graphic artist; is considered a representative of the German Impressionist style.

Adolphe Friedrich Erdmann von Menzel (1815–1905), German painter, graphic artist, and lithographer.

Hans Thoma (1839–1924), German painter.

Pierre Puvis de Chavannes (1824–1898), French painter of monumental and historical scenes and graphic artist.

Henri Fantin-Latour (1836–1904), French painter and graphic artist.

Eugène Carrière (1849–1906), French painter and lithographer. He united elements of traditional chiaroscuro with Art Nouveau ornamentation.

Édouard Manet (1832–1883), French painter, Impressionist.

Constantin Emile Meunier (1831–1905), Belgian sculptor, painter, and graphic artist.

Camille Jacob Pissarro (1830–1903), French painter, close to the circle of the Impressionists.

Odilon Redon (1840–1916), French painter, close to the Nabis.

Pierre Auguste Renoir (1841–1919), French painter, graphic artist, and sculptor, Impressionist.

Paul Sérusier (1864–1927), French painter, member of the Nabis.

Paul Signac (1863–1935), French painter, Neo-Impressionist.

Henri de Toulouse-Lautrec (1864–1901), French painter and lithographer, "inventor" of the artistic poster, influenced by Degas and Japanese woodcuts.

Félix-Edouard Vallotton (1865–1925), French-Swiss painter, close to the Nabis in Paris.

Edvard Munch (1863–1944), Norwegian painter and lithographer. Important exhibitions of his works at Keller & Reiner, 1897.

Max Klinger (1857–1920), German painter, etcher, sculptor, precursor of the Surrealists.

Gerhart Hauptmann: (1862–1946), *Die Versunkene Glocke—ein Deutsches Märchendrama* [*The Sunken Bell—a German Fairy Tale Drama*] (1896).

Mackensen's contribution: Hetsch, p. 40, when Mackensen writes that besides Vogeler he had accepted no pupil other than PB, he is not being quite factual, for when PB arrived in Worpswede, CW was already his pupil (see Hetsch, p. 42); and immediately after PB, in accordance with a previously made arrangement, he accepted Ottilie Reyländer (Hetsch, p. 32).

Aline von Kapff: Aline Charlotte von Kapff (1842–1936), painter and Bremen patroness of the arts.

Paula Becker "chose" Mackensen: Pauli, p. 14.

Clara Westhoff: Clara Henriette Sophie Westhoff (Bremen, November 21, 1878–Fischerhude, March 9, 1954), sculptor and painter. She began her training in Munich, then with Mackensen in Worpswede, and in 1899 with Klinger in Leipzig. From the end of 1899 she lived in Paris where Rodin took her on as a pupil. On April 27, 1901, she married Rainer Maria Rilke.

"There sat Paula Becker": Hetsch, p. 42. Exactly the way CW describes her friend here was the way she sculpted a bust of PB, a work that is generally considered to be her second original and independent work of art. After PMB's death, CRW made a second version of this bust. (Rilke wrote to CRW September 4, 1908: "...how well I can understand your joy and your renewed feeling of participation with PMB by working on this beautiful bust again. ..." First version of the bust (in polychrome plaster of Paris) is in the Rilke Estate in Gernsbach. (See illus. no. 13.)

Ottilie Reyländer: Ottilie Reyländer-Böhme (1882–1962), portrait and landscape painter. Between 1898 and 1908 she was frequently in Worpswede, married in 1908 in Mexico, and lived out her life in Berlin. Her painting *The Three Sisters* is in the Haus im Schluh in Worpswede.

"...modeling instruction...": Hetsch, p. 34f.

Her Album: Following are the works mentioned or quoted in the Album but which do not appear in the body of the text:

Rembrandt als Erzieher [Rembrandt as Educator]: published anonymously in 1889. Its

author was Julius Langbehn (1851–1907). This book enjoyed a continuing and in many respects fatal and dire success with the German middle class which saw in it the intellectual and spiritual harvest of victory and German solidarity. It is a kind of confession of faith of irrationalism and individualism, both of which Langbehn considered to be fundamental racial traits of Germanic nature. For him, Rembrandt was the irrational and individualistic artist incarnate. Even within the various "nations" of Germany, separate individualities were to be fostered. From the various racial strains of the German people, taken in the broadest sense, German art will be renewed; and after the long domination of the Latinate and Catholic South, the Lowland German and Protestant North shall take over the leadership of this new art. Like many others, the Worpswede artists saw in such views confirmation of their work and artistic strivings; their outspoken idealization of Rembrandt was founded not least of all in Langbehn's theory. His theses were part and parcel of Carl Vinnen's protest in 1911 against the *Überfremdung* [excessive infiltration] of German museums by French Impressionistic art. The aftereffects of Otto Modersohn's study of Langbehn's book can be traced through the years in OM's journal. When PB came to Worpswede the book was still being discussed, but she had read it herself some time earlier, and even she was impressed by it at the time. It wasn't until she began to visit, live, and study in Paris that she was able to rid herself of the last vestiges of these dangerous artistic and chauvinistic ideas and memories.

Alfred Lichtwark, "Das Urteil über Böcklin" ["Judgment on Böcklin"], introduction to the catalog of the Hamburg Böcklin Exhibition, 1897.

Gustave Flaubert (1821–1880), *L'Education sentimental* (1869). PB read the excerpt May 26, 1898, while she was still in Berlin.

"Der feine Klang" ["The Fine Sound"], "Der Wanderer," two poems by Richard Holzamer, in *Pan*, vol. 3, no. 4 (1897), pp. 205 and 207. Read in Christiania (Oslo), June 10, 1898.

Anselm Feuerbach (1829–1880), *Ein Vermächtnis [A Testament]*, ed. Henriette Feuerbach (Vienna, 1884).

Gotthold Ephraim Lessing (1729–1781), *Laokoon oder Über die Grenzen der Malerei und Poesie [Laocoon or A Treatise on the Limits of Painting and Poetry]* (1766).

Friedrich Nietzsche (1844–1900), *Zur Genealogie der Moral [Toward a Genealogy of Morals]* (1887).

Leonardo da Vinci (1452–1519), *Trattata della pittura [Treatise on Painting]*. French edition by R. du Fresne (Paris, 1651). German edition, *Das Buch von der Malerei*, ed. E. Ludwig, 3 vols. (Vienna, 1882). PB quotes from a French edition.

Georg Brandes (1842–1927), *Deutsche und dänische Romantik [German and Danish Romanticism]* and *Die Geschichte der englischen Literatur [The History of English Literature]*; see *Main Currents in the Literature of the Nineteenth Century* (English translation 1901–5).

Maurice Maeterlinck (1862–1949), *Le trésor des humbles [The Treasury of the Humble]* (1896). PB quotes from the German translation, *Schatz der Armen*.

Friedrich Hölderlin (1770–1843), *Hyperion oder Der Eremit in Griechenland [Hyperion or The Hermit in Greece]*, epistolary novel, 2 vols. (1797 and 1799). "An die jungen Dichter" ["To the Young Poets"]. PB read this poem on May 12, 1899.

Mechthild. PB read from the works of this famous German nun, known as Mechthild von Magdeburg, born ca. 1207, lived in a Beguine convent around 1230, and who wrote down her visions between the years 1250 and 1265. These she called *Das fliessende Licht*

der Gottheit [The Streaming Light of the Godhead]. Ca. 1270 she entered the Cistercian convent of Helfta, from which time she was known as Mechthild von Helfta. She died c. 1292. PB read her on June 8, 1899; it is impossible to say, however, exactly what she did read; it is certain that her attention was drawn to Mechthild by Carl Hauptmann's friend Hermann Büttner, who was working at the time on his translation of the works of the great mystic Meister Eckart. (See PB's letter to her brother Kurt, Thursday, June 1899.)

Rudolf Alexander Schröder (1878–1962), *Unmut. Ein Buch Gesänge [Displeasure. A Book of Songs]* (1899). PB read this on October 31, 1899.

Deutsche Kunstausstellung [Exhibition of German Art]: Dresden, 1899. Not to be confused with the great International Exhibition of Art there in 1897.

exhibited two paintings and several studies: according to the receipt files of the Bremen Kunsthalle, 1899–1906, PB exhibited two paintings, one entitled *Abend [Evening],* the other, *Weiher [Pond],* and seven charcoal studies. None of these pictures can be identified today.

Marie Bock: née Thormählen (1867–1956). After a brief period of study in Munich, she attended the Art School for Ladies in 1894–95. She was in Worpswede from 1898 to 1902. From there she went to Berlin, studied under Ludwig Bartning and later under Paul Schultze-Naumberg in Saaleck.

Fitger: Arthur Fitger (1840–1909), painter, writer, critic. At the Munich Academy of Arts he studied under Piloty. Murals by him are to be found in numerous public buildings and private houses in Bremen.

Vinnen: Carl Vinnen (1863–1922), painter, close to the Worpswede school and often exhibiting with them without being considered exactly one of the group. He studied in Düsseldorf and Karlsruhe from 1886 to 1889. He lived on the estate of Osterndorf in Beverstedt, not far from Worpswede.

Gustav Pauli: (1866–1938), art historian. From 1899 to 1905 he was the senior professional scholar of the Art Society of the Kunsthalle in Bremen, and from 1905 to 1914, director of the Kunsthalle.

April 11, 1896. To her mother
Perleberger Strasse 23: address of PB's Aunt Paula Rabe.
Haby: François Haby was the creator of the *Es-ist-erreicht* [We-have-succeeded] beard of the Kaiser. Henry van de Velde, the famous Art Nouveau architect, designed the shop of this celebrated barber in 1901.
little Ella: PB's cousin Ella Rabe.

April 15, 1896. To Paula from her father
Auntie Frieda: this is evidently a reference to the unmarried half-sister of Paula's father, about whom old-maid jokes were made by members of the family.

April 23, 1896. To her parents
Stöving: Curt Stoeving (1863–1939), painter. From 1892 to 1910 he was *Privatdozent* [university lecturer] for architectural painting at the Institute of Technology in Charlottenburg. In 1896–97 he taught portraiture and life drawing at the Drawing and Painting School of the Society of Berlin Women Artists. He himself was a portraitist and interior decorator.

The Vision of Daniel: Rembrandt Harmensz van Rijn (1606–1669); *The Vision of Daniel* follows the Book of Daniel, 7:15–27, painted ca. 1650. Today it is in the Staatliche Museen, Gemäldegalerie [State Museum Collections, Painting Gallery], West Berlin. Some authorities doubt the ascription to Rembrandt. But Bauch considers the work genuine.

[Prior to May 18, 1896]. Journal entry?
Taken from the 1919 Edition, p. 15.

May 18, 1896. To her father
sketch the brickwork there: watercolor of the shed in the Beckers' garden, dated "8.6.96."
S/A, p. 19 verso. The Estate.

Excerpt from undated letter. Perhaps to Marie Hill
Taken from the introduction of the 1920 Edition, p. viii. The reference to "my twenty years" suggests a date of 1896. The recipient is thought to be Marie Hill because of PB's frequent reference to her aunt concerning her own reluctance to speak about and demonstrate her feelings and emotions.

July 30, 1896. Illus. p. 61 (Postmarked Hindelang).
This picture postcard to her father is inscribed with a little rhyme, "Kirschen an den Ohren, Kirschen im Magen / Thun wir von Herzen Dank Dir sagen." ["Cherries at the ear, cherries in the tummy, / all of us thank you from our hearts."] PB has sketched, from left to right, Tony Rohland, Marie Hill, and herself. Watercolor in red, brown, light blue, sepia, with white highlights. Private collection. On July 27 her father had asked whether the cherries he had sent from Leipzig had arrived.

October 20, 1896. To Paula from her mother
Your sketch of the Rheinsberg: probably the watercolor known as *Garden*, in the Bremen Kunsthalle, inv. no. 4/177. (Bremen '76, no. 213.)

November 4, 1896. To Paula from her father
The five heads: (1) *Bust of a Man*, signed "Paula Becker 15.10.96," inscribed lower left "my first head with Alberts." (2) *Bust of a Bearded Man*, signed lower right "Paula Becker 21.10.96," inscribed "with Alberts — my pride." (3) *Bust of a Lady*, dated "25.10.96," inscribed "third head with Alberts." All three drawings in the Estate.
the head in red chalk: Bust of a Man, signed lower right "Paula Becker 31.10.96," inscribed "red chalk head with Körte." Collection Haus am Weyerberg, Worpswede.

[Late November, Berlin, 1896]. To her parents
Fragment of a letter taken from Güldenkammer, vol. 3, no. 4, p. 224. Our dating is suggested from a letter from PB's father of December 2, 1896, in which he reacts to her news concerning the beginning of her painting in oil.
Dettmann: Ludwig Dettmann (1865–1944), painter, illustrator. Professor at the Berlin Academy, 1895. Previously and simultaneously teacher at the Drawing and Painting School of the Society of Berlin Women Artists. From 1900 on, director of the Königsberg Academy. Founding member of The Eleven.

December 5, 1896. To Paula from her mother
She will get two of our rooms: Frau Becker had taken on a young American woman as a
boarder.

December 29, 1896. To Paula from her mother
the head of a woman, which you drew twice: perhaps the bust portrait of an old woman with
a white collar, full face, red chalk, white highlights, dated "4. Dez. 1896," signed "Paula
Becker." And the bust portrait of the same old woman, facing left, red chalk, white high-
lights; signed "Paula Becker." (Bremen '76, no. 221.) The Estate.
tender and gaunt figure of a woman: cannot be identified.
Hönerbach: Margarethe Hoenerbach (1848–?), painter, etcher, sculptor. Frequently in Paris
and Italy. At that time the director of the Drawing and Painting School of the Society of
Berlin Women Artists.

January 10, 1897. To her parents
Uth: Max Uth (1863–1914), landscape painter. Pupil of the Berlin Academy, teacher at the
Drawing and Painting School of the Society of Berlin Women Artists. He opened his own
atelier for women painters in 1897.
Fliegende Blätter: a weekly illustrated humor magazine, founded 1844 in Munich.
Körte: Martin Körte (1857–?), portrait painter. Teacher at the Berlin Academy and at the
Instructional Branch of the Kunstgewerbemuseum [Museum of Arts and Crafts]; also at
the Society of Berlin Women Artists.
Hausmann: Ernst Friedrich Hausmann (1856–1914), painter. Studied in Paris 1881–83, ac-
tive in Berlin from 1886 on, as teacher at the Society of Berlin Women Artists and else-
where.
Fräulein von Milde: Nathalie von Milde (1850–1906), writer, principally with the women's
suffrage movement.
Bürgerliches Gesetzbuch: codification of German civil law, a book found in most German
households, even up to the present time.

January 11, 1897. To Paula from her father
our meeting with the painters: four days previously PB's father had written, "I probably
wrote you that the gentlemen with whom I was studying the drawings at the the Kunst-
halle recently have invited the Worpswede painters to join them at the Rathskeller. This is
to take place on the eighth...."
von Emden, ... Odeleben: here as elsewhere Herr Becker is confused about the spelling of
proper names; he refers to am Ende and Overbeck.

January 27, 1897. To her father
the little girl: presumably *Bust of a Girl Wearing a Pinafore*, pastel. (Bremen '76, no. 222;
Hamburg '76, no. 41.)
The laughing girl: Bust of a Little Girl, full-face, dated lower right "23 Jan. 97 Becker." Red
chalk, with highlights. (Hamburg '76, no. 40.) Both in the Estate.

February 13, 1897. To her parents
On the train: from Schlachtensee to Berlin.

ball at the Frombergs': Georg Fromberg, a banker in Berlin. Evidently PB was introduced to the family by Paula Ritter.

Max Grube: (1854–1943), actor. He was a member of the celebrated troupe attached to the famous provincial theater in Meiningen, Saxony, and known as Die Meininger. Later he was with the Royal Theater in Berlin.

Lindner: Amanda Lindner (1868–1951), actress; 1886–90 at the Court Theater in Meiningen; 1890–1911 at the Royal Theater in Berlin.

We three lady painters: PB makes this reference elsewhere, and yet the other two members of this trio cannot be identified with absolute assurance. Surely Paula Ritter was one of them.

Müller-Kurzwelly: Konrad-Alexander Müller-Kurzwelly (1855–1914), painter. In 1881–85, pupil of Gude and a member of The Eleven.

wife of Petschnikoff: Lili Petschnikoff, wife of the then celebrated violinist Alexander Petschnikoff (1873–1949). H. Schwarz's portrait of this beautiful woman was to be seen at the Grosse Berliner Kunstausstellung [Great Berlin Art Exhibition] of 1897.

February 20, 1897. To her parents
Fräulein Winkelmann: cannot be identified.

[Ca. February 27, 1897]. To her father
This letter is dated March 14, 1897, in the 1920 Edition. In his letter of March 2, 1897, however, the father is already reacting to PB's news about her visit in Berlin to the Kupferstichkabinett [Print Room], which contains engravings and works in all graphic media; this collection is one of the world's greatest. She told him of her study of the Michelangelo drawings there. Since PB wrote home every week so her letter would arrive on Sunday, the presumptive date is very likely, especially in view of the fact that her father almost never let much time pass before answering his daughter's letters in detail. Furthermore, it is highly unlikely that he would have waited until the middle of March to thank her for her pastels that had been sent early in February.

a little Hungarian boy: a drawing of this "mousetrapper" cannot be identified.

ugly and thin: probably a study in the same style of Hamburg '76, nos. 56–60.

March 2, 1897. To Paula from her father
Intermission: since her father in one of his next letters (March 30) speaks about a sketch for the magazine *Jugend*, which he can picture to himself thanks to her description ("You seem to have gotten very modern now with your drawing of the birch allee. One can hardly imagine the Worpsweders now any other way"), it is also likely that *Intermission* is a rough draft of an illustration for a magazine. Sketch for title page of *Jugend*, gouache. (Bremen '76, no. 265; Hamburg '76, no. 117.) *Jugend* was the periodical founded in Munich by Georg Hirth in 1895–96. Known as a "Periodical for Art, Literature, Life, and Politics," it attained considerable fame and was the source for the designation Jugendstil to refer to the German variant of Art Nouveau.

March 5, 1897. To her parents
given up instruction in landscape painting: this decision seems to have been either made together with Fräulein Hoenerbach, or at least approved by her, for in Herr Becker's letter of

March 30 he writes, "I will, of course, not pretend to know better than Fräulein Hoener-bach about what is best for you, but it would have pleased me if you could have gone on doing landscapes along with your heads."

Schulte: Eduard Schulte, owner of an art gallery which had permanent exhibitions and dealt in the oil paintings of modern masters in Berlin, Unter den Linden 1; that is, in the Rhedernscher Palais, a building by the great architect Schinkel, which was torn down in 1904 to make way for the Hotel Adlon. Jeanna Bauck was exhibiting at Schulte this March.

April 3, 1897. To her parents

Frau N.: cannot be identified.

at the Du Bois Reymonds': Lucy Dubois-Reymond (1858–1915), painter, primarily land-scape watercolors. She was the daughter of the famous physiologist Emil-Heinrich Dubois-Reymond (1818–1896), professor at the University of Berlin, and his wife Jeanette, née Reclam (1833–1910). She frequently exhibited at the Bremen Kunsthalle and gave lessons in watercolors.

I drew an old man: of the type of *Bust of an Old Man Looking to the Left,* charcoal. (Ham-burg '76, no. 37.) This is a bust of the same man, full face, charcoal. Both in the Estate.

Berlin janitor's wife: these drawings can no longer be identified.

April 30, 1897. To her father

cheerful workingmen… one of them: study of a man standing with sleeves rolled up. Wa-tercolor. The Estate.

those marvelous Botticellis: Alessandro dei Filipepi, called Sandro Botticelli (1444/5–1510), Florentine painter. He was commissioned about 1491 by Lorenzo di Pier Francesco di Medici to illustrate an edition of Dante's *Commedia.* The work was never completed; of the hundred parchment sheets which still remain, the Berlin Kupferstichkabinett [Print Room] purchased eighty-eight of them in 1882, among them three hand-colored sheets. Today a few of these sheets (from the *Purgatorio* and the *Inferno*) are in the Kupferstich-kabinett [Print Room], West Berlin, while the preponderant majority, *Purgatorio* and *Para-diso,* are in the Kupferstichkabinett [Print Room], East Berlin; the balance are in the Vatican. (See *The Drawings by Sandro Botticelli for Dante's* Divine Comedy *After the Originals in the Berlin Museums and the Vatican,* ed. and intro. Kenneth Clark [New York: Harper & Row, 1976].)

[Undated]. From the Album

Jean Paul: Pseudonym of Jean Paul Richter (1763–1825), a novelist and humorous writer. He also wrote *Vorschule der Ästhetik* [*Reflections on Art*].

May 14, 1897. To her parents

Herma as an experimental subject: "As early as 1897 I was put to use as a cheap and usually also willing model in her improvised atelier in the upper story of the old stable which be-longed to the large official house of our father; and so during many holidays I got to taste both the bliss of a stay in the country together with the penance of having to sit as a model." Herma Weinberg-Becker in Hetsch, p. 12.

my little old man: *Old Man,* oil on canvas. (Bremen '76, no. 1.) The Estate.

the Gottheiners': the friendship with the family of Baurat Gottheiner, the municipal sur-

veyor of works, goes back to Dresden days, when he was active in that city.

Wenck: Ernst Wenck (1865–1929), sculptor. Trained at the Instructional Branch of the Berlin Museum of Arts and Crafts and at the Berlin Academy (with Schaper); continued in Paris and Rome.

July 14, 1897. To Marie Hill

my Sunken Bell mood: refers to Gerhart Hauptmann's famous play, *Die Versunkene Glocke,* one of his numerous works that deal with the fate of the artist, in this case with Heinrich the bell founder and his seduction away from his family by the personified spirits of a pantheistic realm and his subsequent death. First performed in Berlin, February 12, 1896.

my rock by the waterfall: probably a favorite place of PB's on the Hills's estate, Willey.

July 24, 1897. Journal

The date accords with that given on p. 23 of the 1919 Edition.

Hamme: small river near Worpswede which flows into the Weser.

understand the peasant so well: in Güldenkammer, no. 4, p. 227, the passage reads as follows: "It seems to me that he could not understand him [the peasant] so well if he, himself, had not grown up in meager circumstances. [How true it is] that a man can never quite get over it if he has once had to battle for every penny, even not in later life when he lives in comfort, at least not the noble man. His wings are clipped without his having noticed because the scissors cut off just a tiny bit each day. Greatness, openness, impetuous rage, that part of man which is Prometheus, all that is lost. Thus it is with Mackensen, too. He is a complete man, enlightened in every respect, hard and energetic, tender and kind to his mother. But greatness, the indefinable quality of greatness, that has been lost to his art." It must be assumed that both versions had been edited by Gallwitz.

Walther von der Vogelweide: most famous of all the German medieval minnesingers, ca. 1168–ca. 1228.

Des Knaben Wunderhorn: first extensive collection of German lyric folk poetry, both genuine folk songs as well as many old and new poems of pseudo-folk character. Put together by the important Romantic authors Clemens Brentano and Achim von Arnim in 1805 and 1808.

[Heinrich Vogeler]... his image of spring: Spring. Illus. in Knackfuss, vol. 64 (1903), the famous volume *Worpswede* by Rainer Maria Rilke, p. 107. In the Haus im Schluh, Worpswede.

a man named Schröder: PB probably means the painter Paul Schroeter (1866–ca. 1945); he had studied together with Overbeck in Düsseldorf and came many times to Worpswede as the latter's friend in the years before and after the turn of the century.

a painter from Berlin named Klein: Philipp Klein (1871–1907). A self-educated man. Member of the Berlin and Munich Secessions.

Fräulein von Finck: Adele von Finck (1879–?), painter. She studied in Munich with Lenbach, in Brussels, and in Paris with Courtois. At the great Exposition in Prague in 1904, she was represented by her paintings, *The Cliffs of Bornholm* and *Worpswede Evening.* Cat. nos. 650 and 777.

July 1897. To her parents

In Güldenkammer, no. 4, p. 227, the paragraph about Hans am Ende reads as follows:

"Hans am Ende showed us many of his sketches and excellent etchings. He has a fine artist's nature, and the gentle way he speaks to his young wife has won me over completely; and also the way he can describe a complete person in few words."

some things by Klinger: Klinger's symbolism had an influence on the Worpswede painters as well as on PB, who got to know him in 1898.

his young wife: Magda am Ende, née Willatzen (1867–1945).

August 1897. To her parents
This date agrees with Güldenkammer, no. 4, p. 228, differing from the 1920 Edition, which gives July.

we: PB and Paula Ritter. In the *Album* there is a drawing dated "Bremen, 12.8.97," entitled *Das fidele Trio* [*The Happy Trio*]. It is of three women seen from the rear, dressed in painting smocks with palettes and paintbrushes; they are facing a hill behind which a sun wreathed in laurel is rising. In the foreground, right, there is an easel; in the midforeground, another palette; the whole, to the right and left, is flanked by "personified" tubes of oil paint. It is signed "Helene Asher." This drawing refers unquestionably to Worpswede, and it is clear that Helene Asher belongs to "we"; however, this name never occurs in PB's writings.

a very blue canal in Südwede: oil on cardboard, dated "189?;" last number is illegible. (Bremen '76, no. 32.) The Estate.

the three Vogeler brothers: Heinrich, the painter; Franz (1876–1915), the art dealer; Eduard (1877–1932), the landowner.

Today we went... Sermon on the Heath: this paragraph is lacking in Güldenkammer. Either it was purposely left out, which is unlikely considering its content, or it was taken from some other letter of PB's and added to this one in the 1920 Edition. However, we have left it in this position.

Schlussdorf: a small village within the township of Worpswede.

my first plein air portrait at the clay pit: cannot be identified.

[Ca. August 20, 1897]. To her mother
The dating is determined by her mother's letter of August 22 in which the latter promises to send Paula clothing for the poor family before the week is over.

"And the cupboard was no longer bare": "cupboard" should be translated literally as "birdhouse" or "nest." The line is from Friedrich Rückert's (1788–1866) poem "Aus der Jugendzeit" ["From the Time of Youth"], which was set to music in 1830 by Robert Radecke and has become one of the most familiar German folk songs. The line PB quotes is from the seventh stanza: "But the swallow returns, the swallow returns / And the empty birdhouse fills to overflowing. / But once the heart is empty, once the heart is empty / It never fills up again."

Welzel's: an inn in Worpswede.

[Undated]. To her parents
an old man from the poorhouse: This has been reconstructed following Güldenkammer, no. 4, p. 229. The text of the 1920 Edition reads: "... an old man from the poorhouse, a colleague of old Olheit." This is a typical example of interfering editing on the part of Gallwitz, and which is encountered often; in order to avoid the use of a footnote the former ed-

itor would often simply invent a clarifying statement and put it in the mouth of PB. In this case, PB's characteristic turn of phrase, "It went very well," was omitted.

[Ca. August 28, 1897]. To her mother
Dated according to the letter from PB's mother of August 26 in which she says that she will send the things for the poor Brotmann family "tomorrow with the afternoon post." The Brotmanns lived in the *Slotschün,* an old building with a thatched roof. It was a kind of poorhouse quarter. "Every family had scarcely more than an apple core and a hearth with an open fire." (Recollection of Frau Frieda Netzel, Worpswede, born 1887.)
Rieke Gefken holding red lilies: Girl with Red Lilies, oil on canvas applied to cardboard. (Bremen '76, no. 5.) The Estate. According to Frau Netzel's recollection, Rieke Gefken was the child of farm laborers who lived in the Huddel, a settlement of huts to the east of Ostendorfer Strasse. Her father occasionally worked in later years in the Modersohn's garden. Frau Netzel remembers Rieke as "a pretty girl with blond pigtails."

October 28, 1897. To her parents
Fräulein L. grabbed hold of me: according to a letter of PB's father of November 24, 1897, it is possible that Fräulein L. is the painter Hildegard Lehnert. To be sure, the adjective "young" is not quite fitting, since the painter was born in 1857 and was nearly twenty years older than PB. Possibly, however, the descriptive phrase that follows is a later "emendation" of Frau Gallwitz, and the proper reading should be: "...grabbed hold of me. She wants to paint me." Hildegard Lehnert was a successor to Fräulein Hoenerbach as director of the Drawing and Painting School of the Society of Berlin Women Artists.
An old woman with a yellow face: cannot be identified.
Dr. Lahmann: Dr. Heinrich Lahmann (1860–1905), naturopath, director of the sanatorium Weisser Hirsch [White Stag] near Dresden, which he had founded. He treated his patients with physical and dietetic cures. He had an enormous clientele; indeed it became the fashion to be treated by him. PB's relatives were frequently patients of Dr. Lahmann.

November 1, 1897. To her mother
a marvelous model: a blond, pale girl: cannot be identified.

November 7, 1897. To her parents
Buss- und Bettag: Day of Penance and Prayer, a Protestant holiday.
Wallenstein: great dramatic trilogy by Friedrich Schiller (1759–1805), written in 1798–99 and first performed at the theater in Weimar under Goethe.

November 13, 1897. To Henner Becker
Freimarkt: literally "open-air" or "free market"; a carnival-like amusement fair held annually during the last week of October in Bremen.

December 10, 1897. To her parents
a wonderful trip [to Vienna]: PB went to the wedding of Lili Stammann (1870–1930) and the sculptor Carl Bernewitz (1858–1934), a pupil of Begas (Reinhold Begas [1831–1911]), celebrated German sculptor and younger son of Karl Begas, the painter. The bride, whose mother was a Parizot, sent PB money for the trip, and her father gave his approval only

under the condition that PB's school would agree to this interruption of her training. In the 1920 Edition this letter is dated December 4. Since her father was awaiting the first news of her trip in her letter of the next day (Sunday), the date of this letter must be either the ninth or the tenth. In any event, it is unsure how long PB stayed in Vienna.

Moretto: Alessandro Bonvicino da Brescia, called Il Moretto (1498–1554). *Divina Justina,* ca. 1530, today in the Kunsthistorisches Museum [Museum of Fine Arts], Vienna.

Titian's noble portraits: Tiziano Vecellio (1488/90–1576). The Titian portraits in Vienna that PB would have seen there at that time include those of Filippo Strozzi, Isabella d'Este, Benedetto Varchi, Jacopo da Strada, the prince elector, Johann Friedrich of Saxony, a self-portrait, and a portrait of his daughter Lavinia.

Rubens: Peter Paul Rubens (1577–1640). Vienna has more than thirty paintings of the master.

Dürer: Albrecht Dürer (1471–1528). In Vienna: *Mary with the Christ Child, Kaiser Maximilian, Portrait of a Young Man, The Adoration of the Trinity,* and *Portrait of Johannes Kleeberger.*

Lucas Cranach [the Elder]: (1472–1553). In Vienna: *The Stag Hunt of Prince Friedrich the Wise, Christ's Leave-Taking from the Women, Adam and Eve, Paradise, Three Young Ladies,* and *The Old Woman and the Maiden.*

Holbein: Hans Holbein the Younger (1497?–1543). In Vienna: *Dirck Tybis from Duisburg, Portrait Bust of a Courtier of Henry VIII, Portrait Bust of His Wife, Jane Seymour, Portrait of an English Lady, Portrait of a Young Merchant,* and *John Chambers, Physician to Henry VIII.*

Leonardo's little portrait of a head: Leonardo da Vinci (1452–1519). According to the catalog of the Liechtenstein Gallery: "A wreath of palm fronds, laurel, and juniper branches on the reverse side of the portrait points to the identity of Ginevra de' Benci (*ginevra/ginepro* = juniper) as Leonardo's model. The ascription to Leonardo, however, is contested and the picture has since been ascribed by some to his teacher Verrocchio or Lorenzo di Credi; if it is by Leonardo, then it must be from his younger years in Florence." Today this portrait is in the National Gallery, Washington, D.C.

the dazzling Van Dycks: Anthonis Van Dyck (1599–1641). In the Liechtenstein Gallery: *Portrait of the Painter Frans Snyders, Portrait of a Nobleman, Portrait of the Canon Antonio de Tassis, The Painter Gaspar de Crayer, Isabella Stadholder of the Netherlands, Maria Luisa de Tassis.* Religious topics: *Saint Jerome, Christ on the Cross, Education of the Virgin* (ascription disputed), and *Mary with the Christ Child.*

December 27, 1897. To Paula from her father
I have decided to leave Bremen: Frau Becker opposed the decision of her husband to leave Bremen with the family to settle in Dresden. By taking in boarders, she was able to contribute to the family's livelihood.

January 2, 1898. Journal
They are wondrous, these two people: this passage was taken from the 1919 Edition, pp. 33ff.

[Cannot be dated]. Journal
How fascinated I am by this girl: it is not clear about whom PB is writing in this reflection; it
 may be her cousin Maidli.

January 26, 1898. To Paula from her father
Pauline Falcke: see letter of October 22, 1892.
L'appetit vient en mangeant: appetite comes with eating.

January 26, 1898. To Paula from her mother
an au pair position: this letter attests to the fact, despite all previous assumptions, that PB's
 plan to go to Paris dates at least a full year before the event.

§ Beginning on the first of February 1898, while PB was in Berlin, the Parisian art dealer
 Durand-Ruel held an exhibition in the Hotel Kaiserhof with works by Corot, Monet, Sis-
 ley, Pissarro, Degas (among others, his *The Woman Ironing*); it is likely that PB visited this
 exhibition.

February 8, 1898. To her parents
[Karl] Stauffer-Bern: (1857–1891), Swiss painter; PB quotes from *Karl Stauffer-Bern, Sein
 Leben, seine Briefe, seine Gedichte* [..., *His Life, His Letters, His Poems*], ed. Otto
 Brahm (n.d.). In the mid-1880s he taught at the Drawing and Painting School of the Soci-
 ety of Berlin Women Artists. In 1887, the first indication of his mental breakdown ap-
 peared. After that he was drawn into an affair with a rich Swiss woman which resulted in
 his arrest and imprisonment. He died in 1891 from an overdose of sleeping potion.
"Lord, what is man...": Psalm 8:5.

[February 1898]. From the Album
"The deeply hidden well": these lines are from Friedrich Schiller's philosophical poem, "Das
 Ideal und das Leben" ["The Ideal and the Life"], stanza 8.

February 19, 1898. To her parents
The Women Artists' Costume Ball: this festivity was indeed held without any gentlemen in
 attendance.
Rautendelein: the seductive water sprite, a character from Gerhart Hauptmann's drama,
 Die Versunkene Glocke.
Karla A.: cannot be identified.
Anna Stemmermann...Helene Lange: Helene Lange (1848–1930), celebrated teacher,
 founded in 1889 and directed the Berliner Realkurse für Frauen [Modern Instruction for
 Berlin Women], which she transformed in 1893 into a regular *Gymnasium.* She was also
 the founder of The Society of German Women Teachers. Anna Stemmermann, M.D.
 (1874–1928), practiced in Bremen later in her career.
a wonderful Boston: slow American waltz popular at the turn of the century.
Hermann the Cheruscan: 17 B.C.?–A.D. 21, great German hero, known also as Armin or
 Arminius, who defeated the Roman Legions under P. Quintillius Varus at the battle of the
 Teutoburger Wald in A.D. 9, after which the Romans never again tried to advance east of
 the Rhine.

Kehraus: literally the "sweep-out," the final lively dance during *Fasching* or Carnival just before midnight prior to Ash Wednesday, the beginning of Lent.

February 20, 1898. To Paula from her father
family by the name of Arons: PB's letter in which she must have mentioned the Arons does not survive. In her birthday book is the address of Käthe Arons, Berlin, Behrenstrasse 581/II; according to her Berlin address book of 1897, Käthe's father was the banker Barthol. Arons.

March 1898. To her father
It is evident that scraps from various letters were patched together by Gallwitz at this point.
another portrait of myself: perhaps the self-portrait on cardboard. (Bremen '76, no. 3.) In the Bremen Kunsthalle.
Von B.: cannot be identified.
Pépinière Ball: pépinière, literally "orchard" or "nursery," in the figurative sense has become a designation for the training establishments for military doctors. In Germany the Prussian military doctor's school in Berlin, founded in 1795, was one of the most important.
six small [post]cards: portrait heads of young women with stylized floral backgrounds and with the inscription "Stollwerck Chokolade." S/A, 59. The Estate. In the magazine *Kunst für Alle [Art for Everyone]* (vol. 13, no. 9 [February 1, 1898], p. 142), there is an announcement that the Stollwerck Chocolates Factory is holding a competition. Fifty groups of six illustrations each were solicited, the winning illustrations to be used as inserts, not illustrations for the wrapper. There were to be two first prizes of one thousand marks each, five second prizes of six hundred marks each, and ten third prizes of three hundred marks each; deadline March 1, 1898.

[Ca. March–April 1898]. To her parents
an old woman: probably *Bust of an Old Woman Facing Left*, oil on cardboard; the Paula Becker-Modersohn-Haus, Bremen, inv. no. 8.
Gurlitt: Fritz Gurlitt, a leading Berlin art dealer from 1880, whose gallery featured permanent exhibitions; at first on Behrenstrasse; from 1892 in a new gallery at Leipziger Strasse 131/I; from 1905 exhibition rooms at Potsdamer Strasse 113, whose decoration was done in part by van de Velde. After Fritz Gurlitt's death in 1898 his widow Annarella (née Im Hof) continued the business, even after her marriage to the art dealer W. Waldecker, until the son Wolfgang Gurlitt was able to take over. From 1883 Fritz Gurlitt promoted the French Impressionists and it was he who was most responsible for having introduced them to Berlin.
Rippl-Rónai: József Rippl-Rónai (1861–1927), Hungarian painter and graphic artist. He studied in Munich, in Paris with Munkascy, and joined the circle of the Nabis (he was known as "Le Nabi Hongrois"). He was particularly close to Vuillard, Bonnard, and Maillol.
the Eleven: Die Elfer—a group that was founded on February 5, 1892, as a Free Union for the Institution of Art Exhibitions out of protest against the conservative exhibition practice of the Union of Berlin Artists and the Academy of Arts, which enjoyed official patronage. Founding members included Walter Leistikow, Max Liebermann, Jacob Alberts, Ludwig von Hofmann, George Mosson, Franz Skarbina; in 1894 Max Klinger and Martin

Brandenburg joined them. The Eleven were precursors of the Berlin Secession (1898) which, like the Viennese and Munich secessions before them and the older Parisian Société des Indépendants, formed a united front against the official art establishment.

Leistikow: Walter Leistikow (1865–1908), painter and so-called discoverer of the landscape of the Brandenburg moors.

April 5, 1898. To Paula from her father

Paul's wedding: PB represented the family at the wedding of her father's youngest half-brother, Paul Becker, in Leipzig.

Studio: PB must have drawn her parents' attention in a no-longer extant letter to the article about Jeanna Bauck in this London periodical: Luise Hagen, "Lady Artists in Germany," *The Studio, An Illustrated Magazine of Fine and Applied Art*, 1898, no. 60 (March 1898), pp. 91ff. The article also dealt with the painter Bertha Wegmann.

poor Baring: see the letter of October 22, 1892, and corresponding note.

[Ca. April 1898]. To her parents

nervous woman's hands: one of three well-known studies, a study of two folded hands, charcoal. (Hamburg '76, no. 55.) Bremen Kunsthalle, inv. no. 53/329.

Regierungsrat M's: member of civic executive council; cannot be identified.

Hans Hermann: (1870–1931), composer, active in Berlin and Dresden. He wrote songs, symphonies, string quartets, and operettas.

[Ca. June 10, 1898]. To her parents

The dating of this letter has been deduced as follows: the date of departure fell on a Sunday which was June 5. On the thirteenth PB's parents acknowledged the receipt of a letter from Christiania; the letter of the twentieth from Lilleon names Wednesday, the fifteenth, as the date of departure from Christiania. The 1920 Edition, different from the 1919 Edition, identifies this text as a Journal entry; however, not only the parents' reference on the thirteenth to a previous letter from PB, but also the very style of the text indicates that this must be the letter.

Christiania: since 1380 the kings of Denmark were also kings of Norway. In 1624 the Danish King Christian IV changed the name of the old Norwegian capital Oslo to Christiania; it wasn't until 1924 that the old name was restored.

along the boulevard: the Strand Promenade; the explanatory clause that follows is doubtless another "helpful addition" of Gallwitz.

Fram: the ship in which Fridtjof Nansen (1861–1930) undertook his North Pole expedition in the years 1893–96.

Sverdrup: Captain Otto Sverdrup (1855–1930) led an expedition to the Canadian Arctic Archipelago, 1898–1902.

June 20, 1898. To her parents

the old Gothic cathedral: first construction in stone in the eleventh century. Cornerstone for the new cathedral laid ca. 1140; consecration of the altar, 1161; Gothic details added after 1170.

Namsos: city north of the 64th parallel. PB compares its river, the Namsen, to the Weser—the major German river that flows through Bremen.

[Undated]. To her parents
flöde: cream.
I am drawing and painting: drawings from Norway in S/I, 30-43. The Estate.

[Undated]. Journal [Lilleon]
my soul spread wide its wings: [dass meine Seele ihre Schwingen weit ausspannte], a quote
of the line from Eichendorff's "Mondnacht" ["Moonlit Night"]: "Und meine Seele spannte
weit ihre Flügel aus" ["And my soul spread wide its wings"]. Joseph von Eichendorff
(1788–1857) was one of the most famous German Romantic poets.

July 3, 1898. To her parents
to the Gehege *[preserve]:* the wilderness park near their home in Dresden where PB had
played as a child.
Jacobsen: Jens Peter Jacobsen (1847–1885), Danish writer. His novels, *Fru Marie Grubbe*
(1876), *Niels Lyhne* (1880), and his novellas were early translated into German and had a
powerful influence on the generation at the turn of the century, not least of all on Rilke.
Clara Rilke informed H. W. Petzet that PB's first present to her was the little Reclam edi-
tion of *Niels Lyhne* which she had decorated with little flowers.
Vogeler is illustrating Jacobsen: Jens Peter Jacobsen, *Gesammelte Werke [Collected
Works],* vol. 2, *Fru Marie Grubbe,* with illustrations and vignettes by Heinrich Vogeler
(Florenz/Leipzig: Verlag Eugen Diederichs, 1898). Vols. 1 and 3 were illustrated by Müller-
Schoenefeld; the complete works were illustrated by Vogeler beginning in 1903.

September 7, 1898. To Cora von Bültzingslöwen
This letter gives further indication that PB had planned her first trip to Paris long in ad-
vance. Despite Gustav Pauli's assumptions, there was a definite connection between her
teachers in Berlin and her plans for Paris, e.g., Jeanna Bauck, whose work was modeled
on the work of the painters of the Barbizon School. An inscription on a PB drawing of a
bare branch, dated "8.9.97," suggests further that plans for Paris were already hatching in
Berlin: for there, at the lower left, she had written "Colarossischule, Courtoi[s], Girardeau
[Girardot]." These are all references to the school and teachers with which PB was later as-
sociated in Paris.
the little bride: PB's cousin, Ella Rabe.
c/o Frau Siem: Martin Siem had a small bakery at the entrance to the village. He also ran an
inn for "better people" and rented out rooms. (Information from Frau Frieda Netzel,
Worpswede.)

[Undated, probably September 7, 1898]. Note to her parents
Bolte's villa: Bolte was the owner of a brick and tile works; his villa, torn down before World
War I, was situated on the land where the Marcus Farm is today in the Ostendorf section
of Worpswede.
of good Bernhard: Bernhard Barnstorf was for many years the messenger in Worpswede.

September 18, 1898. To her parents
the poorhouse: on Bergstrasse, today it is the town hall.

Mother Schröder: she is the *Dreebeen* [*Dreibein* = "Three Legs," because she walked with a stick], whom PB often used as a model; she lived in the poorhouse.

and decrepit Olheit: literally, "our stone-old Olheit"; Adelheid Böttcher, who at that time was about eighty years old. She must have known the Becker family earlier—Frau Becker speaks in a letter of December 29, 1896, of a party at the Rassows' (at which she also met Vogeler): "...I chatted with him [Vogeler] for a long time. Do you know what brought us together? Ohlheid, 'Ohlheid Böttje ut Worbswede,' known to us as the Witch of the Heath. Recently he did an etching of her which he calls *The Frog King.* Added to the fairy tale, indeed set in almost as the main figure, he fabricated an old woman who sits in the meadow and watches over the geese. The woman certainly looked like Ohlheid, and when he described the original it was easy to establish her identity." H. H. Rief, *Heinrich Vogeler, das Graphische Werk* [*The Graphic Works of Heinrich Vogeler*] (1974), no. 12, *Froschkönig* [*Frog King*], 1896.

"Freut euch des Lebens" ["Rejoice in Your Life"]: famous German folk song by H. G. Nägeli, 1793. The first line reads: "Rejoice in your life while the little lamp still glows...."

October 4, 1898. Journal
old Jan Köster: cannot be identified.
old von Bredow: a variant of this passage in *Güldenkammer,* no. 4, p. 230, reads: "Now I am drawing old von Bredow who lives in the Worpswede poorhouse. He has certainly lived some life! He was a student, turned to drink, was a gravedigger in Hamburg during the cholera epidemic, then he was at sea for six years, had a completely crazy life. Now he drives the poorhouse cow to pasture and that's his task in life now. Years ago his brother wanted to get him to live a normal life in the orderly world. But the old man got to love his cow and his dreams so much that he won't let go of them anymore." The sentences that follow are missing in the 1920 Edition and have been taken over from the *Güldenkammer* text. *Portrait of Herr von Bredow,* charcoal. (Pauli, plate 57.) Hamburg Kunsthalle, inv. no. 1917/384. *Old Bredow,* pastel. (Pauli, plate 58.) It is in the Bayrische Staatsgemäldesammlungen [Bavarian State Painting Collection], Munich, inv. no. 13561.

October 18, 1898. Journal
a ten-year-old girl: cannot be identified.
a big window: This addition to the house can still be seen and is a combination of window and skylight which was achieved by enlarging one of the small farmhouse windows and glazing a portion of the thatched roof directly above it. (See illus. no. 10.)
his Martha: Martha Schröder (1879–1961), born in Worpswede, Heinrich Vogeler's wife from 1901, and in later years separated from him.
[tinting] photographs with crayon: PB is referring either to the pseudoartistic process popular at the time whereby a transparent positive image was applied over a backing tinted with pastel, crayon, or watercolor (or painted directly on the obverse), the point being to heighten the image artificially. Or it meant the simple tinting of photographs. PB's phraseology is misleading, for the German literally reads "to enlarge [by which she means enhance] photographs in chalk [crayon, pastel]."

October 29, 1898. Journal
Rembrandt exhibition: exhibition at the Stedelijk Museum in Amsterdam, on the occasion

of the coronation of Queen Wilhelmina of the Netherlands. It is amusing to learn that Queen Wilhelmina had built for herself in 1909 a *Schilderwagen* ["painting wagon"] with large glass windows which is still to be seen today at the royal palace Het Loo in Apeldoorn. It reminds one very much of PB's mention of Mackensen's "glass wagon" (see note to letter of April 27, 1895). One hundred twenty-three Rembrandt paintings were on exhibition (information received from the Rijksmuseum, Amsterdam).

what is healthy, the old Germanic strain: phrases like this very likely reflect PB's reading at the time of the infamous Langbehn book, *Rembrandt as Educator* (see the note to the Introduction to the section 1896–1899 on p. 446–447).

a young mother... sitting in a smoky hut: a picture with this motif is owned by the Art Society of Bremerhaven. Oil on cardboard.

the woman gave her life and her youth and her power... heroine: this is PB still under the influence of Langbehn's style.

[Undated]. Journal
In the 1920 Edition this entry is dated incorrectly October 29.
my young mother again: possibly *Peasant Woman with Child at Her Breast,* charcoal. (Hetsch, illus. p. 64.) Private collection.

November 9, 1898. From the Album
(The Sorrows of Young Werther, *May 17):* the sensationally popular and influential epistolary novel in monologue form by Goethe, 1774. The tragic story of Werther's love for the married Lotte was an instant success all over Europe, was the cause of many suicides, and was a book that Napoleon, among others, always carried with him.

November 11, 1898. Journal
little Meta Fijol: Meta Viol, who lived with her family in the Hörenberg section of Worpswede.
Marie Bashkirtsev: Marya Konstantinovna Bashkirtseva (1860–1884), a young woman of Russian aristocracy and society. Her father, marshal of the nobility at Pultowa, separated from her mother when Bashkirtsev was seven years old. Together with her grandfather and mother she led a restless life of travel from resort to spa in Western Europe. Highly intelligent, she could read and write four languages with equal facility and was gifted in many ways. A talented musician, she trained seriously in Italy as a singer; however, the strain was too much for her delicate health and her voice failed. Even as a young girl she was consumptive and her illness heightened to an almost hectic degree her compulsive activity and powerful need to be recognized by society. It was only when she began to paint that her artistic efforts became serious and concentrated on a single goal. She settled in Paris in 1877 and worked intensely, far beyond her physical capacity, and in the brief time that remained she attained astonishing success. Her self-critical, candid, but also arch and flirtatious journal appeared in installments beginning in 1887 under the title *Journal de Marie Bashkirzeff* in the Bibliothèque Charpentier. Today whole passages of this edition are thought to be spurious, or at least heavily embroidered by the editors. At the time, the book was a sensation.

November 25, 1898. To her parents
my Garwes: the mailman Garves was now renting PB her first studio space.
old Renken: was unemployed and lived in primitive conditions in Osterwede, a village near Worpswede. (Information from Frau Frieda Netzel.)

November 29, 1898. Journal
Frau P.: cannot be identified.
the six musicians: Six Musicians on a Platform, gouache over charcoal. (Bremen '76, no. 243; Busch, plate 2.) Bremen Kunsthalle, inv. no. 3/170.
Die Glocke: this is, of course, no "great drama" by Schiller but rather his famous ballad "Das Lied von der Glocke" ["The Song of the Bell"], 1880.

December 12, 1898. Journal
drawing of Anna Böttcher: this drawing cannot be identified.
this afternoon... "Old Olheit": see letter of September 18, 1898.

[Undated]. Journal
Zarathustra: *Also sprach Zarathustra [Thus Spake Zarathustra],* the most renowned of all Friedrich Nietzsche's (1844–1900) philosophical-poetic excursions. Written 1883–85.

December 15, 1898. Journal
Frau Meyer aus dem Rusch: Rusch is a local Worpswede designation for "field" or "meadow," and refers to the location of Frau Meyer's hut.
a voluptuous blonde: the variant in Güldenkammer, no. 4, p. 230, reads: "a voluptuous blonde, a marvelous specimen of nature. She has a gleaming throat shaped like that of the Venus de Milo. She is very sensual. But isn't it true that natural sensuality must go hand in hand with this productive, voluptuous power? This woman with the full breasts seems to be an image of great Mother Nature. I also feel that sensuality right to the tips of the fingers in union with chastity is the single true and proper concern for the artist." Here, too, PB's reading of Langbehn is recognizable: "Genuine art grows out of strong and innocent sensuality." (*Rembrandt as Educator* [1890], p. 28.) "Full sensuality without a trace of vulgarity is always noble" (op. cit., p. 51).

December 16, 1898. Journal
My blonde... with her little boy: Nursing Mother Wearing a Red Blouse, charcoal and red chalk. (Busch, plate 6; Bremen '76, no. 247; Hamburg '76, no. 85.) The Estate.

January 15, 1899. To Marie Hill
the old Friedrichstrasse: the street in Dresden where the Beckers lived and PB spent her childhood until she was twelve (1888), at which time the family moved to Bremen.

January 19, 1899. Journal
Here in solitude: in the Güldenkammer, no. 4, p. 231, this sentence appears without quotation marks (in contrast to the 1920 Edition), and thus properly indicates this "sentence" (i.e., "thought") to be PB's own.

January 24, 1899. Journal

Oh, holy spirit: the stanza of the chorale by Michael Schirmer (1606–1673) is typically shortened in PB's recollection. The full and correct text is as follows: "Oh, holy spirit, enter and dwell with us, / And let us be your homestead, / Oh, come, you sun of our hearts. / You light of heaven, let your rays / be powerfully with us and in us / As constant joy and bliss. / Sun, bliss, heavenly life / Will you give us, / When we pray — / We guide our steps to you."

[Undated]. Journal

Elective Affinities: the classic novel by Goethe (completed 1809) with a highly complex plot involving social and psychological interrelationships among the four protagonists, the married couple Eduard and Charlotte, Ottilie, and the Captain. Its viewpoints concerning marriage and its dissolution have recently rekindled interest in this novel, which in its time was highly controversial.

my movements should be graceful: Ottilie Reyländer writes in Hetsch, p. 36, "Unconsciously she practiced elegant gestures; for example, in the way she [PB] would gather up her dress, one was involuntarily reminded of old paintings of princesses for whom ceremony prescribed the laws of posture and gesture. Her control of her movements would not even abandon her when she raced across a meadow or sprang over a ditch; one never noticed any *laissez-aller* in her, never any slackening or carelessness. A very erect carriage and a slightly rolling gait were natural to her. All of that together resulted in a nobility of posture and behavior, despite her somewhat awkward limbs and pudgy shape."

Otto Modersohn's lengthy description from his journal for January 27, 1901, is appropriately quoted at this point. The American editors feel that its inclusion at the chronological point in the main body of the text would be awkward and interfere with the flow of the narrative; on the other hand, they feel that it is of sufficient importance to quote in full. It is taken from the appendix to the 1920 Edition:

January 27, 1901. Otto Modersohn's Journal

Paula has all sorts of characteristic qualities of which I became aware from the very first moment I saw her, qualities, I should add immediately, which captivated me.

The impressions we had of her when she first visited us were of liveliness and agility. Her head, with its mass of chestnut brown hair, she tilted gracefully from one side to the other, and there was an occasional cheerful burst of laughter. Whenever she walked by our home, with the old woman from the poorhouse, I delighted in her youthful, refreshing appearance — the way she led the old woman by the arm, the intriguing way she walked, the way her feet would touch the ground, toes first. As often as she visited us, we found her to be a sympathetic person. In fact, we liked her more each time. And for her part, she found Helene (my first wife) to be very sympathetic. She was so natural and relaxed, something we hadn't realized from the beginning. One time, she stretched out on the sofa and put her head back. It made such a strong contrast to the stiff posture of our other visitor, Frau W.

She looked enchanting in her white dress with the red coral belt and her light purple jacket. And how charmingly she would always listen to me, when I was talking about birds and insects. And the way she would tell us about her trips, with practically no money to spend, from Switzerland (from where she mailed me a grasshopper) to Munich, Nuremberg, Dresden, and Leipzig.

She liked the human being in me, the artist in me. Once she was in my studio where I showed her my studies and compositions. "Oh, Herr Modersohn, what wonderful things you have here!" She knelt down on the straw mat and looked at everything with interest. I visited her several times in her studio at the Garves family. One evening I spoke to her about Rembrandt. She was seated in front of the oven; it was very cold in the room. I learned that she had very meager means, which made me feel sorry. And once I went to see the paintings that she wanted to exhibit in Bremen. I did not like them; they were not intimate, they were too poster-like. And I told her so. After a bad review was published in Bremen, she came to my studio with Frau B., cheerful, but enraged at Fitger [who had written the bad review].

The gracefulness of her clothing, her posture, the way she moves, the way she speaks exude a veritable magic, and when she wears tattered old clothes the effect is still totally charming. Someone else could wear *new* clothes and still never obtain that effect. There is grace about everything, the way she dresses, the way she moves, the way she speaks, and laughs, and eats, the way she reads, the way she reclines, and so on. How graceful she seems when she is skating, weaving along before me with her little brown dress and fur jacket. She does droll things with her hands, when she reaches out for something, then she puts a hand to her mouth. She often lets objects dangle from her hand, bending her wrist in a most extraordinary way—there is so much grace in that gesture, too. It is connected with the exaggerated and intriguing tilt to her head, the way she nods forward. Then her feet and legs ...Her gait is idiosyncratic and droll. She takes huge strides. Always setting the tip of her foot down first. Physically as well as mentally she often kicks out with her feet, and then suddenly the tip of her tongue appears like lightning. And her laughter is a whole chapter in itself. There is a smile very often at the corners of her mouth. And she often goes ha, ha, ha, which is a kind of spoken laughter. Her laughter is very dear to me, and I love the fact that it comes so often. It is her cheerful and happy mood that is so becoming to her face. There is also sadness in her and when her tears flow it almost alienates me. She looks marvelous when she's reading in a chair or listening to music; she sits there, a serious look on her face, with her head tilted to one side, with rapt attention.

[Ca. February 12, 1899]. Journal
A week in Berlin: it is not known for what reason PB was in Berlin.

February 12, 1899, To her parents
Schubert's "Allmacht": Franz Schubert (1797–1828), "Die Allmacht" (song), op. 79, no. 2, 1825. The text by Johann Ladislav Pyrker (1772–1847) begins: "Great is Jehova, the Lord! For Heaven / and Earth proclaim His might...."

February 19, 1899. Journal
Tasso: Torquato Tasso (1790), Goethe's classic drama in blank verse based on the life of the Italian poet.
Hauptmann's Fuhrmann Henschel: one of the most celebrated plays by Gerhart Hauptmann during his Naturalistic period. It was first produced on November 5, 1898, in the Deutsches Theater, Berlin, and published the same year.
Helbeck of Bannisdale: a novel by Mrs. Humphry Ward, née Mary Augusta Arnold (1851–1920), the English author. Her novels were written with the intention of propagating

Christianity as a social doctrine while at the same time denying its theological content.

[Ca. March 6, 1899]. Journal

Niels Lyhne: the dating of PB's quotations from this book in her Album permits us to date more precisely her journal entries from and observations about the novel and to date this entry before March 9, thereby correcting the 1920 Edition.

March 9, 1899. To her father

the Overbecks and the Modersohns: Helene Modersohn, née Schröder (1868–1900); Hermine Overbeck, née Rohte (1869–1937), painter, trained in Munich. From 1896 in Worpswede she was a pupil of Overbeck, whom she married in 1897.

March 23, 1899. Journal

Snow and a shimmering moon: this little poem carries this date in the 1919 Edition, p. 59. Gallwitz did not include it in the 1920 Edition.

March 30, 1899. Journal

young Mackensen: Professor Otto Mackensen (1879–1940), doctor of engineering, the youngest brother of the painter Fritz Mackensen.

Alfred Heymel: Alfred Walter Heymel (1878–1914), writer, art collector, and patron of the arts. His fame and success lay in his talent for being a mediator among many important personalities of his day. Together with his cousin Rudolf Alexander Schröder he was the instigator, and with Otto Julius Bierbaum as the third party, the editor of the periodical *Die Insel,* a publication that was to become a gathering point of intellectual talents of the first order. The great publishing house of Insel was a product of this collaboration. Just as PMB has basically good things to say about Heymel, he in turn, after her death, was one of the few who had praise and understanding for her art and was capable of recognizing her value. On May 24, 1909, after he had read Rilke's "Requiem for a Friend" (the poet's great memorial tribute to PMB), he wrote to Joseph Hofmiller: "She had more talent and a greater gift for painting than all the living Worpsweders put together. There was scarcely a man who worked harder than she did; she measured herself against the greatest of the French and struggled with her own nature, which she tried to both realize and overcome; there came into being certain paintings that greatly transcended mere studies, above all still lifes." (From *Für Rudolf Hirsch — Zum Siebzigsten Geburtstag* [*For Rudolf Hirsch — On His Seventieth Birthday*] [Frankfurt: S. Fischer Verlag, 1975], p. 338.)

Rudolf Alexander Schröder: (1878–1962), author, translator, interior designer. Through the influence of Heymel and Schröder, Vogeler's great gifts in the applied arts and crafts were activated; together with Schröder, Vogeler decorated the famous Heymel/Insel House on Leopoldstrasse in Munich and was later engaged in plans and projects for the Vereinigte Werkstätten für Kunst im Handwerk [Association of Studios for the Art in Handcrafts].

Otto Julius Bierbaum: (1865–1910), narrative writer, lyricist, playwright, critic, editor, and in a word, bohemian.

"nigger songs": probably minstrel songs and not a reference to some sort of imitation of black spirituals. PB's use of normally contemptuous words here and at one other place in her writings is in no sense derogatory. These are merely repetitions of unfortunate clichés of the time.

several people there were delighted by me: Ottilie Reyländer described an episode about Vinnen's party in Modersohn's studio which PB does not mention here: "Soon after my arrival [in Worpswede] there was a party in Carl Vinnen's honor. During the evening we all went up to the Weyerberg. A little swarthy writer [Heymel], who was visiting from out of town, took the notion of climbing up the Findorff Monument with a burning torch in his hand. He perched up there like a monkey, and then everybody tried to reach him; he called it 'the struggle for the light.' PB was the first to get to him. From the very top where there was room for no one else, she called down, 'Rabble up here, more down below!' For most of them only got halfway up and many of them had realized from the beginning the hopelessness of success and were simply carrying on as spectators. Carl Vinnen admonished the high-spirited girl by shaking his finger at her...." (Hetsch, p. 35f.) At the beginning of March, PB had been reading Nietzsche's *Zarathustra* and had been taking notes from it. Her humorous application of the phrases about "rabble" above and below are taken from "The Voluntary Beggar" chapter in this work.

April 20, 1899. To Marie Hill
an exhibition in Dresden: Deutsche Kunstausstellung [Exhibition of German Art], Dresden 1899. Mackensen, Modersohn, Overbeck, am Ende, Vinnen, and Vogeler exhibited as a group, calling themselves The Society of Worpswede Artists. They were represented by twenty-two paintings and many drawings.

April 26, 1899. To Kurt Becker
This letter exists in copy only.
Princess Feodora: Feodora von Schleswig-Holstein-Augustenburg (1874–1910). As a poet and short story writer she used the pseudonym F. Hugin. She was a patron of the Worpswede artists, Mackensen in particular.
our new home: Wachtstrasse 43; the house was located on the banks of the Weser River. From the roof one could look down into the old Böttcherstrasse and up river into the streets of the old Schnoor Quarter.

Thursday, June 1899. To Kurt Becker
This letter exists in copy only.
Ibsen: Henrik Ibsen (1828–1906), playwright. *The Wild Duck,* 1884 (German translation, 1888); Hedda Gabler, 1890 (German translation, 1891); *Lady Inger of Östrat,* 1875 (German translation, 1877).
Lartusberg: there is no such designation in Worpswede; probably a misreading by the copyist for "Gartenberg," one of the two "peaks" of the Weyerberg.
Dr. Carl Hauptmann: (1858–1921). Brother of the dramatist Gerhart, he was a friend of Otto Modersohn and frequently a guest in the latter's home. His first attempts at writing were Naturalistic dramas; and then, just at the time of this visit to Worpswede, he was going through a Symbolistic phase. He can finally be counted among the precursors of Expressionism. His best-known novel is *Einhart der Lächler* [*Einhart the Smiler*], 1907.
Dr. Büttner: Hermann Büttner (1867–ca. 1927). Translator of the sermons of Meister Eckhart (ca. 1260–1329). This gentleman is "the Mystic" to whom PB also refers later.
Or should I do some etching: encouraged by Heinrich Vogeler, PB did a series of etchings between 1899 and 1902. See *PMB Œuvreverzeichnis der Graphik* [*Catalog of the*

Graphic Works], ed. Wolfgang Werner (Bremen: Graphisches Kabinett, 1972). (Bremen '76, cat. nos. 384a–n.) The majority of the sheets are at the Kunsthalle in Bremen and artist's proofs done by PMB are in the Estate. Reproductions of the etchings published loose-leaf by Worpswede Verlag, Lilienthal, 1978.

from her short arms: probably a reference to the etching *Sitzende Alte* [*Old Woman Seated*], also known as *Swart war de Nacht* or *Frau mit Glotzaugen* [*Black Was the Night or Woman with Staring Eyes*]. (Bremen '76, no. 384e, three states known.)

Wednesday, June 1899. To Marie Hill

"Only one thing is needful": allusion to the chorale "Eins ist not, ach Herr, dies Eine…" ["Only one thing is needful, oh, Lord, this one…"], by Johann Heinrich Schröder (1666–1699).

June 1899. To her mother

your "gray one": PB's mother always used the same heavy gray writing paper. From this point on, PB frequently refers to letters from her mother as "gray ones."

Abruzzi blanket: a thick, patterned wool blanket, named for the Italian province.

Schützenfest: an annual festivity in many parts of Germany centering around a shooting match.

the "Mystic": Hermann Büttner. See letter to Kurt Becker, June 1899.

I have the skeleton with me: not a true skeleton but rather her own charcoal drawing, *Standing Nude Girl*, with superimposed skeletal structure. The Estate.

July 8, 1899. To Marie Hill

in the Engadine: the upper region of the valley of the Inn River in eastern Switzerland, the Grisons canton, containing Saint-Moritz among other popular resorts.

[Undated]. Journal

W.D.: Perhaps a member of the Donndorf family with whom Marie Hill had a close friendship. PB probably began this trip to Switzerland around the first of July, accompanied on the first leg of the journey by her mother, who was traveling on to Burgstall. (Partial credit for the translation of this little poem is owed to Michael Hurd.)

September 21, 1899. To Milly Becker

Ernst Horneffer: (1871–1954). Author and Nietzsche scholar. In 1918 lecturer and in 1920 professor at the University of Giessen. As a young man he strove in his lectures for an understanding of Nietzsche and a new, personal religion. PB's father, in a letter to her of November 14, 1896, describes the family's initial contact with Horneffer. During a series of lectures by the young scholar in Bremen, Frau Becker approached him, inviting him to spend the evening with them; after Herr Becker learned of the straitened financial circumstances of the young man, he invited him to spend a fortnight with them. From that time on a friendly contact continued among them.

November 10, 1899. To her mother

it cannot do otherwise: an allusion to Martin Luther's famous statement at the Diet of

Worms, 1521, "Ich kann nicht anders. Gott helfe mir. Amen." ["I cannot do otherwise. God help me. Amen."]

November 15, 1899. To her parents
This fragment of a letter was printed in Hetsch, p. 93, but does not appear in the edition of 1920.

December 20, 1899. Review from the *Weser-Zeitung* (Bremen) by Arthur Fitger.
triptych by Count Kalckreuth: Count Leopold Kalckreuth (1855–1928), painter, artistically close to the painters of the Worpswede colony. His triptych bears the title *Unser Leben währet siebenzig Jahre* [*Our Life Lasts Seventy Years*], 1898. (Brachert, no. 97.)
Maheude: female character from a novel *Germinal* (1885), a part of the twenty-volume cycle *Les Rougon-Macquart* by Émile Zola (1840–1902).
Hoch: Franz Xaver Hoch (1869–1916), landscape painter and graphic artist.
Bochmann: Georg von Bochmann (1850–1930), figurative and landscape painter.
Hendrich: Hermann Hendrich (1856–?), painter and lithographer. His favorite themes were Nordic marine landscapes and Germanic mythology as influenced by Richard Wagner. He was highly regarded by the Kaiser.

December 24, 1899. Review from the *Courier* (Bremen) by Carl Vinnen
On December 23, Vinnen sent PB a copy of his reply to Fitger's review with an accompanying letter, in which he wrote: "My very dear and gracious Fräulein [Becker]. Permit me to place under your Christmas tree a copy of the 'Harmless Marginalia to Fitger's Art Criticism' which will appear tomorrow, Sunday, in the *Courier*. Please be good enough to forgive me the fact that considerations of tact do not permit me to make a more friendly judgment of your pictures; indeed, I cannot evaluate them much differently from the way in which I describe them here. Do not let this disturb you. Mistakes are the basis of success. Do not despair, but continue resolutely! And even if you are angry with me, at least you will know that no one, whoever he may be, shall insult our ladies of Worpswede (I have not identified you by name) and escape unscathed. [...]
 "P.S. Since you are a lady, here is a postscriptum! The flower of art grows beneath the thorns of criticism, and no one can pluck it without scratching his fingers. In the case of tender women's hands the thorns hurt all the more. Bring us soon more thoroughly developed work and do not lose your pleasure in and love for art. All of us set out at first on the wrong path."

December 30, 1899. To Otto Modersohn
Dupré: Jules Dupré (1811–1889), French landscape painter, friend of Théodore Rousseau, casually connected with the other Barbizon masters.
the candelabra: this cryptic reference is altogether unclear.

Introduction

the art dealer Vollard: the great art dealer Ambroise Vollard (1868–1939) had his gallery at 6, rue Laffitte from approximately 1895 to 1914. He first showed works by Cézanne in 1895, and beginning in the 1897–98 season he exhibited van Gogh, Gauguin, Maillol, and Picasso. Vollard, *Souvenirs d'un marchand des tableaux* (Paris, 1937). English edition, *Reflections of a Picture Dealer,* trans. V. M. Macdonald (Boston and London, 1936). [*Sic,* the book was first published in English.]

Cézanne: Paul Cézanne (1839–1906), perhaps the most important influence on the painting of the twentieth century.

Charles Cottet: (1863–1925), French painter. At the turn of the century in France as in Germany (and indeed well into the first decade of the twentieth century in Germany), he was considered, together with Lucien Simon and J. E. Blanche, as a leading modern French master. (See E. and B. Göpel, *Leben und Meinung des Malers Hans Purrmann* [*The Life and Thought of the Painter Hanns Purrmann*] [Wiesbaden: Limes Verlag, 1961], pp. 91 and 117.) PB must have known his name from German exhibitions. Cottet honored Puvis de Chavannes and was in close personal contact with him. He was also friends of the group known as the Nabis and subsequently (according to G. Busch, *Paula Modersohn-Becker, Handzeichnungen* [*Paula Modersohn-Becker, Drawings*], p. 10) "in direct contact with the truly active and influential artists of the period."

the human being in the artist: "She liked the human being in me, the artist in me." (Otto Modersohn's journal, January 27, 1901.)

Ostendorf: at that time still an independent village near Worpswede.

handweaving shop: such plans originated with Heinrich Vogeler and Marie Bock. In 1899 the two of them, together with Clara Westhoff, went to the well-known weaving mill in Scherrebeck to learn about weaving. Vogeler also designed patterns for this mill.

a serious illness: there is a note to Paula from Clara Westhoff from which it can be gathered that Clara had asked her mother for helpful advice concerning PB's signs of illness. A letter from Frau Becker of August 4, 1900, also speaks about her concern, which she kept from her husband but revealed to a certain "Rammses" (evidently an old servant woman). Everyone advised the same thing: drink a great deal of buttermilk. More precise symptoms of this illness cannot be discovered.

Otto Modersohn wrote later: "Unfortunately her health was somewhat weakened by a winter of deprivation [in Paris] and the doctor ordered a period of bed rest. I frequently visited her and read aloud to her." (Hetsch, p. 19.)

Carl Hauptmann: according to Otto Modersohn's journal he arrived in Worpswede on August 29, 1900.

Rainer Maria Rilke: (Prague, 1875–Valmont [Montreux], 1926). He came to Worpswede (according to his journals) on August 28, 1900, and remained until ca. October 10, 1900.

It was assumed: Petzet, p. 159, chap. 1, n. 5.

'Lily atelier': PB had a wall-hanging in her room with a design of the heraldic lily. This is visible in the photograph (see illus. no. 17).

Tolstoy: Count Leo Tolstoy (1828–1910) had an enormous influence in Germany through his novels in which he put forth his social and ethical thoughts. Rilke had visited him during his trip to Russia, Easter, 1900.

Georges Rodenbach: (1855–1898), French-Belgian writer; collaborator in the publication *Figaro.*

Hauptmann's Friedensfest: Das Friedensfest [The Feast of Reconciliation], Gerhart Hauptmann's second play (1890), a family tragedy in the vein of Strindberg and under the strong influence of Tolstoy and Zola.

Böcklin: Arnold Böcklin (1827–1901), Swiss painter with profound influence on the Jugendstil. The paintings they saw in Hamburg were *Portrait of Augusto Fratelli,* ca. 1864. (Andree, no. 166.) *Self-Portrait,* 1873. (Andree, no. 267.) *The Repentant Mary Magdalene* (unfinished), 1873. (Andree, no. 277.) *The Holy Grove,* 1866. (Andree, no. 398.)

private collection of the banker Behrens: Eduard L. Behrens (died 1895). The Böcklins in his collection included: *Sleeping Huntress and Two Fauns,* 1877. (Andree, no. 314.) Since 1966 it has been in the Düsseldorf Kunstmuseum [Art Museum].

Corot: Jean Baptiste Camille Corot (1796–1875), French painter of the Barbizon School. In Rome, 1825–28; thereafter in Paris, Ville d'Avray, and Fontainebleau.

January 1, 1900. To her parents

the little early Gothic cathedrals: PB had seen the cathedral in Basel in the summer of 1899 and had drawn the Saint George on the west front. (Hamburg '76, no. 162.) Bremen Kunsthalle, inv. no. 66/215. She perhaps saw the Dominican Church in Bern and unquestionably visited the Grossmünster [The Great Cathedral] and Fraumünster [Cathedral of Our Lady] in Zurich.

boulevard Raspail [Grand Hôtel de la Haute Loire]: according to a remark made by Clara Rilke in later years, PB painted the view from the window of this first atelier of hers. *View from the Artist's Atelier in Paris,* inscribed "Paris 1900." (Bremen '76, no. 18, color plate 3.) Bremen Kunsthalle, inv. no. 785/1959/6.) However, since PB lived there only two weeks and then on January 15 moved to the rue Campagne Première 9, it is more likely that this oil is a view from this second atelier. (See illus. no. 21.)

[Undated]. Journal

My trip lasted seventeen hours: For financial reasons PB traveled to Paris on the *Personenzug,* a train that made frequent stops between Bremen and Paris, as opposed to an express.

January 4, 1900. To her parents

I'm sitting at my French hearth: A play on the title of the volume of short stories by Richard Leander (Richard von Volkmann), *Träumereien an französischen Kaminen [Dreams Besides French Hearths]* (1871).

The nobility of Titian: PB saw in the Louvre his *Madonna with the Child, Madonna with the Rabbit,* two Holy Families, and *Portrait of François I.*

two wonderful Botticellis: Madonna with the Child Jesus and John ("in the background, before a blue sky, trees and a hedge of roses"), *Giovanna Tornabuoni and the Graces* [Virtues], *Lorenzo Albizzi* [Tornabuoni] *and the Liberal Arts.*

the work of Fiesole: Giovanni da Fiesole, called Fra Angelico (1387/88–1455). In the Louvre: *Coronation of the Virgin, The Beheading of John the Baptist, Six Saints, Saints Cosmas and Damian, The Crucifixion.*

Holbein's beautiful, solemn portraits: in the Louvre: *Portrait of Nikolaus Kratzer, William Warham, Archbishop of Canterbury, Erasmus of Rotterdam, Portrait of an Old Man,*

Thomas More, Anne of Cleves, Portrait of a Man, Portrait of Richard Southwell.

della Robbia: a member of the large Italian family of sculptors in the fifteenth century, the most famous of whom was Luca della Robbia (1400–1482): representations of the Madonna in clay and stucco reliefs. Ca. 1903–5, PMB painted a still life with a della Robbia *putto.* (Pauli, 206; Bremen '76, no. 106.) Private collection, Bremen.

Donatello: Donato di Niccolò di Betto Bardi, called Donatello (1386–1466), Florentine sculptor. In the Louvre: five Madonnas in clay and bronze.

with three horses harnessed in tandem: PMB made sketches of carts and horses, but not until later stays in Paris. (Hamburg '76, nos. 181 and 183.) See sketch of the horses p. 153.

The Musée de Cluny: originally the residence in Paris of the abbot of Cluny, the head of the mighty Burgundian reform monastery in the eleventh century. The present edifice was built between 1485 and 1498. It has been a museum since 1848.

the ruins of a Roman bath: the old Lutetia Parisiorum, directly beside the Musée de Cluny.

January 11, 1900. To her parents

Cola Rossi: PB writes his name as two words; the usual spelling is Colarossi. Philippo Colarossi, an insignificant Italian sculptor who got stuck in Paris, took over (probably in the last third of the nineteenth century) the somewhat older Académie Suisse at which Courbet and the Impressionists had studied. These French painting academies were private institutions and those for whom they were named were more businessmen than they were artists. They provided the necessary spaces for their students and procured models for them. The instruction, or more precisely the "critiques," were given by artists who rarely had firm affiliations with the academies. Such places were favored principally by foreigners, for no examinations were necessary for admission. The fame of certain of these academies came from artists who subsequently became famous and who may at one time or another have studied there briefly without ever having been pupils in the normal sense of the word. These academies were particularly important for having been the locations where certain groups of artists congregated.

the same format as in Berlin: the Berlin format refers primarily to charcoal drawings of about sixty by forty centimeters.

the Uhlemanns' in Joinville: the family of a former teacher in Bremen. The son (1876–1953?), who was a professional writer and translator of Lao-tse, used as his nom de plume, Alexander Ular.

Frau Erdmannsdörfer: Pauline Erdmannsdörfer-Fichtner (1847–1916), pianist and pupil of Liszt. This sentence was taken from Güldenkammer, no. 5, p. 298.

Clara Westhoff, with her healthy coloring and her gigantic size: PB frequently poked little bits of fun at her friend Clara, and the latter was able to react to this in a friendly way: one of the particular charms of Paula's nature was her laughter. "Even if it was sometimes at my expense, I still remember with such pleasure that cheerful, superior-benevolent tone of hers." (Hetsch, p. 42.) CW was about six feet tall.

Sarah Bernard: Sarah Bernhardt (1844–1923) was one of the most celebrated and greatest talents of the French stage and remained so even into her old age.

But I will not let thee go, except thou bless me: allusion to Jacob's wrestling with the Angel, Genesis 32:27.

January 17, 1900. To Otto and Helene Modersohn

Corots: there were about eighty paintings by him in the Louvre at that time, among others: *View of the Colosseum, Le Pont de Narni, The Cathedral of Chartres, Souvenir d'Italie, Souvenir of Castel Gandolfo, La route de Sin-le-Noble.* At the World Exposition of 1900 thirty-two of his paintings were on exhibit.

Rousseaus: Théodore Rousseau (1812–1867), French painter of the Barbizon School.

Millets: Jean-François Millet (1814–1875), French figurative painter of the Barbizon School. *A Man in the Field (La fin de la journée),* ca. 1867–69, pastel and pencil. At that time it was in the Galerie Georges Petit, but today it is in the Memorial Art Gallery of the University of Rochester in the United States. No. 181 in the catalog of the Millet exhibition 1975–76 in Paris. In the Louvre: *The Thresher, Church in Gréville.*

that you told me about: OM had been in Paris in 1889.

Courtois: Gustave Courtois (1852–1923), French painter, predominantly of portraits, teacher at Colarossi. PB could have seen works by him during the first days of her stay at an exhibition of the Cercle Volney in the Galerie Silberberg, where he was represented by the paintings *Salomé* and *Resting Bayadère.* The Cercle Artistique et Littéraire, which put on these exhibitions, was named after the rue Volney, where it held its meetings. At the World Exposition, Courtois showed eight paintings, seven of them portraits.

Collin: Raphael Collin (1850–1916), French painter; his main field was decorative wall and ceiling painting, e.g., the ceiling of the Opéra-Comique.

ask what the things cost.: Heinrich Vogeler and Rilke reported (to be sure, with regard to PMB's later stays in Paris, when she was more sure of herself) about the way she would occasionally satisfy her insatiable need for beautiful materials and clothing. She had shopkeepers deliver to her atelier whatever might please her, where she tried on the clothing or draped herself with the fabrics, and then had the things picked up again and returned as "inappropriate." (H. Vogeler, *Memoirs,* ed. Erich Weinert [Berlin, 1952], p. 147). And CWR in Hetsch, p. 49: "Rainer Maria Rilke told me how he had once met and walked along with her into one of the great department stores, the [Grands-Magasins du] Louvre perhaps or the Galerie Lafayette. He said that she asked for a book in which one wrote down the items that one wished to see. And then she fetched a salesgirl who had to carry all the items she had selected—and the arms of this clerk were soon completely laden with dresses and underclothing, lace petticoats and all sorts of other beautiful things which were in fashion at that time. They were then all sent to the address of her atelier where she could try them on in peace and quiet—only to send them right back again afterward."

"All humanity's misery lays hold of me": Goethe, *Faust I,* dungeon scene.

we Germans are better people: allusion to Johann Gottfried Seume's poem "Der Wilde" ("The Wild Man") which concludes: "Seht, wir Wilden sind doch bessre Menschen." ("Behold, we wild men are better people indeed.")

January 18, 1900. To her father

Today I had my critique . . . and am very happy: taken from Güldenkammer, no. 5, p. 298.

Girardot: Louis Auguste Girardot (1858–1933), French painter and lithographer. This is undoubtedly the artist PB meant when she wrote the name Girardeau on a study of a bare twig, dated September 8, 1897.

Académie Julian: This academy, of the same type as that of Colarossi, was founded in 1860

or thereabouts by the painter Rodolphe Julian (1839–1907) from Toulouse. Gauguin and the members of the Nabi circle congregated at Julian for a time.
croquis: basic sketching techniques.

January 29, 1900. To her father
Cyrano de Bergerac: the celebrated play by Edmond Rostand (1868–1918), premiere in 1897.

February 7, 1900. To Paula from Otto Modersohn
Turner: Joseph Mallord William Turner (1775–1851), English painter, now generally considered the greatest of all British artists.

February 8 [1900]. To her parents
This fragment of a letter exists only in a copy and is in the possession of PB's nephew Wulf Becker-Glauch.
the notification about the five [marks]: evidently a present of money from her sister Milly.
Klinger: Klinger, by Max Schmid, Knackfuss, vol. 41.
earlier he was so subjective: PB's first and undated entry in her Album is taken from Langbehn's *Rembrandt as Educator:* "And wherever subjectivity is, there is Paradise."

February 12, 1900. To Paula from her father
(a Gibbon's English Guinea-Topper): Herr Becker refers to his top hat made by the firm of Gibbon and which cost him one guinea, equivalent to more than five dollars at the time.
le cordon: a cord that one pulls to open the latch of a door.
poubelles: garbage cans.

February 29, 1900. To Milly Becker
Salon: the first exhibition by the members of the Royal Academy of Art took place in 1725 in the Salon Carré in the Louvre. Ever since, the designation "salon" has been used to refer to such art exhibitions.
"Boer, Boer!": after the South African uprising of the Dutch landholder farmers in 1880–81, England attempted to reverse the independence that the Republic of South Africa had won. In 1899 the Boer War broke out in which the Boers fell before the rigorous measures taken by the British. Popular opinion all over Europe at the time was decisively anti-British.
Knackfuss: see note for February 8, 1900, letter.
"C'est joli": "It's pretty"; *"C'est beau, pas joli":* "It's beautiful, not pretty."

February 29, 1900. To Otto and Helene Modersohn
Bonnat: Léon Bonnat (1833–1922), French painter of portraits and historical scenes. PB probably saw pictures by him at the exhibition of the Cercle Volney in the Galerie Silberberg. A critic refers to an "agreeable portrait of a young girl, a bust" by Bonnat. Others who exhibited at the same time were: Eugène Cadel, Giraldon, A. Gosselin, Benjamin-Constant, Carolus-Duran, Courtois, Henner, Bouguereau.
Degas: Hilaire Germain Edgar Degas (1834–1917), French painter and graphic artist. From 1877 on, his preferred medium was pastels. PB would have seen in the Louvre (today in the

Jeu de Paume): *Femme à la Potiche, Foyer de la Danse, Pédicure, L'Absinthe, Ballet Scenes, Danseuse au Bouquet.*

Puvis de Chavannes: it can be assumed that PB saw the exhibition of 213 drawings by Puvis in the Luxembourg. (See Chronique, 1900, no. 3 [January 20], p. 21.)

Daubigny: Charles-François Daubigny (1817–1878), French painter, member of the Barbizon School. In the Louvre: *L'Ecluse d'Optevoz, Printemps.*

Courbet: Gustave Courbet (1819–1877), French painter of *réalisme.* In the Louvre: *L'Enterrement à Ornans* (Fernier, no. 91); *L'homme blessé* (Fernier, no. 51); *Combat de cerfs; Remise des chevreuils* (Fernier, no. 382) now in the Musée des Beaux-Arts, Dôle; *Portrait de Peintre, La Vague.*

Monet: Claude Monet (1840–1926), French painter. One of the Impressionist masters. PB probably saw the exhibition at Durand-Ruel, in which Monet, Renoir, and Sisley were represented. Monet with two new paintings: *La Grenouillère* and *Déjeuner sur l'herbe.* (Chronique, 1900, no. 5 [February 3], p. 39.)

Velázquez: Diego de Silva y Velázquez (1599–1660), the great Spanish master.

two little blond Spanish princesses: Infanta Margarita; the second portrait, still at that time in the Louvre, is possibly a representation of Queen Marie-Anne. Today it is no longer considered to be by the hand of Velázquez but rather by his son-in-law, del Mazo. Since 1962 it has been at the Musée des Beaux-Arts in Pau.

Rembrandt: Christ...at Emmaus (Luke 24:13–35.) Ca. 1630, monogrammed. (Bauch, no. 49; Gerson, no. 218.) *The Holy Family,* signed "Rembrandt f[ecit], 1640." (Bauch, no. 71; Gerson, no. 205.)

In these hallowed halls: PB is playing here with Sarastro's famous aria in act 2, scene 3 of Mozart's *Die Zauberflöte* [*The Magic Flute*] which begins: "In diesen heil'gen Hallen / Kennt man die Rache nicht..." ["In these hallowed halls / Revenge is not known..."]. She goes on to refer to the "Weiblein" and the "Männlein" who are there with her as students at the academy. These "little women" and "little men," as she literally refers to them, probably indicate that PB is still thinking of the opera and specifically of the characters of Papagena and Papageno, who are constantly referred to and refer to each other with these diminutives.

the little church and the chocolate address: OM had sent a postcard on February 17 with a little drawing of the small church at Worpswede on which he wrote down the "chocolate address" which PB had probably asked for when she was last in Worpswede; it is the same as in 1898. Therefore, Stollwerck must have opened up a second competition for advertising sketches. On March 25, OM asks her about her progress on this project. (See Bremen '76, no. 268ff., for these sketches.) See illus. on pp. 174 and 175.

And Elsbeth as a great traveler: perhaps a reference either to a study OM did or planned to do of his daughter or PB's reaction to the news that little Elsbeth was about to take a trip. Her reference is vague, as is her following sentence referring to "Heinrich Vogeler at a window on the Weyerberg."

[Ca. March 3, 1900]. To her parents

But new perspectives have opened up: it is more than likely that this is a veiled reference to the time PB first saw paintings by Cézanne. And CRW also places the incident around this time. CRW's account, an excerpt from Hetsch, follows this letter. See also Petzet, p. 79,

where he recalls that CRW later told him that while standing with PB before the paintings by Cézanne at Vollard's, PB said that Cézanne seemed to her to be "like a great brother."

§ March 19 through April 5, 1900. During this period the *Revue Blanche* held an exhibition in its editorial rooms of thirty-nine paintings and fourteen drawings by Seurat. One must assume that PB saw this exhibition. (Chronique, 1900, no. 13, p. 118.) Likewise she was probably at Bernheim Jeune, who exhibited from the second to the twenty-second of April works by Bonnard, Denis, Ibels, Maillol, Hermann Paul, Ranson, Roussel, Sérusier, Vallotton, and Vuillard. (Gordon, p. 17.)

April 8, 1900. To Frau Marie Bock
This letter was discovered among PB's letters to Otto Modersohn.
Fräulein Höbel: Frau Bock had brought the seamstress Fräulein Höbel from her small business at home in Bremerhaven to Worpswede to train her in weaving. This letter proves that PB had occupied herself with carpet and wall-hanging designs even before her trip to Paris. The design *Paula and Martha Keeping Sheep,* now in the Haus im Schluh, as well as the completed article woven by Martha Vogeler, are from PB's hand. (The Haus im Schluh, an old Worpswede thatched-roof farmhouse once owned by Martha Vogeler, is today a privately owned museum housing works by many of the artists associated with the Worpswede colony and an important library.) The design mentioned in this letter is preserved in a color variant as a wall hanging in a private collection in Hamburg. (See illus. no. 5.) A letter by Maidli Stilling-Parizot of July 5, 1902, reveals that PB gave her a wall hanging as a wedding present. ("Are you sure it wasn't too difficult for you to part with your child?") Evidently that design was of a "snowball bush against a blue background." This piece, like everything else in the Parizot house in Pillnitz near Dresden, was lost in the bombing attack of February 13–14, 1945.
The Salon has opened: references to the Salon of the Société des Artistes Français. Exhibiting artists included Despiau, Devalliers, Friesz, Lemordant, Maurer, and Rouault. (Gordon, pp. 17ff.)
Georges Petit: his gallery was at 12, rue Godot-de Mauroy. It was there that the first exhibition of the Société Nouvelle des Peintres et des Sculpteurs was opened on March 10, 1900. (This group had split off from the Société Internationale.) Its president was Gabriel Mourey; it had twenty-one members, nine of them foreigners, and included Charles Cottet, Lucien Simon, and Constantin Meunier. This circle of exhibitors has become known among art historians as the "Bande noire" ["The Black Band"]. (*Histoire de l'Art Contemporaine,* ed. René Huyghe and Germain Bazin; also Jacques Dupont's, "La Bande Noire," in *L'Amour de l'Art,* vol. 14 [March 1933], pp. 60–64.) Cottet's *Triptychon,* which so impressed PB at the World Exposition, was at this smaller show. When she writes about the "personality" and says that the things there "stood all alone on [their] own two feet," she is probably referring to Cottet and Simon. Mourey, who was not only president of the Société Nouvelle but also the regular correspondent in Paris for the London art journal *Studio,* had written two months earlier about this exhibition and in particular about Cottet's *Au Pays de la Mer* (*Studio,* vol. 15, no. 70, pp. 227–41); he said that this triptych was an epitome of Cottet's talents and his special gifts, that it was his masterpiece.
The Exposition: Exposition Universelle de 1900 in Paris. This vast exhibition was simulta-

neously united with the Exposition d'Art Français et des Beaux-Arts, and ran from mid-April to mid-October 1900.

April 12, 1900. To Heinrich Vogeler
This letter was recently discovered in private hands in Hamburg.

April 12, 1900. To Paula from Maidli Parizot
And just now the Maeterlinck arrived: Maurice Maeterlinck, *Weisheit und Schicksal,* the German translation of his *La Sagesse et la Destinée [Wisdom and Destiny]*, 1898.
Klimt's Philosophy: Gustav Klimt (1862–1918), Austrian painter, of the so-called Secession, the Viennese artistic movement close to the international Art Nouveau (cf. German Jugendstil). His painting *Philosophy* was a study on a panel of a large painting for the festival hall of the new University of Vienna. The picture met violent resistance, and the affair resulted in a scandalous explosion. In 1905 Klimt bought back the panel from the authorities; it was destroyed toward the end of the war (in 1945) in a bombing attack. This work did not arrive at the Exposition until the fall, and so PB could not have seen it there.

April 13, 1900. To her parents
Rodin has set up a school for sculptors: Auguste Rodin (1840–1917). In later visits to Paris, PB was to be profoundly influenced by him. Generally conceded to be the greatest of all modern French sculptors.

[Ca. April 13, 1900]. Journal
"I still have such beautiful things before me": the dating for this entry rests on the similarity of this passage and the previous letter to PB's parents.

April 19, 1900. To her parents
Vélizy: CW's descripton of this excursion to Vélizy is mentioned by RMR in his journal. Another favorite goal of their Sunday trips together was Versailles; CW writes in a letter to OM on March 18, 1900: "We liked it *so* much in Versailles. We had already been there twice. When we went there the first time it was almost evening, and in the gray, warm, rainy twilight we drove into the broad, solemn allees, which completely filled our thoughts with the magnificent past so full of fairy tales and horror.... The entire plan of the grounds, the way spaces were divided up and arranged, impressed me enormously; how solemnly the buildings lay spread out there, how solemnly the trimmed trees stood and then immediately next to them the simple, wild, natural nature, voluptuous and rich and almost intoxicating in its voluptuousness. And here we also found again the enchanting gardens with their gray walls over which the ivy was flowing down, so rich and with such fine dark blue fruit. We stood in an allee of tall old trees, some sort of poplars, to the left the forest and to the right a sort of mysterious wall and it was already very dark. 'Can you pick me some of those black berries from the ivy?' said Paula Becker. 'They are too high for me. But I can still just manage to see them against the moonlight.' Imagine the moon in that scene and us deep in the woods and round about us the moist and earthy smell of warm rain and spring...." (From a letter in private hands.) In none of the letters or journals of 1900 that we still have does PB mention Versailles; it is not until the letter of February 26, 1903, to OM that she writes that she wants to see Versailles again.

his Saint-Simon letter: in a letter from PB's father to her, April 16, 1900, he gives her a little lecture about Henri de Rouvroy, Comte de Saint-Simon (1760–1825), the famous precursor of socialism; he had misinterpreted something his daughter had written.

[End of April 1900]. Journal
I have been depressed for days: dated with reference to letters from her parents. On April 30, Herr Becker expresses his regret at not having received the customary Sunday letter. On May 1, Frau Becker replies by return mail to a letter from PB (no longer extant) which had evidently been written in a depressed mood. In it her mother asks whether Paula is ill. On the second her father writes mentioning the same tone of depression, interprets it in his own way, and announces to her that he is sending money. Paula seems to have received it by the fourth and writes on the same day asking for forgiveness for her last "larmoyante" ["tearful"] letter. As a consequence the present journal entry can be dated ca. April 30.

May 1, 1900. Album
[Arnold Böcklin]: PB does not suggest the source of this quotation; however, it is cited in Rudolf Schick's edition of Böcklin's journals from the years 1866–69. An abbreviated prepublication appearance of these journals, edited by Hugo von Tschudi, appeared in *Pan,* vol. 4, nos. 1–3 (1899).

May 4, 1900. To her parents
the story about ... the anecdote: PB's mother had written on May 1, 1900: "Brandes says in the foreword to his *Geistige Strömungen* [*Intellectual Currents*]: 'It is my loftiest goal to be able to reflect the intellectual content of an entire epoch in some sort of *pointe,* preferably in an anecdote.'"
Klinger's series of etchings: Eine Liebe, a series of ten prints, etching and aquatint, op. 10, 1887. (Singer, nos. 157–66.)
Many thanks for the money: from here to the end of the letter taken from Güldenkammer, no. 6, p. 304.
before our holiday trip: the date of this tour is uncertain. It is difficult to fit it into the framework of the letters and journals of this period. There is no word about the goal or course of such a "trip" in any of the extant letters.

Beginning of May 1900. To Otto and Helene Modersohn
an epoch in my life in Paris: [sic], and not so dramatically as in the garbled version of the 1920 Edition, p. 119, "...an epoch in my life."
I would so love to have seen all of them here: to make things clearer, the editors have changed PB's "Sie" to "sie" (i.e., "you" to "them"). She does write in a way in which it might look without the context as if she were saying that she wanted to see everyone in Worpswede here in Paris; but she obviously means to refer to OM's paintings done during her absence from Worpswede.
Zwintscher: Oskar Zwintscher (1870–1916), German painter and writer, he was represented at the Dresden exhibitions of 1897 and 1899 where PB saw and admired his work. In November 1899 he also exhibited in the Bremen Kunsthalle. Through Rilke he came to Worpswede in 1801–2 and lived in Vogeler's guest house. During this period he painted Vogeler,

CRW, and RMR. His self-portrait from the year 1900 was bought in 1902 by the Bremen Kunsthalle.

Cottet: he was represented at the World Exposition in Paris with the following paintings: the triptych *Au Pays de la Mer* (with its panels *Repas d'adieu, Ceux qui sont partis, Celles qui restent*), *Vieux cheval sur la lande, Nuit de la Saint-Jean, Jour de la Saint-Jean, Soir dans le port, Deuil (Isle d'Ouessant)*. (Cat. nos. 502–8.)

Lucien Simon: (1861–1945), French portrait and genre painter. He exhibited a number of paintings, among them: *Luttes, Cirque forain, Les Miens,* and numerous portraits, principally of actors. (Cat. nos. 1766–74.)

Jean-Pierre: According to Chronique, 1903, no. 10, p. 80, and no. 11, p. 83, PB is referring to Jean-Pierre Laurens, who in one of these articles is also named only Jean-Pierre, probably to differentiate him from his father Jean-Paul Laurens. In the next issue he appears with his full name. Jean-Pierre (1875–1932) was represented at the Exposition of 1900 with one painting, *Le Cabestan* [*The Capstan*]. (Cat. no. 1132.) Cézanne was represented at the Exposition with three pictures: *Nature morte, Fruits* (Collection Viau), *Paysage* (Collection Pellerin), *Mon jardin* (Collection Vollard). It is not surprising given PB's purposeful silence with regard to Cézanne that she does not mention these pictures.

the Nordic people: among others, there were pictures by F. Willumsen, Frits Thaulow, Anders Zorn. There were no works by Edvard Munch on exhibition.

Segantini: Giovanni Segantini (1858–1899), Italian painter. Fourteen canvases were exhibited. (Cat. nos. 96–109.)

[Ca. May 11, 1900]. To her parents

This letter is dated May 15 in the 1920 Edition. This cannot be correct since PB's father discusses her visit to the Exposition in his letter of May 14, a Monday. If one sets the previous day as the date of arrival of her letter, Friday, the eleventh, must have been the date on which she wrote.

The whole rapinière: from *rapin,* a "painter's pupil" or "dauber." Thus the word would mean a society or group of daubers or student painters.

"Auch ich war ein Jüngling mit lockigem Haar": first line of the aria from Albert Lortzing's popular *Der Waffenschmied,* 1846. The line translates "I, too, was a youth with a full head of hair."

May 27, 1900. To Milly Becker

the little sculptor Albiker: in the 1920 Edition he is called Abbeken, but a sculptor by this name is unknown. It is almost certain that the editor of the earlier edition misread PB's handwriting and that Karl Albiker (1878–1961) is meant. This sculptor worked with Rodin in Paris in 1899–1900. This assumption is supported by Rilke's letter to Arthur Holitscher, November 23, 1901: "My wife sends you greetings and greetings also to Albiker, and from Hugo, too."

the Swiss cow painter Thomann: again the 1920 Edition refers to the painter "Tormann"; this spelling can be traced back to PB's Album in which she notes the text of a little song in the French-Swiss dialect and refers to her source as the "cow-painter Thormann." There is no question that the reference is to Adolf Thomann (1874–?), the Swiss painter of animals and landscapes. According to *Studio,* vol. 23, p. 52, he first exhibited at the Munich Secession in June 1901.

a painter named Hansen: Emil Nolde (1867–1956), painter, graphic artist, and sculptor. One of the great names in German Expressionism. Hansen/Nolde, a man of practically no financial means, earned money in Switzerland by designing and executing picture post-cards which were humorous personifications of Swiss mountains. In his memoirs *Mein Leben* [*My Life*], Nolde mentions his meeting with PB in a summary fashion: "One noon I met two strange young German women. One of them, Paula Becker, a painter, was small, full of questions; the other, Clara Westhoff, was tall and reticent. I never saw either of them again. But not long afterward the sculptress became the wife of the poet Rainer Maria Rilke. The painter became the wife of the painter Modersohn. During the span of a few years she painted beautifully conceived and humanly touching pictures. And then came cruel death." (Emil Nolde, *Mein Leben,* 2d ed., DuMont Verlag, Dokumente Series [1977], p. 78.)

The circle around PB and CW in Paris must have included also the German painter Emmi Walther, which we can deduce from a letter of August 5, 1900, by her to PB and CW. Emmi Walther (according to Rump, *Lexikon der bildenden Künstler Hamburgs* [1912]) was born in Hamburg in 1860 and was a member of the important art colony in Dachau. The letter, written in Concarneau in Brittany, is full of enthusiasm for Cottet and Simon and describes the landscape, as it were, in Cottet images.

Grande Roue: the great Ferris wheel at the 1900 World Exposition in Paris.

May 31, 1900. To Otto Modersohn

Although at first reluctant to go to Paris (probably because of the poor health of his wife and his dislike of putting his work aside), OM nevertheless changed his mind and went.

[Ca. June 8, 1900]. To her parents

This letter has also been redated. In the 1920 Edition it was absorbed into the letter of June 3. PB speaks about Whitsunday; that was on the third. Friday was her day for writing, thus June 8.

Rodin has opened a special exhibition: Since the committee for the Exposition des Beaux-Arts had rejected Rodin's participation in the vast exhibition on grounds that he was too controversial, he had his own exhibition space built with funds from the city outside the grounds of the Exposition near the Pont d'Alma. It was a rotunda, which he had transported to Meudon after the event. It was the showing of 171 of his works in this *pavillon* which truly inaugurated his international fame and constituted the breakthrough to world-wide recognition. Virtually all his great works were to be seen there, including the *Gates of Hell.*

Bullier: dance hall in the Latin Quarter, much frequented by students and artists.

couturières *and* blanchisseuses: seamstresses and laundresses.

Paris, Friday [June 15, 1900]. To her parents

Frau Modersohn died very suddenly: Helene Modersohn died on June 14, 1900. In his recollection in Hetsch (p. 19) OM wrote: "When we returned exhausted one evening to our *hôtel* there was a telegram which had been sent from home. She [PB] received it and was the one who told me of its shattering message: my poor wife had died suddenly of a hemorrhage. That same night we left for home."

July 2, 1900. Journal
Schlussdorf, Ottelsdorf, Ostendorf: small settlements in and around the area of Worps-
 wede. Ottelsdorf is the High German spelling for the Low German Odelsdorp (= Adolphs-
 dorf).

July 3, 1900. Journal
an abandoned factory: The Brickyard in Worpswede, oil on artist's board, dated lower left
 "1900." Private collection, United States. Charcoal drawing of the same subject, S/XV,
 41. Private collection, Cologne.

July 4, 1900. To Paula from her father
The envelope bears the post-office date of receipt of July 5; this fact establishes the dating
 for the following journal entry.

[July 5, 1900]. Journal
Knut Hamsun's: (1859–1952), Norwegian writer. All his works were instantly translated
 into German. What drew the attention of his German readership in particular was their
 strong feeling for nature which is rooted in the experience of a pervasive life force (*Pan*)
 and their very strong sense for the irrational and hidden qualities of human individuality
 (*Mysteries*). This uncompromisingly realistic novelist won the Nobel Prize for literature in
 1920.

July 1900. Journal
In the Güldenkammer, no. 6, p. 346, this poem is dated "July 1900," whereas the 1920 Edi-
 tion dates it back to 1898. Its entire mood, however, fits completely this period in which
 PB first became conscious of her love for OM.

July 26, 1900. Journal
I know that I shall not live very long: This often-quoted passage from PB's journal bears some
 similarity to an entry from Marie Bashkirtsev's journal, dated December 9, 1883: "Aussi
 je ne vivrai pas longtemps: vous savez, les enfants qui ont trop d'esprit.... Et puis, blague à
 part, je crois que la chandelle est coupée en quatre, et qu'elle brûle par tous les bouts. Ce
 n'est pas que je m'en vante...." ["I shall not live long: you know, children who have too
 much *esprit*.... And then, joking apart, I believe that the candle is cut in four and that it
 is burning at every end. It is not that I boast of it...."] (It is an indication of PB's involve-
 ment with Bashkirtsev that Rilke a half year later refers to Paula as Marie Bashkirtsev in a
 letter of January 24, 1901.)

August 13, 1900. To her mother
my copy of Auch Einer: [*One, Too*]: novel by Friedrich Theodor Vischer (1807–1887), pub-
 lished 1879. Vischer was a professor of aesthetics, and this novel, which deals with the
 "trickery of the object," was much read.
Clara's angels for the church: CW had made designs, two meters by four, of winged heads
 of *putti* for the angle between the wall and ceiling of the church above the midpoint of the
 wooden choir loft, evidently on commission. Now, after their "crime" of ringing the church
 bells, she had to pay for it by forfeiting her honorarium. During recent renovation work

traces of flower bouquets and garlands in oil were found beneath the whitewash around the heads and below them. It was assumed that these had been painted by PB as her share toward payment for the "crime." This amusing assumption, however, has not been proved. PB did a drawing of this "wicked deed," charcoal on brown paper. The Estate. (See illus. p. 197.)

The 1920 Edition dates this escapade August 1899; at this time, however, PB was in Switzerland and CW was studying with Klinger in Leipzig. The present dating relies on an entry in the Worpswede Church Chronicle and on a letter from Frau Becker of August 29, in which the latter writes that she thought the bell ringing was a good joke but that she would have been happier if her daughter had not been part of it.

Martin Finke: the farmer with whose family CW lived.

September 3, 1900. Journal

for a long time: taken from Güldenkammer, no. 6, p. 347, where these notes about the visit of Rilke and Hauptmann are undated, this life-affirming sentence reduces the effect of PB's premonition of an early death and makes it probable that it had been the result of a passing mood of depression.

Dr. Carl Hauptmann: Aus meinem Tagebuch, Gedankliches und Lyrisches [*From My Journal, Philosophical Thoughts and Lyrics*], 2 vols. (1899–1906).

Rainer Maria Rilke: the works by Rilke that had already appeared in 1900 or were in the process of being completed were: *Larenopfer* (1896), *Traumgekrönt* (1897), *Die Weise von Liebe und Tod des Cornets Christoph Rilke* (first version, 1899), *Stundenbuch* (1899–1902) [*Sacrifice to the Lares, Crowned with Dreams, The Ballad of the Love and Death of the Cornet Christoph Rilke,* and *Book of Hours*]. PB's judgment about the meeting of these two men is supplemented by Otto Modersohn's note on September 2 in his journal: "That rare Sunday. She [PB], Sister [Milly], Dr. Hauptmann, Rilke, her cousin. Singing, reading aloud, supper, singing. Dispute between Hauptmann and Rilke." The phrase: "The battle of realism with idealism" is not to be found in Güldenkammer, no. 6, p. 247. It was probably added by Gallwitz.

[After September 12, 1900]. To Otto Modersohn

The envelope is addressed "To the Best of All." Added to it, in OM's handwriting: "Under the stone." OM writes in Hetsch, p. 20: "We did not see each other daily, but we wrote often, and Paula had a charming idea: in a pit on the heath, not far from her studio, the outpourings of our love were placed under a stone."

"hot-blooded iconoclasm": the German reads "das Bilderstürmerblut der Ahnfrau" and literally means "the iconoclast's blood of your matriarchal ancestor." The iconoclasts [*Bilderstürmer* = "image wreckers"] during the Reformation destroyed all Roman Catholic ecclesiastical images within reach, especially those of the Virgin Mary.

"A gentle rustling": reference to Luther's 1 Kings 19:12. In the King James translation: "And after the fire, a still small voice."

"I am yours, you are mine...": PB reverses here the opening line of the famous anonymous Middle High German poem, supposedly by a young girl, found among the letters of Werinher von Tegernsee, end of the twelfth century. "Ich bin din, du bist min / des solt du gewis sin / du bist beslozzen in minem herzen / verlorn is das sluzzelin / du muost ouch

immer darinne sin." ["You are mine, I am yours / of that you may be sure / You are locked within my heart / the key is lost / so you must stay in there forever."]

Wednesday evening. To Otto Modersohn
Written on the envelope: "To My Own." Added by OM: "Under the Stone."
Your Pilgrim: jokingly, PB says of herself that she doesn't walk, she *wallt*, a reference to her manner of walking in an almost tiptoe fashion. No one English verb can render the double meaning of *wallen,* which means both to float, flow, or move in an undulating way, and also to wander or travel as a pilgrim.

[Beginning of October 1900]. Journal
I have rented Fräulein Reyländer's studio: Rilke writes in his Worpswede journal under September 29, 1900, about Ottilie Reyländer's visit with PB on the eve of the former's departure. He says that Ottilie had made a "head over heels" decision to go to Paris. From a letter of December 6, 1900, to PB we learn that she had moved into Paula's room and was using the furniture that PB had left behind. Two things underline the fact that Paula had a very firm intention of returning to Paris as soon as possible: the fact that she did not sell her things to the next renter but simply left them there, and Ottilie Reyländer's question: "Will you be following me to Paris soon, or are you not well enough yet?"
a life study: probably *Life Study of a Peasant Woman.* Paula Becker-Modersohn-Haus, Bremen, inv. no. 11.
afternoons, Herma: there exist a number of portraits by PB of her sister Herma.
ring-around-the-rosy: the German neologism *Ringelreigenflüsterkranz* is an invention of Gerhart Hauptmann's and occurs in *Die Versunkene Glocke* [*The Sunken Bell*], act 1, a play that PB refers to in the following sentence; the word would translate literally as "a garland formed like a ring-around-the-rosy composed of whispering participants."
Gerhart really is quite a person: this is probably a reaction to the gossip about the collapse of Hauptmann's marriage with Maria Thienemann and his living with Margarethe Marschalk, who subsequently became his second wife.
Ibsen's Emperor and Galilean: drama written in 1873.
King Red: a playful allusion to OM's reddish beard. This mode of address and the numerous variations on it occur throughout the letters from now on. König Rother [King Red], a figure from the medieval works connected with the Dietrich Saga, is the title hero of a Middle High German epic of ca. 1150.
He makes me feel pious: PB makes frequent use of the word *fromm* which normally translates as "pious," "devout," "religious." However, the overtones of these three English words do not approximate the full meaning of *fromm,* which is perhaps best rendered by "good," in the same sense as the Latin "pius," which in turn carries the additional meanings of conscientious, affectionate, sacred, and holy. Unfortunately, the English word "pious" today has a somewhat one-sided connotation.

[Undated]. Journal
Throughout this poetic vision there are references to the sun which, to accord with German usage and custom, is always referred to in the feminine gender (just as the moon is masculine—a reversal of English and Romance language usage).

October 15, 1900. To Rainer Maria Rilke

through your sketchbook: probably on the evening before his departure from Worpswede, Rilke sent PB his sketchbook (it is not dated), "in which many of my favorite verses are to be found, for you to keep during the period of my absence." Rilke answered PB's letter of October 15 three days later with the news that he would not be returning to Worpswede. He goes on to say: "Today I am sending you Jacobsen's poems and *Frau Marie Grubbe* for your library and for you to keep." These books still exist in private hands: (1) *Gedichte* [*Poems*] by Jens Peter Jacobsen. On its title page "Ex libris René Rilke" is glued down and changed by Rilke to read "Ex libris Paula Becker." This book is bound as follows: front cover in yellow silk underlaid on its fore edge with a narrow, white, flowered silk ribbon; back cover on both sides is red silk. (2) *Frau Marie Grubbe* by Jens Peter Jacobsen. (Freely adapted from the Danish original by Adolf Strodtmann [Berlin: Otto Janke, n.d.].) Written in ink on the title page: "Ex libris Paula Becker." In Rilke's handwriting on the title page: "An Peter Jens Jacobsen [*sic*] — Er war ein einsamer Dichter / Ein blasser Mondpoet, / Ein stiller Sturmverzichter / Vor dem die Sehnsucht lichter / Als vor dem Lauten steht. / Ein Weihen war sein Kranken. / Er sah versöhnt und ohne Gram / Wie früh ein Fremdes ihm die schlanken / Hände aus den Ranken / Des Lebens lösen kam. RMR." ("For Peter Jens Jacobsen [*sic*] — He was a lonely poet / a pale poet of the moon, / one who silently stepped aside from storms / before whom longing stood more lightly / than it stands before the clamorous. / His illness was a consecration. / Reconciled and without remorse, he saw / how something strange came and released / his slender hands from the entwining vines of life. RMR.") This book was bound by PB. The outside of its covers are in red silk; on the inside the fore edges have a wide, white, flowered ribbon; in their center, yellow ribbon. Both are quilted. The first lines of another poem by Rilke speaks of PB's pleasure in binding books: "Du blasses Kind, an jedem Abend soll / der Sänger dunkel stehn bei deinen Dingen." ["You pale child, every evening the singer / is to stand in darkness amongst your things."] (In RMR's *Worpswede Journal,* pp. 286f., dated "3.10.1900," which was later "Inscribed to the Memory of Paula Modersohn-Becker.") The poem goes on: ". . . and your little books are bound in the silk of gentle bridal garments." On November 5, 1900, Rilke informs PB about a copy of this poem, adding: "It would not exist at all if it were not in your own hands — this very one which began, as it were, with you."

October 25, 1900. To Rainer Maria Rilke

Your Sunday poem: in Rilke's hand, addressed to PB, postmarked: Schmargendorf, October 22: "Sunday night — I know you to be listening: a voice walks about / and it is Sunday evening in the white hall." Signed: "As a sign of a greeting and a longing, Your Rainer Maria Rilke."

The "Annunciation": "Die Verkündigung (Die Worte des Engels)" ["The Annunciation (The Words of the Angel)"] in Rilke's *Buch der Bilder* [*The Book of Pictures*], First Part (July 21, 1899).

"To my Angel": perhaps a reference to the Rilke poem from the collection *Mir zur Feier* (1899) whose title line is "Ich liess meinen Engel lange nicht los" ["I clung long to my angel"].

Herr Modersohn was made very *happy by your letter:* Rilke had written to OM on October 23: "Do you remember that afternoon when you showed your trust in me, a confidence that has made me quietly proud? You showed me the little evening sketches. . . ."

On Thursday [November 1, 1900]. To Rainer Maria Rilke
And now you have your sketchbook once again: RMR had asked for the return of the book
on November 1; consequently this note can be dated as above.
for your second Sunday song: "Ich bin bei Euch, Ihr Sonntagabendlichen...." ["I am with
you, you folk of a Sunday evening...."] Dated by Rilke in his journal "Sunday, on 28 Oc-
tober 1900," the letter signed "Sunday, Autumn 1900." "You have the gift of making let-
ters just as beautiful as evening hours. I read it often and what I wrote afterward is for you
to read and love on the evening you receive it." He then goes on to speak about PB's letter
of October 25: "I shall wait for a very beautiful hour, and the most beautiful one that ar-
rives I shall take to Maidli, the most open one, the one that is most receptive. For you must
measure my giving by what I have received. I am an echo. And you were a great sound
whose final syllable I repeat at a far distance. Greet Clara Westhoff with this Sunday let-
ter from your Rainer Maria Rilke."

November 3, 1900. To her mother
Otto saw Klinger with Pauli: according to Klinger's letters to his friend, the president of the
Bremen Art Society, H. H. Meier, Jr., was in Bremen in October and November 1900.
Meier (1845–1905) was a print collector, one of his special areas of interest being Klinger's
graphic works. He left the Kunsthalle more than one hundred thousand prints, principally
works of the nineteenth century. The topic of conversation during these visits was, among
other things, to procure a position for Mackensen in Dresden, something that Klinger strove
to bring about, but to no avail. Why OM met Klinger with Director Gustav Pauli cannot
be ascertained.

November 12, 1900. To Rainer Maria Rilke
And you say your letter wasn't a letter for me...: PB's answer refers to Rilke's letter of
November 5 in which he thanks her for the autumn foliage she had sent. The chain made
of chestnuts reminded him of the Catholic rosary, and that was his departure point for
speaking of the All Souls' Days of his childhood, at which he broke off, saying, "But I no-
tice that this is no letter for you."
to what extent my brush has learned its language from an apple tree: A probable reference
to *Tree,* oil on board, dated "1900." (Catalog of the Graphisches Kabinett Bremen, 1968,
no. 4.) Private collection. Her later reference to a painting of mother and child and with
the "white-gray, glimmering sky" cannot be identified with any assurance.
your Rodenbach: Georges Rodenbach, *Le Voile* [*The Veil*], a drama, 1894.
"Red roses in the evening air": a probable reference to a line from Rilke which, however,
cannot be identified for certain. Cf. "Die roten Rosen waren nie so rot / als an dem
Abend, der umregnet war. / Ich dachte lange an dein sanftes Haar... / Die roten Rosen
waren nie so rot." ["The red roses were never yet so red / as on that evening filled at times
with rain. / I thought long about your gentle hair... / The red roses were never yet so
red."] ("Gedichte 1884 bis 1905 aus dem Nachlass," *Sämtliche Werke* ["Previously Uncol-
lected Poems 1884–1905," *Complete Works*], ed. Ernst Zinn [Wiesbaden: Insel, 1959],
vol. 3, p. 688.)

[Wednesday]. To Paula from Rainer Maria Rilke
Postmarked Schmargendorf, November 14, 1900. Taken from RMR's journal and entitled

"Brautsegen" ["Blessing of the Bride"]. Inscribed "Mittwoch Brief" ["Wednesday Letter"]. Our translation of this scrupulously rhymed and metrical poem is little more than a prose rendition.

November 26, 1900. Album
Albrecht Dürer: quotation by PB is taken from Dürer's *The Four Books on Human Proportion* (Nuremberg, 1528).

December 1, 1900. To Rainer Maria Rilke
gigantic frieze of Christ on Olympus: 1897; with its support structure which Klinger had erected for this picture, the overall dimensions were five and one-half by nine meters. This supporting structure was destroyed during World War II, but the painting itself can still be seen in the Museum für Bildende Künste [Museum of Arts], Leipzig.
the portrait he did in Rome: most likely *Bianca,* inscribed upper left "Bianca Rom 90 MK," oil on panel. Museum für Bildende Künste [Museum of Arts], Leipzig, inv. no. 1337.
The Green Henry: *Der Grüne Heinrich* is the title of a long autobiographical novel by the most celebrated of all Swiss-German prose writers, Gottfried Keller (1819–1890).
"Kennst du Pan?": "Irrtest du je in dunklen Wäldern? / Kennst du Pan?" ["Did you ever wander lost in dark forests? / Do you know Pan?"]. First lines of the poem "Die Arabeske," in Jens Peter Jacobsen, *Gedichte,* trans. Robert F. Hunold (Leipzig, 1897), pp. 26–28.

December 5, 1900. To Otto Modersohn
I kiss you, my man: the German *Mann* means both man and husband; indeed PB uses it, not incorrectly, to mean also my husband-to-be.
possible for Velázquez to paint: a letter from PB's father, dated December 4, makes it clear that she had been expected at home the previous day but that she had not appeared, and made no explanation for her absence. In the letter Herr Becker regrets her absence all the more because the Kunsthalle was holding an exhibition of works by Donatello (mostly bronzed plaster casts) and full-size photographs of paintings by Velázquez. PB must have gone to see this exhibition on her own which explains her completely unexpected reference to the great Spanish painter.

December 23, 1900. To Otto Modersohn
Saint Christopher in your cathedral: OM was visiting his parents in Münster. In the cathedral there, near the northeast pier of the west transept, there is a gigantic sandstone statue of Saint Christopher, probably done in 1617 by the sculptor Johann von Bocholt. There is an entry in PB's cookbook dated "Dec. 99," expressing the desire to do a painting of Saint Christopher.
his golden leaves: a reference to the gilded branches Saint Christopher holds in one hand.
just a word about Pauli: a letter by OM to RMR of January 15, 1902, reveals that Pauli himself in 1900 had the intention of writing a book about the artists at the Worpswede colony. OM rejected the plan at that time.

December 25, 1900. To Otto Modersohn
Bismarck letters: the gift book from OM to PB was *Fürst Bismarcks Briefe an seine Braut*

und Gattin [*Prince Bismarck's Letters to His Bride and Wife*]. Published by Cotta in Leipzig, 1900.

three Jungbrunnen *books: Jungbrunnenbüchlein. Ein Schatzbehälter deutscher Kunst und Dichtung* [*Little Books from the Fountain of Youth. A Treasure House of German Art and Poetry*]. These books were published monthly by Fischer and Franke in Berlin.

Still Christmas. To Rainer Maria Rilke

Christmas arbor: a custom in the Becker household which developed over the years. At first as part of the general Christmas decoration of the sitting room, Herr Becker's chair received an evergreen garland; and then later, Frau Becker's chair received the same; and then a small Biedermeier sofa for the parents, until finally the youngest Becker son constructed a framework around the sofa which was decorated with greenery until it took on the appearance of a regular arbor. Indeed, the building of arbors of all kinds was one of PB's favorite occupations all her life.

Stories About the Dear Lord God: RMR *Vom lieben Gott und Anderes. An Grosse für Kinder erzählt.* [*About the Dear Lord God and Other Stories. For Grown-ups to Tell Children*]; appeared at Christmas, 1900. Its title later became *Geschichten vom lieben Gott,* a title which PB already anticipates in this letter. RMR's inscription in PB's copy reads: "For Paula Becker and Otto Modersohn with wishes for Christmas and other wishes later to be fulfilled. In Faithfulness Rainer Maria." (See English translation of one of the stories "A Fairy Tale About the Hands of God" by Richard Pettit and Edmund Helminski [Walpole, N.H.: Calliope Press, 1978].)

December 27, 1900. To Otto Modersohn

my Knight with the little dog: allusion to medieval grave markers on which frequently a dog was portrayed at the foot of the knight. The dog was regarded as the symbol of fidelity.

When two are in love: the origin of this little poem cannot be established.

December 28, 1900. To Otto Modersohn

droll caricatures: in his letter of the twenty-fourth to PB, OM had enclosed a sketch of pedestrians walking along a Münster city street.

"as Rilke's talk in Hamburg": the principal themes of this talk, which Rilke gave at a festivity following the performance of Carl Hauptmann's drama *Die Breite* [*Broad Acres*], were set down by the author in his journal. To judge from PB's remarks here, the effect of his talk on the women present was not quite so gripping as Rilke seems to have assumed.

January 10, 1901. To Otto Modersohn

Ritterhude: village in the Osterholz district directly north of Bremen.

to our little church: this is the church of St. Jürgen [St. George], built in 1253 in a low-lying area which flooded annually in the autumn and could be reached only on skates during the winter.

and don't keep looking down: in contrast to PB, OM was not a passionate skater; indeed, he probably had very little inclination for sports. He did, however, try to accommodate himself to Paula's love of skating. PB was elegant at figure skating, an aspect of the sport that was an unknown art to the people of Worpswede and which they, especially the children, greatly admired in her. (Recollection by Frau Frieda Netzel, Worpswede.)

Introduction

Otto's brother: Ernst Modersohn (1870–1948) was a Lutheran pastor.

"[...] They got up at seven in the morning": this according to Herma Weinberg-Becker in Hetsch, p. 16.

child Elsbeth: Elsbeth Modersohn, born August 6, 1898.

Rilke's corrective answer to her letter to Clara: of February 12, 1902.

The word Malweiber *["painting females"]:* cf. a cartoon entitled *Malweiber* by Bruno Paul for a contemporaneous opinion about women painters, with the caption: "Now look, miss, there are two kinds of women painters: those who want to get married and the others who also don't have any talent." In *Simplizissimus,* vol. 6, no. 15 (1901), p. 117, and reprinted in the catalog of the *Simplizissimus* Exhibition in the Bayrische Staatsgemäldegalerie [Bavarian State Painting Gallery], 1977–78, p. 329.

another stay in Paris: from February 15 to March 20, 1903.

"That dreadful wild city...": letter from OM to RMR, January 13, 1903, in Hans Wohltmann, *Otto Modersohn mit Briefwechsel RMR mit OM.* [*Correspondence between RMR and OM.*]

she spent much time in the galleries: Vollard and Durand-Ruel, among others.

the Hayashi collection: sale in the Hôtel Drouot auction gallery by Chevallier and Bing, February 16–21, 1903. It contained sculpture, wood carvings, masks, lacquer, porcelain, ceramics, Chinese small bronzes, Japanese bronzes, religious embroidery work, Japanese paintings. (Chronique, 1903, nos. 8, 9, and 10, pp. 63, 71, 79.)

the Fayum portraits: see letter of February 17, 1903, and also "Portraits funéraires d'Egypte," *Gazette des Beaux-Arts,* 1903, no. 2, pp. 295ff. These grave paintings were discovered in 1887–88 in Fayum, Egypt. Theodor Graf's collection was being shown in Paris for the second time. *Catalogue de la Galérie des Portraits antiques de l'époque grecque en Egypte, appartenant à M. Théodore Graf,* by F. A. Richter and Baron von Ostini, Vienna (Paris: Morin, 1900). (See illus. no. 30.)

a deeper insight into Rembrandt: the Staatliche Gemäldegalerie [State Painting Gallery] in Kassel owns fifteen paintings by Rembrandt, among them three self-portraits (Bauch, nos. 288, 307, 324; Gerson, nos. 30, 157, 310); also *Saskia with the Big Beret* (Bauch, 489; Gerson, 175); *The Blessing of Jacob* (Bauch, 34; Gerson, 277); *River Valley with Ruins* (Bauch, 554; Gerson, 344); and others. The Herzog-Anton-Ulrich Museum in Braunschweig has Rembrandt's *Christ Standing before Mary Magdalene* (Bauch, 83; Gerson, 269); *Man with Goatee* (Bauch, 354; Gerson, 119); *Family Portrait* (Bauch, 541; Gerson, 416); *Stormy Landscape* (Bauch, 547; Gerson, 200); *Portrait of a Young Woman* (Bauch, 465; not in Gerson).

Louis Moilliet: (1880–1962), Swiss painter and friend of the German Expressionist painter August Macke. Moilliet lived in Worpswede from 1900 to 1903 and thereafter was in Worpswede intermittently from 1903 to 1908. His portrait of the Worpswede dentist Monsee (1901) is in the Worpswede Archives. The girl on the bridge in his etching *The Bridge* is Herma Becker; the sketch for the etching is owned by Renate Weinberg.

January 13, 1901. To Otto Modersohn

"Ich denke Dein": from Goethe's poem, "Nähe der Geliebten," whose first line is "Ich denke dein, wenn mir der Sonne Schimmer / Vom Meere strahlt / ..." ["I think of you when

the sun's shimmer / beams from the sea / ..."]. This famous poem has been set to music by a number of composers, foremost among them K. F. Zelter (1758–1832).

I am yours...: Matthew 22:37: "Thou shalt love the Lord thy God with all thy heart, and with all thy soul, and with all thy mind."

January 13, 1901. Journal

This entry is taken from Güldenkammer, vol. 3, no. 7, p. 432.

of the new Hauptmann play: Michael Kramer, first performed December 21, 1900, in the Deutsches Theater, Berlin. Rilke had been present at the dress rehearsal two days before and was deeply impressed by this work. What he wrote about it in his journal was doubtless the theme of the conversation between him and PB: "All the newspapers spread the report that *Michael Kramer* is a 'drama about an artist'; however, it is much more than a drama about a man in a particular field; it is a human drama, and even that is not saying nearly enough, doesn't go far enough...."

That spirit that is related to everything: In his journal entry for October 4, 1900, Rilke quotes PB speaking to him: "I was often surprised at first that you used the word God (Dr. Hauptmann also speaks of Him with that term), and that you can use the word so beautifully. I have so completely lost the use of this word. To be sure, I never have had a passionate need for it. Sometimes, earlier, I believed that He is in the wind, but mostly I never felt Him as any unified personality. I only knew bits and pieces of God. And many of His aspects were terrifying. For death, too, was only one aspect of His nature. And He seemed to me very unjust. He endured unspeakable things, permitted the existence of cruelty and sorrow and remained great at the same time. And the fact that there are many miracles and that many good and mighty things happen to me does not change my feeling a bit. I also lack the intellectual capacity to bring together all these miracles which are so different in their effect and take place so far apart—I cannot bring them together into one point of focus, and I would not have known how to give a name to such a unity, since 'God' does not mean anything to me. Nevertheless, I should so like to believe in a personality around which everything circles, a mountain of strength before which all the lands of all people would lie open." And later: "No, all of this is too foreign to me; to me God is 'She,' Nature. The one who brings, the one who has life and gives it as a gift. [...]"

January 14, 1901. To Rainer Maria Rilke

the electric tramway: answer to Rilke's letter of January 13 in which he had written: "...I shall not attempt to explain that thing as a natural phenomenon. Scarcely had I reached the next corner when something bright rushed up busily to catch up with me, only to stop breathlessly next to me: an electric streetcar, marked Schmargendorf...."

— *Well then, Cassirer and Daumier:* PB refers to an appointment she had with RMR to visit a Daumier exhibition at the art dealer, Paul Cassirer. The Cassirer cousins, Paul and Bruno, had founded the publishing house and art dealership in the autumn of 1898. In 1901 they dissolved their partnership. Bruno continued as publisher and Paul founded the art salon whose galleries were designed in part by Henry van de Velde (see *Deutsche Kunst und Dekoration,* vol. 3, no. 2, p. 26). Paul Cassirer promoted the French Impressionists and worked with the Berlin Secession (and later with the Freie Secession). In 1909 and 1916 he mounted exhibitions of works by PMB.

Daumier: Honoré Daumier (1808–1879), French painter, lithographer, and sculptor. For over forty years he was the satirical caricaturist of his time.
the pale child: see note to letter of October 15, 1900.

January 15, 1901. To Otto Modersohn
Consolation of the Widow: painting by Rembrandt, 1641; today known as the double portrait of the Mennonite preacher Anslo and his wife. (Bauch, no. 536; Gerson, no. 234.)
The little sketch of the Angel: Joseph's Dream (Matthew 2:13); 1645. (Bauch, no. 76; Gerson, no. 210.)
Keller & Reiner: a well-known art gallery at Potsdamer Strasse 122. It grew out of the art workshop of Moritz Keller who produced ivory carvings and works of sculpture, an atelier for paintings in enamel, carvings made of rock crystal, works in chased silver, and the like, with branches in Florence and Lucerne. After Keller's partnership with Carl Reiner was formed in 1897 there was a considerable expansion of the business into exhibitions and the sale of paintings. Van de Velde also worked on the decoration of these galleries.
a Böcklin painting: Frühlingslieder [*Songs of Spring*], 1876; today in the Pushkin Museum in Moscow. (Andree, no. 311, pp. 392–93.) PB had already seen this picture at the exhibition of the Königliche Akademie der Künste von Berlin [The Berlin Royal Academy of the Arts] in honor of Arnold Böcklin's seventieth birthday, where she had also seen the *Holy Grove,* the *Sleeping Huntress and Two Fauns* from the collection of Behrens in Hamburg, and the *Adventurer* from the Bremen Kunsthalle (purchased 1885). There is, however, scarcely any reference at all in PB's letters or journals to these first confrontations with the work of Böcklin.
I saw Velázquez [in the Berlin Museum]: Portrait of the Italian Captain Alessandro del Borro, authenticity questioned as early as 1898, now withdrawn; *Portrait of the Infanta María Anna,* withdrawn; *Portrait of a Dwarf at the Court,* considered by 1898 to be a copy of the original in Madrid; and *Portrait of a Woman,* ca. 1630–33, inv. no. 413E.
the old German masters and their lamentations of Christ: in Berlin: Hans Baldung, called Grien (ca. 1484–1545), *Lamentation of Christ* (ca. 1515); the Master of Messkirch (ca. 1500–1543/1572), *Lamentation* (ca. 1530–38); School of Schongauer, two panels of an altarpiece, the right panel *The Entombment of Christ,* after Schongauer's engraving B18.
the Dürers I saw: in the 1920 Edition the editor has made an astonishing emendation which reads, "But today I saw one Dürer...," as if it were a painful realization that PB would dare to criticize the great Dürer.
fine relief portraits made of colored wax: these cannot be identified.
Hannele: Hannele is the main figure in Gerhart Hauptmann's play *Hanneles Himmelfahrt. Dichtung in zwei Teilen* [*Hannele's Ascension. Dramatic Poem in Two Parts*]. First performed November 14, 1893, in the Royal Theater in Berlin.
"Und meine Seele spannte weit ihre Flügel aus": ["And my soul spread wide its wings"]. From Baron Joseph von Eichendorff's "Mondnacht" ["Moonlit Night"] which begins "Es war als hätt' der Himmel / die Erde still geküsst..." ["It was as if the Heavens / had quietly kissed the earth..."]. It was set to music by Robert Schumann in *Liederkreis,* op. 39.

January 17, 1901. To Otto Modersohn
Earlier dated erroneously January 15.
sailing under Clara Westhoff's colors: just as Rilke addressed Paula's envelopes to Otto, Clara

addressed those of OM to PB so that the engagement would remain a secret in Worpswede. There was probably a feeling that their engagement would otherwise have seemed to have taken place too soon after the death of Helene Modersohn on June 15 of the previous year.

Verrocchio's enchanting lady: Andrea del Verrocchio (1436–1488), Italian painter and sculptor, and a teacher of Leonardo da Vinci. The original of the copy that PB describes here is a sculpture in the Museo Nazionale del Bargello in Florence: *Portrait Bust of a Lady with a Bunch of Flowers.* (Günther Passavant, *Verrocchio: Sculpture, Paintings and Drawings,* trans. by K. Watson [London: Phaidon, 1969], illus. 44, 47, and 49.) PB saw this copy at Keller & Reiner and mentions seeing it again on the occasion of a later exhibition at this gallery.

painting... of the Three Ages of Man: Böcklin, *Spring Day,* 1883; formerly in the National Gallery in Berlin, today in the Art Museum in Bern. (Andree, no. 374, p. 447.)

In his book Böcklin speaks: according to a letter of OM to Gustav Pauli of June 19, 1919, PB and OM together read *The Book of Schick,* i.e., *Notations from the Journal of Rudolf Schick on Böcklin from the Years 1866, 1868, 1869,* ed. Hugo von Tschudi. These notes appeared in book form in 1901, and so PB and OM must have read them when they appeared in *Pan.*

Elysian Fields: painting done on commission by Böcklin for the National Gallery in Berlin, 1878. Disappeared in 1945. (Andree, no. 320, p. 401.) See Robert Adams, *The Lost Museum: Glimpses of Vanished Originals* (New York: Viking, 1980). "Disappeared in 1945" is a very understated way of referring to the fate of the major part of the great collection of old masters (400 or so) from the Kaiser Friedrich Museum. During the bombing of Berlin in World War II the major treasures of both that museum and the National Museum were taken to an antiaircraft tower in the city for safekeeping. At the end of the war the tower fell into the hands of the Russian occupying troops. According to Adams, "they set or allowed someone to set the whole thing on fire. For three days it [the tower] burned—not out of control precisely, because no one tried to control the flames—and not quite spontaneously, because the fire apparently had some help in spreading from the first to the second and third floors of the structure. The fire has been said to represent the greatest disaster to the figurative arts in Europe since the 1734 fire [at the Prado] in Madrid." Aside from "miles of tapestry, mountains of massive plate, ornate furnishings, cabinets of coins and jewels," vast numbers of great paintings were destroyed (the real extent of the losses is not known), including "seven canvases by Velázquez, six Veroneses, six Van Dycks, ten Rubenses, two Brueghels, three Caravaggios, a Bosch, and a Botticelli."

Pietà: (1872–85), acquired by the National Gallery in Berlin in 1888. Disappeared in 1945. (Andree, no. 396, p. 467.)

Dr. Meyer: Dr. H. H. Meier, Jr., of Bremen. PB misspells his name as she does those of so many others.

Sleeping Nymph and Fauns: Fauns Spying on a Sleeping Nymph. On loan to the National Gallery from 1900. Since 1973 the painting has been in a private collection in Tokyo. (Andree, no. 383, p. 456.)

Lilly Stammann: see note on Lili Stammann-Bernewitz to letter of December 10, 1897.

Saw Wilhelm, too: Kaiser Wilhelm II (1859–1941).

Friday [January 18, 1901]. To Otto Modersohn
Arnold Böcklin is now no more: died January 16, 1901.

the family tragedy: his sons Hans and Arnold suffered under severe psychological difficulties; their splendid and promising artistic potential could never be developed. Gerhart Hauptmann's play *Michael Kramer* (see journal entry for January 13, 1901) was strongly influenced by this tragedy in the Böcklin family.

He's singing Schumann Lieder: Maidli Parizot's brother Günther was singing Robert Schumann's song cycle *Myrthen* [*Myrtle*], op. 25. The third song is the famous "Der Nussbaum" ["The Nut Tree"]; it contains the line quoted by PB which translates: "[The blossoms] whisper about a girl who thought all the nights and days through, but alas did not know herself what she was thinking about." (The text is by Julius Mosen, 1803–1868.) Cf. in addition to these letters from PB, written in Berlin when she was first engaged, a letter by Maidli to Herma Becker on September 23, 1906, which reads: "I still remember Paula exactly the way she was when she lived with us as a fiancée. It had never become so clear to me before how beautiful and at the same time chaste and fine an effect sensuality can have on a young and blossoming person. And Paula wanted to have children; she was already speaking about them in her sweet and humorous way, and one day she brought home with her a little coral bracelet which she had purchased from a secondhand dealer on one of her many excursions. She said her daughter was to have it [. . .]."

January 21, 1901. To Otto Modersohn

portrait of the three of us: this triple portrait of PB, CW, and OM had been a Christmas present by her to OM. A little verse accompanied it. "Thee and I, and I and thee, and Clara Westhoff makes us three." The letter makes clear that she had taken the picture along with her to Berlin.

[Vogeler's] room at Keller & Reiner: see *Deutsche Kunst und Dekoration,* article entitled "Heinrich Vogeler," second special supplement, with an accompanying study by Rainer Maria Rilke. (Vol. X, April 1902, pp. 299–330. Illus. p. 326f.)

the tulip pillow: Heinrich Vogeler had arranged for his fiancée to take instruction in embroidery and weaving in Dresden.

Heinrich Hart: (1855–1906), German author with close connections to the school of Consistent Naturalism. The real founder of the Neue Gemeinschaft [New Community], an ethical and religious movement based on naturalistic and positivistic foundations, with its center in Friedrichshagen, was Heinrich's brother Julius (1859–1930). Other members of the Friedrichshagen circle at the time were Gerhart Hauptmann, Wilhelm Bölsche (1861–1939), and Bruno Wille (1860–1928), all of whom the Modersohns met on their wedding trip the following June when they stayed with the Carl Hauptmanns in Schreiberhau.

Gottheiners': see letter to her parents, May 14, 1897.

my little room at the Brünjes': OM had written on the previous day to PB about an improvised supper with CW and the Brünjes family in PB's quarters there.

[January 23, 1901]. To Rainer Maria Rilke

this childlike book: PB had given RMR her journal to read. Rilke answered the following day with a long letter, in which he wrote: "And then I also came to you, the artist. There is something I now must regret: in Worpswede I was always with you in the evening, and I doubtless saw here and there, while we were conversing, a sketch (a canal with a bridge and sky is still very clear in my memory), until words came from you, words which I wanted to *see* at once, so that I denied my eyes the view of your walls, and followed your words,

and saw the vibrations of your silence which seemed to collect around Dante's brow above the lily in its dense fragrance as twilight came. Thus it happened that I never saw much by you; for you yourself never showed me anything. . . .

"You have not lost your 'first twenty years,' my dear and serious friend. You have lost nothing that you could ever miss. You did not let yourself be confused by the eyes in the veils of the Schlachtensee [lake near Berlin], which gazed out of the space which is neither water nor sky. You went home and you created. You will not feel until a great deal later how very much. In your art you will feel it. And there will be somebody who will feel it in your life, a person who will receive it and enlarge it and lift it into new and broader harmonies with his ripe, rich, and understanding hands. . . ." For reference to "first twenty years" see journal entry for November 11, 1898.

Your. . . Hauptmann: Rilke had sent as a gift the photograph of Gerhart Hauptmann which PB had seen and admired.

January 26, 1901. To Otto Modersohn
Plattdeutsch *jokes:* the Low German dialect spoken in the coastal areas of northern Germany.

Frenchman named Gobineau: Count Joseph Arthur de Gobineau (1816–1882), French diplomat and writer. His most important work is *Essai sur l'inégalité des races humaines [An Essay on the Inequality of the Human Races]*, 4 vols., 1853–55, in which he attempted to prove the superiority of the Aryan race and whose thesis had a broad, enduring, and disastrous effect on subsequent history. *La Renaissance, Scènes historiques* (1877) by Gobineau was quickly translated into German in several versions, and this book, too, a celebration of the masterly figures of the Renaissance, had a strong influence on the German bourgeoisie. The concluding fifth section of the book contains an invented conversation between Vittoria Colonna and Michelangelo and is entitled "A Hall in the Palazzo Colonna, 1560." Michelangelo's alleged utterance upon the death of Vittoria, mentioned by PB, is not in Gobineau, but in Condivi's *Vita di Michel-Angelo Buonarotti*. Rome 1553. Michelangelo's sonnets (to Vittoria Colonna?) were at the time a relatively recent discovery. It wasn't until 1863 that they first appeared in Italian. Since that date numerous translations into German and English have appeared.

pupils of Rysselberghe: Théo van Rysselberghe (1862–1926), Belgian painter in Paris, member of the circle of so-called Neo-Impressionists. According to Julius Meier-Graefe in *Der moderne Impressionismus,* p. 23, Rysselberghe's "pupils" were Georges Lemmen and Henry van de Velde. Count Harry Kessler and Henry van de Velde organized a series of exhibitions of these Neo-Impressionists beginning in 1898 at Keller & Reiner; they also included works by Seurat, Signac, and Cross. (Cf. Robert M. Herbert, *Neo-Impressionism,* exhibition catalog [New York: Guggenheim Museum, 1968], p. 245.)

Beckerchen: this diminutive form of PB's last name contains a pun in the German on *Bäckerchen* ["little baker"].

Fräulein Boysen: around 1900 there was a photographer and publisher of picture postcards in Worpswede named Boysen; we must assume that Fräulein Boysen is his daughter.

Lonely People: [*Einsame Menschen*] a drama by Gerhart Hauptmann, first performed in January 1891.

January 31, 1901. To Otto Modersohn
The talk by Lichtwark: three days previously the Neue Gemeinschaft [The New Community] organized a memorial celebration for Böcklin, at which Alfred Lichtwark spoke. Alfred Lichtwark (1852–1914), art historian and teacher of art history, was the director of the Hamburg Kunsthalle from 1886 to 1914.

February 3, 1901. To Otto Modersohn
"Du aber bist der Baum": ["But you are the tree"]: recurring line from RMR's "Verkündigung (Die Worte des Engels)" ["Annunciation (The Words of the Angel)"]. (See note to letter of October 25, 1900, to RMR.)
as a pupil: on February 1, OM wrote to PB about the desire of a young woman from Bergedorf, Marie Charlotte Wenzel, to be instructed in painting. In spite of PB's objection, OM did take her on as a pupil. PMB evidently later did a portrait of her. (Pauli, no. 32.)
the forty marks: PB is referring here to a disagreement with an innkeeper to whom an acquaintance of OM, generally considered to be mentally unbalanced, had given a painting by OM as security for a debt. Kurt Becker assisted his future brother-in-law through this unpleasant affair.

February 7, 1901. To Rainer Maria Rilke
an abundance of apparitions: an allusion to Goethe's "Fülle der Gesichte" ["Abundance of Apparitions"], *Faust I,* scene 2. This is an untranslatable pun as *Gesicht* also means face and Paula is begging off on the excuse that the party has grown too large.
"The Great Window": a scenic spot with a view over the Wannsee, one of the beautiful lakes near Berlin.

February 7, 1901. To Paula from her father
out of the abundance of the heart: quoted from Martin Luther, *Sendbrief vom Dolmetschen* [*Epistle on Translation*]; cf. Matthew 12:34.

February 8, 1901. To Otto Modersohn
your little picture: according to OM's entry in his "Chronological Catalog of My Pictures, 1900–1901," the picture referred to here is one called *Couple.* Cf. *The Bridal Pair,* red chalk, 1901. (*Otto Modersohn Katalog* [Worpswede/Fischerhude, 1977], p. 64, illus. 33.)
Böcklin photograph: OM had sent a photographic print of the painting *Spring Songs.*

[February 8, 1901]. To Rainer Maria Rilke
book on Oldach: Julius Oldach (1800–1831), painter active in Hamburg. RMR probably sent the little volume by Alfred Lichtwark on Julius Oldach (1899?) to PB. Lichtwark had recently rediscovered this charming painter.

February 12, 1901. Journal
Notes on building a house: in the 1920 Edition this text is dated to the summer of 1900, but without any justification. There is a logical connection between this and the letter to OM on February 12, 1901. In particular the reference to the kind of wallpaper she prefers (omitted in the 1920 Edition) and to the Berlin lanterns makes it evident that PB's imaginary house design belongs to her stay in Berlin.

February 12, 1901. To Otto Modersohn
happy and almost embarrassed letter from Kurt: OM had sent Kurt the picture that he had
redeemed from the innkeeper. See note to letter of February 3, 1901.
another mirror: this is probably the mirror that can be seen in the *Still Life with Venetian
Mirror,* dated lower right "1903." The Estate. (See illus. no. 26.)
Goya: Francisco Goya y Lucientes (1746–1828), the great Spanish painter. PB would have
seen in Berlin *The Junta of the Philippines,* 1814–15, acquired 1900. (*L'Œuvre Peint de
Goya: Catalogue Raisonné par Mlle Xavière Desparmet-Fitzgerald* [Paris, 1928–50], cat.
no. 246.)
your French postcard: addressed to PB and CW, February 10, 1901, signed by OM, Martha
and Marie Vogeler, this postcard was written in a playful mood and makes allusions to
ladies' underwear and Paula's culinary arts.
Köster's: H. Köster owned a picture-frame factory, Berlin NW, Schiffbauerdamm 25. It was
here that OM had frames built for his pictures.
a wonderful white lamp: Paula must have bought it, for we see it in the *Still Life with Prayer
Book and Glass Lamp,* signed lower left "PMB"; ca. 1901–2. (Pauli, 213; Bremen '76, no.
139.) Private collection, Bremen. Also *Still Life with Glass Lamp,* ca. 1904. (Pauli, 190;
Bremen '76, no. 138.) Landesgalerie Hannover.
Kellner: Johann Kellner was a baker and the postmaster in Worpswede. PB frequently men-
tions her suspicion that he was the ever-vigilant reader of the mail of his clients.
and you say Hektor is dead: Hektor was Vogeler's dog.

February 16, 1901. To Otto Modersohn
Oh, if only I were further: PB is quoting the beginning lines, with a slight change, of Goethe's
ballad "Der getreue Eckart" ["Faithful Eckart"]: "O wären wir weiter, o wär' ich zu Haus"
["Oh, that we were farther, oh, were I at home"].

[Undated]. Sketchbook, SXXI/ii
an Annunciation: the desire to paint an Annunciation probably goes back to Rilke's poem
of the same name. There does exist a sketch of this subject. (Müller-Wulkow, cat. no. 87.)
Vogeler also painted an Annunciation.

February 16, 1901. To Rainer Maria Rilke
one who sees it and is made happy: PB's happiness is doubtless concentrated here on the
growing union between RMR and CW. On February 17, Rilke responded: "Life is serious,
but full of goodness. I am happy, too. So much lies before me. You will soon hear all of
what I mean."

February 20, 1901. To Otto Modersohn
Aunt Linchen: Caroline von Bültzingslöwen, the sister of PB's maternal grandfather.
dear little lady from the Louvre: portrait by Velázquez of the Infanta Margarita, 1654–55.
See José Lopez-Rei, *Velázquez, a Catalogue Raisonné of his Œuvre with an Introductory
Study* (London, 1936), no. 398. The ascription to Velázquez is questioned.

February 26, 1901. To Otto Modersohn
I have sent Clara W. a package: naturally OM was the intended recipient of the package ad-dressed to CW.

February 28, 1901. To Otto Modersohn
brass foot warmer: the German term that PB uses, *Feuerkike,* is an unusual North German
 expression and refers to a little portable stove heated with charcoal and used by the peas-
 ants in church for warmth.
your beautiful portrait-postcard: this was probably done by OM during his visit to Herr
 Becker. It is not preserved. On March 2 he wrote about this visit: "It was charming to be
 with your family in Bremen. I was there from ten in the morning until eight in the evening.
 The hours flew by. [...] I find much more contact with your family than I had hoped and
 am happy about it."
Struss's smithy: this watercolor is owned by Elisabeth Becker-Glauch. According to Frau
 Frieda Netzel this smithy was a house with a beautiful old thatched roof at the entrance to
 the village below the Weyerberg. Illustrated in Gerhard Wietek, *Die Worpsweder Foto-
 grafien des Malers Georg Tappert von 1906–1909* [The Photographs of Worpswede by
 the Painter Georg Tappert, 1906–1909] (Worpswede, 1980).
Netzel: the bookbinder Friedrich Netzel had a shop on Findorffstrasse and provided for all
 the needs and desires of the painters in the art colony.
Clara W.'s engagement: this created a small sensation in Worpswede and Bremen. The way
 people reacted to it indicates clearly that despite Rilke's close connections with his friends
 in Worpswede, he did not really establish himself as one of the group. OM jokes in a letter
 to PB, "And Friday afternoon — guess who turned up? You've probably got a good idea
 already: Clara W. with her little Rilke under her arm." Frau Becker's reaction in her letter
 to Paula of February 24 is friendlier: "My, that was a full day! No sooner do I get home
 than the news of Clara W.'s engagement greets me. Clara and Rainer Maria! I am aston-
 ished and amazed; at first glance they seemed to be such an unlikely couple, but Milly is
 thrilled and can't imagine anything more beautiful than Worpswede will be in the coming
 weeks. [...] Early this morning Milly went to visit the Westhoffs without knowing any-
 thing about it, but just to say hello to Clara. The only person she found at home was Frau
 W., more scatterbrained than ever. [...] Then the doorbell rang and Milly ran to open the
 door, and there the two of them were standing still completely oblivious and blissfully
 surprised by their own fate. 'Only two weeks ago I would have sworn that it was still only
 friendship,' said Clara. You know, of course, that she left Berlin completely undecided
 about things and then after they parted she felt she couldn't endure being without him,
 and so she wrote a letter to him from Hamburg. [...] Well, that's how it happened. And
 you and I had selected the lovely Rainer for our lovely Maidli." The gentle attempt to in-
 terest RMR in her cousin can be deduced from PB's letter to Rilke of October 25, 1900.

March 4, 1901. To Otto Modersohn
Falsely dated February 4, 1901, in the previous editions.
The Magic Flute: PB's recollection of the trip to Hamburg undertaken by the group from
 Worpswede the previous September where, among other things, they saw a production of
 Mozart's *The Magic Flute.*

I'm tired of the world: a play on Goethe's line from the poem "Wanderers Nachtlied": "Ach, ich bin des Treibens müde" ["Oh, I am weary of it all"].

your painting of a little old woman: OM's picture *Das alte Haus* [*The Old House*]. (*Catalogue of the Königliche Gemäldegalerie* [*Royal Painting Gallery*], Dresden, 8th ed. [1912], no. 2515.)

"What shall Cordelia speak? Love, and be silent": Shakespeare, *King Lear*, act 1, scene 1.

March 6, 1901. To Otto Modersohn

Have you received the Rossetti: Dante Gabriel Rossetti (1828–1882), English painter, who joined the Pre-Raphaelite Brotherhood. In 1848, a group of artists centered around Ruskin, Morris, Burne-Jones. It could not be determined whether PB sent OM a reproduction or a book.

March 23, 1901. To Marie Hill

and Clara Westhoff put them [pussy willows]: besides this little gift, CW also gave PB a handwritten copy of a poem by RMR about Böcklin's painting *Frühlingslieder* [*Spring Songs*], dated March 6, 1901. A reproduction of this painting can be seen in the photograph of Rilke at his desk in his home in Westerwede, taken in 1901. (See illus. no. 12.)

May 13, 1901. To Clara Rilke-Westhoff

the Tiebrucks': this name cannot be found in any of the town records or archives in Worpswede. It is perhaps a confusion with the frequently encountered name Viebrock, and miscopied by the previous editor.

the sun that divides everything up: see Maurice Denis' comment about Cézanne: "...he always complains when the sun is shining and won't work much; he needs gray weather." (M. Denis, *Journal*, vol. 1, 1884–1904 [Paris, 1957], p. 157.)

From Otto Modersohn's Travel Journal.

Bruno Wille...[Wilhelm] Bölsche: they were at the center of the Naturalist group in Berlin. Bölsche was cofounder of the Verein Freie Bühne [The Free Stage Society] and of the theater itself; he was also editor for a time of the periodical *Freie Bühne für modernes Leben* [*The Free Stage for Modern Life*], which became in 1894 the *Neue Deutsche Rundschau* [*New German Review*]. His major work was *Die naturwissenschaftlichen Grundlagen der Poesie* [*The Scientific Foundations of Poetry*]; but his most popular success was *Das Liebesleben in der Natur* [*Love Life in Nature*], 1887. After the Modersohns, Vogelers, and Carl Weidemeyer (1882–1976, painter and architect) read this book together in 1905, they collaborated in painting a group picture entitled *Love Life in Worpswede*. (Petzet, illus. no. 19.) Today the painting is in the Worpswede Archives.

the tour to Dachau: this trip to the artists' colony at Dachau (according to OM in Hetsch, p. 22) was undertaken to visit a friend of Paula's, Emmy Walther, with whom she had studied in Paris, according to a letter of Emmy Walther's to Emil Nolde.

Picture Postcards written on the wedding trip.

To her parents [pp. 259–262]

May 27, 1901. [Postmarked Visselhövede]

"Sunday. Arrived this evening in Wisselhövede [*sic*] during a thunderstorm. Am sending

Mother some beautiful asparagus. If it rains tomorrow, we'll be off to Berlin." Drawn and written by PMB.

May 30, 1901. [Postmarked Dresden]
"The young wife upon her departure from Berlin. She is rushing to the Anhalter Bahnhof [the Anhalt train station in Berlin] in the fresh morning hours—did you get my little drawing from Visselhövede? We are happy to be shaking the dust of Berlin from our feet. This town can hardly hold a candle to Worpswede. More tomorrow. Many thanks for Kurt's card. Our address from June 2 will be Schreiberhau, Silesia, Dr. Carl Hauptmann. Loving thoughts to all of you. My dear father. From your two children." Drawn and written by OM, and from the words, "Many thanks," written by PMB.

May 30, 1901. [Postmarked Dresden]
"Evenings at the Bellevue where our soul is returning after the sun of Dresden fried it out of us. We had only just entered the Exhibition when we sold the *Waldfrau* [*The Woman of the Forest;* illustrated in RMR's monograph on Worpswede, 1903, illus. 19]. Now we have all these little sacks [of money] in our possession. We kiss you. How is Father? Please do write a postcard to Schreiberhau. We'll be there the day after tomorrow. But we are already looking forward to returning home. *The Woman of the Forest* will find her way into one of the finest galleries in England." Drawn and written by PMB. Collection of Edm. Davis, London.

June 13, 1901. [Postmarked Prague]
"A nocturnal hunting expedition in Prague—killing the game." Drawn and written by OM.

June 1901 [second letter]. To her parents
[Carl Hauptmann's] wife: Martha née Thienemann, born 1862, married 1884.
with five sisters: PMB should have written "four sisters." The five were: Trude, Olga, Marie (born 1860, married Gerhart Hauptmann, 1885), Martha, Adele (married Georg Hauptmann, 1882).

June [12], 1901.
in the hands of Dr. Ploetz: Alfred Ploetz (1860–1940), "racial hygienist" [*Rassenhygieniker*] and a phrenologist.

June 24, 1901. To Martha and Carl Hauptmann
the Bergschmiede: title of Carl Hauptmann's newest play which translates as *The Mountain Forge,* published in 1902.

September 3, 1901. To Otto Modersohn
The postcard could have been written in Kirchrode near Hannover. Or the postmark could refer to the railroad route Hannover-Walsrode. It is not known whom PMB was visiting. The rowboat she desired she received in the form of a picture placed on her Christmas present table.

February 9, 10, 1902. To Paula from Clara and Rainer Maria Rilke

There was a lecture: on February 9, Rilke had given a talk on Maeterlinck in Storm's Bookstore in Bremen.

staging Sister Beatrix: drama by Maeterlinck. The reading was performed by amateurs on the occasion of the opening of the new addition to the Bremen Kunsthalle. The suggestion was evidently Rilke's and preparations had been going on since the previous September. Rilke directed the performance and had written an additional festival scene himself which later appeared in a private printing. The closing lines of this dialogue between the burgher and the artist reads: "Here the human being comes to maturity. Here in this house / One learns to see for his whole life long, / The one who had made his way through the crowds as a blind man; / And here is church, here God is given, / And where you stand is consecrated soil." (From Hans-Jürgen Seekamp, *Einweihung des neuen Hauses der Kunsthalle 1902* [*The Dedication of the New Wing of the Kunsthalle in 1902*]. In *Museum-heute, Ein Querschnitt* [*Museum Today, A Cross Section*], a publication celebrating the 125th year since the founding of the Kunsthalle [1948], p. 20.)

my latest work: RMR refers to his publication *Die Letzten* [*Recent Works*], (Berlin, 1902); now entitled *Erzählungen und Skizzen der Frühzeit* [*Stories and Sketches of the Early Period*].

February 10, 1902. To Clara Rilke-Westhoff

the hotel behind the castle: probably the hotel known at the time as the Hotel Stadt London [City of London]. "Behind the castle" has reference to the country seat of the Landgrave Friedrich von Hessen built in 1718 and by that time already long in ruins. In exchange for the services which the landgrave rendered to Sweden in the Thirty Years War he was ceded in 1649 the monasteries of Lilienthal and Osterholz and their lands together with Worpswede.

February 12, 1902. To Paula from Rainer Maria Rilke

According to this and other letters from Rilke, PB's journal must have contained a good deal more about Clara than is known to us from existing material. The journals themselves were destroyed during World War II.

February 24, 1902. Journal

a bowl where people can put fresh flowers: in February 1908, CRW, without knowing of this journal entry, sent her brother to Worpswede so that he could set a bowl with fruit on PMB's snow-covered grave. (Helmuth Westhoff to Dr. Günter Busch.) And in Rilke's "Requiem for a Friend," 1908, there are the lines "For that you understood: the full fruits. / You placed them into bowls before you / And counterbalanced their weight with your colors."

February 27, 1902. To Marie Hill

my same little room of old: her studio at the Brünjes' family farmhouse.

your young lady friend who paints: Marie von Malachowski (dates unknown), who evidently lived with Marie Hill in 1901 and who had now written to PMB from Dresden asking for practical advice about studying art in Paris. PMB met her there in 1903.

for a German to paint of his wife: presumably the one painted in 1888. (Brachert, no. 55, color illus., p. 49.) Stadtmuseum in Leipzig [Museum of the City of Leipzig].
a little garden refreshed after a rainstorm: painting entitled *Rainbow,* 1896. (Brachert, no. 172, illus., p. 129.) Neue Staatsgalerie [New State Gallery], Munich.
a young musician... named Petri: Egon Petri (1881–1962), son of the violinist Henri Petri from Dresden; he was a pianist and pupil-collaborator of Busoni.

March 11, 1902. From Otto Modersohn's Journal
This text, in abbreviated form, was an appendix to the 1920 Edition.
two heads of girls against the sky: two canvases but difficult to determine exactly which; cf. *Portrait of a Girl,* dated lower right "VII 1901"; on artist's board. (Bremen '76, no. 58, illus. 9.) Städelsches Kunstinstitut [Städel Art Institute] in Frankfurt. Cf. also *Portrait of a Sick Young Girl,* dated lower left "VII 1901." (Pauli, 114; Bremen '76, no. 57.) Landesmuseum [Provincial Museum], Münster.
still lifes... on slate board: Still Life with Milk-Glass Goblet and Apples. (Pauli, no. 239, illus.)
portrait of a head... on slate board: Portrait of a Girl in Front of a Window, slate applied to linen. (Pauli, no. 104.) The Estate. (See illus. no. 25.)
my three pictures in Bremen: PMB had also submitted pictures for this exhibition but they were all rejected by the jury. (See Pauli, p. 44.)
Fräulein von Steinsdorf: unknown.
Mackensen's Fisher: painted in 1901. (Illustrated in Rilke, *Worpswede* [1903], p. 40, illus. 18.) Private collection.
(Böcklin's Magdalene): Mary Magdalene Mourning over the Body of Christ, 1867–68. (Andree, no. 201, pp. 306f.) Kunstmuseum [Art Museum], Basel.

[March 25, 1902.] From the Album
Dated March 5 in the Album, but a few lines later the twenty-second of March is mentioned as having already passed and there is a comment about Easter's almost having arrived. Our date must be very close to the correct one.
Frau Böttcher (the spinner): Peasant Woman Spinning, ca. 1899, charcoal. (Hamburg '76, no. 74, illus. p. 65.) Private collection.

Easter Week, March 1902, Journal
and held them up... against the sky: cf. *Hand Holding a Bunch of Flowers,* ca. 1902. (Pauli, no. 117a.) Paula Becker-Modersohn-Haus, Bremen, inv. no. 25. In Bremen '76 this painting is considered to have a connection with the painting *Young Girl with Yellow Flowers in a Glass Vase,* dated upper left "1902." (Pauli, no. 81; Bremen '76, no. 79, illus. 13.) Bremen Kunsthalle, inv. no. 954–1967/21.)

March 30, 1902. Journal
the Titian book: Knackfuss, vol. 29, *Tizian* (by H. Knackfuss).

April 22, 1902. To Marie Hill
our miniature garden: cf. *Garden,* charcoal, S/VI, 27. (Bremen '76, no. 319, illus. 51.) Bremen Kunsthalle, inv. no. 65/408.

a silvery glass globe: these large glass balls were often to be found in farmers' gardens in the area of Worpswede. Their use was ornamental but might also have been used to frighten away birds. They are frequently encountered in PMB's work; for example, in the famous painting, *Old Woman from the Poorhouse,* 1906, a large portrait of old "Dreebeen" [old "Three-Legs"]. Paula Becker-Modersohn-Haus, Bremen, inv. no. 47. (See illus. no. 37.)

April 29, 1902. To Paula from her mother
paint the boy: PMB did paint her brother Henner on the eve of his departure on a training cruise with the North German Lloyd line. The portrait is inscribed lower left "HB" [Henner Becker]. (Pauli, 127; Bremen '76, no. 52, illus. 7.) Private collection.

May 2, 1902. Journal
Rilke once wrote: see RMR's letter of February 12, 1902.

May 29, 1902. Journal
my husband painted me: this painting is in a private collection. A thematically related painting by PMB, known by the title *The Veiled Bride* (a title not selected by PMB), is dated "January 1902." It appears almost to be an anticipation of what Paula describes here, a hovering between dream and reality. (Not in Pauli; Bremen '76, no. 66, color plate 8.) Private collection.

June 3, 1902. Journal
truly remarkable colors: cf. *Portrait Bust of a Woman Holding a Carafe.* Charcoal on blue paper; inscribed below: "Black Green Gray/My Three Ribbons." Bremen Kunsthalle, inv. no. 66/248.
a book... on Segantini by Franz Servaes: G. J. Segantini, Sein Leben und Werk [*G. J. Segantini, His Life and Work*], ed. the Royal and Imperial Ministry for Culture and Education. Text by Franz Servaes (Vienna, 1902). A letter of RMR to OM on June 25, 1902, shows that the former had drawn the Modersohns' attention to this work: "It was a great joy for me, a great joy, that it was no simple, subjective coincidence my recommending the Segantini book to you." For the *Bremer Tageblatt* edition of March 19, 1902, RMR wrote a review of this book. OM's journal contains numerous references to the work of Segantini during this period.

June 5, 1902. To Martha Hauptmann
Mackensen is also engaged: the engagement must have been broken, for Mackensen was not married until 1907 to Herta Stahlschmidt (1884–1949). The woman from Bremen cannot be identified.
a Sermon on the Mount: completed in 1907 and exhibited at the Glass Palace in Munich. Presented by the artist to the University of Heidelberg in 1911; now on loan to the University Chapel at St. Peter's Church in that city. According to Rilke's Worpswede monograph (1903), p. 42, the picture was in Mackensen's atelier and barely begun at this time. See Ulrike Hamm, *Studien zur Künstlerkolonie Worpswede 1889–1908 unter besonderer Berücksichtigung von Fritz Mackensen* [*Studies of the Artists' Colony at Worpswede 1889–1908 with Particular Reference to Fritz Mackensen*], (diss., Munich 1978; Catalogue of Dissertations no. 128).

June 15, 1902. From Otto Modersohn's Journal
This excerpt from OM's journal was selected by him to be published in the 1920 Edition where it appears under the year 1903. This error was continued in all subsequent editions. *old Three-Legs, goat, chickens:* Old Peasant Woman with Goat and Chickens, dated "VI 1902," oil on canvas. (Pauli, 49b.) In the Saarland-Museum, Saarbrücken. Cf. the painting by OM, *The Old Three-Legs,* dated lower left "VI 02," oil on board. (Otto Modersohn Catalog [Worpswede-Fischerhude, 1977], no. 237.) Thematically related: *Cow Tended by a Boy,* inscribed lower left "1902." (Bremen '76, no. 61.) The Estate, on permanent loan to the Office of the German Chancellor.

June 27, 1902. To her mother
Today: boys swimming: both PMB and OM frequently painted pictures of naked children swimming in the canals and little lakes around Worpswede; e.g., *Children Swimming,* dated lower left "5 02," on board. (Bremen '76, no. 65.) The Estate. *Boy in the Sun,* dated lower right "02," canvas. (Bremen '76, no. 60.) The Estate. *Naked Children by the Water,* board. (Bremen '76, no. 98.) Private collection. *Three Boys Swimming.* (Not in Pauli.) Private collection, United States.

July 6, 1902. To her mother
Frau Becker and Herma had been visiting the Bulthaupts in Burgstall in the Allgäu region of Bavaria.
study of Elsbeth: Elsbeth. (Pauli, 39.) Paula Becker-Modersohn-Haus, Bremen, inv. no. 12. (See illus. no. 24.)
"Create in me a clean heart, O God...": Psalms 51:10-11.

July 8, 1902. From Otto Modersohn's Journal
Paula's painting with the glass globes: Boy with Grazing Goat, inscribed lower right "VII. 1902/PMB." (Pauli, 82.) In the Von der Heydt-Museum, Wuppertal.

November 4, 1902. To Otto Modersohn
the first big separation in our marriage: OM was visiting his parents in Münster.
Frau B.: cannot be identified.
Laura: Laura Winkhaus, née Modersohn (1861–1946), OM's sister, married to Rudolf Winkhaus (1855–1939).

November 7, 1902. To Otto Modersohn
little Frau Vogeler with her child: fragment; the portrait of the child, Marie-Luise Vogeler, is preserved but has been finished by an unknown hand. (Pauli, 68.) Haus im Schluh, Worpswede.
Bernheimer: well-known antiques and decorating firm on Lenbachplatz in Munich.
Christel Schröder's: Christel, Gustav, and Metchen Schröder ran a first-rate business for materials, notions, etc., in Worpswede. (This information from Frau Frieda Netzel.)
His Highness Gefken: worked occasionally as a gardener in the Modersohns' garden.
Gritli: a much read children's story in several volumes by Johanna Spyri, author of *Heidi.*

December 1, 1902. Journal
looking at Mantegna: Knackfuss, vol. 27, Henry Thode, *Mantegna* (1897).
the grave monument with the eight figures carrying it: the grave of Philippe Pot, grand mar-
shal of Burgundy, died 1493. PMB made a drawing of it: S/XXI, 16 verso. (Bremen '76,
no. 275.) The Estate.
Kalckreuth... The women with the geese: Old Age, 1894. (Brachert, no. 90.) Gemäldegal-
erie [Painting Gallery], Dresden.
the old woman with the baby carriage: The Journey into Life, 1897. (Brachert, no. 95.)
Formerly in the Silesian Museum, Breslau (now Wroclaw), Poland.

December 15, 1902. To Carl Hauptmann
Mathilde: latest novel by Carl Hauptmann, 1902.

January 29, 1903. To Marie Hill
Frau D.: possibly Frau Donndorf.

February 10, 1903. [Postmarked 10.2.1903]. To Otto Modersohn
PMB set out on her trip to Paris before February 8, traveled with Otto as far as Münster,
and stayed there briefly to celebrate her mother-in-law's birthday.

February 10, 1903. To Otto Modersohn
to the Rilkes: RMR had been in Paris since August 28, 1902. CRW followed him there on
October 1, 1902. However, they lived and worked apart from each other.

February 12, 1903. To Otto Modersohn
The original of this letter is lost.
"There are voices arising in the night": no source for this quotation can be found, but it has
all the earmarks of a line from Rilke.

February 14, 1903. To Otto Modersohn
on the rue Laffitte: the Société nouvelle de peintres et de sculpteurs was having an exhibition
at the gallery of Durand-Ruel from February 14 to March 7, where they were showing their
latest works. (See Chronique, 1903, no. 7, p. 56.) The Société nouvelle was the group
around the painters Cottet, Simon, and Zuloaga.
"the artistic" in art: OM's journal entry for January 31, 1903, reads in part: "There is some-
thing that plays the greatest of all roles in art; the best term I have for it perhaps is 'the ar-
tistic' in art. It is the signature of the spirit, of the personality, of freedom, of imagination,
etc. Only when one remains silent will it appear; when one tries to say everything it disap-
pears. All conscientiousness, anxiousness, everything petty and fussy will drive it away in
an instant. A sketch is more likely to have it than any finished picture."
Anton von Werner: (1843–1915), German painter of the Wilhelminian Age. His best-known
painting is *The Imperial Proclamation at Versailles, on the 18th of January 1871.*
Decamps: Alexandre Gabriel Decamps (1803–1860), French painter and etcher. In the
Louvre: *Bulldog and Terrier, Cheveaux de halage* [*Barge Horses*], 1842. In the Luxem-
bourg: *La Caravane.*

Muther: Richard Muther, *Studien II* (1900–1), p. 119, mentions Decamps in his essay on French painting.

Millet: in the Luxembourg: *The Bathers, Spring, The Gleaners.*

a wonderful little marble sculpture of a woman by Rodin: cannot be identified.

February 15, 1903. Journal

an exhibition of old Japanese paintings: the collection of Hayashi which was being auctioned at the Hôtel Drouot.

"Rien à peu-près": "No half measures."

February 17, 1903. To Otto Modersohn

I have moved: cf. Rilke's letter to CRW of May 11, 1906: "I rented a room in the little Hotel Rue Cassette (No. 29), where we once visited Paula Becker: the room on the third floor under the one she had. It still looks out across the walls and one sees and feels the presence of the green trees of the cloister...." Two days later his letter to Clara describes the surroundings: "Over there are the trees of the cloister, and up above. Down below, an old garden wall unfortunately covered over with posters: a Nubian flashing his teeth, which is supposed to advertise shoe polish; next to him Beethoven and Berlioz; Les Artistes Indépendants in washed-out yellow; 'Bernot, fin de Saison, Rabais considerable' ['End of Season Sale at Bernot—Considerable Savings'] on black. And in blue on dark gray: the 'Palace Hotel' in Lucerne. But above it is an old rounded wall coving, vaulted, and at its outermost edge, which always dries quickly, bleached bright by the sun, and farther on in its rounding, dark gray, here and there covered with something green, very lively and full of inspiration. And even farther above, the chestnuts, great, old, which already have fully grown 'hands'; and higher, still higher, somewhat to the left, a fragment of the nave of a church, which rams its way without a mast into the sky like a wreck into the sea. And higher up and behind it and to the right and left: Paris, brilliant Paris, silken, which has faded once and for all—to its very heavens and its waters, into the very heart of its flowers—under the too brilliant sun of its kings."

"Travailler, toujours travailler": "Work, always work."

Veronese: Paolo Caliari, called Veronese (1528–1588), Venetian painter. In the Louvre: *The Wedding at Cana, Feast in the House of the Pharisees.*

Stuck: Franz von Stuck (1863–1928), German painter and sculptor.

copies of sketches by Ingres: Jean-Auguste-Dominique Ingres (1780–1867), French painter and graphic artist; classicist. The sketches are presumably those reproduced in Henry Lapauze, *Les Dessins de J. A. D. Ingres de Musée de Montauban* [*The Drawings by J. A. D. Ingres in the Museum at Montauban*] (Paris, 1901), or in his *Les Portraits Dessinés de J. A. D. Ingres* [*The Portrait Drawings of J. A. D. Ingres*] (Paris, 1903).

the Rafaelli oil crayons: Jean-François Raffaelli (1850–1924), French painter and inventor of oil color crayons which for a brief period OM favored.

February 18, 1903. To Otto Modersohn

There is a little thing here by him: in spite of its size (142 cm × 142 cm) Paula is doubtless referring to Rembrandt's *Bathsheba at Her Toilette* (2 Samuel 11:2–3), 1654. (Bauch, 31; Gerson, 271.) PMB drew a copy of the painting, S/XXII, 17. Private collection, Bremen.

Cf. also her drawing, S/XXII, 4, after Rembrandt's *Venus Caressing Amor* in the Louvre. (Bremen '76, no. 275a.) The Estate.

Holy Family: 1640. (Bauch, 71; Gersòn, 205.)

two pensive little philosophers: Scholar in a Room with a Spiral Staircase, 1633. (Bauch, 156; Gerson, 91.) There is only one scholar present; the vaguely suggested figure in the right foreground is a servant.

The Good Samaritan: Bauch (under no. 581) writes: "After the cleaning of the signature, this painting proved to be falsely ascribed. According to Falck this may well be the work of Barent Fabritius." In 1907, PMB herself painted a *Good Samaritan.* (Pauli, 183; Bremen '76, 203, color plate 30.) Paula Becker-Modersohn-Haus, Bremen, inv. no. 107.

February 23, 1903. To Otto Modersohn

Since this letter was begun on February 19 and continued four days later, it is placed ahead of the journal entry of February 20.

—*Well, the monograph has been published:* Knackfuss, vol. 64, Rainer Maria Rilke, *Worp-swede—Fritz Mackensen, Otto Modersohn, Fritz Overbeck, Hans am Ende, Heinrich Vogeler* (Bielefeld and Leipzig, 1903).

a sculpture of Björnson's daughter: Dagny Langen, née Björnson, wife of the Munich publisher Albert Langen, who was foremost in introducing Scandinavian literature to Germany. Such a work by CRW is not known.

Björnson's: Björnsterne Björnson (1832–1910), Norwegian dramatist and fiction writer.

little Tanagra figurines: painted clay figures of the fourth century B.C., so-called from the place of discovery in Boeotia, where the figurines were produced en masse. They were first found in 1873. See drawings by PMB: S/XXI, plates 24, 25, and 26, recto and verso. The Estate. Also S/XXII, plate 11: *Zwei Tanagrafiguren,* prototype unknown. (Bremen '76, no. 282.) Bremen Kunsthalle, inv. no. 66/212.

silver globe: the first one of these mentioned by OM had broken, so Paula gave a second one to him as a birthday present.

February 20, 1903. Journal

the gentle vibration of things; their roughened textures, their intricacies: this description by PMB of the way in which she hopes to be able to work and express herself has rightly been taken by a number of authorities in the field to be one of her most important self-analytical statements. The German reads: "Das sanfte Vibrieren der Dinge muss ich ausdrücken lernen. Das Krause in sich." In particular the phrase "das Krause in sich" defies exact translation. We have tried to render it with "roughened intricacy of things." The word *kraus* also carries the implication of things that are crisp, wrinkled, weathered, curly, ruffled, wavy, eroded, and worn.

life-size nude of Frau M.: Frau Meyer aus dem Rusch, 1902. (Pauli, 20.)

the Temple: the 1912 German edition of Baedeker's *Paris,* p. 198, reads: "Farther to the east in the rue Francs-Bourgeois, on the right at no. 55 is the Municipal Pawnbrokers' Building.... The next cross street is the rue Vieille du Temple," where the Marché du Temple, with its stalls for old clothes, is located.

"Mais si chère,...": "But it is very expensive, monsieur, it is old."

"Ah, mademoiselle, c'est le contraire...": "Ah, mademoiselle, it is just the opposite from us, who are expensive when we are young."

February 25, 1903. Journal
no real feeling for the antique: copies by PMB after ancient books of art: S/XXII, 8: *Two Men Fighting,* fragment of a Greek relief, prototype unknown. (Bremen '76, no. 279.) Bremen Kunsthalle, inv. no. 66/217. Also S/XXII, 9: *Warriors and Horses,* after the frieze on the Treasury of Siphnos in Delphi, after a reproduction. (Bremen '76, no. 280, illus. 63.) Bremen Kunsthalle, inv. no. 66/255.
the A. family or the N. family: cannot be identified.

February 26, 1903. To Otto Modersohn
Rodin['s]...*conversations on art:* Judith Cladel, *Auguste Rodin, pris sur la vie* (Paris: Edition de la Plume, 1903).
Duval: a string of restaurants in Paris which charged moderate prices for relatively simple meals.
Manet, the nude with the Negress: Olympia, 1863. Its title is taken from Zacharie Astruc's *La Fille des Îles.* (The painting reproduced in Rouart/Wildenstein, vol. 1, no. 69.) In 1890 it was in the Luxembourg, 1907 in the Louvre, and 1929 moved to the Jeu de Paume, Paris.
the scene on the terrace: Le Balcon, 1868–69. (Rouart/Wildenstein, vol. 1, no. 134.) In the Jeu de Paume, Paris.
Renoirs, but not as beautiful as the one we have: Paula was probably referring to a reproduction that she and Otto owned. The explanatory addition of "in Bremen" in the 1920 Edition is incorrect if it is taken to mean one of the Renoirs in the Bremen Kunsthalle, for they were not acquired until after 1903.
Zoloaga [sic]: Ignacio Zuloaga (1870–1945), Spanish painter. PMB, not surprisingly, always writes Zoloaga. From this point on the error is corrected in the text.
our Rousseau landscape: a reproduction, probably of *Sortie de forêts à Fontainebleau, Soleil couchant;* painted on commission from the State in 1848. Now in the Louvre.

March 2, 1903. To Otto Modersohn
Boucher: Alfred Boucher (1850–1934), French sculptor.
Injalbert: Jean Antoine Injalbert (1845–1933), French sculptor.
"femme d'un peintre très distingué": "the wife of a very distinguished painter."
"La travaille [sic], *c'est mon bonheur":* "Work, that is my happiness."

March 3, 1903. To Otto Modersohn
"Yea, yea" or "Nay, nay.": Paula is alluding to the Sermon on the Mount (Matthew 5:37): "But let your communication be, Yea, yea; Nay, nay: for whatsoever is more than these cometh of evil." In other words Rilke does not know how to speak plainly or directly.
I save my praise for Muther: PMB refers here to Muther's passage in his *Studien und Kritiken* [*Studies and Critiques*], vol. 2, *Worpswede,* pp. 280ff.
Ellen Key: (1849–1926), Swedish philanthropist and writer. Her best-known book was *The Century of the Child,* translated into German in 1902.
Why don't they leave old Fitger in peace: PMB seems here to be defending the man who had written such a devastating criticism of her show in 1899. The group around Director Pauli at the Bremen Kunsthalle was highly critical of Fitger, who in turn hated Pauli and all the modern art which Pauli and his circle were steadfastly defending.

March 6, 1903. To Martha Vogeler
This and the following letters to Heinrich and Martha Vogeler were first published in Konrad Tegtmeyer, *Paula Modersohn-Becker* (Bremen: Angelsachsen Verlag, n.d. [1927?]). The originals are in the Worpswede Archives.

March 6, 1903. To Wilhelm and Luise Modersohn
I do a lot of drawing there: cf. the grouping of the study drawings done during PMB's various stays in Paris. (Bremen '76, nos. 275–85.) After 1900 both in Berlin and in Paris she was particularly interested in Egyptian sculpture.

March 7, 1903. To Otto Modersohn
your "armor": a dark brown "Manchester" suit which OM wore while taking walks and going on hikes. Made of a very heavy corduroy, this material was imported from and named after the city in England.

March 9, 1903. To Martha Hauptmann
that little message: PMB writes "das kleine Wörtlein," which literally means "the little little word."
German [woman] painter: see note to letter to Marie Hill of February 27, 1902.

March 10, 1903. To Otto Modersohn
Blanche: Jacques-Emile Blanche (1861–1942), French portrait painter, graphic artist, writer on art, and novelist.
Rilke has lent me a beautiful book: in a note on a calling card from Rilke of March 8, he recommends that she read in Hugo's *Notre Dame de Paris,* above all the chapter "Notre Dame" in book 3, and also in chapter 2 of the same book, "Bird's Eye View of Paris"; further, in book 4 the third chapter; and finally the second chapter of book 5. In addition, he sent her a volume of poems by Francis Jammes, remarking particularly on the poem "Jean de Noarrieu." Rilke goes on: "There will soon follow a beautiful book by Georges Rodenbach in which you will find excellent essays on Rodin, Monet, Carrière. And don't forget to buy the March issue of the *Plume* with the continuation of the Cladel-Rodin Essay." Victor Hugo (1802–1885), French Romantic author. His long novel *Notre Dame de Paris* appeared in 1831. Francis Jammes (1868–1938), French poet. It cannot be determined which edition Rilke sent to PMB. The poem "Jean de Noarrieu" is a cycle of seven "Fragments" (1901); see the Jammes anthology *Choix de poèmes* (Paris: Mercure de France, 1946), pt. 3, pp. 141–53. The Georges Rodenbach book: *L'Elite* (Paris: Bibliothèque Charpentier, 1899). Cladel-Rodin Essay, see note to letter of February 26, 1903, to OM.

March 12, 1903. To Otto Modersohn
David: Jacques-Louis David (1748–1825), French painter and founder of French classicism.
Delacroix: Ferdinand Victor Eugène Delacroix (1798–1863), French painter.
Ingres: PMB made a copy of his *Mademoiselle Rivière,* 1805, S/XXI, 22. The Estate.
Chardin: Jean-Baptiste-Siméon Chardin (1699–1779), French painter of still lifes and genre scenes. Cf. Rilke in letter to CRW, October 8, 1907: "…(One could imagine writing a monograph on the color blue; from the thick, waxy blue of Pompeian wall paintings, to

Chardin, and down to Cézanne: what a history that would be!), Cézanne's own very special blue has this genesis; it comes from the blue of the eighteenth century; Chardin removed its pretensions, and with Cézanne it no longer has any extraneous meanings. In all of this, Chardin was the agent; his fruits no longer think of having a place on a beautiful table, they lie about on kitchen tables and no longer care about being consumed in an elegant way. With Cézanne their edibility comes to an end altogether, so objective and real have they become, so indestructible in their obstinate presence...."

Dreyer's stable and barn: the farmyard next to the Modersohns' house in Worpswede.

Goya's etchings: copy, S/XXII, 5, by PMB after no. 45 of the *Desastres de la Guerra.* (Delteil, no. 164.) Bremen Kunsthalle, inv. no. 47/86.

In the Louvre there are three paintings by him: Lady in Black, Portrait of the Marquesa de la Solane, 1794–95. (Gassier-Wilson, no. 341.) PMB's copy, S/XXI, 18 verso. The Estate. *A Lady,* three-quarter portrait; also known as *Young Woman with Fan,* possibly portrait of Manuela Goicoechea, 1805–10. (Gassier-Wilson, no. 890.) PMB's copy S/XXI, 19 recto. The Estate. *Gentleman in Uniform,* portrait of Ferdinand Guillemardet, French ambassador to Madrid, 1798. (Gassier-Wilson, no. 677.)

§ From March 12–26, 1903, Durand-Ruel had an exhibition of paintings, pastels, and drawings by Odilon Redon which PMB perhaps saw before her departure. (See Gordon, p. 64.)

March 17, 1903. To Otto Modersohn
I love you, as you do me: "Ich liebe dich, so wie du mich," from "Zärtliche Liebe" ["Tender Love"], text by Karl Friedrich Herrosee, set to music by Ludwig van Beethoven. On March 20, 1903, PMB was back in Worpswede.

[Postmarked Münster, July 30, 1903. Written "29 Julius 1903"] "Open letter to the Family." The envelope is addressed "To the Most Noble and Esteemed, Eminent, and Virtuous Frau Mathilde Becker, née von Bültzingslöwin and her Kinfolk at Bremen, Wachtstrasse 43." Paula did not misspell her mother's maiden name. The use of the second *i* instead of an *e,* or the feminine form, is a German word play which makes her mother a lioness rather than a lion. The full letter is illustrated on pp. 319–322.
Oh, freedom that I love: from a familiar German song, "O Freiheit die ich meine," text by Max von Schenkendorf, 1813; music by Karl Groos, 1815.

August 11, 1903. To Otto Modersohn
Kück's coach: Dierk Kück, a Worpswede peasant, had taken over the coach service between the village and Bremen.

August 14, 1903. To Otto Modersohn
"And they sat by the waters of the brook...": here Paula is paraphrasing very loosely the familiar line from Psalms 137:1: "By the rivers of Babylon, there we sat down, yea, we wept, when we remembered Zion."
Else: probably the servant girl.
the poems of Wenzelau: no reference can be found to such a poet.
met "Black" Garmann: Friedel Garmann, owner of an old Worpswede store which dealt in dry goods and groceries. It stood opposite what today is the Worpswede Kunsthalle. He

also ran a small restaurant for "the better people." He was a devout Catholic (therefore "black") and as a consequence was a considerable rarity in the village. (Information from Frau Frieda Netzel.)

November 30, 1903. To Milly Becker
After her first engagement was broken, Milly left Bremen.
a trip to Münster: according to OM's travel journal, November 11–18, they took a side trip to Wolbeck and bought things for their house from the antiques dealers Grothus and Settken.
[OM's] *little sketches and compositions:* today in the Otto Modersohn Estate Museum in Fischerhude. (See Otto Modersohn Catalog [Worpswede-Fischerhude, 1977], esp. "Meine Kompositionen" ["My Compositions"], pp. 43ff.)

December 30, 1903. To Carl Hauptmann
your Harfe: Des Königs Harfe [*The King's Harp*], title of Carl Hauptmann's latest play, 1903.
Oh, you wonderful insect life: a reference to the book given to Elsbeth by the Hauptmanns, whose author and illustrator was August Johann Rösel von Rosenhof (1705–1759), from Augustenberg bei Arnstadt: zoologist, illustrator, painter of miniatures, and engraver. His five-volume work, *Insektenbelustigungen* [*An Entertaining Guide to Insects*], was published between 1746 and 1760. He also wrote *Die Lebensgeschichten einheimischer Insekten und verschiedener Süsswassertiere* [*The Lives of Indigenous Insects and Various Fresh Water Fauna*]. He illustrated his own writings in masterly fashion.
Hansel and Gretel were there: cf. the print by Vogeler, copy in the Haus im Schluh, Worpswede, depicting the two children in the foreground and the witch approaching from the rear.

January 18, 1904. To Milly Becker
revising his "Ideals": OM was accustomed to think through, and then to write down, observations about his personal relationship to nature and art, form and color, art and its personalities. These volumes, bound in colored paper, are in part still in private hands. For the most part, however, the notes he took about his "Ideals" were made part of his journals.
George Sand's: nom de plume of Aurore, Baronne Dudevant (1804–1876), author of novels dealing often with themes of social criticism and women's emancipation. Her *Lettres d'un voyageur* appeared in 1837–38.

February 6, 1904. To Luise Modersohn
all the Bohlwegers: Bohlwege was the name of the home of PMB's sister-in-law Laura Winkhaus; therefore "the Bohlwegers" refers to all the members of this household.

March 2, 1904. To Milly Becker
a little art trip: this did not take place until July, according to OM's travel journal.
about our Henner: their brother Henner was, at the time, on his second training cruise with the merchant marine.
the two boys: Milly was engaged as a governess with a family who were friends of the Beckers.

April 15, 1904. To Otto Modersohn
OM was with his parents in Münster.
our old "Empress" from the Klinkerberg: between Hüttenbusch and Heudorf, several kilometers from Worpswede in the moor, was the settlement of Fünfhausen. Because of the nearby dump, it was known in Worpswede as "Klinkerberg" ["Dump Town"]. A number of very poor people lived there, in part those who, because of relatively insignificant "crimes," had been sent to jail. After they got out they were no longer acceptable in town and had to go "into the moor"; here they lived by making brushes and brooms, or by begging. Among these people was the family of Kaiser with their many children. *Kaiser* = emperor; *Kaiserin* = empress. (Information from Frau Frieda Netzel.)
Villa Mackensen: built around 1900 on the Susenbarg, the western slope of the Weyerberg.
papers from the Berlin Secession: having to do with the exhibition of the Berlin Secession. OM was a member.

April 15, 1904. To Milly Becker
Goethe's Correspondence with a Child: *Goethes Briefwechsel mit einem Kinde,* by Bettina von Arnim (1785–1859). The book appeared in 1835 and enjoyed great popularity; its extreme sentimentality is hardly to today's taste.
Bierkaltschale: a chilled dessert made of beer and fruit syrup which has been slightly thickened with cornstarch.
Hildebrand's atelier: Adolf von Hildebrand (1847–1921), German Neo-Classic sculptor; designer among many other monuments and buildings of the Wittelsbach Fountain in Munich and the Bismarck Memorial in Bremen.
your connection with Römer: Georg Eduard Römer (1868–1922), German sculptor and maker of medallions.

April 30, 1904. To Marie Hill
Paula's Aunt Marie, now widowed and evidently living in reduced financial circumstances, ran a *pension* in Stuttgart primarily for young foreign women whom she instructed in German language and literature and with whom she traveled.
dancing à la Duncan: Isadora Duncan (1878–1927), the famous American dancer, developed her so-called "expressive dance" style in opposition to classical ballet. She strove toward a total development of body, soul, and spirit. She was generally considered to be a warrior in the battles of liberation of the period against traditional narrowness and conformity. Paula, along with many other members of her family, both on the Becker and Bültzingslöwen sides, was an enthusiastic adherent of Duncan's thinking.

From Otto Modersohn's Travel Journal. [1904]
Berkelmann's: an inn in Fischerhude.
Sächsische Schweiz: literally, "Saxonian Switzerland," a picturesque and mountainous area of Saxony in southeastern Germany, now in East Germany.
Paula's grandmother: Bianca von Becker, née von Douallier, was the third wife of PMB's paternal grandfather. Paula's father was a child of the first marriage.

December 24, 1904. To Herma Becker
that pastor's family of yours: in order to perfect her French, Herma took au pair positions
with French families.
Frau Overbeck: she was often in ill health.
Rilke's back in the country again: shortly before Christmas RMR came from Sweden to
Worpswede to visit his wife and child, and after the holidays stayed on for some time with
them in Clara's parents home in Oberneuland near Bremen.
a goldfish bowl: this appears in the *Still Life with Goldfish Bowl,* inscribed lower left
"P.M.-B.," probably 1906–7. (Pauli, 207.) In the Von der Heydt-Museum, Wuppertal. See
also *Naked Child with Goldfish Bowl,* 1906–7. (Pauli, 23.) In the Bayrische Staatsge-
mäldesammlung [Bavarian State Painting Collection], Munich.
from Hauptmann: Carl Hauptmann.

January 2, 1905. To Herma Becker
a skating tour to Amsterdam: PMB means this literally. In cold winters the entire canal sys-
tem in the lowlands of Germany and the Netherlands would freeze, making it possible to
undertake very extensive skating tours.
your Rohland Foundation: this foundation was established by the merchant Julius Georg
Bernhard Rohland (1826–1882). He designated the city of Bremen as principal heir to his
fortune with the provision that most of the income be used for the beautification of the
city. The administrators of the foundation had a free hand in how this was to be done. It
is possible that the linguistically gifted Herma Becker occasionally received small grants
from this generous source.
Milly's engagement: her sister Milly had become engaged to the merchant Hans Rohland
who, however, did not belong to the family of Julius Rohland (see above note).

January 3, 1905. To Martha and Carl Hauptmann
King of Italy with His Consort: one of the "remarkable, comic pictures" to which PMB refers
in her letter of December 24, 1904, to Herma.
her magic yarn ball: a customary present to a young girl which serves as both a continuing
source of surprises and an incentive to creativity, for as the child learns how to knit and
uses up the yarn, the surprises, which are attached at various points inside the ball, come
tumbling out.

January 29, 1905. To Clara Rilke-Westhoff
Here is the Brandes book: the reference is perhaps to the letters of Jens Peter Jacobsen, edited
by Eduard Brandes, which Rilke mentions in a letter to CRW of October 8, 1904.
the Bojers' address: Johann Bojer and his wife Ellen, who were living in Paris at the time. Jo-
hann Bojer (1872–1959) was a Norwegian writer.

February 9, 1905. To Herma Becker
Otto's brother Willy: Prof. Dr. Willy Modersohn (1859–1935), LL.D., chief justice of a
higher district court, and his wife Elisabeth, née Lautz (1863–1953).

Introduction

captured in drawings: in Sketchbooks XV and XIX. (Hamburg '76, cat. nos. 171–87; those illustrated: 174, 175, 185, 176, 180, 178, 177, 181, 187; Bremen '76, nos. 313–18, and illus. no. 72.) Bremen Kunsthalle, inv. nos. 51–147.

Gauguin: Paul Gauguin (1848–1903), greatest of the masters of the painting school of Pont Aven.

the great Gauguin collection of Fayet: Gustave Fayet, conservator of the museum in Béziers in the south of France. The collection contains twenty canvases, several watercolors, over twenty drawings, and wood and ceramic sculpture. It is not possible to determine where in Paris Paula and Otto saw this collection, for it was not until 1906 that the Collection Fayet became available to the public in Paris in connection with the great Gauguin Retrospective at the Salon d'Automne.

Otto's travel journal was put together after the event and made up from jottings and notes from other sources. Still this short note ("We saw the Gauguins at Fayet's; and Buffalo Bill. The time [in Paris] was not pleasant," from Otto Modersohn's travel journal, March 29 to April 7, 1905) has the ring of authenticity.

And on Paula's return to Worpswede in 1905 she showed great interest in Gauguin literature and commissioned Herma to buy her periodicals with articles on Gauguin. In a letter from OM to Gustav Pauli of June 19, 1919, we read: "I should first of all like to remark that Gauguin was someone very close to Paula. The Memorial Exhibition of the Salon d'Automne in 1906 was particularly important in fostering her familiarity with him, and this was also strengthened through our visits to the Collection Fayet." As the Collection Fayet was exhibited as part of the Retrospective at the Salon d'Automne there was no need for Otto to distinguish between the two unless Paula had seen the Collection Fayet at another time.

Artistes Indépendants: those represented in the important exhibitions of this group were: Bernard, Bonnard, Camoin, Delaunay, Denis, Derain, Vlaminck, Dufy, Guérin, K. Kollwitz, Matisse (represented among others with his famous *Luxe, Calme et Volupté),* Munch, Puy, Rouault, Rousseau, K. X. Roussel, Seguin, Sérusier, Signac, Vuillard — most of them with eight pictures apiece. There were also retrospectives of the work of Seurat (forty-four works), and of van Gogh (forty-five paintings; see Gordon, p. 123). In other words, PMB doubtless saw in 1905 significant work by Henri Matisse and his circle which caused such excitement at the Salon d'Automne and for which the critic Louis Vauxcelles invented at the time the phrase "Les Fauves," or "The Wild Animals."

Osthaus's: Karl Ernst Osthaus (1874–1921), merchant, art historian, and collector, was the founder of the Folkwang Museum in Hagen, his own private collection of modern art which later formed the nucleus of the Folkwang Museum in Essen. He was also cofounder of the Deutscher Werkbund (an organization of artisans and craftsmen). At the instigation of Curt Stoermer and Heinrich Vogeler, Osthaus was one of the first to mount a large exhibition of the works of PMB in his Museum Folkwang in February 1913. At the time he also acquired her *Self-Portrait with Camellia Branch.* (See illus. no. 28.) Subsequent to this purchase he began a correspondence with Frau Mathilde Becker, Paula's mother, who wished to interest him in being the editor of her daughter's letters and journals. In one of the letters Osthaus writes: "The self-portrait of your daughter with the camellia branch is something I bought for the Folkwang Collection. I find a great similarity in it with the way

she appeared. And remarkably enough it has exactly the impression of her which has always remained in my memory. I would never have recognized her from the other self-portraits." (From Herta Hesse-Frielinghaus, "Paula Modersohn-Becker im Folkwang-Museum Hagen," *Westfalen,* vol. 55, nos. 1–2 [1977], pp. 181ff.) August von der Heydt (1851–1929) took over this exhibition from Osthaus, and as a major collector himself, showed it to the public in his house on Kerstenplatz in Wuppertal. As a consequence of this exhibition von der Heydt began to buy PMB's paintings. By 1918 he had accumulated one of the largest collections of her work, twenty-eight paintings.

beckoning call to the great world: CRW wrote: "[...] perhaps I might also describe another winter afternoon when the two of us were sitting by her stove in her little studio. Paula was throwing one piece of peat after the other through the little squeaky door and into the fire; and one tear after the other rolled down her cheeks as she tried to explain to me how very important it was for her to get back into 'the world,' back to Paris. 'That's what I mean when I think: the world.'" (Hetsch, p. 49.)

and he said things about them which did her good: RMR was able at this time to express his understanding and appreciation of Paula as an artist to others. On January 16, 1906, he wrote from Meudon to his friend the banker, writer, and collector Karl von der Heydt (1858–1922): "Worpswede was still a place far removed from everything. [...] The most remarkable thing was to see Modersohn's wife in the midst of a very important stage of the development of her art; I found her painting relentlessly, as though driven; the things and objects of Worpswede and yet which nobody else had seen or could paint in that way. And they were, in their own very individual way, strangely close to van Gogh and the direction which his painting took."

[RMR and CRW] *buying one of her paintings: Infant with Its Mother's Hand,* ca. 1903. The painting is a fragment and was trimmed by PMB herself. (Pauli, 128; Bremen '76, no. 96, illus. 29.) Bremen Kunsthalle, inv. no. 692–1955/12. This painting was one of the three or possibly four works by PMB that were bought during her lifetime.

Werner Sombart: (1863–1941), economist and sociologist. PMB's small portrait is considered today to be one of her most important and revolutionary paintings. (Pauli, 84b.) Bremen Kunsthalle, inv. no. 625–1953/16. (See illus. no. 34.)

Must not all of us: in the letter from Maidli Stilling-Parizot to Herma Becker of November 23, 1906. The loss of PMB's letters to Maidli Stilling-Parizot in World War II is all the more tragic since, according to her son Eric Stilling, the human warmth and friendship of the two women was much more thoroughly expressed in Paula's letters than was indicated in the early editions of these documents. It is most regrettable that the original editor made no use of this material which was at her disposal. Maidli Stilling was killed in the bombing of Dresden in February 1945. Her house in the suburb of Pillnitz and all her letters from PMB were destroyed.

Bernhard Hoetger: (1876–1949), sculptor and painter. The work PMB saw was being exhibited at the Salon des Artistes Indépendants and is illustrated in Chronique, 1906, no. 12.

In his cursory notes about his first meeting: these consist of (1) the brief text that he contributed to the little memorial volume on PMB edited by Uphoff, and (2) a section of his unpublished memoirs written down in Switzerland in 1932 in which he speaks about his first encounters with Paula. (Wilhelm Teichmann, Hoetger's executor, granted the editors permission to inspect these memoirs.)

Hoetger's wife: Helene (Lee) Hoetger, née Haken (1880–1967).

the portraits... of Rilke: this small canvas is in the Paula Becker-Modersohn-Haus in Bremen, inv. no. 34. Petzet (p. 111) has proposed a convincing argument for the time that this portrait was executed. On May 13, 1906, Rilke had left Rodin and Meudon and consequently had the time to sit for this portrait which had clearly been planned long in advance. OM was in Paris at Whitsuntide (June 3) and therefore the sittings were interrupted and, as is proved by a card from Rilke of June 17, never resumed. It is almost certain that Rilke's famous poem "Self-Portrait" (1906) has a direct connection with this painting. (See illus. no. 33.)

he often invited her: on April 2, 1906, RMR writes to CRW: "Saturday, March 31, I spent three hours with PB; breakfasted with her at Jouven's [restaurant on the boulevard Montparnasse] and then took a walk with her. She is courageous and young, and it seems to me on a good and ascending path, alone as she is and without any help!" Materially she was not "without any help," since OM sent her money every month.

to Chantilly: a castle north of Paris, once in the possession of the Condé family, filled with art treasures and surrounded by a vast park.

Aristide Maillol: (1861–1944), French sculptor and graphic artist, acquainted with the Nabis. PMB had already familiarized herself the previous spring with some of his works and had seen works by him in the Folkwang Museum in Hagen. She loved his art. (Letter to her sister Herma of November 8, 1905.)

the wife of George Bernard Shaw: Charlotte Payne-Townshend (ca. 1857–1943) married in 1898 to GBS (1856–1950). They were in Paris at the time because GBS was sitting for the bust Rodin was making of him.

Still Life with Apples: probably the *Still Life with Apples and Bananas,* signed lower right "P.M.-B.," ca. 1905. (Pauli, 193.) Bremen Kunsthalle, inv. no. 49–1908/22. (See illus. no. 27.)

Still Life with the Bambino: *Still Life with the della Robbia Putto,* ca. 1903. (Pauli, 206; Bremen '76, no. 106.) Private collection.

The Sleeping Child: ca. 1904. (Pauli, 64; Bremen '76, no. 125.) Private collection.

Head of a Girl with Black Hat: *Head of a Blond Girl with Straw Hat,* ca. 1905. (Pauli, 123; Bremen '76, no. 151, illus. 30.) In the Kunst-und Museumsverein [Art and Museum Society], Wuppertal.

Pellerin Collection: Auguste Pellerin owned a great Manet collection, which he sold when he recognized that Cézanne was an even more important painter. According to Venturi he owned forty-eight paintings by Cézanne.

the great exhibition of Cézanne's paintings: in the Salon d'Automne from October 1–21, 1907.

February 15, 1905. To Otto Modersohn
the postcards translate as follows: [first postcard]: "In Aachen / I am very happy / From Herbesthal [I send] / Kisses without number / From Verviers / Another kiss / From Liège to Namur / I think of the menagerie of aunts / At Charleroy / I think of Grandmama / To Paris / I look forward as never before. I am yours / Your little Parisian / With her round hat. She's going to see the world / With her gray hat / And carefree."
[Second postcard]: "D[ear] O[tto]. I'm in Paris. Finally. But I have not yet seen our little Herma despite my telegram, and I don't have my pretty little room on the rue Cassette, the

one with the view of the garden. Tomorrow we shall see about that. Now I think that I shall take a good nap. A thousand [kisses] for the three of you. Your Paula."

je pense de faire un bon someil: play on the famous line from Schiller's *Wallensteins Tod* [*The Death of Wallenstein*], act 5, scene 5: "Ich denke einen langen Schlaf zu tun" ["I think I shall take a long sleep now"].

February 16, 1905. To Otto Modersohn
portrait by Roll: Alfred Philippe Roll (1846–1919), French painter and sculptor.
Meier-Gräfe is right: the art critic and historian Julius Meier-Graefe (1867–1935) was one of the first who appreciated the high importance of Impressionist painting. What he sternly rejected was the officially recognized art of France, the art that was honored with prizes and medals and that decorated the walls of the Musée de Luxembourg.

February 19, 1905. To Otto Modersohn
terribly many of those loud Englishwomen: we can sense here evidently PMB's negative recollections of her stay in England when a very self-conscious and self-assured society demanded that she accommodate her behavior to their quite foreign ways. And there is also a touch of contrariness toward her aunt Cora for whom everything English became her model, ever since Aunt Cora's youth in the Far East colonies.
qui t'aime avec tout son coeur: who loves you with all her heart.
the address of the Munsees from Heudorf: PMB was probably once again looking for a housemaid to hire.

February 23, 1905. To Otto Modersohn
the family: PMB means with this phrase the "Worpswede Family," and in this particular case the Vogelers.
petit chapeau gris: my little gray hat.
a still life... oranges and lemons: presumably the *Still Life with Oranges, Lemons, and Water Glass.* (Pauli, 234, C. G. Heise, *Die Sammlung des Freiherrn August von der Heydt* [*The Collection of Baron August von der Heydt*] [Elberfeld and Leipzig, 1918], no. 179, plate III.) Private collection.
cabaret-style letter: the German word "Überbrettlbrief" means a letter written in the style of the intellectual cabaret, popular in the large cities of Germany at that time.

February 28, 1905. To Otto Modersohn
Hernani: 1830. It was with this play that Victor Hugo broke with the fundamental rules of classic French theater and first worked in a Romantic vein.
Mathilde Dörstling: cousin of PMB's father.
the Becker factory in Chemnitz: according to family tradition, this was a textile weaving factory. Chemnitz is today Karl-Marx-Stadt in East Germany.
his brother: Woldemar Becker's brother, Oskar Becker (1839–1868), had a brief and notorious career. On July 14, 1861, as a student, he attempted to assassinate King Wilhelm I of Prussia on the Lichtentaler Allee in Baden-Baden, but wounded him only slightly. He explained this act, which took place on the anniversary of Bastille Day, with his conviction that "His Majesty" stood in the way of the unification of Germany. He was condemned to

twenty years in prison, but was granted pardon by King Wilhelm I in 1866 on the condition that he leave Germany. He went to the United States but remained only a short time, after which he went to Egypt where, according to the family story, he died of some unknown illness.

Cottet now has a great exhibition of studies: Exposition des Orientalistes in the Grand Palais.

he wants to paint Elsbeth: according to Frau Elsbeth Modersohn, she never sat for a portrait by Mackensen.

March 6, 1905. To Otto Modersohn

a vaudeville performance: Despite PMB's warning not to read this letter to the family, OM did circulate it, whereupon Paula received an outraged letter from her brother Kurt, accusing her of corrupting the morals of their sister Herma.

dessous: women's undergarments.

your Worpswede Festival Day: this was OM's color reproduction in the magazine *Jugend,* no. 5 (February 1905), p. 87. This print was reproduced again in the Otto Modersohn exhibition catalog (1977), no. 92, p. 122.

At the Académie Colarossi: this little story about Rilke having scribbled a graffito on the wall is a fabrication by Paula with which she intended to amuse her husband.

Have you seen the Rilkes at all: from March until the second half of April 1905, the Rilkes were on holiday and staying at the Weisser Hirsch near Dresden. RMR dates one letter from Worpswede where, however, he stayed only a very short time while CRW moved into a new studio in the village at Bergstrasse 16.

March 10, 1905. To Otto Modersohn

grief has entered your life: Otto's mother died on March 8, 1905. Paula's mother wrote her that it was Otto's wish that Paula not interrupt her stay in Paris to come to Münster for the funeral.

the very most modern artists: PMB is referring here to the thirty-four works by Picasso which were on exhibition in the Galerie Serrurier from February 25 to March 6; among them was the series of the *Saltimbanques,* which were to have a profound influence on Rilke's poetry. (See his *Duino Elegies.* Gordon, p. 119.)

I plan to look up Vuillard and Denis: Edouard Vuillard (1868–1940), French painter and graphic artist, member of the Nabis, and Maurice Denis (1870–1943), French painter, likewise one of the Nabis. In the 1920 Edition this bit of information was erroneously tacked on to the letter of February 28. According to Herma Becker's letter to her mother of March 31, 1905, the visit with Denis took place on March 25: "I must quickly tell you about last Saturday; it was wonderful spring weather and we went out to St. Germain-en-Laye. [...] And there we paid a visit to a painter, Maurice Denis, who has his little house out there with its vineyard and atelier with a beautiful view of the hills. He was a charming man with dreamy eyes like Heinrich Vogeler's. He seems to be a devout Catholic and paints many pictures from the Scriptures with great simplicity and warmth. And then we went to a little church in Le Vésinet in which he has completely decorated the chapel [Chapelle du Collège de Sainte Croix, 1889]—simply beautiful."

Bonnard: Pierre Bonnard, French painter and graphic artist (1867–1947), another of the Nabis.

I saw two things of his: presumably at the Première Exposition des Intimistes at the Galerie

Henry Graves from February 10–25, 1905. There were two Bonnards, an interior by Matisse, and four Vuillards. (Gordon, p. 115.)

March 14, 1905. Journal
The date can be established from OM's letter of March 13 in which he writes that he would put Paula's flowers in his mother's hands at her burial. In the 1920 Edition, on p. 404, this passage is added without reason to one of Paula's observations about art.

March 15, 1905. To Otto Modersohn
an exhibition opens at Georges Petit's: Exposition de la Société Nouvelle. (Chronique, 1905, no. 12, p. 91.)
famous wallet: this reference is vague. PMB is probably referring to an address book which was "famous" for always being left at home.
our two Bulgarians: it has been impossible to establish the identity of the sculptor; the law student was Christof Kaneff (letter from Herma of December 1905).
the oldest professors: cf. Julius Meier-Graefe: "The enormous difference between the atmosphere of the French and the German painting academies finds its explanation here. The Frenchman enters an apprenticeship; he learns how to draw, and it is always the good old classically trained teachers who take care of the instruction: they have never had anything to do with the real development of painting; indeed, they are not even artists, merely teachers, but as such and in spite of their tough ways, they are excellent." ("Beiträge zu einer modernen Aesthetik," *Die Insel,* vol. 1, no. 5 [February 1900], p. 216.)
Folies Bergère: a theater for revues in Montmartre near the rue Bergère.
Wintergarten: a variety theater in Berlin.
fromages doux: sweet cheeses.
mon coucou: my cuckoo.
sunbaths... in Fischerhude again: see excerpt from OM's travel journal July 2–5, 1904. Sun- and air bathing were hardly everyday activities in Germany at this time. As a consequence Paula and Otto found it necessary to conceal themselves modestly while engaging in this healthful activity.
Je suis à toi de tout mon coeur: I am yours with all my heart.
Ta petite femme aimante: Your little loving wife.

March 18, 1905. To Otto Modersohn
Heymel and his wife: Marguerite (called Gitta) von Heymel, née von Kühlmann (1878–1951).
Sparkuhle: Philipp Sparkuhle (1860–1930), Bremen merchant and collector.
Wiegand: Willy Wiegand, LL.D. (1884–1961), printer, typographer, publisher. Together with Lutz Wolde, he was the founder of the *Bremer Presse.*
they will hardly be taking the good things back home with them: PMB was quite mistaken in this, for the group, particularly Heymel and Wiegand, were art connoisseurs.
little influenced by European manners: humorous allusion to Johann Gottfried Seume's poem "Der Wilde" ["The Wild Man"], which begins: "A Canadian still unfamiliar with Europe's rouged politeness...."
newly certified doctor: PMB's brother Kurt.
the "Poet": probably a humorous reference to the local barber.

La Duse: Eleonora Duse (1859–1924), Italian actress, universally considered one of the greatest theater heroines of modern times.

March 20, 1905. To Otto Modersohn
news of the thousand marks: OM had informed his wife about the sale of several of his paintings with a drawing on a postcard: a little forest from which a few church towers rise and entitled "Paris." Beneath that a little train puffing smoke, the whole surrounded by big and little bags of money from which coins and bills are spilling. (Cf. PMB's postcard celebrating OM's sale of another painting in Dresden, May 30, 1901. See illus. p. 261.)
Ernst and Gertrud: Ernst and Gertrud Modersohn, PMB's brother- and sister-in-law.
Manet's Lola de Valence: 1862. (Rouart/Wildenstein, no. 53.) This famous painting passed through a number of private collections, was acquired by the Louvre in 1908, and is today in the Jeu de Paume, Paris.
So you want to paint me in the nude: OM did so, and according to Heinrich Vogeler (*Erinnerungen* [*Memoirs*], pp. 116f.) it caused an altercation with Mackensen and Hans am Ende, who asserted that his doing so was an insult to the artists' colony.
little figures by Maillol: probably at Vollard's gallery.

March 22, 1905. To Kurt Becker
Postcard: addressed to M. Le docteur de sa Majesté le Roi Rother [To Monsieur the doctor of His Majesty King Red]. The text reads in French: "The two Parisians issue you an invitation." (See illus. p. 364.)

March 22, 1905. To Otto Modersohn
Salon des Indépendants: in connection with PMB's judgment, cf. Meier-Graefe's "...the Indépendants among whom sheer anarchy never ceases to reign..."
van Gogh: Vincent van Gogh (1853–1890), most famous of all modern Dutch painters.
Seurat: Georges Seurat (1859–1891), French painter and leading *pointilliste.*
pointillisme: a technique in which colors are applied in dots rather than brush strokes.
Bode's Rembrandt: Wilhelm von Bode (1845–1929), art historian. From 1872 the director (later general director) of the Berlin museums. W. Bode, *Rembrandt,* 8 vols. (1897–1906), written with Cornelis Hofstede de Groot.

March 24, 1905. To Otto Modersohn
the brown hat: the deletion contains only more details about how "to freshen it up."
I am yours, you are mine...: see note to letter of September 12, 1900.

From March 29–April 7. From Otto Modersohn's Travel Journal
Buffalo Bill: William Frederick Cody (1846–1917) organized his "Wild West Show" in 1883 and toured with it for many years in America and Europe.

April 11, 1905. To her mother
green stenciled borders: the German word that Paula uses is *Christelbänder,* an unusual term, probably local, which refers to a stencil or pattern used by painters for the application of designs on an interior wall, usually as a false molding. Here PMB uses the stencil to mean the design itself.

April 21, 1905. To Herma Becker

Bergedorf: small settlement near Worpswede.

("Once upon a time there was a tomcat"): the German reads "Es war einmal ein Kater," in imitation of a standard opening line of a fairy tale. The untranslatable component, however, is the word *Kater,* which is not simply a Puss in Boots, but also the standard German term for a hangover, resulting either from too much alcohol or too much emotional confusion—in this case, the latter.

on the impériale: the top of a double-decker bus.

the iron band...broke in two: allusion to the Grimms' fairy tale, "The Frog King or Iron Henry."

the Overbecks: Overbeck had bought a house in Bröcken near Vegesack, primarily because of the ill health of his wife for whom the weather in Worpswede was harmful.

Heilbuth: Emil Heilbut (1861–1921), painter and art historian; he was editor for the first three years of the journal *Kunst und Künstler [Art and Artist],* founded in 1902.

Köster: there were two brothers of this name who painted in Worpswede on occasion, Heinrich (1883–1909) and Eduard (1885–1910).

Scholkmann: Wilhelm Scholkmann (1867–1944), a painter who spent a great deal of time in Worpswede from 1900 until his death.

Fräulein Rhone: Maria Rohne (1881–1961), painter and second wife of Carl Hauptmann. At this time she had PMB's former studio at the home of the postman Garves.

Meyer: Emmy Meyer (1866–1940), landscape painter, pupil of Otto Modersohn. Her studio was at Bergstrasse 16, where CRW occasionally stayed.

Beta Schröder: Martha Schröder Vogeler's mother, widow of a local teacher (ca. 1842–1917).

the Russian girl: presumably the one mentioned in the letter of February 23, 1905.

our swarthy Bulgarians: refers to the two young men with whom the sisters flirted.

the Hoffmann girls: two young women whom Herma (who was their own age) was employed to accompany on their walks as a chaperone.

Salon: Salon des Indépendants.

Noa-Noa: Paul Gauguin and Charles Morice, *Noa-Noa,* 1891–1893 (Paris: Edition La Plume, 1900).

The biography of Gauguin, by Ch. Morice: Charles Morice, "Paul Gauguin," *Mercure de France,* October 1903.

Study about Gauguin...: according to the Bibliothèque Nationale in Paris, the *Revue Encyclopédique* for the years 1901–5 bore the title *Revue universelle: Recueil documentaire universel et illustré* (published under the direction of Georges Moreau). In the volume for 1904 there was no study about Gauguin, only a reference to a few of his paintings from the collection of M. Lerolle which were exhibited in the Salon d'Automne in 1903 (no. 102 [January 15, 1904], p. 46; reviewed by Ch. Saunier). On the other hand no. 96 of this publication (October 15, 1903, pp. 535–37) contains several short illustrated essays on Gauguin on the occasion of the opening of the Salon d'Automne: H. Gastet, "Gauguin" [a thumbnail biography]; Marius and Ary Leblond, "Gauguin en Océanie"; and Charles Morice, "L'esthétique de Gauguin" (a partial reprinting of the article that had appeared in the *Mercure de France*).

L'Occident, *1903:* PMB is again mistaken; the author of the article is not Signac, but Armand Seguin, "Article sur Gauguin," *L'Occident,* vol. 3, nos. 16 (March), 17 (April), and 18

(May) 1903. This essay gives a thorough description of Gauguin's years in Pont Aven.

Article by Montfreid: "Sur Paul Gauguin," by G. Daniel de Monfreid, in *L'Ermitage: Revue Mensuelle de Litterature,* vol. 28, no. 12 (December 1903), pp. 265–83. The painter Georges Daniel de Monfreid (1856–1924) was a close friend of Gauguin and Maillol. Herma answered on May 28, 1905, that she had not been able to find the copies of *L'Occident* and *L'Ermitage;* that "the *Mercure de France* costs 2 fr., the *Revue Encyclopédique* and the *Plume* each cost 0.75 fr. As you can imagine, that is only an essay of two to three pages with just a few illustrations."

June 7, 1905. To Marie Hill

Elsbeth...has a little white rabbit: PMB painted Elsbeth with her pet: *Child with Rabbit,* oil on canvas. (Pauli, 26.) Bremen Kunsthalle.

June 14, 1905. To Carl Hauptmann

four hundred marks for someone else: despite PMB's request that Carl Hauptmann not tell OM about this loan, it is unlikely that she is asking for money for herself. However, it cannot be determined who the third party is; possibly CRW, considering the financial plight of the Rilkes at this time.

the Schiller Prize: an important literary award established in Bremen in 1904 by the German Goethe Societies and given every three years for the best dramatic work produced within that period. First awarded in 1905, the prize amounted to the generous sum of three thousand marks but was divided among Richard Beer-Hofmann, Gerhart Hauptmann, and his brother Carl (for *Bergschmiede*).

a room with works of his own: this installation of paintings and furniture by Heinrich Vogeler was at the Nordwestdeutsche Kunstausstellung [Northwest German Art Exhibition] in Oldenburg. The accompanying catalog ("With...Special Exhibition by Heinrich Vogeler—Worpswede") contained written contributions by Karl Schaefer and Rainer Maria Rilke.

October 14, 1905. Postcard to her mother

Postmarked Münster; written and drawn by PMB. Text: "Otto is dragging us through the streets. But we are having a good time. We three. Greetings from Otto and H. Vogeler." (See illus. p. 371.)

November 5, 1905. From Otto Modersohn's Journal

Evenings in the "white hall": OM refers here to the main room in the Barkenhoff, Vogeler's home where the "Family" would get together.

November 8, 1905. To Herma Becker

in your "convent": from the middle of October, Herma was living in very modest quarters in a home run by nuns in Paris.

Clara Rilke was here last evening: on October 6, 1905, CRW had written Paula a card from Meudon, where she was a guest of Rodin's for a month, and on it she said that she had left without saying good-bye. She then writes, "Paris in autumn. That is something that you must experience. Follow my example and surprise me with a firm decision."

Little Frieg: Will Frieg (1885–1968), painter from Soest in Westphalia. In the series *Junge*

Kunst [Young Art], vol. 12 (Leipzig, 1920), Frieg wrote a monograph on the painter Wilhelm Morgner. In Worpswede 1904–5. Friend of the poet Theodor Däubler and the artist-dramatist Ernst Barlach.

the museum owned by a Herr Osthaus: see reference to Osthaus on p. 342 in the introduction to this section and the accompanying note.

Minne: Georges Minne (1866–1941), Belgian sculptor and graphic artist. In the Osthaus collection: *Boy,* marble, first version, 1898; it was later used as part of a fountain in the museum's inner courtyard at the urging of van de Velde. *Boy with Water Hose, The Orator, Boy in Relief* (all in marble); *Female Bust* (limestone); *The Wrestlers* (wood).

Meunier: sculpture by him in the collection: *The Porter; Man Drinking; The Drinking Trough* (all bronzes).

Gauguin: in the Osthaus Collection: *Seaweed Gatherers in Brittany,* 1889 (acquired from Vollard, 1903–4); *Ta Matete,* 1892 (today in the Kunstmuseum, Basel); *Riders on the Shore,* 1902 (acquired from Vollard, 1903–4); *Girls with Fans,* 1902 (probably acquired from Vollard); *Contes Barbares,* 1902 (from Vollard). See Folkwang Museum (Essen) catalog for the nineteenth century (1971), nos. 51–54.

an old Trübner: Wilhelm Trübner (1851–1917), German Realist painter. In the collection: *Lady in Gray,* 1870.

an old Renoir: Lise, 1867.

couple named Hartmann: Richard Hartmann (1868–1931) was in Worpswede from about 1902 to 1909; his wife Magda was, in fact, a writer, not a painter.

Frau Philine: Philippine Vogeler, called Philine, née Scholz (1877–1952).

the Warburgs: PMB's sister Milly was a friend of the eminent Hamburg banking family Warburg, among whose members was the cultural historian Aby Warburg (1866–1929), the founder of the Warburg Library (originally in Hamburg, but from 1933 on in London). It could not be ascertained which members of this large family the Modersohns intended to visit.

The nude . . . by Maillol: according to the catalog of the Salon d'Automne, 1905, this might have been no. 1011, *Femme* (plaster statue). (See Gordon, p. 1387.) According to Rewald, *Maillol* (Paris, 1939), p. 13, his sculpture *La Méditérranée* was exhibited there, but according to the Maillol catalog for the Baden-Baden exhibition of 1978, Count Harry Kessler and not Osthaus owned this figure. To further complicate matters, it was Kessler who urged Osthaus to buy Maillol's over-lifesize figure *La Sérénité.* It may have been this figure PMB refers to. It was later set up in the Düsseldorf Palace garden and was destroyed by the invading Allied troops at the end of World War II.

November 26, 1905. To her mother

Frau Becker was visiting her brother Wulf von Bültzingslöwen at his house Sunnyside near Pillnitz.

painting Clara Rilke in a white dress: (Pauli, 85.) Hamburg Kunsthalle. Cf. CRW's letter to PMB of May 9, 1906: "Every time I look at your portrait of me it seems, to me, to be something very grand. And real greatness must grow from this beginning—it is already a true path—an upward path." (See illus. no. 35.)

As Rodin's secretary, Rilke: Rodin had requested Rilke to remain with him in Meudon while Rilke was preparing the lecture tour on Rodin's work which together they were in the process of planning.

December 1, 1905. To Herma Becker
Günther's letter: their brother Günther was having a very difficult time making a living in New Zealand.

December 6, 1905. To Milly Rohland-Becker
Herr and Frau Krummacher: Karl Krummacher (1867–1955), genre and landscape painter of the second generation of Worpswede painters, artisan and craftsman, and writer on art.
Otto's gray trousers: cf. the series *Pictures from Family Life,* an illustrated letter written and drawn by PMB and OM for Frau Becker on her birthday, November 3, 1905. (See illus. pp. 372–374.)
Eysoldt: Gertrud Eysoldt (1870–1950), actress; from 1897 on in Berlin (from 1905 at the Deutsches Theater). According to Petzet, PMB once met the actress at a garden party given by the Westhoffs, but certainly not at the time of the guest appearance in Bremen mentioned in this letter.
Hofmannsthal's Elektra: *A Tragedy in One Act, Freely Adapted from Sophocles* (1903), by Hugo von Hofmannsthal (1874–1929).
Wilde's Salomé: *Dramatic Ballad* (1893) by Oscar Wilde (1854–1900).
Frau W.: cannot be identified.
Wagner-Wesendonk Correspondence: between Richard Wagner and Mathilde Wesendonk (1828–1902), the wife of a Düsseldorf-Zurich merchant, herself an author. The letters appeared in 1904. Wagner's love for her finds its expression in his great opera *Tristan und Isolde* (1859). Paula's surprisingly negative comments on the opera and on Wagner's "un-Germanism" are quite remarkable for this period of almost universal adulation of the composer.
Centennial Retrospective Exhibition: Deutsche Jahrhundertausstellung: Ausstellung deutscher Kunst aus der Zeit von 1775–1875 in der Königlichen National Galerie Berlin 1906 [German Centennial Exhibition: Exhibition of German Art from the Period 1775–1875 in the Royal National Gallery in Berlin, 1906]. This important show came about as a result of the urging by Julius Meier-Graefe and of the director of the National Gallery, Hugo von Tschudi. It led to the rediscovery of the German Romantics.
Otto is sitting for Clara Rilke: if such a bust was ever made it is unknown today.

December 18, 1905. To Herma Becker
confiture de fraises: strawberry preserves.
old Frau Viol: a local seamstress. The name is still a familiar one in Worpswede.

January 15, 1906. From Otto Modersohn's Journal
Reicke: Georg Reicke (1863–1923), writer, and in 1903 the second (or deputy) mayor of Berlin. His wife Sabine (née Kolscher, 1865–1945) was a portrait painter.
Lotte and Miezi Hauptmann: Lotte (1858/1859–1943) was the only (and unmarried) sister of the Hauptmann brothers. Miezi (Agathe) was the daughter of Georg Hauptmann (brother of Carl and Gerhart) and his wife Adele (née Thienemann, ca. 1884–ca. 1968).
Anna Teichmüller: (1861–1940), a woman talented in many areas and one who lived her life according to her own dictates; a friend of Carl Hauptmann.
Nikodé: Jean-Louis Nikodé (1853–1919), composer. In 1878 he became a teacher at the Dresden Conservatory of Music, and in 1888 the director of the Dresden Philharmonic

Concerts. In 1899 the so-called "Nikodé Concert Series" began. He was one of the leaders in promoting modern music of the time, above all Bruckner and Richard Strauss.

Frau Bienert: OM refers here either to Frau Bertha Bienert (née Suckert from Langenbielau, 1868–1945), wife of the Dresden mill owner Theodor (Heinrich Vogeler designed Ex libris in 1899 and in 1901 for them; they were members of the Hauptmann circle in Schreiberhau) or to her sister Ida (1870–1965) who was married to Theodor Bienert's brother Erwin. Ida Bienert was an important collector of modern art.

Otitschko Müller: Otto Mueller (1874–1930), painter and influential Expressionist, a member of the important group in Dresden known as "Die Brücke."

Helene Kosslowski: cannot be identified.

Göllner: the name cannot be definitely deciphered from OM's handwriting; it could also be Güllner or Güttner. There was, however, a painter Kurt Eberhard Göllner (1880–?) who was a pupil of Karl Bantzer in Dresden and also an independent sculptor.

the Rembrandts in Dresden: The Entombment, 1653. Today ascribed to Ferdinand Bol, with assistance by Rembrandt. (Bauch, A11.) OM's "Old Man" is probably the *Old Man in Festive Costume,* 1654. (Bauch, 208.) The painting OM refers to as "the man with the heavily painted chest" is probably *Old Man with Large Beret.* (Bauch, 247; Gerson, 147.)

[Rembrandts in] Berlin: Joseph Accused by Potiphar's Wife, Genesis 39:17–20. Painted 1655. (Bauch, 32; Gerson, 274.) *Hendrikje Stoffels at the Window.* (Bauch, 518; Gerson, 399.) OM's "The Brother" is *Man in a Golden Helmet,* 1650; the model for the painting was for many years thought to be Rembrandt's brother Adriaen. (Bauch, 199; Gerson, 261.) OM's "Tobias" is *The Old Tobias and His Wife,* Tobias 2:20ff. (Bauch, 26; Gerson, 209.) OM's "small Manger scene" is *Joseph's Dream,* Matthew 2:13. (Bauch, 76; Gerson, 210.)

Carstanjen Collection: this collection was created by the Rhenish businessman Wilhelm Adolf von Carstanjen (1825–?), who lived in Berlin from 1881. He made the collection available to the public. From October 1906 it was on loan by the family to the Kaiser Friedrich Museum in Berlin; from 1928 it was on loan to the Wallraf Richartz Museum in Cologne, which finally purchased it in 1936. (See Max J. Friedländer, "Die Sammlung Carstanjen im Kaiser-Friedrich-Museum," *Kunst und Künstler,* 1906, pp. 157ff., and Horst Vey, "Die Sammlung Carstanjen," in *Wallraf-Richartz-Jahrbuch,* vol. 30.)

a portrait by Rembrandt: probably *Portrait of Jan C. Sylvius.* (Bauch, 392.)

a small nude: Rembrandt's *Christ at the Pillar,* ca. 1646. (Bauch, 192.)

a self-portrait: Rembrandt, ca. 1665, (Bauch, 341; Gerson, 419.)

Leibl: Wilhelm Leibl (1844–1900), German Realist painter.

Feuerbach: Anselm Feuerbach (1829–1880), German painter.

Marées: Hans von Marées (1837–1887), German painter, one of the Deutsch-Römer [German-Romans].

V. Müller: Viktor Müller (1829–1871), German painter belonging to the circle of Leibl, Trübner, Scholderer, and Haider.

January 17, 1906. To Milly Rohland-Becker

Riesengebirge: range of mountains in Silesia, the "Mountains of the Giants."

Kaiser Friedrich Museum: the opening dedication of the museum was on October 18, 1904.

February 5, 1906. To Herma Becker

Die Woche [The Week]: a Bremen weekly which like many other newspapers of the time sometimes ran competitions.

February 5, 1906. To Paula from her mother

thirty years ago today: in fact, PMB's birthday was on the eighth of February; however, it is not likely that Frau Becker does not know this and is using the word "today" to mean the day on which her daughter was likely to receive the letter.

Woldi: Frau Becker's nickname for her husband Carl Woldemar.

the wife of Councilor Fraenkel: Frau Geheimrat Fraenkel, the widow of Wilhelm Fraenkel (born in Odessa, Russia, 1841–?), doctor of engineering, a boyhood and student comrade of Woldemar Becker. From 1869 Fraenkel was professor at the Dresden Polytechnic Institute.

February 11, 1906. To her mother

Napoleon and women: Frédéric Masson, *Napoléon et les femmes,* 1894; translated into German the following year.

February 17, 1906. To Rainer Maria Rilke

"the little child": Infant with Its Mother's Hand, *ca. 1903. (Bremen '76, no. 96, illus. 29.)* Bremen Kunsthalle, inv. no. 692-1955/12. It was this painting that the Rilkes bought from PMB. During Rilke's visit to Paula's studio in Worpswede and other visits which he paid her while he was in Worpswede over the Christmas holidays 1905–6, Paula informed him, as she had already informed Clara, about her plan to leave Otto and go to Paris again. Rilke was very supportive of these plans.

the Salon: Le Salon des Artistes Français at the Grand Palais.

your friend Norland: PMB refers to Ernst Norlind (1877–?), Norwegian painter, graphic artist, and later also writer. He was a pupil of Hölzel at the Dachau colony and had an exhibition in Paris in 1905.

I am — Me: a possible allusion to Heinrich, the protagonist in Hauptmann's play *The Sunken Bell,* act 3: "…so bin ich: ich" ["…and thus I am: I"].

§ To greet Paula on her arrival in Paris, Clara had written from Worpswede on February 23: "Dear Paula Becker, I wish you all the best for your new beginning! I am writing this on my knees in my new rooms, which make me very happy. May all the new things that are to come make you bright and greet you gloriously; and may all difficulties be good for you and important and nothing but fruitful. Many good paths in Paris are wished for you by your Clara Rilke." (Address: Monsees-Haus, Bergstrasse 11.)

February 27, 1906. To Otto Modersohn

Dr. Voigt: Dr. Robert Voigt (1865–1933), lawyer in Bremen, brother-in-law of R. A. Schröder, friend of the Westhoffs. CRW probably gave PMB his name as someone from whom she could ask advice.

March 2, 1906. To Otto Modersohn
This letter is incorrectly dated February 22, 1906, in the 1920 Edition, but with no justification; the date on the original letter is clear.
Manet... Man with Guitar: proper title: *The Spanish Singer,* 1860. (Rouart/Wildenstein, vol. 1, no. 32.) Exhibited at the Gallery Durand-Ruel. (See "Les Manets de la Collection Faure," Chronique, 1906, no. 10.) Since 1949 in the Metropolitan Museum in New York.
a rabbit: Un Lapin, 1866. (Rouart/Wildenstein, no. 118.) at Durand-Ruel in 1906; today in a private collection.
Odilon Redon: Durand-Ruel showed twenty-two paintings, twenty-three pastels, four drawings, and four prints from February 28–March 15, 1906. (Gordon, p. 151.)

§ PMB does not mention anywhere, although she most certainly saw them, a group of paintings by Cézanne then on exhibition at Vollard's. (Chronique, 1906, no. 10.) It is typical of her not to mention what had the most profound influence on her.

March 8, 1906. Journal
Last year I wrote: see journal entry in Paris (ca. March 1905).

March 9, 1906. To Otto Modersohn
a very beautiful concert: this was the Concert Lamoureux; on the program were the first three symphonies of Beethoven (according to a letter from Herma to her mother, March 8, 1906).

March 19, 1906. To Otto Modersohn
Professor Modersohn: OM had written on March 18: "By the way, something is in the works; I am supposed to receive the title of Professor; probably I and Mackensen. I had to compose a brief autobiography." In a later letter he writes that the whole thing was probably nothing more than a little practical joke concocted by Mackensen.
excellent courses in anatomy: one of the works PMB did for this course testifies to her statement: *The Muscle Man,* charcoal. (Hamburg '76, no. 216.) The Estate.

§ Exhibitions at this time in Paris that PMB probably saw were those of the Indépendants, with pictures by Bonnard, Braque, Denis, Matisse, Munch, and Rousseau (Gordon, pp. 152ff.), from March 20 to April 30, 1906. Also that at the Galerie Druet where fifty-eight drawings and lithographs by Matisse were shown (Gordon, p. 152) from March 19 to April 7.

April 9, 1906. To Otto Modersohn
in any other place: OM had made the proposal that the two of them meet and spend several weeks together on the island of Amrum, where they had spent such pleasant days in 1903.
Sturm und Drang *period:* storm and stress period. The phrase comes from a play written by Friedrich Maximilian Klinger in 1776, whose title, *Sturm und Drang,* was extended to designate the entire literary epoch in Germany from the 1760s through the 1780s, a period of pre-Romantic emotionalism, political consciousness, and calls for liberation in all fields. Inspired primarily by Shakespeare, other British writers, and Rousseau, the great names of later German classicism had their literary beginnings in this period: Herder, Goethe, Schiller, etc.

a colossal still life with hollyhocks: La Femme aux Fleurs ou le Treillis, by Courbet, 1863. (Fernier, vol. 1, no. 357.) Exhibited in 1906 at Durand-Ruel, the painting is today in the Museum of Arts, Toledo, Ohio.

§ Further exhibitions PMB probably saw during these weeks were: at the Société des Beaux-Arts (Hall 5), by Maurice Denis, *Paysages mythologiques* [*Mythological Landscapes*], *Nausikaa, Calypso, L'heureux verger* [*Happy Bower*]. (Chronique, 1906, no. 15, p. 115.) The Bonnard Exhibition. (Chronique, 1906, no. 16, p. 124.) At Bernheim Jeune, Félix Vallotton, forty-four paintings. (Chronique, 1906, no. 18, p. 141.) At Bernheim Jeune (May 19–June 2), thirty-two paintings by Vuillard. (Chronique, 1906, no. 20.)

April 19, 1906. To Rainer Maria Rilke
the famous Ommeles and chicken: these omelets and chicken were special dishes served at the restaurants on Mont-Saint-Michel.

April 25, 1906. To Otto Modersohn
wonderful reclining nude: PMB refers to this as "Frau Saga" in her letter to Hoetger of April 27, 1906.
the small head in Bremen: bronze, 1905. (See *Bernhard Hoetger, Plastiken aus den Pariser Jahren 1900–1910* [*Bernhard Hoetger, Sculpture from the Paris Years, 1900–1910*] (Bremen: Graphisches Kabinett [Print Gallery] Wolfgang Werner. Exhibition, March 4–May 15, 1977; cat. no. 60.)
The Indian photographs: photographs of pieces of Indian sculpture which Cora von Bültzingslöwen had brought back to her niece Paula from her trip to New Zealand, ca. 1902 (according to a letter from OM to Gustav Pauli, June 19, 1919).

May 5, 1906. To Bernhard Hoetger
This letter survives only in a copy. According to information given by Albert Theile it is written in the hand of Lee Hoetger, the sculptor's wife. Hoetger published it in 1919 as part of an essay he wrote on PMB in *Genius: Zeitschrift für alte und werdende Kunst* [*Journal for Old and Contemporary Art*] (Leipzig: Kurt Wolff Verlag), bk. 1, pp. 35ff. In his contribution to Uphoff's small publication on PMB (see Bibliography), Hoetger wrote in 1920: "After weeks of intense interchange of thoughts she let a little sentence slip out: 'Well, yes, I would certainly have done that differently.' What, you paint? And then a modest 'Yes.' I got up, and for the first time I went into her atelier, full of curiosity. There I experienced, quietly and full of emotion, a miracle. She hung on every word from my lips. The only thing I could say to her was: 'All of them are great works. Remain true to yourself and give up further instruction.' She had been advised to continue schooling, because in Worpswede they all still believed that she had yet to learn how to draw. She was wonderfully relieved and on the following day wrote me a touching letter." Hoetger's comments in his memoirs, written in 1932, differ from the above only in minor details. (There is also an almost identical statement in a brief note by him in the journal *Die Tide: Niedersächsische Heimatblätter* [*The Times: News of Local Interest for Lower Saxony*], vol. 6, no. 7 [July 1929], pp. 267–71.)
Nevertheless, Hoetger's memory is faulty in several regards. If one compares what he has to say with PMB's letters, then her first visit with him must have been between April 9 and

13, after she had seen a work by him at the exhibition of the Indépendants. Easter was on April 15 and she traveled to Saint-Malo at the latest on the previous day and was still there on the nineteenth (according to the postmark on a card to Rilke). The second visit had not taken place by April 27 because Hoetger was still present at an exhibition of his works in Cologne and PMB reminded him of his permission to visit him and his wife once again. The second or third visit must then have taken place on May 4. Hoetger had written: "on the following day [she] wrote me a touching letter"; May 5. In all events, he can hardly have been accurate in speaking of "weeks of intense interchange of thoughts." To be sure, there can be no question that he was moved by what he saw; Herma's letter to OM is proof enough of that. However, to Otto himself Hoetger wrote a very much more reserved judgment about Paula. "Whenever I praised your wife I was always careful to temper it with an additional remark, out of a natural and sincere urge; for, as you must know, we can consider the great talent of your wife only as a still untutored gift which will not come into blossom until serious conflicts of the soul permit her to recognize good discipline, and until calm consideration leads her to apply it to her work. You see, dear Modersohn, what my thoughts about this are. The point of my praise is to give her strength for the attainment of her goals" (August 10, 1906). The contradictions in Hoetger's recollections, which extend over a long period of time, would probably not be worth mentioning if there had not arisen a disagreeable argument between him and OM beginning in 1911 as to who had been the first to recognize the importance of PMB's work. Apart from all contention and disagreement, however, the important function of Hoetger at this period remains, for his approval and encouragement of Paula's painting unquestionably freed her to discover her real potential as an artist.

In connection with the battle over who discovered PMB first, it should be noted that the still constantly recurring assertion that no one in Worpswede had any understanding for PMB's work needs a certain revision. The fact that her work as a whole did not come to light until after her death was in great part her own fault. She concealed what she had created. Indeed, her artistic legacy was full of works that were unknown even to her husband. After Heinrich Vogeler got to know these pictures, he immediately vouched for her importance as an artist. And even Fritz Overbeck, whom Paula believed had always been distant to her art, wrote on January 3, 1908 (not even two months after her death), to OM, urging him to include paintings by his wife in an exhibition in Düsseldorf: "...she left us with such treasures that it will be no problem at all to make a good selection. I once spoke with [Gustav] Pauli about this matter, and for his part he would gladly exhibit a fairly large collection of her works, and during the time that you are here he will possibly want to negotiate with you about this. As far as I am concerned, that could be not only an extremely valuable exhibition artistically, but also a tribute to the dear departed, of whom it is surely unnecessary to say that she would deserve it in the highest degree." And on March 9, 1908, he writes even more explicitly: "In recent years we in Worpswede, with the exception of your wife, have basically produced nothing that could make us proud of ourselves...." (The Overbeck family kindly submitted the letters of Fritz Overbeck to the editors for their use in the preparation of this book.)

Your sister-in-law: Clara Haken (ca. 1885–ca. 1960), married to the sculptor Nieder. See PMB's double portrait of Lee Hoetger and Clara Haken, August 1906. (Bremen '76, no. 198, erroneously identified as a portrait of PMB and CRW in the catalog.) In the Museum am Ostwall, Dortmund.

[Postmarked] May 5, 1906. To Herma Becker
Took the portemonnaie: the word means "purse," and if intentional the reference is unclear. More likely Paula meant to write *portefeuille:* "portfolio."
a very beautiful girl: Clara Haken.

[Postmarked] May 5, 1906. To Herma Becker
I want to do a study of you: Portrait of Herma Becker, on canvas. Private collection. (See illus. no. 32.)

May 6, 1906. Herma Becker to Otto Modersohn
This letter is very similar to one Herma wrote to her mother on May 11, 1906; the latter was still in Italy and knew nothing about what had happened: "Paula is working very hard and discovering satisfaction in her work. Hoetger, this fine sculptor—Paula thinks he will be our greatest one—was greatly pleased by her things and is inflaming her with encouragement. All this week she has been in a veritable fever of work and painting without stop from morning until evening, so that she simply collapses dead tired in bed at eight o'clock. Hoetger says that she has much talent and will become a fine painter. In human terms she has also very quickly grown close to him and his quiet blond wife and has spent beautiful and fruitful hours together with them. He has [...] become very wise and kind as the result of a difficult and industrious life and because recognition has been denied him. But now, during the past few years, he is making his way and has magnificent plans for the future."

[Ca. May 8, 1906]. [On a loose sheet of paper.]
Marées and Feuerbach: in the main body of the text we include only that section for which we have PMB's manuscript. This was discovered on a separate piece of paper among the letters. The text in the 1920 Edition is somewhat more extensive and includes the following as a journal entry for May 8, 1906. Although the journals were destroyed in the war, this excerpt has the ring of authenticity. In its complete form it reads, "Marées and Feuerbach. Marées is the greater; Feuerbach makes concessions. They say that the task of painting is to represent appearance. In that, Zuloaga attains greatness. But the way in which he attains it is dry and sober. It has to be a mystery. Great style in form also demands great style in color. Zola says in *L'Œuvre:* 'Delacroix is in the very bones of us poor Realists.' We can say: Zola himself is in our bones."
L'Œuvre: novel by Zola (1886), one in the series known as the "Rougon-Macquart Cycle." It is an unsuccessful novel about a painter whose protagonist is based on a composite model of Cézanne and Manet. The hero is a rather painful mixture of genius and insanity.

May 8, 1906. To Paula from her mother
Vogeler wants to buy your "Apples": Still Life with Apples and a Green Glass, dated lower right "1906," which means that it must have been painted between January 15 and February 22. (Pauli, 225; Bremen '76, no. 182.) Now in the Paula Becker-Modersohn-Haus, Bremen, inv. no. 29.

May 10, 1906. To her mother
Dated May 8 in the 1920 Edition; however, the date of receipt in Paris on the envelope of the mother's letter is May 10, and so the answer can hardly have been written previous to

its receipt. Internal evidence indicates that this letter must have been written on that very day.

It would be appropriate to quote at this point from an undated note from Rilke. Its envelope is dated in another hand with two different dates, April 2 and May 10. The latter date is surely the correct one, for the letter reads like a reaction to Paula's cry of jubilation, very like others she wrote to those close to her during these days. Rilke writes: "Dear Friend, Life, the truly good life, has taken you by the hand; you have every right to be happy, to your very depths. By the way, I wish you to know that your Rainer Maria Rilke is happy about you and with you." The Estate.

May 15, 1906. To Otto Modersohn
the Knackfuss volume: Rilke's Worpswede monograph.

May 21, 1906. To Martha Vogeler
despite what Otto Modersohn thinks: it is clear from the context of this letter that OM thinks PMB is psychologically out of balance.
Mining: Heinrich Vogeler's nickname.
Gottlieb: Gottlieb Sämann was a houseman who worked for the Vogelers.
Which little girl with a black hat do you mean: Girl with a Straw Hat Holding a Daisy. (Pauli, 62.) It is more likely that the Vogelers were referring to the *Head of a Blond Girl in a Straw Hat,* ca. 1905. (Pauli, 123; Bremen '76, no. 151, illus. 30.) Now in the Kunst- und Museumsverein [Art and Museum Society], Wuppertal. In a letter from OM dated June 22, 1906, however, he writes: "Vogeler only wants the *Still Life with the Red Blanket and the Green Glass* [for one hundred marks]."
your two roans: Vogeler had bought horses which now had to be taken care of.
Hoetger is working now in a very severe style: the reference is to two busts: *Lächeln* [*Smiling*], and *Gedankenflug* [*Fleeting Thought*], for which Lee Hoetger and Clara Haken were respectively the models. (See *Bernhard Hoetger, Plastiken aus den Pariser Jahren 1900–1910* [*Bernhard Hoetger, Sculpture from the Paris Years 1900–1910*], (Bremen: Graphisches Kabinett [Print Gallery] Wolfgang Werner, cat. nos. 62 and 63.)

June 8, 1906. Herma Becker to her mother
Otto will tell you everything: OM had come to Paris for about a week on the day before Whitsunday.
to tell her all of it so openly: OM presumably said that the old Worpswede friends of PMB disapproved of her actions.

June 30, 1906. To Otto Modersohn
They both continue to be so considerate and charming to me: cf. Hoetger's recollection in Uphoff, p. 13: "Out of some mutual need we worked together and visited frequently, often early in the morning. At those times we would take our morning coffee together. She would come in early with arms full of flowers and carrying fruit which she had bought at the market. She possessed the most refreshing of natures. She loved splendor and joyfulness; she was modest and had a wonderful womanly sense which manifested itself whenever close friends came to her. She became a good friend to my wife."
Frau Brockhaus has bought my still life: cf. this excerpt from a letter that Paula's mother

wrote to her on June 22, 1906: "Old Frau Brockhaus, whom you met in January at Sunny-side [Pillnitz, near Dresden], has come to Bremen for a few days and wanted to see Worps-wede. Yesterday [...] we went out there and asked to be taken [...] first to Heinrich Vo-geler. Then Otto fetched us and brought us to his studio where your still lifes were on ex-hibition. And then when she saw your Apples and Banana it came like a shot out of a pistol: 'What does that cost?' A hundred marks. 'I should like that, please.' And so it seems that you have sold all your apples at the marketplace, since Heinrich Vogeler has purchased, for himself, the apples with the green glass."

Frau Louise Brockhaus, née Rath (1845–1921) was, according to information from her granddaughter Frau Mili Gruner of Lörrach, the buyer. According to her son's diary she was indeed in Bremen in June of 1906 and must be the Frau Brockhaus in question. Frau Gruner is unable to give any information about what could have happened to this paint-ing. It is not cataloged in Pauli. Nevertheless, Frau Louise Brockhaus has the honor of be-ing the only certain buyer of a painting by PMB during the artist's lifetime, with the excep-tion of her friends Vogeler and the Rilkes. A possible buyer was a Frau or Fräulein Wall-brecht from Hannover who may have purchased a still life of pussy willows in a striped vase. This is according to a letter discovered in the Bremen Kunsthalle in 1980. Further-more it is listed in Otto Modersohn's inventory of 1915 as sold to a Fräulein Wallbrecht for 120 marks in 1906 with a question mark following the date.

July 30, 1906. To Heinrich Vogeler

This letter is Paula's reply to Vogeler's gently worded letter of July 17, reminding her of Worps-wede and the people there.

the Gurlitt exhibition: OM, together with other painters in Worpswede, was preparing an autumn exhibition for the Bremen Kunsthalle which was to go on exhibition at the Berlin gallery of the art dealer Gurlitt between Christmas and New Year's.

their art gallery: Franz and Philine Vogeler founded the Kunst- und Kunstgewerbehaus Worpswede [The Worpswede Arts and Crafts House] in 1905; after Franz's death in 1914 his wife ran it as Galerie Philine Vogeler, from the 1920s as Kunsthalle Philine Vogeler Worpswede, and even later as the Worpsweder Kunsthalle, under which name it is well known today. The first memorial exhibition for PMB took place in this gallery in the sum-mer of 1908. Beginning in 1915 Philine as well as Heinrich Vogeler, together with Bern-hard Hoetger, were the decisive influences in gathering together the Paula Becker-Moder-sohn Collection funded by Ludwig Roselius.

your clay pit: this was located on a piece of property that belonged to the former brickyard near the Barkenhoff.

a pair of Grünhagen shoes: Grünhagen was a well-known shoe store in Bremen.

July 31, 1906. To Rainer Maria Rilke

It's suddenly so terribly hot here: Rilke did not reply to this little call for help and excused himself in a letter eight months later from Capri on March 17, 1907: "For now I may tell you that I have been feeling guilty all this time for not having written in reply to the little letter from you which was forwarded to me in Berlin, the one in which you wrote that you would like to come and join us. I was so absorbed during those days in seeing Clara and Ruth again, and East Dunkirk did not make a very convincing impression on me. Later, however, I remember feeling that I had committed an injustice in not answering and had

been inattentive [to you] during a moment of our friendship when I should not have acted that way...."

August 3, 1906. To Otto Modersohn
the portrait of Frau Hoetger: PMB painted three portraits of Lee Hoetger, two of which are very closely related. These are: *Portrait Bust of Lee Hoetger* (Pauli, 70d; Bremen '76, no. 169, illus. 34), in Paula Becker-Modersohn-Haus, Bremen, inv. no. 39; and *Portrait of Lee Hoetger* (Graphisches Kabinett [Print Gallery] Bremen: Wolfgang Werner). The third portrait of Lee Hoetger (Pauli, 28; Bremen '76, no. 168, illus. 33), in Paula Becker-Modersohn-Haus, inv. no. 35. PMB was still working on these portraits until shortly after August 12, 1906. (See the letter to Milly Rohland-Becker of this date.)
Recently they took me with them to the country: Hoetger writes in Uphoff, p. 13: "We were living for a few days in Bures near Paris where she visited us. We picked flowers for still lifes. We looked at the summer, we listened to the humming of the bees. She would often raise her hand and hold the flowers against the blue of the sky, and then smile." It was perhaps during these days in the country that the third portrait of Frau Hoetger was painted, or at least conceived, the one that shows her standing before a somewhat gardenlike background. There are probably connections between this picture and the naive art of Henri Rousseau (known as Le Douanier, 1844–1910), one of whose pictures hung in Hoetger's atelier. However it was not at his atelier but at the exhibition of the Indépendants in 1905 that Paula first saw works by Rousseau.
Hans: Hans Rohland, merchant, Milly Becker's husband. They were married the previous year.

September 16, 1906. To Milly Rohland-Becker
in your lovely Amorbach: the Rohlands were living in this small town in the Odenwald, south of Frankfurt. PMB visited her sister in the second half of August. Milly was expecting her first child.
And read over again what Nietzsche has to say about cooking: this is possibly a recollection of something she read in *Zarathustra,* but it is difficult to cite exactly what chapter PMB has in mind.
"What is Truth": allusion to the so-called question of Pontius Pilate to Christ before the Crucifixion, the question not answered (John 18:38).

September 16, 1906. To Otto Modersohn
chambre garnie: furnished room.

November 1, 1906. To her mother
Otto's being here: OM came at the end of October in order to spend the winter with his wife in Paris. The Vogelers either accompanied him or arrived shortly after he did and stayed for a brief period. The four of them visited the Salon d'Automne in the Grand Palais (October 6–November 15, 1906). On exhibition were contemporary Russian art, 3 Bonnards, 10 Cézannes, 2 Delaunays, 8 Derains, 10 Jawlenskys, 20 Kandinskys, 5 Matisses, 10 Puys, 8 Redons, and a Courbet retrospective. Above all, however, was the great Gauguin retrospective with 227 works, 60 from the Collection Fayet, 33 from the Collection Vollard, 61

from the Collection Durio, 11 from the Collection Fabre, 11 from the Collection de Monfreid, 5 from the Collection Sainsère, and others. (See Gordon, pp. 170–78.)

November 11, 1906. To Paula from her mother
Paula, what do you say to this fanfare: Frau Becker actually dates this letter on the tenth, but she was mistaken, for Pauli's newspaper article on PMB's work at the Kunsthalle appeared on Sunday, the eleventh (*Bremer Nachrichten*, section 2, issue 311).
little Dr. Waldmann: Dr. Emil Waldmann (1880–1945), art historian, from April 1906 adjunct academic aide and in 1907 directorial assistant at the Bremen Kunsthalle; in 1913 director of the Kupferstichkabinett [Print Room] in Dresden, and on July 1, 1914, Pauli's successor as director of the Bremen Kunsthalle.
whose lantern lighted the way: Frau Becker is mistaken in this matter; Pauli was in fact more interested in PMB's work than Waldmann ever was.
I really cannot stand that portrait: the family's skepticism about Paula's art is rarely so directly expressed as in this letter from her mother. In a letter from Kurt to his brother-in-law OM of about this same time, we read that Paula should not put too much faith in Pauli's praise, "since the article was doubtlessly inspired by someone else and does not contain Pauli's real opinion." It was, of course, Pauli himself who in 1919 wrote the first monograph on PMB.

November 13, 1906.
From the Bremen Courier: Anna Götze, the reviewer, was a painter and writer on art, born 1859, who lived until 1933 in Bremen, and then moved to Wismar. From 1920 to 1922 she ran the Graphisches Kabinett [Print Gallery] (J. B. Neumann) in Bremen with Carl Weidemeyer.

November 17, 1906. To Clara Rilke-Westhoff
the misunderstanding between you and Otto Modersohn: Otto Modersohn had a difficult time accepting the fact that his wife had spoken with the Rilkes extensively about her plans and that they unquestionably had not only advised her to take the steps she did but also actively supported them. In addition there was the estrangement of 1902 which, on Paula's side, had already long since been overcome as a sort of stage in the growth and ups and downs of their friendship, but which Otto could not get over so easily. His letters of the spring and summer of 1906 are filled with severe attacks against the Rilkes, above all against RMR. His personal relationship with CRW was gradually revived in the course of time, especially after Paula's death. He probably never met Rilke again. It is evident from Clara's letter of October 19, 1906, that she and her husband were not prepared for Paula's decision to return to Otto. PMB's letter of the seventeenth is the answer to it: Clara had written: "My dear Paula Becker, we often think of you and wonder what you are doing. Is your life in Paris continuing to be the same as it was in the summer? In case you are [still] planning to remain alone and are having a difficult time, we would perhaps have a possibility for you in mind. If you would write me anything at all about your wishes and plans, I would be extremely happy...."

November 18, 1906. To Milly Rohland-Becker
Hoetger is doing a plaster bust of him: this seems to be another piece of sculpture by Hoetger for which there is no record.

January 29, 1907. To Milly Rohland-Becker
It's a pity that the boy: their brother Henner (Henry) was on leave from the merchant marine and Frau Becker expressed the wish that Otto and Paula come from Paris to Bremen over the holidays. They did so, also spending time in Worpswede and Fischerhude. During this whole period Elsbeth was staying with Paula's mother in Bremen. At the time of this Christmas visit, PMB, in order to make her description of her Paris atelier on the boulevard Montparnasse clearer, drew a quick sketch of it on the envelope of a letter that Herma had written to Otto in Bremen on December 30. See illus. on bottom of p. 399, which indicates just which paintings PMB was working on at this most important time in her artistic career.

February 16, 1907. To her mother
a book with old Egyptian portrait heads: probably F. A. Richter and F. von Ostini, *Katalog zu Th. Grafs Sammlung antiker Portraits [Catalog of Antique Portraits in the Collection of Theodor Graf]* (Berlin–Vienna, 1889). OM's travel journal reports additional purchases: "Books, pictures, clothing, porcelain from Brittany." He also mentions other trips that they took together. "Meudon to visit the Bojers and Rodin; to Saint-Denis to visit the Royal Tombs; to Versailles with its wonderful parks; to Fontainebleau and Barbizon." Unfortunately, he does not list the exhibitions visited. According to a notice in Chronique, 1907, no. 2, they could have visited the Théâtre des Funambules in January, where Hoetger was exhibiting. Bernheim Jeune was showing works by Paul Signac from January 21 to February 2, 1907. (Chronique, 1907, no. 4, p. 28.) No. 12 of the 1907 Chronique (p. 94) reveals that from March 3 to April 4 the Salon des Artistes Indépendants was exhibiting at the Serres du Cours-la-Reine; room 7 was devoted to Matisse and room 6 to Signac, Vallotton, Rouault, Sérusier, and Puy.

February 21, 1907. To Milly Rohland-Becker
Hauptmann and his wife plan to come here: Carl Hauptmann and his wife arrived in Paris on the twelfth of March.

February 27, 1907. To Elsbeth Modersohn
a little Italian girl: Pauli, nos. 24, 92, 94.

March 10, 1907. To Rainer Maria Rilke
the new edition: of Rilke's *Buch der Bilder [Book of Pictures,* poems], second much-expanded edition (Berlin: Axel Juncker Verlag). Written in Rilke's hand in the presentation copy: "To Frau Paula Modersohn-Becker in Friendship Rainer Maria Rilke/Capri 1907."
The photographs of ancient art: Rilke wrote on February 5, 1907: "These reproductions of a few ancient paintings [...] are meant to bring with them many greetings to you, and not only mine but also Clara's. We selected these photographs for you especially with your art in mind...." Although they no longer exist, it is most likely that they were photographs of paintings from Pompeii and Herculaneum in the National Museum of Naples.

Carl Hofer: (1878–1955), German painter. Judging from Paula's phraseology one might deduce that she did not meet him in Paris in 1900 despite Petzet's assertion (p. 97).

Rilke answered this letter one week later, on March 17: "And even though the outward circumstances [of your life] have turned out quite differently from the way we once thought they would, nevertheless only one thing is decisive: and that is that you are beginning to bear up courageously and that you have attained the possibility of finding freedom under these circumstances. For freedom demands everything indestructible in you in order to become the utmost it possibly can. Solitude is really something that is inside us. The best and most valuable step forward is to realize that and to live one's life accordingly. We are dealing with things which do not lie in our own hands, and success, something so simple after all, comes from a thousand different things — indeed, we never really know what it comes from. As for the rest, simply leave me to my expectation of you. It is so great that it can never be disappointed. [...] And I am the last person to be bothered by how long it might take you to travel this path. [...] Yes: 'I hope everything will be all right this way.' It is not possible to wish for anything more; but how very much I do."

In this same letter Rilke asks whether PMB has seen the Vente Viau; several Cézannes were sold at this auction: *Paysage d'été* [*Summer Landscape*], *Paysage de Pontoise* [*Landscape at Pontoise*], *Clos des Mathurins* [*Hermitage at Pontoise*], and *Fruits*. Besides, the collection also had two Breton landscapes by Gauguin. (Chronique, 1907, no. 10.) In no. 13 of Chronique, p. 110, there is an announcement of the sale on the following day of a portrait of a child by Cézanne and a still life of oranges and lemons by Gauguin.

It is lovely that the trip is so rewarding for her: CRW was spending several weeks in Egypt.

April 5, 1907. To Rainer Maria Rilke
sitting again in my little studio: since the Modersohns planned to be back in Worpswede by Easter (March 31), they must have left Paris one or two days before.
I did see Cézanne[s] during our very last days there: in the Pellerin Collection and probably at the Vente Viau.
Salon d'Automne: ran from October 1 to 22 with the Cézanne retrospective (twenty-five works from the Pellerin Collection, twelve from the Collection Cézanne Fils, and nineteen from the Collection Gagnat. (See Gordon, p. 224.)
marchand bric à brac: junk and secondhand dealer.

April 8, 1907. To her mother
the last of your brothers: Wulf von Bültzingslöwen, Paula's Uncle Wulf with whom she took the trip to Norway in June and July 1898.

May 10, 1907. From her mother to Herma
old Gellert: Christian Fürchtegott Gellert (1715–1769), famous and beloved writer of the Age of Enlightenment and professor of philosophy at the University of Leipzig, who wrote poems, plays, and fables; perhaps the most universally popular writer in the history of eighteenth-century German letters. "Mein erst Gefühl sei Preis und Dank" ["Let my first feeling be praise and thanks"] is the first line of the "Morgengesang" ["Morning Song"] from *Geistliche Oden und Lieder* [*Spiritual Odes and Songs*], 1757.

July 1907. From Bernhard Hoetger to Otto Modersohn
Holthausen: Holthausen Castle near Büren in Westphalia, rented by the Hoetgers. Shortly after July 12, OM arrived for several days.

August 10, 1907. To Rainer Maria Rilke
And Cézanne, about whom you write: in RMR's letter of June 28 he writes: "[...] Bernheim Jeune was exhibiting watercolors by Cézanne. [...] The watercolors are very beautiful. Just as self-assured as the paintings and just as airy as the oils are massive. Landscapes, with the lightest possible pencil lines sketched in, and on them here and there for emphasis, as it were, as a reassertion, a hint of color, a row of spots of color, wonderfully ordered and done with such an assured touch, as if a melody were being reflected. [...]" Bernheim Jeune: watercolors, pastels, gouaches, and drawings by Berthe Morisot, Cézanne, Degas, Guillaumin, Jongkind, Manet, Monet, Renoir, and Sisley. (Chronique, 1907, no. 32.)

Summer 1907. To Bernhard Hoetger
This fragment exists only in a copy.
"Dear God, make me good...": "Lieber Gott, mach mich fromm, dass ich in den Himmel komm." This child's prayer is roughly the equivalent of the English "Now I lay me down to sleep..."

[Prior to October 8, 1907]. To her mother
Hauptmann: Carl Hauptmann.

October 8, 1907. To Herma Becker
I'm painting again: Paula was perhaps painting her final *Still Life with Sunflower and Hollyhocks,* which according to her brother Kurt was on her easel at the time of her death. (Pauli, 184.) (See illus. no. 46.)
a new book by Meyer-Gräfe: possibly Meier-Graefe's *Der junge Menzel* [*The Young Menzel*], 1906, or *Die Impressionisten,* 1907.

October 17, 1907. To Rainer Maria Rilke
your essay on Rodin: R. M. Rilke, "Auguste Rodin," *Kunst und Künstler,* vol. 6, no. 1 (October 1907), pp. 28–39.
the catalog of the Salon d'Automne: Rilke answered on October 21 telling her that he had sent off the catalog, together with two issues of the *Mercure,* and added: "[They contain] notes on Cézanne from which one may gather, behind the back of their quite disagreeable author [the painter Emile Bernard], nothing more than a few facts and figures." (Emile Bernard, "Souvenirs sur Paul Cézanne et lettres inédites" ["Recollections of Paul Cézanne Together with Unpublished Letters"], *Mercure de France,* October 1 and 15, 1907.) On October 18 CRW wrote Paula from Oberneuland, "You were asking about Cézanne; all of Rainer Maria's letters are filled with Cézanne now. He asked me to tell you that there are 56 Cézannes, 174 pictures and drawings by Berthe Morisot, and 16 by Eva Gonzalez at the Salon d'Automne. I believe he has no idea how impossible it is for you to go to Paris now; otherwise he wouldn't be giving you so unfeelingly all these numbers. [...] But I plan to come to Worpswede in the next few days and shall read some of RM's letters to you; I think they'll make you happy, too."

Gauguin once ascended the same staircase: there has been no way of ascertaining when Gauguin might have lived at 49, boulevard Montparnasse.

October 21, 1907. To Clara Rilke-Westhoff
Do you still remember what we saw at Vollard in 1900: see CRW's recollection (p. 173) for further evidence of the immense and pioneering influence Cézanne had on PMB. In the face of all this testimony it is most surprising that Otto Modersohn minimizes, indeed re-presses, the significance of Cézanne on Paula's artistic development in his letter to Gustav Pauli of June 19, 1919, in which he emphasizes instead the influence of Gauguin. In this same letter OM remarks that Paula, on her final return to Worpswede, declared that she was not satisfied with the painting she had done in Paris in 1906–7.

October 22, 1907. To her mother
This great glorious beast: Frau Becker's wing chair.

[Undated]. A note by Clara Rilke
This note was taken from Hetsch, p. 50, and must have been written either on October 21 or 22.

November 5, 1907. From Frau Becker to Milly Rohland-Becker
Dr. Wulf [sic]: Member of the Board of Public Health, Dr. Ludwig Wulff (ca. 1850–1915) was a general practitioner and obstetrician in Worpswede.
Osten: August Diedrich von der Osten (1846–1915), an old friend of the family.
"herself as young as a rose": "selbst wie eine Rose jung"; possibly a quotation from Gellert, but exact source cannot be located.
Franz Hals: Frans Hals (1580/84–1666), Dutch painter. *The Nurse with the Child* is more properly known as *Portrait of Catherina Hoeft with her Nurse,* ca. 1619–20. It is now in the Painting Gallery of the Staatliche Museen Preussischer Kulturbesitz [State Museums for Prussian Culture], West Berlin.
Frau Osmer: midwife.
a photographer…from Dresden: this was probably the well-known portrait photographer Hugo Erfurth (1874–1948); he had been an acquaintance of Vogeler since the latter's stay in Dresden somewhere during the end of the 1890s. (Cf. CRW's recollection in Hetsch, p. 50.)

November 18, 1907. From Frau Becker to Herma Becker
Dreyers: the farming family who owned the property next to the Modersohns' house in Worpswede.

December 4, 1907. From Frau Becker to Herma Becker
Fellner: Johann Christian Fellner, engineer in Frankfurt and a close friend of the family.

The earlier editions of the *Briefe und Tagebuchblätter* [*Letters and Leaves from the Journals*] contain the following passage. Some doubt has been cast on the authenticity of this "family letter." Although it is undoubtedly accurate in detail, the "letter" referred to has never been discovered:

On the second of November, Paula gave birth to a healthy girl. On the twenty-first [sic] she died. The following excerpt from a family letter describes her end:

Kurt bicycled out on the eighteenth day after her birth. His "Yoo-hoo" can be heard from way down the road. Then there is a cheerful echo from the nursery: "Yoo-hoo!" Kurt gives her one more thorough examination and says that she may get up. The nurse quickly helps her into her clothes, and then she walks about the living room with little effort, supported on each side by her husband and her brother. An armchair is moved into the middle of the room where she is happily enthroned, the men of the family to the right and left of her. The infant has just been nursed and is bursting with health. Paula says that all the candles in both chandeliers have to be lighted: "It's almost like Christmas... Oh, I'm so happy, so happy!" Suddenly her feet seem to become heavy, there are a few gasps for breath. She says softly, "A pity,"... and dies.

Her grave is in the hilltop cemetery in Worpswede. A monument by Bernhard Hoetger, depicting a dying mother, commands the spot.

It is generally conceded that a more accurate description of Paula's death was given by Clara Rilke-Westhoff, following the account given to her by Otto Modersohn and printed in Hetsch, pp. 50ff. It may be found here at the conclusion of the Introduction to the section on the years 1905–1907. This passage continues as follows: "The news of her death reached me belatedly in Berlin. As dawn gradually broke on the morning of the last day of November, I walked along the allee of birches with a bouquet of autumn foliage in my hand—the same allee which we had so often walked along together. I found the house empty—Otto Modersohn had gone away. Milly had taken the child with her, and Paula was no longer there."

RILKE AND THE LETTERS AND JOURNALS
OF PAULA MODERSOHN BECKER

In the autumn of 1916 Frau Becker sent a packet of her daughter's letters and journals to Rainer Maria Rilke, asking him to be their editor and to see them through publication. She had doubtless been prompted in this by the poet's earlier suggestion to her son Kurt that (all) these materials be published. Rilke had read the selection published in 1913 in the *Gülden-kammer* and had been impressed. Many weeks passed before Frau Becker received Rilke's reply from Munich. This long letter, a document of considerable importance, appears in the second edition of H. Petzet's *Bildnis des Dichters*, and we quote at length from it. The letter is dated December 26, 1916.

"No hour was peaceful enough for me; indeed, I felt that I was awaiting a consecrated moment in order to begin to deal with them. Finally, on Clara's birthday, I began (or rather we began, for Clara was the most natural and knowledgeable helpmate throughout) the reading, which (how can I say it all at once?) caused us anguish and tribulation and evoked such an infinitude of memories. How could it have failed to do so? Yet as deeply as my feelings were touched and as much as I felt myself to be a participant, even the first reading that evening made us realize clearly that the editing (and publication) of these papers would be wrong, if for no other reason than that the picture of Paula Modersohn to which they contribute would inevitably be an indescribably inferior image to the one she ultimately attained in her final year and in the great beauty of her departure from us. Much of what was unique about her would, of course, be conveyed, but not she herself—only what was ready and waiting in her. But not her freedom, not her great productive heart, nothing of the rapid, sudden ascent which is revealed and remains preserved in the final stages of her art....

"When I wrote some time ago to your eldest son, having been impressed by what I had read of her writing in the *Güldenkammer,* and told him that I wished to see much, indeed all, of her written remains published, I did so in the anticipation that from her last years, from those years of ruthless independence and accomplishment, notebooks and letters would have been found. You see, much too much has happened in painting to justify our promoting [Paula's] confrontation with the work of Böcklin or Cottet or Lucien Simon as sufficiently important in the life of one who in her critically formative period accepted and made creative use of Rodin, Renoir, and above all Cézanne. The publication of those youthful opinions and impressions would be justified only if one could counterbalance them—indeed, outweigh them—through the revelation of specific and important indications of her subsequent experience, and if, most importantly, her own later and mature work had been clarified and verbalized in some sort of written form. Ever since the two volumes of van Gogh's letters and journals were made available to us, we have had a right to be unusually demanding vis-à-vis the writings of any painter; an entire generation went through its most decisive artistic experience with and in him, and as a consequence any recounting of the experience of being a painter which is less complete or less passionate than van Gogh's is rendered ineffectual by the very existence of his writings.... There can be no doubt that in her final years Paula experienced her task as a mature artist both amply and passionately. But it would

appear that this experience manifested itself exclusively in her rapidly completed paintings and sketches. When I really think about it, the time left her was much too brief to allow for any other form of expression. Paula's 'new life,' whose inception is dated February 24, 1906 (Paris, 24, rue Cassette), knew only two things: work and fate. It would seem that words about it were scarcely ever set down. Only if we were fortunate enough to find preserved written evidence describing that most tumultuous period of her life, would we be justified in evoking those earlier, tentative writings as testimony in her behalf — reaching backward in time, as it were, from fulfillment to beginnings. Only through the spirit of such later writings might one be able to apprehend retrospectively what is valid and permanent in the earlier writing. As it is, these papers are negated, canceled out, obliterated by the artistic production of this valiant and struggling woman. Up until February 1906, she somehow insistently clung to being 'worthwhile and likable' ['mit Werth lieblich,' literally, 'with validity lovable,' i.e., to count for something artistically but at the same time continue to be domestically and socially 'acceptable']. This phrase which she applied to herself could stand as a motto for the entire packet of letters and notebooks. But it is precisely for that reason that we would be doing her memory an injustice if we wished now to recall and fix it permanently under this motto, ten years after her departure. Concerned, indeed, worried, about being charming and gracious, but at the same time fundamentally obligated to being so, indeed promoting these qualities in the face of the frequently coarse conditions of her life, Paula caused a certain compromising nature to take hold of and activate her responses. In the ultimate and absolute sense, most of what she wrote is not truthful; rather it is adapted to a way of living in which agreeableness and graciousness were the decisive qualities. Even about death, even about the grave, [her writing] still had this same half-outward conditioning. But in order that her art attain the heights to which it aspired, emanating as it did from this earnest and heartfelt condition, a basic transformation had to take place. In her very late writings there is only the merest handful of passages that gives us a taste of this change. It is in her work, the work of that ultimate, abundant year, that she attained the fulfillment which in the end decisively wins us over to her. It was then that a 'validity' finally commanded her attention that no longer depended on her own scale of measurements; and so far as [personal] charm and grace were concerned, only a quite unguarded and involuntary remnant of them was now left to be transformed from emotional involvement into the shape of her art. And so there arose out of desperation and hope, out of unconditional self-liberation, that incomparable work of hers to which she surrendered concern about validity and grace, in order that they now might be truly metamorphosed. Whenever one evokes the name of Paula Becker, one has implicitly to assert that in the power of her later work she produced an extraordinarily personal style, and one will never come closer to this 'personal' essence than by realizing that it resides in that most astonishing tension between validity and grace. For precisely in the middle, between a validity already remote from her and a newly entered state of liveliness, already grown modest, there stands and endures her pure, free, sacrificial achievement.

"I remain convinced, as thoroughly as I ever was, about Paula Modersohn's creative significance, and at the same time I am excluded from being the editor of these papers which you expectantly placed in my hands. For even at the moment that the greatest image of her comes alive within me, how in that very moment am I to bring myself to put together and then promote an inferior and tentative image?

"It is not with an easy heart that I retreat before this eagerly anticipated task. Again and

again I have tested myself with these papers and hesitated returning to your maternal care an undertaking which, as you know, touched and obligated me in the deepest possible way. But as you see, I must do it, in spite of everything...."

More than half a year later Rilke wrote to his Insel Verlag publisher and friend, Anton Kippenberg, to whom, after Rilke declined it, the editorship and publication of the letters and journals had been suggested. In these letters, from the summer of 1917, the poet further tries to elucidate his position and opinions in this vexed and difficult matter. "After much thought and hesitation I finally decided last winter not to edit the written remains of Paula Becker; indeed, I advised Frau Becker to abandon altogether the idea of such an edition." Kippenberg was concerned that still-living persons might somehow be hurt or offended by things PMB had written. But in Rilke's view this was no cause for concern. The seeming "indiscretions" committed by "so young a person" were much too harmless and tentative for that, he thought; and he continues: "If only the manuscript *did* contain things that, so to speak, resided on the far side of indiscretion, beyond indiscretion, greater, riper, more mature judgments. But it never reaches that point. It may be that writings from the later years were removed (possibly by Paula B. herself); or it may simply be that her final years were too short to permit any articulation whatsoever alongside the breathless progress of her art—in any case, only such [written] proof of pure achievement would be able to place those early journals and letters within the light and law of the life which by the time it came to its end had become indescribably more than the written remains, such as we have them, can begin to suggest.

"My principal argument against their publication is this: that they depreciate rather than enhance the already tenuous image and understanding of her art which, as it is, is scattered and has never been exhibited or described in its totality. The most beautiful letters are those that were published years ago in the *Güldenkammer*. They develop certain lines of honest emotion, congeniality, joy, and melancholy, and emphasize the dominant theme: work, which is evident almost from the beginning. Yet even taken together they still do not amount to so much as a prelude to this life. For where do they give us a glimmer of the fact that this accommodating creature who so compliantly and cooperatively devoted herself to familial harmony would later, seized by the passion of her task and renouncing all else, take upon herself a life of loneliness and poverty? ... Quite apart from her development as a human being, how is one supposed to gather from [these documents] that we are dealing with the painter, the artist, who... with ever greater decisiveness welcomed the influence of... van Gogh, Gauguin, Cézanne, the appearance of Maillol, indeed probably even of Matisse and Henri Rousseau, and who in her increasingly bold artistic production even anticipated on occasion the work of the followers of these painters in Germany [the Expressionists]...."

This is not the place to analyze Rilke's obviously complex and ambiguous feelings in this matter nor the question of his desire to avoid being identified with what he perceived to be an inadequate and perhaps uncomfortable project. Prior questions, more pertinent and probably difficult to resolve with full assurance, are these: Just what was sent to Rilke in Munich in the way of letters and journals? Who decided on the contents of the "packet"? Did he see more, or less, than what was eventually put into the hands of S. D. Gallwitz and published in the first edition of the *Briefe und Tagebuchblätter* [*Letters and Leaves from the*

Journals]? Is one correct in reading into these letters to Frau Becker and Kippenberg, Rilke's suspicion that documents were being or would be withheld?

One thing is certain. There is an enormous amount in the present volume that Rilke would never have been permitted to see and much that he could not have seen under any circumstances, since it was not in the hands of the family at the time. How far would the collection of documents, as it now stands, have gone in providing Rilke with the material he so sorely missed? It is unlikely, for example, that Rilke saw any of the letters to Carl and Martha Hauptmann or to Heinrich and Martha Vogeler or to Otto Modersohn after Paula had left him.

Without question there are a number of journal pages and letters that have been lost, but it is unlikely that any of them contained the sort of disquisitions on art and artists that Rilke sought in vain. Paula herself felt little desire to write about her work in the abstract. As she wrote her sister Milly on February 21, 1907, "You say you are sad that I don't write you about my work. Dear Milly, art is difficult, infinitely difficult. And sometimes one doesn't want to talk about it at all." When she did wish to talk or theorize about art, her style and manner were at a great remove from Rilke's. In writing to Otto on March 3, 1903, about Rilke's monograph on the painters of the Worpswede colony she alludes appropriately to the Sermon on the Mount, "It becomes clearer to me by the day that this is not the right way or manner to write about art. Let your way of speaking be a simple 'Yea, yea' or 'Nay, nay.' He knows nothing about that."

<div style="text-align: right">

A. S. W.

C. C. H.

</div>

Biographical Outline

1876	Born February 8, in Dresden, Germany.
1888	Becker family moves to Bremen.
1892	Stay in England; first instruction in drawing and painting.
1893–95	Seminary for women teachers in Bremen; instruction with the painter Bernhard Wiegandt.
1895	First confrontation with work of the Worpswede Colony in the Bremen Kunsthalle.
1896	Takes part in a course at the Drawing and Painting School of the Society of Berlin Women Artists; in the fall begins a two-year training course at this school. Teachers: Jacob Alberts and Jeanna Bauck. Summer, trip to Hindelang with stopover in Munich.
1897	July and August, first stay in Worpswede. Early October, visit to Dresden. November, trip to Berlin.
1898	March and April, international exhibition of lithographs at the Berlin Gewerbemuseum with works by Puvis de Chavannes, Manet, Renoir, Toulouse-Lautrec, Munch, and so forth. April, trip to Leipzig; visit to Klinger's atelier. June and July, trip to Norway.
1898–99	Stay in Worpswede, instruction with Mackensen; beginning of friendship with Clara Westhoff.
1899	August, trip to Switzerland, return via Munich, Nuremberg, Leipzig (to see Clara Westhoff), and Dresden (German Art Exhibition). December, exhibition of several of her studies at the Bremen Kunsthalle; devastating review by Arthur Fitger.
1900	January to June, first stay in Paris; study at the Académie Colarossi. Teachers: Courtois, Collin, Girardot. Discovery of paintings by Cézanne at Vollard. Paris World Exposition; Charles Cottet and the sculpture of Rodin. Correspondence with Otto Modersohn; visit by the Worpsweders to Paris. Return to Worpswede; new lodgings with Hermann Brünjes in Ostendorf. End of August, Carl Hauptmann and Rainer Maria Rilke come to Worpswede. September 12, engagement to Otto Modersohn.
1901	January–February, stay in Berlin to attend cooking school. Short visit to Dresden. Frequent visits with Rilke. Böcklin's paintings. May 25 — married to Otto Modersohn; wedding trip to Berlin, Dresden, Schreiberhau, Prague, Munich, Dachau. November, death of her father.
1902	Alienation from the Rilkes.
1903	February–March, second stay in Paris. Hayashi Collection of Japanese art. Visit to Rodin at Paris atelier and in Meudon. Fayum portraits, Rembrandt, Classical antiquities. July, trip to the Frisian island of Amrum with Otto and Elsbeth.
1904	Summer trip to Dresden, Kassel, Braunschweig (Rembrandt).
1905	February–April, third trip to Paris. Constant companionship with her sister Herma. Life drawing at the Académie Julian. Acquaintanceship with the Norwegians Johan and Ellen Bojer. March, death of her mother-in-law. Visits to

the ateliers of Vuillard and Denis; meets Maillol. Otto Modersohn, Milly Becker, and the Vogelers in Paris; visits with them to Rodin at Meudon; the Gauguins in the Collection Fayet; Salon des Artistes Indépendants with retrospective shows of Seurat and van Gogh; Matisse. Beginning of November, excursion to Westphalia with visits to the Folkwang Museum in Hagen; acquaintanceship with the Osthaus family. Christmas, Rilke sees the work of Paula Modersohn-Becker. PB plans for another return to Paris. End of year, visit to Carl Hauptmann in Schreiberhau; meeting with Werner Sombart and Otto Mueller. To Dresden and Berlin (Kaiser Friedrich Museum, Centennial Exhibition).

1906 February 23, leaves Worpswede and Otto for Paris. Encounters with Maillol and Ellen Key. Middle of April, first visit with Bernhard Hoetger. Short trip to Brittany. About May 4, Hoetger in PMB's atelier. The weeks of her most intensive work (portraits of Rilke and Lee Hoetger). Whitsuntide, Otto Modersohn in Paris. October, Otto Modersohn comes to Paris for the winter. November, review by Gustav Pauli of PMB's works on exhibition at the Bremen Kunsthalle. Christmas and New Year, short visit by PMB and OM to Bremen.

1907 March, sees the Cézannes in the Collection Pellerin. Return to Worpswede with Otto. July, short visit with the Hoetgers in Holthausen.

November 2, birth of daughter Mathilde (Tille).

November 20, death due to embolism.

NOTES ON THE ILLUSTRATIONS

The illustrations in this text have in part a documentary function and were not always chosen to illustrate the quality of PMB's paintings and drawings. Their selection was often made on the basis of works, persons, and places mentioned in the letters and journals. More detailed information about the works of art illustrated here can be found by the interested reader in the Bibliography.

In the notes that follow, reference to paintings and drawings by PMB is to be assumed unless otherwise indicated. In the case of paintings only, the support or ground (canvas, board, slate), and not the medium is given. PMB used true oil paint only very rarely, having done most of her "oils" in the Wurmsche Öltempera, an oil tempera manufactured by the Wurm Company. Without a precise chemical analysis it is very difficult to be certain about the exact media which she used. Height is always given before width. In the case of drawings, the size of the full sheet is given. All measurements are given in centimeters. We do not always distinguish between signatures on the works in PMB's own hand and those which were added ("inscribed") by Otto Modersohn after her death. Dating has been done either on the basis of dates given by the artist on the work itself; in the absence of that information, by deducing an exact or an approximate date from the letters and journals; or by placing it in the context of other dated works clearly done in the same period. In certain cases where no close dating has been possible we have given only an approximate date (viz., "ca."). The notations Pauli and Bremen '76 refer respectively to the catalog by Gustav Pauli, *Paula Modersohn-Becker*, 3d edition, and the catalog to *Paula Modersohn-Becker zum 100. Geburtstag*, Bremen Kunsthalle, and the Paula Becker-Modersohn-Haus, Böttcherstrasse, Bremen (from February 8 to April 4, 1976).

These notes are divided into two sections: illustrations in the body of the text and numbered illustrations which are in unpaginated groups.

Illustrations in the Body of the Text

Page 61 Picture postcard to her father, postmarked July 30, 1896
 Watercolor, 9 cm × 14 cm
 Inscribed: "Cherries at the ear, cherries in the tummy, / all of us thank you from our hearts."
 Left to right: Tony Rohland, Marie Hill, Paula Becker
 Private collection, Berlin

Page 153 *Three Horses Harnessed in Tandem*, Paris, ca. 1906
 Charcoal, 21.8 cm × 29.5 cm
 Sketchbook XV, 27
 Graphisches Kabinett Wolfgang Werner, Bremen

Page 172 Picture postcard to her mother, postmarked March 1, 1900
 Watercolor and ink, 8.7 cm × 13.9 cm
 Inscribed: "Picture Puzzle/Solution: Your daughter with decoration. In the *Concours* I won the medal."
 Private collection, Berlin

"Here she paints a piping child / in the midst of the cruel, howling cold wind."
Charcoal and pencil, 17.7 cm × 20 cm
"The lady painter with her picture / She steps along like a wild one."
Charcoal and pencil, 17.7 cm × 17.7 cm
Paula paints two children by a birch tree
Charcoal, 30.2 cm × 22.8 cm
The Estate

Page 399 Compositional studies, Paris, 1906
Pencil, 24 cm × 31 cm
Upper left: *Woman with Cat and Parrot*. Pauli, 34
Lower left: *Standing Woman*. Böttcherstrasse, Bremen.
Upper right: The left-hand figure has close connection with the *Composition with Three Female Figures*, in which the center figure is a self-portrait (see illus. no. 42) and with the *Self-Portrait in the Nude*. Pauli, 1a
Kunsthalle, Bremen

Page 399 Sketch of PMB's last atelier in Paris, 49, boulevard Montparnasse; on the envelope of a letter from Herma Becker to Otto Modersohn, postmarked Basel, December 30, 1906
See note to the letter of January 29, 1907
Pencil, 11.2 cm × 14.5 cm
On the wall are sketches of paintings she was working on in 1906. *On the left*: *Woman with Cat and Parrot*, Pauli, 34. *On the right*: *Mother and Child*. (See illus. no. 43.)
The ladder leads to a storage loft which Herma sometimes used as a place to sleep when she was visiting. (Cf. Hetsch, p. 18.)
The Estate

Numbered Illustrations

1. Self-Portrait on green background with blue irises, ca. 1905.
 Canvas, 40.7 cm × 34.5 cm
 Pauli 10a, Bremen 76, no. 175
 Private collection
2. The Becker family in the garden of their home, Schwachhauser Chaussee 29, ca. 1893. *Left to right*: Herma, Paula, Edmund Schäfer, Lili Stammann, Mother, Father, ?, Milly, ?, Henner
 The Estate
3. The father, Carl Woldemar Becker, ca. 1895
 The Estate
4. The mother, Mathilde Becker, with the twins, Henry (called Henner) and Herma, ca. 1890. Property of Eva Weinberg
5. Apple tree, wall hanging, ca. 1900
 215 cm × 70 cm
 Colors: background, natural; fruits, reddish brown and light brown; outlines, blue

Using a design by Paula Becker, Marie Bock had this woven by Fräulein Höbel. See letter of April 8, 1900.
Private collection, Hamburg

6. Paula Becker's first atelier in Paris, 1900, at 9, rue Campagne Première
7. Entrance to the Académie Julian, 31, rue du Dragon, which (according to information given Hans Hermann Rief by Clara Rilke-Westhoff in 1951) PMB also attended.
8. Class for women pupils of painting at the academy run by Philippo Colarossi.
 From an illustration in an article on "Lady Art Students' Life in Paris," Clive Holland, *Studio*, vol. 30, no. 129 (1903), p. 224
9. Paula Modersohn-Becker in Otto Modersohn's studio, Worpswede, 1901
 The Estate
10. Paula Modersohn-Becker's studio with the skylight.
 Photograph taken in 1911; in the Worpswede Archives
11. Paula Becker and Clara Westhoff in the former's studio, probably at the home of the tailor Ranke, ca. 1900
 On the wall, the charcoal drawing *Old Poorhouse Woman*, ca. 1899
 The Estate
12. Rainer Maria Rilke in his workroom in Westerwede, 1901
 On the wall, a painting by Otto Modersohn, and at the left a reproduction of Böcklin's *Songs of Spring*, 1876
 The Worpswede Archives
13. Clara Westhoff
 Bust of Paula Becker, 1899
 Plaster of Paris, polychromed, 47 cm in height
 Signed l. r. on the base: "C. Westhoff"
 (The second important work by Clara Westhoff at Worpswede)
 Cohrs Collection, Worpswede
14. Heinrich Vogeler
 Summer Evening (Concert at the Barkenhoff), 1905
 Left to right: Paula Modersohn-Becker, Agnes Wulff, Otto Modersohn, Clara Rilke-Westhoff, Martha Vogeler, Martin Schröder, Heinrich Vogeler, Franz Vogeler
 Oil on canvas, 175 cm × 310 cm
 Signed l. r.: "HVW 1905"
 Formerly the painting was mounted in a white architectural framework with a triangular Greek pediment. Between pairs of pilasters stood statues: on the left the poet Anacreon, on the right the poet Sappho. The whole was raised to the height of a few steps by a 90-cm base.
 Ludwig Roselius Collection, Grosse Kunstschau, Worpswede
15. Outside the Barkenhoff, exterior view of the right hand side, ca. 1904
 On the lintel is Rilke's blessing for the Vogeler house: "Licht sei sein Loos, ist der Herr nur das Herz und die Hand des Bau's, mit den Linden im Land wird auch sein Haus schattig und gross" ["May light be its destiny; if only the Lord and Master is the heart and the hand of its building, then his house will also be shaded and great with the linden trees on its land"].
 Left to right: Herma Becker, Philine Vogeler, Otto Modersohn, Heinrich Vogeler

with his daughter, Martha Vogeler, Elsbeth Modersohn, Carl Weidemeyer (?) obscured by Paula Modersohn-Becker
The Estate

16. Paula, Otto, and Elsbeth Modersohn in the Vogelers' garden.
Photograph by Martha Vogeler, ca. 1904
The Estate

17. Paula Modersohn-Becker in her studio at the Brünjes' home (in what Rilke called her "Lily atelier"), Worpswede, ca. 1905

18. Paula Modersohn-Becker and Elsbeth, ca. 1902
The Estate

19. Paula Modersohn-Becker with her daughter Mathilde shortly before the artist's death, November 1907
Photograph probably by Hugo Erfurth (see note to letter of PB's mother to Milly, November 5, 1907)
The Estate

20. *Self-Portrait with Amber Necklace*, ca. 1906
Canvas, 60 cm × 50 cm
Pauli, 4
Provinzialmuseum, Hannover; confiscated in 1937 as "degenerate" and auctioned by Fischer in Lucerne (Switzerland), June 30, 1939, lot no. 97
Kunstmuseum, Basel

21. *View from the Artist's Atelier in Paris*, 1900
Artist's board, 48.7 cm × 37.3 cm
Dated l. r.: "Paris 1900"
Inscribed l. r.: "PMB"
Bremen '76, no. 18
Kunsthalle, Bremen

22. *Birch Tree Trunks*, ca. 1900
Artist's board, 50 cm × 40 cm
Inscribed l. l.: "PMB"
Private collection

23. *Girl Playing Horn in a Birch Woods*, 1905
Canvas, 110.4 cm × 90.2 cm
Inscribed l. l.: "PMB"
Pauli, 21; Bremen '76, no. 153
Ludwig Roselius Collection, Böttcherstrasse, Bremen

24. *Elsbeth*, 1902
Artist's board, 89 cm × 71 cm
Pauli, 39; Bremen '76, no. 71
Ludwig Roselius Collection Böttcherstrasse, Bremen

25. *Head of a Girl at a Window*, ca. 1902
Slate, 39.3 cm × 49 cm
Pauli, 104; Bremen '76, no. 69
Private collection

26. *Still Life with Venetian Mirror*, 1903
 Artist's board, 46.5 cm × 49.2 cm
 Dated l. r.: "03"
 Pauli, 209; Bremen '76, no. 105
 Private collection

27. *Still Life with Apples and Bananas*, ca. 1905
 Canvas, 67 cm × 84 cm
 Inscribed l. r.: "PMB"
 Pauli, 193; Bremen '76, no. 159
 Kunsthalle Bremen

28. *Self-Portrait with Camellia Branch*, 1907
 Artist's board, 62 cm × 30 cm
 Inscribed l. l.: "PMB"
 Pauli, 3; Bremen '76, no. 199
 Folkwang Museum, Hagen (from 1922 in Essen). Confiscated in 1937 as "degenerate art"; returned to museum in 1957

29. Paul Cézanne
 Still Life with Apples and Oranges, 1895–1900
 Oil on canvas, 73 cm × 92 cm
 Venturi, *Cézanne* (Paris, 1936), no. 732
 Louvre, Paris

30. Mummy portrait of Irene, from Fayum, ca. A.D. 40
 Encaustic on wood
 Württembergisches Landesmuseum, Stuttgart (formerly collection of Theodor Graf, Vienna)

31. *Otto Modersohn with Pipe*, ca. 1906–7
 On panel, 70 cm × 47.2 cm
 Bremen '76, no. 84 (with different dating)
 Private collection

32. *Portrait of Herma Becker*, 1906
 Canvas, 57.5 cm × 51.5 cm
 Bremen '76, no. 171
 Private collection

33. *Portrait of Rainer Maria Rilke*, June 1906
 Artist's board, 32.3 cm × 25.4
 Inscribed l. l.: "PMB"
 Pauli, 116; Bremen '76, no. 172
 Ludwig Roselius Collection, Böttcherstrasse, Bremen

34. *Portrait of Werner Sombart*, ca. 1906
 Canvas, 50 cm × 46 cm
 Pauli, 84b; Bremen '76, no. 173
 Kunsthalle, Bremen

35. *Portrait of Clara Rilke-Westhoff*, fall 1905
 Canvas, 52 cm × 36.8 cm
 Pauli, 85; Bremen '76, no. 161
 Kunsthalle, Hamburg

36. *Self-Portrait with a Red Rose*, ca. 1905
 Artist's board, 65.5 cm × 46 cm
 Pauli, 2b; Bremen '76, no. 134
 Private collection
37. *Old Poorhouse Woman*, ca. 1906–7
 Canvas, 96 cm × 80.2 cm
 Pauli, 27; Bremen '76, no. 178
 Ludwig Roselius Collection, Böttcherstrasse, Bremen
38. *Old Peasant Woman with Hands Crossed at Her Breast*, ca. 1906–7
 Canvas, 75.5 cm × 57.5 cm
 Pauli, 38
 Formerly Kunsthalle, Hamburg; confiscated as "degenerate" in 1937
 Detroit Institute of Arts (Gift of Robert Hudson Tannahill)
39. *Self-Portrait with Blue and White Striped Dress*, 1906
 Canvas, 49 cm × 26.6 cm
 Pauli, 6
 Ludwig Roselius Collection, Böttcherstrasse, Bremen
40. *Self-Portrait with Hat and Veil*, ca. 1906
 Canvas, 67.5 cm × 57.5 cm
 Pauli, 2; Bremen '76, no. 166
 The Haagsche Gemeentemuseum, Hague
41. *Self-Portrait on Her Fifth Anniversary*, May 15, 1906
 Artist's board, 101.5 cm × 70.2 cm
 Scratched into the paint l. r.: "This I painted in my 30th year on my 5th wedding
 anniversary PB"
 Pauli, 1b; Bremen '76, no. 195
 Ludwig Roselius Collection, Böttcherstrasse, Bremen
42. *Composition with Three Female Figures*; in the middle, a self-portrait, 1907
 Artist's board, 110 cm × 74 cm
 Inscribed l. l.: "PMB"
 Pauli, 139
 Location unknown (according to Heise [see Bibliography, 1961] it was destroyed)
43. *Sleeping Mother and Child*, 1906
 Canvas, 82 cm × 124.7 cm
 Inscribed l. l.: "PMB"
 Pauli, 144; Bremen '76, no. 207
 Ludwig Roselius Collection, Böttcherstrasse, Bremen
44. *Nude Girl with Vases of Flowers*, 1907
 Canvas, 89 cm × 109 cm
 Inscribed l. l.: "PMB"
 Pauli, 29; Bremen '76, no. 209
 Von der Heydt-Museum, Wuppertal
45. *Mother and Child*, ca. 1906–7
 Canvas, 113 cm × 74 cm
 Pauli, 141; Bremen '76, no. 211
 Ludwig Roselius Collection, Böttcherstrasse, Bremen

46. *Still Life with Sunflower and Hollyhocks*, 1907
Canvas, 90 cm × 65 cm
At the time of the artist's death this was on her easel and was one of her final works.
Pauli, 184; Bremen '76, no. 212
Kunsthalle, Bremen

Checklist of Exhibitions

Compiled by Wolfgang Werner
(With additions by A.S.W. and C.C.H.)

Listed below are the four exhibitions in which PMB was represented during her lifetime (there was no one-woman show while she was alive), all exhibitions devoted solely to her work from 1908 to 1982, and all important group shows in which works by the artist were included.

1899 BREMEN. Kunsthalle. 2 paintings and 7 studies.

1906 BREMEN. Kunsthalle. 4 paintings in the exhibition devoted to the artists of Worpswede.

1907 BERLIN. Galerie Gurlitt. Exhibition of Worpswede artists as in the Bremen Kunsthalle, 1906, above.
WORPSWEDE. Kunst- u. Kunstgewerbehaus. 1 still life in an exhibition of Worpswede artists.

1908 WORPSWEDE. Kunst- u. Kunstgewerbehaus. "Paula Modersohn-Becker," paintings; first retrospective exhibition after her death.
BREMEN. Kunsthalle. PMB, 47 paintings.

1909 DRESDEN. Galerie Arnold. PMB, paintings, together with Emile Bernard.
BERLIN. Salon Paul Cassirer. PMB, 44 paintings.

1913 HAGEN. Folkwang Museum. PMB, paintings and drawings. Catalog: Curt Stoermer, first installment of projected oeuvre catalog (unfinished), Worpswede, 1913.
MUNICH. Neuer Kunstsalon (P. F. Schmidt and M. Dietzel). PMB, paintings and drawings; catalog as in Hagen, 1913, above.
JENA. PMB, paintings and drawings; catalog as in Hagen, 1913, above.
ELBERFELD. In the private house of Baron von der Heydt. PMB, paintings and drawings; catalog as in Hagen, 1913, above.
BREMEN. Kunsthalle. PMB, 129 paintings, 47 drawings, 8 etchings.

1914 HAMBURG. Galerie Commeter. PMB, paintings and drawings.

1916 BERLIN. Salon Paul Cassirer. PMB, paintings, together with Pauline Kowarzik and Bernhard Hoetger.

1917 HANNOVER. Kestner-Gesellschaft. PMB, 119 paintings, 11 drawings, 9 etchings. Catalog.

1919 BERLIN. Graphisches Kabinett I. B. Neumann. PMB, paintings, together with Lyonel Feininger. Catalog with no checklist.

1920 BREMEN. Kunsthalle. PMB, 120 paintings.
HANNOVER. Galerie von Garvens. PMB, 19 paintings, drawings, etchings, together with James Ensor. Catalog.

1922 BERLIN. Kronprinzen-Palais. PMB.
DRESDEN. Galerie Emil Richter. PMB, paintings and drawings.

1923 BREMEN. Graphisches Kabinett. PMB, about 12 paintings, together with Oskar Kokoschka.

1924	BERLIN. Galerie Goldschmidt & Wallerstein. PMB, drawings.
1925	HAMBURG. Kunstverein. PMB and Bernhard Hoetger.
	OLDENBURG. Landesmuseum. PMB, 28 paintings, 7 drawings, 6 etchings. Catalog.
1926	KASSEL. Kunstverein. PMB.
	STUTTGART. Kunstkabinett Baumgarten. PMB, paintings and drawings.
	DRESDEN. Galerie Emil Richter. PMB, 25 paintings, 1 watercolor, 62 drawings, 6 etchings. Catalog.
1928	BERLIN. National Galerie. "Neuere Deutsche Kunst aus Berliner Privatbesitz." PMB, 8 paintings, together with artists from "Die Brücke," "Der Blaue Reiter," and the Bauhaus; also Emil Hansen-Nolde, Oskar Kokoschka, Ernst Barlach, and Wilhelm Lehmbruck. Catalog.
	DUSSELDORF. Galerie Flechtheim. PMB.
1929	BERLIN. Galerie Ferdinand Möller. PMB, paintings and drawings. Catalog with no checklist.
1934	HANNOVER. Kestner-Gesellschaft. PMB, 90 paintings, 30 drawings, 10 etchings. Catalog.
	BERLIN. Galerie Nierendorf. PMB.
1936	BASEL. Kunsthalle. PMB, 46 paintings, 1 watercolor, 15 drawings, together with August Macke. Catalog.
1947	BREMEN. Kunsthalle. PMB, 115 paintings, 136 drawings, 2 sketchbooks, 11 etchings. Catalog.
	COLOGNE. Galerie Dr. Werner Rusche. PMB, 17 paintings, 1 watercolor, 8 drawings. Checklist.
1948	BERN. Kunsthalle. PMB and the painters of "Die Brücke," 15 paintings by PMB. Catalog.
	CELLE. At the Castle. PMB, 29 paintings, 1 watercolor, 1 drawing, together with Otto Modersohn. Catalog.
1949	OLDENBURG. Galerie Schwoon. PMB, 25 paintings, together with Clara Rilke-Westhoff. Checklist.
	BREMEN. Graphisches Kabinett GmbH. PMB, 14 paintings, watercolors, drawings.
1950	HANNOVER. Kunstverein. "Friedliche Kunst, Niederdeutsche Maler 1900–1914." PMB, 39 paintings, 16 drawings, together with Leopold von Kalckreuth, the older Worpswede painters, August Macke et al. Catalog.
1951	HANNOVER. Kestner-Gesellschaft. PMB, 45 paintings, 20 drawings, together with Gabriele Münter. Catalog.
	HAGEN. Karl-Ernst-Osthaus-Museum. PMB, 69 paintings, 40 drawings, 9 etchings. Catalog.
1952	THE HAGUE. Gemeentemuseum. PMB, 50 paintings, 78 drawings, 11 etchings. Catalog.
	HAMBURG. Galerie M. Grabo-Stevenson. PMB, 20 paintings, 10 drawings. Catalog.
	HAMBURG. Kunstverein. PMB, paintings and drawings.
1954	BREMEN. Graphisches Kabinett GmbH. PMB, 12 paintings, 52 drawings.
	MUNICH. Galerie Wolfgang Gurlitt. PMB, 94 drawings, together with

James Ensor and Oskar Kokoschka.

WUPPERTAL. Kunst- und Museumsverein. PMB, 47 paintings, studies, drawings, together with Bernhard Hoetger. Catalog.

1957 BREMEN. Paula Becker-Modersohn-Haus, Böttcherstrasse. Memorial exhibition, fiftieth anniversary of PMB's death, 83 paintings, 159 drawings, 10 etchings. Catalog.

MUNICH. Städtische Galerie im Lenbachhaus. PMB, loan exhibition from the Paula Becker-Modersohn-Haus, Böttcherstrasse, Bremen, 1957, as above. Catalog.

NEW YORK. The Museum of Modern Art. "German Art of the Twentieth Century." PMB, 2 paintings, 2 etchings. Catalog.

1958 MANNHEIM. Städtische Kunsthalle. PMB, loan exhibition from the Paula Becker-Modersohn-Haus, Böttcherstrasse, Bremen, 1957, as above. Catalog.

DUSSELDORF. Kunstverein für die Rheinlande und Westfalen. PMB, loan exhibition from the Paula Becker-Modersohn-Haus, Böttcherstrasse, Bremen, 1957, as above. Catalog.

NEW YORK. Galerie St. Etienne. PMB, 19 paintings, 4 drawings, 4 etchings. Catalog.

GRONINGEN. Groningen Museum. PMB, 39 paintings, 25 drawings, 7 etchings. Catalog.

1959–60 LUBECK. Behnhaus. PMB, 65 paintings, 35 drawings, 9 etchings. Catalog.

1960 BERLIN. Haus am Lützowplatz. PMB, 58 paintings, 62 drawings, 9 etchings. Catalog.

1961 DUSSELDORF. Galerie Alex Vömel. PMB, 5 paintings, 26 drawings. Checklist.

1963 FRANKFURT. Steinernes Haus. PMB, 55 paintings, 40 drawings. Catalog.

1968 BREMEN. Graphisches Kabinett, U. Voigt. PMB, 10 paintings, 62 drawings, 10 etchings. Catalog, with oeuvre catalog of the prints.

1969 LUDINGHAUSEN. Nordkirchen Castle. PMB, 20 paintings, 7 drawings, 8 etchings, together with Otto Modersohn et al. Catalog.

1971 BREMEN. Graphisches Kabinett Wolfgang Werner. PMB, 12 paintings, 3 gouaches, 16 drawings. Catalog.

1971–72 NEW YORK. La Boetie. PMB, 4 paintings, 28 drawings, 12 etchings. Checklist.

1972 MUNICH. Galerie Gunzenhauser. PMB, 15 paintings, 13 drawings. Checklist.

BREMEN. Graphisches Kabinett Wolfgang Werner. PMB, the graphic work: preparatory sketches and drawings, together with all prints in all stages. Catalog, including revised oeuvre catalog of the graphic works.

1973 BREMEN. Paula Becker-Modersohn-Haus, Böttcherstrasse. PMB, drawings and etchings from the collection.

1974 WORPSWEDE. Kunsthalle. PMB, the graphic work: preparatory sketches and drawings, together with all prints in all stages. Together with the graphic work of Heinrich Vogeler and Fritz Overbeck. Catalog as in Bremen, 1972.

1975 FRANKFURT. Kunstkabinett. PMB, 18 paintings, 33 drawings, 13 etchings. Catalog.

1976	BREMEN. Kunsthalle and Paula Becker-Modersohn-Haus, Böttcherstrasse. PMB, Centennial Retrospective ("Paula Modersohn-Becker, zum 100. Geburtstag. Gemälde, Zeichnungen, Graphik"). 212 paintings, 170 drawings, 2 sketchbooks, 13 etchings, together with documentation: PMB's thematic material, examples of influential sources. Catalog.
	WUPPERTAL. Von der Heydt-Museum. "Paula Modersohn-Becker zum hundertsten Geburtstag," 102 paintings, 66 drawings, 13 etchings. Catalog.
	ZURICH. Galerie Kornfeld. PMB, 34 drawings, 10 etchings. Catalog.
	HAMBURG. Ernst-Barlach-Haus. "Paula Modersohn-Becker zum hundertsten Geburtstag." Paintings. Catalog as in Bremen, 1976 (selection of paintings from the major exhibition there).
	HAMBURG. Kunstverein. PMB, 242 drawings, pastels, sketches, and etchings. Catalog.
1977	FRANKFURT. Kunstverein. PMB, loan exhibition from Hamburg Kunstverein, 1976, as above. Catalog.
	ZURICH. Kunsthaus. PMB, loan exhibition from Hamburg Kunstverein, 1976, as above, with the addition of 17 drawings and 21 paintings. Catalog.
	COLOGNE. Kunstverein. PMB, loan exhibition from Hamburg Kunstverein, 1976, as above, with the addition of 17 drawings and 18 paintings. Catalog.
	LOS ANGELES AND BROOKLYN. Los Angeles County Museum and Brooklyn Museum. "Women Artists: 1550–1950." PMB, 4 paintings, 1 drawing. Catalog.
1978	NEW YORK. La Boetie. "Three German Artists' Colonies, 1890–1914: Worpswede, Moritzburg, Murnau." PMB, 4 paintings, 5 drawings, 5 etchings. Illustrated brochure.
	WILLIAMSBURG, VIRGINIA, AND CHAPEL HILL, NORTH CAROLINA. College of William and Mary and Ackland Memorial Art Center. "Arthur Strauss and the German Expressionists." PMB, paintings, together with works by Wilhelm Lehmbruck, Franz Marc, Oskar Kokoschka, and Christian Rohlfs.
	LENINGRAD. Hermitage. "German Painting, 1890–1918." PMB, paintings, together with many other German artists. Exhibition later shown at the Pushkin State Museum, Moscow, and the Städelsches Kunstinstitut, Frankfurt. Catalog.
1979	WELLESLEY, MASSACHUSETTS. Jewett Arts Center (Wellesley College Museum). PMB, 9 paintings, 4 drawings, 1 etching, together with Auguste Rodin's *Burghers of Calais*. With the exception of the etching, this private collection of PMB's paintings and drawings was here exhibited for the first time as a group.
1979–80	LONDON. Royal Academy of Arts. "Post-Impressionism. Cross-Currents in European Painting." PMB, 3 paintings, cat. nos. 261–63, illustrated with 1 color plate and 2 illus. The same exhibition at the National Gallery, Washington, D.C., 1980.
1980	NEW YORK. La Boetie. "Pioneering Women Artists: 1900–1940." PMB, 3 drawings. Brochure.
1980–81	NEW YORK. The Solomon R. Guggenheim Museum. "Expressionism, A German Intuition 1905–1920." PMB, 5 paintings, 1 drawing. Catalog.

BREMEN. Graphisches Kabinett Wolfgang Werner. "Paula Modersohn-Becker, 1876–1907, Gemälde, Aquarelle, Zeichnungen, Druckgraphik." PMB, 32 paintings, 49 drawings, 4 pastels, 4 watercolors, 12 prints, 2 stereo-monotype transfers from oil self-portrait. Catalog.

1981 SAN FRANCISCO. San Francisco Museum of Modern Art. "Expressionism, A German Intuition 1905–1920." As above, 1980–81, New York.

1982–83 BREMEN. Kunsthalle. "Paula Modersohn-Becker—Die Landschaften." Landscapes, 1899–1902. Catalog.

Bibliography of Works on Paula Modersohn-Becker

Compiled by Wolfgang Werner
(With additions by A.S.W. and C.C.H.)
All entries are arranged according to the year of publication.

1. Books and Monographs

(Important exhibition catalogs are included)

1913 Stoermer, Curt. *P. Becker-Modersohn, Katalog ihrer Werke. Gemälde, Studien, Zeichnungen und Radierungen.* Worpswede: Horenverlag, 1913, 16 pp., with 6 illus. This is the first fascicle installment of a planned oeuvre catalog. Additional fascicles, though announced, never appeared. This installment catalogs 77 paintings, 45 drawings, and 9 etchings.

1919 Pauli, Gustav. *Paula Modersohn-Becker.* 1st ed. Leipzig: Kurt Wolff Verlag, 1919, 92 pp., with 1 color plate and 58 illus. Includes a catalog of 260 paintings, 10 etchings, and a summary catalog of the important drawings. 2d enlarged ed., Munich, 1922; text partially changed. In this edition the oeuvre catalog has been enlarged to include 50 additional paintings and changes in ownership are cited. 3d ed., Berlin [1934]; dedicated to Ludwig Roselius. The catalog in this edition has been further enlarged to embrace 26 more paintings (total now 336). The catalog of etchings now includes 11 plates, for 2 of which the various states are given. The summary identification by name of the large drawings was here omitted. Identification of ownership given only for museums.

 Uphoff, C. E. *Paula Modersohn.* 1st ed. With an essay by Bernhard Hoetger. "Junge Kunst," vol. 2. Leipzig: Klinkhardt & Biermann, 1919, 15 pp., with 1 color plate and 32 illus.

1925 Frank, Hans. *Meta Koggenpoord.* Novel, 535 pp. Stuttgart-Heilbronn: Walter Seifert Verlag, 1925. Roman à clef about Paula Modersohn-Becker.

1927 Biermann, Georg. *Paula Modersohn.* With an essay by Bernhard Hoetger, "Erinnerungen an Paula Modersohn." "Junge Kunst," vol. 2; 16 pp., with 1 color plate and 32 illus. Leipzig and Berlin: Klinkhardt & Biermann, 1927. This is essentially a revised edition of the 1919 Uphoff book, with text by Georg Biermann and new illus.

 Die Paula Becker-Modersohn Sammlung des Ludwig Roselius in der Böttcherstrasse in Bremen. Catalog edited by Walter Müller-Wulckow. Bremen: Angelsachsen-Verlag [May 1927], 42 pp., with 17 illus.

 Tegtmeier, Konrad. *Paula Modersohn-Becker. Eine kleine Lebensgeschichte.* With five unpublished letters to Martha and Heinrich Vogeler. Bremen: Angelsachsen-Verlag [1927], 20 pp., with 4 illus.

1932	*Paula Modersohn-Becker. Ein Buch der Freundschaft.* Edited by Rolf Hetsch. Berlin: Rembrandt-Verlag, 1932, 112 pp., with 75 illus. Contributions to this In Memoriam book are by Herma Becker-Weinberg, Otto Modersohn, Heinrich Vogeler, Ottilie Reyländer-Böhme, Fritz Mackensen, Clara Rilke-Westhoff, Rudolf Alexander Schröder, Rolf Hetsch, Helene Nostitz, Emil Waldmann, Hildegard Roselius, Maria Paschen, Albrecht Schaeffer, and Manfred Hausmann, as well as Rilke's "Requiem, An eine Freundin," 1908.
1947	*Meisterbilder. Paula Modersohn-Becker.* With an introduction by Manfred Hausmann. Biberach an der Riss: Kunstverlag Walter Blüchert [1947], portfolio, 8 pp., with 2 illus. and 10 loose-leaf color plates.
1949	Busch, Günter. *Paula Modersohn-Becker. Handzeichnungen.* Bremen: Angelsachsen-Verlag, 1949, 24 pp., with 2 illus., and 40 plates with 46 illus.
1957	Augustiny, Waldemar. *Paula Modersohn-Becker. Ein Gedenkblatt.* Bremen: Carl Schünemann [1957], 16 pp., with 1 color plate and 2 illus.
	Petzet, Heinrich Wigand. *Das Bildnis des Dichters. Paula Modersohn-Becker und Rainer Maria Rilke. Eine Begegnung.* Frankfurt: Societäts-Verlag, 1957, 206 pp., with 7 color plates and 5 illus. New, revised edition: Petzet, H. W. *Das Bildnis des Dichters. Rainer Maria Rilke, Paula Modersohn-Becker. Eine Begegnung.* Frankfurt: Insel Taschenbuch, 1976, 180 pp., with 8 color plates and 16 illus.
1958	Stelzer, Otto. *Paula Modersohn-Becker.* Berlin: Rembrandt-Verlag, 1958, 120 pp., with 16 color plates and 72 illus.
1959	Seiler, Harald. *Paula Modersohn-Becker.* Munich: Bruckmann, 1959, 36 pp., with 7 illus. in text and 32 plates.
1960	Augustiny, Waldemar. *Paula Modersohn-Becker.* Gütersloh: Sigbert Mohn Verlag, 1960, 48 pp., with 19 illus.
	Busch, Günter. *Paula Modersohn-Becker. Aus dem Skizzenbuch.* Munich: Piper-Verlag, 1960, 64 pp., with 41 illus.
1961	Heise, Carl Georg. *Paula Becker-Modersohn, Mutter und Kind.* "Werkmonographien zur bildenden Kunst," no. 62. Stuttgart: Philipp Reclam jun., 1961, 32 pp., with 17 illus.
1968	Werner, Wolfgang. *Paula Modersohn-Becker, Radierungen — Œuvreverzeichnis.* 24 pp., with 16 illus. This catalog of the etchings is part of the general catalog: *Paula Modersohn-Becker, Gemälde, Zeichungen, Œuvreverzeichnis der Graphik.* Bremen: Graphisches Kabinett U. Voigt, 1968. Expanded edition of this catalog: Werner, Wolfgang. *Paula Modersohn-Becker, Œuvreverzeichnis der Graphik.* Bremen: Graphisches Kabinett Wolfgang Werner, 1972, 28 pp., with 18 illus.
1971	Augustiny, Waldemar. *Paula Modersohn.* Hildesheim: August Lax, 1971, 38 pp., with 2 color plates and 8 illus.
1976	*Kunsthalle Bremen und Böttcherstrasse Bremen, Katalog der Ausstellung Paula Modersohn-Becker zum hundertsten Geburtstag.* Bremen: Kunsthalle and Böttcherstrasse, 1976, 372 pp., with 32 color plates, 79 illus., and 33 documentary illus. This centennial exhibition catalog includes 212 paintings, 170 drawings, 2 sketchbooks, 13 etchings, and 133 examples of artwork from PMB's formative environment. Edited by Günter Busch, Gerhard Gerkens,

Anne Röver, Bernhard Schnackenburg, Jürgen Schultze, and Annemarie Winther. Republished partially and in different format as catalog for the somewhat reduced exhibition in the Von der Heydt-Museum by the Kunst- und Museumsverein, Wuppertal, 1976.

Kunstverein in Hamburg. Katalog der Ausstellung Paula Modersohn-Becker. Zeichnungen, Pastelle, Bildentwürfe. Hamburg: Kunstverein, 1976, 150 pp., with 107 illus., and 19 illus. in small format. This catalog includes 241 draw- ings. Contributions by Günter Gerkens, Christa Murken-Altrogge, Anne Röver, Uwe M. Schneede, and Wolfgang Werner.

Wachtmann, Hans Günter. *Paula Modersohn-Becker, Kommentare zur Sammlung, Heft I.* Wuppertal: Von der Heydt-Museum, 1976, 56 pp., with 1 color plate and 23 illus.

1977 Murken-Altrogge, Christa. *Paula Modersohn-Becker, Kinderbildnisse.* Munich and Zurich: R. Piper & Co. Verlag, 1977, 64 pp., with 12 color plates and 21 illus.

1978 Puvogel, Edgar H. *Paula Becker-Modersohn. Bilder aus der Sammlung Rosel- ius.* Lilienthal: Worpswede Verlag, 1978, portfolio, 2 pp., with 8 loose-leaf color plates.

Werner, Wolfgang. *Paula Modersohn-Becker. Die Radierungen.* Lilienthal: Worpswede Verlag, 1978, portfolio, 2 pp., with 11 loose-leaf plates. All etch- ings are reproduced here in their original size. The text follows that of the *Œuvreverzeichnis der Graphik* of 1968 but is somewhat shortened.

1979 Perry, Gillian. *Paula Modersohn-Becker. Her Life and Work.* London: The Women's Press, 1979, 149 pp., with 25 color plates and 96 illus.

1980 Murken-Altrogge, Christa. *Paula Modersohn-Becker, Leben und Werk.* Co- logne: DuMont Buchverlag, 1980, 128 pp., with 37 color plates and 127 illus.

Paula Modersohn-Becker, 1876–1907, Gemälde, Aquarelle, Zeichnungen, Druckgraphik. Catalog for exhibition at Graphisches Kabinett Kunsthandel Wolfgang Werner, Bremen, December 7, 1980, to January 31, 1981, 60 pp., with 34 color plates and 64 illus.

Paula Modersohn-Becker, Porträt-Zeichnungen. Lilienthal: Worpswede Ver- lag, 1980, unbound portfolio, 2 pp., with 10 plates, 4 of them in color.

Perry, Gillian. *Paula Modersohn-Becker. Her Life and Work.* New York: Harper & Row, 1980, 149 pp., with 25 color plates and 96 illus.

1981 Busch, Günter. *Paula Modersohn-Becker, Malerin, Zeichnerin.* Frankfurt: S. Fischer Verlag, 1981, 204 pp., with 49 color plates and 172 illus.

II. Articles in Periodicals and Anthologies

(Not included are articles from general surveys of twentieth-century art
or material in encyclopedias and dictionaries, with the exception of
several basic American studies of the development of Expressionism.)

1909 Steudel, Friedrich. "Zweierlei Kunst." *Das Blaubuch,* vol. 4, no. 2 (January 1909), pp. 43–45; and no. 3, pp. 70–75.

1911 Märten, Lu. "Paula Modersohn-Becker." *Frauen-Zukunft,* vol. 2, no. 5 (1911), pp. 383–91.

1913 Pauli, Gustav. "Paula Modersohn-Becker. Ein Vortrag zur letzten Ausstellung ihres künstlerischen Nachlasses." *Die Güldenkammer,* vol. 4, no. 2 (November 1913), pp. 92–96.

Stoermer, Curt. "Paula Becker-Modersohn." *Die Güldenkammer,* vol. 3, no. 6 (March 1913), pp. 378–80.

———. "Paula Modersohn." *Der Cicerone,* vol. 5, no. 16 (August 1913), p. 593. The same essay, slightly expanded, under the title, "Das Schicksal der Werke Paula Modersohns" in *Die Güldenkammer,* vol. 4, no. 1 (October 1913), pp. 65–67.

1914 Stoermer, Curt. "Paula Modersohn." *Der Cicerone,* vol. 6, no. 1 (1914), pp. 7–15, with 10 illus.

1918 Küppers, P. E. "Paula Modersohn (In Memoriam)." *Das Kunstblatt,* vol. 2, no. 2 (1918), pp. 65–74, with 4 illus.

Löhnberg, Dr. [Emil]. "Paula Modersohn." *Die Aktion. Wochenschrift für Politik, Literatur und Kunst,* vol. 8, nos. 9–10 (March 1918), pp. 126–27.

1919 H., B. [Hoetger, Bernhard]. "Paula Modersohn-Becker." *Genius,* vol. 1, First Book (1919), pp. 34–38, with 1 color plate and 3 illus. The same article in *Die Böttcherstrasse,* entitled "Weltbild der Frau," vol. 1, no. 5 (September 1928), pp. 6–7, with 1 color illus.

Schapire, Rosa. "Paula Modersohn-Becker." *Kunstchronik und Kunstmarkt,* vol. 54, n.s., 30, no. 41 (July 25, 1919), pp. 865–67.

Uphoff, Carl Emil. "Paula Modersohn." *Der Cicerone,* vol. 11, no. 17 (September 1919), pp. 535–44, with 10 illus. The same article in *Jahrbuch Der Jungen Kunst,* vol. 1 (1920), pp. 128–40, with 14 illus. (Text and several of the illus. identical to Uphoff, "Junge Kunst," vol. 2 [1919].)

Westheim, Paul. "Paula Modersohn-Becker: *Alter*" (etching). *Die Schaffenden,* vol. 1, folio 1 (1919). The etching by PMB, entitled *Age,* is on the second page of the four pages of text accompanying the publication of this folio series of original graphic works.

1920 Schaeffer, Albrecht. "Paula Modersohn." *Das Hohe Ufer,* vol. 2, no. 7 (1920), pp. 99–105.

1921 Scheffler, Karl. Review of the two books, *Paula Modersohn-Becker* by Gustav Pauli, and *Paula Modersohn-Becker. Briefe und Tagebuchblätter. Kunst und Künstler,* vol. 19, no 9 (1921), pp. 331–32.

1922 Biermann, Georg. "Paula Modersohns Stilleben mit Blumen im blauen Krug." *Der Cicerone,* vol. 14, no. 8 (April 1922), pp. 336–37, with 1 illus. The same essay in *Jahrbuch Der Jungen Kunst,* vol. 3 (1922), under the title "Ein Blumenstilleben der Paula Modersohn," pp. 60–61, with 1 illus.

Gallwitz, S. D. "Dreissig Jahre Worpswede" (pp. 7–52) and "Paula Modersohn-Becker. Von Worpsweder Leuten" (pp. 72–75, with 7 illus.). *Dreissig Jahre Worpswede.* Bremen: Angelsachsen-Verlag, 1922.

1923 Behne, Adolf. "Paula Modersohn und der Übergang zur Bildkonstruktion." *Sozialistische Monatshefte,* 1923, pp. 294–99.

Schürer, Oscar. "Das Werk der Paula Modersohn-Becker. Mit zehn erstmalig

veröffentlichten Wiedergaben ihrer Bilder." *Der Cicerone,* vol. 15, no. 18 (September 1923), pp. 813–26. The same essay in *Jahrbuch Der Jungen Kunst,* vol. 4 (1923), pp. 59–72.

1925 Biermann, Georg. "Zeichnungen der Paula Modersohn." *Monatshefte für Bücherfreunde und Graphiksammler,* vol. 1, no. 1 (January 1925), pp. 32–39, with 8 illus.

1926 Eulenberg, Herbert. "Paula Modersohn-Becker." In *Sterblich Unsterbliche.* Berlin: Verlag von Bruno Cassirer, 1926, pp. 114–25.

1927 Beaulieu, Heloise von. "Gespräch um Paula Modersohn." *Niederdeutsche Heimatblätter,* vol. 4 (July 1927), pp. 256–59, with 1 color plate and 2 illus.

Biermann, Georg. "Paula Modersohn." *Velhagen und Klasings Monatshefte,* vol. 41 (July 1927), pp. 487–96, with 8 color plates and 2 illus. Text identical to that in article in "Junge Kunst," vol. 2 (1927), with minor changes.

"Die Einweihung des Paula-Becker-Modersohn-Hauses." *Weser-Zeitung,* vol. 84, no. 68 (a supplement to issue of June 2, 1927), 4 pp., with 11 illus.

1928 Hegemann, Werner. "'Mendelssohn und Hoetger' ist nicht 'fast ganz dasselbe?' Eine Betrachtung Neudeutscher Baugesinnung." As part of the same article (pp. 423–24), "Paula Modersohn Als Malerin Und Bauherrin." *Wasmuths Monatshefte für Baukunst,* vol. 12 (1928), pp. 419–26.

Hildebrandt, Hans. *Die Frau als Künstlerin* ("Mit 337 Abbildungen Nach Frauenarbeiten Bildender Kunst Von Den Frühesten Zeiten Bis Zur Gegenwart"). Berlin: Rudolf Mosse Buchverlag, 1928, pp. 113 (with 1 illus.), 117, and 119–21 (with 4 illus.).

Hoetger, Bernhard. See 1919.

1929 Hoetger, Bernhard. "Erinnerungen an Paula Modersohn." *Die Tide. Niederdeutsche Heimatblätter,* vol. 6, no. 7 (July 1929), pp. 267–73, with 1 color plate and 5 illus. Text identical to "Junge Kunst," vol. 2, *Paula Modersohn.* Leipzig and Berlin: Klinkhardt & Biermann, 1927.

1930 Eberlein, Kurt Karl. "Paula Becker-Modersohn: Selbstbildnis." *Das Kunstblatt,* vol. 14, no. 4 (1930), pp. 110–11, with 1 illus.

Roselius, Ludwig. "Rede zur Einweihung des Paula-Becker-Modersohn-Hauses 1927." In Walter Müller-Wulckow, *Das Paula-Becker-Modersohn-Haus. Führer und Plan.* Bremen: Angelsachsen-Verlag, 1930, pp. 3–17.

1932 Roselius, Ludwig. "Rede zur Einweihung des Paula-Becker-Modersohn-Hauses 1927." In *Reden und Schriften zur Böttcherstrasse in Bremen.* Bremen: von Halem, 1932, pp. 41–53, with 1 color plate.

1934 "Paula Modersohn-Ausstellung. Zur Zeit in der Galerie Nierendorf in Berlin." *Die Kunst der Nation,* vol. 2, no. 24 (December 2, 1934), pp. 3–4, with 3 illus.

Thorwald, [?]. "Paula Modersohn-Becker." *Die Kunst der Nation,* vol. 2, no. 8 (April 15, 1934), pp. 3–4, with 1 illus.

1935 "Bremer Böttcherstrasse heute noch zeitgemäss?" *Das Schwarze Korps,* August 21, 1935, 2 pp., with 9 illus.

1938 Vogeler, Heinrich. "Paula Modersohn-Becker," *Das Wort,* vol. 3, no. 11 (1938), pp. 115–28.

1947 Märten, Lu. "Paula Modersohn-Becker." *bildende kunst,* vol. 1, no. 2 (1947), pp. 11–14, with 3 illus.

1951–52 Busch, Günter. "Die Worpsweder." *Westermanns Monatshefte*, vol. 92, no. 1 (1951–52), pp. 50–53.

1952 Pfeilstücker, Suse. "Paula Modersohn-Becker." In *Reichtum des Lebens. Ein Buch für junge Mädchen*. Düsseldorf: Hoch-Verlag, 1952, pp. 22–33.

1957 Haftmann, W.; Hentzen, A.; and Liebermann, W. S. *German Art of the Twentieth Century*. New York: The Museum of Modern Art, 1957. Entry on PMB, pp. 27–32, with 1 color plate and 1 illus.

Myers, Bernard S. "Paula Modersohn-Becker." In *The German Expressionists, a Generation in Revolt*. New York: Frederick A. Praeger, 1957, pp. 53–58, with 2 color plates and 5 illus. German edition: *Malerei des Expressionismus, eine Generation im Aufbruch*. Cologne: DuMont Schauberg, 1957.

Selz, Peter. "Regionalism, Worpswede, and Paula Modersohn-Becker." In *German Expressionist Painting*. Berkeley, Los Angeles, London: University of California Press, 1957, pp. 39–47.

Z., L. [Zahn, Leopold]. "Paula Becker-Modersohn." *Das Kunstwerk*, vol. 11, nos. 5–6 (November–December 1957), pp. 72–76, with 5 illus.

1958 Busch, Günter. "Paula Modersohn-Becker." *Die Kunst und Das Schöne*, vol. 56, no. 9 (June 1958), pp. 333–35, with 1 color plate and 6 illus.

1959 Payne, E. H. *"An Old Peasant Woman Praying* by Paula Modersohn-Becker." *Bulletin of the Detroit Institute of Arts*, vol. 39, no. 1 (1959), pp. 20–21.

1960 Haftmann, Werner. "Paula Modersohn, Zur Entstehung der modernen Malerei in Norddeutschland." *Die Zeit*, January 12, 1948. Reprinted in *Skizzenbuch. Zur Kultur der Gegenwart. Reden und Aufsätze*. Munich: Prestel-Verlag, 1960, pp. 174–76.

Heise, Carl Georg. "Paula Modersohns Wiederkehr, 1957." In *Der Gegenwärtige Augenblick. Reden und Aufsätze aus vier Jahrzehnten*. Berlin: Verlag Gebr. Mann, 1960, pp. 156–58. Reprint of exhibition review in *Die Zeit*, October 17, 1957.

1961 Leonhardi, K. "Fünf Zeichnungen aus dem Besitz der Kieler Kunsthalle." *Nordelbingen*, vol. 30 (1961), pp. 141–50.

Schmalenbach, Fritz. "Paula Modersohns Selbstbildnis mit dem Kamelienzweig." *Der Wagen 1961. Ein Lübeckisches Jahrbuch*, pp. 106–8, with 1 illus. The same essay in Schmalenbach, F., *Studien über Malerei und Malereigeschichte*. Berlin: Verlag Gebr. Mann, 1972, pp. 88ff. Also in *Neue Zürcher Zeitung*, January 15, 1961.

1965 Küppers-Sonnenberg, G. A. "Zwei Künstler—Zwei Menschen, Paula Modersohn-Becker und Heinrich Vogeler." *Sontraer Gesundheitsbote*, vol. 19, no. 3 (May 1965), pp. 3–8.

1966 Bruggen, Coosje van. "De Betekenis van Worpswede en Parijs voor de Kunst van Paula Modersohn-Becker." Dissertation, Groningen, 1966. 47 pp.

1967 Chabert, Philippe. "Le peintre Paula Modersohn-Becker." Dipl. d'études sup. *L'information d'histoire de l'art*, May 12, 1967, pp. 228–30.

1969 Petzet, Heinrich Wigand. "Paula Becker-Modersohn." *Der Schlüssel. Zeitschrift für Wirtschaft und Kultur*, no. 2 (May 1969), pp. 20–23, with 1 illus.

1972 Canaday, John. "An Adventurous Woman's Works: A Modersohn-Becker Exhibition Is Held." *The New York Times*, January 1, 1972. Review with 1 illus.

Mellow, James R. "Nature Served Them Both Well." *The New York Times,* January 16, 1972. Review.

Schmalenbach, Fritz. See 1961.

Vernarelli, Lucia. "Paula Modersohn-Becker." *Woman and Art,* 1972, p. 10, with 4 illus.

1973 Busch, Günter. "Über Gegenwart und Tod—Edvard Munch und Paula Modersohn-Becker." Henning Bock and Günter Busch, eds. *Edvard Munch, Probleme—Forschungen—Thesen.* Munich: Prestel-Verlag, 1973, pp. 161–76, with 1 color plate and 13 illus. The same essay in Busch, Günter. *Hinweis zur Kunst. Aufsätze und Reden.* Hamburg: Dr. Ernst Hauswedell & Co., 1977, pp. 138–45, with 2 illus.

Werner, Alfred. "Paula Modersohn-Becker: A Short Creative Life." *American Artist,* vol. 37 (June 1973), pp. 16–23, 68–70, with 14 illus.

1973–74 Davidson, Martha. "Paula Modersohn-Becker: Struggle Between Life and Art." *The Feminist Art Journal,* Winter 1973–74, 4 pp., with 6 illus.

1974 Murken-Altrogge, Christa, and Murken, Axel Hinrich. "Kinder, Kranke, Alte und Sieche: Symbole menschlicher Hinfälligkeit und Grösse. Medizinisches im künstlerischen Werk von Paula Modersohn-Becker." *Deutsches Ärzteblatt,* vol. 71, no. 18 (May 1974), pp. 1354–59, and no. 19 (May 1974), pp. 1433–37, with 9 illus.

1975 Munsterberg, Hugo. *A History of Women Artists.* New York: Clarkson N. Potter, 1975. Article on PMB, pp. 68–70, with 1 illus.

Murken-Altrogge, Christa. "Der französische Einfluss im Werk von Paula Modersohn-Becker." *Die Kunst und das Schöne Heim,* vol. 87, no. 3 (March 1975), pp. 145–52, with 8 color plates and 4 illus.

1976 Bode, Ursula. "Leben—ein kurzes Fest. Auf der Suche nach sich selbst: Paula Modersohn-Becker." *Westermanns Monatshefte,* July 1976, pp. 24–36, with 8 color plates and 3 illus.

Böttcher, Cordella. "Paula Modersohn-Becker. 'Du lebst, du Glückliche, lebst intensiv: du malst!'" *Die Christen-Gemeinschaft,* vol, 48, no. 3 (March 1976), pp. 84–88.

Bürklin, H. Review of the 1976 Bremen exhibition. *Pantheon,* vol. 34 (July 1976), p. 244.

Busch, Günter. "Paula Modersohn-Becker und die Malerei ihrer Zeit." *Europäische Hefte,* vol. 3, no. 4 (1976), pp. 70–81, with 4 color plates and 4 illus. In French and German.

Flemming, Hanns Theodor. "Paula Modersohn-Becker In Neuem Licht." *Weltkunst,* vol. 46, no. 21 (November 1, 1976), p. 2110, with 2 illus.

Hecht, Axel. "Rebellin aus dem Moor. In Bremen wird die grösste Ausstellung mit Bildern von Paula Modersohn-Becker gezeigt." *Stern,* vol. 29, no. 7 (February 6–12, 1976), pp. 125–27, with 5 color illus.

Kandt-Horn, Susanne. "Ich wollte den Impressionismus besiegen." *Bildende Kunst,* vol. 24, no. 2 (1976), pp. 83–85, with 6 illus.

Kipphoff, Petra. "Der unbeschreiblich angeeignete Gegenstand." *Die Zeit,* February 20, 1976. Review article about the 1976 Bremen exhibition, with 1 illus.

See German newspaper indexes for the many other reviews and articles in conjunction with the 1976 Bremen exhibition.

Oppler, Ellen. "Paula Modersohn-Becker: Some Facts and Legends." *Art Journal,* vol. 35, no. 4 (1976), pp. 364–69, with 6 illus.

Parthes, Paul. "Paula Becker-Modersohn. Una documentación radiofónica con motivo del centenario del nacimiento." *Humboldt,* vol. 16, no. 59 (1976), pp. 34–49, with 4 color plates and 8 illus.

Petersen, Karen, and Wilson, J. J. *Women Artists: Recognition and Reappraisal from the Early Middle Ages to the Twentieth Century.* New York: Harper & Row, 1976. Entries on PMB, pp. 2–3 (with 3 illus.), p. 104, and pp. 108–11 (with 5 illus.).

Rudloff, Dieter. "In Einfachheit gross werden. Zum 100. Geburtstag von Paula Modersohn-Becker." *Die Kommenden,* vol. 30, no. 6 (1976), pp. 11–14.

Schneider, Norbert. "Das Problem der 'wahren' Wirklichkeit im Werk der Paula Modersohn-Becker." In *Kritische Berichte.* Giessen: Anabas Verlag, 1976, pp. 67–75.

Sello, Gottfried. "Geschichte einer Emanzipation." *Die Zeit,* October 15, 1976. Review article.

———. "Malerinnen (1) Paula Modersohn-Becker." *Brigitte,* December 30, 1976, with 1 color plate and 3 illus.

Weichardt, Jürgen. "Bremen huldigt Paula Modersohn-Becker." *Weltkunst,* vol. 46, no. 7 (April 1, 1976), pp. 592–93, with 3 illus.

Winter, Peter. "Paula Modersohn-Becker." *das kunstwerk,* vol. 29, no. 2 (March 1976), pp. 42–43.

1977 Blocher, Heidi. "On Paula Modersohn-Becker." *Woman Art,* vol. 1, no. 4 (Spring–Summer 1977), pp. 13–17, with 6 illus.

Busch, Günter. See 1973.

Galichon, Eugène. Review article about the 1976 Bremen exhibition. *Gazette des Beaux-Arts,* series 6, vol. 89 (April 1977), supplement 28.

Harris, Ann Sutherland, and Nochlin, Linda. *Women Artists: 1550–1950.* Catalog of exhibition at Los Angeles County Museum and Brooklyn Museum. New York: Alfred A. Knopf, 1977. Entry on PMB, pp. 273–80, with 5 illus.

Hesse-Frielinghaus, Herta. "Paula Modersohn-Becker im Folkwang-Museum Hagen." *Westfalen,* vol. 55, nos. 1–2 (1977), pp. 181–85, with 1 illus.

Wernery, Toja. "Paula Modersohn-Becker 1876–1907." *Künstlerinnen international 1877–1977.* Exhibition catalog. Berlin, 1977, pp. 14–20, with 6 illus., and p. 145, with 1 illus.

1978 Hamm, Ulrike. *Studien zur Künstlerkolonie Worpswede 1889–1908 unter besonderer Berücksichtigung von Fritz Mackensen.* Dissertation, Munich, 1978, 211 pp., with 58 illus. Entry on PMB, pp. 51–59, with 8 illus.

Murken-Altrogge, Christa. "'…zu sehen wie weit man gehen kann…' Die bildnerische Selbsterfahrung Paula Modersohn-Beckers." *du. Europäische Kunstzeitschrift,* June 1978, pp. 8–10, with 5 color plates and 5 illus.

Röver, Anne. "Die Nachzeichnungen Paula Modersohn-Beckers." In *Niederdeutsche Beiträge zur Kunstgeschichte.* Vol. 16. Berlin: Deutscher Kunstverlag, 1978, pp. 201–14, with 11 illus.

1979	Schmidt, Gerlinde. "Paula Modersohn-Becker: Die Stilleben." Dissertation, Frankfurt, 1979.
	Weltge-Wortmann, Sigrid. "Paula Modersohn-Becker." *Die ersten Maler in Worpswede.* Lilienthal: Worpswede Verlag, 1979. Chapter on PMB, pp. 120–55, with 3 color plates and 19 illus.
1980	Conti, Rita Calabrese. "Paula Becker. Tra Pittura e Letteratura." *Communità,* no. 181 (1980). Università degli studi di Palermo.
	The Letters and Journals of Paula Modersohn-Becker. Translated and annotated by J. Diane Radycki. Metuchen, N.J.: The Scarecrow Press, 1980, 344 pp., with 16 illus. This translation of the 1920 edition of *Die Briefe und Tagebuchblätter* contains a series of introductions and notes, together with an introduction by Alessandra Comini, a translation of Rilke's "Requiem, An eine Freundin," and a poem by Adrienne Rich, "Paula Becker to Clara Westhoff."
	Urban, Martin. "The North Germans: Paula Modersohn-Becker, Christian Rohlfs, Emil Nolde." In *Expressionism, A German Intuition.* New York: The Solomon R. Guggenheim Foundation, 1980. Catalog for the exhibition of the same name held in New York and San Francisco, 1980–81. Entry on PMB, pp. 29–31, with 1 color plate and 4 illus.
1981	Schultze, Jürgen. *Worpswede.* Ramerding: Berghaus Verlag, 1981. Includes 9 color plates and 9 illus. of works by PMB.

INDEX OF LETTERS

Letters of Paula Modersohn-Becker to

Letters to Paula Modersohn-Becker from

Other Letters

INDEX

Grimm, Herman, 35, 86, 442n
Grimm, Jacob, 519n
Grimm, Wilhelm, 442n
Groos, Karl, 508n
Grube, Max, 69, 451n
Gruner, Mili, 530n
Gude, Hans, 451n
Guérin, Charles François Prosper, 512n
Guillaumin, Armand, 535n
Gurlitt, Annarella, 458n
Gurlitt, Fritz, 225, 405, 406, 458
Gurlitt, Wolfgang, 458n

Haby, François, 55, 448n
Hagen, Luise, 459n
Haider, Karl, 523n
Haken, Clara, 393, 395, 406, 527–29n
Hals, Frans, 379, 426, 536n
Hamsun, Knut (Knud Pedersen), 194, 481n
Hansen-Nolde, Emil. See Nolde, Emil
Hart, Heinrich, 235, 492n
Hart, Julius, 492n
Hartmann, Magda, 370, 376, 521n
Hartmann, Richard, 370, 376, 521n
Hauptmann, Adele, née Thienemann, 498n, 522n
Hauptmann, Agathe (Miezi), 379, 522n
Hauptmann, Carl, ix, 6, 134, 136, 148, 149,
 179, 198, 206, 212, 253, 259, 261–64,
 266–67, 279, 287–88, 309, 326, 334–36,
 343, 368–69, 379–80, 390–91, 394,
 402–03, 416, 423, 431–33, 448n, 467n,
 470n, 482n, 487n, 489n, 492n, 498n,
 503n, 509n, 519–20n, 522n, 533n, 541
Hauptmann, Georg, 498n, 522n
Hauptmann, Gerhart, 49, 51, 122, 126, 134,
 148, 149, 200, 225, 230, 232, 235, 236,
 238, 241, 260–62, 267, 268, 379, 446n,
 453n, 457n, 465n, 467n, 471n, 483n,
 489n, 490n, 492–93n, 520n, 524n
Hauptmann, Lotte, 379, 522n
Hauptmann, Margarethe, née Marschalk,
 483n
Hauptmann, Marie, née Straehler, 261
Hauptmann, Marie, née Thienemann, 379,
 483n
Hauptmann, Martha, née Thienemann, ix,
 212, 225, 262–64, 266–67, 278–79, 288,
 308–09, 326–27, 335–36, 379–80, 403,
 414, 416, 431, 433, 498n, 533n, 541
Hausmann, Ernst Friedrich, 65, 73, 75, 82,
 84, 450n
Heilbut, Emil, 367, 519n
Heine, Heinrich, 200
Hendrich, Hermann, 142, 469n
Henner, Jean-Jacques, 474n
Herder, Johann Gottfried von, 525
Hermann, Hans, 98, 459n
Herrosee, Karl Friedrich, 508n
Hesse, Friedrich, Landgrave of, 499n
Hetsch, Rolf, 51, 52, 432, 437n, 446n, 464n,
 467n, 469n, 472n, 475n, 480n, 497n,
 513n, 536–37n

Heydt, August von der, 513n
Heydt, Karl von der, 513n
Heymel Alfred Walter, 130, 360, 439n, 466n,
 467n, 517n
Heymel, Marguerite von (Gitta), née von
 Kühlmann, 360, 517n
Heyse, Paul, 443
Hildebrand, Adolf von, 332, 510n
Hill, Charles, 17, 19, 20, 22, 23, 25, 27,
 29–30, 32, 34, 35, 37, 438n, 439n
Hill, Marie, née Becker, 17, 20, 21, 22, 23,
 24, 28, 30, 31–36, 37, 38–39, 49, 53,
 75–76, 121, 130–31, 135–36, 137, 204,
 220, 256–57, 265–66, 271–72, 288–89,
 332, 337, 368, 438n, 439n, 449n, 468n,
 499n, 510n
Hirth, Georg, 451n
Höbel, Fräulein, 174, 476n
Hoch, Franz Xaver, 142, 469n
Hoenerbach, Margarethe, 64, 83–84, 450n,
 451–52n, 455n
Hoetger, Bernhard, 6, 344, 345, 392–95,
 398, 400, 403, 405–06, 408, 410, 414,
 416, 419–22, 431–32, 513n, 526–31n,
 533n, 535n, 537n
Hoetger, Helene (Lee), née Haken, 344, 395,
 398, 400, 403, 405–08, 410, 419–20,
 513n, 526–31n, 535n
Hofer, Carl, 418, 534n
Hofmann, Ludwig von, 458n
Hofmannsthal, Hugo von, 377, 522n
Hofmiller, Joseph, 466n
Hofstede de Groot, Cornelis, 518n
Holbein, Hans, the Younger, 86, 153, 318,
 456n, 471–72n
Hölderlin, Friedrich, 52, 133, 447n
Holitscher, Arthur, 479n
Holstein, Franz von, 442n
Holzamer, Richard, 447n
Hölzel, Adolf, 524n
Horneffer, Ernst, 139, 468n
Huch, Ricarda, 441n
Hugo, Victor, 310, 312, 314, 331, 352, 353,
 507n, 515n
Hurm, Frau, 44, 445n
Hurm, Johann Gustav Karl Wilhelm, 43, 44,
 444n

Ibels, Henri Gabriel, 476n
Ibsen, Henrik, 49, 133, 156, 200, 467n
Ingres, Jean Auguste Dominique, 311, 504n
Injalbert, Antoine, 303, 506n
Irving, Sir Henry (John Brodribb), 29–30,
 441n

Jacobsen, Jens Peter, 105, 106–07, 127–28,
 182, 211, 460n, 484n, 486n, 511n
Jammes, Francis, 507n
Janson, Ida C. W., 438n
Jawlensky, Alexej von, 531n
Johanne (Modersohn maid), 386, 388, 395,
 404, 420